BEFORE THE FLAMES

A Quest for the History of Arab Americans

BEFORE THE FLAMES

A Quest for the History of Arab Americans

by Gregory Orfalea

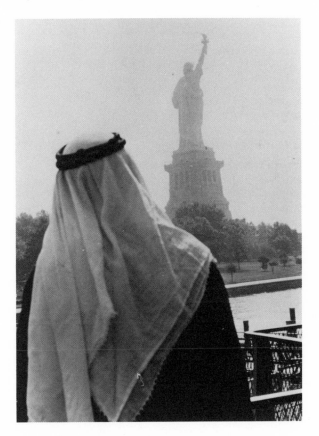

University of Texas Press ᗡ Austin

First Edition, 1988

Requests for permission to reproduce material from this work
should be sent to Permissions, University of Texas Press,
Box 7819, Austin, Texas 78713-7819.

*The publication of this book was assisted by a grant
from the Andrew W. Mellon Foundation.*

Library of Congress Cataloging-in-Publication Data
Orfalea, Gregory, 1949–
 Before the flames.

 Bibliography: p.
 Includes index.
 1. Arab Americans—History. I. Title.
E184.A65074 1988 304.8'73'0089927 87-19131
ISBN 0-292-70748-7

Title page: Aramco World Magazine; photographed by
Katrina Thomas.

To the memory of my father, Aref Joseph Orfalea, who taught me that success was not measured by power or wealth but in speaking the truth, and whose courage and love had—unlike life—no limits.

Contents

Preface

My interviews for this book were conducted—with some familial exceptions—over the period 1982–1986. I traveled to over twenty American cities, Beirut twice, and Syria once, subjecting over 125 individual Arab Americans—immigrants from three waves of migration as well as their relatives and descendants—to a battery of questions that ranged from their reasons for immigration to aspects of their lives in America. In some cases, I adhered strictly to a prepared list of twenty questions; in others, I varied the approach with a more informal discussion.

A majority of these interviews were tape-recorded, and most of those were transcribed. On occasion, due to a breakdown in equipment (I went through three recorders in the process), copious notes in journals had to suffice. Some of those interviewed did not want to be taped, preferring that I take notes. A few celebrities and others requested a review of the text, which I was glad to provide. (The transcriptions, tapes, and journals are in my possession.)

In all cases I attempted to interweave the oral history with research collected from secondary sources in libraries and in institutional and private collections.

The individuals that I interviewed were chosen for a variety of reasons. Some were prominent in their communities and in American public life (curiously, many of these had never before been interviewed about their ethnic background). Community leaders in turn referred me to those less "known" who might offer valuable testimony. Some were referred by a network of cousins spread out—not untypically—across America; some I stumbled upon quite by accident. In all cases, my intent was to interview people who evoked a broad spectrum of Arab American life, assuring regional, occupational, religious, ideological, and generational diversity.

Even in conducting opinion polls—which I did not do—the limits of "objectivity" are obvious. The individual questioner cannot at all times ask every question that should be asked; neither can the interviewee answer at a given moment every side of a question he or she would like to. History—to this more than casual, less than degreed historian and journalist—is often a murky subject, and the diversity of the Arab Americans assures their own history of more than the normal opaqueness. To pierce that opacity at least somewhat was my intention.

An ethnic community of two million offers many more colorful and instructive souls than those I was limited to by time, finances, and the vagaries of personal selection. To be sure, much of the material gleaned from my informants could not, for similar reasons, be incorporated into the final manuscript. A note about age references: Wherever possible, I have tried to avoid confusion caused by the time lapse between interview and publication regarding the age of those interviewed. The reader will note that, for the most part, an informant's date of birth is given to avert this problem. However, where age is noted, it is pegged to the date of the interview, given in the text or the notes.

The title of this book suggests a theme both chronological and spatial. The century-long history of Arab Americans culminates in the extremely traumatic 1982 invasion of Lebanon. Since a majority of Arab immigrants and their ancestors derive from Lebanon—or what was the Lebanon province of Syria—the virtual destruction of that country in over a dozen years of civil war, which peaked but sadly did not stop in the 1982 invasion and siege of Beirut, marks, to my mind, the end of an era. The flames that encircled Beirut form a terrible bracket. But a friend was not being entirely laconic when he asked, "Which flames?" His reaction led me to interpret the title as referring to the fact that Arab Americans and their ancestors always seem to be caught standing before flames, staring into the ruins, heartbroken, more or less powerless to help those in them, at best taking their loved ones or just themselves to a new world. Psychologically, even then, they stand before the flames and contemplate their meaning from a distance in America, certainly more safe than in Beirut but becoming less safe day by day as the fallout of America's Middle East policy draws ever closer to these shores.

Acknowledgments

This book is the result of the hopes, generosity, and sacrifices of a great many people too numerous to name here. But there are some whose constancy and aid need to be pointed to directly.

First and foremost, I want to thank Les Janka, former White House deputy press secretary, longtime Middle East expert, and friend, who secured the grant that allowed me to formalize research and begin to interview people in communities across the country. As well, I must acknowledge the purveyors of that grant, the American Middle East Peace Research Institute in Cambridge, Massachusetts. AMEPRI's executive director, Dr. Clifford Wright, was always a welcome facilitator.

Dr. John Duke Anthony, president of the National Council on U.S.-Arab Relations, furnished much-needed clerical assistance when the final manuscript was typed. His interest in my endeavors was unflagging.

The Institute for Contemporary Studies in San Francisco also provided a grant to help with the typing chores. Special thanks are due the institute's former chairman, Dr. Joseph Jacobs. The kindness of Dr. Albert Malouf and his wife, Nancy, I hold dearly.

At the Library of Congress, Dr. George Dimitri Selim of the Near East Section gave generously of his time, both in pointing out useful and rare texts and in transliterating Arabic words in my manuscript. The director of the Library's Near East Section, Dr. George Atiyeh, also helped with transliterations, as did specialist Fawzi Tadros. Over the years Clyde Mark of the Library's Congressional Research Service has been a most reliable, intelligent, and congenial source of information even beyond his specialty of the Middle East.

Many thanks are due Dr. Rudolph Vecoli, director of the Immigration History and Research Center of the University of Minnesota, and his capable staff, especially Stephanie Van D'Elden and Anne Bjorkquist, for opening the archives of the Philip K. Hitti Collection to me.

Dr. Eric Hooglund—mentor, guide, exacting critic—cannot be adequately thanked for suggesting the University of Texas Press, whose editors and other staff members have been unstinting in their aid and encouragement.

Catherine Williams of the Watkins-Loomis Agency was tireless and inspiring in her devotion to the manuscript. Her colleague Margaret Carlson also made a

steady contribution. Michael Kinsley, editor of the *New Republic,* pointed me in the right direction when it came time to find an agent.

John Dietsch must be singled out for his "cutting blade extraordinaire" taken to the manuscript when it was three times the current size, and for which I was ordered to shut my eyes. Barbara Burgess, confidant and companion in the early years in which this book was developed, deserves special thanks. Others who gave invaluable critical readings of all or part of the text were Daniel Goodwin, David Catron, Dr. Ann Bragdon Alkadhi, Robert Asahina, John Hildebrand, Dr. Nicholas Habib, Pablo Medina, Stephen Davies, Gary Fisketjon, Robert Hedin, and Naomi Shihab Nye.

Certain magazine editors who published parts of the manuscript (in a different form) must be thanked for their comments and criticism: Robert Fogarty (*Antioch Review* 42, no. 1 [Winter 1984], of which Chapter 6 is a revised version used by permission of the Editors); Joseph Bruchac (*Greenfield Review*); Michael Wall (*Middle East International* [London]); and the late Paul Hoye (*Aramco World Magazine*). Mr. Wall gave needed early encouragement that I expand my work into book form, as did Michael Hathaway, former staff director of the U.S. Senate Energy Committee. Omar Kader, former executive director of the American-Arab Anti-Discrimination Committee, published "The Mosque and the Prairie" in the ADC anthology *Taking Root* (vol. 2).

A number of people performed ably in transcribing the endless tapes of oral history: Dottie Smith, Eileen McKeone, Barbara Burgess, Robin Bourjaily, and Eileen Orfalea. Typing of the final manuscript was expertly managed by Denise Hahn, along with Denise Brooks, Michele Lalumia, Susan Lalumia, Sheila Williams, and Kathy Everhart.

My "secret sharers" of authorship, of course, are the many Arab Americans I interviewed across the land. To each and every one of them, heartfelt thanks (it was sad that a few of my informants of the older generation died before the book was finally published). Of special note for their indefatigable efforts in supplying me with leads, material, and a place to rest for the night were Michael Malouf, Anthony Bashir II, Edward Baloutine, Jeffrey Baloutine, Gary Awad, the Reverend Nicholas Saikley, Joseph Aossey, William Aossey, Abdeen Jabara, Charles Juma, Sr., the Reverend Nicholas Samra, Jean Abinader, Nabila Cronfel, Naomi Shihab Nye, Dr. Lois DeBakey, Raouf Halabi, Robert Laffey, and William Ezzy.

My deepest appreciation, naturally, is reserved for the four original immigrants who regaled my childhood ears with tales that became imprinted on my memory, namely, my grandparents: Aref Isper Orfalea and Nazera Jabaly Orfalea, Kamel Hanna Awad and Matile Malouf Awad. Grandmother Matile was especially helpful in securing interviews in Pasadena, and her porch, as the last chapter intimates, provided an enchanting respite and locus for my writing over the years.

I thank all those who entrusted their priceless photographs from family albums to me. Lila Awad, Jeannette Graham, Vernice Jens, Carmen Awad, and Nancy

Malouf were quite helpful in securing photographs from family strands through-out the country.

My mother, Rose Orfalea, managed, while working in her store seven days a week, to be one of the great "gold finders" in the photo hunt. Appreciation for her constant love and support cannot be adequately expressed. Likewise, that of my brother, Mark, and sister, Leslie. My father's imprint on this work needs no acknowledgment: it is self-evident throughout.

Finally, for her devotion, insight, patient good cheer, and love without which more than this book would be lost, I thank my wife, Eileen. Bringing two children into the world and a husband back from the brink of futility that dogged him in the six years of work on this book can only be regarded with something akin to awe.

BEFORE THE FLAMES

A Quest for the History of Arab Americans

Introduction

Los Angeles is my hometown, a real place—contrary to the popular myth fueled by diminutive Brahmins from the East. I was born within a mile of Angel's Flight downtown and grew up in Anaheim and Tarzana. On our block we were one of two Arab families, two Jewish, two Irish, and one Italian, for good measure. Between the Jewish and Arab families, who faced each other, footballs were fired in the street.

In the fifties nearly everyone in Los Angeles was building gardens and "landscaping," as it was called—dry lots dissolved into green oases. At night thousands of snails would ooze from the soil to feed on the tender shoots of dichondra, a ground cover popular then in California that did not have a blade like grass but a thin round leaf about the size of a collar button. It did not wear well, this dichondra, through baseball games of "pepper" on the lawn and the hordes of feeding snails. While planting hedges and birds-of-paradise, somehow the Rototiller that gave us bloody knuckles and tore up the soil also crushed, if we weren't careful, the newly planted mint. The Arabs call mint *naᶜnāᶜ*.

As a child I repeated the double negative over and over: *naᶜnāᶜ*, *naᶜnāᶜ*. And delicious mint with olive oil and raw lamb entered the nose, then the mouth. To call a favorite vegetable of an entire people by a negative was like saying *no* to all you loved and thereby expecting it to increase. Such was life. My mother's mother, who watched two brothers starve to death in the Lebanon mountain range during World War I, used to say, "Can't be no worse!" The shish kebab can't be no worse, the health of her favorite son can't be no worse, the flowers of her acacia tree can't be no worse.

Early lesson: the mint lush in America was also subject to a stray Rototiller (and flagstone and fancy cement borders). But a negative was a positive and a positive a negative. What you loved most "can't be no worse." Why? I wanted to learn about the world of such a strange language that called mint *naᶜnāᶜ* and why everyone was sad when *naᶜnāᶜ* was clipped halfway down the redolent leaf—like a butch haircut—by the new machine that drew blood from knuckles.

So, lost mint could be a reason for this book.

So could the blind great-grandfather who put his hands on my face when I was 9. I felt the trembling as if his hands had brought my heart into my face, and felt its beat there, right on the cheeks. His hands were veined ridges; his whitened

blue eyes searched the ceiling of his small apartment out back of Great Uncle Mike's house. They say Great-Jaddu (great-grandfather) Malouf liked me. What could be read from a nose that wasn't big yet, from a voice that was blessedly idiotic like the voices of all children reverent before the aged? Could he tell that I was afraid of him? I was afraid he would die in front of me, having heard he was close to 100. Or worse, that he would poke my eye out while searching my face for a clue to who I was. But they said, "This one likes stories." I was also the first grandson—the first born in California, with no stain of Ellis Island, or Atlantic Avenue in Brooklyn, or New York's Washington Street, an enclave in the New World where Arabs first peddled goods, worked in sweatshops, lived in tenements, and hung their own signs on stores. Needless to say, no stain of the tormenting Old World, either. There was no empty praise for the Old Country in my family; they feared it like a harpoon that was still seeking them out fifty years later with its sorrow.

Number two reason to write this book: fear that forced me forward into what I feared—my own people's past. To see and not be blind in the seeing.

The reasons mount without my knowing it. There were grand arguments on the porch of my grandparents in Pasadena into the hot night, and shoutings amid the snapping of aces on mosaic tables made of cedar, cherrywood, mahogany, olivewood. They were playing whist, or *basrah*. And of course *tāwilah*, or backgammon. Grandfather Awad, who directly descended from what is believed to be the first Arab immigrant family to the United States, in 1878, cries out, "Nasser will take what he must take! Give me a glass water, Matile!"

"Nasser will take the Suez Canal and sit on his people another one hundred years," spits ʿAmmu (uncle) Mike. "Get me a glass ʿaraq, Wardi!"

"Nasser go to the Roosian," quietly says ʿAmmu Assad. "Get me cup coffee, Noor."

All the while overseeing this card game on the packed porch and the debate over the fate of the Arab world is Great-Thatee (great-grandmother to us, but more correctly in Arabic *sitt*), smoking her *arjīlah*. (It would be an evening after the Orthodox Easter when small bags of sweetened barley and anise seeds and sugared almonds lie strewn on the porch floor.) I loved to hear the bubbles of Great-Thatee's hubble-bubble! She never argued, only pulled on the hose tip of the olivewood water pipe and emitted a smoke pure and clean from the rubber tube. No, this was not hashish (though later I found out that Grandfather had set burning marijuana leaves under his inhaling nose in the thirties to break up congestion from his emphysema). Great-Thatee, who was almost six feet tall, had a marvelous swirl of black-and-white hair like the topping of a licorice birthday cake, and was smoking a small overturned cup of tobacco. It was a clean smoke, I was told. She was a clean woman. I think the two sons she lost in the Lebanon mountains were bubbles in the glass belly of the *arjīlah*. She was playing with them, I am sure. But this was not something I thought then. Only later, at the end of a long journey seeking the heritage of Arab Americans.

The book, the search, was to be a tribute to the four grandparents—Kamel and Matile Awad, Aref and Nazera Orfalea—and all the immigrants like them who went on to spawn two million Americans of Arab descent. I was proud of their idiosyncrasies and courage, their foolhardiness and *joie de vivre*. They, like other immigrants, had added their color to America, but the color was known by so few. They kept it to themselves.

Kamel Awad lifts the apricot, which has the shape and feel in miniature of the torso of a beautiful woman. The color of the apricot skin is the color of a blush. He lifts it one day when I am about to enter teenage years and says, "Look how the birds have eaten this side." The pit has been pecked. But he turns it. And the other side is smooth, curved, delectable, and sensuous. "This side is why I came to America."

As I grew, I began to find more of the savaged side of the apricot. And my search had to tell of it.

The old ones took me by the jugular, with love. Very few had told their stories, except in passing. Like the Poor and Burning Arab in the short story of that title by William Saroyan, they too often sat drinking their demitasses of bitter, silent, communicating for hours this way, dusting off the lint from the pant leg and then one day dying. They were too involved with dissolving into America, disappearing, sinking like old coffee into the new soil. The Arabs are connectors of people, bridges, but they are also great hiders, vanishers. There is something savage they wish to forget. Instead of popping from the lamp of Aladdin, they jumped in willingly and stoppered it with the cork of America, because in America they could be what they are best—stubbornly, beautifully individual and lovers of family—without having to deal with the contest of nations on their native soil. But try as they might to avoid it, the oppressive present so far away somehow found them—in a headline, in news of a death, in a crumpled letter.

"Mad Ireland hurt you into poetry." This was said of W. B. Yeats by W. H. Auden. Substitute "Lebanon" for "Ireland" and say that Mad Lebanon hurt me into this history. And for Lebanon substitute as well Syria, Palestine—the entire Arab world hurts one into leaving or, in this case, penning some explanation of the reasons to come to America, to try to find a place, even in the snow, to plant a fig tree. (I am thinking just now of the uncanny 100-foot-long glass-encased planter in the solarium home of architect Karin Rihbany of West Roxbury, Massachusetts. It is filled, behind snow heaps up to the windows, with figs. Rihbany made the "impossible dream," figs in winter.)

If the Arabs hurt one into writing a history of the Arab Americans, what about the splinter state that has never quite "taken" or been absorbed into the Arab body politic as it persists in twisting and turning in the wound it originally made? In a way the Israelis have played a role the Greco-Egyptian poet C. P. Cavafy presents in his famous poem "Expecting the Barbarians." A decadent, bejewelled, flatulent Roman society awaits the barbarians with fear and expectation. But they do not come. The last two lines read: "And now what shall become of us without

any barbarians? / Those people were a kind of solution." The air in the Arab world today is still thick with the odor of decay, and the "civilized" Israelis have brought neither themselves nor the Arabs any solution. As for the good tax-paying Arab Americans, they bear as much responsibility as anyone for the chaos in the lands of their origin, and therein the dilemma.

Three events influenced my decision to write this book.

June 5, 1967, was the date of my high school graduation. On that glistening day, a day of Disneyland and pool, of hot dogs and stolen beers—my family was entertaining the graduating class. As boys and girls danced liberation from the Immaculate Heart Sisters and the order of Carmelite Fathers, my father's ears were glued to an intercom speaker on the wall in the breakfast room. It was a radio report. The rock music out back gave way as I stared at his forlorn face. Mother, serving selflessly, as always, plates of ham and sliced beef, stopped to regard him. Israel had invaded three Arab countries—Syria, Egypt, and Jordan—and had destroyed the entire Egyptian Air Force on the ground. Father's face continued to lose its color. I graduated from more than high school that day.

Two years later, I published an article arguing the case for Palestinian rights in Georgetown University's student newspaper. Those were days when mentioning "Palestinians" could engender complete blankness or hateful stares. My article was based on notes from a class taught by Dr. John Ruedy and from George Antonius' seminal study *The Arab Awakening*. Original it was not. Two letters to the editor intimated that I must be a Nazi. One of the respondents was a local head of the Jewish Defense League (JDL). At the time I was stunned—having many Jewish friends—and withdrew from further criticism of Israel in public for what I thought would be an indefinite period.

The third and most important event of all was a trip on invitation of Grandfather Awad to the lands of his birth, particularly Arbeen, Syria, a little apricot-and-olive-farming village four miles east of Damascus.

Thus, the material for this book gathered like a tumbleweed for nearly a decade. It was on the first trip to ancestral lands, with a relative who had left fifty years previous, that I began to learn that we, Arab and Arab American, were responsible for and in some ways indicted each other. I found the blood bond that was previously invisible. Sometimes it is tight and sometimes it is loose. But it is there.

It began to nag me that there were no available volumes about Arab Americans. We have all reveled in *Roots* and the search for black identity by such writers as Gwendolyn Brooks, Alice Walker, Amiri Baraka. The search for "Jewish identity" is in some ways synonymous with contemporary America's own self-searching. It is not an exaggeration to say that the history of the American novel since World War II is the history of the alienated Jewish intellectual struggling with the universe to wring from it some drop of meaning. The names are myriad—Bellow, Malamud, Singer, Shaw, Heller, Roth. Much of their at times profound, at times wrangled, but always robust work was taken directly to heart by

me. The Holocaust had become a literary touchstone of Western life pained by existence. I felt it. But I wondered if there were touchstones peculiar to my own background.

There were portrayals of Chinese, Japanese, Irish, Hispanic immigrant experiences, and a surge of work on native Americans. There were many treatments of Italian American life, from mafia to sainthood. Even the Armenians, one-fourth the size of the Arab population in America, were captured in the classic *Passage to Ararat* by Michael Arlen. Had the Arabs fallen into the black hole of Atlantic Avenue?

The Arab Americans' silence about their past contributed to the general silence. But other reasons—spurred by events in the 1970s—became evident. The Arabs' unique and unpleasant status of becoming, since the oil embargo of 1973, "the last ethnic group safe to hate in America" (Nicholas Von Hoffman) had something to do with the general disregard and reinforced Arab American reticence.

Some voices have told part of the story in ways of which I am admittedly incapable. Too many dissertations on Arab American communities and history have languished and died a quick, inauspicious death in the card catalogues of academia. One such is the fine, detailed 1961 Ph.D. dissertation of Adele Younis. I am indebted to the sociologists Philip and Joseph Kayal's *The Syrian-Lebanese in America: A Study in Religious Assimilation,* now out of print. It is a well-researched, if somewhat repetitive, treatment of the largest—though not only—Arab American population, that which is Syrian-Lebanese Christian. The Kayals are most interested in how the Eastern Christian's trappings of religion began to disappear here, particularly those of the Melkite and Maronites rites. (The Kayals are Melkites.) *Becoming American,* by Alixa Naff, concentrates on early Syrian life, stopping at 1939; her main interest is with the Syrian peddler. The best-written book on the subject, however, is long out of print and outdated: Philip K. Hitti's *The Syrians in America* (1924).

I am also grateful for the anthologizing work done by Barbara Aswad (*Arabic-Speaking Communities in American Cities*) and the brothers Nabeel and Sameer Abraham (*Arabs in the New World*), Detroiters who concentrate on Detroit, whose essay collections have gathered essential data on a community that, for some reason, has never been designated as a minority by the U.S. Census Bureau. Recently published are the diverse, excellent anthologies edited by Dr. Eric Hooglund for the American-Arab Anti-Discrimination Committee (ADC) (*Taking Root*) and for the Smithsonian Institution Press (*Crossing the Waters*).

I am not writing a detached history. This is the result of a personal quest, a realization that took root in me slowly that I was not one, but two, and that the heritage of my people was simply not known and was often distorted in the United States. This seemed a dangerous mix, given the nature of U.S. politics and the implication, particularly since 1967, that I was descended from a people considered to be an enemy of America, though indeed we were not at war with any Arab country. In some ways, the Arab Americans live the oddest double life

of any ethnic group. I wanted to chart how they dealt with it—radical disavowals and radical assertions of heritage and everything in between—even up to the ringing of Beirut by a wall of fire on their television sets in 1982.

Who were we to deserve this? Who were we *not* to deserve it? Who, indeed, were we? Suddenly, strange purple *kūfīyahs* were in fashion during the siege of Beirut, and women wore them on the boulevards of Washington, D.C., as scarves. They seemed like pelts. *Ḥummuṣ*, the erstwhile spread that Arabs made of chickpeas, was found in 1981 to be called "Israeli dip" in the Farmers Market near Beverly Hills.

Who were we? Internationalists, or burrowing lemmings? Exemplary Americans by virtue of what we did and confronted, or merely good Americans by virtue of what we avoided? What made a Philip Habib come out of retirement to negotiate cease-fires in Lebanon and risk a third heart attack? What made Najeeb Halaby, former president of Pan Am and head of the FAA under President John F. Kennedy, assume the post of chairman at Beirut's American University just when the country was being torn asunder by Israel, Syria, and fifty factions? What made Helen Thomas, the chief and touted veteran UPI White House correspondent, eat her evening meals at Mama Ayesha's Calvert Café, a restaurant in Washington, D.C., owned by an old family of Palestinians from Jerusalem?

What made me, a teacher of English and literature, find myself in a decade moving from the classroom in a little California college surrounded by bougainvillea to Washington, D.C., to become the first full-time Arab American lobbyist and, finally, to Beirut, where I would be offered a "job" as an American fighter for the Palestine Liberation Organization?

What made me stand before the flames? To see what faces were in them and try to hear what they were saying? The answer lies in a long history, and it began for me in a journey to the oldest city on earth.

1 Generations Reunite in Arbeen, Syria

A telephone call that will change a life cannot immediately be recognized. It rings like any other.

Before I pick up the phone, it is fitting to say what I was doing in 1972: 22 years old, on my first job out of college as an obituary writer. At $60 a week averaging ten obits a day for the *Northern Virginia Sun,* that made roughly a dollar an obit. I was hungry in more ways than one.

A morning exchange with the funeral directors would go something like this: "Eaves Funeral Home" (tone reverent, calm).

"Hello, Mr. Eaves, this is the *Sun.* Have you got anything today?"

"No, nothing today!" the voice sings at the recognition of an accomplice.

Or: "Bingham Funeral Home."

"Hello, Mr. Bingham. Got anything today?"

"Well, young fellow, sure do. I got a Rotarian for you. I got a lovely little lady from the D.A.R., and, by gosh, you've got yourself a general with four stars and a biography already written by the bereaved."

"Thank you, sir; have you got the numbers?"

"Numbers ready to roll!"

The phone call that summer day of 1972 in Arlington, Virginia, could have been from a funeral home with "something today."

The voice was light and snowy.

"Boy?" came over the static-plagued line.

"Yes."

"Boy, this is your Jaddu." It was Grandfather Kamel.

"I don't believe it."

"You better believe it. It cost me lotta money to call you."

"Okay, I believe it. Are you all right?"

"Never been better. Boy, what are you doin' next week?"

"Working."

"What you do for work?"

"I write about dead people."

"Dead beeple?" The voice began to laugh with a wheeze. "How 'bout you come write about live beeple."

"What do you mean, Jaddu?"

"Boy, you comin' with me and Matile and Rosie, you mother, and Gary, you uncle, to Damascus."

I let the line talk to itself in a sound that is a little like scratching the head, a little like the heart being perforated.

"Boy, you comin' to al-Sham. You know what al-Sham is? Damascus. I bought you ticket today. We goin' back to where I was born. You can get ready?"

"Jaddu, I don't believe it."

"Boy, you betta believe it."

"What should I do with my job?"

"I think you betta quit that job."

"But . . ."

"I gotta go now, Jaddu. Just bring some clothes to wear and clothes to give. I'm talking about the boor beeple over there. I'm talking about Arbeen!"

Arbeen. It clanged a bell inside me.

"We leave one week. To Baris. Then we all meet there and go to Beirut. Then the *bilād*."

Grandfather's cockeyed alliteration told me: he had chosen two of his children, his wife, and his eldest grandchild to rendevouz in Paris from where we would fly to Beirut and drive over the Lebanon mountains to the dusty village of his birth in his home country (*bilād*), Syria.

I hung up, dazed. Kamel Awad had been back to see his five brothers and one sister in Arbeen only once since emigrating to the United States in 1920. Except for one brother, Issa, none of his immediate family had ever been to America, and except for his wife, Matile, none of his family in America had ever seen the Old Country. In fact, few had left California since the Awads had moved from Brooklyn after World War II to settle in the hot dry climate of the West because of Jaddu's emphysema. For a time, the Awads had tried to sell their Corday hand-bags—an embroidered bag popular during the war because of the scarcity of canvas and leather (used up by the military)—in Florida. But in the words of Grand-mother Matile, "Florida was no good, honey, because they don't wanna buy handbags; they only want the sunshine. In California, they want handbags *and* sunshine."

Pasadena, California, was good to the Awads of Arbeen. As a boy I would climb up to the roof of Grandfather's handbag shop on Colorado Boulevard where folding chairs had been placed for the family to look out on the Rose Parade on New Year's Day. When we got bored by the overwhelming smell of a million chrysanthemums, the cousins would sneak down into the musty old store and play blindman's buff among the display cases. Many a New Year's was rung in with us hiding, muffling laughter behind naked mannequins.

Corday handbags faded as an item of demand, and by the mid-fifties Grand-father had opened a small contracting firm of twenty sewing machines to produce women's ready-to-wear dresses and sportswear. Soon nearly all of the Awads and Orfaleas had plunged into some form of "rag" business; for Jaddu it meant

twenty-five more years in a sweatshop. He added his own special touch to gar-
ments with the emboidery machine; even after his retirement, he was the only
one to use it.

I think at an early age I developed a hunger for beauty against the backdrop of
greasy, sweating sewing machines and the hum of the cutter's blade. After my
father had launched his own venture as a garment manufacturer with an orange
dickey, I was exposed early on to the bustling, at times manic, at times alluring,
world of fashion and as a boy worked summers picking orders, boxing dresses,
and sweeping dust, thread, and cloth piping from the long aisles. If I was over-
awed by the sleek turns of models, I was also never far away from the oilcan on a
Singer, the steam of a presser, and the electric flash of Mexicans traveling through
fields of cloth with their foot-long blades.

No one would have guessed among us cousins that bundling chunks of dresses
for sewing at Jaddu's factory would contribute to a success that would prompt
him in old age to invite one of us to the land of his birth, a place that had come
down to us in stories and myth. I was the lucky one. The pilgrimage to Arbeen
meant that we would take boxes of clothes for our poor relatives instead of send-
ing them, as we had each Christmas, with a prayer that they would arrive in Syria
and not the Bermuda Triangle. Arbeen—with its olive and apricot orchards and
fields of *fūl* (fava beans)—was distinguished by little, other than from it came
what was assumed by scholars to be the first Arab immigrant family to Amer-
ica—the Arbeelys. Family folklore linked us with them (Mother's birth certifi-
cate listed her as an Arbeely). The 1972 journey would somehow relink a century
of wandering. I was excited, nervous, even afraid—the feeling a plug must have
when it is about to enter a socket and light up a million phone calls under the
ocean. How many loves and tragedies would this late-twentieth-century hookup
with our Syrian origin start?

In 1878, Dr. Joseph Awad Arbeely, a native of Arbeen, packed up his wife and
six sons and came to America. Dr. Arbeely was not the typical Syrian peasant; he
was president of a college in Syria and came to America for freedom and oppor-
tunity. It has also been said that he was soured by internecine warfare in his own
land and had witnessed and miraculously escaped the massacres by Druze in 1860.

Arbeen, today a mixed Muslim and Christian town of 25,000, is four miles
east of Damascus. In 1860, the uprising of the Druze, a schismatic sect of Islam,
caused five thousand deaths in the Damascus area. Arbeely fled with his family
to Beirut, but eighteen years later he dared to cross as many seas as he had to to
get to America.

An article in the *New York Daily Tribune* on June 20, 1881, painted a picture
of the strange new arrivals in Manhattan and hinted that already the Arbeely sons
were divesting themselves of things Arab:

Yusif Arbeely, who with his wife and six sons came to this country from Damas-
cus, Syria in August, 1878, arrived in this city recently from Tennessee with his

son, Nageeb. The father is about sixty years old and has many of the characteristics of his race. He still adheres to the dress of his native country. He wore yesterday a shirt made of purple silk striped with yellow, a fancy scarf about his waist, baggy trousers buttoned at the ankle, and a red cloth conically shaped hat called a tarboosh. Nageeb and his brothers have only retained the red cloth cap. Both sons and father have dark olive complections, black eyes and black crisp hair and beards. Nageeb, who is very handsome, appears to be thirty, although he said he was only nineteen. The Arbeely family enjoys the distinction of being the only Syrian family that has ever come to this country.

Joseph, the father, crisp hair and all, described his reasons for coming to America:

I left my relatives and friends behind because I desired freedom of speech and action and education advantages for my children. In coming here I have escaped the disadvantages of a retrograding civilization and a tyrannical government and have found all that I came in search of. My friends were greatly surprised at me. It was an experiment, but it has proved successful. You ask me why more of my countrymen do not come. There are two things in the way. One is that the Turkish government is opposed to emigration from the country, not only discouraging it, but taking measures against it; the other is that correct ideas of your great institutions here have not been spread among the people.

Whatever the image of America in the Arab world—a universally good one until recent years—a century after Arbeely's "experiment," there were two million Americans of Arab descent. Democracy suited them well, freedom better. If there were any incorrect ideas as the lands of their birth receded, gained independence, then became embroiled in an endless series of wars that slowly implicated the new land of their choosing, those misconceptions they found targeted the opposite way.

Nageeb Arbeely, Joseph's eldest son, became the examining doctor on Ellis Island for the Arab immigrants. Another son, Ibrahim, later ministered to Theodore Roosevelt in Washington, D.C. And we were to travel back to Arbeen, the source of the westward Arab stream, to discover the life they left. Our lives were to be put in stark relief. I gave notice on the death desk in Arlington. My editor said, "Don't get caught in a war."

At Orly Airport in Paris, Jaddu—a peppery, squat charmer with twinkling brown eyes—toted a respirator around with him like a poodle. We were delayed there for hours waiting for a connecting flight and Jaddu, breathing heavily, smiled like the Buddha. He'd take a few hits of oxygen and ask for an El Producto cigar.

"Matile, why you give me this stuff? I wanna good smoke."

"Sorry, my honey," Grandmother said, wagging the oxygen hose at him. "You gotta be strong for the *bilād.*"

He flirted with the stewardesses on the flight and made sure to tell them all that he was taking his family to Syria, the land of his birth, for the first time.

Over the Aegean, a fire ignited in one of the plane's engines and the Boeing 707 was forced to drop nearly all its fuel into the sea. The plane made an emergency landing in Athens. By this time Jaddu's brow was knitted in folds like a stack of Oriental carpets. He was losing energy and began to wonder aloud if we were doomed never to see the *bilād* together, and that he would die a half-step short in Greece, the country that had the bad taste to put ladles of oil on stuffed grape leaves instead of the saving potion of lemon juice. To die amongst greasy grape leaves! This would be a bad fate. It was late at night in the Athens airport and the passengers were sleeping on their duffle bags. Not Jaddu. He lit an El Producto.

"Boy, if I go, why not with something in my mouth besides that damn hose?" he pronounced. "If I go, I go up in smoke, not air conditioning."

Finally the plane was repaired and refueled and, a day after leaving the United States, our expectant group opened the drapes of the plane window to see land coming at us like a green squall. It was Lebanon, and dawn. The sun caromed off the plane's silver wings and hurt our tired eyes. In an instant we came to life at the sound of the cockpit's announcement to fasten seatbelts, *défense de fumer,* prepare to land in Beirut. We hid the cigars from Jaddu even though the lesson had come at me: if you are in this Arab clan you make a negative to print a positive. You smoke like an ocean liner stack in order to breathe well, your lungs billowing. You have emphysema, but you unfurl your lungs like a flag of your joys and agonies and wave it, coughs and all, to the homeland.

Approaching Beirut is like approaching a wall in Paradise. The beaches rush at you, then the boulevards and *sūqs* (marketplaces) and apartments and houses of limestone. Then the wall of green—the Lebanon mountains. In many ways the Beirut coast resembles that of Santa Barbara—both cities are set on the only stretch of coastal land on the American Pacific and the eastern Mediterranean that runs East-West instead of North-South. The land indents for Beirut and Santa Barbara. It allows the sun to follow a methodical path across the horizon; in Beirut and Santa Barbara you always face the sun. But both cities, known for their lush acacias, eucalyptus, palms, and pines, rest in front of abrupt geologic surges. The mountains in Lebanon are higher and steeper than the Santa Inez range in California, however.

We alighted in the strength of dawn. The roads in from the airport were baking and dust climbed over the taxi in a dawn wind.

We had had too many cartons of clothes for the Arbeen people, and the Lebanese customs officer was about to chalk up a hefty overweight fee. Jaddu slipped him a picture of U. S. Grant. The official touched the black patent leather border

of his officer's green felt cap, flipped the bill over to see if it had a back, stared beyond his shoes to make sure no ant was looking, and, without lifting his head, said, *Ahlan wa sahlan, ya akhi* (Welcome, my brother).

We were shooed through the line into a taxi where a man with one gold front tooth opened the door and gave the same greeting to us.

We drove through the quiet streets. This was 6 A.M., Sunday. It was like stealing through swirls of silent dust into a dreamlike promenade with no people in front of the green ocean. I felt weightless. A light breeze rippled dusty palms along the beach. The eyes of the shops were closed with corrugated iron lids—so many garages snoozing. After we splashed our faces with cold water at the hotel, something changed. The heat felt clearer.

The Mediterranean Sea was not to be ours that first day because of construction along the shore in front of the hotel. We could only regard *mare nostrum* through a tangle of barbed wire. It was not an auspicious start, to see a captive sea, but we made little thought of that. This was, after all, the Promised Land. It was the land my grandparents cursed and praised daily; never an olive dropped into the mouth without someone saying, "They have olives like that every day in the *bilād*."

It is worth emphasizing here that *bilād* does not connote a certain country— Syria, Lebanon, Egypt—but rather a whole milieu, a world that to me as a child festooned the imagination with pomegranates and figs as in the grandparents' backyard. The *bilād* meant the Origin Point, a secret place where we all came from, God's arms. To go to the *bilād* had nothing to do with wrapping oneself in a flag. More to do with thyme—on the hands, in the fields, and bitter enough to curl the tongue. Thyme and time. Both were your birthright and you would possess both if you returned there. Political accusations could be thrown out against any one Arab government or all of them as a whole. But the *bilād* was different. The *bilād* was the magic coat we carried in our hearts. Jaddu was opening the sleeves for us so we would not be cold in America again.

The first morning in Beirut we enjoyed a breakfast at our hotel on the Corniche, the northeast corner of the city that juts over the sea. Waiters put out dishes of *labanī* (a thickened yogurt spread with oil, with mint dashed on top), piles of Arabic bread, dishes of apricot jam, and cups of Nescafé. Only Jaddu ordered the watery earth that is Arabic coffee. It took the rest of us a while to warm up to it at every meal. By the end of the summer our tongues were well burnt. To this day I can drink the hottest substances without a flinch. Some lands give you a birthmark; others give you a burnt mark.

To have Arab food in the morning in public was new to me, my uncle, and Mother. Breakfast is the most private of meals, and Arabic food was a private food for us in America. Here all was public. The waiters smiled; their gold teeth shone in the sun, all the more for the gaps surrounding them.

Jaddu did not want us to fall for the Western lures of Beirut until we had seen

Syria, his world. Within a day he was ordering a taxi driver to take us to Damascus sixty miles away up over the Lebanon mountains. A special stand downtown was the place to wait for an al-Sham (Damascus) taxi. A driver called out as we approached: Al-Sham! Al-Sham! It sounded like a poignant, declarative, unembroidered statement that he was ashamed. But no. He was just eager for the twenty-five dollars to take a carload to Damascus.

None of us was prepared for the driver's madcap style over the mountains—gunning the gas around blind corners and passing vehicles on same. More than once Mother would bark, ʿAla mahlak! (a colloquial for "Take it easy"). It was our introduction to the land of no lanes and few stoplights, where every turn is Mr. Toad's Wild Ride.

The drive in the mountains was gorgeous, the summer air fragrant with the smell of acacias and pepper trees—exactly the trees in my grandparents' yard in Pasadena. But now a whole country! As we ascended we passed old limestone houses notched in the mountains, mules and sheep hardly acknowledging our presence on the road. At Shatturah we stopped to sample rolled Arabic bread wrapping sugared labanī, a special sweet of the area.

The road was clear through the mountains, though twisted. This was 1972. There were no roadblocks of Syrian soldiers, or the PLO, or Phalangists, or Israelis. It was one of the last years that ancient road from Beirut to Damascus was open to the traveler.

Over the mountains into the Biqaʿ Valley, Lebanon's breadbasket, a vendor of cherries caught our eyes. It was here that Mother climbed right out of her body.

We were eating the cherries and spitting out the pits, looking out over a grove of cherry and olive trees. On the other side of the road swayed a wheat field, the breeze brushing the wheat back and forth in the mild heat. Jaddu kept saying, "Watch for the worm, boy"; we ate avidly, though the cherries were warm and bland. The taxi driver ate his in the car; we saw an arching of pits come out his window, some tapping against the old Mercedes. The Middle East is filled with old Mercedes and fruit pits.

Mother heard something. None of us heard it, but she did. She said it was a flute. We went on nibbling the cherries, trying to absorb the fact that this was actually Lebanon and not the canyon road to Dead End Beach in California. Mother stopped eating and turned her head toward the wheat field.

A dragonfly buzzed over the ruts in the road. Mother let it pass and walked across to the wheat field and disappeared. After a while we ran across and looked. Through the strands of wheat we saw a distant green upland and two figures facing each other. One was Mother, beautiful, in a long, persimmon-colored dress; the other was the figure of a shepherd with a kūfīyah over his head, playing on a crooked wooden flute. The tones were low, sonorous, and almost swallowed by the swishing wheat.

Perhaps the shepherd was entranced: Arab women did not usually dress so well

in the country and Mother was fluent in Arabic. For her part, she stood motionless. He would stop, shrug his shoulders. She gestured with her hands for him to continue.

Suddenly the shepherd boy responded to a distant figure who appeared to be shouting at him. No doubt it was his father. The boy was neglecting his flock of sheep. Green-carpeted hills beyond the wheat shone like satin. The shepherd bowed, picked his tunic up from the ground, and ran off.

Mother came back entranced. "I felt like I was Ruth in the Bible listening to Boaz."

"Did you speak to him?" we asked.

"Yes. In Arabic."

"Was he surprised?"

"He said he didn't know there were people in America who spoke Arabic."

"What was he playing?"

"Some Arab tunes on his flute. But he kept apologizing, saying he had a real copper flute at home and this one was only for when he was with the sheep. He said it was broken."

And then her eyes teared up. "He wanted to give me the flute. But I refused."

"You refused?" My uncle and I were furious. It would have been a fine keepsake.

"But that is okay. His music went right in." And she thumped her heart, said "Hurry," it was time to go, and all piled in the taxi and left the shepherd looking back in the wheat.

Later, a boy waved what looked like a green fan at us alongside the road and made the taxi stop. He was selling fresh stalks of chick-peas whose kernels were green and crisp. They were a common snack that summer. I had never seen chick-peas "in the raw"; in ḥummuṣ, yes; in yellow soft beans, yes. But not like this. They made all of us sneeze, as if we had an allergy to the way they really were.

At the Syrian-Lebanese border we went through the first of many tie-ups with passport check. Since Lebanon became a free country in 1943 and Syria in 1946, ambassadors have not been exchanged between the two countries. The border, the distinction, has been kept purposely vague by much larger, much stronger Syria, and passage of nationals between the two countries was always easy.

The taxi driver dickered for two hours with the Syrian border police, finally getting our passports stamped with a visa. We were to find out over the summer that as American travelers in Damascus we were unique. In five weeks I saw only a sprinkling of European tourists and never met one other American in the ancient city's bazaars, cafés, and hotels.

The only distinguishing geography between Lebanon and Syria is a short rise of dry hills covered with scrub brush. Quickly the road descends into the desert. There, on the road to Damascus, Saul of Tarsus was thrown off his feet by a bolt of lightning. The distance from the border to the capital city of Syria is short—twenty miles—but for us it was too short. We wanted to savor the approach that

took us along a surprising slit of green that became the Barada, or "ice-cold," River. Few cities, according to Philip Hitti, have as much reason to be thankful to a river as Damascus has. In the ninth century B.C., Naaman, the Syrian general, questioned whether there were any waters in Israel to match the Abana (Barada) (2 Kings 5:12), and poets in A.D. 700 praised the cold river as creating an earthly paradise. Traveling the road where persecutors are made saints, you want to linger. I looked up at the sky. No lightning bolt for me!

More palms out of the desert crust. The Barada deepens, its banks grow. The white dust on the western approach to Damascus seems to come into molecular collection little by little—a donkey, its driver with a brocade white cap, a telephone pole, another, a vendor of wild berry juice lifting the ladle from his shoulder, buildings shaped from limestone. And then the throng! The incredible stir of humanity in the world's oldest continuously inhabited city (3,500 years) raced between honking donkeys and Mercedes.

Our hotel—the Samiramis—had not yet been rebuilt and modernized. For years it was the only hotel in the center square of Damascus. It was a landmark for Grandfather, a personal friend of the owner. In 1977, the Hotel Samiramis was stormed by then-Iraqi-based terrorists led by Abu Nidal, and the owner was shot to death in the scuffle. This was the same Abu Nidal who has haunted PLO Chairman Yasser Arafat for a decade, killing PLO moderates throughout Europe and the Middle East in an effort to stop compromise with Israel. Ironically, Abu Nidal later held court in Syria and Libya, still shadowing Arafat and even targeting Americans.

But that summer the Samiramis was our haven, and we checked in to the hugs of the owner and his family.

Jaddu collapsed in the hotel room, asking for his respirator. We gave him a few hits and then he bubbled, "Nobody accept any invitation to stay with relatives. We stay here at Samiramis."

"Why?" we asked.

"Because if you stay with one relative, then the others will take offense. Then you never get rid of them. They will pull you apart."

Within minutes, bursting into the room were two cousins from Arbeen who had heard from the hotel owner that we had arrived. They were to be our closest companions for the rest of the trip, and they were irrepressible.

Sami Awad Hanna[1] pulled Grandfather up from the bed with one strong jerk and squeezed him with authority and love. Sami, about 30 then, was tanned as shoe leather (that's what we called pressed apricot, "shoe leather," or *qamar al-dīn*). His agate brown eyes went across the room, his finger pointing to each head in mental notes, kissing this cousin, that one. He had the short, abrupt movements of a soldier and we were not surprised to learn that he was a captain in the Syrian army. He spoke a halting English and tended to be quiet unless addressed.

His brother, the other emissary from Arbeen, was a little ball of fire. If Sami

contained his warmth like a generator, Adeeb Awad Hanna spewed it forth like a conical firework. An Arab leprechaun with green eyes and a smile as wide as the Cheshire cat, Adeeb had a spirit that was formidable. When he smiled his teeth spread like an accordion and his nose picked up as if it had been darned and pulled by the God of Mischief. Adeeb became my fast favorite. When introduced, he held me by the shoulders and looked up, his eyes beaming. "Greek!" he pronounced.

Adeeb danced over the bare floor of the hotel room. He slipped on a fallen bedspread, laughed, embraced my mother, asked Gary what was on our tape recorder. He pressed it, and Arabic tunes came out. Adeeb snapped his fingers and danced around in a circle in the small space, churning his hands alongside like gears.

"Boy," Jaddu wiped his brow from the heat—there was no air conditioning. "You do not know what you in for tonight."

He was right.

Later, Adeeb and Sami arrived with a large deputation of cousins and flagged three taxis out in front of the Samiramis in the crowded square. Damascene men rushed by, arm in arm, lecturing the air, heading home after a day's work.

Time condensed into an amber gel—everything slowed as the taxis moved northeast out of the city on the road toward Homs. The taxis moved in amber. A wave of a seller of charred ears of corn was as if in a slowed movie projector. In the dimming light a sign flickered: ARBIN. It was the French spelling of the little village's name. Our turn was executed soundlessly and Syrian dust billowed around the cabs like clouds. We passed a small open market, a cobbler nailing shoes, another standing and watching the road. Slowly, from the cumulus on earth, the children emerged and clustered alongside the taxis. From out of the old, whitewashed clay walls they came. Their faces were beam points of color in the amber. Soon, it was as if the children had inhaled all the dust and dispelled the darkness; they were oozing from the crevices of the village, smiling, shouting. Outside the glass of my window one fellow was waving his hand as if to say: Do Not Forget Me in This Crowd You Are About to See!

The taxis were forced to halt by children jumping on the hoods and on their tops. We watched feet dangle into the windows, brown-skinned lads making faces upside down. By now there were over one hundred children surrounding the three vehicles. Our driver began to curse and Jaddu told him to shut his mouth.

"Me shut my mouth? Who do you think you are?"

"I am Kamel Awad from America!"

"And I am Muhammad Izzedine from the moon."

"Do you like it on the moon?"

"My brother, the moon is a civil place compared to this hellhole of your relatives."

We stepped out into the amber. The children swarmed around Jaddu. His face and name were a legend in Arbeen. He was the only one of his generation to

leave the village for Damascus, not to mention America (though there he had taken one brother, Issa). Five brothers and one sister still lived in Arbeen. They had stayed working the apricot groves and the bean farms and tending the flocks of sheep.

The adults of the village lagged back, letting the children carry the first wave of their excitement. Children spun around Gary and me, but they stood back from Mother. Was she an "*artiste*" (Syrian parlance for actress, singer, but also a woman of the night)? Their own mothers wore heavy black dresses, with white scarfs over their heads; their skin was wrinkled and toughened by the hard life of the soil. No one believed that this finely dressed woman was my mother. They held back from her smile and persimmon dress as if from a flame.

"*Ya dīnī* [literally, "my religion"]," Mother said, lifting a little girl in her pink pinafore to ask her name. "Noora!" she squeaked. Mother sang the first verse of an Arab song to her. And it was as if the flame had turned into a pond. The children mobbed her.

Meanwhile I had noticed a taller fellow inching toward me—someone about my height and age and coloring, with well-combed dark hair, high cheekbones, and dark eyes. For a second I had the weird sensation of a shadow approaching.

"Greek, I am . . . your cousin, George." Every word had been carefully prepared.

We embraced, kissed on both cheeks as is the custom. My hands were used to the texture of cloth after a boyhood working in a dress manufacturing plant; I felt the polished cotton of his shirt pull over his shoulders. Something strange went through me. I stood back. He was wearing my shirt!

It was a dark paisley-print sport shirt sent in one of the boxes of clothes marked for the Old Country at Christmas. In that instant, I experienced a kind of vertigo. The ten thousand miles from Los Angeles to Damascus shrank to the foot of Syrian earth between us. This was one of those rare moments outside of lovemaking when a person feels his whole being transformed into another. I looked at George. A dab of shyness went over his chiseled face. The shirt fit him perfectly. He was to enter engineering school at the University of Damascus in the fall, but he still helped his father, Selim, till the soil and pick the apricots. If it had been Jaddu's brother Selim who had decided to leave the land of his birth and step on the gangplank to America, I would have been George, he would have been me. At that moment, as I was feeling the paisley pattern along the shoulder blades of my cousin, the Arab past made a direct, electric current into my life. I was no longer a resistor, an inert listener to tales, an intellectualizer. I realized that except for a small twist of fate I would be the one worrying about induction into the Syrian army. I would have been the one to risk his life on the Golan Heights. I would have been the one to sleep with three other brothers in one room and use a toilet that was a gaping hole in the floor. And George would have enjoyed a car of his own at 16 in California, diving into swimming pools, perhaps with the luxury of a conscientious objection against the Vietnam War. There are no conscientious

objectors to military service in the Arab Middle East. Unless you flee your country.

In short, two worlds crossed inside me in a deep and personal way. All from one shrunken paisley polished cotton shirt pulled from a crumpled carton addressed to Syria.

George and I walked arm-in-arm, as the Syrians do, through the flowering mob of children. Soon my grandfather's five brothers and one sister, Shahda, came to greet us. The brothers were ᶜAbdu, Tawfiq, George, Selim, and Amin. Only Issa, who had come with Kamel to America, was missing. He had died in Pasadena some years back, shortly after placing his last bet on the dogs at Santa Anita.

The first thing that struck me—besides the midnight blue pantaloons of the men and their shirts tied at the neck with strings and the rilled, leathered skin of these farmers—was the fact that Jaddu had the only brown eyes of the bunch. They were all either blue- or green-eyed, with cheeks of bronze, a handsome tribe to be proud of. Jaddu's puckish, shining, dark eyes were the exception in his village family, and I pondered that the dominant gene, surrounded by dominating recessives, had been the one to cast his fate to the wind.

Were the Crusaders of the eleventh century responsible for these twinkling blue and green eyes in the mostly Christian village of Arbeen? It seemed possible. There are many fair Muslims, as well.

We were swept by the crowd into the courtyard of Amin. Slow-minded or troubled by ill-hearing, Amin had ten children then and by now has eleven. Early on we noticed that he had difficulty with his speech. He had eyes as blue as the height of noon, a chin with white hair bristles, and a balding head with white hair flying up as if about to jump before falling out.Though he was the youngest, Amin looked like the oldest of the brothers. There were rumors of brain damage at birth. When Jaddu had left Arbeen in 1920 he was told by his mother: "Don't you ever forget your brother Amin." It was to Amin's family that most of the boxes of clothes were routed; he was the poorest of the farmers of the village.

The crowd had forced us to the head of Amin's courtyard where there were chairs set out for us, Jaddu to be at center. All eyes were on us on the porch. The buzzing and rumble that had grown from the road to here began to simmer down. There is nothing wrong for one to feel at least once in a lifetime like a king or queen. This we all felt. Gary and Mother were speechless before the crowd. What had we done to deserve this red-carpet treatment? We had done nothing but be Americans, and come back to see them. Far from distrusting us, they were spellbound, by our fine clothes and—who knows?—sheen of prosperous innocence. Syria had been billed as Archenemy Number One of the United States in the Middle East. If policymakers had been present that day in Arbeen when children sang through the trellises for the Americans, I am sure they would not have been able to fit Syria into a box marked "demon."

The rumbling of the crowd compressed itself, waiting. Perhaps they wanted to see if we would metamorphize into F-4 Phantoms!

Grandfather Kamel stood up, all pockets of his lungs called into action. He raised a glass of *araq* from his squat boxer's frame and shouted: "I bring you your cousins from America!"

He may as well have stripped naked. They went crazy. He introduced each one of us, but they did not clap; they instead sang a folk song on each introduction. It was as if each one of us was a pause between verses of a song. Arbeen brims in my ears and heart as a place where song was talk. This should not have been a surprise, though. The first words of a song were found in Syria on clay tablets dated 1400 B.C.

Soon the children were singing to one another. The boys hung on one white wrought-iron trellis and the girls on the opposite one. They alternated verses, singing to each other, *La la, ni ni nii; yen ni nin nin nii!* The feeling was that of being inside a nickelodeon. Whether the boys and girls sang separately by intention, I do not know. But it made for a wondrous syncopation. Staged, I would call it the Almond Opera, because these children's faces—bright, teeth yellower than American kids' but spread wide and gleeful—they appeared as singing almonds.

We were given a tour of Amin's house though there were only two rooms to see. How he fitted ten children in there no one really found out.

Adeeb, the lawyer-firework, leapt up at a pause and saluted Jaddu with a poetic speech that found him flinging his fingers out and back as if he were directing an orchestra of himself. And then, just when Adeeb seemed finished, he would point toward heaven with a diminutive digit, smile slyly, pull back the flesh around his eyes, and fling out a song.

This speechifying and song making and poetry shooting (*zajal* is a tradition where one poet jerks up and tries to out-metaphorize the other) went on for over two hours. Then preparations were begun to slaughter a sheep.

Throat slit, the animal dug its hooves into the soil and kicked the basin a young cousin had put out to catch the blood. The basin hit a little girl in the shins; she screamed and wanted her mama. The mama came and retrieved the basin, putting it under the spurting neck. The boy, embarrassed but game, pushed the sheep's head to the ground over the basin and kept looking up at us in case we would like to take a picture of the pouring blood. Mother gasped and went back to the porch. She stuck to vegetables that night.

I searched for a place to put an olive pit and one cousin put out his hand, took the pit, and hurled it over a wall onto the street. Others wolfed down pieces of cheese we handed over our backs, spinach pies, hot shish kebab. It was an eerie thing to eat with so many people staring over your shoulder. It put a knot in the stomach. For a second I thought of the debaucheries of the Roman senators, who threw legs of chicken over their heads to the dogs or eunuchs.

After dinner we were taken for a tour of the barnyard where there were milk

cows, a few chickens, and goats. A donkey stood off in the corner, chewing gristle. Adeeb grabbed Gary and jumped on, cranking the thing's tail as if it were a Model T. The children laughed; Mother said, *Ḥarām, al-himār,* a lovely alliterative inversion that means "the poor ass."

Back at Amin's, the *ʿaraq* was poured. When I was a child it was a thing of marvel to watch an aunt pour water into *ʿaraq,* a clear liquor much stronger and stiffer than anisette but with that licorice flavor, and turn it white as milk. It was a delicate chemistry akin to the priest turning water into wine, and wine into blood. Of course, in the Catholic mass the wine never really turned to blood; it still tasted like sweet wine, which made the mystery all the more mental and strange. I tended to identify Father's family (the Catholic one) with unprovable miracles, whereas Mother's side (Orthodox) found miracles a daily occurrence, as easy as tipping a jug of water and creating a spool of cloud that whitened the glass!

So it has been all my life—the Eastern Orthodox side giving me palpable mysteries, earthen wonders, the Roman Catholic side bequeathing an Intellectual God, a God of Abstract Belief and Complex Theology. In the Catholic church, when you are married you go up an aisle and back, once. In the Orthodox, you go around in circles, endlessly, with your crown tied to your betrothed's crown. As an Orthodox, you either get very dizzy or you lose your bride! A God of Blurred Distinctions versus a God of Infinitesimal Distinctions. St. John Chrysostom versus Aquinas.

But anyone can drink a glass of *ʿaraq;* it just so happened that in my family the Orthodox side liked it, the Catholic side did not.

We were on an island in the desert that is Damascus of the Barada and Al-Awaj rivers. And our cousins in Arbeen could not stop praising the night. Cousin George held the *darabukkah,* or bongo, and another readied the eggplant-shaped guitar, or *ʿud.* They were poised.

"Oof oof ooooooooooof!"

This was not someone getting his toes stepped on, or lifting a crate of soda bottles with a herniated disc. This was a singer telling the crowd that he was clearing his throat and ready to belt one out. It is the singer's way of telling everyone to stop talking and listen.

"Oooooooooof!"

A head that looked like it was going to burst from pressure of too much blood was quieting the crowd. It was Nassif, of the House of Daoud. His lungs spread like a bellows and many nights to come were hushed by his "Oofing."

I want to linger a bit on the phenomenology of Oof. Like Aretha Franklin or Otis Redding stretching a note out a capella at the beginning of a soul song, the audience punctuates each end of the long note pulled like an eel from the lung with a *Ya Allāh,* or *Aywah* (yes), or suchlike. It is the equivalent of "Amen, brother," "Tell it like it is," or "Don't you know I know you know I know?" Oofing is a way of speaking for the audience, of collecting their pains and loves into one big blasting voice. But the key to Oof is the relishing of the approach pattern, the runway.

There is another way to Oof at an Arab night festivity. And that is stretching out the word *layl,* or "night." For a people whose days are relentlessly subjected to the sun, the nights take on deified, quenching proportions to the Arabs. Night is all, philosophically, musically, and literally. Above us was no roof. The hovels of Arbeen did most of the entertaining in the courtyards outdoors.

Both Oof and *layl* may seem like ends in themselves but they are not. After many Oofs and *layls,* the singer will trigger in the collective memory of the crowd the first words of a song and everyone will join in, clapping, the *darabukkah* slapped forcefully, the swollen ʿ*ud* plucked.

Mother rose. Rose rose.

She began to dance, kneading the air as an Arab woman does, her hands twirling around some invisible rope. The dignity of her unmoving but smiling head captured all. Her eyes filled with the *layl* of the song. The crowd of cousins and villagers whooped, the teenage boys craned their necks, the old women delighted, the embroidery of their bosoms heaving. I was relieved she stood up. I was afraid to say something; my Arabic was poor. Let her speak for us with her dance, we of the first and second generations who didn't know how to address the villagers.

She danced in front of her father, in front of the myriad cousins who had heard of her as Rose, the only daughter of Kamel from America. Slowly she pocketed the whole village without closing her hands.

A cock of the roost flew up onto the long run of tables. It was Adeeb. Everyone laughed and held their breath and plates. What a sight—little Adeeb three feet higher than Mother, who continued for a while, then faded back into the porch, clapping for him. He strutted. He pronounced. He glided. He exuded. Not a pro like Nassif, Adeeb used his lawyer's eloquence and sly eyes and accordionlike teeth to make the most of his song. He was adept at punctuating words; in fact, I saw a small slingshot of saliva fly out of his mouth over the table at the word for bread, *khubz.*

The music intensified. George's hands turned beet red from pounding the *darabukkah.* From the street through the courtyard door stumbled the Ashishi. Music to him was like catnip to the cat. (When riding his favorite jackass, the man had the habit of telling the animal to stop by saying "*Hish! Hish!*" He also once shouted at a runaway horse, "Hashashu! [Stop him!]." Thus the nickname.) The Ashishi had just finished sweeping the dust off icons at the Orthodox church in town. He had kicked a can or two, cracked a few green chick-peas between his teeth, and, no doubt, downed a bottle of ʿ*araq.* He was the custodian of the church and his face was red with tincture of alcohol.

The music, which had stopped at his entrance, immediately whipped itself into a fever when the Ashishi began fondling his stomach and dancing around in a Sufic trance. From his mouth sprang verses of an ancient Arab folk song celebrating the nine months of pregnancy. Each verse is a month; each verse the pillow gets lower in the Ashishi's robe, until, vibrating like a drunken cobra, he

shrieked, gave up the spirit, and pulled the pillow from his stomach like a disgorged rabbit.

The crowd revolved like a joyous wheel of fortune, spontaneous song and dance and poetry and mime erupted from one cousin to the next. When the invisible wheel turned at me, I was shaking. My uncle Gary had acquitted himself well with a toast to the cousins, "May you live as long as you want, but never want as long as you live," given deftly in Arabic but stolen from Abbott and Costello. He poked me in the ribs at the delirious applause. Grandmother gave her timeless "God bless you and keep you safe" toast with a glass of red wine she takes for her anemia. "Can't be no worse," she commented later on the content of her toast. The needle of the wheel pointed at me. And it came in the form of a bowl of loquats and a bottle of ʿaraq.

For every loquat I ate, Adeeb poured a glass of ʿaraq. Claps at each toss, huzzah, pandemonium. I stood to give an invocation:

> Brothers and sisters, the heart is a Hindu apricot.
> The night is like the heart.
> The heart is like an airplane.
> The airplane is like the wind.
> Awad and Orfalea came from America
> To see your faces like roses.
> Your beautiful faces.
> Your faces turn our hearts to butter
> And our heads to ʿaraq!

George promptly put a hole in his *darabukkah* and had to borrow a new one. The music hit a quick fever pitch. Pulled by the singing and rhythmic clapping of the crowd, and by Adeeb's urgent hand, I got up to dance.

All spun round. "Abu Ali! Abu Ali!" Adeeb shouted. This was some Islamic folk warrior known for his bravery and large moustache. Remarkably, I managed not to fall over, but bowed to all, blew a few kisses, sat down. Fifteen minutes went by. I rushed blindly to the toilet, which was nothing but a cotton curtain hiding a hole in the tiled floor. It was there that I deposited the whirling minaret and church steeple, the snide days of youth, the *mishmish Hindī* (loquat), and the ʿaraq.

I awoke in the night. I was lying down on a cot indoors. An old man whispered in the darkness, his hand rubbing my stomach in calm circles. A tight pain gripped me there. Over the distant roars, the voice took command. The old man's face bent into the moonlight. It was ʿAbdu, oldest of Jaddu's brothers, the father of Adeeb. The moon made a rim of light on his *kūfīyah*. Slowly, the pain subsided under the swirl of a weathered hand. I put my hand on his. It felt like the bark of a pepper tree. The pain was over. ʿAbdu knew, for he stopped praying, pulled a blanket to my chin, and went back to the crowd.

Since our summer in Arbeen I have been a believer of quiet miracles in the face of innumerable furies. ʿAbdu's cure was the first of three miracles that summer, the second was out in the Syrian desert at Sidnaya, and the third was in the Lebanese mountain village of Zahle.

Damascus is so old that the famous seven gates, or *babs,* to the city, built in ancient Roman times, are considered relatively new structures.

It is interesting to note the sites that our relatives from Arbeen found most important: St. Paul's Sanctuary, the grand Omayyad mosque, and a Palestinian refugee camp on the outskirts of the city.

Because most of the Arbeenians were Christian (about 85 percent of Syria's now eleven million people are Muslim; there are about five thousand Syrian Jews), the site of St. Paul's escape near Bab Kisan was very important to them.

Damascus became the first place Saul tested his new name, Paul, and his new faith, preaching in the synagogue. Some of the Jews did not trust him and plotted to kill him. But his disciples put him in a basket and lowered him over the wall of the city, and he escaped to Jerusalem.

Adeeb took us to where a sanctuary had been built on the site of Paul's late-night basket ride, which even marked the window from which Paul was supposedly lowered. In earlier days, a church had been there and then a mosque. The present chapel was built in 1941; since 1964 the boys' orphanage next door is run by Melkite Catholics.

Inside the chapel the air was cool, the limestone blocks shielding worshippers from the Damascene heat. Above two small altars are marble carvings, one of St. Paul's vision, the other of his midnight ride in the basket. A prayer in a pamphlet we were given by a monk, to be recited in St. Paul's Sanctuary, ensured the faithful of three hundred days' indulgence by decree of Pope Pius X. In pre-Vatican II parlance this meant that, if you were going to purgatory after death to atone for a few sins, you'd get three hundred days cut from your sentence. The Catholic church has since disbanded the practice of indulgences. We said the prayer anyway; you never know what another pontiff will decree.

Then we headed to the grandest of all Damascene structures: the Omayyad mosque.

The Omayyad mosaic depicts, well, everything. It runs one hundred feet high and fifty feet long—an entire high wall. The tiles sparkle gold-green and blue. In it, the pageant of humanity from the Garden of Eden flowed through the waters of the Nile and Barada to Damascus and beyond. It is not, however, a panoply of famous warriors or historical figures. The Palestinian geographer Maqdisi visited Damascus in 985 and described the Omayyad mosque mosaic as "bearing representations of trees and towns and displaying inscriptions, all the ultimate in beauty, elegance, and artistry. Hardly a known tree or town does not figure on the walls." Not wars, but nature and civilization adorn the mosaic.

At the center of the courtyard gurgles a fountain whose water is an exotic turquoise, as if a secret pipe had tapped the South Seas under the desert. Raucous Damascene streets and marketplaces surround the mosque; stand anywhere in the Omayyad courtyard and you hear only the gurgle of water. It is transfixing. It has the stilling effect of a bowl of roses put in the center of a Quaker prayer meeting. It turns the spirit to a river, its natural state (what is the body, 90 percent water, but a red delta of veins and arteries?).

It was in this inner sanctum of the mosque that we discovered a dome within the dome: a sarcophagus styled like a Romanesque church in which it is said St. John the Baptist's head is buried. Thus, Christianity is contained within Islam. The great precursor of Christ, John the Baptist, was ordered decapitated in a rage by Herod, the King of Judah; the head was served up to him on a platter for Salome. The head is cradled like a talisman inside the grand mosque of Damascus. Still, it gave us an odd feeling, if for no other reason but that it seems gruesome to imagine a head revered by itself anywhere.

On the way out Adeeb gave us some history of the mosque. It was built in 705 by al-Walid, the grandson of Mu'awiyah, who started the epochal Omayyad caliphate in Damascus, which shifted the center of Islam from the Arabian peninsula to Syria.

Mu'awiyah himself, after Mohammed and Umar, has been called one of the ablest men in the history of the Arabs. Under him Islam, according to Philip Hitti, "breathed more of the Mediterranean and less of the desert." He was quite tolerant of Christians and Jews; Christians were placed in charge of the Islamic state's treasury, and the poet laureate of the empire, al-Akhtal, was likewise a Christian. Mu'awiyah had his detractors, among them the traditional northern Arabians (thus he wooed the southern Arabians). He is reputed to have once said, "I apply not my lash where my tongue suffices, nor my sword where my whip is enough. And if there be one hair binding me to my fellow men I let it not break. If they pull I loosen, and if they loosen, I pull."

The Omayyad caliphate reached its peak in one generation; after the demise of al-Walid, eight caliphs followed, one worse than the other. Signs of affluence and decadence pulled the regime down—slaves multiplied, concubines flourished, wine poured in enlarged goblets. It was to have a fate similar to Beirut's so many centuries later, but not until one of the caliphs indulged himself swimming in a pool of wine, gulping enough of it to lower its surface. This same scoundrel committed an extraordinary sacrilege. He took target practice with bow and arrows at an opened volume of the Koran![2]

It wasn't long before I became enchanted with a deaf girl of the village. During the opening night festivities, her struggle to greet Jaddu (she was one of Amin's daughters) brought the only quiet interlude of the night.

"She is very beautiful," Adeeb said to me as the crowd hushed at her purposeful push to the porch. "Her name is Fayzi."

She dressed like none of the young women in the village, even then. A shapely figure, she had on Western women's slacks and a shiny midnight blue synthetic blouse that matched the dark blue of her eyes, which had flecks of brown in them. A loving smile lit her pale cheecks. She hugged Jaddu forcefully as if he would help her. She held out dead batteries and a bad hearing aid in an open palm, as if they were betrayers. Her words were an urgent, garbled telegram.

Jaddu began to cry. That set off Mother and Grandmother. The seed was planted there for Fayzi's coming to America; but no one knew then that the doctors across the sea could offer no more help for her problem than could the Syrian doctors. She had a neurological loss; no operation could fix it.

There was a christening and then a funeral in Arbeen that summer. For the first, Fayzi dressed luminously in white lace—it was her newest brother's baptism. At that event, I realized the close-knit weave that celebration and violence can have in the Middle East.

The boy was named for Grandfather Kamel. He was Amin's latest child; Mother became his godmother. The *khūrī,* or Orthodox priest, came to Amin's house. He had the longest hair of anyone in the village and tied it in a ponytail like some patriot of 1776. Hundreds of the villagers turned out for the evening baptism. All were given candles and the priest took the baby in his hands, candles afire surrounding. He plunged the child into a basin of water, baptising him by immersion in the Orthodox tradition. Just when everyone thought the boy was drowning, the *khūrī* pulled him up with hairy forearms. Little Kamel's mouth was as wide as a sea bass; he dripped a trail of water and seemed to say in his surprise, "Who is this lunatic? Get me a towel!"

The villagers crowded around, joking in the steamy air made more hot by the candles. The priest did not hesitate to punctuate his incantations over the sopping child with curses to the crowd. "I have baptized you with the water of life, shut up everyone, and with this miracle you have entered God's chosen kingdom, please harness your tongues, and hereby do offer you eternal, damn the country of everyone of you, eternal life, for the power of God is greater than you, who are really getting me nervous now, greater than all the hatred in the world."

We were sitting at the sparkling dinner tables laid end to end when it happened. In the midst of the low roar of guests' talk and the clinking of glasses and plates, I heard the report of a revolver from the far end of the tables. I jerked my head and focused on a dull-looking, fat man in khaki clothes being shoved by a woman, looking as if he had been slapped. By the expressions of the women around him and their intense downward stares, it was obvious someone had been hit, and hit low.

The man had earlier saluted his Bacchus by shooting the pistol into the air above our heads, a feat guaranteed to land a bullet or two in someone's ʿaraq, if not skull. Luckily, no one had been hurt. But now something else had happened. Extreme efforts were being made to spare the American visitors alarm or contact with the injured. But out of the corner of my eye I saw a little girl about five years

old being whisked away through the crowd. There was blood on her leg. She had been hit by shrapnel flying up from the cement floor torn by the bullet.

The singing and eating went on. Jaddu held up a piece of cheese, unaware of what had happened. It was as if the crowd's voices had risen to cover the tragedy. Mother, who had heard something, accepted the explanation that it was a pop-gun. I glanced over my shoulder, unable to locate the injured girl or trail of blood. The fat man whose gun had done it all went on eating. His careless approach to praise had brought suffering. I was angry that he wasn't expelled immediately from the table, accident or not. I was livid that everyone seemed to sweep the little girl's bloody limb under the table.

Soon desserts came, and I was assured by Adeeb that it was nothing, her foot was bandaged. But to me, the table had become a world, the world, where beauty and suffering were as tightly woven together as reeds in a basket. Which reed is the tragic one, which the comic? It is hard to tell. In Arbeen that night I sensed a predilection for taking violence in stride in the midst of happiness that was both awesome and disturbing. I was not so sure it was peculiar to Arabs, or to villagers. Modern life is lived at fever pitch, risks inherent at every turn. The more comforts multiply in the West, the more lunges for discomfort occur, it seemed. I thought of a recent rock concert at Altamont where a member of the audience, excited by the Rolling Stones, was stabbed to death by one of their body guards, the Hell's Angels. So much for the Age of Aquarius . . .

Later in the week an old man of the village died and a funeral occurred.

At the hand-dug grave on the outskirts of town, the procession stopped. A boy of fifteen recited a poem to his departed grandfather after the wood casket was set in the hole. It was this young poet, and not the *khūrī,* who had the last say. His words brought tears from relatives and friends; they seemed to sob in tune with the rhythms of the poem. Finally, three eggs were placed in the grave. Sustenance in the afterlife.

The next day Adeeb fished us from the Samiramis to take a walk to the Suq al-Hamidiyah, the great bazaar darkened by a crude roof of corrugated metal slats in the center of Damascus. Adeeb was nervous, excited. He had news. Three Japanese commandos had sprayed machinegun fire at Lydda Airport in Tel Aviv, killing twenty-five people and wounding seventy-eight. Two of the commandos had committed suicide; one was captured.

"You see!" Adeeb pronounced. "The whole world is on our side!"

I did not share his synecdoche—the world was certainly not represented by a few crazed gunmen, nor, for that matter, were those who sympathized with the Palestinian cause. There was a note of desperation behind Adeeb's glee. After all, Syria had fought in and lost two wars with Israel and was sliding toward a third.

I knew only the rudiments of the Arab-Israeli conflict then. (I am not so sure learning its complexities is edifying.) But a decade later as I was touring the refu-

gee camps and PLO installations in Beirut and southern Lebanon, the collection of international idealists and malcontents struck me as a foreboding motley. In its hunger for comradeship against oppression, the PLO appeared to have let in all kinds of inauthentic elements that infected the organization with the nihilism surrounding a "hopeless cause," rather than the cool headedness of an idea whose day had come.

Our side? We did not want our relatives hurt by Israel or anyone else. But the Japanese commando raid left us cold. The duality of being an Arab American became starker that day.

Reaching the Suq al-Hamidiyah, we saw the white holes in metal slats above our heads where musket shots had pierced through in the Arab revolt against the Turks during World War I. More holes were added during the Syrian rebellion against the French, who finally pulled out in 1946 when Syria became independent. Some holes were larger than others—perhaps bullets from new battles had followed old bullets. The Suq's ceiling was a constellation of war.

One Arab merchant began to barter over a table of *kūfīyahs*. He asked for fifty lira ($10).

"Uncle, I give you twenty-five lira; it is, after all, very wrinkled."

"My brother, do you know the more wrinkles the more distinguished? Forty-five lira."

"Uncle, what is this spot here? It must be an ash from someone's *arjīlah*. Thirty lira."

"My dear brother, no one is smoking the *arjīlah* within two blocks. This is a collector's item. The brown spot marks the signature of the craftsman. Forty lira."

"O my uncle, the gentleman in the next stall is selling *kūfīyahs* for ten lira and throwing the ʿiqāl (ropelike fastener) in for free. Thirty-five."

"Little brother, the jackass that you call a gentleman in the next stall is selling *kūfīyahs* made of the great false fiber of the West. This *kūfīyah* is cotton. And I will throw in an ʿiqāl. Thirty-eight lira."

"Most gracious uncle, your work is the best in the Suq al-Hamidiyah. Your coffee is also the most delicious, and your hospitality is second to none. Thirty-six lira."

"Young brother, all my life I have wanted to go to America and meet the cheapest people on earth. Thirty-seven lira and sold."

After the strange news about the Japanese commandos and the gunshot at the christening, we were in need of another miracle on the order of George Hanna's paisley shirt. And we got it—deep in the eastern Syrian desert at a convent called Sidnaya. Where the lame are made to walk and the blind to see.

Over the years, I have retained a skepticism of "big" miracles. If Jonah was swallowed by the whale, I tend to think he did not take weekend accommodations

but was regurgitated as a bad meal. If the Red Sea was parted by Moses, no doubt it was also parted by the winds of the imagination. The miracles I hold to are the infinitesimal ones, occurrences that may not defy science but certainly defy probability.

Sidnaya in the eastern Syrian desert is the Eastern Orthodox's Fatima and Lourdes, though a much older site than either. Not commonly known in the West, Sidnaya is far out in a vast sand. Its altar is covered with crutches of the lame who were cured.

Approaching Sidnaya along the sand-strewn road in a desert struck white by the sun, the feeling is of a mirage. The convent appears to be carved out of a limestone escarpment. A few old limestone block houses of the village stand below it, vibrating in the heat. Approaching Sidnaya cars miraculously disappear. We were the only vehicle for miles. We found ourselves stuck behind a donkey loaded with lettuce for the convent, led by bridle by a man who looked one hundred years old.

The term "Sidnaya" derives from Aramaic, the language Christ spoke, still spoken in a few villages near the miraculous site—Maloula, Gabaadine, and Bakhaa. It means "Our Lady," but also "hunting places." The history of the convent at Sidnaya dates back to A.D. 547 and Justinian I, emperor of Byzantium, who was to bestow on the empire a most advanced and tolerant legal system. Justinian was traversing the desert of Syria on his way to attack the Persians when his troops camped, thirsty beyond measure since their last water had been drawn in Damascus, roughly twenty-five miles west. The emperor spotted a gazelle and gave chase up a rocky hill until it halted at a spring of sweet water. On the escarpment Justinian watched as the gazelle transfigured into an icon of the Blessed Mother, blazing with light. According to the story, a white hand came out of the icon gesturing toward the kingly hunter and the icon said, "No, thou shalt not kill me, Justinian. But thou shalt build for me a church here on this hill." Both the vision and the gazelle then vanished.[3]

On the request of the abbess to a Greek monk living in Jerusalem, one of the four original icons painted by St. Luke the Evangelist came to rest at Sidnaya many years after Justinian. In the Syrian desert, the monk was attacked by jackals and wolves and highwaymen, but each time he repelled them with the elevation of the miraculous icon of St. Luke.

We stopped the taxis at the base of a long staircase of stone, and walked up it, zig-zagging past the ass with the lettuce. The driver did not care. He knew we would wait for him for lunch. A young nun greeted us at the massive door to the convent. Through a colonnade a larger nun, older, came out of the shadows. She stopped about forty feet from our group.

"*Ya tiqburnī!*" Grandmother Matile sang. (This is impossible to translate; the literal meaning is "Bury me!")

"Matile, may God be praised!" the abbess sang back.

The abbess and Grandmother ran into each other's arms and romped around in a circle like schoolgirls. We were bewildered. Jaddu thought his wife was laying it on a little thick for a complete stranger.

But this was no stranger. And here is the first part of the miracle of Sidnaya: the abbess and Grandmother had been childhood friends two hundred miles to the west in another country, the mountains of Lebanon. They had not seen each other for fifty-six years—1916. Not since World War I.

Suddenly Matile Malouf Awad's piety in Pasadena with candles floating in oil never extinguished in front of her miniature icons and holy cards of the Blessed Mother made sense. She had always been the one in our family with a special religious—even mystical—touch. Here she was exclaiming "Bury me!" at various octaves to an abbess who looked like she had just seen Justinian. The two of them could have been gazelles.

Grandmother dropped to her knees to kiss the ring of the abbess. But the abbess would have nothing of it, and bent to the floor as had Matile. She kissed Matile's ring. I think they could have kept on this way for another fifty years, up and down like two jack-in-the-boxes. We followed the two of them; the tall abbess's arm on Matile's shoulder, little Grandmother sliding her short, sturdy legs forward at the speed of delight.

"Gary," I said. "Do you have anything you want cured? I think we are in a privileged position. Why don't you ask for more hair?"

"Why don't you ask for less? Why don't you ask for a nose job?"

"But a cure. We have to be sick."

"The next time we fall in love we have to come to Sidnaya."

After a meal with the nuns Grandmother strode with determination to the chapel. It was a place she was born for, a place in which she totally belonged. For here was her chest-of-drawers small altar at home burgeoned to the size of grandeur. All in care of her old friend.

Above the altar hung hundreds of crutches like sleeping bats. In the sanctuary a strange, compacted light glistened like ice. Thousands of jewels were piled in heaps above the tabernacle in an alcove sheathed in satin. As we approached the communion rail Grandmother dropped to her knees. Jaddu standing behind her. He was never a religious man, preferring to read the newspaper on Sunday.

As if in a trance, Matile stood, a woman possessed by a kind of love no one knows anymore. She went under the railing, never taking her eyes off the altar. Halfway toward it she stopped, crossed herself, still whispering private prayers to the Virgin, slipped off her wedding ring, and left it among the countless jewels at the altar of Sidnaya.

Jaddu shook his head, still standing outside the sanctuary.

Matile prayed for some minutes more, crossed herself, turned, and never looked back. Her finger was as bare as fifty years before when Kamel had stolen her at age 15 from her family house in Brooklyn before they married on the run.

It was as bare as the day in Lebanon during the Great War when her mother announced that the second of two brothers had starved to death. It was as bare as the Syrian desert where Justinian saw the gazelle linger by a spring. As bare as the room of an anchorite.

It was a custom, we were told later, for pilgrims to Sidnaya to leave jewelry, and millions of dollars' worth of wedding rings, necklaces, lovers' pendants, brooches, and earrings were left there in the desert, guarded only by a colony of nuns. Yet no one ever stole even a ring from the altar.

Thus concluded the second miracle of the summer of '72.

The third and last miracle of the trip occurred a few days later. I had been asked by my bedridden grandmother on the other side of my family back home to visit the town of her birth in Lebanon—Zahle. It is on the eastern side of the mountains descending into the Biqaᶜ Valley. She was certain I would like it.

Crossing the border late in the day, we arrived in Zahle by nightfall and checked into the Hotel D'Amerique. We could hear the rush of a river across the way, the one that flows straight down a hill through the center of Zahle. But we were too tired to explore the town and took two rooms, grandparents and Mother in one, Gary and I in the other.

At about 2 A.M., there was a knock at the door. Gary went to look. A yellow light from one naked bulb in the corridor stole into the room and I tried to bury my eyes in the pillow. But it was useless. I got up and went to the door. There was a dark figure of a man in an overcoat.

"Don't you know your own father?" the shadow demanded.

My mind was blank. My father was supposed to be in New York City on a business trip. He could not come with us.

The figure moved into the yellow light and it was him and I leapt at him. Gary later said I flew across a space of about ten feet, which could be a record for the standing broad jump, not bad for being half-asleep.

If I was tired, Father was goggle-eyed. He had been without sleep for forty-eight hours, ever since leaving the United States to seek us out, not knowing just where we'd be. No problem. Only the whole of Syria and Lebanon to search through.

Father had been lonely.

Some, when lonely, go to a show, or two shows; some go to a bar, or a night-club; some hire a lady of the night. Some drop pills or make long-distance telephone calls. Some read pulp novels, or Nobel Prize winning novels. And some visit Times Square.

Father found himself on business, alone in New York City, and bought a ticket to Damascus.

Problems: for one, no one on the Orfalea side of my family speaks good Arabic. Father was no exception. Problem two—he had never been to the Middle East, and since World War II he had not been to Europe. Problem three—we were

three weeks into the trip; for all he knew we could have checked out of the Samiramis long ago and, in fact, had. In short, he had done something very crazy. But he was always a master of surprise, and this was to be his grandest surprise.

He motioned me to be silent. Gary went and knocked on the grandparents' door, stood back, and told Mother there was a message for her.

Mother is adept at hyperventilation and when she saw the moustachioed man with the overcoat now draped over an arm she did a good rendition of the Hyperventilation Nocturne, orchestrated by the Lebanese crickets and Bardūnī River.

"Easy, Rose, easy."

"A-Aref, A-Aref, A-Aref!"

I'll put the curtain down on that scene.

The owners of the D'Amerique awoke in all the commotion and were amazed at the night visitor's arrival. They turned the entire kitchen and food cache over to us, eliciting a promise to get the whole story in the morning.

It went like this: Father had had to fire a salesman who had stolen samples of dresses he was marketing in New York. Father's spirits were down. And he missed the family. He purchased a ticket to Damascus, via Paris, just as we had done. After one more day in New York's garment district, he hopped to Kennedy Airport, then to Paris where he bought a bottle of Chanel No. 5 at the duty-free shop, then to Beirut, then to Damascus by the wild ride over the Lebanon mountains. Syria had been the birthplace of his father, Aref Isper Orfalea, Sr., too (at Homs). But his motive for travel was not roots; it was flowers. He had come not for history, but for history's bloom—his own family.

Arriving at the Samiramis he was stunned that we were not there, and collapsed on a sofa in the lobby, chain-smoking Marlboros. Bread and cheese offered by a waiter did no good. Father figured he had blown three summers' vacation money. We were not globe-trotters. A big trip for us during my childhood was hauling off to Lake Tahoe or the lower Sierra Nevadas. Father glanced out the window; there were very few women in Damascus square, and the ones that were there dressed in long robes with scarfs over the heads. There was no way to write this one off as a business trip. Damascus was not a place to sell miniskirts or granny dresses.

The owner took pity on him. He brought over the telephone number of Adeeb, and one ʿId al-Annouf, who was married to Adeeb's sister, Suad. ʿId knew English better than the Arbeenians, having served with the British army in Syria as a telegrapher during the Second World War. Father gained his first speck of hope hearing ʿId's voice over the crackling telephone line, dialed at an old-style black metal phone. ʿId had a high laugh.

Soon Adeeb and ʿId—at six feet five inches, one of the tallest Arabs any of us had laid eyes on—arrived at the hotel. ʿId lifted Father off the ground like a brown bear. Adeeb pranced around, tickled that Aref had come all the way from the United States on an impulse.

"Where are they?" Father asked, adjusting his thick-lensed glasses looking at a map.

"They are here, in Zahle," said ʿId.

"You mean I missed them by only one day?"

"Yes."

"How do we get there?"

"Tomorrow," said Adeeb. "We can take taxi."

"But they might leave for Beirut by then. I have to go tonight."

ʿId and Adeeb looked at each other, the giant and the gnome.

"We're with you," ʿId said, and Adeeb nodded quickly.

"What about work?"

"Work? I will call Suad. She will tell work that we are on an important commando mission in Lebanon!" ʿId's brown eyes blazed, and his big hands lifted above his head.

So the three of them got a fast taxi and drove out of Syria around midnight. Here was Father passing through the land of his ancestors as if it were so much flotsam to pass through to get where he really had to go.

When they made it to Zahle, it was so late that all the shops and restaurants were closed. One by one they woke up people at the hotels along the Bardūnī, asking for the Awad or Orfalea families. There was only one hotel left at the end of the line. Utterly exhausted, ready to give into sleep after the depressing trip, father dropped his hand down on a desk bell at the D'Amerique, rousing a young man named Said.

"Yes, we have a Kamel Awad here. Two rooms."

ʿId and Adeeb punched Aref and beamed with stifled glee.

In our nightclothes we heard the story in the hotel kitchen until dawn. Then we slept and heard the story again.

Father joined us to tour Zahle, the town in which his peddler mother, Nazera, had been born in 1886.

The Bardūnī River is a legend. Crystal and cold, it speeds down the mountain and is indeed Zahle's main road. Cafés and restaurants snuggle along the river as it descends through the mountain town in small falls and cascades. We ate lunch at one that served endless dishes of *mazzah* (hors d'oeuvre), including *tabbūlah* (parsley and bulgur salad), *baba ghannūj* (eggplant dip), and *hummus*, but also lamb brain and spinal cord (a white, rubbery string). We inhaled the pure Zahlewean air, a refuge for asthmatics throughout the Arab world.

Zahle's roads are pitched, winding. The main street sported Jabaly's theater. The owner stood on the steps in a three-piece suit, checking his gold fob watch. I asked if he knew a Jabaly family that had spawned a Nazera Jabaly a century before; she was among the first thousand women immigrants from the Arab world, and she was my grandmother. He said the woman was his aunt!

I have mentioned three miracles. There were also three warning signals that something malignant lurked in the fragile societal body of Lebanon, even in this boom year for tourism in 1972.

The first warning was in Zahle; it was during a meal served by a great-aunt, another relative of Nazera.

The aunt took us on a tour of Nazera's house of birth. She barged in with no deference to a Muslim couple's small abode that one hundred years before had birthed one incredible woman. At the age of 87, Nazera could still remember the poplar leaves outside her window in Zahle three continents and eighty of those years away. There they were, swishing in the Zahlewean breeze.

Later, the aunt, a gruff woman with thick calves, put a gigantic spread of food out for us. As she pointed an upturned palm for us to sit, eat, she turned around and faced a 12-year-old-maid. "Go sleep on the floor in the kitchen, you little dog!" she spat out.

With one sentence, she had turned our appetites sour. Mother—for the second time—could not eat.

Chances are the maid was a Palestinian girl from one of the camps near Baalbek in the Biqaᶜ Valley. The little girl actually went and lay down on the stone floor with only a tattered throw rug underneath. This short exchange showed us a deep wound in the society.

Later, we traveled to another mountain village, Mheiti (also Shreen), near Bikfaya, where Grandmother Matile had been born. She went on foot to her ancestral home, which overlooked the blue mountains. There relatives presented her with a thirteenth-century axe with curved blade that had been left by the Crusaders. Matile had no use for axes; she gave it to her daughter. It now hangs above a wet-bar in our California home alongside a painting of Hank Aaron.

Adeeb roused us earlier than usual, banging at our door at Samiramis.

"Today we go to Palestinian camp. *Yallah.*"

Yallah is the Arabic version of *ándele, vite,* and *pronto!* It is almost synonymous with the desire to go; few go slowly.

Father had been received in Arbeen and Damascus as a hero, a kind of Humphrey Bogart figure. But before we once again slid into the night gaieties, Adeeb wanted us to see Yarmouk, the Palestinian camp on the outskirts of Damascus harboring about twenty thousand refugees. We were game.

We traveled along a whitewashed adobe wall east of the city as if to go to Sidnaya. But this was not miracle day. Nor were we following a road to Palmyra, where in the eastern Syrian desert stands the largest spread of Roman ruins outside Italy. We followed a wall that turned to contemporary ruins. These were the ruins of the Palestinians. The inhabitants of the pock-marked labyrinth of walls and shacks had lived in the camp for a quarter-century.

In some ways, the hovels were not much different from the village of Arbeen.

The quarters were more squashed, if that was possible, and the walls to the tiny dwellings in more disrepair. But my first thought was that the Palestinians in Syria were living on a par with the peasant farmers that were our Syrian relatives.

But the air was different; there was a nip of hostility from the start. Gary immediately disappeared on the backstreets of the camp with his Minolta camera. Faces of people peeling onions or lounging in broken chairs turned and watched him silently make his way into the children-strewn street.

We had a number of Syrians with us, translating, including Adeeb and Sami. I noticed a man in his fifties who was brushing an old horse. As we began talking, a crowd of about twenty gathered around to listen. I asked the man where he was from.

"Sarafand, in Palestine," he said, still brushing dust off the horse. Sarafand is on the coast, south of Haifa.

He had been in the Syrian camp since 1948 when his family fled Palestine in the war that eventually led to the creation of Israel and uprooted 750,000 indigenous Palestinian Arabs.

I asked if he had sunk some roots in his twenty-five years in Syria.

"I cannot grow even vegetables here—there is no land for it," he spoke calmly, but distinctly. "The land is Syrian government land. I used to have 100 dunams [25 acres] of land in Sarafand and farmed it. Now, like everyone else, I take any work I can get—shine shoes, sell Chiclets, work in restaurants, or do nothing and live on nothing."

The man adjusted his white cotton cap, shifted his head upward, and stopped working on the horse. The horse neighed softly, picking up a hoof. His raw skin showed in patches; the hide had fallen out from some disease.

The man said, "I want to die in my homeland."

The man with the cotton headpiece and the flea-bitten horse pointed to a series of walls down across the road from the camp. "It is the Jewish cemetery here," he said, with no particular expression.

The third unlikely neighbor in this triangle of tragedy—in addition to Palestinian refugees and Jewish dead—was a series of scattered cardboard boxes in a field past the camp. Crude holes for windows had been cut in the large boxes, as if they were playthings of a giant's children. I guessed they might be domiciles of gypsies or of Bedouins. No. They were the dwellings of Syrian refugees from the Golan Heights, captured by Israel in the 1967 June war. It is a fact that the Syrian refugees were living in worse conditions—at least in 1972—than their Palestinian counterparts. It may have had something to do with their more recent refugee status—only five years out of their homes.

One Palestinian roof, however, was planted—literally—with something other than electricity. This Palestinian had nurtured a tall, dusty juniper in sod. It stood proudly against the bleached hovels and the dry sky. It was not green but it was alive, and it was more important to that refugee than connection with the news.

That dusty juniper spoke of a modest hope amid all the bitter reasons to despair or hate.

As for the Syrians from the Golan Heights, it was still a shock to see them living literally in refuse in their own homeland, five years or not. It gave an inkling—with no substantiation other than the scattered boxes for homes—that Syria would deal as severely with its people, and perhaps more so, as with Israelis or the Palestinians.

One of the Golanis was stirring a brazier of coals outside his home-sweet-box. His face was leathered by sadness. It resembled beef jerky: thin, lined, dark reddish brown. There was no spice in it, though. His wife, robed in black even in the hot sun, held an infant. His boys played in the dry lot around them, kicking tumbleweed with a stick. He offered us coffee.

Suddenly we heard a shout. It came from the Palestinian camp, which, in back of the Golani boxes, looked like a real town. We realized that Gary had not come with us and rushed back. Sure enough, Gary was being chased by a mob led by a woman who was shouting "Devil! Devil!" We hopped out of the taxis. She grabbed her large breast, pushing it up with her hand, incensed at the sight of us: "Get out of here you American Jews! Get out of here right now!" The woman's wrath communicated itself to a growing crowd of about one hundred.

"What in hell did you do?"

"Nothing," Gary said. "I took a picture of her breast-feeding her kid."

"You idiot! Couldn't you have taken a picture of a donkey?"

"Does it matter?"

"Does it matter! Look at this crowd. They want to lynch us. That gal probably has her breast photographed by every UPI and AP cameraman east of New York. But she doesn't expect it from you. You're an Arab. Or you're supposed to be. You're supposed to honor her by not doing those things."

"Hogwash."

It was too late to argue, to tell them we really were Arab Americans, that not all Americans were against them, nor for that matter were all Jews. The husbands were getting angry, the children expectant of violence. Sami and Adeeb took one look at the breast-feeding woman's toothless anger and raised stick and said, "*Yallah*. We go back to Arbeen."

Father, who was still fatigued from his long trip, was most shaken. He mumbled, staring out the window, "Terrible. Look what we have done." He wasn't talking about the snapshot. For an instant our Arab heritage was obliterated.

Gary sheepishly wound the film in his Minolta. Something in that woman snapped today, I thought. If we had cameras, we were Americans, and if we were Americans, we were Jews. And all of it was the enemy. She had had enough, for that day, and probably for her life. I'm not sure it would have made a difference if we had convinced her we were Arabs. Our clothes were too shiny, and our curiosity too detached.

Beirut awaited. Its grand hotels, casino, decadent nightlife, sparkling forbidden beaches, and beggars. A Palestinian poet puts it more bluntly: "Beirut is a rat where a car runs on artifical turf / off a cliff."[4]

Speaking of cliffs, they seem to get steeper going west over the mountains toward Beirut, than leaving it. From high up, Beirut appears a far-off island, a flat intricacy of the sea. How free the road was driving down the mountains to Lebanon's capital! And how treacherous. How unfree it is today—blocked by armies and militias—and how treacherous. Guardrails cross the road today, but never ran along the sheer drop, and still don't. Peacetime or wartime, no one will ever be protected from falling in Lebanon.

Driving into Beirut was an exhilarating recognition: familiar trademarks of the West were everywhere. Coke bottles tipped to a Bedouin's mouth, script in Arabic, skyscrapers, tall cranes, luxury hotels that had given the city its nickname, "the Paris of the Middle East." As we turned the roundabout in the center of the city, I caught sight of warning number two of impending cataclysm in Lebanon.

A legless man straddled, with his stumps, the center divider of the roundabout, putting his hat out to both incoming and outgoing traffic of the capital. He was a startling unofficial greeter. He saluted those who dropped a lira or two into his hat and smiled broadly under his black-and-white *kūfīyah*. Like some kind of traffic signal the beggar's hat—it was Western—went back and forth to leaving and arriving cars. Behind him towered the Phoenicia Hotel and the Holiday Inn. The latter, nearing completion, would have three years of bustling life until it was completely gutted in the civil war. The large gap between rich and poor in Lebanon told its grim story in the legless man of the roundabout. It was not easy to forget the little maid forced to sleep on the floor in Zahle or this cripple in the capital in spite of the ensuing excitement.

We pulled up to the esplanade in front of the Phoenicia Hotel. Ice-cold air conditioning hit us on entering, glass doors opened by velvet-gloved Lebanese and Palestinians. The grandparents and parents checked in, and from their sweeping window looking out on the Beirut port they could see the elegant old St. Georges Hotel resting on the waterfront like a golden galleon. The St. Georges was then the favorite of journalists; later the war made them take cover in the nondescript Commodore Hotel downtown. Below stood the fake Doric columns of the esplanade. No one could foresee in that splendid view that those columns would tumble, and the glass of every window in the Phoenicia shatter, and the St. Georges turn into a haven for rats, drug pushers, and people with bodies to dispose of. That was three years down the road yet, the Battle of the Hotels. . . .

Gary and I wanted to be in the heart of the city, so we found a little pension, the Salaam House, in the Hamra district. It had only three floors and we stayed on the top one in a room freshly painted gray.

I remember parting the small curtain of the window in the pension shower in the mornings, looking out through the steam of hot water and seeing a woman flattening *ṣafīḥah,* or meat pies, with her hands on a stove across the way. The

streets of Beirut are narrow, and the love, death, and food of one's neighbors are not more than an arm's stretch across the alley. I inhaled. The air was blessed.

We soon made friends with a dark beauty, Hind, the daughter of the Salaam House's owner, and her blonde, rather feline Lebanese friend, Cynthia. They became our constant companions.

I see a tableau of the porch at the Salaam House, whose name is scripted in turquoise on the white stucco; the wrought-iron balconies and lattices are also turquoise. It is a small peacock, this pension! On the porch is the old Iraqi diplomat taking his morning tea.

"So, you work for an oil company, Gaary?" Hind says, pulling her shiny, straight umber hair over a shoulder before pouring coffee and hot cream for him.

"Yes."

"But you have come to the wrong country. You must go to the Gulf to discover oil. Here we only have olive oil."

"My company doesn't have Middle Eastern oil. Only in the North Sea near Britain do we have concessions overseas. It's mostly domestic."

"So you will never live abroad," her eyes shone. "What a pity. You better find an Arabic girl while you can, rather than those spoiled American women."

"Someone who can really pour the hot cream," I offered.

"Precisely," Hind smiles, and puts a plate of olives in front of us.

The Iraqi diplomat takes this all in with a gold-toothed smile. Comes the fine figure of Cynthia up the steps.

"Babe! I want you to meet two Americans."

Cynthia does not shake a hand, but curls hers and lays it limply in mine.

"You are not American; you are Arab, aren't you?"

"Arab Americans. And you don't look Arab yourself."

"My father was British, but my mother . . ."

"Her mother, yi!" Hind adds, holding a hand up.

"My mother is Lebanese to the bone."

"You have more freckles than an Irish colleen."

"My father dropped them into the yogurt," she spreads her teeth, neatly gapped in front.

Gold bracelets of both young women tinkle in a kind of harmony as we pass dishes and eat. The Iraqi diplomat has read his paper five times over, twice right to left, twice left to right, once up and down.

"America I don't like," Babe pouts.

"Why?"

"Americans are chameleons. They don't know who they are. They are gruff and arrogant people, and childish, too."

"Would you like to join us for a movie?"

"Americans think the whole world revolves around their little finger."

"We could go to dinner, too."

"Americans are presumptuous."

"I understand you have a lot of cats."

"Twelve."

"Who will watch them while you're gone?"

"My dog. And Mother. Americans are so practical."

We later saw *Husbands* with French and Arabic subtitles; it was drastically cut. Babe pointed to the screen and whispered, "You see how nasty your American men are to their women? Going all the way to London to cheat on them."

"Americans are so impractical."

We had a fine time with Hind and Babe that summer. But Babe never stopped criticizing America, its men, its foreign policy, its mores, and its boorishness. She did, however, like American soft drinks.

During our Beirut stay, we ran into a number of American friends. Walking down the shopping district of Hamra, we bumped into Khalil Hakim, who had studied with Gary at the University of Chicago. Khalil was now manager of the Libby Foods plant in Beirut; food chemistry was his specialty. He took us on a tour of the plant and showed how ptomaine poisoning was prevented in the preservation of canned goods.

Khalil drove us to his family home near Damour; it was made of the traditional limestone. He warned us on the way that trouble was brewing in Lebanon. Neighborhoods had to pay extortion money to civil authorities in order to get sewage and telephone lines, which were months, years, in the waiting. The Muslims, he contended, had little to show for themselves, and their areas were always the ones slowest to be upgraded by the Maronite-dominated government. He said the regime of President Suleiman Franjiyah was thoroughly corrupt.

"In Chicago I was very interested in the Middle East crisis. But since 1967 our people have had so many setbacks. The disunities have crippled us, and I believe we have made some big blunders. I've lost my sympathy."

He was to lose more. The Libby plant was destroyed during the civil war in 1975 and Khalil would flee to Athens, and then to Saudi Arabia. It would be another forced exile for him—he was born a Palestinian in Jerusalem.

Life went on as usual in Beirut.

Even then, the gun was never far away from pleasure. One night we cooked out with the girls from the Salaam House. I gave Cynthia a 10-pound note and asked her to buy some hot dogs, kerosene, and buns. She bought caviar and expensive cheese. ("I hate those crass materialists!") We hired a cab driver for 25 pounds to take us to a free beach just under the casino's snapping red lights in east Beirut (I do not remember anyone then actually referring to "east" or "west" Beirut). He pronounced he would get up at 1:30 A.M. to come and get us and promptly fell asleep by the side of the road, mouth gaping against the car window.

Soon we were rolling away from the glowing coals on the cold sand. Babe murmured with a voice that resembled Lauren Bacall's. We tried to roll away from the casino marquee, but there was no escaping; its periodic flashes turned the whole beach pink.

A few nights later, we four took Adeeb, who had come to visit from Damascus, on a beach walk at Summerland, south of Beirut. It was there that the third warning came.

Just as Babe reiterated she couldn't put all her eggs in one foreign basket, Adeeb called out, "There's someone with Gary."

Four dark neolithic figures approached, sloshing in the tide. Two were Hind and Gary. The other two were Lebanese soldiers in fatigues, automatic rifles slung over their shoulders. The beach, they barked at us, was under heavy guard against a sea commando raid by the Israelis, and what in hell were we doing on it, particularly with these American girls. One soldier poked Babe in the arm and accused her of being an Israeli spy. Babe, who had the misfortune of being light of skin and hair, was speechless. Adeeb fumed. Clarence Darrow couldn't have done a better job.

"You idiots! These women are Lebanese, not Americans. These men are not Arabs, but Americans. And I am a Syrian, you dopes. Not in Syria do we have such ridiculous surveillance. How dare you! I am a lawyer in Damascus."

The elder of the two soldiers, a corporal, started examining Babe and Hind's bodies with a flashlight, first the face, then the breasts, and then the legs. Babe told them we were lovers who had come to the beach to kiss.

"No," the corporal said, dropping his cigarette. "You came out of the sea as spies."

Babe took over from Adeeb and lambasted them in the filthiest Arabic I have ever heard. They were finally convinced. No foreigner could curse like that.

Though the country was not exactly at ease, even then, it was not reassuring how quickly those Lebanese soldiers substituted appearance for reality, how fast they mistook their own for an enemy. Lebanon's history as a bridge between two worlds—East and West—had made for xenophilia, a spirit of internationalism. But in Babe's fears, and in the soldiers' paranoia, I sensed a counterstrain of xenophobia, a repugnance for outsiders. Which strain would win?

"It may have been that day at the Palestinian camp outside Damascus."

Father was speaking from his hospital bed at the American University of Beirut hospital. His ulcer was bleeding. He had complained of pain in his stomach ever since the little riot at Yarmouk. Jaddu, too, did a stint at AUH when his emphysema acted up. But the look on my father's face mirrored a strange torment; it was not unlike the paleness I saw when his ear was glued to the radio report of war in 1967 back home in Los Angeles. It was strange; his family was so Americanized. He was born in Cleveland, played high school football, grew up to be a respected leader in the West Coast garment industry, moving easily among the Jews, Arabs, and hurried racks of clothes. He was a parachutist with the 82nd Airborne during World War II and helped liberate the Provence town of Draguignan. He was as American as anyone can get, yet there was something in his face that needed answering.

Shortly, the parents left for the States; the grandparents stayed on.

Though it took some convincing, Hind and Cynthia accompanied us for a day trip to southern Lebanon. It was known then as Fatahland.

The road south of Beirut grew weeds; it was lined by a listless stand of eucalyptus. Before long it became a mirage of dust. The first check point, at Sidon, was manned by Lebanese soldiers (in ensuing years it would be manned in turn by United Nations forces, the PLO, the Israeli army, and the Shiʿite militia, Amal). From Sidon south the taxi driver we'd hired began eating red pistachios fervently, piling up the shells on the front seat. A soldier at Tyre told us we had to proceed at our own risk anywhere in the next twenty-five miles to the southern border. The area was almost entirely under the control of Palestinian guerrillas. The taxi driver took his stand at Tyre: no farther. He reached for a fresh bag of pistachios.

Silently, we walked down the mosaic-tiled road amid columns of Roman ruins. Closer to the Tyre port there were older ruins—four thousand years old—of the Phoenicians. We looked down the shore. A silver wing of land glinted in the sun: Israel.

Passing Palestinian refugee camps on the way back to Beirut outside Tyre and Sidon, the Lebanese women scoffed at our dismay. The cabbie was now smoking. The women said we were idealists. The Palestinians, recently kicked out of Jordan (1970) were already espousing Lebanon as the main staging ground for attacks on Israel and were already treating people in the south like dirt.

"Mark my words," Hind said. "No good will come of this."

We countered that it would be good for Lebanon to show compassion if it was to expect it itself. The presence of half a million Palestinian refugees in Lebanon (grown from the original 150,000 in 1948) cried out for a permanent solution. Such a large group of homeless needed a home, as did the Jews who fled the terror of Nazi Germany. The natural solution was some part of historic Palestine as a state for the Palestinians.

Hind shook her head, "Is Lebanon only a floor mat?"

Adeeb in Damascus had said of the PLO, "The guerrillas are men without a country. Such men have nothing to lose."

I am not so sure about that now.

Just before leaving Beirut, we went to visit the caves at Jaita. Inside the caves the air was cool. Stalactites dropped in spears as old as the earth. Stalagmites had formed below them, yearning upward at a most patient rate. In the smaller caverns, the golden formation of sand met and made pillars. Pipe organs. Faces of struggling men. Women with huge breasts. A horse rider. A lonely child. They were all there under the earth at Jaita in mute forms of sandstone. The farther we went down from the light of day, the deeper our own heartbeats seemed to pound. Finally, we stopped. A subterranean river was below, a sloshing. Maybe by such a canal the damned could be taken from hell.

Back in Damascus, a meeting was arranged for me with President Hafez al-Assad's press secretary, a Syrian administrator for UNWRA (United Nations Works and Relief Agency), and a Palestinian spokesman, originally from Jerusalem. A surprise in the small group of journalists there was Otis Chandler, publisher of the *Los Angeles Times,* my hometown paper.

Much of the meeting was predictable, some ironic, and some prophetic. The press secretary emphasized that the Arabs were not against the Jews, but against the expansionism of Israel. Syria was against the Rogers Plan (an earlier version of the Reagan plan that would have attached the West Bank to Jordan). Syria was "against any project which does not come from the Palestinian people themselves." (Ensuing years proved the irony in that statement. In 1976 Syria stopped the PLO in Beirut and in 1983 expelled Arafat and his forces from Tripoli.)

The Syrian spokesman was irritated by "a lot of rumors in the West that Syria is torturing Jews and violating some Jewish ladies. We have opened our Jewish Quarter in Damascus to visitors who can speak with Jewish professionals, doctors, traders," he declared. "Did you know the largest department store in Damascus is owned by a Jew? That we have thirty Jewish students at the University of Damascus?" We had visited the Jewish Quarter ourselves and found it clean and quiet.

The press secretary uttered an angry clarion: "Let the battle cover the whole Arab nation. Let the battle continue. Unless we make of Palestine another Vietnam, American public opinion will care less about us." In short, one breath had him washing his hands of America, the other hankering after American opinion.

I left the meeting troubled and went out into the Damascene streets. It was late afternoon. An assault of smells distracted me—rosewater, crushed berries, bitter coffee grinds. An old man poured purple berry juice from a jug balanced on his shoulder into a cup for a peasant. I walked past a sherbet seller fashioning a cone of the only flavor in the city—pistachio. *Māʾzahr,* or orange water, was in the sherbet and almost made me sick, for by now I could sniff it on any sweet. Fruit stands hung oranges and grapefruit like groups of women with their heads turned. Damascene workers lingered, broke their arm-in-arm stride, threw a few piastres down, drank a glass of juice, and continued on, pointing to heaven.

I came to the Street of Gold, and Wahib Awad Hanna's little gold cubicle. (Wahib was one of eight children of ʿAmmu Selim, another of Jaddu's brothers. George Hanna of the paisley shirt was a younger brother of Wahib.) Wahib of the upturned jaw smiled while hammering medals of the Blessed Mother and miniature embossings of Koranic suras. Sweat dripped from his forehead. He was tired of staring at gold with a hot needle. He motioned through the window for me to kill an hour in the Suq al-Hamidiyah and come back; then we would leave.

I went back into the lengthening shadows of the city of my ancestors. The streets were thickening with workers on their way home from the cotton mills, from the new ambitious highway projects, from markets and bread ovens, from the stores that sold everything from frankincense to orange water. The people's

faces were leather, oiled by sweat. They seemed to seethe with a collective need through the streets. Their quickly moving loins and mouths showed life and ideas running through their systems like precious water dissipated all too soon in the heat.

The muezzin pierced the golden air with a call to prayer. Some of the crowd bent right where they stood; most hurried, as if to blur their bodies before the sight of God.

In front of the Suq, I stopped to buy a glass of berry juice. My eyes fell absently on a little girl who had pieces of dried lamb on her bottom lip. She was in the center of the street, not more than four years old. She flickered among the spokes of bicycles, through the striding legs of workers and students, behind burdened donkeys and carts, and past the wheels of cars. She seemed to be looking for something. No adults were attached to her.

Why, of all the people on earth, had we found ourselves enemies of these?

She was so young, but in the ancient sun she seemed already turned to sedimentary rock. Her legs were bruised and her brow dirtied. Her eyes, though, burned a little amber behind a vagrant whisp of hair.

I followed her a while and then realized she was going nowhere, would never go anywhere. She was a spoke of the street. She would know little and want little, and perhaps have a husband one day who would die at war with a country my taxes kept unyielding. Or with my own.

But she was my own.

A hand gripped my bicep.

"You . . . were lost?" Wahib asked in quiet English.

"What can we do for that girl?" I asked, turning back. But she had disappeared in the street.

A timeless time came to an end.

Wahib put a medal he had made around my neck—the gold Blessed Mother. I looked one last time in Arbeen at the faces of the village—and for a second wished Jaddu had never left. There was Shahda, his one sister, the marvelous rills of time on her face. She was trembling. Great Uncle Tawfiq: handsome, sunburnt forehead, sad. And Great Uncle Selim and his moon-round face. There was little Great Uncle ʿAbdu, who had cured me with the swirl of his ancient hands. There was Adeeb, this wide smile furled like a ship at anchor. He was silent. ʿId—the tall, giant bear. And the children, one after the other, bestowing kisses like flowers on our skin. Fayzi held me tightly. Her little sister, Nora, who had followed Jaddu so closely the whole summer, even helping him with his oxygen. And then George Hanna, who was wearing in farewell the paisley shirt again.

Over the next decade news from Arbeen was scarce. Letters were rare. The ones I sent—including a long poem to the villagers—were never responded to. Yet somehow word came. During the 1973 war, Wahib, the goldsmith who res-

cued me from a feeling of despair on the Damascene street, was killed with his twin infant daughters and two others when a Syrian army transport truck plowed into his car head on in a freak accident. Old ⸌Abdu died a natural death, as did Shahda. An Israeli bomb fell on ⸌Abdu's farm during the war but did not go off due to his heavily irrigated fields. The children found it in the mud. Adeeb and Sami married in their late thirties, as is common in our family.

A tie across the globe had been made, however bad connections were through the mail. Fayzi did come to America, though her sojourn was difficult. Accompanying her was little Nora of the pink pinafore. Fayzi returned to Syria before Nora, who went quickly to the head of her class in English, being a fast fan of the Los Angeles Dodgers. She returned to Syria after ten years in America in 1984, marrying her cousin, George Hanna of the paisley shirt.

But flying back over the Atlantic in 1972, Wahib's medal touching my breastbone, I looked below for a long time. The water was a dark gray-blue, like a restless hide of some animal never satisfied. In America we are all bitten by the independence bug; in Syria and Lebanon that summer I had felt a glorious communion that does not extinguish personality but blends it into a soup of spice. The blending, the warmth, is all-important, and, one sensed, the roles fairly set. I wanted to stay but knew I could not, that I somehow did not quite fit though I had never felt more at home in my life. Then I thought that, paradoxically, if Jaddu had not had the courage to leave at the century's beginning, the power of that reunion and kinship might never have happened.

Down on the hide of that blue watery beast below, Jaddu came in 1920 in a ship seeking a better life; the hive of Damascus had been stifling in some way. No doubt that was the other side of such warmth. I imagined the great ocean liners, and steamers, the barges filled with immigrants from the Old World in the hold, so many nets of sardines, so many catches from oppression, neglect, and poverty. They were the Irish in mid-nineteenth century with no potatoes; the Italians with blistered vines; the Jews with scars of pogroms; and after them, the Greeks and Slavs and Russians fleeing bloody revolutions.

But there were also Arabs—a trickle at mid-century that grew after 1890 and reached a peak at World War I of about ten thousand a year. They came from the destitute Syrian province of old Ottoman Turkey, and the Lebanon mountains in that province. I saw them below creating the waves of the great blue animal that led to America; they, too, had the mighty No! in their eyes, seeking a Yes.

I wanted to find out why they came, these Syrians, Lebanese, but was also curious about those from other Arab countries, such as Egypt, Yemen, Palestine, Iraq. I wanted to trace where they settled, the lives they lived in the New World, the dilemmas they faced, the contributions they had made to America. Finally, I wanted to try to do something to right the political wrongs by which our relatives and their people suffered and for which, partly, we were responsible. On my return I began gathering information, in an informal and then increasingly for-

malized way, about the history of the two million Americans of Arab descent. I had no notion, looking out on the Atlantic that day, that my search would lead me back to Beirut once again.

If a final tilt was needed, it was provided on a dark night in a hospital on October 4, 1974. From the day of our return from the triumphant reunion in Syria, Jaddu's health deteriorated. In two years, he was on his deathbed in Pasadena, breathing fast, oxygen tubes in his nose and a mask over his mouth. Crosstown that very night, in another hospital, was Nazera Jabaly Orfalea, Father's mother, the one who came from Zahle. She had just passed away at 88. Kamel had always said, "When the old lady goes, then it will be time for me." Nazera and he had been close friends cross the marriage, both cut from the same tough immigrant cloth. Kamel did not know, however, that she had died, nor even that she was hospitalized.

Members of the family took turns standing watch through the night. At one point, I was in Jaddu's room with a cousin and a brother.

He struggled for air. It seemed he had struggled for air most of his life. This was a man who, in a sense, had introduced me to myself, or at least had shined a light on a dark, submerged chunk of the soul I had hardly known existed. He had, by taking me to Arbeen, passed a baton. He did not guarantee that it would be clean, or light, or without smudges of blood.

"Jaddu," I suddenly touched his chest. "I know you cannot speak. But I must ask you something, and if you answer yes, raise your left hand. Otherwise, raise nothing. Do you think life is good?"

Seconds became years. My brother and cousin were transfixed watching the motionless man on the hospital bed.

Though in a coma, he raised his left hand slowly—intravenous needles and all—then dropped it. Five hours later, he was dead.

2 Seeds to the Wind: The First Wave of Arab Immigration, 1878–1924

Scouts, navigators, translators, Eastern rite missionaries, escaped slaves, and camel corps trainers: these first explorers of the New World from Arab lands found America as exotic as did any Western visitor the Orient. On his deathbed, my grandfather from Syria had proclaimed that life was good; his predecessors daring the Atlantic westward would have also said: life is wild, lonely, and short.

The Arabs were to come in groups and sizable numbers only after the emigration of the Joseph Awad Arbeely family in 1878 from grandfather's village of Arbeen, Syria. By contrast, the first gathering of Jews in the New World were the twenty-three who landed in New Amsterdam (New York City) in 1654, about two hundred years before the first documented lone Arab settler. But history flares with a few daring Arab soldiers-of-fortune who traveled by force of will (or forced will) across the Atlantic—in Arabic, "The Sea of Darkness"—before any thought of settlement.

The Stuff of Myths: Arab Adventurers in the New World

Grandfather Awad arrived in New York City from Arbeen in 1920 aboard a tramp steamer. He could never have known that a much earlier notch may have been made on American stone by sailors from Lebanon before the time of Christ. They were a people for whom a sea horizon was as enticing and capable of mirage as a desert. They were the Phoenicians.

In New Hampshire's Pattee's Caves and on hewn stones in southern Pennsylvania near Mechanicsburg are strange inscriptions that have led at least one historian to conclude that the Phoenicians landed in America between 480 and 146 B.C., long before Columbus or the Vikings. The ancient cities of Phoenicia—Tyre, Sidon, Berytus—are part of the modern state of Lebanon. Whether these inscriptions in stone in rural America—ciphers of the world's oldest alphabet—were carved by some overzealous Lebanese eager to establish a patrimony beyond the smoldering ruins of modern Lebanon, or were indeed the markings of history's first crew team, is left to speculation.[1]

Fascinating recent evidence has been unearthed of an ancient North African— and particularly Libyan—presence in the American Southwest. There archaeolo-

gists with no knowledge of Arabic or ancient tongues as late as 1962 found inde-cipherable petroglyphs and labeled them "Great Basin curvilinear." But in 1980 the linguist and fossil expert Barry Fell revealed that an inscription on rock in the Valley of Fire, Nevada, was written in ancient Kufic Arabic and spelled a man's name, Hamid (or tranquil). Fell also found striking similarities between south-western Indian pueblo and pre-Islamic Tunisian and Libyan architecture, pottery, and dress. Among many other petroglyphs unlocked was an exhortation not to offend Baal written in ancient Numidian (North African) script and dated 650 B.C. According to Fell, these ancient Libyans of the western American high desert did not come just to explore; glyphs of alphabet and math lessons show they were teaching their young.[2]

The Columbian era is lit by some Arab torches. Columbus' monumental voy-age may have been inspired by an escapade of eight Arab sailors who took a ship from Lisbon before Columbus and landed in South America. The Arab geogra-pher al-Idrisi documents the voyage of the eight Arabs, but historians discount the claim that they inspired Columbus to try to reach the East by sailing west. Nevertheless, a visitor at the five-hundredth anniversary of Columbus' birth in Italy found a copy of al-Idrisi's account among Columbus' belongings on display.[3]

In 1492, Columbus did choose as his primary translator a Spanish Arab, or Moor, converted to Christianity after the fall of Granada, which had been ruled by the Arabs for six hundred years. His Christian name was Louis de Torre and he was in all likelihood the first man of Islamic culture to set foot on North Amer-ica. He was of no use in speaking to the American Indians, though he would have been useful in speaking to East Indians.

Morocco—linked by Gibraltar to Arab Spain—was to have a special relation-ship with the New World and, later the birth of the United States of America. In 1539, a Moroccan Arab named Estaphan (Istefan) was picked as a guide to Fra Marcos de Niza, a Franciscan sent by the viceroy of New Spain to explore the Southwest. Estaphan was killed by a Navajo arrow before he could get back to tell the Spaniards about the cactus. Finally, Morocco—under Mohammed III—granted free passage to all American ships in 1777, thus becoming the first coun-try in the world to officially recognize the independence of the United States. A "Treaty of Friendship" between Morocco and the United States was drawn up and signed in 1787 by Mohammed III and George Washington.[4]

In spite of Morocco's contribution in scouts and diplomacy, North African Arabs were not to contribute much to the large First Wave migration from Arab lands to America (it was over 95 percent Syrian-Lebanese-Palestinian). But one North Carolina family—the Wahabs—claim to trace their ancestry in America back to an Algerian shipwreck in 1779. During the American Revolution the Continental Congress negotiated with Algeria to stock horses for Washington's depleted cavalry. A ship carrying the horses hit a reef southwest of Cape Hatteras and some of the men and horses swam to shore. Today there is a cemetery on Ocracoke Island, North Carolina, with the name Wahab (a giver of strengths or

talents in Arabic) carved on gravestones dating back to the early nineteenth century.[5]

Evidence from 1790 supports the possibility of Arab adventurers and traders settling early in the Carolinas. In the House Assembly of the state of South Carolina, a distinction was made between Moors and blacks, that is, "sundry Moors, Subjects of the Emperor of Morocco," were to be tried according to laws for South Carolina citizens and not under the codes for black slaves. A century later, however, Syrians were forbidden to vote in many states as part of the "yellow race" and did not get a definitive court ruling on their right of franchise until 1915. This chronic question of what color hole to fit the Arab in only compounded the identity crisis of a people who had been dominated by the Turks for five hundred years and had difficulty showing fealty outside their own village.

Another early trade agreement, such as the one with Morocco, that brought contact but not settlement between the new American nation and the Arabs was the arrival of an Omani cargo ship in New York harbor in 1840. The rotund commander of the *Sultanah* did not care to market oil or base rights; he certainly had no idea of the value of Oman's Strait of Hormoz to oil tankers a century later. He probably wanted a square meal and fresh water. After eighty-seven days at sea and weighing 350 tons, the *Sultanah* and its crew caused a stir during their three-month stay in New York. Its commander was "a small, slightly corpulent, bearded Arab gentleman, to whom all paid deference. His complexion was tawny, his eyes were black and piercing. . . . About his person hung an air of natural dignity. To the surprise of gaping port officials, he addressed them in tolerable English."[6] This was Ahmad Bin Naaman, and his English should have been no surprise since the British had been in Muscat and Oman for a century. Today the Omani commander's portrait hangs in New York City Hall.

There is very recent evidence of a Jermiah Mahomet settling before the Civil War in Frederick, Maryland, where he raised horses and worked in real estate.[7] But the two most celebrated "first" immigrants from the Arab world dying on American soil were not recorded until 1854 and 1856. One was a Bible student who died young in Brooklyn; the other was a camel driver who lived to a ripe old age in Quartzsite, Arizona. One wanted to return to Lebanon (or Syria, as the Ottoman Turkish vilayet was called); the other did not. One was a Christian, the other a Muslim. Their stories encapsulate the solitary lives of the first Arab sojourners in America. With them, an era both begins and ends.

If it wasn't for Palestine, a Lebanese—and a Maronite at that—would not have been singled out by Philip Hitti as the first official immigrant in America from Arab lands. If it wasn't for the magnetic pull of the Holy Land on tourists from America, Antonios Bishallany would never have made it to Boston harbor in 1854. Bishallany was a dragoman, a tour guide, in Palestine.

Born in Salima, a small village of olive trees and pines in the mountain district of Metn in Lebanon in 1827, Bishallany had a simple childhood of tending to olive trees and the family vineyards. The limestone-bricked house of his family

had been theirs for over a century. What pushed him to notch his name in history was a combination of family tragedy, personal pluck, and a burning desire to expand his learning.

At the age of 10, Bishallany was uprooted with his family from their home in the pastoral mountains after their vineyards were burned to the ground by marauders. They moved to a town outside Beirut, but in two years his father died. At 12, Bishallany became the breadwinner. He developed a taste for travel while in the employ of the Italian consul in Beirut, who took him as his valet to such Mediterranean ports as Smyrna and Algiers.

At 23, Antonios—typically enough for Lebanese—wanted to be his own boss and started as an independent interpreter and guide for tourists to the Holy Land. He provided his clients with tents, food, maps, and itineraries and accompanied them through Syria, Palestine, and Egypt. He must have been quite an entrepreneur; though his Italian was good, his English was poor. Nevertheless, one New Yorker recorded his first impressions of Bishallany in Beirut: an energetic, good-natured young man unconcerned about payment—"All that he would demand was a letter of recommendation."[8]

Two years later, in 1854, the New York businessman found a young man wearing the *ṭarbūsh,* or fez, entering his office. Antonios had sold everything he owned, had taken the $300 receipts, and had sailed for America, landing in Boston after a two-month voyage. He immediately went to New York, met with former clients he had guided around the Holy Sepulchre, Mount Sinai, and the like, and finally settled in with a wealthy Fifth Avenue family as a butler. The housewife of the family would earn his obsessive thanks for taking care of him when tuberculosis struck all too soon.

A Dickensian character, Bishallany amazed his New York businessman friend, who knew his butler was impoverished, with his ability to move naturally through the homes of the New York patricians. Soon he was a much invited guest to Manhattan drawing room receptions. Many, however, attracted to the olive-skinned stranger with pot-shaped hat and gold tassel, were more interested in his reaction to their ways than in discovering the peculiar troubles of his homeland. A Reverend Charles Whitehead wrote in 1856 about the Syrian's arrival: "The appearance of a city in this western world so different from oriental cities and towns in the style of architecture, street, conveyances and costume of the people must have deeply interested him and we presume that few objects escaped the notice of his observing eye."

Soon Bishallany was exchanging Arabic lessons for English lessons and "the light was never put off in his chamber before midnight."[9] But in his first American winter, he displayed signs of the illness that would eventually be fatal, and by the summer of 1855 he was taken by his New York benefactor to the summer resort of Richfield Springs, which reminded Antonios of Lebanon.

In the autumn he entered Amenia Seminary School in Duchess County, New York, but began coughing fitfully as winter set in. The principal loved the young

man's zeal to learn, particularly his repeated desire to return to Lebanon and help his country. Afraid that Bishallany would be made the butt of schoolboy jokes, the principal found the opposite—the other students competed for his attention: "The chap was extremely polite, sociable, simple-hearted, excellent in conversation and wit, and to the extent that the most brutal student could not keep from being attracted to him." [10]

He complained in a letter to his family in Lebanon that doctors refused to "phlebotize" him, because bloodletting "is not practiced in this country." He quoted from a poem of homesickness, said he had no money to bequeath to them—all had been spent on medicine and education—and that he purposely left off dating the letter because "I am cognizant of the time the Lord will send for me."

By fall of 1856, Bishallany was dead. He was buried in the Greenwood Cemetery in Brooklyn, the symbols of the lion, serpent, and lamb carved in the gravestone of lot #181. For one who coughed practically from the day he arrived in America, he was remarkably serene at the end, ready to leave "this transient world." Brooklyn and New York City would be the centerpoint of Arab settlement in the New World forty years later.

Bishallany made his stand in America, though short, by the grace of a Yankee merchant. His Muslim counterpart, however, owed his American sojourn to a Confederate president. It was Jefferson Davis who thought of a scheme for a camel highway in the American Southwest.

While Bishallany was in New York in 1855, Davis—as secretary of war—assigned a U.S. Army major and Navy lieutenant to round up camels in the Middle East. They traveled to Cairo and Smyrna and other ports to barter for creatures durable in hot waterless climes. The first trip, in 1856, brought back thirty-two adult camels, two calves born aboard ship, two Turks, and three Arab camel drivers, one of whom was called a "Bedouin-and-Camel medicine man" (the American Indian shaman's role appropriated easily to other "savages"). One of the Arabs was Hadji Ali, then 28, nicknamed "Hi Jolly" and referred to as "the happy little Turk." Since the Arabs had been under the yoke of Ottoman Turkey since the sixteenth century, the misnomer was probably not a happy one for Hadji Ali. Westerners commonly blurred (and still do) the ethnically different Semitic Arabs with the Indo-European Turks. In fact, it was not until 1899—twenty years after their immigration stream started—that Syrian immigrants gained a separate classification from "Turk in Asia" at Ellis Island. The identity problems common to all immigrants were compounded for the Arabs in the United States: first they were taken as Turks; then Syrians became Lebanese; Lebanese hid behind "Phoenician"; and today Arabs are often mistaken for Iranians. Hadji Ali would not be the first Arab American for whom the question "Who am I"? was a particularly piercing one.

In 1857, an Army engineer, Edward F. Beale, set out on orders to blaze a camel trail from Fort Defiance near Goliad, Texas, across the northern deserts of

New Mexico and Arizona to the Colorado River bordering California. California had recently entered the Union, and Jefferson Davis wanted to connect to it at once. Hadji Ali and the camel trainers went on strike early in the journey; in fact, they never left Camp Verde near San Antonio. It seems they had not been paid in six months. Beale wrote Washington that something was amiss and wondered why the government was delinquent in paying the camel tenders. He regretted not having them on his trip with the camels, for they were "the only men in America who understand them."[11] The American Civil War broke out two years after the desert expedition ended, and Jefferson Davis had more to tend to than blazing trails in sand. He became the first and last president of the Confederate States of America.

Other obstacles presented themselves. With the coming of the railroad in the Southwest, camel traffic, as well as horse and muletrain traffic, was made obsolete. Six native trainers weren't sufficient to deal with the camels. There also grew a belligerence between camels and men, mules and horses. Contrary to Beale's initial ecstasy, the camels had trouble with surfaces that were more gravel than sand: "Their soft-padded feet were literally cut to pieces by the dry, rocky ground of the Southwest."[12] In 1866, the War Department sold 66 camels to Bethel Coopwood of San Antonio, Texas, for $31 a head. Some would later turn up in parks or circuses, or hitched to a rancher's buckboard. The camel was woven into the folklore of the Southwest as a ghoulish figure that could appear out of the desert, stir up trouble, and vanish.[13]

Hadji Ali prospected for gold awhile and then settled into a job as a scout for the U.S. Army. In a move that prefigured name changes at Ellis Island, Ali became a U.S. citizen in 1880 at Tucson under the name Philip Tedro. Shortly thereafter he married Gertrude Serna; they quickly had two daughters. But "Hi Jolly" was called by the desert more than married life and he returned to prospecting in 1889 in Quartzsite, about a hundred miles west of Phoenix. It was there in the Arizona desert that the first Muslim immigrant in America died in 1903, unknown by 5,551 fellow Syrians who arrived in America that year escaping deprivation.

"Hi Jolly" was the last of the era of sole adventurers who dared the Sea of Darkness from the Arab world to get to America. He became something of a legend in Arizona and was cared for in his old age by ranchers and prospectors, who appreciated "his gentle nature, his personal integrity and his unfailing kindness to animals and to his fellow man."[14] Whether or not he practiced Islam is unknown. His name suggests that he had been a "Haj," one who had done his duty by visiting Mecca. His final Mecca was in a land just as hot, but profane.

Both Bishallany and Ali were enshrined for their pioneer roles in American history. The Lebanese student's home in Salima was made a national museum by Lebanese President Suleiman Franjiyah in 1971. "Hi Jolly" received his accolade in the New World. In 1935, the Arizona Department of Highways erected a pyramid on Ali's grave, topped with a copper camel.

The Withered Cedar: Why the Arabs Left Syria and Lebanon

It was appropriate that a highway department memorialized Hadji Ali. Wander-lust has never been foreign to the peoples of historic Syria, Lebanon, and Pales-tine. From earliest times, the long, blue arm of the Mediterranean pulled the inhabitants of its eastern shore to the West; they followed not only the setting sun but also native impulses ranging from intrepidness to trade. Those longboat strokers—the Phoenicians—established early colonies in North Africa (at Car-thage), in Sicily, and in southern Spain, selling among other things a purple dye made from the murex mollusk that would become the color of nobility in ancient Rome. The ancient Hebrews migrated from Palestine to Egypt to Europe. The Roman poet Juvenal complained about Syrian immigration to Rome, saying the Orontes River (of Damascus) was flowing into the Tiber. In 1283, the first and one of the largest emigrations of Maronite Catholics from Lebanon occurred when they escaped Ottoman oppression by fleeing to the island of Cyprus. Mongol and Tatar hordes from Asia, and periodic political and religious up-heavals, only encouraged the native love of wandering that flowed in the Levan-tine's veins from earliest times. Facing deserts or mountains to the east, they chose the sea.[15]

Longstanding contact with Western powers through trade and conquest—as well as their geographic given as the crossroads of East and West—made the his-toric Syrians often oscillate between xenophilia and xenophobia, two opposed cultural urges that played themselves out over the centuries in a hospitable inter-nationalism, as well as a distrust of invaders. Except for the classical Omayyad caliphate centered in Damascus in the seventh and eighth centuries, Syria—and its Lebanon province in particular—was never militarily powerful or able to de-fend itself against outside, predatory forces. These realms were caught between conflicting forces, for instance, the Mongols and the Seljuks; the Turks and the French and English; and, in the case of Palestine, British and Jewish colonizers.

What were the causes that propelled emigration from the Arab world to the United States, which began in the 1870s, crested at World War I, and was halted by immigration laws by 1924? The answer has been the subject of much contro-versy, ranging from economic venturesomeness posited by Alixa Naff to Philip and Joseph Kayal's emphasis on a desire to flee sectarian and political conflict. Salom Rizk, one of the few early Syrian immigrants to chronicle his passage to and experience in the United States, cites visitations in his village of ʿAyn Arab by "two kinds of plagues: one of locusts, the other of men."[16] The men were, specifically, tax collectors and conscriptors for military service from the Turkish capital.

The political economist Charles Issawi sees Arab immigration to the New World as being sparked by the following: "tensions accompanying economic and social transformation; the imposition of conscription; the spread of foreign edu-cation; the improvement of transportion; and the massacres of 1860."[17] Most cer-

tainly, a growing population caused by the advent of better hygiene and a scarcity of cultivable land—particularly in the Lebanon mountains—was an important factor, as well as periodic famines, insect blights, and droughts that, among other things, wrecked the crucial sericulture, or silkworm production, that was a staple of the Lebanese economy in the nineteenth century.

However, some are quick to point out that the protected *mutaṣarrif* of Lebanon—granted some autonomy after the massacres of 1860—was relatively tranquil in the last decades of the nineteenth century. While the initial and immediate spur for the trickle of Arab immigrants that boarded European steamers to America may have been no more spectacular than the desire for adventure and prosperity (rumors of "streets of gold" in America were as tempting to the Arab peasantry—who formed 90 percent of the First Wave immigration—as they were to the Irish, the Italians, and others), Naff's assertion that "no memorable political or economic event unleashed Syrian migration to the United States" strikes one as interpretive of the skin of history, rather than its underlying currents. Naff, for instance, barely mentions the Druze-Maronite massacres and is strangely silent about what to many Syrian immigrants is *the* most traumatic collective experience (whether firsthand or through relatives)—the starvation in World War I. It is almost as if Naff's central thesis—that Syrians were the most quickly assimilating of ethnic groups in America—must hinge on less than traumatic reasons for coming to the country in the first place, as opposed to say, Eastern European Jewish immigrants, who fled pogroms and were imbued with a strong ethnic identity that played itself out obsessively in literature and politics. (She also dismisses the many firsthand accounts of trauma at the hands of the Turks, tax collectors, or war as calculated modus operandi of early immigrants to ingratiate themselves with their fellow Americans by earning asylum as any other "troubled masses" would.)

If one is looking solely at the first clusters of Arabs who came to Ellis Island in the 1880s, the motivations of my own informants ratify the thesis of the age-old Levantine wanderer looking for a new market. But statistics show that in the first year of World War I—1914—more Syrians came to America than in the whole period of 1869 to 1895. If the first courageous, plucky few set off to get sick in steerage for opportunity, it is just as certain that those who followed them shortly had more licking at their heels than the desire for a dollar. And though studies have shown at least a quarter of Syrians returned to their homeland after coming to America—and more wanted to—few stayed there. After the First World War, Lebanon was in wreckage, Syria and Palestine embroiled in growing battles for independence from European mandate powers. In short, there was little to go back to. If they migrated first in fairly venturesome spirits, after the "war to end all wars" they stayed here because the bridge was cut behind them and left burning.

In fact, the spur to original Syrian migration was multitudinous, and grew more and more complex as the century waned and World War I approached. As Irving Howe has said in his massive study of East European Jewish immigration,

World of Our Fathers, "to separate for any but analytical reasons, the most exalted notions for the migration from the most self-centered is probably a mistake." My own studies indicate five areas of importance, some neglected and some oft-cited: the wooing and salubrious role of American missionaries in Syria; the shattering of the religious mosaic in 1860; economic uncertainties exacerbated by overpopulation and the land squeeze; the death throes of the Ottoman Turkish empire and ensuing lawlessness, taxation, and conscription; and the starvation of one-quarter of Lebanon's population during the Great War. In particular, I want to dwell on the last reason because no one since Philip Hitti in 1924 has done so—at least in book form—and because my informants in the Arab American community repeatedly and obsessively refer to it.

American Missionaries Preach to the Converted

One of the reasons Arabs chose to emigrate to America in the nineteenth century owes itself to a religious oddity: American Christians proselytized the original Christians of the Holy Land. Of course, in Greater Syria and environs, Islam was dominant, but in the area where missionaries concentrated—Lebanon and parts of Palestine—well over half the population was already Christian.

The early New England evangelists were filled with zeal, adventure, goodwill, and a pinch of arrogance. Whatever they guessed were the needs of Christians surrounded by heathens, or heathens surrounded by a need for meaning (i.e., schools and medical supplies), they guessed right and by the mid-nineteenth century earned for themselves "an inestimable position in the hearts and minds of the Syrian people."[18] They did not, however, effect a mad dash to Protestantism; few converts were made. The Maronite Catholic hierarchy saw to that.[19]

The center of a haystack would hardly seem like the place to hatch a plan to spread the Gospel in the land where it was first spoken. Their fervency for other lands' woes intensified by a storm, a group of students at Williams College chatting on a country road took refuge in a haystack in 1806. By the time they emerged, they had crystallized a plan—not unlike an early Peace Corps but with religion as the zinger—that they would present to the faculty of Andover Theological Seminary four years later, to minister to the Levant.

The first two young ministers licensed to serve in the Holy Land from the new Comissioners for Foreign Missions were Pliny Fisk and Levi Parsons, formally appointed in 1819. In a sermon that he gave on October 31 in Old South Church in Boston, Fisk touted an item of some commercial value—Bibles. He spoke of the eastern Mediterranean as a "radiating point" into the Far East for tons of the religious books. The Syrian archbishop of Jerusalem was having trouble obtaining printed Bibles in Arabic, having been turned away in both Rome and Paris, with only minor success in Britain.[20] And so with a little American ingenuity, Fisk stunned his listeners with his goal to explore the Holy Land, replete with salable Arabic Bibles. It was with the assumption of backwardness and its offense to "Christian sensibilities" that the Foreign Missions gave final instructions

to Fisk and the other departing evangelists: "From the heights of the Holy Land and from Zion, you will take an extended view of the widespread desolations and variegated scenes presenting themselves on every side to Christian sensibilities . . . The two grand inquiries ever present in your minds will be 'What good can be done? and by what means?' " [21]

The directive betrayed an indecisiveness as to the mission in Lebanon and Palestine. The comissioners did not tell Fisk to ask the natives what they wanted; they postulated a kind of solipsistic internality once they touched down on Sacred (but backward) Ground. It is as if the purpose of the mission were an existential awe and self-questioning. The Middle East had Othello; it did not need Hamlet.

As for the "Mohammedans" (an inaccurate appellation for Muslims that prevailed for centuries in the West), no doubt the first American missionaries contained in their intellectual grab bag the knowledge that Dante had stuffed Mohammed in the eighth of nine circles in Hell and in the ninth of ten Bolgias, there to wallow in his own filth right on the edge of Lucifer's stronghold. The great figures of Islam, such as Avicenna, Averroës, and Saladin, though admired by Dante, are still unsaved, and, as Edward Said points out, "condemned, however lightly, to Hell [the first circle of the Inferno]." [22]

The Stockbridge Indians gave Levi Parsons a donation of $5.87, two gold ornaments, several ornamental baskets, and a pocket lantern inscribed, "This is to illuminate the streets of Jerusalem." [23] If the American Indians—so recently colonized and subjugated—had discovered that Jerusalem's streets needed lighting, those streets must be dark indeed.

Parsons and Fisk both died young—after three and seven years, respectively—in the mission service, Parsons buried in Bethlehem, Fisk in Beirut. But they had established Beirut as the center of American missions in the Near East. Adele Younis described their zeal and later that of William Goodell (the three were all born in 1792) as the overseas afterglow of the spirited American Revolution: "The young evangelists were symptomatic of their times: intellectual responsibility carried with it firm moral and spiritual obligations. This manifest restlessness drew attention to the Americans who became known as a 'nation of doers.' It seemed strange at first to the Arabic-speaking people that so much selfless effort should be exerted in their behalf without ulterior motives. It was almost incomprehensible, but the Americans became genuinely accepted among them." [24]

Three positive contributions were made by the Americans in early-nineteenth-century Syria, which at that time included modern Lebanon and most of modern Israel. They helped to stimulate the Arab printing presses, which effected a renaissance in public reading. They established schools, which dotted the mountains. Last, they introduced medical help to a province of the Ottoman Empire that the Turks had all but abandoned for social services.

In a way, the Europeans gave the Americans a special "in." After the massacres of 1860, French links with the Maronites were tightened, as were British

links with the Druze. Therefore, the American missionaries, considered un-biased, were sought after by both sides. It was to their credit that the mission-aries, for the most part, did not take flight in the 1860 bloodshed. The home of the Reverend and Mrs. Simon Calhoun became a sanctuary for both sides, with Maronites, Orthodox, and Druze women storing their jewelry, money, and clothes with them, so that "these missionaries who had been before cursed and excom-municated by the Maronite patriarch, bishops and priests as 'incarnate devils' now held in trust without receipt all the wealth of both Christians and Druzes."[25] In the midst of the massacre at Deir al-Qammar, Calhoun kept his head. He steered clear of condemning the Druze as a people: "It may seem strange to you, but so it is that we have moved from place to place without fear, through the midst of the Druze. They never offered an insult, and permitted us to protect the Maronites and their property without a word of objection." Calhoun's counsel could echo tragically through a century of Western mishandling of the Middle East: "I urged all to wait patiently in hope that all grievances will be redressed in due time."[26]

It would be wrong to infer that the Arabs themselves stood by stiffly as the slaughter took place. Many helped with humanitarian deeds; one, the Algerian ʿAbd al-Kadir, who took Syrian Christians into his home during the massacre in Damascus and was rewarded for his valor by a present of two gold-mounted pistols from American President James Buchanan (who would be leaving office as his own country was about to plunge into civil war). ʿAbd al-Kadir wrote many tracts, as a Muslim, against the massacre, "as contrary to Islam and the Koran, and these were widely distributed."[27] The leader of the Druze, Said Jumblat, protected Christian merchants with whom he had close ties at Deir al-Qammar.[28]

Immersion in the life of a troubled country was not without pitfall for Ameri-cans. Dr. Cornelius Van Dyck, who liked to dress in an Arab ʿabā while he min-istered to the wounded—and who spoke perfect Arabic—was almost executed as a Christian Arab. A Druze interceded, shouting, "This is Hakim [wise one] Van Dyck!" Years later, Van Dyck saved the would-be executioner's life in his hospi-tal.[29] The disturbances of 1860 in Syria brought in $150,000 in world relief—one quarter of it from the United States—for 26,000 refugees. Henry Jessup, a mis-sionary for over three decades in Syria, published thirty letters in the *New York Herald* describing the catastrophe in which 20,000 were killed and serene vil-lages, such as Zahle, were reduced to cinders. Daniel Bliss, the founder of the American University of Beirut, later figures that "the events of 1860 were a kind of mental earthquake that shook the people out of a self-satisfied lethargy and made them long to know more of the world outside Syria."[30]

Certainly the selflessness of medical missionaries like Calhoun, Van Dyck, and George Post made for gratitude. The founder of the first cooperative hospital in America—in Elk City, Oklahoma—a Syrian named Dr. Michael Shadid, made explicit his indebtedness to the example of an American surgeon at the

time: "And here, . . . [Beirut] was Dr. George Post, famed throughout Syria for his skill and almost miraculous surgery, the man who became my ideal, inspiring me with a burning determination to become a doctor, to go out to little villages like Judeidet and heal the sick."[31] One Christian woman in New York City spoke of the Americans as "God-sent to our country. They took care of our eyes and hair." A Druze businessman in New York called them "angels in our land."[32] An Orthodox woman in Pasadena, California, related that so salubrious was the example of the Presbyterian missionaries to her husband in Syria that he stubbornly refused to go to the Orthodox church, preferring the Presbyterians, who also gave him and his wife the necessary support to get through the Great Depression in New York.[33] In an atmosphere of crimped financial opportunity, overpopulation, and growing turmoil, the Americans gave the Syrians an example of a better world. It is one of history's tragic ironies that when the Americans arrived in Lebanon a century later they did so not with doctors or missionaries but with guns.

The Religious Mosaic Shatters

Most historians place the origin of Lebanon's civil war in the inequities fashioned into the Lebanese constitution when the country became free in 1943. Maronite Catholics, whose only large numbers in the Arab world are in Lebanon, were given predominance in the parliament and were guaranteed the presidency. Others date the problem back to 1932—the last time a nationwide census was taken in Lebanon—when somewhat suspicious polling gave the Maronites the largest segment of the various confessional groups that made up the country.[34] Nevertheless, the most striking early example of intersectarian strife was in the 1860 massacres. Before that, it is simply incorrect to say that Lebanon's problems—massive as they are—are "centuries" old. At most, they are a century old and coincide with full-scale European power intervention that wrested some control over the Lebanon mountains from the Ottomans, ensuring it a measure of autonomy, however fragile and fractious.

Maronites and Druze hold at least two things in common: both are special offshoots of their respective religions (the Maronites have their own Catholic rite, which uses Aramaic, the language of Christ); Druze are a schismatic Muslim sect believing in reincarnation who do not have imams or mosques. Both share the Lebanon mountains as chief ancestral homeland.[35] The Maronite monks fled to the Lebanon mountains from Syria in the seventh century after repression, not by Muslims but Byzantine Christians under Justinian II. The Druze were a heretical sect of Islam founded by the Shi‘ite Caliph Hakim in the tenth century. Forced out of Egypt, they took refuge—as did so many other splinter groups—in the backbone of the Lebanon mountains, specifically the southern part, the Shuf.

Relations between Druze and Maronites were amicable for the better part of a millennium, up to the nineteenth century. The Druze actually helped the Maronites many times: "Throughout their history, especially in their dealings with

their sometimes zealous Maronite vassals, the Druze have displayed a tolerance toward other religions that is scarcely characteristic of the cradle of revealed religion and fanaticism that is the Middle East."[36] Indeed, in the sixteenth century, two Maronite patriarchs, chased by their own Maronite brethren from the Qadisha Valley, hid in caves until given asylum in the homes of Druze amirs in the Shuf. If anything, Maronite expansion and prosperity were the result of a Druze "open-door policy" toward Maronite developers for two hundred years. The Druze amir Fakreddine admired the hard-working Maronites of the northern ranges and openly invited them to clear land in the south where Druze and Shiʿites predominated. If the land was cultivated for ten years, it was given to the Maronites in ownership.

But by the early nineteenth century, an old Lebanese cycle began to turn again: generosity (or laxity) to outsiders goes out of control, tightens abruptly, and xenophilia turns to xenophobia. The Maronites began pushing for political power commensurate with economic successes. Now the Maronites had virtually surrounded the Druze in the mountains, the latter losing ground in the Shuf. The Maronite population was growing and hunger for more land added to rising tensions. One Englishman, who lived among the Druze for a decade between 1840 and 1850, found the Maronite style in Deir al-Qammar to be obnoxious. Col. Charles Churchill reported opulent Maronite estates: "Their leading men amassed riches. They kept studs, their wives and daughters were apparelled in silks and satins and blazed with jewelry. The few Druzes who still inhabited the town were reduced to insignificance as hewers of wood and drawers of water."[37]

Riots occurred in 1820 and 1840. But the tinder for the worst explosion occurred in an argument over a chicken between two Maronite and Druze boys in Beir Meri, erupting into a gangfight that killed more Druze than Christians.[38] The backlash was extreme. The Maronites were not prepared to meet the more disciplined and smoldering Druze fighting forces. The Druze struck at Deir al-Qammar in May 1860, flaying the Maronite abbott alive and poleaxing twenty monks. In a bloody twenty-two days, 7,771 Christians were murdered, 360 villages destroyed, 560 churches ruined, 43 monasteries burned, and 28 schools leveled.[39] By the end of the year 20,000 Christians had been killed, including 5,500 as far away as Damascus. Many Druze perished, as well. As for the ruling Turks, they gave Christians asylum, only to disarm them and turn them out to face their oppressors.

The 1860 slaughter was to have repercussions far into the twentieth century. According to an informant, when Maronite Phalangists inserted themselves deeply into Druze territory in the wake of Israel's 1982 invasion of Lebanon, Dr. Samir Geagea, head of a Phalange unit, was asked by Druze notables what he was doing there, to which he replied, "I am returning to you the visit you paid to us in 1860." Killings followed. And Deir al-Qammar was blocked by the Druze for ten days with no water or food entering for its thirty thousand residents. Memories die hard in Lebanon. Historians agree that because of the Druze-Christian dis-

turbances 1840–1860 were the two darkest decades in Syria since the Ottoman Turks captured the area in the sixteenth century.

After witnessing and miraculously escaping the massacres in Damascus, Dr. Joseph Arbeely took his family to Beirut for an eighteen-year stretch, finally deciding to leave the Middle East altogether "for the progress of my children." An Orthodox, he resisted the urgings of the Russian consul in Beirut to go to Russia; he selected America. Arbeely had been imbued with a love for learning from his earliest days when he walked from Arbeen to Damascus to school "until the Patriarch recognized his literacy in an age of darkness when reading and writing was limited to three percent of the population."[40] He learned medicine under an American medical missionary named Boldine, and he collaborated with Dr. Cornelius Van Dyck on a Bible translation into Arabic.

Arbeely was not alone in specifically mentioning the horror of the massacres as propelling him westward. Another survivor, who settled in Pittsburgh, said: "The Druze and Mohammedan Syrians, backed up and helped by the Turks, themselves attacked us. For three days the men and women of our village fought back. My husband shot and killed two of them and I was loading the guns. They killed a good many of our neighbors before we fled. I had six young children by that time but I was determined that if I ever got the chance to leave this place I would do so."[41]

Though there was no real intersectarian fighting in Syria and Lebanon from 1861 to World War I, to suggest that such a bloodbath as occurred in 1860 did not have psychological aftershocks would be disingenuous. If a physical wall was not erected between Druze and Maronites in the mountains, a psychological one was erected by the disturbances and has never really been torn down, as recent skirmishes attest. That being said, what could explain the lag time of twenty years from the massacres until the largely Christian Arab emigration began? There are reasons beyond the oft-cited quest for a better living that historians seem not to have detected, at least in the context of the massacres themselves.

First, emigration from Syria did begin after the massacres, but to Egypt rather than America. The boat fare was cheaper, and Egypt was an Arab country where the language was Arabic and the milieu familiar—and, at least for a while, more free. Educated Syrians also wanted to help the Khedive, the ruler of Egypt, with his new water projects attendant to the opening of the Suez Canal in 1869. Jessup mentions at least one thousand Syrian "refugees" leaving for Alexandria, Egypt, in the wake of the 1860 massacres in Damascus. By 1907, emigrant Syrians in Egypt possessed 10 percent of that country's total wealth and numbered thirty thousand.

Second, historians have disregarded what was going on in America and Europe at the time. In 1860, the United States was hardly an inviting nation—it was in the throes of its own Civil War, which lasted five more years. As for Europe, troubles erupted in the Franco-Prussian War in the early 1870s.

Third, confirmation that America could be a place to make a real living—as opposed to providing a temporary escape—only came when stories filtered back from the international trade expositions starting in 1876. This activated U.S. steamship promotion in Syrian ports.

Fourth, Syrians had some reasons to believe that justice might finally issue forth from Constantinople, the seat of the Ottoman sultan. In 1856, the Sublime Porte announced that a Muslim could convert to Christianity without being put to death. Though shocked by the massacres, many Syrians took hope when 4,800 Druze were found guilty. But Turkish authorities dragged their feet and eventually shut their eyes. Only 48 were sentenced to death, 11 to life imprisonment; most of these never served their sentences.

Three Syrian memoirists who emigrated from the Lebanon mountains to America at the turn of the century discussed intersectarian tension. Each dealt with it in a different way, each showing a distinct strand in the loom that made a Syrian emigrant.

George A. Hamid was a circus owner who might have rivaled the Ringling Brothers in the forties in the United States. He was a legendary tumbler who had performed in the Wild West shows of Buffalo Bill with Annie Oakley; he said, "In my early showdays, 'Arab' and 'acrobat' were synonymous." Hamid, who claimed to have tumbled through a thousand cities and "thumped the dirt of almost every hamlet in America," came from Broumana, Lebanon, to the States in 1906. Hamid describes an incident that took place in his village when he was 7, when the Muslim and Christian communities almost took each other to the sword over a broken *braak* (actually *ibrīq*, a water jug). A Muslim girl pushed him as they struggled to fill their jugs at a well, making his jug crack on the ground. Hamid head-butted her and stole her jug.

Within the hour a Muslim group of fifteen men with clubs were shouting outside Hamid's home. The circus owner's description of the confrontation between his father and the Muslims is both a testimony to the typical First Wave Christian's stereotyping of Muslim violence ("As killing was a fairly common practice over there with wholesale massacre no rarity, and these were Mohammedans to boot, I knew that this mob might really mean business") and a salute to his father's diplomatic acrobatics, which averted a disaster:

> I stood up, slowly. "Father, I—," I began.
> "Silence!" he roared.
> He turned to the Mohammedans.
> "Neighbors," he said. (Holy smoke! calling them neighbors? What if my father had possessed plaguing power, there would be no Mohammedans left in the world!) "Good neighbors," he went on, "I can plainly see that my cur of a son has done you an unforgivable injustice. But I, his father, demand the privilege of killing him." . . .

Then—crash!—I was on the floor. Pain lashed through me and I was jarred by two heavy kicks. The last sounds I heard were the satisfied jeers of the Mohammedans.[42]

The ardor of Hamid's father in portraying the anger Muslims felt helped defuse the situation—once again, the Levantine use of masque, of theater in this case, deflected tempers that had a habit of igniting too much too soon, before suddenly disappearing.

Salom Rizk, chosen by *Reader's Digest* in the forties to lecture across America as the quintessential American immigrant, describes the anomalous fate of one in Syria whose religion could not be pinned down. Nursed at the nipple of the three monotheisms (he claimed to have no mother), Rizk was a man set apart from a society that lived by sectarian divisions: "In Syria there is a saying that he who drinks the milk of a cow becomes like a cow. I had drunk the milk of Christians, so I should become a Christian. But I had also drunk the milk of a Mohammedan. Would that make me a Mohammedan? No. What was I, then? I was a child of Shaitan, the devil. Who else but the devil would inspire the milk of mortal enemies, of people of whom God disapproved? I was terrible. I would turn out to be a monster. I must be avoided."[43]

A number of immigrants, however, testified that nursing at multisectarian breasts was not a problem and, in fact, common, especially for orphans. Assad Roum, from Arbeen, Syria, for instance, found it unproblematic to take his half-sister to Muslim women for suckling.[44]

This dialectic of the "stranger," and its implications for the Arab American character, finds another striking expression in the memoirs of the Reverend Abraham Rihbany—whose articulate account of his emigration from Syria to the United States found its way onto the pages of the *Atlantic Monthly* in 1913. Rihbany makes no bones about it—clannishness was a staple of Syrian life. His birth in the town of El-Schweir is seen as a blessing, not because of his beautiful brown eyes but because the fighting strength of the Rihbanys was increased by one male member in its struggle with the rival clan in the town—the Jirdaks. (Both clans were Christian.) Rihbany castigates the Hatfield-McCoy syndrome in the Lebanon mountains. In describing his family's fate, however, when they moved to the Druze-dominated Shuf town of Betater, Rihbany unwittingly stumbled on what I take to be a ruling disposition that emigrants took west from Syria, namely, the safety of the stranger:

Betater was inhabited by Christians and Druses, who were in the majority and the ruling class, and some Mohammedans. The Christians represented the Greek Orthodox, Greek Catholic (Melkites) and Maronite churches. As usual, they lived at war with one another and united as "Christians" only when attacked by the Druses. The clannish feuds also existed within the various sects. We, however, were "strangers," and, having no clan of our own in the town, were immune from attacks by any and all of the clans because of our weakness. "Thou

shalt not oppress a stranger" is a command which is universally observed in Syria.[45]

The Rihbanys were treated well in the town and escaped cross fires because they were new and unknown. The Orthodox welcomed them, but so did the Druze. When a 5-year-old Rihbany died, nearly the entire clan of Druze notables showed up to pay respects—an unusual number—largely because the Rihbanys were "sideless" by nature of their strange new presence in town.

Rihbany happened onto something. The Syrian had the oldest history on earth as his heritage, historical roots so deep it is a wonder they did not find the earth's molten core. But in the nineteenth century he began observing the care of the stranger. And then in growing waves of tumult, he became him.

Economic Gyrations, the Land Squeeze, and Overpopulation

After a century of chaos and decay, Syria and, particularly, Lebanon began to achieve some measure of economic well-being in the latter part of the nineteenth century, spurred by the unprecedented onrush of European ships calling at Levantine ports after the European powers intervened forcefully in the disturbances of 1860. There is no doubt that the Syrian peasant man, stirred by the progress that had trickled down to him in his hamlet, wanted more than a trickle and began reading the literature of steamship companies with avidity.

Steam navigation in the Mediterranean began to make European traders a regular sight at the Levantine ports. In 1840, two lines, British and Austrian, had regular services to Syria; by 1914 nine lines had regular services to Syria on a weekly to monthly basis. In the 1830s, total shipping into Beirut was 50,000 tons; by 1886 it had risen to over 600,000 tons.[46] The building of a modern port in Beirut by the French in 1880–1895 nearly tripled that figure by 1910.

With the establishment of the first silk-reeling factory in Shimlan, Lebanon, in 1846 (by an Englishman), the centuries-old native silk-weaving industry increased. By mid-century, one quarter of all exports from Lebanon were silk. By 1857, the British consul in Palestine put the number of Jaffa oranges exported at 6 million; increased quantities of Syrian barley and hard wheat—used for beer and dough—were sold abroad. By 1911, an average of 20,000 tons of soap was being manufactured, with centers in Nablus and Jaffa. Tobacco was grown for export in Palestine, the Biqaᶜ Valley, and near Latakia, though checked in 1860 by a Turkish government monopoly, which in 1884 transferred rights to a European consortium.

Much cultivation, however, continued on an age-old subsistence basis, peasants working for landlords to produce grapes, lemons, pistachio nuts, figs, almonds, and melons, as well as maize, lentils, chick-peas, beans, rice, and sesame. The traditionally strong Syrian cotton crop, however, was threatened by competition from Egyptian and American cotton and was crippled by a bad drought in the years 1889–1892.

Other factors made the economic prosperity less than uniform or salutary. The

opening of the Suez Canal in 1869 diverted some of the transit traffic to the East that would ordinarily have stopped for overload transport on the Syrian coast. Steamships going through the Black Sea had a similar effect. Also, high Turkish taxation on loom industries and the lack of tariffs to protect against the onslaught of cheaply priced machine-made goods slipping in from Europe hurt the traditionally strong Syrian cloth industry. Perhaps the most serious blow to the native Syrian economy in the midst of this whirlwind of trade, however, was the silkworm blight of 1865–1871, which hit sericulture production just as it was beginning to prosper. Though partly aided by the importation of silkworm eggs from France, the production of Syrian silk never really recovered; by the early 1920s, it was down 85 percent from late-nineteenth-century figures.

Better medicine—once again introduced by American doctors—sharply reduced epidemics and, coupled with a virtual elimination of famine—brought the Syrian population to double from the 1830s to 1890 (from an estimated 1.3 million to 2.7 million). Beirut's population increased from 10,000 in the 1830s to 150,000–200,000 by 1914; Tripoli, from 15,000 to 50,000.[47] This overpopulation, especially in the Lebanon mountains, which had little arable land, began to squeeze péasants, whose holdings were already small. Fathers who would normally divide their land with their sons were having more children than could make a living on the diminishing parcels. Many immigrants and their descendants pointed to this land squeeze, ratifying the opinion of Abdeen Jabara, whose family came from the Biqaᶜ Valley of Lebanon, that there was no more land to divide.[48]

The Lebanon mountain area was relatively tranquil for the rest of the century after the massacres ("Happy was he who had a goat's resting place in Lebanon" the saying went). The surrounding areas did not share in this peace, however, and were more exposed to Ottoman policies, which grew increasingly oppressive nearing World War I. But even the Lebanon mountains weren't devoid of the restive. Najib Saliba notes: "The situation was not totally satisfactory because Mount Lebanon was cut off from its fertile hinterland, the Biqaᶜ plain, as well as the plains of Sidon and Tyre. Its territory was largely mountainous and little suitable for agriculture. With a high birth rate, little farming and virtually no industry, emigration served as a safety valve for what might otherwise have been an explosive situation."[49] As Hitti put it, "Women were more prolific than soil" in Lebanon, and the cramped conditions made people hanker for a journey and a change. J. M. "Maroun" Haggar, the nonagenarian founder of Haggar Slacks in Dallas, mentioned that there was "nothing to do" in his hometown of Jazzine, Lebanon, which he left in 1906. "We were starving to death," he said.[50]

Many immigrants from this period cited heavy and arbitrary taxation as a prime reason why they sailed out of Beirut to the New World, a stimulus not unlike that which drove the American colonies to revolt from Great Britain. The American novelist Vance Bourjaily recalled anecdotes of his grandmother from Kabb Elias in the Biqaᶜ Valley: "My grandmother spoke with a great deal of ani-

mosity of the Turks and particularly their tax-collecting methods . . . Stories about how her family outwitted them by hiding their assets when they got word from the next village that Turkish tax collectors were there. Sometimes her brothers would get in caves out in the hills and throw rocks at the tax collectors on their horses, try and scare them. I guess some would get hit on the head with the flat side of swords." [51] Albert Rashid, one of the last surviving original store owners on Atlantic Avenue in Brooklyn, put it this way: "There was no fairness, no humanity shown by the Turks toward the population. Turkish taxmen came and assessed our land as owing 100 bushels of wheat; because of draught, we couldn't get that, so they took our family reserve and left us hungry." [52] Rashid emigrated in 1920 from Marjayoun in southern Lebanon.

In addition to contact with American missionaries, European traders, and European officials that "protected" the mountains after the 1860 massacres, a prime stimulant to Syrian emigration was the praise heaped on the United States by those who exhibited wares at the international trade expositions and came back to Syria selling America as one big Suq al-Hamidiyah. The first of these to attract Arab exhibitors opened in 1876 as the Centennial Exposition in Philadelphia. Tunisia, Egypt, and the Ottoman Empire exhibited everything from cotton to coffee. Religious items from Palestine were especially sought by Americans: rosaries, olive wood carvings of the Star of Bethlehem, crosses labeled "Made in Jerusalem." The Syrians also vended ceramic vases, gold filigree jewels, and amber "worry beads." The Tunisian café served Arab coffee for 25 cents a cup, and spices, nuts, and perfume of attar of rose made one visitor catch "delicious whiffs of . . . the sweet, stimulating perfume which must be the breath of the Orient . . . a faint, intoxicating aroma." [53]

One commentator thought the huge Carthaginian mosaic of a lion attacking a horse was the best artwork of the entire exhibition. Others must have thought so, too, and a wire screen had to be put around it after vandals began stealing its tiles for souvenirs. A Moroccan kiosk was transported for the exhibition intact and displayed arts and crafts. Americans could smoke waterpipes at cafés. The Arabs and Turks, who won 129 awards, sent 1,600 individuals and firms, more than any other exhibitors except the British and the United States itself. Immigration records show that eight Syrians emigrated to the United States the year of the Philadelphia fair; some had undoubtedly decided to stay on.

The other important international fairs were in Chicago (1893) and St. Louis (1906)—in my travels I happened upon the long bar from the Chicago fair, now in a skid row dive in New Jersey. J. M. "Maroun" Haggar arrived in St. Louis just after the fair there. St. Louis at the time was the wholesale dry goods capital of America and the source of supply for many of the earliest Syrian peddlers in the Midwest, including Haggar, who went on to found a $300 million clothing business.

The Hard Hand of the Turkish Sultan

If the Lebanese "cedar" began to be cramped at the roots by overpopulation, the spirit of the people also began to wither throughout Greater Syria from the policies of an increasingly worried Ottoman sultan. Taxation, lawlessness, crop snatching, and conscription combined with fear of revolt that was brewing in Syria and broke out in World War I in the Hejaz region of Saudi Arabia. As Sir John Glubb, commander of the Arab Legion for seventeen years, once wrote, "from first to last, 1517 to 1917, the Ottomans had never been able to feel much sympathy for their Arabic-speaking peoples." [54]

If there were authorities for wheat tax—too many of them—there were none for arresting a highwayman who had knocked a brother cold and snatched his purse. From the time of the Druze massacres, the Sublime Porte—ordered by the British and French—withdrew most of its security forces from the Lebanon mountain area, leaving it underpoliced and exposed to lawlessness and domestic violence. Justice in such circumstances was piecemeal at best and nonexistent at worst. One Lebanese immigrant who settled in Los Angeles as a successful realtor reported that, when he had accidentally dealt a mortal wound to a friend while cutting tobacco with a large shearing blade, a policeman on horseback from Beirut came up the mountain and surreptitiously arrested him. Though it saved him from an imminent lynching, he feared for his 12-year-old life, since they were heading for Tahdin prison in Beirut, a place few came out of alive. The officer was finally "bought off" by relatives who got him drunk at a café and helped release his young prisoner. [55]

As for court trials for civil disputes, the results were hardly edifying. A Lebanese immigrant from Duma near Tripoli—an accountant who later met with Harry Truman about the establishment of the State of Israel—fingered corruption in the Turkish court as the main reason his father brought his family to the New World. Simon Rihbany's father had been educated by American missionaries in Tripoli and was imbued with ideas of democracy. In a court trial over inheritance of property after Simon's grandfather died, the Turks were evidently conniving to snatch the land: "Right in the middle of hearing in Tripoli my father, 17 years old—already cultured in the American tradition and English justice in Egypt—just blurted out, 'They're lying!' Because you know, we Rihbany people are very free in our opinions and very honest. . . . It was true. A wealthy, powerful man could bend the law. It was not government by law, but by individuals. And it has been the same thing in Lebanon all along." [56] Though the Rihbanys won the case, the father "was disgusted. He came to his uncle and mother and said, 'I want to leave this country and go to the land of justice.'" Within a few months he sailed from Beirut to Marseilles to Philadelphia. It was 1891.

Given the sense of injustice and brewing hunger for independence, it is no surprise that few Arabs wanted to serve in the Turkish army. Although protected from conscription until 1908, after that, Christian subjects, too, were forced into

the army. Some tried to buy their way out. But many served. The mortality rate of Arab soldiers in the Turkish army was high: of 240,000 conscripts, 40,000 were killed, many of them thrown into the front lines of battle in the First World War; 150,000 Arab conscripts deserted. Albert Rashid's brother would dress on the streets of Marjayoun as a woman to avoid the draft, until he could stand it no longer and took the 12-year-old Albert with him to America.

The Turks' reaction to resistance by Arab subjects was hardly soft; they did, however, make attempts to borrow money from Germany to upgrade services in the Syrian province. But it was too late. By 1913, one observer found Turkey wanting any government or institutions and its leaders suicidal: "It [Syria] is a land which might have become the wealthiest in Asia if natural forces at work had been allowed free play. But they have been paralyzed systematically by the masters of the country, who are the Turks, and whose steady aim has been to drain the land of its resources and use them for their State."[57]

On May 6, 1916, fourteen Christian and Muslim Syrians were hanged in Beirut and seven in Damascus by the panicking Turkish government. Both Lebanon and Syria today commemorate this event and named each site "Martyrs Square." Under the swaying shadow of hanging men, many made plans to leave the country as soon as they could. Some participated in the open rebellion. The owner of an engineering and construction company in Los Angeles, who grew up in Brooklyn, recalled that his father fled the country after strangling a Turkish officer.[58]

A. Ruppin estimates that in the thirty years leading up to the First World War the population of the Lebanon province was reduced by one-fourth, due to 100,000 emigrants. Although records are not reliable due to Syrians being lumped together with Greeks, Armenians, and others under the "Turkey in Asia" category before 1899, Saliba estimated that 5,000 Syrians had reached the United States by the turn of the century. The increasingly forlorn Levantines also went to Africa, Latin America, and Canada. By 1901 there were 4,000 Syrians in Australia and by 1903 there were 1,000 in Canada. In Latin America, particularly, the *qashshah* (peddler's bag)–carrying Syrians would rise not only to commercial prominence, as they did in the United States, but also to political prominence.

A last insult by the Turks to the growing sophistication of the Syrians was suppression of the free press. In collaboration with some conservative church authorities, the iron hand of Sultan Abdul Hamid II (1876–1909) repressed the publishing ferment in 1880. Thousands of books were burned or buried in the ground to keep inspectors away; writers were fined, expelled, or imprisoned.[59] The Syrian intellectuals who could get away took refuge at first in Cairo and have dominated the Egyptian press ever since. Others went to America and effected a literary revolution in Arab letters through Kahlil Gibran's touted Pen League. One poet who took flight from Zahle to Rio de Janeiro, Fawzi al-Malouf, died young there, an Arab Keats. He wrote, "O wings of the imagination, mightiest of wings

against whom the winds break their back." In World War I, it was Lebanon whose back was broken.

Lebanon Starves

The traumatic event that shadows the collective mind of the original Syrian immigrants is the starvation that gripped Lebanon during World War I. Records show that the peak years of First Wave Syrians arriving in America were 1913 and 1914—9,210 and 9,023 immigrants, respectively.

Ironically, the cause of the starvation was not primarily the Turks. The Allied fleets—British and French—blockaded the coasts of Syria and Lebanon from the time the Ottoman Turks entered the war on the side of the German Kaiser. These Allied ships prevented any food from entering Syrian ports to relieve the already overtaxed domestic farmers, whose small crops were being confiscated by Turkish battalions. For four years, there was virtually no food imported into Syria; the mountain range—which endures heavy snows in winter—was hit the hardest. Though a quarter of the population had already left the mountains, at the height of the blockade most were too poor or too weak to move very far. Original immigrants I have interviewed talk of eating lemon and orange peelings from garbage heaps; one woman said they picked up horse dung, washed it, and ate the remaining hay. People lay dying in their mountain hovels or on the street. Some murdered for a piece of bread, or were murdered. Others charged murderous prices, and it was not uncommon to see Lebanese mountain elites exchanging fine jewelry and china for a few sheaves of wheat.

Salom Rizk watched refugees from the First World War pour over the Lebanon hills: "They told of a salt shortage so severe that the women walked long, weary miles to the sea with jugs on their heads to get sea water, only to have the soldiers make a brutal sport out of shooting the vessels from their heads."[60] One of the women Rizk may have seen shunting back and forth across the mountain searching for food and water was Mary Kfouri Malouf. Her father was the mayor of the mountain village of Shreen. During the war he sold his property to feed the poor, but he died in the midst of the war. Mary, his daughter, then began an ordeal to feed her four children. One of them was my grandmother. Over the years she has related to me a series of stories of uncanny pathos. From them a picture can be drawn of a dark and snowy mountain, wolves waiting to devour humans, who themselves were hunting for food:

> My mother used to leave for us one loaf of bread, for me and my two brothers, Wadiᶜ and Taniyus. They were smaller and I used to take care of them. I used to give them small pieces of bread like this, about two or three inches, that's all—a day. That loaf of bread has to last us for three days until mama come back. . . .
>
> At that time I run to the little store in my country up the block. I said, "Please, *Allāh yikhalliki* [May God preserve you]! Please give me a loaf of bread. When my mother comes she will pay you for it." The woman said, "Go

ahead, you! Your mother die now. She's not living any more. Go on. Get out!"
She chased me away. She don't give me no money for the bread. We go around
begging for a piece of bread from the people.

So I came, we sit—I never forget that as long as I live. Me and my kid
brothers were sitting at the edge of the door, crying, hungry. If we stay that night
without food I am sure, I am very sure, we die. So we were sitting down like that
and I saw my mother coming down on the street. We stopped crying, calling her,
"Mama! Mama!" She had some ʿadas [lentils]. She boiled them and gave us
some soup because our stomach is dry. Because we don't eat for three days. She
boiled the qamh[grain kernels], the ḥummuṣ, and the ʿadas. I told her the story
about the lady who don't give us a piece of bread. "Ya-ḥarām [what a shame]!"
my mother said.

Again she buys stuff and she goes back. She went to stay up the hill, waiting
for somebody to go by so she could go to Zahle. She can't go back by herself
because the robber come, hit them, and kill them. And the wolf eat them if they
walking by themselves. One boy up the hill, he went with his blanket on his
back. My mother saw him on the road, dead, laying in the street. From hunger
on the way to Zahle.

In the end my mother said, "I am very tired. I'm gonna take you to Zahle with
me and I work over there. We try and do something to support you." So we took
a little room in Zahle. Mother left us to come back ʿa bilādna [to our country, or
village] to buy stuff to go back to Zahle. We have nothing to eat. We go around;
nobody give us nothing. Taniyus die from hunger. My mother, when she came
back, "Wiynu akhūkī [Where's your brother]?" Qult, "Mat" [I said, "He died"].
Sarit tibki, ḥarām [She started to cry, sad to say].

She left us there in one room and goes back and forth. She said, "Maybe there
you feel better." A couple of weeks after, the other one die—Wadiʿ.

So she said, "No more. Let's go back to our country." So we came back—one
day walk. My mother and Mike [a brother] still go back and forth to Zahle. One
day I see a truck coming, picking up people from the street, dying. Just like you
were hauling boxes of cabbages, dirty clothes, or dirt. They pick up the person
and throw him in the truck. I was small, you know. I said I'm gonna walk after
them and see what they gonna do with those people. I followed them maybe two-
three blocks. They have a hole over there and they dump the truck just like you
dumping dirt, and they cover them. That's all. No priest. No nothing. They throw
them down. I was maybe six or seven. That's all.

One time couple of doors up the hill, I see a lady. She was digging a hole
under the tree. I was watching her. She go in the house; she take her son, put
him in the hole, and cover him. Right in front of her house under the tree.

Her family sustained two more deaths related to the war and the lawlessness of
the mountains. Her mother's brother was robbed on the road to Zahle, beaten
severely on the head. He barely made it home. His wife opened the door, he

walked into the house, and he dropped dead. Grandmother's oldest brother, Milhem, was mortally wounded when Turkish soldiers shot at his horse-drawn wagon: "When the war is finished, my brother came back from Baalbek sick. When he walks, he walks backward. Brain injury. He told my mother, 'When I was coming here the soldiers were marching in and the horse got scared and started running.' He was sitting in a *tunbur,* a wagon, and it started running with the horse down the hill. He fell with the horse and the wagon on the cemetery. Right on the cemetery. That's why he hurt his head."[61] It was morbidly fitting that Milhem Malouf died from striking his head on a gravestone, for that is what Lebanon became in the First World War, a giant gravestone, whose inscription would be written by expatriate poets and by colonizing French, who took over the country.

About the Holocaust of the Second World War, when six million Jews died (or one-quarter of world Jewry), much has been written—so much that the black event itself loses its bottomless horror in the constant churning of movies, novels, television series, memorials, and panels on the Nazi death camps. Of Lebanon, where it has been estimated that at least 100,000 people starved to death during World War I (a quarter of the population), there has been a deathly silence. It is like a blank spot in history, about which little is known. Part of the reason for this is that little has been told: the emigrant Lebanese-Syrians affected a uniquely evasionary character about the subject with outsiders. Most of the first-person eyewitness sources of the mass starvation are in Arabic. Only small bits of these invaluable stories have been translated into English. Of the "many moving accounts" Saliba notes about the famine, he points out four, all of which are written in Arabic and none of which has been translated—not even a sentence—into English. This appears to have been a classic case of "avoidance syndrome" in the emigrant community. During the war, only one source, the 1916 special issue of *Al-Funun* dedicated to the starvation in Syria (written by the Lebanese émigré poet Nasib Arida), was published in the United States (New York), and it, too, remains untranslated.

By 1916 fatherless and motherless children strayed into the desert to be picked up by Bedouins. The Druze population of the Shuf stumbled toward Houran and the Golan Heights in southern Syria. Hitti quotes an eyewitness report by a professor at the American University of Beirut: "Those who did not flee to the interior in quest of sustenance joined the ever-increasing horde of beggars in the city. Among the beggars were those with enough energy to roam the street and knock at doors, ransack garbage heaps or seek carcasses. Others would lie down on the street sides, with outstretched arms, emaciated bodies and weakening voices. Still others, including infants, could speak only through their eyes. . . . By 1918 the entire lower class of society had been virtually wiped out."[62] Hitti himself concluded that, in Lebanon's case, the evidence showed "a deliberate effort to starve and decimate the people."[63]

Complicating an already horrid situation, in which typhoid, malaria, dysen-

tery, bubonic plague, and yellow fever were breaking out, a dark cloud "veiled the sun" over the Syrian countryside in the spring of 1915, stripping whatever fruit trees were bearing. The calamities in Syria during the First World War began to resemble the biblical landscape of Job. It is appropriate that one of the most eloquent recountings of this catastrophe should come from one of America's largest potato growers. Born in 1902, Amean Haddad, who sells the Safeway Markets firm about half of its spring potatoes, survived the worst of the famine in the mountains during the war. His parents had left him behind in their flight to America, and Haddad weathered the brunt of the bad years virtually alone, in his early teens:

> What added to the misery was the locusts. When the locusts came they seemed to have been directed to go to areas where there was a lot of green. My town was Kabb Elias in the Biqaᶜ Valley, and the plums were just about to be ripe. We had peaches, apricots, vegetables, just about to be picked. And when the locusts came they wiped everything out. You would see the stems of a tree peeled. They have eaten the skin. And you see the trees, instead of being green, they have turned white. All you saw under the plum tree was the pits. It was not only bad; it was a sight you will never forget. You are hungry and here is an animal who came over and ate what you could have lived on. That was what disturbed me. Why did the *jarād,* the locust, come and eat all our food? Our grain, our wheat, barley, corn, vegetables, our plums—everything. Why?

Since the Turks provided no help, makeshift relief efforts by civilians were all people could rely on. Haddad described them:

> You would be walking on the street and you would see a body lying on the ground. And you would get to it, nod, just a dead body. And that happened many, many times in a day. A friend of mine, Tawfiq Filfli, my age, volunteered with me—there was no law and order—to make a stretcher out of two long pieces of wood. We made it like a step ladder. We carried those dead people way out away from town. Because nobody would come. And many people caught their disease but we didn't. And we were the ones who carried them. He took one end, I took the other. They didn't weigh very much because they died from hunger.[64]

Yellow fever, *al-hawa al-asfar,* was cited by Haddad as the second-largest cause of death in Syria at the time.

At war's end, my grandmother's brother Michael Malouf witnessed a most bizarre thing. In a town near Zahle, named Riyeh, the Germans and Turks had hidden armaments and bombs underground. "They had a city on top and a city on the bottom," said Mike Malouf. Wheat and oats from the surrounding villages were stored there, all confiscated by the Germans and Turks. Above the munitions dump and cache was a field of wheat and oats. The English, pressing their advantage, began bombing Riyeh:

> I was right on a big field over there. I was walking; all of a sudden I see something in the air and a big bomb dropped. And you should see the fire that started. And then the soldiers running away all over the place. But the people—it was killing them left and right. What happened then—ammunition is for nothing. Take what you want. Guns. Everything you need. You want gold. You want money? Free-for-all. If you were lucky, you survived. If not, you get your head blown off . . .
>
> There was one lady there, she had two boys with her. She saw the wheat was about forty, fifty feet high in the air. The wheat, piled up outside. She wanted to start picking the wheat, taking the wheat. All of a sudden the bomb hit her, took her head completely off. So one of the boys starts crying and hollering, "I want my mother's head! I want my mother's head!"

The woman had apparently nudged a live bomb dropped by the British, or one of the explosives hidden by the Turks and Germans.

Malouf also witnessed vengeance by the local populace: "The people was killing 'em, shooting them down. There was one soldier over there in charge of the whole army. He used to know a beautiful girl and came to see this girl all the time. The people in her town know this. When the war was finished, he tried to hide over there. One day they took him and put a hole in the ground and bury him right in front of the house. They buried him alive. Because he was very mean." [65]

As if the Deity himself had gone crazy at the war's devastation, a severe earthquake hit the Lebanon mountains on Armistice Day, November 11, 1918. Pete Nosser, a retired businessman in Vicksburg, Mississippi, remembered that the tremor came while he was working in the almond grove in his village of Shekarn: "I could see the bucket of syrup [*dibs kharrūb*] shaking. I looked up at the tent— it was shaking. I looked over at the houses and they shook like the trees. An American Arab who had come back to our village shouted at us, 'Get out of your houses! This is an earthquake!' We didn't even know the word." [66]

Lebanon had lost half of its population to famine and emigration. Is it any wonder that it would fare so poorly in the dice game of nations, that it would so easily fall prey to the avaricious, both inside and outside? Luckily, the emigrants did not forget the suffering of those they had left behind. If they tried to sweep the tragedy under the carpet of prosperity, Syrian émigrés still sent over $259 million from the four corners of the globe to Lebanon during the First World War.

Certainly, the refugee problem was not born in Lebanon with the Palestinians in 1948. Besides the Lebanese themselves, thousands of Armenian refugees came into Lebanon from the Turkish domain during the war. (The Armenians had been subjected to near genocide at the hands of the Turks, losing one million.) Thirty thousand refugees lived in tents in and around Beirut during the war. Many villages and cities were emptied. By the end of the war, ancient towns that had been lived in for thousands of years were ghost towns. The coastal town of Batroun went from a prewar population of 5,000 to 2,000 by war's end. From

Sidon south, American records showed that, of 77,000 inhabitants, 33,000 had died in four years of war. Mirroring the ruined mountains, over one-quarter of the dwellings in southern Lebanon were wrecked. Of the survivors in the south—about 40 percent were paupers. There were 2,600 orphans in the south alone.

Sixty-eight percent of the early Syrian emigrants were male, a majority unmarried and in their twenties. Of those that were married, only 12 percent brought their families to America in the First Wave, from 1878 to 1924. As one commentator put it, "many villages lost their young blood and became shelters for senior citizens."[67] By war's end, one village in the mountains, Bayt al-Shibab, or "Home of Youth," was transformed in parlance to Bayt al-Ajazah, or "Home of the Elderly." Palestine, too, lost many to emigration. Jewish Palestinians were reduced by one-third of their prewar total though Jewish immigration to the country rose sharply under the British Mandate.

What all this foretold for the future of Syria—and especially for its Lebanon sector—was not difficult to surmise. With the brain drain to Egypt, Boston, and New York, and the large size of migration from the worker-peasant class, the few men of means and education who did stay had a virtual lock on power. And it is these men—the Franjiyahs, Gemayels, Chamouns, Jumblatts, Salaams, Karamis—who suckled as infants on a withered breast. They became the warlords of contemporary Lebanon. It does not seem unlikely that if they could not rid themselves of the habit of exceptional blood feuds it was because of their initial status as the kingfish in an abandoned sea.

Who Am I? The Syrians Dock in America

Assad Roum stood on Ellis Island in 1939, nineteen years after he had first come ashore at the famous immigration processing center in America. He was now a citizen, recently married in Syria, and had established an embroidery and Corday handbag manufacturing business in Brooklyn. He waited in the mist that day for his new bride to arrive. But when Nora Roum docked from her month-long voyage across the sea, pregnant, Assad barely had a chance to embrace her near the traditional "Kissing Pole" in the island. Immigration authorities detained her for several months in the hospital ward there; for Nora had trachoma, the dreaded eye disease that sent so many immigrants—Syrians included—back to the homeland with no chance of becoming American. Nora gave birth to the Roums' first child on Ellis Island. When she was approved as an immigrant and could go to the mainland of New York to join her husband, she was so ecstatic that she convinced Assad to name their infant daughter Elsie, after Ellis Island itself. Today Elsie Roum is a physical education teacher in California.[68]

More than half the current U.S. population can trace its heritage through Ellis Island; more than half have relatives who staggered through the doors of the great emporium with its chandeliers, topped by magnificent steeples across the water

from the Statue of Liberty. In the period 1880–1924, 16 million of the world's destitute (or 60 percent of the 27 million immigrants to America at this time), were processed at the little islet made from the landfill of the New York subway. Among them was the vast majority of 150,000 Syrians (see Appendixes 1 and 2), including Assad Roum.

Today, Ellis Island is in ruins. Shut down by the Immigration Service in 1952, by which time airplane had replaced boat as primary conduit to freedom, Ellis Island became a hangout for daring teenagers, who would motorboat over from Jersey or Battery Park. It fell prey to mice, vandals, and, in 1976, the National Park Service, which today takes tourists through a mist of ghosts and huge empty halls with walls of peeling paint, rusty pipes, cobwebs. Old files and medical equipment are still there. One old wheelchair in the tent of a spider web has wooden footrests. It will take $300 million to restore this once majestic first home of so many whose hearts quickened at the sight of America and who, in fact, laid the foundation of the America we have today. As of this writing, some government officials want to turn Ellis Island into a hotel resort, against the hopes of the Statue of Liberty restoration committee, who want to preserve it as a historic site.

A Park Service tour guide at Ellis Island in 1983 started his hour-long discourse about immigrants with an anecdote of Golda Meir's father, who escaped a pogrom in Russia. The moving story was followed by a less interesting one about an immigrant from Barbados; three stirring references to Jewish immigrants were sandwiched in with mention of German, Irish, Italian, Greek, African, Chinese, Polish, Japanese, even Cambodian immigrants. But when told that by 1924 at least 150,000 Syrians had immigrated to America, the guide drew a blank. For me, it was a disconsolate note, as I listened to the ghosts of the Syrians, nauseous as so many were from the seas, try to spell out their names in English, or be turned away because of trachoma, or wander wide-eyed into the cacophonous corridors filled daily with up to 15,000 ragged but hopeful immigrants from around the world. They seemed as unknown in 1983 as they were a century back, when they were miscalled "Turks" and listed as such until 1899, a humiliating reference given the fact that most were Christian and had sacrificed so much to get away from Ottoman Turkish rule. Perhaps it was at Ellis Island that their identity crisis in America would begin, where Yaccoub quickly became Jacobs, and first names became last.

Perhaps it was due, too, to the fact that they were among the last in line of an immigrant surge that crested at the turn of the century and was shut down by law in 1924. Though by 1913 nearly 10,000 Syrians were leaving ships at American ports a year, they were but a drop in the bucket and a late drop at that. The largest single ethnic group in America—the Germans—had begun to immigrate as far back as 1710, and by 1900 German Americans numbered 5 million, accounting for a quarter of the population of America's largest fourteen cities. By the time of the first Syrian immigrant family to American in 1878, there were already 200,000

German Jews in the country. Nine thousand American Jews fought in the American Civil War at a time when "Hi Jolly" and Antonios Bishallany were just about the only Syrians in the United States. Syrian immigration at its peak between 1900 and 1914 was only 7 percent as large as Jewish immigration at the time. In the first decade of the twentieth century, the Syrians ranked 25 of 39 immigrant nationalities.[69] Yet the Syrians came to America at such pace that they alarmed the Ottomans and other authorities who felt the very schools the Americans had set up for them would be emptied. By 1924, many of them were.

The Syrians at the end of the nineteenth century moved by donkeyback or a three-day foot trip to the harbors—Beirut, Tripoli, Haifa, and Jaffa. There they encountered eager steamship merchants, as well as a whole class of hucksters ("sharpers" poet Amin Rihani called them), who would do everything from bribing Ottoman officials for passports (*tadhkarahs*) to securing $30–$50 tickets for the short dinghy voyage to the steamer as well as the long overseas journey. All this was done for a price, of course, and middlemen made quite a profit. But the Syrians paid for their blankets and ferries, ready to take what would be the longest sea voyage anyone took east-to-west to America. Three bribes were not uncommon to receive the necessary endorsements to get on the ship in Beirut—a half *madjidy* (or Turkish dollar) to passport officials, another 50 cents to an inspector of the rowboat between wharf and steamer, and yet another 50 cents to the final inspector at the steamship's gangplank. As the Reverend Abraham Rihbany said after running this gauntlet at the end of a tiring trek, "We left our mother country with nothing but curses for her Government on our lips."[70]

The ship ride across the old sea was "unfriendly," and Rihbany tried to sleep on crates filled with quacking ducks: "Other human beings joined us in that locality, and we all lay piled on top of that heap of freight across one another's bodies much like the neglected wounded in a great battle." An argument broke out between a Syrian in the "duck apartment" and an Egyptian woman: "*Lawajh Allāh* (for the face of God), said the kind-hearted Damascene, and squeezed himself a few inches to one side. In an instant, the wrathful Egyptian wedged herself in, squirmed round until she secured the proper leverage, and then kicked mightily with both feet, pushed the beneficent Damascene clear out of the wave-washed deck" (p. 175).

In Marseilles, Rihbany saw electric lights for the first time in his twenty-four years, as well as his first train. Marseilles unveiled the last Sirens for the Syrian peasant before he braved the Sea of Darkness to America. The port seethed with hawkers of everything from Western clothes to sex. Some Syrians ran hostelries and guided the weary Levantines, giving them directions and lodging for the nights they must wait. Rihbany bought a Western bowler hat, flinging his Oriental fez hat aside; it gave "a distinctly Occidental sensation . . . stiff and ill-fitting" (p. 176). Another immigrant through Marseilles from Zahle remembered meeting a merchant marine uncle who threw his newly purchased British safari hat into the sea, saying no one in America wore them.[71]

Amin Rihani, the poet who came to the United States in 1888 from Freiyka, Lebanon, compared the cramped lodgings in steerage to Lebanon's sericulture: "I peeped into a little room, a dingy smelling box, which had in it six berths placed across and above each other like the shelves of the reed manchons we build for our silkworms at home." In his sardonic novel of the Syrian immigrant experience, *The Book of Khalid* (1911)—the only of its kind—Rihani called the pathway of the immigrant a virtual "Via Dolorosa" with the Stations of the Cross Beirut, Marseilles, and Ellis Island.[72]

Salom Rizk remembered a cabin mate who "would dangle a rosary from the porthole when the seas were rough," and how, when he once left the porthole open after quieting a storm with a medallion of St. Christopher, a huge wave washed in and flooded the cabin. Two angry stewards mopped up the mess and threw the medallion into the sea.[73] Steerage for most immigrants was time spent in the belly of the whale, with little hope for regurgitation, save that of their own sick stomachs.

Syrians and other immigrants went through the "boiling down" effect of steerage, and got their first taste—though a foul one—of life in a democracy, where accidents of race, class, privilege, and religion in the Old Country were steamed into a common "new man," linked by little more than the desire of a whiff of clear air, a foot on terra firma. Arab refugees from Jerusalem bartered crosses of olive wood for an extra cup of clear water. *Tarbūshes* of the proud were tossed around like so many insignificant footballs, battered, lost at sea. How bizarre it must have been to be suddenly a minority as a Muslim, now amongst a horde of Christians and Jews. One Christian immigrant—who translated poetry by Kahlil Gibran—recalled being helped with food and comforting words by a Muslim on his journey across the sea.[74] The enmities of sectarianism drained off in the sea and the agony of adjusting to a new country. At least they had Arabic—treasured tongue—in common.

Some avoided danger more threatening than the sharpers of Marseilles. Said Hanna, a Syrian immigrant from Damascus, told a story of initial frustration when he had arrived in Marseilles too late to catch his ship, which was to link up in Southampton, England, with a huge new oceanliner bound for New York. But when the *Titanic* sank at sea, he counted himself a lucky man and never again worried about being late.[75]

The "Island of Tears" awaited them in New York as they entered the misty harbor, passing the great statue holding a flame surrounded by wire. "Tears" because, of the sixteen million immigrants who arrived in this period at Ellis Island, two million never got out of its examination rooms, except to be sent home because of disease, mostly trachoma. Actually, those who arrived before 1893 were processed at Castle Garden, attached to Battery Park by landfill. It was there that in 1877 seven Algerians who had escaped prison in French Guiana had been "exiled" by the mayor of Wilmington, Delaware, where they had been arrested as vagrants: "The men are quiet and very attentive to their religious duties.

They go to the northeast side of the building four times a day and quietly perform their devotions, at the same time 'looking toward Mecca.' They are all somewhat proficient in the French language."[76]

But Ellis Island was the site of entry for most Syrians (some came through Pawtucket in Rhode Island, Philadelphia, or New Orleans). Woozy, disoriented by raucous shouts in five different languages to go "Forward! Quickly!," they found themselves herded into the throng in the huge emporiumlike structure, probably the largest building any of them had ever entered. They had to traverse three stations of doctors, the first of whom pulled out an average of one in six immigrants marked for further checking by crayon or chalk: *H* for heart, *K* for hernia, *Sc* for scalp, and *X* if the immigrants were suspected of being insane or mentally retarded. At Station Two, the immigrants had to walk up a long flight of stairs; if they hobbled, they were chalked. Surviving that, they were checked for communicable disease. Leprosy? A scalp disease called favus? Syphilis? (The latter had entered Lebanon for the first time when the French came into the country in 1861, bringing with them the "Franji sore.") The final, most dreaded stage of this gauntlet was the trachoma check. It was here that Brooklynite Sadie Stonbely from Aleppo, Syria, was poked so badly in the eye during the examination that she had bad vision in her left eye for the rest of her life.[77] In spite of these pitfalls, according to one Syrian immigrant, Ellis Island was fondly called *bayt al-hurrīyah* (the house of freedom).[78]

An American senator aided an early Syrian constituent from Worcester, Massachusetts, whose two boys were being held at Ellis Island because they had trachoma. He telegraphed President Theodore Roosevelt to "prevent an outrage which will dishonor the country and create a foul blot on the American flag." Roosevelt responded quickly, and soon the boys were allowed to join their mother. Years later, Roosevelt visited Worcester himself and discovered that the boys' eyes had been damaged by the glare of sea water, not trachoma.[79]

Arriving indigent, or penniless, could keep an immigrant mired on Ellis Island. One man who escaped a Turkish pogrom against Armenians in Tripoli, Lebanon, at the turn of the century by disguising himself (with the help of Muslim friends) in Muslim clothes ("He had to step over dead people, the ground wasn't showing") had sons already in America when he arrived at Ellis Island. They worried that he had no money to show immigration officials. And they hatched a scheme:

The story—it's a secret but I'll tell you now. It's too late; everybody's dead. My brother went and bought a box of candy and he lined the bottom of it with gold pieces, and he put the candy on top. And he went to the boat dock, down in the pier. Downstairs they sell fish, they sell, you know, nibbles, things like that. My brother bought a lot of things there and put them in a basket (with the candy and gold). My father was standing up on the boat. And he told my father in Armenian, "Take the box of candy and leave everything else to anybody who wants it.

Just take the candy and go to your room. You'll find out why I sent it up there."
When he went he found, sure enough, I don't know how many pieces of gold.
Because when he comes at Ellis Island they've got to show a certain amount of
gold to come in here, that you were well enough to take care of yourself. [80]

By 1907, the Syrian Ladies' Aid Society was in full force helping Syrians ac-
climate themselves to New York once they got through the Ellis Island checks.
Many emigrants spoke with warmth and appreciation about Dr. Nageeb Arbeely,
who was chief Arabic examiner in the early years on the Island, as well as his
brother, Dr. Ibrahim Arbeely, who published an English-Arabic grammar for the
immigrants in 1896. Relatives gathered at the famous "Kissing Pole" to greet the
newly processed arrival with anxiety and ecstasy before the new would-be Ameri-
can from Syria crossed the lapping waters of the Narrows and caught a first sight
of that huge zither—the Brooklyn Bridge.

Life on Washington Street

By 1900, over half the Syrians in America lived in New York City, most of these
squashed in with the "shanty" Irish near the wharf on the Lower West Side on
Washington Street. There they set up coffeehouses, bazaars, weaving factories,
and groceries in direct contradistinction to more-established inhabitants of the
area: the bankers of Wall Street, who viewed them with much curiosity.

Washington Street—the closest thing to a Little Sicily the Arabs ever had in
America—was alive from dawn to dusk with noisy, guttural shouts, price barter-
ing (there was no fixed price in an Arab marketplace, as if commodities only take
on value in the give-and-take of human personality). Odors of anisette and *ar-
jīlah* smoke rose into a street already heavy with fumes of coal and gas from
lamps and heating furnaces. A café owner poured Turkish coffee at the noon
hour, and the demitasses clattered at the passing of a horse-drawn carriage, a
Syrian boy with a heap of linens in a satchel ready to go out door-to-door.
Peddlers fanned out from the mother colony on Washington Street, supplied with
notions, linens, and silks hauled in their *qashshah*, or little wooden or leather
cases. They loved to be outdoors "smelling air," as Rihbany put it, and, as Naff
has shown, peddling in strange streets across the land was a good, open-air class-
room for learning English.

Syrians in Manhattan and New Jersey resurrected their silk industry, which
had been throttled by blight in the homeland. By 1924, there were 25 Syrian silk
factories in Paterson and West Hoboken. The federal Industrial Commission
quoted a New Jersey proprietor referring to the Syrians' "instinct for weaving
silk"; he preferred their work to those of the Italians or Armenians. Hitti de-
scribed the kimono industry in New York—35 manufacturers on Washington
Street—as being exclusively in the hands of the Syrians, and almost all the
Madeira lace outlets were owned by them. Nevertheless, their chief competitors,
the Jews, owned 241 garment factories by 1885, or 97 percent of all such facto-

ries. Still, half the sweaters made in New York were made by the early Syrians. The N. P. and J. Trabulsi Co. was called the "king" of the woolen knits. F. A. Kalil, on Broadway, won a national competition to use "Red Grange" on a sweater.[81] Though few ventured into subterranean mines or worked in blast furnaces, the Syrians endured their sweatshops for a foothold in America.

From dawn until late into the night, a seamstress bent over her Singer sewing machine, pulling its black wheel down like a maid drawing water. Spools of thread twirled and slid under the needleworker's jabbing spindle. Steam hissed off the pressers. Helping her husband in a shop as well as peddling on the street, the Syrian woman probably never saw the white of the silk or linen she spun and stitched because the turn-of-the-century gas lanterns cast a yellowish tint on everything. One Lebanese woman related how she juggled the two worlds—children and work—with literally every limb: "I used to work for the people my mother worked for. I used to work day and night. When I get my son, Joe, I put him in the carriage. When he cry, I shake the carriage with my feet and work with my hands. I used to work for Barsa and Mrs. Stonbely. I sleep a little. I put the work next to my bed. Then I get up quick. I said, people gonna come tomorrow morning, got to work. I work very very hard in my life to raise my kids." To her, there was little chance to even walk the bazaars of Washington Street: "I don't know the difference. I'm workin'. When the baby small, I put him on the fire escape outside. When he start moving, I put him inside. I never go anywhere. Only on Sunday I take them in my hand, go to church, and come back. That's all." [82]

But there was pride, too, in the craftsmanship of clothes, rugs, fabrics. One Syrian needleworker on Washington Street told a haunting story, which jumped unconsciously from Aleppo to Pennsylvania linked by the struggle for life represented to her by the loom: "My father-in-law used to go to the Aleppo cemetery—they used to tell us that—to weave some design. He used the cemetery wall to put [hold] his loom. I know my cousin used to have next door to our home a loom factory. . . . My son was in Korea and he was wounded. In Valley Forge Hospital he used the loom to exercise his arm because he was shot in the neck and his arms were paralyzed. For a whole year in Valley Forge Hospital he used that loom and he made a rug for me." [83]

Though the patriarch had the bark in the Syrian family, anyone who spent more then three days in an early Syrian home knew that the wife and mother had the bite. Though not "liberated" in the modern sense of having choices, the Syrian mother, as peddler, needleworker, or shopkeeper, achieved, by dint of her forceful labors and strong good sense, the power in the Syrian home. William Peter Blatty makes this heroic, dominant role clear in the memoirs of his peddler-mother, *Which Way to Mecca, Jack* and *I'll Tell Them I Remember You.* Novelist Vance Bourjaily called his immigrant grandmother from Kabb Elias "the total strength in my life," a woman of "incredible character and vision." She had come to America in 1894, leaving a wastrel husband behind, supporting her chil-

dren while making beds and cooking at a boarding house for Syrian mill workers in Lawrence, Massachusetts.[84] Liberation was work and sacrifice, the two words virtually synonymous. If anything, the dominant role of the Syrian mother was diluted somewhat when the firstborn generation became mothers themselves and scarcely worked outside the home.

Pay for garment workers was abysmally low, hovering around $10 a week, and women usually got half that. Peddlers often did better, earning between $200 and $1,500 a year: "They began coming in small groups in the garb of mendicants. They wore red fezzes, short open jackets, short baggy blue trousers to the calves of the legs and ill-fitting shoes. As soon as they had passed the immigration authorities they would at once go out into the street to ply their trade. At the end of the first day in America the whining Maronite would have added five dollars to his hoard, while the Irish or German immigrant would be bustling about trying to find work to enable him to earn a dollar."[85]

The peddler from Washington Street became an emissary from the exotic land and, at the same time, an American entrepreneur in the making. He even helped the American export trade. When World War I cut Latin America off from European trade, the Syrian peddler—supplied by the Syrian-owned warehouses in New York of the Bardawill, Jabara, Tadross, Ackary, Sleiman, and Atiyeh families—fanned out to South America, where Syrian emigrants provided necessary rest stops: "The Syrian merchant in every country of South America, Asia and Africa, and Australia thus became the distributor of the products of the United States."[86]

Though Syrian hardihood and venturesomeness was generally acclaimed, the land of the free was far from accepting the "colorations" the gene pool was undergoing with massive immigration. In 1882, the Chinese Exclusion Act barred Chinese immigration. In 1899, the Associated Charities of Boston reported its opinion that "next to the Chinese, who can never in any real sense be American, [the Syrians] are the most foreign of all foreigners." In 1902, Sen. Henry Cabot Lodge tried to ramrod a halt to all immigration, vetoed by President Theodore Roosevelt. That same year descriptions of "Oriental warfare" filled New York papers when a police roughing up of five Syrians at 70 Washington Street turned into a melee, one Syrian described as a "giant" who could hold nine men on his shoulders. The image of the Syrian colossus (in contrast to the cartoon "vermin" image of Yasser Arafat seventy years later) was exploited when a murder on Washington Street made front-page news, the headline October 29, 1905, reading in the *New York Herald:* "FACTIONAL WAR IS WAGED BETWEEN SYRIANS OF NEW YORK CITY. CUTTING AND SHOOTING. BROTHER AGAINST BROTHER, VILLAGERS AGAINST VILLAGERS, AND OLD FRIENDS ARE PARTING. VOICES OF WOMEN HEARD." The *New York Times* on October 24 spoke of "wild-eyed Syrians [showing] the glint of steel in two hundred swarthy hands." The cause of the scuffle? Typically enough, religion. A disagreement over the merits of the Syrian Orthodox bishop. The press overreaction contrasted with a more sober report by

Lucius Miller: "In his love of law and order the Syrian cannot be excelled. . . .
The universal testimony of the police authorities is that there is no more peaceful
and law-abiding race in New York City."[87]

Though they were often co-religionists, a more chronic, low-level trouble oc-
curred between the cedar green and the shamrock green—the Syrians and the
Irish. The Industrial Commission Report on Immigration said, "The Syrian in
New York has housed himself in the tenements of the old First Ward from which
he displaced an undesirable Irish population, the remnant of which torments
him." Settlers from that period report many kinds of harassment: a Syrian
peddler woman had her *qashshah* lifted out of her hands by a taunting Irish win-
dow washer letting down a hook;[88] the owner of the Courtland Hotel on Washing-
ton Street remembered that on Halloween the Irish "fill up stockings with flour
and go and beat the Orientals with it."[89] Another woman remembered a Cockney
Englishwoman shouting over a Brooklyn fence of grape leaves after witnessing
the Syrian neighbors beating raw lamb in a *zidra* (stone bowl) outdoors for *kib-
bah nayah:* "Cannibals! Uneducated people!"[90] The Irish-Syrian tiffs declined
when intermarriages occurred—for the rare times when they ventured out of
their own community in wedlock, the Syrians preferred the Irish. The whole era
takes on a mirthful cast when one knows today that the closest confidant and
trainer of the top Arab American boxer—middleweight contender Mustapha
Hamsho—is an Irishman.

It is hard to believe today, when Arabs are represented in film and theater as
little more than terrorists or rich philanderers, that the early Syrians were the
subject of a very popular Broadway play in 1919, *Anna Ascends.* The heroine
was a Syrian waitress named Anna, working at a Washington Street coffeehouse
run by the worldly-wise proprietor, Said Coury. Playwright Henry Chapman
Ford, who had been mesmerized by a Syrian waitress in the Boston Beach Street
colony, Anna Ayyoub, spoke of a Syrian family he had known in Washington,
D.C., in 1912: "Their family life, their clean way of living impressed me and I
decided that the Americanization of such a race was a big factor in making the
'melting pot' one of the greatest nations of history." Ford went on: "I figured here
is a people who could read and write probably six thousand years before the
northern 'blue eyes.' Here is a race who had a fine culture along with the great
Egyptian dynasties, and as criminology seems to be a statistical fad at the present
writing, here are a people who have less, en ratio, in prisons, than any other in
the world. Hence, I figured, why not write a Syrian drama, a virgin field, anent
the Syrians?"[91]

The play did not do for a bar what O'Neill's *The Iceman Cometh* did, nor did it
capture the pathos and music of ghetto life as did *Fiddler on the Roof.* Neither
high tragedy nor robust musical, *Anna Ascends* owed more to the light comedy
intrigue of Noel Coward and the unabashed energy of George M. Cohan. Anna
herself is a study in the Syrian working-class girl on Washington Street: "She
carries a two-gallon olive oil can in each arm. Strings of garlic are around her

neck. A small pocket dictionary is under the pit of her left arm and a sheet of paper with an order written on it in Syrian is in her mouth. In her blouse pocket is an American flag." [92]

Whatever good intentions Ford certainly had, his play connected Anna's attractiveness to her ability to "ascend" the social ladder and hide her Syrian past. The Syrians, like Anna, were ready to ascend, too, virtually from the day they stepped off the boat at Ellis Island. If a name was to be sacrificed, more power to the new name. Only decades later would the dropping of Arabic names cause one Arab American poet to lament:

> . . . even my father lost his, went from
> Hussein Hamode Subh' to Sam Hamod.
> There is something lost in the blood,
> something lost down to the bone
> in these small changes. A man in a
> dark blue suit at Ellis Island says, with
> tiredness and authority, "You only need two
> names in America" and suddenly—as cleanly as
> the air—you've lost your name. [93]

But as the Reverend Rihbany had shown, there was convenience in being "the stranger," even to one's own people.

Peddlers and Factory Workers

The present-day mayor of St. Paul, Minnesota, is not recognizably Syrian. His name is George Latimer, but his mother was named Nassar, and her father was a Syrian peddler moving a cart of notions back and forth along the railroad tracks of Poughkeepsie, New York. On a summer day in 1983, Grandson George shook his head, jumped down the steps of his modest home, and drove off to see about lower-income housing, better plumbing, and preservation of the heritage of Swedes. [94]

When America listens to its favorite disc jockey it is listening to the son of an early Syrian peddler. Casey Kasem noted that his Druze father, Amin, left al-Moukhtara in Mount Lebanon in 1895, peddling up through South America and Mexico before dipping his body in the Rio Grande to become "an old olive-skinned wetback." Kasem remembered with fondness a figure from his Detroit childhood, "a Druze man who was always neat, clean-shaven, who made such a good reputation downtown in every Detroit office building carrying his little case as a peddler up until ten, fifteen years ago." [95] Though this would have been half a century after the peddler era, the man struck Kasem as a cipher of lost times.

The Syrian peddlers went everywhere—from Washington Street in New York City they fanned up toward Utica and Buffalo; from New Orleans they peddled in Mississippi, Louisiana, and Texas; along the Rio Grande olive-skinned "wetbacks" at the turn of the century peddled in border towns (one family rivaled

Haggar slacks in El Paso—the Farah slack people whose founder was, yes, a peddler); they peddled out across the Midwest to Indiana, Iowa, the Dakotas; they peddled, shouting, "Buy sumthin', ya ladies—cheap!" by the shores of the Pacific.

Before parcel post, and J. C. Penney stores, the car and bus and subway, the Syrian peddler took to the American farmwife, factory worker wife, and country squire wife an invaluable item—the marketplace. The marketplace—the *sūq*—in one little *qashshah* (from the corruption of the Spanish word *caia*). It usually contained dry goods: notions of thread, ribbons, handkerchiefs, laces, underwear, garters, suspenders. A hook to lure the interest of the woman who might otherwise be afraid of this character with the dark hair, baggy pants, and sunburned grin was a special satchel of holy items fresh from the Holy Land (no matter that often these crucifixes, rosaries, and Orthodox icons were manufactured in the Japan of its day—New York—they were *holy*). One 14-year-old boy from Karhoon, Lebanon, peddling in Worcester, Massachusetts, was nicknamed by customers, Jerusalem.[96] As Naff points out, rosaries were often displayed on a stick (to heighten the drama) or arranged on an arm like spaghetti straps from an alluring dress. Thus did the holy take on the touch of the sensual. To the Iowa farm wife, whose husband spent his day covering himself with dust and wallow and corn, this Syrian visitor, however odd, was welcome. And she bought—to the tune of a $60-million business for the Syrians by 1910.

For the peddler, hoisting his 50-to-200-pound packs or carrying the notions cases was a way to overcome isolation in his new land. It allowed him to literally walk out into America, without the tedious, sometimes humiliating attempts to adapt to American behavior in a fixed setting. Others peddled: German Jews, Irish, Swedes. But apparently the early Syrian took particular pride in it as if it defined his intrepidness. Too, it seems the Syrian was adaptable to both rural and city markets. He thrived on the empty spaces, once again that blessed stranger.

The highways in Sioux Falls, South Dakota, owe their origin to a Muslim construction company owner who came from Karhoon, Lebanon, in 1878 and peddled. Ali Ahmed al-Oodie had also sunk his stakes as any pioneer, homesteading in the Black Hills.[97] Down South, along the rural stretches of the Mississippi River, the father of the man with the longest service in the Mississippi legislature peddled at the turn-of-the-century: "He bought in Vicksburg what he could carry on his back, 'cause he walked in the beginning, went through the countryside. Then as he was able he got a horse and buggy, then a wagon. He became a merchant with a store in Hermanville, then a store eventually in Vicksburg." Above the store was the home, "very Lebanese in feel" with arches and off-white, buff brick, and porches looking out over the river—the manse of a peddler from destitution.[98]

It was backbreaking work on the road where the Syrian's biggest enemies were the cold and exposure without a roof. As Joe Hamrah, an immigrant from Zahle, Lebanon, told about his father's peddling in Connecticut: "They slept in garages

and hay lofts. Pop, he got shot somewhere." To the elder Hamrah, Connecticut was lucrative because of Yale and "you had people that were pretty well off from the old school that liked the laces and what have you."[99]

On the road for up to six months (others peddled for a few weeks at a time, some were only day peddlers), they had to do everything possible in cold weather to keep from freezing to death. Still, there are tales of women's frozen skirts cutting their ankles, of blackened frostbitten faces, and of men sleeping in buggies who froze to death by morning.[100] One horrid night a Syrian shepherding a woman married to a fellow villager in Lebanon was caught out in the cold and stole into a small building: "I opened my *kashshi* and I used a scissors, No. 9, and I put it under the frame of the window, it opened, and we entered. We saw two cases in which they put the coffins. I told her that this room had two beds, one for her and one for me. From our fatigue and the darkness, we did not see the graves. . . . Then the moon came out. The woman looked outside and cried out . . . 'We are sleeping in a mausoleum and the dead are beneath us in the boxes.' And she leaped out of the shed and I after her."[101]

Inevitably there was a mixup over customs that could get the peddler in trouble. Given a room for the night, an anxious shaking Muslim peddler seized the beard of his Norwegian host in Sioux Falls, South Dakota, and kissed it, a gesture of reverence or request in the Arab world. The Norwegian began strangling him until he was rescued by his companion, who had been waiting out on the road.[102] Disaster was usually warded off by an explanation and a great deal of nervous laughter. Humor would be the Syrian's key to the heart of America. It is no mistake that three of the most famous actors of Lebanese origin are comedians— Danny Thomas, Jamie Farr, and Vic Tayback. Their ancestors peddled, and peddling was the longest and hardest burlesque stage in any town.

The average per capita income for an American in 1910 was $382. For the Syrian, it was three times that, at least $1,000 per annum. This annual salary was four times that of the American farmer, slightly less than twice the income of a factory worker, a coal miner, or a salesman in a shop. In short, for the immigrant considered by one report to be, besides the Chinese, "the most foreign of all foreigners," it was not a bad showing.

It was also a testimony to how the Syrians had made American self-reliance their own. The current American ambassador to Morocco remembered his father from ʿAyn Arab peddling "socks and shoes and levis and tablecloths" to the farms around Cedar Rapids, Iowa, which he "bartered for food [until he] got enough food to start selling." The diplomat recalled: "The one thing we were always taught by my father was never to work for anybody else. Just be responsible for your own destiny and not live under anyone else's leash." These Emersonian lessons, however, did not preclude a shrewd understanding of customer and "niche" market: " [As a youth] I would hit the road with my dad, mainly just for company for him. At this time he was peddling rugs out of his truck to the farmers and eventually to the Catholic church. He was selling almost exclusively to

the Catholic priests because they were the only ones who could afford an Oriental rug." [103]

While it is safe to say that a sizable number of pioneer Syrians peddled, by no means did all or even a majority do so for their first work. Some thought the work was beneath them (particularly those who were educated in the Old Country). Others preferred the less risky and soon-to-be more profitable line of supplier, the storekeeper who stocked the peddler. It was an inevitable step up for a peddler, too, to open his dry goods store in Cleveland, or Cedar Rapids, or Detroit. For many, factories near the port of embarkation in America lured them with the prospect of quick cash. [104]

Take the case of this rousing, raisin-faced gentleman in a cardigan sweater whose laugh is that of a jaybird. Before he became "Taxi Joe," Elias Joseph went straight into the woolen mills of Woonsocket, Rhode Island. In 1912 at Ellis Island, "we land nine o'clock in the morning; like I tell you, six o'clock I went to work." Soon he was involved in a fight with a fellow steam-powered loom worker who needled him about his origins:

I work nights. Ten cents an hour. I want you to get this down because it's how it's happened and what's happened. I went to work—only word I say, "No." That's the only word. Third night I was working and the boss came and make me clean up the machine. Another fellow sits next to me; he keeps pestering me. He says "Are you Greek?" "No." "Are you Syrian?" "No." "Are you French?" "No." "Are you English?" "No." "Romanian?" "No." "Bulgarian?" "No." "No?" "No, no, no." "Spanish?" "No." "American?" "No." And after, I get so mad I say to him, "You go ahead till you die," in Arabic, "I'm not going to answer you no more." I get up and I let him have it—one over the head. I says, "I'm dying to have somebody to talk to. And you pestered me for two hours and you wouldn't talk to me."

Taxi Joe found new work at Woonsocket Dye, where "lot of Syrian people working in it." The superintendent of the factory taught him how to mix the base (vicerol) for the dye for a raise from 10 cents to 12½ cents an hour, the wage everyone else was making (Syrians comprised one of the cheapest labor pools at the time): "This dye house is a dirty job, you know what I mean? They get raw wool and they put it in a kettle and they put the dye, and steam 'em and dye it. I make base. I take the dye stuff and I mix 'em with gum and with this and with that. Lot of mixture. And I steam it, and two days after—you couldn't use it right away—the owner come and say, 'Well, this is you job. But you don't do nothing. You boss. You just tell them what to do.' I say, 'Okay. But I want to do it myself, I want to do it myself!'"

Even as he was promoted, Taxi Joe was worried that he couldn't do the guts of the job himself, the typical Syrian self-starter. His hourly wage increased from 12½ to 17 cents. "If I know what I know today," he said, reflecting on the pittance he thought bounty then, "they would have paid me. I would have make him

pay me, you know what I mean? But I don't know nothing. I can't even read or
write or even talk." [105] After a stint with the U.S. Army in World War I, Joseph
returned to Woonsocket and purchased the first "closed car," a Ford, in the town.
It was called a "limousine." Joseph became "Taxi Joe," Woonsocket's first taxi
driver, and, at last, his own man.

Many Syrians worked in the New England cloth mills at the time in Lawrence
and Fall River, Massachusetts, wool and cotton centers of the world then. A re-
tired lieutenant colonel in the U.S. Air Force, Edward Abdullah, recalled taking
his father's lunch to him at one of Fall River's cotton mills:

> I would run home when school let out at 11:30, get something to eat and take
> my father's pail to him, usually something like lentil soup and a kind of Lebanese
> goulash made from lamb, rice, and peas. The mill sold milk to the workers. But
> nine times out of ten—I remember this well—he would save the milk for me and
> I would drink it walking back to school. Going into the mill was like walking into
> an oven. It was 110 degrees in summer! And the steam, which was to keep the
> threads from snapping, and the noise . . . the vibration of those looms! My
> generation, the first-generation Americans, vowed we would never go to work
> in the mills. [106]

In Maine, most Syrians worked in the factories, in the sardine cannery of East-
port and the woolen mills in such places as Dexter, Madison, and Vassleborough.
By 1915, Waterville had the largest Syrian population in the state, brushing up
against French Canadians who had immigrated to the town during the same pe-
riod and constituted the largest ethnic group in the city. The two groups, predict-
ably, fought in the factories under the eyes of the Yankee owners. [107]

One of the centers of America's industrial boom at the turn of the century,
Detroit—destined to become the city with the largest Arab American popula-
tion—had 50 Lebanese Christians, mostly single men, in town by 1900. Just
sixteen years later, according to archives at the Henry Ford Museum, there were
555 Syrian men working at the Ford car plants, a sizable amount even for the tail
end of the so-called peddler era. [108] In short, though the Syrian liked to be his own
boss, what he was most after was a steady job. Family waited back home for his
remission. If Ford rang the whistle more than the lonely road, so be it. He would
take Ford. Among other Syrian factory workers who eschewed the peddler path
was one Nathra Nader, who arrived in Newark, New Jersey, in 1912 from Zahle.
But his experience was short-lived. He worked one year in a machine shop there
and later said, "I see how factories work." [109] The man was the father of Amer-
ica's leading consumer advocate, about whom columnist Michael Kinsley has
said, "No living American is responsible for more concrete improvement in the
society we actually do inhabit than Ralph Nader." [110]

Some like Nathra Nader fled abysmal factory conditions and took to the open
road. A retired civil servant in San Francisco remembered that his father had

come from Homs, Syria, through Ellis Island in 1906 only to be lured to a shoe factory in Montreal. But after he contracted what was then called "miner's consumption," or silicosis, from leather dust he journeyed to Hosmar in the Canadian Rockies, where "it was high and dry. I think my parents were the only people of Arab heritage in that region. They sold in the mining camps, rented a horse and buggy, and peddled merchandise. The miners would pay in gold coins. He did quite well, regained his health, and moved to Vancouver." [111]

Similarly, George Milkie, who had come from Bishmizeen al-Kura, Lebanon, in 1913, quit work in a steel mill in Seattle to offer residents of the foggy northwestern town a different kind of notion—fresh fish from a basket! Milkie, as with so many, graduated from basket to horse-drawn buggy to Model T Ford to fishmongering from a refrigerated truck. [112]

Some bypassed peddling, shopkeeping, and the factories to get right into the marrow of America—banking. George Faour, along with his brothers Daniel and Dominic, started the first Syrian-owned bank in the United States in Manhattan on Washington Street in 1891. Among the earliest Syrian arrivals to Boston, in the 1880s, the Faour brothers made their money in linen. According to a Syrian associate of theirs who worked at Chase Manhattan Bank, the Faours—who were the main lenders to "Little Syria" in New York during its first difficult years—had slept in the basement of a store on Washington Street, subsisting for days on a diet of bananas and bread. Though the richest of the early Syrians, the Faours lost $1 million in the Depression, and George died alone in a boarding house.

The Chase Manhattan associate emigrated from Egypt in 1913 because of "a lot of talk of war" and Italian and Turkish skirmishes. George Fauty's grandparents had come earlier in 1905, through Pawtucket, Rhode Island. His father "couldn't get himself" to work in the silk mills in Pawtucket. Being educated he struck out for Manhattan, enrolling son George in P.S. 20 on Albany Street, nesting in the Syrian enclave on Washington and West streets. Both parents worked in a crowded apartment of three rooms with four children and two adults. In a year they had moved to a cold-water flat in Brooklyn, where "a quarter in a box gave you enough gas for a while and then when we'd see the gas going down, you put another quarter, and that keeps you going. In other words, you were never billed. You paid right on the spot." Fauty worked through high school for "pin money." He quit, though, and found a job with the Daniel Reeve chain store where a checker didn't have an adding machine. He totaled figures "on a paper bag." A supervisor took a liking to this "excellent mathmetician" and got him an interview at Chase Manhattan, where he got a job at the age of 16 and never left. It was 1922.

Antisemitism was not exactly subliminal in those days. Fauty had to leap one barrier: "Before I got the job in a bank . . . they didn't hire Jews in those days. That was a mustn't. And the personnel director told me, 'You go to your parish. I want a letter from the priest of your parish.' My father took me to the Reverend

Basil Kherbawi, who was pastor of Saint Nicholas Cathedral and a graduate of Columbia University. He prepared a letter for me: my father handed him a dollar."

Being Syrian may not have been much of a help, either: "A cousin of Eddie Baloutine's used to sell ties. He couldn't get a job anywhere because he was a foreigner. And everytime I would see him down in that area in the street selling ties he would ask, 'How in the hell did you get a job in the bank? I can't understand it!' . . . My thinking was older. I never said anything to anybody and they believed it [that he was an American WASP]. Due to the fact that I completed high school and spoke well. And on my application I never said I was born in Cairo, Egypt. I said I was born in Brooklyn, New York. I was aggressive. I told you I was well read. No one ever questioned it." [113]

Others entered WASP America through manufacturing: the Merhiges with silks in Brooklyn, the Bardwills of Manhattan with linens and silks. Some started making items other than cloth. The father of Joseph Jacobs, owner of Jacobs Engineering, had a U.S. monopoly on straight-razor manufacturing in Brooklyn when during the First World War Americans could not get German imported razors. The peddler began to fade by 1910 with the influx of new inventions, such as the car, bus, and subway, and the entry of Sears' mail order catalog and Woolworth's five-and-dime stores. He had, however, entered America's literary imagination. A short-story writer in 1912 dealt with the Syrian honorifically in "The Peddler." A children's author recalled youthful days in *The Laugh Peddler*, in which a bronzed-faced Yusuf Hanna, burdened with heavy bags, saves the life of a boy drowning in a Minnesota river.[114] Memory of the Syrian peddler also inspired the character of Ali Hakim in the musical *Oklahoma!*

Perhaps no better tribute to the Syrian peddlers can be found than in their own words, their own tales. I used to listen to the stories of my paternal grandmother, Nazera Jabaly Orfalea, for days as a boy under a grape-leaf trellis, alongside a dollhouse in her Los Angeles backyard. In 1893, she was one of the first thousand Syrian women in America and peddled her notions all over the eastern seaboard as a young girl before being caught in matrimony by a Syrian linen store owner in Cleveland, though she did everything to avoid surrendering her independence. She kept a journal—the only one extant by a woman Syrian peddler, to my knowledge. When I asked how she managed to offer holy water from her notions case, she proudly proclaimed, "Why, I blessed it myself!" [115]

Family and Religion

The early Syrian's family was the fountain of life from which everyone drank, perhaps too much as one can sometimes drink water in enough great gulps to become dizzy. One can get drunk on water if dehydrated; one can also get drunk on family.

The Syrian love of family is not unique; the Italians, the Jews, the Irish, and other ethnic groups try to hold fast to family ties in the Age of the Pill and Di-

vorce. But for Arab Americans, family has always been especially valued, to the point that the quest for self often begins and ends in family. In many ways, the family is the self, the self by itself a highly foreign, existential concept, only a puff of air. Family life is a vindication of the multiplicity of existence and in it the lessons and responsibilities of life are learned deeply, or not at all. The paradox of the gregariousness of the Arab American is that it is rooted in ancestral isolation—the isolation of Druze and Christian Lebanese mountaineers, and the more ancient confrontation with empty space that the desert presented the Arab. The colloidal suspension of minorities in the millet system of Ottoman Turkey made for a fragmented society but bullet-tough families, families woven as tightly as a prize carpet.

Families worked hard together, pitching in every available limb. On Sunday, after church, the Washington Street Syrians would amble uptown to take the children for a walk through Central Park. There they marveled at an alcove of green they identified with Lebanon, and a 224-ton obelisk called Cleopatra's Needle, donated to the United States by the Khedive of Egypt in 1881 to better U.S.-Egyptian ties. Today the hieroglyphs of the 3,500-year-old obelisk have been virtually rubbed out by the smoke and smog of New York factories and autos, making it as mysterious today as was the arrival of Syrians a century ago.

At first too small in number to warrant parishes of their own rites, Syrians welcomed the arrival of the first Melkite priest in 1889, the first Maronite priest in 1891, and the first (non-Russian) Orthodox priest in 1896. Before they set to work founding their own missions and churches, Protestant and Roman Catholic churches serviced them. (Louise Houghton listed ten Roman Catholic churches with large Syrian congregations and eighteen Protestant churches with Syrian pastors in 1911.)

Though the Melkites were the first to minister to their own, in 1890—when the very old St. Peter's Church in Manhattan became known as a "Syrian Catholic Church"—their first original mission was established in Chicago in 1893, and the first Melkite church built from the ground up was in Lawrence, Massachusetts, in 1902. The Maronites administered to their group at a Catholic church in Manhattan in 1890 and set up three of their own churches in Boston, Philadelphia, and St. Louis in 1897. The first Syrian Greek Orthodox parish was begun at 77 Washington Street in Manhattan in 1896, with a second in Brooklyn in 1902.

Thus, by 1890, there was one church for each of the Melkite, Maronite, and Syrian Orthodox communities in Manhattan.

The Reverend Basil Kherbawi, an Orthodox priest, was the first cleric to document the numbers of Eastern churches in America. In 1913, Kherbawi found sixteen Melkite parish churches in operation, sixteen Maronite churches, and eighteen Eastern Orthodox (which often included in their congregations Ukranians, Slavs, and Russians).[116]

By 1924, Philip Hitti counted thirty-three Maronite churches, twenty-two Orthodox churches, and twenty-one Melkite. Though these figures are not solid be-

cause on occasion a mission community without its own structure was counted as a "church," the evidence indicates that among the First Wave Syrian immigrants Maronites were the largest and most organized group. Today, however, the Antiochian Orthodox diocese far outdistances the Maronites and Melkites in both churches and communicants, the latter's decline foretold by the fact that five of its earliest churches were closed due to declining membership and assimilation into both the Roman Catholic community and the Orthodox. Other Christian sects, such as the Iraqi Chaldeans, the Egyptian Copts and the Syrian ("Jacobin") Orthodox came much later (see Appendix 4).

The existence of an early Melkite church in Rugby, North Dakota, had been lost to history until very recently. Rugby was founded by Syrian immigrants from Forzol and Zahle in 1897, scarcely a decade after North Dakota had joined the Union. They were mostly farmers taking advantage of the Homestead Act, including Father Seraphim Roumie, who sold his own claim for $400 to help build the Melkite church there in 1903. But in 1911, a severe famine hit the area, and a fire destroyed the church; the Melkite Syrians of Rugby disappeared, leaving the place a virtual ghost town.[117]

Though there would be no Arab mosques in America until the late 1920s, Houghton listed nine Muslim "religious bodies," three Druze and one Shiʿite community in Sioux City, Iowa, by 1911. (It is interesting that the well-known sociologist did not incorporate "Shiʿite" into "Muslim.")

Though there were about seventy-five Eastern churches in the United States by 1924, more than half were in the east, and, as Naff has said, most of the western Syrian immigrants went without their own churches for a generation.

Today the only remaining evidence of the early Washington Street community—save two prosperous stores of the Awns and Jabbours, which cater to Wall Street—are two churches, St. George's Melkite and St. Joseph's Maronite, both established in 1915. Perhaps it was fitting. As the Kayal brothers have noted, "The Syrians do not regard 'place' as the root of their community identification. Rather, they prefer to utilize the primordial ties of blood and faith."[118]

For baptism, the Eastern rite churches would immerse the infant in a large basin of water rather than sprinkle the baby as the Roman Catholics do. For funerals, the community would gather, as in the Old Country, for "a meal of mercy" (wake) that would often separate female from male mourners, the former dressing in black and wailing over the casket. But nothing moved the early Syrians—and later ones—more than a wedding.

As they have from time immemorial, weddings hold out the hope, at least symbolically, of rectifying conflict, or reconciling antipathies, and many of the early Syrians and their Arab American progeny reveled in stories of ceremonial harmony. A Maronite priest now serving in Youngstown, Ohio, elatedly told how at his grandmother's marriage in Mount Lebanon the neighboring Druze had an important role: "When she was married they put her on a wild white stallion and the Druze attended and they were burning incense. They had two men holding the

stallion down as they led her in a procession from her village to her husband's village." [119] The "enemy" Druze literally delivered the Maronite bride to her husband.

In America, weddings may have lacked white horses, and in early days they were often held in the immigrants' parlor. But with the growth of the churches the splendor of an Eastern wedding rite unfolded on freedom's shores.

The Orthodox wedding, in particular, stood out for its beauty, grace, and solemnity. Golden crowns connected by a sash of silk were placed on the bride and bridegroom's heads. During the priest's blessings the couple would join hands with the wedding party, moving in a circle in the sanctuary. Not a few times the silk band between crowns got tangled. A further mixup sometimes occurred in the complex activities of the priest canting in ever louder decibles, "The hand-maiden of God, Elizabeth, is wedded to the servant of God, Joseph, in the name of the Father and of the Son and of the Holy Spirit," as well as touching one spouse's crown to the other's forehead four times. In the confusing repetitions, Elizabeth could easily become the servant of God and Joseph, the handmaiden.

At the sumptuous wedding feast, a lace sac of almonds was placed along with sweetened barley and raisins (*qamh* and *zibib*) near each guest's placesetting. Much dancing and singing ensued. Mary Macron described the wedding feast vividly: "The women, too, vied with each other to compose beautiful chants. Rhyming and lilting, laughter and joy were captured on a golden chain of words ending in the pealing, exultant cry of the *zaghrūt, La la la la lu lullu li-ᶜayshah!* 'To life,' they sang. 'To life!' An Arab wedding was not just a family event, a community occasion, and a weekend of festivities. It was, rather, a command performance. Everyone had to sing, everyone had to dance." [120]

With the ratio of men to women at least four or five to one in the First Wave, it was natural that many Syrian men went back to Syria to find wives. Over a quarter of the early immigrants did return to Syria, many to effect a match begun via the mails, though few stayed in the Old Country. Some, out of sheer loneliness and the sparse crop of Syrian women, married outside the community, though by 1910 only 6 percent of Syrian children were the products of a "mixed" marriage (the figure rose to 8 percent in 1920, and has steadily increased to this day). Results were often problematic: in 1928, the editor of the *Syrian World* said that many of 125 Druze who had married American women had become divorced. [121]

Clearly, though, the risks were worth taking since, especially for a Syrian male, as one author intimates, being single was "both unnatural and deplorable." [122] A March 5, 1899, article in the New York–based Arabic paper, *Al-Hoda* put it bluntly: "Bachelors value money lightly; they [presumably the urban immigrants] squander it in clubs, theaters, and houses of ill repute. All of these places are traps for immigrants in a foreign land. A man who marries and has a family is respected, responsible, and motivated to save. Therefore, men should marry, not at an early age but between the ages of twenty-two and thirty, and their

mates should be chosen not for their wealth but for their education. Such wives will create enduring happiness."

Some First Wavers waited many decades before returning to the Old Country to choose a bride. The wife of one tearfully told a touching story in a spring when her husband, then 82, was in the hospital with a stroke. Nicholas Bitar, born in 1900, was a kind of legend to the villagers of Bazbina, Lebanon, which is located in the Akkar, the northeastern corner of the country. At the age of 8, before World War I, in conditions where food was getting scarce, the boy Nicholas had a hunger to learn. He would go from town to town in the Akkar trading his food allowance to teachers for lessons. This continued into the war, when he in essence traded the last of his food to unemployed teachers, who were starving. He went to Tripoli by donkey and traded the animal for books. Bitar came to the United States after the war, and soon found himself ministering not as a priest, but as a doctor to the Syrians in Pittsburgh who worked in the steel mills and peddled razor blades. For decades his story became a way of punishing indolent children in Bazbina to the effect that "there's a man from here who sold his own meals to get an education and now he's a doctor in America."

Nelly Bitar grew up hearing these stories of Nicholas. When she was only 11, Dr. Bitar revisited Bazbina and met her. They were cousins through her mother (whose maiden name changed from Bitar to Khouri when her father became a priest) and he asked her what she would like as a present. "*Chocolat,*" she said in French. He replied, "All I have is chewing gum. Take that." Then Bitar leaned and whispered to her mother, "Take care of this one—she's a beauty."

During a 1950 reunion, Bitar came back to Bazbina and was stunned by the dark-haired, green-eyed Nelly Abdo. But he didn't remember her from his former trip. As Nelly put it, "I remembered him, however. He said, 'I used to have black hair but now it is gray.' I said, 'It hasn't changed so much.' He was surprised that I would be able to compare what he had looked like then with now. He sat by me after that, and said that I was a rose in a field of daisies."

A year later, at 50, Bitar took his 19-year-old bride on a strenuous honeymoon up in the Lebanese mountains to Bhamdoun. They toured Beirut and the Biqaᶜ Valley and even then Bitar was pointing out to Nelly the tragic overspill from the Palestine war. She remembered him saying, "If they don't put these differences aside and help the Palestinians in the camps, those damn rich Arabs, a bloodbath will take place." She said, "It sent shivers down my spine. He worked from day one, 1948 and the war, sending clothes to the old country and the refugees." [123]

Romantic as is the Bitar story, it was education, not beauty, and industriousness, not pleasure, that were most attractive to early Syrians in marriage. This is no better represented than in the store ledgers of Johnny Nosser of Vicksburg, Mississippi, which show that he took one day off to marry in 1925, and the next day was back at the register.

Marriage, religion, and a profit mixed hilariously in the life of a grandfather of an early immigrant to high-altitude Pensaco, New Mexico. Pete Sahd, born in

1911 in Roumieh, Lebanon, told the story about his ancestor, Abdo Yussef, who came to Las Vegas, New Mexico, in 1892: "He sent back to Lebanon for a picture of his wife. When it arrived in Vegas, someone else received it and promptly sold it for $50.00. He claimed the photograph was the Virgin Mary, the patron Saint of Lebanon." [124]

Syrian Doughboys

Though the leader of the immigrant communities was usually a priest, Washington Street's first "defender of the peddlers' was a Syrian bricklayer. Genial, college educated, Musa Daoud was described as "strong as a titan" in warding off a gang attack on a Syrian peddler (*New York Times,* June 4, 1894). A helper of Dr. Nageeb Arbeely on Ellis Island, Daoud often welcomed new arrivals in his apartment on Washington Street, who marveled at his library. But the Syrians' view of politics was at best squinty eyed and skeptical. In 1924, Hitti declared, "Syrians cut no figure in the political life of his nation." Much of their traditional shyness toward the halls of politics stemmed from their experience under the Ottomans; for centuries the Syrians had had no experience with representative government and had been conditioned to distrust the authority of pashas, caliphs, and garrison heads of the Sublime Porte, who could tax them severely or draft them into wars in which they had no stake.

Fifteen thousand Syrians—or 7 percent of the entire community—served as doughboys for Uncle Sam, many registering without waiting for the draft, eager to get some licks in on behalf of their new freedom and against their former Ottoman oppressors. Hitti found that in the long lists of pro-German, pro-Turk sympathizers supplied by the U.S. government after four years of war, there was not one Syrian to be found. Their fervency was marked. In Portland, Maine, all the Syrian youth in the town (15) volunteered before the draft was called. A world's record—2,805 rivets hammered into a steel ship in only nine hours—was set by a Quincy, Massachusetts, plant gang whose foreman was a Syrian. The *Boston Herald* editorialized, "There are no better Americans these days than Charlie Mulham and his fellow Syrians." [125]

Michael Suleiman has translated from Arabic a book on Syrian participation in World War I, *The Syrian Soldier in Three Wars* (1919), in which Lt. Gabriel Ward highlights his own activities serving in the Spanish-American War, fighting guerrillas in the Philippines, and serving in the Great War in Europe. With the American flag as a frontispiece, the book recorded "pride in serving his new country and heaps praise upon his fellow Syrians who also joined the U.S. armed forces." [126]

A fig picker ("Eat dead figs—the best thing for your heart!") from al-Maʿrrah, Syria, who emigrated because he did not want to serve in the Turkish army fought for the United States in Europe. Before the Armistice and his relaxed encampment underneath the Eiffel Tower, he had a harrowing experience with a fellow Syrian American doughboy: "I was friendly with one fella, they call him

Deeb. He was just like a brother. When we went to the front line he was under a shell and all of a sudden the poor fella go down. *"Lakin* [but], come on, Deeb, you gonna die there, come on!" I tried to help him. I held him a little bit, and a little bit, and after that I said, 'Well, I can't help you no more.' We promised each other no matter what happened to us we gonna stick together. But when you are there you fight for yourself. You don't care for your father or mother or sister or brother. So I left him and I didn't see him no m-o-o-r-e! [sings in dirge]"[127]

But one of the most vivid accounts by a doughboy from the Levant was that of Ashad Hawie. A member of the famed 42nd "Rainbow Division," 167th Alabama Infantry Regiment, he was probably the most decorated Syrian in the war. Hawie compared the forced march of Christmas 1917, when many of his fellows were barefoot, to his ancestral homeland. "When we reached our halting point in the valley of the Marne after six days on the march, my own feet were swollen and bloody, though snow and low temperatures were not new to one reared in the Hills of Lebanon." Finally, when he was sleeping, exhausted, standing up in a trench, "a yellow flare from the German line" exploded in a "flash brighter than sunshine." It was gas, chemical warfare introduced into the human race, and Hawie's first battle.

Later, in July 1918, he received the Croix de guerre from the French when, on the Nevers Sedan road, he captured a German quartermaster sergeant, who carried instructions from the High Command for a resupply of munitions; Hawie also successfully led a grenade counterattack on the elite Prussian Guard. He fought at the ferocious Battle of Verdun, in which more than half his company were killed. But he had to pull up more courage than he thought he had for the pivotal Argonne Meuse battle, often called "the death blow to the German Army." Facing the famous "Kreimhilde Stellung," the Germans' intricate trench system, Hawie's Rainbow Division was trapped in the Argonne woods, facing a machine gun nest. Six messengers were sent out in desperation—all were killed. Hawie volunteered to be the seventh. After crawling to the machine gun nest where four Germans were firing away, he tossed in three Mills hand grenades. Gen. John Pershing pinned the Distinguished Service Cross on Hawie's chest, saying, "Young man, to my mind you are the greatest type of American citizen. You have won your citizenship, not by the scratch of a pen in a quiet court office, but grappled it from the mouth of a cannon."

Hawie was wounded five hours before the Armistice was signed November 11, 1918, after sparing the life of one German soldier who had fired on his group from a house showing a white flag. Hawie told his surprised fellows, "This is a Christian army. Unnecessary slaughter is not Christian. We must teach the Hun they must not kill."[128] Hawie evidently did not know that the army had plenty of Jews and some Muslims in it, too. Hawie's fate took an especially pathetic turn, however, when he returned from the war to find that his mentally disturbed brother was on trial for murder. Largely because of Hawie's public speaking and war record, the brother was spared execution.

One Syrian American veteran who took his aches and pains back to Lebanon was discovered by another such veteran in the Second World War to be working in a road gang between Tripoli and Beirut: "He was pleased to see the jeep and the American flag. He thought it one of the American wonders." The same GI encountered another World War I Syrian veteran named Matouk running a coffeehouse in Tripoli. Kissing the eagle emblem of his cap, Matouk cried softly, "God bless America." [129]

During the Great War, the American Syrians purchased "much above their proportionate quota" of liberty bonds, according to Salloum Mokarzel. In the Fourth Liberty Loan campaign alone, 4,800 Syrians from the New York area, roughly 64 percent of the population there, bought $1.2 million worth of war bonds. They had also established Red Cross and Boy Scout chapters in numerous cities. But the final coup for the newcomers who shouldered the rifle for America came when they captured the silver medal for second prize in the 1918 Fourth of July parade down Wall Street. It must have weighed on some of the Syrians leaning out of a brownstone window to watch their float pass how strange it all was. To be in America, winning prizes celebrating freedom and the ending of a war that had stripped one's homeland of its trees, food, and people. To be in America, with shreds of free press in confetti matting one's hair, to be happy, foolish even, dancing the *dabkah* on the float among this symphony of strangers moving down Wall Street—but knowning that others in the Lebanon mountains had so recently been eating dung as they starved.

One exhausted American doughboy recently returned from the French front was probably not among the revelers. Soon to become the guiding critical force behind the cluster of Syrian émigré poets in New York City, later the biographer of Kahlil Gibran, and today as he nears the age of 100 a prime candidate for the Nobel Prize in Literature, he wrote a poem about the terrors of war and the cost of the famine in Lebanon. Memorized by students throughout the Arab world, the poem remains virtually unknown to his fellow Americans. Here is part of "My Brother" by Mikhail Naimy:

> Brother, if after the war a soldier comes home
> And throws his tired body
> > into the arms of friends,
> Do not hope on your return
> > for friends.
> Hunger struck down all
> > to whom we might whisper our pain
> > except the ghosts of the dead.
>
> Brother, if the farmer returns to till his land,
> And after long exile rebuilds a shack
> > which cannon had wrecked,
> The waterwheels have dried up

And the foes have left no seedling
 except the scattered corpses.[130]

Strangers among Strangers: The Early Muslims

There is a legend about a Muslim settling in America before "Hi Jolly": In the early sixteenth century, an Egyptian named Nosreddine came to nestle in the Catskills of New York where he fell in love with Lotwana, the daughter of a Mohawk chief. Dutchmen bet Nosreddine that he could not win her heart; the game Muslim lost the bet and, frustrated, strangled Lotwana. For this, he was burned at the stake.[131]

Legends aside, most Syrian Muslims—who made up less than 10 percent of the First Wave migration—began coming to America about twenty years after the Christian migration started in the 1880s. (A few Yemenis managed to slip through the Suez Canal in 1869 to head to America.) Some Muslims peddled, as did the other Syrians, but many were attracted to the great booming midwestern factories of steel, tin, automobiles, and trains in cities like Pittsburgh, New Castle (Pennsylvania), Detroit, and Michigan City (Indiana). Not a few were attracted by the Homestead Act to the midwestern heartland, taking up farming as they had done in Syria. Detroit civil rights lawyer Abdeen Jabara traces his heritage back to a maternal grandfather, who came in 1898 from Musda Bulheist in Lebanon's fertile Biqaᶜ Valley on the promise of free land: "He landed in Mexico, having heard that they were giving land away in the United States, up in the northern part of the United States. He rode in a wagon from Mexico to North Dakota where he got 160 acres of land if he would agree to farm it."[132]

Jabara's father followed the other major trend of the early Muslims—the lure of quick riches that has played its rhythms to the poor of the world since the beginning of the smokestack age. Sam Jabara arrived in New York in 1920 with a piece of paper that said, "Boyne City, Michigan"—240 miles north of Detroit. Thus he bypassed the auto factories where many fellow Muslims were employed to work in lumber camps, livery stables, and a tannery factory where he was injured by acid. The ruination of the father's lungs by chemicals influenced the political activism of his son in later years.

Perhaps it was shyness about religion and the fear of quoting from the Bible, rather than the Koran, to eager housewives that turned the Muslims more quickly from peddling to factories and farms. Hearing that America was the "land of unbelief," no doubt, kept Muslim Syrians from migrating in groups until the turn of the century. As an elderly Muslim woman put it, "In 1885, my father planned to accompany some Christian friends to America. He bought the ticket and boarded the boat. Shortly before sailing he asked the captain whether America had mosques. Told that it had none, he feared America was *bilād kufr*, a land of unbelief. He immediately got off the boat."[133]

Four early Muslim settlements lay claim to the honor of being the first to build a mosque in America—Detroit, Michigan City (Indiana), Ross (North Dakota),

and Cedar Rapids (Iowa). Abdo Elkholy, the principal Muslim Syrian historian, says the first mosque built in America was in Highland Park, Michigan, in 1919. But it was dismantled within five years and is now a church. Other historians refer to the founding of Islamic associations in Highland Park in 1919 and in downtown Detroit in 1922. A dome was put atop a rented building in 1924 in Michigan City, Indiana, according to the son of one of the mosque's founders, Hossein Ayad. "You could tell it was a religious building," said Abe Ayad. It fell prey to urban renewal in the late 1960s and had been "misused" for years. "They tore the rugs up for prayer when there was a wedding or funeral. These are violations of the sanctuary, things you would not find in a mosque in the Middle East. The mosque is for prayer, and prayer alone." [134]

It seems likely that the first structure built solely to be used as a mosque was in Ross, North Dakota, in 1929. One hundred Syrians comprised the isolated community of farmers and peddlers in Ross in 1900, but it took thirty years to build a crude building that resembled a large, sunken duck blind. The Cedar Rapids community was the first to build a mosque with minaret and dome from scratch in 1935. Rebuilt with a minaret from which one can see the Quaker Oats Company's giant grain silos, it is probably the oldest surviving mosque in America.

Lured by General Motors and Ford to Detroit, U.S. Steel to Pittsburgh, box factories and Willis Auto to Toledo, or the loom factories in Quincy, Massachusetts, the Muslim Syrians also found themselves working on train cars in Michigan City, Indiana. Many of the first mass-produced autos were built by the olive-skinned hands of the early Syrian Muslims. So were the elegant, velvet-lined Pullman cars in Michigan City. It was not a little ironic, inasmuch as these modes of transportation were scarcely evident in the land of their birth. So numerous were these workers at one plant that when Muslims celebrated ʿId al-Fitr after fasting for the thirty days of Ramadan, Pullman National had to shut down.

A former director of the Islamic Center in Washington, D.C.—founded by Palestinian Muslim Joseph Howar in 1949—recalled his imam father's work founding the mosque in Michigan City and one in Gary, Indiana, where the Muslims worked in the steel blast furnaces. It was at the Gary house of worship that the son found his father shot to death one day; he memorialized it in a powerful poem. [135] In the early years imams were hard to come by. After Abude Habhab wrote repeatedly to Egypt in the 1920s requesting an imam, he finally received a positive answer. Hitching up his horses, he went down to the train station at Gary and waited, but no Arab imam emerged. A Hindu figure clad in white approached him, though. He spoke no Arabic and little English. Habhab and the man ended up communicating through the Koran. This was the Sufi Bengali, famed among the early Syrian Muslims as their first official imam from the Old Country— though it was India. He traveled widely over the Midwest, settling in Chicago. His book in English, *The Life of Mohammed,* was widely read by Syrian Muslim children in the United States. [136]

Druze, who took to peddling even less than did other Muslims, set up colonies

in Appalachia where their mountain hardihood could be tested, and as early as 1908 they could be found in numbers in Seattle, Washington. Some Druze peddlers made it to California, too. The oldest living original Druze immigrant there, Albert Kiwan, arrived in California in 1911 and still works as a tailor in West Covina. Amil Shab, who arrived in Detroit after World War I, later settled in California, running a ten-acre citrus orchard. For him it was a replacement for the famine in Lebanon: "All my six brothers, my mother and father died of starvation and illnesses in one year. I lived off berries, cactus, and weeds."[137] A sizable number of Muslim Palestinians settled in Chicago in the early part of the century, working the stockyards and setting up grocery stores.

The difficulty of identifying people of Syrian descent was often compounded when they turned out to be Muslim. A New Mexico family from Zahle named Hind, who raised sheep, were thought to be Hindus and were derogatorily called "Turco" and "Gypsy."[138] An old Ross, North Dakota, farmer described his transformation from "Syrian" to "Finlander," which, to the surrounding Scandinavians, was appropriately remote. The same farmer told of cooperation in the old days between Muslim and Christian Syrians, faciliated no doubt by a mutual lack of clergy. Their beliefs blended into an elemental monotheism: "God is one that raises the sun and the moon. Isn't that right? I couldn't interpret it but put your fingers on it, see. Who let your fingernail grow? The one above, the good Lord. But they carry it too far—put Christ ahead of God. Number one is number one. We used to have Tom Danz and Abdullah Danz who were Christians, and they felt the same way and associated with the Muslims. When we were at an evening [affair], the Christians and Muslims all together *nilʿab waraq* [play cards], cuss like hell. But there's no need for partiality."[139]

The Syrian peddler-turned-farmer worked the hard soil as if the earth were a loom, stretching his seed along an invisible warp. But the Dakota Muslims generated their oddities. One of them was Joe Albert, who gained local fame as a bear wrestler. When the community was subjected to the Dust Bowl drought of the 1930s, a locust plague, and a horde of "army worms" that ate through fenceposts, many began to leave. But those who stayed witnessed something of a miracle at the hands of the visting imam from India: "Remember that Bengali? They hadn't had rain here for weeks and everything was dry and dusty. He told us—this missionary from India—to come to church [i.e., the makeshift mosque], and we were going to get rain. He fascinated the heck out of me. And he prayed. There wasn't a cloud in the sky. and Ahmed Abdullah went home in a car and had a wreck with it on account of the storm. Half their chickens were drowned. I never forgot that. He preached at the theater, too. Either he had the weather checked way from Washington all the way down, or something."[140]

Christian, Druze, or Muslim, by the mid-1920s, most of the Syrians knew that, come hell or high water—like the Jewish tailor, the Irish pub owner, and the Japanese farmer—they were here in America to stay.

3 Transplanting the Fig Tree: The First Generation on American Soil, 1924–1947

Because of the restrictive quotas of 1924 and the worldwide financial depression, Syrian immigration to the United States was only a trickle between the two World Wars. From 1920 to 1930 only 8,253 Arabs entered the country, 2,933 of them Palestinians. From 1930 to 1940, the foreign-born Syrian population here actually declined, though entering Palestinians doubled (2,933 to 7,047), due to disturbances with Zionist settlers and the British in Palestine.

The Depression and the Syrian Americans

Among those interwar immigrants was Sam Kanaan, whose father had come to Boston from Lebanon in 1888, returning to die during the First World War. His young son witnessed cannibalism in Tripoli during the famine. Kanaan, told that he could pass as a U.S. citizen if he fetched his father's papers from a trunk, took a steamer to Providence, Rhode Island, in 1928. He couldn't have come at a worse time. The country was sliding toward the Depression, and, as if by cruel reminder that the heyday of quick money and prosperity for the Lebanese peddler and entrepreneur was over, it was given to Kanaan to care for the poet Kahlil Gibran, who was dying of alcoholism: "No work. I used to go to nightclub. I met Gibran. Well, he was a great guy. But the time I came people know Arabic. And he talk to me and the people play cards. He don't play no cards. He like a drink. He said to me, 'Sit down here, you come from our country. Tell me, what's this and that.' Twelve o'clock. One o'clock, everybody go home. And then the guy who own the club, he say, 'Take him home.' He used to live on Tyler; I live on Hudson Street. So I take him home. Too many times. He gave me a picture [of the Good Shepherd]."

Kanaan described the food lines and lack of heat in Boston: "But I come in 1928; was the wrong time because was Depression. Can't get no job, no nothing. We used to stay by line about a mile. A lawyer, a doctor, in a line till we have coffee and a doughnut. Many times we get to end of line, no more left. Because there's too many in line. I have a hard time. We sleep in a room. Get up in the morning, water frozen in the pipe. We sleep in room, no heat, no nothing. We only get papers from the street to burn them up in the stove. And warm them up."[1]

Kanaan went back to Lebanon in 1933 because of pneumonia; a doctor had recommended a dry climate—Kanaan thought of California but felt it was better to go where his family was. The problem of employment, however, was the same as when he left. There was simply not enough farmland for the extended family—when they did farm, it was only for two or three months. Kanaan also mentioned troubles with the French. When the American consulate called on him in 1936 in his village and said he had twenty-four hours to get back to the United States or lose his citizenship—in spite of an American accusation that he was a spy affiliated with a leftist "club" (anti-French Kataʾib)—Kanaan came back. There was work in the United States. And in a quintessentially Lebanese statement, he exhorted, "Don't ever sit down and cry if you can move."

A Palestinian from Taybe who arrived in Providence in 1926 had quite a different depression story. Educated by American Quaker schools in Palestine, Shukri Khouri became a lawyer in the United States and was befriended by the Massachusetts state treasurer, Charles F. Hurley, who later became governor. Khouri helped in his election campaign and by the mid-thirties was appointed by Hurley to be assistant liquidation counsel for the state. At the same time that a Palestinian American was liquidating U.S. banks in Boston for the governor, the British were liquidating the last sustained Palestinian resistance to their rule, during the general strike and revolt of 1936–1939. Khouri spoke out in an interview in 1937 with the *Worcester Telegraph*. When asked if he was attacked for views critical of Zionist aims in his homeland, he responded, breathing heavily after a long illness in his home in Chevy Chase, Maryland: "They didn't give me threats. I gave them threats!" There was hell to pay in the garment factories, however: "I attacked the senatorial committee that was sent from here to study the question of Zionism in Palestine. In fact, I accused them of being prejudiced, biased. That is what the Zionists resented so much. They were cutting [firing] Arab workers in their factories. Yes, our girls were working in dresses." [2]

Many among the most prosperous Syrians in America went broke. The millionaire Faour brothers—the first bankers from the community—lost a million dollars, lost their beautiful homes on Shore Road in Brooklyn, and went out of business. Others among the wealthier Syrians managed to hold on and even to help the American community at large during the hard times. Iser Tibshareny, for instance, had established in 1927 one of the first real estate and investment firms in central Arizona (many Lebanese peddlers had been attracted to Arizona in the 1890s mining boom). In the 1930s, when the town of Mesa was suffering from the Depression, Tibshareny showed "resourcefulness and humanness" in the way he handled commercial tenants. Instead of evicting them because of their inability to pay rent, he devised a lease plan, in which tenants paid a percentage of their income. According to one sociologist, "the plan helped soften the Depression blow and kept several merchants from leaving the area." [3] There were others who actually improved, testing their mettle against the hammer of pain and diffi-

culty. George Fauty, the immigrant from Egypt who worked his way up through Chase Manhattan Bank, found himself making $2,100 a year when the average was between $1,200 and $1,500 during the Depression. "I was very fortunate," he recalled, wiping the sweat off his head in a Brooklyn summer. "Like I say, I must be cloaked with the Holy Spirit."[4]

Others took advantage of the desperate climate to speculate and boldly advance a business interest. As the following story of a Brooklyn chauffeur who had started his own auto shop demonstrates, investments could be had in the worst areas of town during the Depression, with a kiss, a prayer, and not a little graft:

> I was just working. In the Depression, where there's no money, nothing. . . . So I went to New York—over there you could do anything and get away with it as long as you paid graft. I saw a Jewish fellow over there, Leon. I said, "Leon" (he was in with the politicians), "we have to pass those plans. What are we going to do to build the building? Because you gotta be two hundred feet away from the church, school, or hospital in order to have gas tanks. What do you think it will cost me to have plans approved?" He says, "Five hundred dollars under the table." I said, "Okay, you go ahead." He went ahead and he got everything stamped approved. We went ahead with the building.

In addition to the courthouse across the street, there was also an Elks Club that operated as a speakeasy on Saturday nights. The Syrian went to his garage one night and found a mob: "I can't believe it. I can't even go in the garage. Cars all over the street. All blocked up. Big Cadillacs, limousines, chauffeur driven, and everything else, from one street to another. The whole street is blocked. I took an ice pick! I took an ice pick and I just walked like this—you can't believe it—to all the tires! You could hear the air!"[5] The ice-pick caper was just one example of the toughness, even meanness, that it took to navigate a successful business during the Depression. But the auto shop owner—who had experienced starvation in Lebanon during the First World War—was not going to disappear from his spot on the earth now, not in Brooklyn. Here the law—malleable as it was—was on his side.

The tough grew soft befriending another Syrian—this one from outside Damascus—whose business in Brooklyn, Pyramid Embroidery, went bankrupt:

> People selling apple on the street. We couldn't do anything; we have to cover up and feed the family. Really, sometimes we haven't got a nickel to go on the subway. This was worse than the war for couple years. So we ask him [foreclosure broker], "If you are Christian, or not Christian, if you believe in God, we are a family of four brother and one sister. We got seven kids in the family. Just think twice before you do anything like that." . . . He stopped. We asked him if he wanna sell the house, maybe we try to sell it to somebody to, you know, support

us with the money. He was asking $15,000 for the house. We went down to Mike Malouf. He bought the house for us. Those days he have a good garage, have business, gasolines, sell tires. He make quite a lot.[6]

The Syrians' attitude toward President Franklin Roosevelt was universally good. Independent and entrepreneurial as they were, they admired his compassion for the downtrodden and his extended hand to the immigrant. Taxi Joe (Elias Joseph) of Woonsocket, Rhode Island, called Roosevelt "the father of our country" and contrasted him to Hoover: "He [Hoover] used to tell the people, 'If you wanna go back to your country, we'll pay your fare and put you on a boat.' Well, the people decided to go back. So Roosevelt took over. He says, 'Well, I need those people. Don't send them back!' I want everybody to live.' "[7]

It was actually during the Depression that Maroun Haggar from Jazzine watched his fledgling pants business begin to grow. By 1929, the year of the crash, Haggar had six thousand feet of floor space—two floors—and employed 250 people in what was then called the Dallas Pant Manufacturing Company. Even as the country was barely beginning to recover, in June 1933 Haggar organized a "Prosperity Picnic," marching his employees down Main Street in Dallas singing, "Happy Days Are Here Again." In the midst of 15 million unemployed nationwide, Haggar—later called by some the "General Patton of pants"—was hiring.[8]

A general storekeeper in Vicksburg, Mississippi, had more difficulty than Hagger in the Depression, though he offered everything from pants to river paddles. But he appreciated Americans' generosity and returned it. Native of Shekarn, Lebanon, Johnny Nosser pointed a finger skyward:

> The groceries in the store belong to the wholesaler, don't belong to me. I didn't have anything left. That's the history of the Depression for me. And many others like me. I was going to quit. I went to that wholesaler (I owed him $1,575). I said, "Mr. Luston, I'm going to quit before I eat all what you got in there, and they belong to you." He said, "Forget about it. John, you've been my good friend since 1924. You been a good customer. You been paying bills every time it's due. Where you wanna go? What you wanna do? Sleep on the street? You better stay where you are . . . Forget about this money you owe me at the present time."
> And sometimes I have two and a half, three dollars I'll pay on that bill. O God! I paid all that money to that man and we stayed in business and by 1939, everything in the store was mine. Faith in God get you on your feet! Friends![9]

Stores were sacred to the Syrians; the loss of them, or threat of loss, was a blow akin to sacrilege, though most were plucky enough to pick themselves up and start over again. One granddaughter of a Lebanese immigrant woman who ran a speakeasy during the Depression in Schenectady, New York, readily admitted that her favorite memory of childhood was time spent at "Nana's store." The grandmother herself clung to the place long after it had stopped turning a profit.

As Faith Latimer, daughter of the Arab American mayor of St. Paul, Min-

nesota, described it: "For years my father and uncles had been exasperated with Nana for not selling and 'getting out of there.' Nana and Grampa were getting older, robberies were becoming more frequent (it was ridiculously dangerous), and they could get along without the income. I am unclear why Nana resisted giving the store up for as long as she did. Was she afraid of leisure time, the way many old people are, who are used to hard work? Did she fear financial insecurity?" [10]

The Syrians in America feared it, yes, especially after their initial financial successes in the New World peddling, weaving, selling over a counter. In October 1931, *Miraat al-Gharb,* the Arabic émigré newspaper published in New York, editorialized feverishly for a national Syrian relief committee—not for Lebanon and famine—but for the U.S. Syrians in the Depression. Typically, the emphasis was on self-help, not welfare. The Syrian Ladies' Aid Society of New York City was distributing food and money to especially hard hit Syrian families in the city. Benefits were given—oudists strummed and Syrian chanteuses wailed—to raise money for the prostrate. An organization of people from Aleppo—al-Kalemat—gave $1,291 from a benefit to the Aid Society. St. Nicholas' Young Men's Society gave half the proceeds of a *haflah,* or party, on October 17, 1931, to victims of the Depression. [11]

More was lost besides businesses. A surprisingly successful Melkite school in Rhode Island—the first in America—which had as many as 156 students enrolled to learn Arabic, closed down in 1934 after thirteen years of operation, a victim of the Great Depression. [12] The hard times effectively quashed what inclination there was in the first native-born generation to learn Arabic. It was difficult enough to eke out a paltry living from the unregenerate edifice of English-speaking America in broken English; it was impossible to do it in Arabic. Jobs were found by English. To Sam Kanaan—who wrote a memoir in meticulous Arabic script—writing Arabic in America was "like pissing in the wind."

America, however, took some solace at the onset of the Depression from poems by Mikhail Naimy. The very few he did in English were published then in the *New York Times.* [13] In one of its last editorials, the *Syrian World* noted that national governments were having trouble "balancing their budgets," as were large corporations. But editor Salloum Mokarzel's greatest sadness was saved for "the most pathetic case . . . that of the small man, the one who through systematic savings and self-denials accumulated a small capital with which to open a shop, a store, or some other industrial undertaking." Out of work, he is "in a position of utter helplessness, for he is neither fit by training nor capable by former connections to find other means of earning a livelihood. . . . The Syrians fall mostly into the latter category." [14]

Thrift and "mutual helpfulness" might ease the small Syrian businessman's woes, but Mokarzel knew what he was talking about. In 1932, after seven years of publication, he printed the last issue of the *Syrian World.* With it passed the only nationwide vessel in English of the Syrian intelligentsia, an inculcator of roots, a symbol of unity across all the Arabic journals whose points of view were

scattered on Druze, Maronite, and Orthodox compasses. In many ways, the *Syrian World*'s death was also the death of pan-Syrian American culture. The Depression took away more than businesses. It took the cornerstone of ethnic pride. Once again, the Syrians were left to their own gregarious, protective, culturally solitudinous selves.

World War II

Aref Orfalea, 18, was dreaming on the porch of his Cleveland, Ohio, home in 1942. The war had begun in Europe and he was restless, feeling his school days useless. Recently, he had fallen asleep in a movie theater and had slept soundly through both features into the night, managing—in his dreamy, slumped state— to avoid the detection of even the popcorn clean-up. He was rescued from his slumber by his mother, a former peddler from Zahle. Perhaps if she hadn't come he would have, like Rip Van Winkle, slept through the war. Aref left high school, as did so many young American boys, to test his courage in the crucible of battle. Hitler's Germany had to be stopped. Too, Aref's older brother had already joined the army and was stationed in Burma. When you are restless and uncertain of your destiny you do not like being left behind by siblings—even if the destination is a kind of hell.

Aref would find himself jumping out of an airplane over Draguignan, in the controversial subsidiary D-Day landing in southern France called Operation DRAGOON. Jumping into the dark, Aref would say forty years later, was the most terrifying experience of his life. Though ground resistance was surprisingly light (DRAGOON would be dubbed "the Champagne Campaign"), Aref strained himself carrying a 75-pound radio over the Maritime Alps into Italy, sloshing through mud and cold. Later, attached to James Gavin's 82nd Airborne, Aref was one of only 110 of 839 of his 551st Parachute Battalion to survive the brutal Battle of the Bulge. Some of his fellows were killed hitting the snow-packed earth or in midair, wrenching their guts, hung as if on a cross of air and snow. Many others, wounded, froze to death in a bad winter in Belgium. According to historian Clay Blair, no battalion at the Bulge sustained higher casualties than the ill-fated 551st. Aref's feet had frozen and threatened to become gangrenous. He was evacuated stateside, 20 years old. The war came to a close over the radio in his Ft. Meade hospital room.

Because ethnic records were not kept, and since there were few Arab American VFW groups (the John Gantus VFW in Los Angeles is still active), it is difficult to ascertain exact numbers. But it is a reasonable estimate that at least 30,000 GIs of Arab lineage fought for this country against Hitler, Mussolini, and the Emperor of Japan. Judging by isolated records, it is likely that a greater percentage enlisted than in World War I—in one small Catholic parish in Woonsocket, Rhode Island, from 25 Syrian families, 29 more served, including nine sets of brothers.[15]

In fact, America's first World War II flying ace was Col. James Jabara. A Native of Wichita, Kansas, and of Lebanese background, Jabara would later shoot down fifteen Russian MIGS in the Korean War to extend his top "ace" status into the fifties (a fighter "ace" is designated when a pilot downs more than five of the enemy's aircraft). Jabara was virtually unknown by the Syrian community in the United States until his name was flashed across banner headlines in the *New York Times*. He was awarded two Distinguished Flying Crosses, and in 1950 he was named by the Air Force Association as its most distinguished aviator.[16]

Other young Syrians destined for fame aided the war effort in unusual ways. A young officer out of Dallas, Texas, where his father ran an interior decorating service in the Neiman-Marcus Building, was Najeeb Halaby. It was at Langley Air Force Base that Halaby became one of the first Americans to test the jet. These sound-barrier breakers that went to Mach 1 were very unstable in those days. A number of P-51s and P-46s lost their tails in dives, which caused the latter to be nicknamed "The Widowmaker."

Among the pilots Halaby instructed in the YP-59A, a new and ultimately unusable jet, was an American legend. The man was Charles Lindbergh. It was a humbling moment for the young Halaby to run his boyhood hero of the solo *Spirit of St. Louis* flight across the Atlantic into the grim, supersonic jet age. He was filled with mixed emotions, too; Lindbergh had not been a fan of America's entry into the war. He had been, in fact, an isolationist and pacifist, who was disliked by Roosevelt. The president cast Lindbergh as a traitor, according to the aviator's biographer, Walter S. Ross, not just for patriotic reasons but also for political reasons. However, Lindbergh did draw highly secret combat-zone test flight assignments during World War II; he flew thirty-six combat missions and even shot down one Japanese fighter. Halaby became good friends with his pupil: "Lindbergh was open, modest, friendly, and intensely interested. In his questions and responses, he seemed to be looking beyond the relative simplicity of a machine into the mysteries of intuition." Halaby called Lindbergh, "an echo of Da Vinci."

Halaby almost lost his life when testing a captured Messerschmitt near Newark. It was one of the few planes capable of reaching 500 mph in level flight, and he had a premonition of disaster on entering the cockpit and not being able to read the German panels. The brakes were terrible and the steering was "as agile as a Panzer tank." He lined up on a runway notorious for crashes, pointing straight at the city of Newark. To top things off, the fuel tank was half empty:

I charged down the runway and got off the ground successfully but that's when everything hit the fan. The plane just started to climb, the nose going up all the time until I was close to stalling out right over downtown Newark. I kept pressing the elevator tab switch forward to get the nose down, while simultaneously pushing the stick forward with my right knee and all my 170 pounds. No response, except that the climb got steeper. The 262 began to shake in the ominous warn-

ing of a stall—she practically was standing on her tail. Suddenly it hit me: on a German airplane, that tab switch had to be reversed. Instead of pushing forward to get the nose down, maybe it should be pulled back—the exact opposite from the American tab controls. I pressed the tab switch back instead of forward and the nose obediently came down a split second before I would have stalled out. I flew down to Patuxent—and only my laundry knew how scared I was.[17]

Halaby's glorious moment as an aviator, however, came just before the end of the war in the Lockheed Shooting Star, the nation's first operational jet fighter. On May 1, 1945, Halaby took off from Muroc AFB, California, and arrived five hours and forty minutes later in Patuxent, Maryland—the first transcontinental jet flight in U.S. history. He had become a Lindbergh of the shock wave, a soloist of the American land mass, rather than the cold, dark Atlantic on which his forebears had come in ships. Perhaps it was emblematic that now the firstborn generation Syrians were in the United States not only to stay but also to lead.

Leadership could take odd forms. One Syrian GI took experience gained working in textiles with the Maloufs of Salt Lake City and led with needle and thread. Pvt. William Ezzy eased what was literally an explosive situation serving with the navy in the North Pacific: "When we were in Kiska [Alaska] we had to detonate a lot of unexploded bombs; because of the tundra, they didn't detonate. And many times with the demolition squads the shrapnel would fly up. We lived in tents. And as I was the only one on the island with a fabric background I had to go around and patch the tents. So I guess I got the name of Omar the Tentmaker."

One of the more down-to-earth memoirs of combat was written by Lt. Louis LaHood of Peoria, Illinois. He flew thirty combat missions—five over Berlin— in the bombardment that "softened up" the German war machine before the Normandy landing in June 1944. None of his crew was hurt in these missions, and he later received the Distinguished Flying Cross.[18] But LaHood encountered death before the enemy. One of the B-17s that flew with him across the Atlantic at night en route to Ireland went down into the sea. A young pilot had forgotten to open his auxiliary tanks, and they had frozen shut, with no place to land. "We're going down!" was the last LaHood heard on the radio.

LaHood's log descriptions of thirty B-17 bomber missions over Germany, France, and Belgium testify to both the steely detachment and the nervousness that come into the mind of a bomber pilot dropping so many thousand pounds of destruction:

Berlin again! Guess Doolittle wants the place blown off the map. But I wish he'd come along with us some time. Instead of sitting on his fanny and telling all the people that he bombed Tokyo, Rome and now Berlin. . . . This was the third raid to Berlin in four days. I was so damned tired that I couldn't fly formation over 15 minutes at a time. I thought my arms were going to fall off a couple of times. (Mission #12, Berlin, March 9)

This Cherbourg is a flak house if I ever saw one. In about two minutes they had hit about seven engines and one boy got a direct hit and went down out of control. Nobody got out of the ship and he hit the ground going straight down! Our ship had several holes in the wings, fuselage, and a tail. Nobody dropped their bombs on target. I feel like an old man at 25. (Mission #29, Dessau, May 27)

Waste—of life, limbs, money, and matériel—impressed itself on LaHood in moments of deep reflection years later. His words aren't the standard rah-rah, sis-boom-bah of the decorated pilot: "From the air Germany is a very pretty country. The fields are sectioned off by hedge rows. There must have been many ancient structures and much history there. The Air Force could level a town in a matter of minutes. I felt very sorry for the German people. The Eighth Air Force heavy bombers would go over in the morning and when they were returning, the medium bombers were going over. They would return early in the evening and then the British heavy bombers would go over at night. So they were being bombed round the clock." [19]

At home, the Syrians at that time worried and prayed like other American families that their children would come through the terrors of battle safely. One Syrian community published a regular magazine about happenings on the home and war fronts that was sent to GIs around the globe. Published privately in Brooklyn, *Greetings from Home* was put out irregularly in 1944 and 1945; issues are still cached in musty trunks by ex-GIs from Brooklyn. The miscellany is a treasure trove of humor, information, and erudite and imaginative writing gathered to keep the Brooklyn Syrians together, even though they were dispersed in uniform from the Coral Sea to Corsica.

A *Greetings from Home* published on the Fourth of July 1944 sports a cover photo of the Statue of Liberty, a giant American flag, and three thoroughly American faces—one obviously a grandma, another a father, and another a sister or sweetheart. The editors described their mission: "In this year of 1944, Easter comes to a world torn by wars of unparalleled destruction. It will dawn alike upon scenes of violent carnage and quiet sacrifice. From our own little corner of this world, we, the Syrian community of Brooklyn, are also making sacrifices. Our boys have gone forth as fighting men to the service of country, adding their physical prowess and valor and their intellectual heritage to the great armies of the Allies to speed the inevitable victory."

Greetings from Home reveals a stateside world typical of the community during the war and its state of heightened anxiety, yet mobilized "cheer." We are told of a "One Man Service Center" on 293 Henry Street in downtown Brooklyn, Michael Shaheen, whose café-store on Atlantic Avenue was a meeting place for draft inductees before the war. Shaheen and his wife kept up a steady correspondence with their "Write-a-Letter Club" to the GIs, emanating from their store filled with the odors of Arabic coffee and *baqlāwah,* the diamond-shaped sweet.

A Syrian Red Cross drive was held on February 13, 1944, at the St. George Hotel. A fourth War Bonds drive of the Syrian-Lebanese-Palestinian Committee (interesting that by then the Syrian identity was now splayed to include separate Lebanese and Palestinian identities) was aiming for a $2 million goal. Apparently, the community in Brooklyn had already raised millions for the war effort and was complimented officially by the Treasury Department. George Hamid, the circus impresario and owner of Atlantic City's Million-Dollar Pier and Steel Pier, raised $300,000 as chairman of the Army-Navy Emergency Relief Society from the theater industry alone. He was also appointed by the Navy Relief Society to be general chairman of outdoor amusements.

Gloria Amoury's efforts—probably the best in the *Greetings from Home*— culminated in a long poem that fronted the Christmas 1944 edition sent overseas. Unabashedly sentimental—and not a little warning that Penelope was being wooed ("Fresh roses from a suitor fat and gray")—the poem contains stock figures from a Syrian family home in America that would touch the right chords of GIs with that heritage: "It's Christmas in a Brooklyn home. / The soft Turkish rugs muffle the sound of the restless feet."

Sally Mansour and Selma Daas penned an endearing satire on Arabic accents that would remind GIs of their older generation back home in a "Dear Fuad" letter. Here is an excerpt: "How you like this new work you doing? To me it sound a little danger, Fuad, but of course, I don't tell Mama that. You remember how she always afraid when you drive our automobile—how I'm going tell her now you driving ten-ton truck? Dinchu worry about it, baby. I tell her is only— *shū ismūh* [what's his name]—jeep. . . . Don't forget wear your raincoat and rubbers whens rain."

Some of the most interesting reading in *Greetings from Home* was provided by GIs in the field. Cpl. Thomas Hattab wrote from a South Pacific battle zone about first donning his helmet, "M-1, Helmet, Steel": "All was Stygian darkness. I lifted it up, and staring back at me were two burning eyes peering from a cavernous pit. I put it away for the rest of that trip. The shock was too great."

Although the Syrian community did not have celebrated conscientious objectors, at least one chap, whose relatives came from Kabb Elias in Lebanon, entered war, as did Hemingway before him, as an ambulance driver and came away with conclusions about modern warfare as dreadful and perhaps even more nihilistic than Papa Hemingway's. Vance Bourjaily's first novel, *The End of My Life,* was published in 1947, a year before a close friend at the time, Norman Mailer, published his own landmark first novel, *The Naked and the Dead.* Mailer's antagonist, Croft, slogs through the fetid swamps of the Pacific campaign against the Japanese. Joseph Heller satirized the bombing mission of American forces over Italy in *Catch-22; The Young Lions* by Irwin Shaw dealt with the European front. But Bourjaily chose Syria and Lebanon as his war setting because he had gone there with the Ambulance Corps.

Bourjaily treats the Middle East with empathy, sometimes awe, though he is

never patronizing. About Beirut's poorer sections he says: "Most of them were Moslems back in there, and in there were their stores, their restaurants, their coffee shops. It was Hell's Kitchen, the Lower East Side, the heart of the city. There were stories of soldiers who had gone into the district and never come back: others of those who had crawled back, robbed and beaten." Bourjaily characterizes the Arabic-speaking people that the hero, Skinner, and his company meet as "warm people, with a long tradition of hospitality. They offer enmity where enmity is offered them; they respond to friendliness with friendliness; they are, except when angered, or when one tampers with their customs or ceremonies, humorous, humble and wise." [20]

It is interesting that one of Skinner's best friends on their grim adventure is Benny, a Jewish American who is altogether immersed in the concept of a Jewish state brewing in Palestine: "Benny is a lonely guy. All evangelists are lonely; everyone who believes something as zealously as Benny believes is shutting off parts of himself from other human beings. And, since the people who share the belief are similarly cut off, he needs people who will respect without agreeing or disagreeing; people whose minds work differently, who like him without reference to his central belief." [21]

Bourjaily finds war absurd but natural. The ending of Bourjaily's novel is even darker than that in *Catch-22*. Yossarian had a life raft at least; Skinner has only a cell to which he walks, "impatiently," after a nurse he has taken to the front is killed by a shell. It would be wrong to identify Bourjaily's vision as the "Arab American" response to World War II though it is certainly the only World War II novel set in the Middle East. But in its vision of the war as evidence of the chaos of being, of its refusal to see the war in a nationalistic way, it has the internationalism that marks great novels, and something ancient in the Syrian consciousness. It is also, with one or two exceptions, the last novel on American bookshelves that does not paint the Arab world on a moral level lower than our own.

Making a Name: First-Generation Celebrities

The generation of Syrian Americans who were the first to be born on American soil were growing up in the 1920s when U.S. courts were finally determining that Syrians were not Chinese (and that Chinese were not subhuman). This first generation came of age during the Depression and World War II—many of them fought for the United States in the battles for Europe and Japan. It was for this generation, too—perhaps the most Americanized of all—that Arabic was a tongue whispered in warmth or shouted when a glass was broken at the dinner table. It was not the language that made friends or secured work, and it certainly was not useful in assembling a field rifle in the army. In many ways, the first generation—now reaching the end of their work lives in America and moving into retirement—was the most assimilated of all. They embraced the Kiwanis, Rotary Clubs, Masonic orders, PTAs. They were full-fledged members of their

church boards and helped enhance the reputation of their mosques. They held fast to the Eastern religious life of their ancestors.

I interviewed many first-generation Syrian and Lebanese Americans but was intrigued especially by the emergent celebrities of that group. They were the ones who, in fact, put the name "Syrian" or "Lebanese" into the American vocabulary before there was much consciousness at all of the Arab world other than as a place of sand, strife, and belly dancers. In some ways, since their efforts at Americanization were at the highest levels of society and their chosen fields, the images they projected were as determinate, and probably more so, of American perception of Syrian values and beliefs as those of the rank-and-file themselves. Lacking unity and punch in groups, each of these celebrities carried a lot of ethnic weight. Some were conscious of it, some not, some quite willing to utilize it for gain, some for philanthropy, and some tried their best to disregard it.

Danny Thomas' home hangs over the San Diego Freeway from a craggy point in Beverly Hills. On the other side of the freeway a flowered hillside hides Los Angeles' largest dumpsite. When I was younger, Thomas' was a home that people would point out to me—"There's Uncle Tannous." Of course, Uncle Tannous was Hans Conried on "Make Room for Daddy," the family shows that lasted eleven years and went into at least nine seasons of reruns. Danny Thomas was his fictional nephew. But I wanted to find out who was the real Uncle Tannous. And on a spring day in 1983 I did.[22]

Villa Rosa's wrought-iron front gate opens with an electrical command from inside the house. The noisy Open Sesame barely gives enough time—will the thing close back fast?—to note the Latin inscription of the coat of arms: *Beatus qui intelligit cur natus sit*, Blessed is he who understands why he was born. On either side of the gate as I entered were lighted kerosene lanterns. A robin called out innocently: *The Day of the Locusts*. Behind, cars with Hollywood-map-equipped passengers idled by, like sharks circling a diver whose air hose is conspicuously tangled. The front doors had knockers of the theatrical comic face. A maid opened a door for me as I rapped with the face of laughter. I was taken to a huge den with a circular card table ladened with cups of cigarettes and nuts. As I sat down, I became aware of piped-in music, and for the rest of our interview mild tunes filtered behind us.

One expects Danny Thomas to be, somehow, in a bathrobe, as "Daddy" on a Saturday morning, holding a cup of coffee (Maxwell House, Brim). Instead, a man wearing jeans, a western belt with large buckle, a demure sportshirt, and a two-day growth of beard almost stumbled into the room. He was about 5' 11", slender, and looped a large cigar through his fingers. He would dab it so gently into an oblong copper ashtray to break the beginning of an ash. It was Danny Thomas, *the* Lebanese personality when I was growing up. As he came over to shake hands, squinting the warm eyes through glasses, the famed hooked nose

seemed to measure me. My impulse was to squawk: "Welcome, Uncle Tannous!" I felt at home in the clasp of Amos Jacobs of Toledo who grew up in an impoverished family of nine children, raised, in fact, by his aunt and uncle. Amos created a stage name from the names of his oldest brother (Danny) and youngest brother (Thomas). The fusion made him his brothers' keeper.

It was the infant Danny—Amos Jacobs' brother—who was responsible in a way for St. Jude's Hospital being built. A few months old, little Danny was bitten in his crib by a rat and later went into convulsions. (The Jacobs family lived over a pool hall then.) The actor's mother, who had the proverbial Lebanese immigrant mother's devotion to the Blessed Mother (Adhrā'), on her knees in prayer promised that if her child was saved she would beg alms for a year for the poor. He was, and she did.

There was the sense about Danny Thomas, even at age 68, that he didn't quite believe the opulence that surrounds him. I found him quite serious in our conversation, cracking few jokes, and vulnerable, even anguished. Arab Americans who don't know each other often introduce the topic of Lebanon as if it were still a resort. Strangers, all the Lebanese diaspora are travel agents for a place that they know is completely riddled by violence.

> I never saw such civilization in my life as they got in Lebanon [Danny Thomas intoned, taking his seat at the card table trimmed with Arabic calligraphy. He took not one pine nut, or cigarette the whole time.] In Beirut, gorgeous women lying on the hulls of the speedboats in their bikinis and the great French Casino du Liban is the biggest gambling casino in the world—it's all marble. It's marvelous.

> I went in 1962; God, they went crazy. They went nuts. Oh! *Allāh yarhamu* [God rest his soul], Emil Bustani was my host. He was to be the next president, but he died in a light plane crash in the Mediterranean. His bones are still down there; they never retrieved them. Anyway, when I went up to Bsharri they had big signs in Arabic and English, *Bsharri Welcomes Her Son.* It was just beautiful.

Thomas sprinkled Arabic throughout our conversation in an accent not different from any of my relatives. Unlike Yiddish, however, Arabic isn't familiar to Americans. "My vocabulary in Arabic is not small," he asserted, however, and he has used it for Arab crowds.

Born in 1915 in Deerfield, Michigan, Amos Jacobs was the son of Shadid Ya'qub of Bsharri, who came to the United States in 1901 and had witnessed Ottoman Turk atrocities. Ya'qub eventually ended up in Toledo because many Maronite Bsharraniyah were there—the colony was founded by an M. H. Nassar, who, according to Thomas, "had a dry goods store and also a produce stand. He used to grubstake those guys who would come."

And where did Danny Thomas get the inspiration for Uncle Tannous? Thomas smiled and blew a thin stream of smoke upward. "That's my uncle Tony—Tani-

yus in Arabic. Funny man, oh, yeah. Beautiful man. Great sense of humor; he loved to laugh." Uncle Tony ran a boardinghouse and café in Toledo and actually raised the waif Amos Jacobs.

Like so many Syrians coming over in the First Wave immigration, Thomas' maternal grandfather was turned back at Marseilles because of trachoma. At Ellis Island, his father had to make sense of his name in a hurry. It went from Ya'qub to Jacobs in the flash of a hand. "My mother," Thomas said, "is Tawq and father's family is actually Karuz. They're both prominent families to date. They've had members in parliament since they had a parliament in Lebanon. Habib Karuz just retired as minister of tourism. Gibran Tawq is in the parliament now—a handsome boy, a bright boy. I think he'll make president one day."

"But what of Ya'qub?" I asked.

"We stopped with one of the grandfathers called Ya'qub. You know, every other generation used to take the name of the great-grandfather and delete the word *ibn,* for some reason. Actually, by this time our family should have been Boulos, because he's the last great-grandfather that I know about."

I was getting dizzy—Karuz, Boulos, Ya'qub, Jacobs, and now Thomas. Which was it?

"Well, it's *ibn, ibn, ibn,* that's all," Thomas retorted, as if this made perfect sense. "Hell, my uncle Tony was known as 'Stambuli' because his father was the first ever to go to Istanbul. Ibn Stambuli. So when he came to this country he was Ibn Stambuli and va-va-voom—they forgot the *ibn* and he became Stambuli. My father's name in Bsharri was actually Abou Miflih. Miflih was the first born. Dad named us all with the Arabic phonetic 'Meem," "Miflih, Milhim, Majid, Mufrij, and Mizyid."

"How did you go from Mizyid to Amos Jacobs?" I asked, reeling.

"My American name was Amos Jacobs," Thomas said without a pause. "Amos Joseph Alfonso Jacobs."

"Your father changed it."

"He didn't change anything, We were all born here."

"But his last name . . ."

"His name is Shadid Ya'qub—Shadid Karuz Gemayel Ya'qub. *Ibn, ibn, ibn, ibn!* Ya'qub was out of the Bible—Jacob. They just translated it. Yousef is Joseph. Taniyus is Anthony."

Mixing with the background music, I could almost hear "Who's on first, What's on second, and I-Don't-Know's on third."

Thomas spoke fondly of his father, who was a peddler selling his wares from farmhouse to farmhouse. "He was smart," he smiled. "He didn't carry it on his back. He put it in a cart." When I mentioned the story of my grandmother Nazera blessing her own water to sell as Holy Water, he sang out, in Arabic: "*Ya 'aynī! Ya akhī!* [My eye! My brother!]."

Thomas has, at times, been accused of being chauvinistic toward Lebanon and ignoring other Arab states and causes. But he poked fun at those who refuse to re-

member how everyone was once called *Syrian*: "Funny, we all say, even staunchly, 'We're Lebanese! We're Lebanese! Remember that.' And then, 'Pass the Syrian bread, give me the Syrian cheese!'"

In 1974, Thomas made his second trip to Lebanon just before the country descended into a savage civil war. He did a benefit for the al-Salib al-Ahmar (Red Cross) for Madame Franjiyah, the president's wife. A cover photo from *Middle East* is framed on the wall of his study. I asked him what had changed between the 1962 and 1974 trips in Lebanon.

"They were building more," he mused, then halted, perhaps thinking of the incipient destruction. "Also, I noticed that the refugee situation was closer to the city now, on the ride from the airport, whereas before they were on the sides of the roads. I really felt for them and so did all of our people. They entertained us—the various dancers and singers were Palestinians in all the places we went to. We slipped 'em a few hundred dollars, couple hundred here, couple hundred there. We had to look like the land of milk and honey! You didn't give 'em five or ten dollars. Besides, everything was picked up. It was costing me nothing and I thought, this is insane. Let's share the wealth here. I did and they loved it. I didn't do it in a pompous and asinine way. I did in on the quiet."

I brought up an incident my father had told me about a convention in Ohio years back where a cousin of ours, Henry George, had witnessed a Maronite priest stand up and attack Danny Thomas. He remembered it immediately, "Youngstown," he mused, his chin wrinkling. "That was the Syrian-Lebanese situation. We established ALSAC [American Lebanese-Syrian Associated Charities] in 1957. It has to be 1958. I knew there were the people who were die-hard Lebanese—some in the eastern states refused to join ALSAC because the word 'Syrian' was in it. So I was bringing that point up, 'Don't forget. We were all Syrians when they came here. There was no Lebanon.' And this priest jumped up. Oh, he was livid. It was the very beginning of my speech and it loused up everything. But we finally won him back." I wondered what the priest's name was. Thomas demurred: "He died. *Allāh yarhamu, dashshiruh* [God rest his soul, let him be]."

The idea of starting a hospital for children with so-called incurable diseases is a bit of folktale among Hollywood philanthropists and among certain Arab Americans, as well. Thomas has described it many times. In 1940 he was working a supper club called the Club Morocco in Detroit, where he had just met and married Rosemarie Mantell, an Italian American singer. A baby was on the way (Marlo Thomas), and the fledgling showman was struggling to buy groceries, enough so that his wife suggested he go into the grocery business. During a time filled with "an agony of indecision," something happened. He described it in a publication of Norman Vincent Peale's: "On Tuesday night a man came into the Club Morocco. He was celebrating something. His pockets were filled with little cards that he was handing out to people as he tried to tell them about an incredible thing that had just happened to him."[23] The man's wife had been miraculously cured of cancer. The next day Thomas went to church and when he reached into

his pocket to make a donation, he found the card of St. Jude, patron saint of the hopeless, or "The Forgotten Saint." It was then he promised that if St. Jude "would help me find some clear course in my life" he would build him a shrine.

The Club Morocco closed, forcing Thomas to take his small family to live with his parents in Toledo from where he struck out in an old Buick toward Cleveland. But instead the car veered toward Chicago; he picked up a job as a stand-up comic at the 5100 Club, opening before eighteen customers in a converted automobile showroom. But the news spread, and soon the lines were extending for the hilarious new comic who could speak in five different accents and whose nose seemed to grow with every laugh elicited. He discovered, in fact, that on Chicago's South Side was a national shrine to St. Jude. Chicago was Jude's and therefore his—a place for the lost.

Thomas' career took off but it wasn't until the 1950s in New York that he had a dream that reminded him of his promise: a boy injured in a car accident who bled to death with people looking on. It all flooded back in his mind: his mother's pleading for her son's life and subsequent begging, his infant brother Danny's "grabbing hold of life just when he was dying," the man at the Club Morocco, Chicago as his lucky town. It took ten years to raise the money but St. Jude's Children's Research Hospital opened its doors in 1963.

It was in raising the money that Thomas learned some hard facts about the Lebanese-Syrians in the United States. A few helped out enormously. Thomas credits Mike Tamer of Indianapolis as the guiding force of ALSAC. Al Joseph helped in Chicago. "But we couldn't get the masses," Thomas admitted. "We could only get those that understood what we were trying to do. I went all over the country. I said, by our deeds we are going to resurrect the dead of our grandfathers and grandmothers who came here and fought language and customs barriers. They died and are buried in western cemeteries in a land strange to them. They came here and made possible our birth in the United States and educated us and many of us have succeeded. We're denying our heritage by allowing them to · die and never to be known. 'By our deeds they shall be known.' In Arabic, I said, 'Mnerfaᶜ al-mawta min al-qabr [We can raise the dead from the tomb]!' Well, they starting firing salutes to me in New Jersey, New York, going crazy. God—the Messiah had come! I said to Mike Tamer, 'This is it, pal, this is beautiful. This is gonna really go.' Two weeks after I left they forgot I was there."

St. Jude's current $63 million budget is funded by a few very dedicated philanthropists, some Arab American, those with names like Ajhar, Jamail, Coury, Maykel, Ayoub, Harris, Haggar, Elias, Maloof, and Karam. Door-to-door solicitations by teenagers and mail appeals bring in $1.5 million a year, and Thomas' benefits add considerably more. But a few people pull the largest load. No child pays for treatment at St. Jude's. The hospital is free.

The experience left Thomas with this sober conclusion, "On an individual basis many people of our heritage have contributed much to their own commu-

nity, their state, and even to the country. On a cooperative basis, taking in the entire population they have done nothing. I tried with ALSAC to make them all come in and say, 'This great institution of pediatric research is ours.' I still do it in spite of them. It is being done in their name."

His first tips in comedy came from watching Abe Reynolds, a Yiddish comic, play a burlesque in Toledo at which Thomas sold soda pop. "Reynolds," he recalled, "was a funny man, never said hell or damn on the stage, sang parodies, and told stories apropos the song he was going to sing, which was a kind of modus operandi for me, which I don't do anymore. I mean, parodies. The ethnic comics were prevalent in those days—the Italian, the Irish, what they called 'the Southern Negro,' of course the Yiddish—and they were funny. They were funny making fun of themselves, which I think all minorities have to learn to do in order to survive. You make fun of the tragedy at hand." Which Thomas did. "The Wailing Lebanese" is the title of a 1951 sheet music booklet of songs he wrote.

About school Thomas proclaimed, "My academic education is from the street. I'm a street bum. And it turned out for me to be the proper place to get the education for what became a career." For a kid of the streets who never graduated from high school, Thomas expressed amazement at his honorary degrees: "I have a zillion of them." They include five in the humanities, two in the performing arts, and one honorary law degree from Loyola University of Chicago. "What are we gonna do with this guy?" he laughed. "We're running out of degrees! So the L.L.D. I didn't believe it!"

Rosemarie Thomas interrupted us, questioning why her husband had placed a map of Lebanon where he did. "I didn't want to lose it sweetheart," he responded. "And I know we'll lose it." She showed him a few custom-made shirts and Thomas nodded amiably, cigar poised, but balked. "Those aren't *my* fronts!" his voice raised with alarm. Rose left, mumbling something about the collars.

We discussed the nature of comedy and comedians Danny has known through the years. "We have a rule of thumb," he nodded. "Show me a man in trouble and I'll show you a funny man. Not catastrophic trouble. But trouble. Charlie Chaplin was a great exponent of that. People have to relate to you. They can associate their problem with yours and you kind of solve theirs. And you laugh as you go." He went down a list of the greats. W. C. Fields—"An angry man." Edgar Buchanan—"The Master of the slow burn. The slow burn was a big part of my career. When I did the flat tire and no jack stories. Slow burn. Anticipation, which is never as good or bad as consummation when your mind conjures up oh so much more than what's there at the end."

Rosemarie Thomas entered again with her husband's shirts, some of whose collars were frayed and needed mending. The comedian and his wife discussed the size of the collars in what seemed to be an old duet of, well, *trouble*. Finally Thomas said, "Honey, you gonna barge in and out like this all day?" Rosemarie said she had a lot of work to do. "Oh, my goodness, you're a busy lady," he

flipped his eyebrows up, shaking his head. "She's so efficient, my wife. Drives me crazy. Can't stand efficient people. I'm a procrastinator. I don't do it until it has to be done."

And what of The Show Must Go On tradition? Had Danny Thomas ever faced tragedy in the middle of a comedy routine like Lou Costello, who continued his radio program right in the midst of news that his infant son had drowned in the pool? One week after Thomas' very first opening at a major Las Vegas stage— the Sands in December 1952—his mother died. Describing it was one of the few times he lost composure. (The other was not being able to take sides on the issue of Lebanon.) "I flew back to Toledo to attend her funeral, God love her, came back and did the New Year's Eve show," he murmured. "I really didn't do well. It was difficult for me to make people laugh at that time."

The night Robert Kennedy was assassinated, Buddy Hackett had called Thomas, who was on stage at the Sands, and cried on the phone. Thomas tried to cancel the show, but the manager refused, saying it was sold out.

"I walked out into a sea of teeth," Thomas dabbed his cigar, demonstrating by smiling widely. "Because they were looking to me! They were looking to the Sands! They were looking for the din and the glare! The music and the lights to pull them away! So I didn't say a damned thing. I just went out and did it. And they screamed; it seemed they appreciated me more than they would normally. We did a long show because they were escaping."

A quirky, obstreperous, but loving father has been the projected image of Danny Thomas. Of "Make Room for Daddy," he admitted, "Yes, we were a daddy to a lot of daddies, and the people who didn't have daddies, I guess. Or working mommies and daddies. A disciplining, loving father because we disciplined and we loved, which is the way we were brought up." Thomas agreed that the Lebanese have a respect for the elderly. "They say, '*Akbar minnak, walad,*' I'm older than you, kid!" he laughed. About Hollywood's discarding of the aged, Thomas was incensed, "They seem to have an aversion to older people playing the leads. They're strongly and sadly mistaken because demographics will show that the over-50s and under-50s are almost on a par. Those people need to be entertained."

And what of himself now as he neared 70? "St. Jude's keeps me hopping," he said. And hotel openings and clubs and fairs. In 1983 he did the Ohio State Fair, Atlantic City twice, Bloomington, Minnesota, Atlanta. He declared, "As long as I have my health I'll never retire. [St. Jude's] depends upon me. I am the head and the tail of the thing."

What about Vietnam? What did America's most identifiable father of the family think about it? His voice lowered. "It was not a popular war. No war that you are not permitted to win is a popular war. If you were going to see a fight, a boxing match, and they told you in advance it was going to be a draw, you're not gonna go see it. All we could hope for was a draw. A lot of people were absolutely against that, to use the flower of youth in a draw—in really a meaningless

war. We should never have been in it. The French warned us. The French couldn't conquer it. I don't know. Politics and I are not good friends."

Thomas admitted he was urged to run for Congress. During an anniversary party of Kennedy's inaugural emceed by Peter Lawford for which Thomas and Rosemary Clooney provided entertainment, then Senator Thomas Kuchel slapped him on the back with an "I got to know you better, young man." "Everyone was jumping on this camel!" Thomas exclaimed at the memory. Even Give-'em-Hell Harry pulled him aside about the decision to drop the atom bomb on Hiroshima.

Since he had brought up his impromptu audience with the man who opened the nuclear age, I thought to ask him if he'd ever heard what Truman said—erroneously—about not having hundreds of thousands of Arabs among his constituents. Thomas had not heard of that. Clearly the subject troubled him. He became unsettled, saying, "I don't like to be a jack-of-all-trades and a master-of-none. I zeroed in on St. Jude's and actually I've been almost blind and deaf as to what else is going on around me."

He felt he didn't have a disposition for politics: "I'm a volatile man. I often speak before I think and sometimes say the wrong thing. But there was a sign on my dressing room years ago—I Can't Give You the Formula for Success, but I Can Give You the One for Failure: Try Pleasing Everybody."

Danny Thomas has been accused by some Arab Americans of being "soft" on Israel, of not standing up for the suffering in the Arab world. In 1982, Thomas did get involved narrating a film called *To Lebanon with Love* by George Otis of High Adventure Ministry, an evangelist who operated out of southern Lebanon in collusion with Israel and its proxy army there then under Maj. Saad Haddad. It backfired. Thomas was stunned at the furor it caused. A woman in Los Angeles wrote a letter accusing him of being against his heritage, and the then director of the American-Arab Anti-Discrimination Committee, James Zogby, wrote a letter to him that Thomas called "scathing."

Thomas, who prides himself on having lifted the image of the Lebanese in America for thirty years, was predictably outraged. He contacted Richard Shadyac and Alex Dandy, Christian and Muslim board members of ALSAC (Shadyac was a founding member of ADC, as well) to set Zogby straight. He also wrote a personal letter, announcing, "A wise man once said, 'Reason is the Queen of all serious situations,' so let us reason this matter by learning the facts before we condemn. I did it for one purpose and one purpose only—to help the innocent victims of war—both Christian and Muslim." Thomas apologized to those he hurt and promised to check with ADC on any future broadcasts on the subject.

One year later, Danny Thomas was on stage for the ADC and others at the Kennedy Center as MC of a symphony concert for the victims of the war. He read excerpts of poems by Kahlil Gibran. I asked Thomas if his Arab heritage had hindered or helped him in show business. "No difference. In show business we have one prerequisite. Do you have the talent? Do you belong? You go out there and prove it. You could be purple in color or a Druid."

During our interview, he expressed many views on Israel's invasion of Lebanon, the Sabra and Shatila massacres, the PLO, Yasser Arafat, the Phalange, but he literally begged me not to print them, standing up at one point and exclaiming, "Don't you know? My horror is that I *can't* take sides!" He meant that he couldn't compromise his efforts on behalf of the children at St. Jude's.

Thomas said, "We all did things on the quiet . . . spoke up for Lebanon, for its sovereignty. We are still doing it; President Reagan has been a friend." As for hopeless causes, he agreed that the Palestinians were the primary ones in the Middle East: "Every night on my knees I pray for them. They gotta give 'em a country, where they can govern themselves. I'm sure our government's for that."

He twisted in his seat in his jeans with the cigar almost out—dabbed silently on the ash—and told about a scheme he cooked up for Sid Caesar and him about a couple of patriarchs, but ABC turned it down because it didn't include profanity or sex. There's bitterness here with the outcome of the medium that made him famous in the fifties. He thought about kids raised today with two working parents and wanted to do something for them. The ones who won't know what it is "to sit down on the floor and put your face on your mother's knee and listen to her, and your father, in his arms . . . the way we grew up."

Danny Thomas was talking about stories. "Like my son says to me, 'Gee, Dad, all the stories you tell about the old days with your parents and your uncle and your aunt and the tough times and the fun times. What am I gonna tell my kids? I was born in Beverly Hills? My parents got me a brand new car when I was sixteen?' I said 'What do you want from me? Tell them about their grandfather!'"

This one popped out a laugh. And, as if on cue, Thomas went into Uncle Tannousism playing two voices (Uncle Kanut, he said, to the Nordics!): "To him everything in Lebanon was greater than here. 'Oh, we got dat deere. We got better.' 'You play golf?' 'Whaddya mean, sure I blay.' 'What do you shoot?' 'Whaddya mean what do I shoot?' 'You good?' 'Yeah, very good. We got over there golf.' 'What do you shoot—in the 70s?' He said, 'More!' '80s?' 'More!' He got up to 120. Thought that the higher the score the better. 'More!' *Kull shay* [everything] over there bigger. The watermelon is that big, and the grapes are like that, a woman's shoulder couldn't come in the door. Everything was larger than life. And the water was ice cold, you couldn't put your finger in it for ten seconds, which was true back then. Everything he says is true." Perhaps there is more truth to an Uncle Tannous than a Danny Thomas. Perhaps our fictions define us.

I was grateful to him for that ending, that flourish of vintage Tannous, spontaneous, beautiful, hilarious—the Lebanese masque vanquishing again. But soon the giant iron gate sprang closed behind me with a loud electric buzz, and I faced the circling tourist cars again, maps like tongues out the window, the lanterns at Villa Rosa competing with the sun.

The written stories of Helen Thomas (no relation to Danny) cannot be tall, though they must represent as much of the truth as is fit to print (with all the ambiguity in that famous *New York Times* "fit"). If laughs rode on the stories told by Danny Thomas, it may not be too much to say that the state of the nation rode on the stories written—sometimes ten a day—by Helen Thomas, the senior White House correspondent and something of an icon to American journalists, young and seasoned.

Employed by United Press International since the days of Franklin Roosevelt, Helen Thomas is often the first to ask a question during presidential press conferences (AP and UPI alternate the privilege), and always, due to seniority, she is the last to speak: "Thank you, Mr. President." Presidents from Camelot to Contragate have often cringed as she stood, dark hair closely coifed, coal-black eyes steady on her notes, a nasal voice cutting the ribbon of the room as if with a blunt knife. Sam Donaldson of ABC News has said of her, "I think she's the best. A lot of us have learned how to ask questions from watching Helen. I'm pretty well able to hold my own . . . to get the attention of the White House. But when push comes to shove, I defer to Helen." [24]

As a straight news journalist, she is one of the best, if not the best in the business, acknowledged by many milestones and awards: the first woman to be named White House bureau chief for a major wire service; the first woman officer of the National Press Club; the first woman admitted to Washington's prestigious Gridiron Club; and the first woman recipient (in 1984) of the National Press Club's Fourth Estate Award (Theodore White, James Reston, Eric Sevareid, and Walter Cronkite have preceded her). She is a living antithesis of the stereotypical image of the demure Arab woman. Helen Thomas is polite, cogent, direct. No embellishment, rather concision. She has, in fact, asked for only one word to be etched on her tombstone, "Why?" A reporter in the afterlife, no doubt.

As for her background, she does little to hide it or her relishing of it. Jackie Kennedy Onassis once called Thomas and her then AP rival Fran Lewine the "harpies," and thought they were of Spanish descent. Thomas set her straight— they were Arab and Jewish, respectively. She eats most evenings at Mama Ayesha's Calvert Café, a quaint little Middle Eastern restaurant next to a bus rest stop run by Palestinian immigrants from Jerusalem who came to Washington, D.C., in 1950 during the Second Wave of Arab American immigration. She has a special affection for Ayesha Howar, the 80-year-old founder of the Calvert Café, whom she affectionately calls "my second mother." Ayesha has often read Helen's fortune in an overturned coffee cup's grounds and "her predictions often hit the bull's eye."

No doubt the eyebrows of Mama Ayesha raised in 1983, when Helen stood up to ask the first question of President Ronald Reagan about vigilante activity by Jewish settlers against Arabs on the West Bank. It caught Reagan off-guard. He had not heard about these shootings, he said. The admission made headlines.

Since the West Bank is where Ayesha was born (Jerusalem), and since the Calvert Street Café hosted Helen's wedding reception, it seemed natural to conduct our interview at Mama Ayesha's. Helen suggested it, in fact. It is right down the street from her condominium. She came with a friend, Joanie Rashid, the daughter of a director of St. Jude's Hospital, Bud Rashid.

Helen greeted me, eyes warm as the strongest Arabic coffee, teeth stained by that coffee. She asked me—good reporter switching the interview around—about myself and the book. On the Middle East issues she asserted, motioning the waiter for *mazzah,* that "Eisenhower showed more courage than any president. In the end none of them have been able to call a spade a spade." [25] It reminded me of a remark made by the chief aide to the House Foreign Affairs Subcommittee on the Middle East in the midst of the invasion of Lebanon in 1982. When asked what would move the House to cut arms to stop the invasion, Mike Van Dusen said, "Concentration camps for the Palestinians." "There's your lead for the book," Helen lit up.

Helen Thomas was born in Winchester, Kentucky, on August 4, 1920, to Mary and George Thomas, Lebanese immigrants of a shipbuilding family in Tripoli. Third to last of nine children, she was destined to cut a broad swath in journalism. Her father followed the broad swath of a peddler, selling shoelaces and dry goods. In 1924, he moved the family to Detroit and opened a little grocery store (a Maronite and Orthodox family tradition in Detroit that would be followed much later by Third Wave Iraqi Chaldean immigrants).

Why did the famous newspaper woman's folks come to the United States? "This story is so hackneyed," she shook her head, stirring sugar into the coffee. "Everyone's the same. They were still seeking something better. From Tripoli to Winchester to Detroit. It confounds me, however—their courage."

Of her Detroit neighborhood in the twenties of Germans and Italians, with blacks in an outer ring, she said, "My first awareness of being different was in kindergarten where everyone was blonde and blue-eyed. I felt I was dropped from another planet. They wanted to make you feel you weren't 'American.' It was only after World War II that Americans discovered there were 'people' living elsewhere."

"We were called 'garlic eaters,'" she smiled, tasting some Syrian bread and eggplant dip. With such a big brood of nine kids, eating was "a convivial sport." She laughed, reminiscing, "We were alive! Every dinner table was a mass argument. We played off each other, fed off each other. Big families are a brawl. We brought our interests from all over town and the country. It was inspirational. But by the time nine kids were there it was kind of out of hand . . ."

For her parents, as for many immigrants, "education was the Holy Grail." Helen was enjoined to achieve—she wasn't pressured to marry as a young woman. (Helen married at 51 to AP rival correspondent Doug Cornell.) Whether or not it was the shipbuilding and seafaring heritage of her Tripolitan ancestors, "freedom

for us was far more than for most Arab American families," she asserted. So Helen took a burning desire to make something of her life to Wayne State University, with a decision to pursue journalism.

From the early years in Detroit's Arab community she also took two other things: a sensitivity for the outcast, the one without a voice, and a sense of the sacredness of life. When I asked her for her favorite "Arab" gesture she responded by raising her hands upward, eyes in supplication to the ceiling of Mama Ayesha's where, no doubt, there were remnants of coffee grounds! Throughout the interview, Helen Thomas would punctuate remarks with a *nashkur Allāh*, thanks to God. "God is running through everything all the time in Arab parlance," she smiled. She remembered her mother's *qūnah*, or icon, fronted by a burning wick floating on oil as a guiding light of her childhood.

She admitted that when she was called "foreigner" in Detroit schools she came home crying. "But you stayed the course," she reminded. "You had your life. I was made aware of prejudice at an early age, which I never forgot all my life and that's why I'm a liberal. I was hardly mutilated, but I was deeply impressed. I spent the rest of my life fighting discrimination."

In 1942, during the war, Helen traveled to the nation's capital seeking her fortune. Her first job was hostessing at a restaurant; then she landed copy girl work at the now defunct *Washington Daily News* for $17 a week. After a year fetching coffee for other reporters she was laid off, a blow that almost propelled her back to Detroit. "Who the hell wants to get dismissed?" she asked. "But every knock is a boost. They did me a big favor, as far as I'm concerned."

They certainly did. Soon she joined United Press (now UPI) for $24 a week and for twelve years rose before the sun at 5:30 A.M. to fill the Washington news ticker with stories and to do local radio. Even today—the "super ego" of the White House press corps, according to *New York Times* correspondent Steve Weiser, Helen gets to work earlier than anyone, usually about 7:30 A.M., reads the major dailies, fetches an errant cup of coffee, and is ready for the 9:15 briefing with the president's spokesman. "I have to do my homework," she said. "*Post, New York Times, Wall Street Journal.* If you get to work at 9:00 A.M., you've lost the day."

Helen Thomas' first glimpse inside the White House was at the 1944 Christmas party by invitation of Franklin and Eleanor Roosevelt. She still experiences "a sense of awe when I walk through those black iron gates, waved through by a policeman, my press pass dangling around my neck."[26] At the same time she underscored, "The presidency awed me, but presidents do not." She told one reporter, "I think that presidents certainly have the toughest job in the world, but I don't have a bit of sympathy for them. They asked for it to the tune of millions of dollars, and to the pain of their families and their friends. So I think it's toe-to-toe. Presidents should know when they get into the White House that they have to be accountable."[27]

The waiters at Mama Ayesha gathered round, the Arabic music clomped a *darabukkah* and clinked castanets in the background. Mama herself hunched over the phone as if waiting for a call from Andropov or Reagan.

Helen actually got to her eminent slot through "patience concerning the female side." She was asked to follow the wife of the president and "domestic affairs." She began with Bess Truman (whom she found "different, but very much an individual"), but it wasn't long before her boss, Grant Dillman at UPI, acknowledged that she was handling as many major stories as her male counterpart, and as well.

Came the steaming *kuftah* (meatball with bulgur) and shish kebab at Mama's! And the rice that seemed to rise in its own steam. Studiously casual, Helen drew more ears as she told of her favorite White House—the Kennedys.

Helen makes it clear in her autobiography that she had an eye for the inseam of Camelot, a way of picking out the hidden tension between Jackie and Jack. She recounted that on Thanksgiving Day 1960, an eight-months' pregnant Jackie could "barely manage a smile to hide her distress" from photographers. Jack was leaving her behind in a jaunty mood to vacation at his father's beach house in Florida. When John Kennedy, Jr., was born, Helen caught JFK by the sleeve and asked him if he wanted his son to grow up to be president. The president paused and said, "I just want him to be all right." Helen had seen Kennedy's pain from his legendary back troubles to the agonized steadfastness over the Cuban missile crisis.

Though she was not crazy about the hauteur and aloofness of Jackie, she marveled at her "brittle wit." Helen offered intimate glimpses of the president. One of her favorite JFK insights is: "If we cannot end our differences, we can at least make the world safe for diversity." When he died the victim of a crazed assassin in Dallas, his UPI shadow mourned: "I don't think anything in my years at the White House can compare to the death of Kennedy. I still feel the pain of his death . . . like a death in the family, a personal loss."[28]

Helen remembered a luncheon in the Blue Room of the Johnson White House during the Vietnam War when the black singer Eartha Kitt shocked everyone by standing up and crying out, "You send the best of this country off to be shot and maimed. They rebel in the street. They will take pot . . . and they will get high. They don't want to go to school because they're going to be snatched off from their mothers to be shot in Vietnam." Helen called it "one of the most dramatic moments I have ever observed in the White House."[29]

The morning after Lyndon Johnson's decision not to run for re-election, spurred by the Tet offensive and the growing furor in the country over the war, the president invited RKO's Evans, Jack Sutherland of *U.S. News and World Report,* Dan Rather of CBS, Max Frankel of the *New York Times,* Helen Thomas of UPI, and Doug Cornell of AP into his jet cabin for steak and chili. He proceeded to launch into a stream-of-consciousness confession kept off the record until Helen printed it in her autobiography seven years later. Helen called it "heartrending."

Nixon was a reporter's president. His darkness made glistening news. Helen devoted the largest section in her book to him. She noted the prevalence of "Zieglerisms" during Watergate, evasions by Nixon's press secretary, the repugnance Frank Sinatra showed the press during these years. It was the enigmatic Nixon himself who riveted her with a "Pray for me" in the middle of the worst hours of Watergate. His suggestion that Helen change from her traditional slacks to a dress incensed women's liberationists.

Helen saw it all, reported on it as the government unraveled and official by official resigned or was fired. She followed Nixon to the Middle East, where she found it a tremendous irony that several million Egyptians danced for him while several million Americans were holding their noses. Just before the end in July 1974, when Helen checked into a motel in Laguna Beach, California, near the summer home of Nixon, the owner said, "This is your last trip, isn't it?" She thought to herself in Arabic, *Maktub*, "It is written."

Helen sat back from reminiscing, and ordered a *baqlāwah*.

Mama Ayesha roused herself from her meal and phone: "*Salamtik* [your health], ya Helen!"

"I come here for comfort and good luck," she winked at me.

"Remember when you screaming?" Mama seemed caught in a private reverie.

"She reads my cup," Helen said.

Mama continued: "I have no family. Everybody dead. You family is your father and mother. When they die, it's over."

Helen: "You love your family, don't you?"

Mama: "Not now! You know what they did to me?" Mama deferred from explaining further and the waiters dispersed.

Helen met Mama Ayesha in 1950 and they became fast friends. She has visited Mama's home—"It's on a beautiful site in Jerusalem on the Mount of Olives." The blatant American siding with Israel, she admitted, pained her: "In 1967, after the Six-Day War, they were dancing the Hava Nagila in front of the White House, and I must say I mourned the Arabs who died and who lost their country."

Mama took Helen's coffee cup, now drained to grounds. She flipped it and stared at the pattern down the procelain sides. "That's the best cup of all!" Mama cried, looking up through her thick glasses, smiling. Her "daughter" from Detroit—the mongooselike reporter who has said, "I wanted to give people the truth—people profit more from an objective piece"—smiled back. And we all went into the night of the West Bank of the Calvert Street Bridge. Tomorrow, Helen would rise for the president; I would rise for her; Mama would rise to cook for all.

"Everybody in America is my child!" proclaimed Mama Ayesha Howar when I returned to interview her two years later.[30] She draws all stripes of the Washington community to her café as if to an undying flame. A hint of Ayesha's own attraction to the capital can be found in the motivating force of her first cousin to

come to America, the Sunni Moslem A. Joseph Howar, who left Jerusalem with two British pounds, stowing away on a ship in Jaffa. Howar then traveled to Bombay, India, where he worked as a servant until finally arriving at Ellis Island in 1903 with $63. His name was changed by an immigration officer who, he once said, didn't want to let Muslims into America. It went from Mohammed Asa Abu-Howah (the last name meaning "Father of the wind") to Abraham Joseph Howar. He explained his emigration: "I was very small for my age—I've always had a slight build. Looking back, it probably was the Turkish Army and my size that prompted me to leave home. I wanted to avoid conscription. And I was tired of being told that I was too small 'to be worth the skin of an onion' as a worker in the fields. Very quietly I made my plans."

When he was asked by immigration officials where he was going, Howar retorted, "Where does your king live?" They laughed and told him the United States didn't have a king, but a president, in Washington, D.C. Howar responded, "If it's good enough for the president, it's good enough for me." [31] Too small even to peddle bananas by pushcart, Howar took to cleaning silver at a hotel until some Arabic-speaking pack peddlers convinced him that good profits could be made on the road. He saved enough money to open a women's clothing store in Washington, and by the century's first decade, he was making between $30,000 and $40,000 a year. Soon Howar got into the contracting business; he built the Islamic Center in 1949—the year cousin Ayesha emigrated; and he bequeathed the profitable business to two sons, Raymond and Edmond.

Like her elder cousin, Ayesha came to escape war conditions—though not Ottoman Turkey's, but those of the new Israel—and she wanted to be near relatives in the capital. At the end of 1949 she spent a few days celebrating New Year's in Damascus, then came to America, in time for Raymond Howar's wedding.

"Ahlan!" Mama greeted me on a July night in 1985. Her head lifted like that of a Galápagos tortoise; she hardly ever moves from her maroon Naugahyde booth in back of the Calvert Café, telephone always at her side. Looking at her with her white hair in pigtails, I slid back in memory to student days twenty years before when a waiter named Mahmoud, who resembled Humphrey Bogart, would dance around the tables balancing ᶜaraq in a glass on his head.

Most assume that Ayesha has never married, but she wasted no time in telling me they were wrong. She was married to a Shafiq Koutana in Jerusalem when she was 21, but he had divorced her in the Muslim way. "He went to the Muslim law, the Sharia, and said, 'I have no wife,' and I wasn't his wife anymore after one year." Koutana refused to come with her to America, living in her house on the Mount of Olives with another wife until recently passing away. Mama has never gone back to see it. He paid her a visit twenty-five years later in Washington, but she wasn't too impressed. Shortly after arriving in the United States, Ayesha married a second time—to a Palestinian American veteran of World War I named Issa Abraham. When he died in 1956 he was buried in Arlington National Cemetery. "They made twelve shots and they gave me the flag."

Mama motioned to a waiter to bring demitasses of Arabic coffee and told me about her life before leaving Palestine. She remembered seeing Scotsmen in the country during World War I. "We used to bring skirts to see if they're women or men," she spoke in her inimitable, slow, gravelly voice. During the famine that hit the Levant at the time, Mama remembered, people would be lucky to eat orange peels, "Everybody they go to the grave and come back." Cholera broke out and killed her mother. "Every day thirty to forty people dead," she said. When asked why the Palestinians didn't revolt against the Turks at this time, she said, "They had no food to move. Everybody stay home."

In the interwar years, Mama raised pigs, making one thousand pounds of pork a week for the British, as well as providing vegetables. The British liked her, "I worked with the British nurses at the hospital. I go buy them every vegetable, everything they ask for. They teach me how to cook English food. I know how to cook it better than the English people!"

Helen Thomas, ever present in the evenings, brought some birthday cake over to Mama, who greeted her, "*Salamtik,* ya Helen!"

Mama related bizarre stories of the British sitting in her house picking German shells off the carpet. After the Second World War she would give them rest in her home. In the middle of the night British soldiers would get up shell shocked, "They used to scream in their sleep and wake up, shouting 'The planes!'"

In the forties, Mama was an honored ally; the British would take her in their limousines on her rounds to gather food supplies to Sarafand, Ramle, Lydda. "Just like I am the King!" she smiled. "Nobody else, only me, because I am honest with the British." But she remembered the bombing of the King David Hotel by Menachem Begin's Irgun with a stare through her thick lenses: "Joe Howar's brother was killed there. They brought a bomb in a can where they put the milk, throw the can on the floor, and it blow up." She heard the explosion: "I think it was awful. Do you think it was right? That's why I came here. I get tired of seeing these things. When the British gone, I get lost. I missed them a lot. If you want to write a history about me, you'll find it in the British Army."

She went for a time with the British Lincoln Regiment to Jordan, but she was in Jerusalem when the war broke out between the Jewish settlers and the Arab Palestinians. She was just up the road when the massacre at Deir Yassin, also by Begin's Irgun, happened: "We have some relatives murdered there from my home town. You know what they did? The women with the pregnant they cut them and take the baby outside in the woods. One woman came, she cry for her daughter and they kill her and put her with her daughter. *Wallah* [by God], the Palestinians suffer a lot." A nephew of Mama's later related to me that his wife's family—the Zahrans—had forty-five people killed at Deir Yassin. His wife's father, Juma Zahran, had lost his first wife, three daughters, and a son; the man now lives in Amman, Jordan, one of the last survivors of Deir Yassin.

Mama described the exodus of Palestinians to surrounding Arab countries, but she thought "the Arab world sold Palestine. I got sick. I wanted to leave." Her

cousin Jimmy Howar met her at the train station in New York in 1950, but in Washington she got lost: "I went for the first time to the streetcar. They go round and round and round. I can't speak well and one man came, asked, 'Where you going?' and I said, 'To my cousin's on First-a Street.' He let me out there."

Mama worked for a year at the Syrian Embassy, then started a small café serving Greek food at the corner of Sixth and F streets, but "it wasn't good business, not far from courthouse, but lots of poor people." Sales tax was one cent on a dollar. In 1960, she started the Calvert Café. "I am the cook, the cash register, the waiter—I am everything!" she crowed, clearly speaking in the historical present tense, since she very rarely moves from her telephone-on-chair these days. In 1965, her sister Sophie came from Jerusalem to nurse Mama, who had broken her arm. Mama has another sister, Miriam, who came in 1972, and a brother, Mohammed, still in Jerusalem (another brother died). In 1967, she and Sophie watched another war in their homeland—this one on television—and they suffered through it, worrying about loved ones.

A nephew of hers, Abdullah, came to join us and suggested it was time to call Jerusalem. Each night, Mama calls her relatives halfway around the world. When she finished, I asked her if she'd like to return for the first time in thirty-five years. "I want to see my house again. I'd like to go. Maybe I go. Who knows? If it's no trouble I will go. I don't want trouble because I had enough." Her relatives that night told her that prices in the West Bank were skyrocketing along with the 200 percent inflation in Israel. She said she had the biggest family in Jerusalem still, with one uncle having 250 children, grandchildren, and great-grandchildren. One built-in feature might assure Palestinian voice in Israel: "Still, they nearly soon be up with the Jews because every house you have 12 to 15 people." She also muttered that her family there feared war with Syria.

What was Mama Ayesha's solution to the Middle East problem? Ever the entrepreneur, she thought a profit motive could help: "Well, it's better for the Jews to be together with the Arabs because they make money. This way they can go to the Arab world and make business. Now they can't go anywhere. The Arab Jews, they are better off than other Jews [from Europe]. Those [Askenazim] will never forget the problem. They scared. They think the Arab is like a snake biting. They're wrong. The Arab people are nice people. There's no sense to say—I don't want you. This is your hometown. You will come here and we will live together. Like America."

Only one American is a queen and therefore only one American is the father of a queen. He is Najeeb Halaby. His daughter is Queen Noor of the Hashemite Kingdom of Jordan and the fourth wife of King Hussein. In many ways, the tall, handsome Halaby, in his seventies, set up the unlikely match, striking up a friendship with Hussein as far back as thirty years ago. They are both avid airmen.

Both men have headed up entities imperiled by the forty-year-old Arab-Israeli

conflict. Hussein's Jordan has fought four wars with the Jewish state since 1948, when Najeeb Halaby was working under Secretary James Forrestal at the Department of Defense. Halaby is chairman emeritus of the American University of Beirut and tried, after taking the reins of the embattled school in 1983, to stem the loss of faculty and students in the midst of relentless violence. It was not easy. Shortly after Halaby took over, his hand-picked president, fellow Californian Dr. Malcolm Kerr, was shot in the head by a Lebanese gunman.

But the tragedy did not stop Halaby. How do you stop a man propelled by his past? How do you stop the man who test-piloted America's first jets during World War II, coached Charles Lindbergh in one, and set an aviation record for the first transcontinental solo jet flight across the United States? This is an informed daredevil, Stanford and Yale educated. This is also the man who was head of Pan Am Airlines when the first hijacking of a jumbo jet 747 occurred in 1970. The hijacker was a Palestinian commando. An Arab American faced off with an Arab. The result was a blown-up plane.

Najeeb Halaby has been thought by many in the Arab American community to have "shirked" his origins. Speaking with him in his modest condominium in Washington, D.C., revealed that nothing could be further from the truth. Sky blue—that is the color of Najeeb Halaby's eyes. But the nose is certainly not Semitic and neither is the height. He revealed himself confidently, in measured cadence, letting the concern come through his voice in careful dropperfuls of emotion. There'd been a fire on the first floor. Unperturbed, Halaby steered through the maze of workers and seated me in front of—a crackling fireplace! This was a man who takes danger in stride. Fire last time did not mean fire the next.

Halaby is gifted with a bi-ethnic heritage: his mother is of Scots-English background (and was still going strong then at 96). His father, Najeeb Senior, came to the United States from Zahle, Lebanon (the family originated in Aleppo, which in Arabic is Halab). He arrived in steerage at Ellis Island in 1900 and, at age 12, began peddling along the eastern seaboard with copperware, jewelry, rugs, and damask material.

The elder Halaby was a particularly good hawker of exotic wares. As his son once wrote, "I think he could have sold Stars of David in the middle of Baghdad." [32] Some of the more intrepid peddlers found their way to wealthy Americans—Halaby heard about Bar Harbor, Maine, a summering ground for the rich where he met Mrs. Grover Cleveland, whom he charmed and who supplied him with the letters of introduction that launched his career.

By 1912, the man from Zahle hightailed it to Dallas where, he had heard, wealth came in the form of cotton and oil. It wasn't long before he had married Laura Wilkins, daughter of a Confederate soldier from Tennessee, and the two put together the venerable Halaby Galleries, which lasted through the 1920s as a sought-after interior decorator on the top two floors of the Neiman-Marcus building. Najeeb's shrewdness with sales linked with Laura's Christian Science re-

liance on rationality and control. Their work space came by way of an invitation from Stanley Marcus. As the son would put it later, "An Arab and Jew working together in a temple of luxury trade a half century ago!"

Halaby's own description of his father is apropos of many original immigrant Syrians who "made it" in the United States:

> My father was a handsome man, just under six feet, and very attractive to the ladies. Toward me, his only child, he vacillated between penitentiary discipline and a marshmallow permissiveness. He could be very sweet, generous, compassionate, and sentimental. He also occasionally beat the hell out of me. He was loving and very emotional, with a short-fused temper and tremendous pride in his Arab heritage. Unlike many Syrians, Lebanese, and others from the Middle East, he refused to change his name or pretend to be anything he wasn't. To my later regret, we never spoke Arabic at mealtime, as did many Arab Americans, but I did pick up a few epithets in the old man's native tongue.[33]

The elder Halaby did much to assimilate as fast as possible. He broke the racial prohibitions against Arabs, Armenians, Jews, and blacks at the Dallas Athletic Club where he entered with full privileges. No doubt his wife's strength and "uncompromising nature," as well as her beauty, helped. As coffee arrived in care of his second wife, Allison, Najeeb drew a psychological portrait of his father vis-à-vis his own development:

> I've gone through several phases [in ethnic identity]. One is like my father trying to be more American than the Americans. That first generation of the immigrant Arabs really wanted to be 100 percent American and changed their names and their religions even. They wanted to be in the Rotary and the Shriners and the country club. And they wanted to arrive socially, politically, professionally. And so when you're raised in that kind of atmosphere, you wanted to be all-American. Yet, underneath, you sensed a deep—the buzzword is heritage. It's also probably genetic. I've found in going back to Syria or Lebanon, through the food, the atmosphere, the air, the sights, sounds, you feel a root that just comes without logic or intellectual activity. It just is down inside you.[34]

Interest in public service, which would involve work under four presidents (Truman, Eisenhower, Kennedy, and Johnson), stirred in son Halaby at an early age. Halaby credits his parents' "high priority in the budget for education" for this concern for public service, but also the Christian Science that obsessed his mother, took over his father, and was pressed into him.

"The Arab has quite an affinity for the other dispossessed, disinherited," he said thoughtfully, folding his fingers into each other. "Because he's had that. He came to this country as a minority. He's remained a minority. Though some travel with the hot shots, the rich set, and forget the minorities, others have said, well my God, but for the grace of good fortune, there go I. I could still be peddling

my wares in a cart. I find people like [Ralph] Nader and [James] Abourezk are dramatic examples of champions of the powerless."

Underdog advocate at the beginning of his law practice, Halaby worked for the Legal Aid Clinic in the Watts area of Los Angeles. He called himself "an FDR Democrat" who was not always popular with his own family in his adoption of liberal causes (his mother voted for Nixon, even though Kennedy had appointed her son FAA head).

One of the things that bothered Halaby about his father was his attitude toward the Jews. "It was partly based upon competition in business and professional life, partly based on envy of commercial and social success, and partly wanting to distance himself from an unpopular minority, one even more unpopular than [Syrians] themselves. [By meeting many Jewish law students] I pretty much rid myself of the feeling that my father had about Jews as an ethnic-religious group. But the great equalizer was World War II. It made us all feel we were equal."

The elder Halaby died when his only son was 12 and had recently experienced the pain of his parents' divorce. As with Danny Thomas and others I interviewed, it wasn't just poverty that spurred the great ones to excel, but poverty of parental attention, or an abundance cut tragically short.

Internationalism became second nature to Najeeb Junior since his folks took him every summer to Europe and the Middle East on antique furniture and rug hunting trips for their gallery in Dallas. His childhood was filled with horizons few children see. It fed his love for air travel, and his sense of social mission led him in the war effort to pioneer the testing of the new jets, including his then-secret cross-continental solo flight that took 5 hours, 45 minutes, far better than the standard DC3's 22 hours. It did not go into the record books till years later because of its secrecy. Halaby called the experience "ethereal, a unique sight to fly over the Rockies and over the desert. Before that, you had to go through the valleys, and suddenly now you just overfly everything! There was kind of a sense of . . ." His awe was sadly cut short by a telephone call from one of the president's Advisory Committee on Lebanon, Joe Jacobs of Jacobs Engineering.

He nudged the cookie plate toward me—the unflappable Arab host. In 1948 Halaby went to work for Secretary of Defense James Forrestal. He remarked about that, "It was considered kind of risky of Forrestal to appoint an Arab American in a very sensitive job—international security affairs." From there he became one of the civilians who helped put NATO together and became first chairman of its Military Production and Supply Board.

Halaby tangentially touched a Middle East fiasco in the making. Forrestal was soon to become one of the first—and certainly one of the most tragic—targets of Zionist apologists frantic about the creation of a Jewish state in Palestine. Forrestal was, in a word, not for it. Halaby's immediate superior was Robert Blum, a Jewish American assistant secretary for international affairs.

Forrestal, as Halaby remembered it, had made a pack of enemies, even before the Israel issue hit him in the ribs, including Truman and J. Edgar Hoover. Then

Forrestal ran into the juggernaut that was Zionism in 1948. The defense secretary worried that the creation of Israel would lose America more friends than it would gain. He commissioned the respected publisher of the *Louisville Courier-Journal*, Mark Ethridge, to study the impact a major Middle East conflict would have on U.S. access to oil and on U.S. security. Ethridge reported that the military would be in serious trouble in the event of a cataclysm there.

Truman received the report. Halaby recalled, "Forrestal was damned by the Jews for pursuing the American strategic interests rather forcibly. Some of his Jewish friends in New York portrayed him in caricature in newspapers as anti-Semitic." Forrestal ended up jumping to his death from a twelfth-story window at Bethesda Naval Hospital. By then, Truman had ignored the Joint Chiefs and carried the U.S. vote "Yea" for an independent Jewish state in Palestine.

Halaby reflected on the mood in the United States at the time: "That was the peak of sympathy for the Jewish people. There wasn't much understanding of Zionism as distinguished from Judaism. The issue was really a homeland for the homeless Jews, and the Zionists were active, but nobody was really aware of it. There is still a deep, wide sympathy for the Jews who suffered in the Holocaust. You might say justice for a few Jews is an injustice for a few Arabs in the total world scene. And we've never gotten that thing balanced." For Halaby, the dispossession of the Palestinians is "a major unfinished business of the American conscience."

"It's total hypocrisy to send $10 million a day for a bullyboy like [Ariel] Sharon to occupy Lebanon and repress West Bankers." He opened his hands now and leaned forward, "I mean that's contrary to everything we ever believed, taught, lived. We can't live with that. And yet we can't quite deal with it, either."

Appointment by newly elected President Kennedy to head the Federal Aviation Administration was a unique honor for Halaby: "That was a thrill in the sense that it was the first time anyone of Arab American background had ever had a presidential appointment," he smiled. "I don't think he was trying to find a house Arab or anything like that. It was that I had achieved a certain technical expertise and capability which was sought by some of my friends in the administration like [now Justice] Byron White and Sarge Shriver, who was doing a lot of recruiting for the president. That was a very high point in my life; I worked hard at that job for four years and I think did a superior job of it."

JFK, Halaby asserted, would not have let the Middle East crisis sit on the back burner, exploding at will while the United States looked on powerless. He believed that Kennedy would have tackled the problem at the root: "Because he really resented overpressuring and because he really wasn't as dependent upon Jewish [campaign] money as some have been. On the other hand, Johnson was considerably more influenceable." It was under President Johnson that large-scale arms shipments from the United States to Israel began. Their effectiveness was demonstrated within two years—the Six Day War of June 1967, when Israel for a time tripled its size in conquest.

The FAA job was filled with challenge and gut-wrenching pathos. Halaby recalls his on-site inspection of the first crash under his stewardship. In 1962, a Continental Air Lines 707 went down in Iowa: "I remember lifting up a metal piece of the tip of the cockpit in the hole the cabin had bored into the ground, and there was the open skull of the captain with the red-warm, almost live brains draining out." [35]

The three accidents that occurred with Pan Am's planes during his stewardship were not with the 747s, which proved to be very reliable, but with 707s. Halaby had a perfect safety record with the jumbo jets over six years at Pan Am, except for one horrible Labor Day weekend in 1970.

A Connecticut state trooper fetched him from his cottage on Fisher's Island off New London, where he had stowed away with his family. Soon he was reading a coded message from Pan Am in London—AFTER DEPARTURE AMSTERDAM FLIGHT 93/06 SEP SUFFERED 9052 REPEAT 9052. That number was the code for hijacking. Two men armed with revolvers and hand grenades commandeered the flight en route to New York. The gunmen were from the Popular Front for the Liberation of Palestine (PFLP). The "unfinished business" of Palestine, as Halaby called it, had turned grim. The hijacking era had begun, and it had begun on an Arab American's watch.

Halaby refused to give into the hijackers' demands to fly to Cairo with a demolitions expert. He ordered a Pan Am truck parked in front of the 747 on the Beirut runway and said that it was not to be removed. But everyone—including the Pan Am chief in Beirut and the deputy chief of the U.S. Embassy there—felt this was too risky. The hijackers' demands were granted, and two minutes after the plane landed in Cairo and was evacuated it was dynamited.

The fiasco did serve to begin the stiffening of security surveillance at airports that is today standard procedure. But the event shook him up: "It was ironical: the loss of the first jumbo jet in flames set by the craziest of the homeless, frustrated Palestinians, who missed their assigned Israeli target and hit an airline headed by an Arab American aviator who had labored long to help get recognition of the rights of the Palestinian people—and in my father's homeland, too!" [36]

But Halaby admitted to me that he had been "under wraps" concerning opinions on the Middle East issue while serving at Pan Am and with the FAA, roughly a period from 1960 to 1972. Only by the 1973 October War was he free to speak out. In fact, the day of the massive airlift of U.S. armaments that rescued the Israeli Army from defeat by the Egyptians, who had just about recaptured the Sinai, Halaby was waiting for an audience with King Faisal of Saudi Arabia. "The airlift," he recounted, "was outrageous to me. I resented the outcome of the 1967 war, but I wasn't really emotionally involved in it. It seemed to me to involve Egypt and Syria more than Lebanon. From 1973 on I have gotten emotionally, actively involved."

I asked him for specifics. He had individually lobbied certain policy makers and congressmen. Halaby was in the Senate gallery the day of the vote on ship-

ping AWACS to Saudi Arabia. Sen. John Glenn, an ill-fated 1984 presidential candidate for the Democratic nomination, is a personal friend who stymied him by "going back and forth" on Middle East issues. George Shultz, the secretary of state, was a Bohemian Club campmate of Halaby's in 1982 during the siege of Beirut. Shultz asked him for ideas for U.S. action. Shortly after the September 1 unveiling of the Reagan Peace Plan, Halaby shook hands in a White House receiving line with Shultz and the secretary said, "Well, did you see your handtracks in that speech?" There were elements of Halaby's notes in the plan. He has had his effect. He felt it "justifies not being a joiner."

Halaby thought most Arab Americans wouldn't buy the "whole Arab cause," and that their political groups live in an illusion: "Well, [most Arab Americans] don't want to defend Qaddafi. They don't want to be identified with the total Arab cause or Arafat or Hafez al-Assad. They say 'I'm a Syrian American or a Lebanese American, or Palestinian American. Why should I take all of the burden of the mythical Arab nation on my back?' There isn't any such thing as the 'Arab Nation.' The Arab cause is too diverse and inconsistent, so to hell with all that." He stood, pacing, reading notes for some meeting. "Arab Americans don't want to get spread too thin. They might give some money anonymously to ADC and NAAA [National Association of Arab Americans], but they're not going to go to Congress on behalf of an association. And finally—why let yourself be a target? Do things anonymously, quietly. If one of my colleagues wants to go see Bob Dole about arms control, he'd do it that way rather than through David Saad [executive director of NAAA]."

I asked him what, exactly, was the stigma of such political groups. "They could become more reputable and more powerful only by shedding some of the zealot fringe, such as Jim Zogby [then of ADC] and Bob Basil," he said. He was especially incensed at the American Lebanese League [ALL], run by Basil, allied with right-wing Phalange in Lebanon whose chauvinism, he felt, would "really blow-torch it for the Christians in Lebanon."

As for Halaby's personal relationships, he went through a "painful but amicable divorce" in the mid-seventies and heads the international venture capital group, Halaby International, with Laurance Rockefeller and others as backers. In 1977, he participated in the group that wrote the landmark Brookings Report that later became a blueprint for the Camp David Accords. But the real apex came when his personal and private lives dovetailed in dramatic fashion.

Lisa, his eldest daughter, in 1976, while at Princeton, began to work for Arab Air Services, jointly owned by Halaby and ALIA, the Jordanian national airlines. Her first task was to design the first Arab university of the air—her father had pledged it would train pilots, mechanics, and controllers for the entire Arab world. But Ali Ghandour of ALIA lured her away to design a new Dulles-like airport for Amman, Jordan. King Hussein soon met the tall, blonde Lisa in the path of the first 747 to touch down at the airport. Within several months of

"working, water-skiing, motorcycling, dining, and caring," as Halaby recounted it, the king asked for his daughter's hand in the old-fashioned way. Lisa had already told Najeeb she loved the Jordanian monarch, and soon the engagement was announced to the world, something, the *New York Daily News* wrote, "pleasant out of the Middle East at last."

Najeeb Halaby picked up photos of two grandsons (two granddaughters came later) as I rose to leave, thanking him. It was obvious he was proud of them and even somewhat beguiled by the extraordinary windfall and drama of this marriage between a Princeton co-ed, whose grandfather was a Syro-Lebanese peddler, and an Arab king.

It took him back to Lebanon, a memory of 1974 when he had lived there: "There was a terribly large gap between rich and poor growing every day. You could see the corruption, the prostitution. Cars are driven with a force—blaam!—like a huge penis! Maybe it needed to be shocked, but not battered as it is. At any rate, we want to give Lebanon the best now. Why not give Lebanon the Bechtels instead of the Basils?"

Vance Bourjaily was hunting coyotes with a shotgun the day I pulled into Iowa City, Iowa. His tall wife, Tina, a weathered woman with sunburnt face and eyes fiery blue as black opals drove me through their 500-acre farm in a Jeep, bouncing over ruts, pointing out the carcasses of dead sheep. Four sheep had been attacked by coyotes the night before, and their entrails were pulled out of their stomachs. "Well, it's the tastiest for them," said Tina, though they'd eat the meat later. The stench of the decaying bodies, meshed by flies, was ungodly. I opened up three gates for us before two figures approached in the distance, one tall, one short, shotguns slung over their shoulders like the crossbars of a crucifix.

Vance Bourjaily is one of America's preeminent novelists. Once friends with Norman Mailer, Bourjaily and the storied Mailer diverged in their careers, the latter to millionairedom, stardom, and six wives, the former to a life of teaching at the famed University of Iowa Writer's Workshop, eleven critically acclaimed but not altogether profitable books, and, for thirty-eight years, one wife.

The short Bourjaily and his tall son, Philip, threw their guns in the Jeep and we headed for the farmhouse. Philip's eyes were heated blue, too; Vance's blue, less fiery, but large with contained mirth and some pathos. At the farmhouse on Redbird Farm, Bourjaily got out cold bottled beer, a relief on the hot summer day in 1983, and showed me around. On the walls of the disheveled, earthy place were mementos of nearly four decades of marriage and writing. There was a framed broadside of "Hamlet in Springfield," the poem signed by its author, Vachel Lindsay. A birthday gift of "The More Fool" from his teenage daughter, Robin, with a photo of Vance, legs up, pouring himself a beer. The poem reads: "Nor ever shall / Until I die / For the longer I live / The More Fool am I." A large crew oar (his son's) above a painting by Tobias Schneebaum, an abstract of a mannish

figure torn, in conflict, circling strokes of his own flailing arms. The man has a doglike head. "It's an in-transition house," Bourjaily grinned, spreading crows-feet, though they'd lived there since 1965.

As we sat to chat, a dog named Moss fell asleep between us. Bourjaily fondled a kitten as he talked, beer in his other hand. Vance Bourjaily is the only serious American novelist of Lebanese heritage to make a name for himself in fiction. (William Peter Blatty has made far more money with demonic potboilers.) He welcomed the chance to reminisce about his father, Monsour Bourjaily, known to the world as Monte, who, among other things, had earned a high living at one time with United Features Syndicate as the ghostwriter of Eleanor Roosevelt's daily column, "My Day." He also probed his ancestral past.

His father, whom he has described as a "round-armed, fluent and persuasive man, with irresistible brown eyes behind business-like glasses," [37] was born in Kabb Elias, Lebanon, in 1894 and was brought to America by his ruddy mother at age 5. The reason appeared to be a bad marriage. Her husband was a cousin known as a big drinker who, when drunk, exhibited feats of strength: "His favorite was to lie down on his back, have one great fat man stand on his stomach and one on each shoulder, and then raise himself up. Six hundred pounds of fat men with him. Apparently he did that once too often and tore himself up inside and died." [38]

Before that happened, Vance's grandmother had had enough of his "kick[ing] her around" and stole off one night over the mountains to Beirut, hiding in a cave with her son, Monsour, watching her husband ride by on horseback searching for them. They went through Marseilles—where the Arabic name was given a French lilt by a French official—and on to Ellis Island. In the United States, the grandmother settled in the Syrian colony of Lawrence, Massachusetts, working in a boarding house for Syrian mill workers, cooking, making beds, cleaning up. She had also taken up her *qashshah* and peddled linens, enough to put her son through high school and to save for return passage to Lebanon.

As I heard this story, I marveled at how similar it was to that of Kahlil Gibran's mother, whose father was an imprisoned dissolute. Or, for that matter, my own grandmother, Nazera, whose father immigrated after his wife had abruptly deserted the family, to die in Brazil. The shatter of marriages was not a common theme for the early Syrian immigration, but perhaps it was good for fomenting in the progeny the life of a writer! Bourjaily's grandmother had "incredible character and vision" and made an enormous impact on his life. He remembered living with her in the house when growing up, listening to her tales.

As for his father, who married a farm girl journalist, Barbara Webb, there is deep respect, love, and some puzzlement. In an *Esquire* piece entitled "My Father's Life," Bourjaily recalled days when he was a titan heading United Features Syndicate, friends with Eleanor Roosevelt and other New York mandarins, as well as days when he fell from grace.

Monte Bourjaily launched syndicated comic strips, including Al Capp's "L'il

Abner." But he also took a big risk cashing in his UFS stock for three-quarters of a million dollars, for he lost most of it with a picture magazine that anticipated the great success of *Life* and a humor magazine, *Judge*, the comic book before its time. By 1940, he was broke; his son described the pathos with a scene of his overqualified father slipping blotting paper into a pair of expensive wingtips where the soles had worn through as he worked on a dock: "He is explaining to me, this morning, in his residential hotel room, that his job involves bossing longshoremen, overseeing the opening of bales of unsold comic books which have been returned by the wholesalers. The books must have their covers re-turned by the wholesalers. The books must have their covers cut off so as to be exported as bulk paper, not resold as some kind of reading matter. The irony there, given the choices my father made, is thicker than those British soles are thin."

Having served as an aide to Gen. John Pershing in World War I, Monte Bour-jaily hit the pinnacle of journalism, threw it (and two wives) away, and ended up scratching a living in small-town papers. Years later, in 1976, Vance received a letter from a friend of his father from high school years in Syracuse, now 83, who reassured the writer that Monsour "had a peculiar habit of hitching up his pants—and he had an infectious laugh . . ." His father by then was 82, in Flor-ida, slipping in his treasured English, Arabic creeping into his weakening voice. Vance concluded his touching memoir, "It's okay, Dad. You and mother gave so many of those words to me." [39]

Dislocation marked the early years of the author-son's life. Born in Cleveland in 1922 (where his parents were both writing for the *Cleveland Plain Dealer*), he was soon moved to Syracuse, then New York, and took long trips overseas. Bour-jaily glibly recalled seeing a young girl in England expose her female parts under a bathing suit to him when he was only 5, and a friend of his mother's trying to fondle him on board ship back to America. Discovered, she grew hysterical and tried to pitch him out a porthole. Vance's mother rescued him. His mother or-dered the children to drink wine instead of water, which she thought was con-taminated. Before grammar school, Vance Bourjaily figured he had learned some lessons about "sex and violence and a taste for booze."

By age 7, little Vance had penned his first poem, "The Dance of the Fireflies," where the fireflies outlast a battle with beetles. By 10 he fancied himself some-thing of a young playwright and took on the role of Puck in *Midsummer Night's Dream*. He was 12 when his parents divorced, and he was sent to boarding schools in three different states, a grim time that he developed into his novel *Confessions of a Spent Youth* (1960).

Bourjaily went to Bowdoin College in Maine, near where his father was edit-ing the *Bangor Daily News*. At 19, he volunteered to join the American Field Service as an ambulance driver in World War II and was stationed in Lebanon as well as Italy. The seeds of this experience went into *Confessions* and his first novel, *The End of My Life* (1946). That book's last scene, where an ambulance

driver's girlfriend is killed by strafing at the front while he is trying to woo her, was drawn from real life, except the real girl was not fired upon: "Fiction, I was to learn, may be the art of telling what never happened, or of telling what damn-well-did, but often it comes out of the masochistic mysteries of might-have-been." [40]

Though his father admired his novels, he was sometimes embarrassed by their sexual frankness. To Monsour, a writer was measured best by, said Vance, "whether you're in the newspaper. You're page one; that's better than anything else." But Vance's career took off on what looked like a rocket in wartime and just after when "book publishing boomed along with the cannons"; the wisdom went, "If he can spell his name the same way twice, give him an advance." [41] After inspecting a sheaf of his poems and plays, the legendary Scribner's editor Maxwell Perkins gave him an advance of $750 to write a novel. He was, at the time, just returning from Osaka, Japan, where he had been sent after being drafted in 1944 into the real live army, only to watch over the ruins of a defeated nation.

Perkins helped him give his rough novel a beginning and an end, things Bourjaily learned to appreciate in fiction. *The End of My Life* was followed by another with Scribner's, *The Hound of Earth* (about a man who deserts his work on the Manhattan Project after witnessing the devastation of Hiroshima), before Scribner's faded for awhile from the publishing scene. Soon, though, Bourjaily had an eight-book contract with Dial Press, one that sustained him for twenty years until he completed *A Game Men Play* (1980).

What a different world it was then for the promising but untutored young author when advances were given to writers on raw talent. In the competitive climate today one must be a star, or languish for decades sitting on moldy manuscripts. As he told me, he thought my generation of writers was hampered by excessive scholarly inspection of the theories of writing: "Your new generation of writers knows a hell of a lot about writing novels. You haven't had a chance to catch up technically with what you can do unless it's matching what you know about it. And it makes it difficult." When he started out, he knew nothing about Henry James' theories of fiction—getting them second-hand through his idols Hemingway and Fitzgerald—and wrote purely from instinct, as did Mailer, Bellow, Shaw, and others at the time.

In 1946, he married Tina Yensen, a beautiful young horsewoman, who was working at the State Department in Washington, D.C. In New York he fell in with the crowd of exciting postwar authors with whom he became friends—Mailer, Bellow, Capote, Shaw, Miller. A critic, Jack Aldridge, gave his already out-of-print *The End of My Life* a boost in *After the Lost Generation*, favorably comparing its treatment of the "loss of youth in war" to *This Side of Paradise* and *A Farewell to Arms*.

Bourjaily edited a literary magazine, *discovery*, which published early pieces for the New York crowd, including Mailer's "The Dead Gook" and Styron's "Long March." Closest to Norman Mailer, with whom he and Tina shared "a belief in

the transcendental necessity of parties," Bourjaily proudly noted that at his best party James Jones met Montgomery Clift and picked him for the lead role in *From Here to Eternity.* Bourjaily swapped his manuscript of *The Hound of Earth* for Mailer's *Barbary Shore,* each giving the other needed critical suggestions for revision. They lived near each other in Mexico City for a time and often went to bullfights together, following the Hemingway trail.

Bourjaily combined some short pieces ("Quincy at Yale" and "The Fractional Man" were published in the *New Yorker*) into his only novel to have an Arab American protagonist, *Confessions of a Spent Youth,* in which the hero, Quincy, visits his ancestral village of Kabb Elias. A quarter-Welsh and half-Lebanese Quincy says, "The largest fraction I was brought up not so much to conceal as to ignore." He broods on his movement in America through a "fluid society [with] no community of moral belief" and contrasts himself to his Old World relatives as "uselessly complicated and discontent as they were simple and steadfast and proud."[42] Quincy's at first comical, then insistent attempt to mask as an Arab leaves him lost. An Arab American critic has written cogently about *Confessions*: "For Quincy, to pose as Arab may well be a way of simultaneously approaching and keeping at arm's length his earliest memories of home and connection to others. To decry the consequences of emigration may well be to lament his premature passage into loneliness."[43]

By 1979, Bourjaily had left Iowa for the University of Arizona; in 1985 he took the job as head of the writing program at Louisiana State University. Bourjaily's wandering, troubled, outsider heroes had finally injected themselves into his professional life.

I wondered why Bourjaily had written only one of his ten books from the point of view of a hero of Arab origin, especially when some of his literary associates, such as Mailer and Bellow and Roth, had milked their Jewish heritage quite strongly. To do that, he felt, an author "would have to have been a kid who was brought up in an Arabic-speaking ghetto, or working-class neighborhood, who is really confined in folk ways, in customs. These have to be the tensions of his boyhood and adolescence. They certainly weren't for me." He thought Saroyan had done this admirably for Armenians, where "the ethnic community is seen as confining, restricting, but perhaps if you get wounded, you go back to it to get bandaged. But the felonious American immigrant novel would be my father's novel, not mine." His grandmother from Lebanon, however, had appeared in fictitious form in *Confessions;* she was "the total strength in my life," he said.

His father's sensitivity to being of Arab background forced him to distance himself from it, particularly when he wanted to move up in American society, and probably imbued in his son a similar distancing. "Whatever it was in the Lebanese boyhood and adolescence which Irish kids teased him about—being dark, big nose, not speaking English very good, poverty—he didn't want to be tarred with it," Bourjaily said. Though raised Eastern Orthodox himself, Monte Bourjaily went to the Roman Catholic Church. Yet he didn't completely sever his

ties to the Syrians. He was friends with composer Anis Foulihan. Vance remembered as a boy frequenting the legendary Sheik Restaurant (once on Washington Street), when it was in Brooklyn, and meeting Salloum Mokarzel, the editor of the *Syrian World,* whom Monte admired. Vance recalled Mokarzel: "He looked like Adolph Menjou, with black moustache, urbane, spoke unaccented English, and had pretty daughters. I was sorry they weren't a little younger! Mokarzel was a sophisticated man with something of a magnetic personality which could draw back temporarily to the Lebanese community people like my father."

But the estrangement from the renowned Mailer flickered through when I asked if it ever bothered him that, as accomplished a novelist as he is, he had never been on the Johnny Carson or Merv Griffin shows. "Oh sure," he smiled. "We all want success in its various guises, and one of them is to be a public figure. But it's hard for me." A short man who speaks in almost a whisper, he indicated he hadn't had the ability to be a self-publicist, such as Mailer and Capote. "If I could have done it, I probably would have," he said.

The death of President Kennedy was a turning point for him as a writer and citizen. "I felt very strongly that there had been a kind of rebirth of hope in the country with Kennedy," he said. "There was a tremendous identification on the part of guys my age. He was the best of us. So when he was killed it was like— they got us." One of his most praised novels is *The Man Who Knew Kennedy.*

Bourjaily wanted to stretch a bit on the hot summer day and suggested we take our beers and some cheese and crackers to his study in an old abandoned schoolhouse on their property up the road. There he got out some old photographs of writer friends, including one of him riding an elephant in a South Carolina parade with poet James Dickey. Another was of Ralph Ellison and his wife, one of close friend Kurt Vonnegut and him in Biafra. A pile of books on the floor, reaching up over Bourjaily's head, were authored by his former students, including John Irving.

I popped open a cork on the subject of the Middle East with the pacifist author of Lebanese background. The invasion of Lebanon had shaken him, he admitted: "What I felt was, the poor, fucking Palestinians, and I didn't mean the PLO. I meant those miserable Palestinian old men and women and children who live in refugee camps and have all their lives, who are pawns in a game the PLO, Syria, Lebanon, and Israel don't give a damn about. They're suffering human beings. And that's where my heart was. Whoever went in and gunned them down and then burned their camps—I thought the real victims of the war were being attacked directly at that point."

Bourjaily ran his gnarled hand over a bronzed dome and short, graying hair: "My emotions about that part of the world are enormously complicated. It has to start back forty-five years ago to an enormous sympathy with the Jews. A lot of the reason I went to the Second World War was because of what Hitler was doing to the Jews. I got to what was then Palestine. I had family feeling for the people I was seeing in Lebanon, but I also was very enthusiastic about what the Jews were

doing on the kibbutzim. I went down on a leave and helped them harvest the wheat on a kibbutz. I took the naïve view, I suppose, that we were all so much together. If you were anti-Semitic, it meant you were anti-Jewish and anti-Arab, too."

In some ways, he chuckled, his deepest sympathies at the time were for the people in the middle—"the poor goddamn British policemen getting shot at by both sides!" But the "first flaw in my admiration and support for the Jews," he thought, was the terrorism of Begin's Irgun. He had not, however, ever heard of the massacre at Deir Yassin. Though the Jews in Israel seemed to him "better disciplined, more rational," than the Arabs, "my adherence to their [Israel's] side probably grew gradually weaker through the years so that I was ready to lose a lot of it when they invaded Lebanon. When that happened, they lost me."

Knowing of the tremendous commercial success of a book that chronicled the heroic independence of Israel, *Exodus,* I wondered what prevented a similar book for the Palestinian diaspora experience? Bourjaily thought there was a reason. He referred to a candid speech given fifteen years ago at the Iowa Workshop by an editor from New York, who said that in the publishing business the rule of thumb is, if you sell New York, you sell the country. In New York, according to the editor, 90 percent of hardcover buyers are Jews. Such a book on the Palestinians would turn them off. And the Arab American readership in the United States, the novelist believed, isn't significant.

But Bourjaily did not discount that such a book could be written and with merit: "I think if you were to take the plight of the Palestinians—and I think it's one of great dignity—you would have to make that shift in focus from partisanship to symbolic condition. The reader would have to say, yes, we're all refugees in some sense or another, in this world."

He admitted finding Yasser Arafat to be "more appealing" over the years, with "a wonderful urchin look about him."

This wanderer-farmer was involved in "trying to fight off a new decadence" in American fiction. The "wonderful reforms in language simplification" brought by Hemingway and Gertrude Stein "have largely been forgotten," he thought. For him, the existential view that sees the world as populated by chaos and isolated individuals was not his view and "has never been."

"I like being very connected to the land, very connected to the animals of the land, and to my students," he admitted. "There are areas of reserve, of course, but I'm a family guy. And I would like to feel very connected to my readers." Getting married early and the kind of woman he married "were stabilizing factors" for him. Otherwise he had found himself "attracted to the wastrel writer's life, of being an alcoholic—obviously marrying Tina prevented this." But he grew pensive, "Whether if I hadn't gone that road and written a few masterpieces and gone mad, who knows?" He called his wife "my Katharine Hepburn."

He gazed out the hazy window of the old schoolhouse writer's loft, where he and his wife had slept in a bunk: "I am neither wealthy nor well known. Perhaps fulfilled."

Before my leaving, he gave me an impromptu seminar in fiction writing better than anything I had gotten in graduate school. I told him I was stymied by a story based on a true incident: a Lebanese American fellow was robbed, stripped naked in Times Square, and after being chased by a raucous crowd leapt to his death on the subway rails. Bourjaily listened. He thought it might be good to write the story from the end back: "Inevitability is much more powerful than surprise." If it were to be done "realistically," he suggested introducing the narrator as the policeman recounting the incident through a series of interrogations. "The fact that he is Lebanese American is irrelevant; that he is from the provinces, okay. My inclination is to write it as a comedy, not as a protest of the callousness of New York. I don't want to see his naked body crushed, or molested by homosexuals. Nothing of what could happen in reality. I'd make it a story of surviving, making friends with cops and hookers—it's not a heavy story then, but a good one, a viable one."

Vance took me to play tennis on the farm's court by a lovely, teeming pond. His strong, short legs made for sure strokes, but he didn't let me be embarrassed by the series of balls I hit over the fence: "You're not playing in the right shoes," he suggested gracefully. And walked me back past the dead sheep for a last beer.

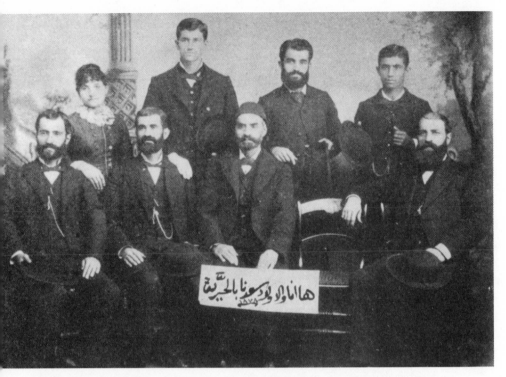

Professor Joseph Arbeely "enjoying freedom in America" (sign) with his six sons
and a niece after their immigration in 1878; the empty chair signifies an absent
relative. *(University of Texas Institute of Texan Cultures)*

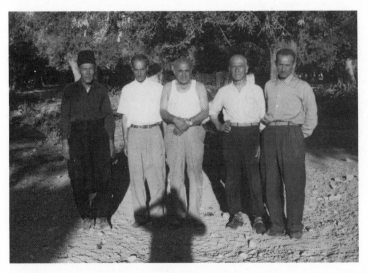

Kamel Awad *(center)* in Arbeen, Syria, with four brothers—Salim, Amin,
ᶜAbdu, and Tawfiq. *(Matile Awad collection)*

Naif Khouri, First Wave Palestinian immigrant, in his cabinet shop in Syracuse, New York, ca. 1910. *(Robert Khouri collection)*

Salim Baloutine *(center)*, a First Wave immigrant from Haifa, Palestine, to Brooklyn, is pictured in 1916 with lace and silk exporters in Japan from whom he imported material for ladies' nightwear. *(Edward and Alice Baloutine collection)*

In a parade in Provo, Utah, on July 24, 1914, the Malouf brothers—Bert, Ernest, William, and Frenchy—drive their horse-drawn float dubbed for their company, Western Garment Mfg. *(Edmond and Kitty Malouf collection)*

A typical Syrian "sweatshop" where women made garments, the Arida Brothers kimono factory was established in New York in 1905. *(Tārīkh al-tijārah al-Sūrīyah fī al-mahājir al-Amrīkīyah [The history of Syrian trade])*

Matile Awad *(right)* and Wardi Malouf hold hands in Brooklyn, 1928. *(Matile Awad collection)*

A young Edmond Malouf does a Charlie Chaplin imitation, ca. 1916. *(Edmond and Kitty Malouf collection)*

Joseph Hamrah *(upper right)* as a boy ca. 1920 with his parents Rose and Butros, brother George *(upper left)*, and cousin James Hamrah *(center)*, in Zahle, Lebanon, before emigrating to Connecticut. *(June and Joseph Hamrah collection)*

Friends and relatives gathered in Boston to meet Kahlil Gibran's casket in 1931. Pictured, *front row, left to right:* Marianna Gibran, Zakia Gibran Diab, Maroon George, Rose Gibran, Amelia Parent; *back row:* Barbara Young, Assaf George, Mike Eblan, N'oula Gibran, and Stephan El-Douaihy. *(Jean and Kahlil Gibran)*

Yousef Yacoub, agent, or *wakīl,* for the Geneva Cutlery Corporation, works at his New York desk, ca. 1920. His son, Joseph Jacobs, later established Jacobs Engineering Group in Pasadena, California. *(Tārīkh al-tijārah al-Sūrīyah fī al-mahājir al-Amrīkīyah [The history of Syrian trade])*

Aref Isper Orfalea, Sr., the original linen merchant in Cleveland, Ohio, stands in the late 1920s in his Avenue Gift Shop on Euclid Avenue. *(Vernice Jens collection)*

Joseph Lupus *(third from right in second row),* an immigrant from Dibel, Lebanon, mans the engine of the Denver–Rio Grande railroad in 1912 at Helper, Utah. *(Carmen and Joseph Awad collection)*

Charles Roum runs the Corday handbag machine at his factory in Brooklyn in the 1920s. *(Assad Roum collection)*

On January 15, 1927, the New Syria Party held this banquet in Detroit in honor of Shakib Arslan, the leader of the Druze revolt against the French. *(Robert Khouri collection)*

At his Atlantic Tire and Battery service station on Atlantic Avenue, Brooklyn, in 1929, Michael Malouf *(left)* works with his father, Abraham *(right),* and two friends. *(Michael and Wardi Malouf collection)*

Overleaf:

In 1928 in Natick, Massachusetts, Fr. Gabriel Barrow of St. Mary's Orthodox Church celebrated mass in a field, then invited the congregation to picnic. *(George and Janet Mousalam collection)*

Ayesha Abu El-Hawa (Howar) on her wedding day with husband Shafiq Koutana at her home in Jerusalem, February 27, 1927. *(Ayesha Howar collection)*

J.M. (Maroun) Haggar, Sr., at his desk in 1926 in the Sante Fe building in Dallas, Texas, where he started the Haggar men's slacks manufacturing firm. *(The Haggar Company; courtesy of the University of Texas Institute of Texan Cultures)*

Jean Abinader, Sr. *(right)*, works with his father, Rashid *(center)* in their peddler's canoe on the Amazon River in Inapary, Peru, near the Brazil-Bolivia border, August 1929. *(Elizabeth and Jean Abinader, Sr., collection)*

In 1930, one year after he had traveled west from Boston, Carim Rihbany joins his wife, Nazira, and their partner in a new grocery store, Santa Paula, California. *(Nazira Rihbany collection)*

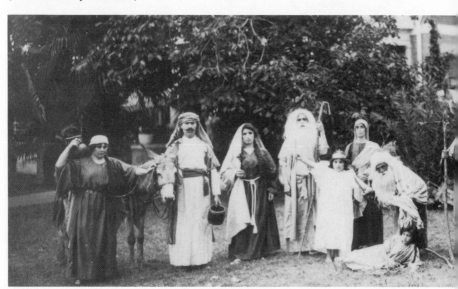

A religious play performed by the Syrian community in San Antonio, Texas, ca. 1922. *(The Semaan family collection, courtesy of the University of Texas Institute of Texan Cultures)*

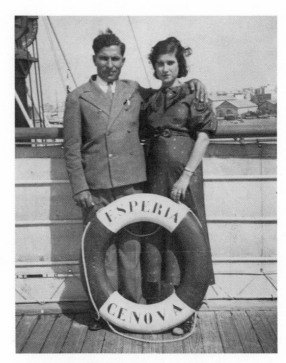

Assad Roum and pregnant wife, Nora, en route in 1937
on the *Esperia Genova* from Arbeen, Syria, to Brooklyn.
(Assad Roum collection)

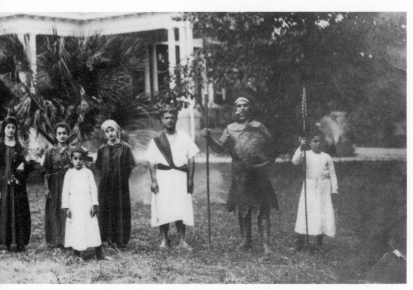

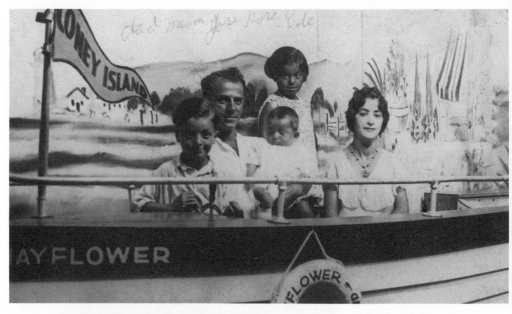

The Kamel Awad family at Coney Island, ca. 1930: *(left to right)* Joseph, Kamel, Edward, Rose and Matilda. *(Rose Orfalea collection)*

During the Palestinian Arab revolt and general strike against the British in protest over Zionist immigration policies, Naim Halabi wears the *kufiyah* in Jerusalem, 1936. *(Naim Halabi collection)*

The bridal party of Jamil and Katrina Halabi pause before going to the church in Jerusalem, Palestine, 1935. *(Naim Halabi collection)*

The Halabi, Farradj, and Sununu families from Jerusalem stand on the Allenby Bridge over the Jordan River, December 1941. *(Naim Halabi collection)*

The Easter procession moves through the streets of Brooklyn in 1943 from St. Nicholas Orthodox Church to St. George Orthodox Church. *(Matile Awad collection)*

Dr. Nicholas Bitar *(lower left)* joins other members of the Eastern Federation of Syrian and Lebanese Clubs on ramp of plane just after landing in Beirut for the first "Reunion" convention, 1950. *(Mrs. Nelly Bitar collection)*

Monsour Bourjaily with his mother, Terkman *(upper left)*, wife, Barbara Webb, and three sons, in 1928 *(Vance Bourjaily is at right)*. *(Bettina Bourjaily collection)*

Lt. Alfred Shehab, 38th Cavalry *(left)*, with Lt. Edward Kuzinski, 2nd Rangers, sitting on a German tank their platoons knocked out in World War II. *(Lt. Col. Alfred Shehab collection)*

Aref Orfalea of Cleveland, Ohio *(right)*, with GI friend in Europe during World War II. *(Rose Orfalea collection)*

First Lt. Louis LaHood of Peoria, Illinois, pilot of the Flying Fortress "Black Magic," lost a propeller after a bombing raid over Schweinfurt, Germany, March 24, 1944. *(Louis LaHood collection)*

Nazera Jabaly Orfalea as air raid block warden for her street in Cleveland, Ohio, during World War II. *(Jeannette Graham)*

Mr. and Mrs. Bobby Manziel *(right)* of Tyler, Texas, with daughter, Merigale, pose with Sen. and Mrs. Tom Pollard at the dedication of the Merigale-Paul oil field, 1946. *(University of Texas Institute of Texan Cultures)*

Amean Haddad *(front)* inspects water pump at one of his Bakersfield farms in 1945. *(Amean and Wydea Haddad collection)*

Essa Lupus, First Wave immigrant from Dibel, Lebanon, comes home after a day's work at the steel mill in Orem, Utah, in 1943. *(Carmen and Joseph Awad collection)*

In Bazbina, Lebanon, Dr. Nicholas H. Bitar of Pittsburgh marries his hometown sweetheart, Nelly Abdou, on July 22, 1951, before bringing her to his new home in the United States. *(Nelly Bitar collection)*

Ayesha Howar is joined at her Mount of Olives home by an officer of the British regiment posing in Arab garb in Jerusalem during the Second World War. *(Ayesha Howar collection)*

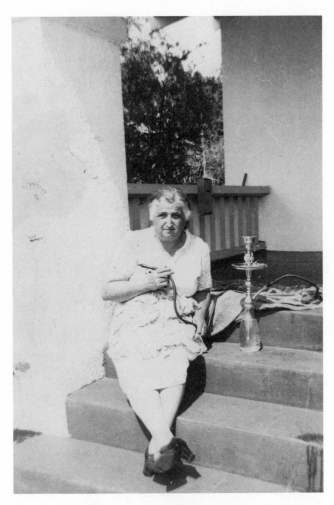

After losing family to famine and war in Lebanon during World War I, in 1948 Mary Kfouri Malouf has her waterpipe on a porch in Pasadena. *(Matile Awad collection)*

October 3, 1951: President Harry S. Truman greets representatives of Arab American organizations. *(UPI/Bettmann Newsphotos)*

In January 1952, Maj. James Jabara *(center)* explains to Capt. Eddie Rickenbacker *(left)* and Gen. Hoyt B. Vandenberg how he shot down six Russian MIGs over Korea. *(Federation Herald, and Immigration History Research Center)*

Egypt's first woman paratrooper, Shahdan El Shazly, boards a plane for a jump in July 1960; El Shazly is now an investment advisor in San Francisco. *(Shahdan El Shazly collection)*

A few years after the Palestine debacle, Edward Awad, first-generation Arab American, serves with the U.S. Armed Forces in Korea. *(Rose Orfalea collection)*

Queen Noor of Jordan (Lisa Halaby).

Najeeb Halaby *(right)* receives handshake of President John F. Kennedy at the White House after his 1961 swearing-in ceremony as head of the Federal Aviation Administration, as his mother, Laura, watches. *(Najeeb Halaby, Jr., collection)*

Helen Thomas *(center)* on her wedding day in 1971 with her eight brothers and sisters *(from left):* Matry, Isabel, Genevieve, Anne, Barbara, Josephine, Katherine, and Sabe. *(Harry Naltchayan)*

Emile Khouri in 1975 at the site of his
architectural conception—Disneyland.
(Aramco World Magazine)

Abe Gibron, former professional football player and, in 1975, coach of the Chicago
Bears. *(Aramco World Magazine)*

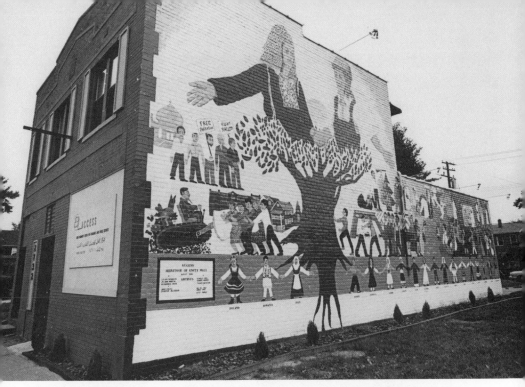

The remarkable mural at the A.C.C.E.S.S. social services building in Detroit, completed in 1980 by 11 artists, depicts Arab history and the history of Arab immigration to America. *(Millard Berry)*

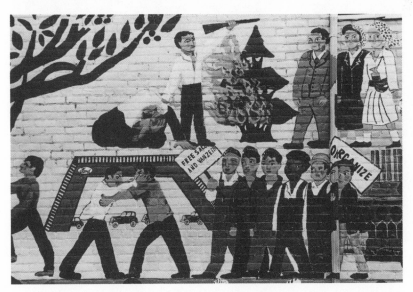

A close-up of the Detroit A.C.C.E.S.S. mural shows *(top left)* the suffering of Lebanon (burning cedar) and *(top right)* Arab immigrants changing from native dress to American suit. Depicted at bottom are auto workers at the Ford plant in Dearborn. *(Millard Berry)*

Novelist Vance Bourjaily at Redbird Farm, Iowa City, Iowa, July 1983. *(Gregory Orfalea)*

Aziz Shihab of Dallas, Texas, stands with his mother, Kadra, in Sinjil (the West Bank) in 1983. *(Michael Nye)*

Circuit court Judge John Ellis administers the oath to practice law to his youngest brother, Robert, at the Vicksburg, Mississippi, courthouse, 1982. *(John Ellis collection)*

In 1983, Charlie Juma, Sr., stands at the entrance to the Muslim cemetery in Ross, North Dakota. *(Gregory Orfalea)*

Peter Nosser, Vicksburg department store owner, is joined at home by the Reverend Nicholas Saikley, March 1984. *(Gregory Orfalea)*

With his bicycle-built-for-two (side-by-side), Jean Abinader, Sr., is ready to take wife Elizabeth *(center)* for a ride in Carmichaels, Pennsylvania, 1983. At right is a cousin visiting from Lebanon. *(Gregory Orfalea)*

Mayme Farris stands on the porch of her home in Vicksburg, Mississippi, 1984. *(Gregory Orfalea)*

In front of a field of asparagus, ADC Delano coordinator Ahmed Shaibi (in suit and tie) stands with Yemeni farmworkers in Delano, California, 1983. Second from right is disabled worker Mike Shaw. *(Gregory Orfalea)*

Ninety-five-year-old Jora Sallie sits on her front steps in 1985 near her daughter, both members of the New Castle, Pennsylvania, Muslim community. *(Anthony Toth)*

Turn-of-the-century Syro-Lebanese immigrants to Detroit worked at the River Rouge Ford plant in south Dearborn, pictured here, before the mosque was built on Dix Avenue to service Yemeni and other Third Wave Arab immigrants, also car factory workers. (*Michelle Andonian, Detroit News*)

4 The Palestine Debacle: The Second Wave of Arab Immigration, 1948–1966

Alfred Farradj, a middle-aged Californian with water combed into his silver hair, owns a typewriter and office machine store in Berkeley, where he has lived for more than two decades. He loves the San Francisco Bay area, its lush, blue inlets, its Golden Gate Bridge, the freedom that blows in with the breeze or hippies. People have been good to his family and it has prospered. So much so that Alfred Farradj was sure he could get me a good discount on a new typewriter. Other than Detroit, the Bay City appears to be the Palestinians' favorite in the United States. The old Chinese groceries in San Francisco are now owned largely by Palestinians. When a new Palestinian arrival is greeted on the streets of San Francisco, he isn't asked, "How are you?," but rather, "*Wayn fatah?*," or "Where are you opening?"

Over lunch with a view of the water, Alfred sat back, wiped his mouth, and said, "I felt more a foreigner in Jerusalem than in San Francisco." But Alfred Farradj was born in Jerusalem. He did not leave it because he wanted to.

In 1946, Farradj was a 26-year-old accountant working for Freeman Company, a British-owned distributor of Morris cars. His father ran a candle shop in the old city of Jerusalem. Alfred looked up from his desk one day to hear a grim report: Menachem Begin's gang, the Irgun, had blown up the King David Hotel. Alfred's brother, Ibrahim Farradj, who was working for the Palestine government at British headquarters there, was killed in the explosion, along with eighty-seven other mostly civilian British and Arabs and fifteen Jews.

Two years later, in 1948, full-scale war broke out between the Zionist forces and the indigenous Palestinian Arabs, poorly reinforced—if that is the word at all—by a ragtag collection of Arab forces. On November 29 of the previous year, the UN General Assembly had voted for a partitioned state in Palestine—one part Jewish, one part Arab—and by May 15, 1948, the British pulled out. On that day, Alfred Farradj became—without knowing it—a refugee. He was hurried off by friends to Bethlehem: "It was three months before my parents knew if I was alive or dead. I finally made it by foot—it took hours because every time there was fighting we had to detour. I stayed with my aunt, who was alone and hard of hearing. Eight hundred bombs they said fell that night on Jerusalem and the doors would fly open. I took her downstairs. At my parents so many bombs fell that the room was covered with black dust." [1]

Shortly afterward, Farradj was to go to Amman, Jordan, as one of about 750,000 native Palestinians (of 1.3 million) displaced by Israel's war for independence. By 1968, he would finally come to the United States to settle, one of 331,958 Arabs listed as immigrants to the country between 1948 and 1985. Though some estimate that Palestinians account for a majority of the combined Second and Third Wave Arab immigration to America, it is safe to say that at least one-third of the immigration was Palestinian, leaving us with today 120,000 Palestinian Americans.[2] That figure, about 5 percent of the total Palestinian diaspora worldwide (excluding those who live in Israel, the West Bank, and Gaza) is 16 percent of the number of original Palestinian refugees. The fact that a sizable group of those refugees emigrated to the country that most supported the forces that evicted them is perhaps one of the strangest paradoxes in U.S. immigration history (see Appendix 3).

Though U.S. immigration statistics list only 4,806 strictly "Palestinian" immigrants from 1948 to 1967, tens of thousands more immigrated from other lands of first refuge. The routes they took were as various as the sealanes and airlanes of the vagabond world they entered. Some came directly from the newly created Israel—where the remaining Arab population had to live in degraded, second-class citizenship. Some came after spending time in exile or in camps in Egypt, Jordan, Lebanon, Iraq, Syria, and the Jordanian-occupied West Bank. Some, like Alfred Farradj, came after they were fed up with the pain of working in Arab countries and seeing their homeland being eaten up little by little with no Arab army able to stop it. Some, like Columbia University professor and literary critic Edward Said and Georgetown University professor Hisham Sharabi, were stranded in America, enrolled in universities and unable to return to Palestine because of war.

The Second Wave of Arab immigration to America, dominated by the debacle of Palestine, also included the beginning of what would be called the "brain drain" from newly independent Arab states, such as Egypt, Syria, Iraq, Jordan, and the North African Arab countries. Some were dissatisfied with the series of coups that occurred frequently in these new states, some wanted a better standard of living, and some were political exiles from intra-Arab squabbles and the Arab-Israeli crisis.

Much distinguishes the Palestinian and other Arab immigrants in the Second Wave from their forebears who charted the path to America in the First Wave. Economic concern, the search for a better livelihood, was the primary reason most early Syrians came to the United States, with political deterioration and warfare a secondary reason. These factors were reversed for the Second Wave Arabs, who, arriving in the United States after 1948, would not have come if it hadn't been for upheaval. Unlike the First Wavers, many were refugees and exiles who had lost a land that was not to be regained and would be transformed beyond recognition:

Unlike the early Syrians—who were 90 percent Christians—the Second Wave
Arab immigrants were 60 percent Muslim.

The Second Wave immigrants arrived more by plane than boat and tended
to be in much better financial position than were the early turn-of-the-century
Arabs.

The Second Wavers were better educated than the earlier group, whose members
were overwhelmingly illiterate before coming to the United States.

This combination of distinctive differences between the Second Wave and the
First Wave kept the two communities for many years separate and distinct, until
the cataclysmic wars of 1967, 1973, and particularly 1982, drew them into a
unique political cohesion, however ephemeral. On the one hand, the Second
Wave Arab Americans had every reason to be even more grateful to the United
States than did the previous group. Since many were exiles from war and politi-
cal upheaval, the United States provided for them a secure haven. Their superior
education and skills might be assumed to have helped them adapt to the sophisti-
cated post–World War II American society more quickly than did their peddler
and factory laborer forebears.

But this was not necessarily so, for a number of reasons. First, the very skills
they carried with them to the New World on 707s, which initially slid them into
U.S. society more easily, also gave them access to social structures that required
them to hide their views. Because 60 percent were Muslim, many were more
spiritually alienated than the First Wavers. Third, as Palestinians—drawn by
U.S. freedom—they were concomitantly repelled by U.S. policies, and this
made for extremely torn feelings, ambiguities not as marked in the early-wave
immigrants and their progeny. Fourth, whereas early Arab immigrants and their
offspring shared in the wholesale adaptation to the mores of America—wanted
them, gloried in them—because in most cases they had come from lands where
national independence was still unmet, the Second Wavers kept "their bags
packed" much longer than had earlier immigrants. Fifth, the alienation the Sec-
ond Wavers carried with them into U.S. society was not alleviated much by inter-
action with the earlier Syro-Lebanese immigrants, whose status was sunk deep
into America by this point; in any case, they did not want to be reminded that the
Middle East was once again smoldering. In short, First Wave and Second Wave
immigrants did not socialize much, though they might attend the same churches
and mosques. Hisham Sharabi described, for instance, meeting an old Lebanese
family descended from the turn-of-the century immigrants in Chicago at the time
of the Palestine war: "Arab Americans had no status, no entity, no conscious-
ness, no existence whatsoever. We once were invited to a Lebanese home. Po-
litically they had no consciousness whatsoever. They didn't even bring the sub-
ject up." [3]

Syrian Americans React to the Brewing Palestine Conflict

Contrary to the benumbed Lebanese the student Sharabi met in Chicago in 1947 who had no notion—or didn't let on if they had—that Palestine was in the process of being excised from the Arab world, there were attempts by Syrian Americans from an early date to speak out on the issue in U.S. forums. The attempts were certainly not the result of mass galvanization. They were not nearly as organized and fervent as those of U.S. Zionist institutions. They were isolated blips on a dark screen, warnings that went unheeded or unheard.

In 1927, *Al-Bayan,* the Druze journal in New York, dealt with a U.S. congressman's suggestion to issue coins and postage stamps commemorating the Zionist "rule" in Palestine. *Al-Bayan* believed that Palestine was certainly "rich" enough in "historical facts" of its own. A little disdain is couched in *Al-Bayan's* injunction to native Palestinians "to rally to the defense of their rights so that the Zionists may not monopolize the offices and resources of the country head and tail."[4]

No doubt the worst riots to date in the growing abrasiveness of Jewish colonists and Palestinian Arabs—those in August 1929 in Hebron—spurred the 1929 debate between Syrian American novelist and poet Amin Rihani and M. Weisgal. It was during the bloody confrontations of 1929 (sixty-four non-Zionist religious Jews were killed in Hebron) that a young Alfred Farradj first heard Arabs shout, "Down with Balfour!" He also remembered "some [Arab] sympathy for the [Jewish] Hebronites. In fact, there were Arabs who smuggled some people out of Hebron to spare them from the massacres."[5]

A nearly forgotten chapter in the battle for Palestine—the 1936 Gandhi-like, nonviolent six-month general strike by the Palestinian Arabs—was recalled by many Second and Third Wave immigrants. Naim Halabi, born in 1900 in Jaffa, had a mixed reaction to it: "It was terrible. You couldn't find anything to eat. You have to smuggle things from place to place. All the boats were on strike. Only government officials used to work. But during this period Jews took advantage of the situation and built a port in Tel Aviv."[6] It was a strike that cut across all classes. According to Shukri Khouri from Taybe, whose father fought for the United States in the First World War, "a strike of the automobiles" was monitored by a Mr. Dajani of the national bank in Palestine. "There was no driving," said Khouri. "Naturally, anybody who operated his car did so against the desire of a coalition headed by Dajani."[7] Alfred Farradj remembered, "There was nothing to do for all the Arabs. You couldn't go to your business or your school. Prices dropped to nothing. Twenty-five eggs for a shilling. Lamb for 25 cents a pound. Women went door to door begging for money for vegetables they were selling. It wasn't a wholehearted feeling about the strike."

Economic pressures finally were too great for the people, and the very group that had started the strike—the Arab Higher Committee—called it off (at the urging of three Arab kings who cautioned reliance on "our friend," the British).

Within a year, open Arab rebellion against the partition of Palestine reached its peak, and the members of the Arab Higher Committee were exiled by the British to the Seychelles Islands. Alfred Farradj recalled with some irony that upon returning from exile one of the leaders, "Khalidi [mayor of Jerusalem], gave stamps to us children at school from the Seychelles."

Palestinians still contemplate that remarkable six-month experience in nonviolence. A recent immigrant from Ramallah (West Bank) to Washington, D.C., who had been imprisoned by the Israelis, called the 1936 event "an exception of the time" under an occupation authority that was actually trying to get out itself. "Nowadays if you strike for one day, the occupation [forces] will come and get welding machines, hacksaws to force open the stores," he said. "There's no chance for that kind of long-term thing. Also, for the shopkeepers themselves, they can't win, because if you strike you're going to get it from the Israelis, if you don't get it from the Palestinians themselves.[8] In spite of such understandable skepticism, the concept of nonviolent resistance appears to be resurfacing on the West Bank a half century after the brave, ill-fated experience in 1936.[9]

With the back of the Palestinian Arab resistance broken in 1939, and the increasingly listless British resistance to Zionist gun-running and emigration, by the mid-forties it appeared that the makings of a bloodbath were irreversible. The on-hand U.S. Arab voices were few. The only groups that had existed from the early 1930s were the so-called regional Syrian-Lebanese Federations—Eastern, Midwest, Southern—which were largely social in function. They had resisted national unification, as well, and hence were no match for the highly organized American Zionists who had, as early as 1922, elicited congressional backing for what the Balfour Declaration in 1917 had called a "national home" for the Jews in Palestine.

But some isolated Arab Americans decided to play catch-up ball. In the mid-forties, the community was called to testify before Congress on the question of Palestine. This was a first, and the community elected Dr. Philip K. Hitti, the eminent historian from Princeton, to deliver testimony.

Dr. Hitti minced no words in his statement before the Foreign Affairs Committee of the House of Representatives on February 15, 1944: "From the Arab point of view political Zionism is an exotic movement, internationally financed, artificially stimulated, and holds no hope of ultimate or permanent success." Hitti reminded congressmen that the last attempt to construct an alien state in the Holy Land—the Crusaders'—lasted less than fifty years. Hitti traced uniform Muslim opposition to the idea of a Jewish state that had grown to a fever pitch in states fighting British colonialism, such as India. But this opposition "does not spell anti-Semitism," Hitti emphasized. "Of all the major peoples of the world, the Arabs perhaps come nearest to being free from race prejudice."

Sympathy with the Jewish plight in Germany was strong among the Arabs, Hitti confirmed, but the idea of a state that would exclude 90 percent of the indigenous inhabitants was odd to them. Hitti then made an offer to persecuted

Jewry that directly challenged the U.S. government's moralisms over Palestine—why not open U.S. soil to Jewish immigration? "They [the Arabs] fail to understand why the American legislators, so solicitous for the welfare of European Jews, should not lift the bars of immigration and admit Jewish refugees, millions of whom could be settled on the unoccupied plains of Arizona or Texas. This certainly falls within their jurisdiction."

It has often been said that the creation of Israel was acquiesced to by a U.S. government adamant about unlocking the immigration door it had opened so generously at the turn of the century, to German Jews, Polish Jews, Italians, Irish, and, of course, Syrians, as well as many others. Hitti's suggestion to use Arizona and Texas stuck in the craw of representatives from those regions, no doubt. Hitti's unique, but unsettling, offer was quickly muffled and forgotten.

Hitti continued his tireless work as the decade moved toward all-out war in Palestine, but to no avail. Records show that the Maronite academician met with Muslim and Jewish groups in October of 1944 for reconciliation strategies. He helped found in the waning hours of the year the Institute for Arab American Affairs (IAAA) in New York City and testified on its behalf before the Anglo-American Committee on Palestine in 1946.

Sidestepping the inevitable fracas over membership, IAAA tried to disseminate its publications among U.S. policymakers. One interesting booklet, *Arabic-Speaking Americans* (1946), written by Habib Katibah and Farhat Ziadeh, was the first attempt since Hitti's own *The Syrians in America* (1924) to translate the community to the American public at large. The book had a unique organization: it cataloged and described Arab Americans by profession from kimono and negligee manufacturers to artists and musical composers like the then-popular Anis Foulihan. It was also the first known organization that referred to a distinctly "Arabic-speaking American" community, as opposed to Syrian-American, or Lebanese-American. It was not until the late 1970s that the appellation "Arab American" would begin to be used by the community at large, and even then not widely.

American Middle East policy, which during the First World War Seth Tillman found to be "ambivalent," by World War II was clearly "contradictory." [10] During the 1944 presidential campaign, President Roosevelt personally endorsed unrestricted Jewish immigration to Palestine and the establishment of a "Jewish commonwealth." His wife, Eleanor, was even more fervent for such goals. Yet, in 1945, Roosevelt met with King Abd al-Aziz of Saudi Arabia on the USS *Quincy* in the Suez Canal, later reassuring him in a letter that the United States would "take no action . . . which might prove hostile to the Arab people."

Though Roosevelt had met with top Zionist leaders, such as Rabbi Stephen Wise, the closest that Arab Americans came to his administration was a meeting with his secretary of state, Cordell Hull, in the early forties. According to Shukri Khouri, he, George Kheirallah, Faris Malouf (a First Wave immigrant peddler

who became a prominent Boston lawyer), and Dr. Fuad Shatara met with Hull and a Jewish delegation, with both sides presenting their views.

After Roosevelt's death in 1945, the Zionist leaders in America jumped on Give 'Em Hell Harry Truman as soon as he was in the saddle. After some initial reservations, he gave them heaven. At a key meeting in 1948, recalling the long efforts of Zionist leader Chaim Weizmann on behalf of persecuted world Jewry— and the inability of Weizmann to secure a meeting with Truman at the zero hour—Eddie Jacobson, a former partner in a men's clothing store with Truman in Kansas City, broke into tears. Those could be called the most weighted tears in post–World War II American history. Truman, at first piqued, scheduled a meeting with Weizmann. The rest, as they say, is history.

Before the fateful hour in 1948 the Syrian Americans did not meet with Truman. In 1946, Truman told American diplomats serving in the Arab world, "I have to answer to hundreds of thousands anxious for the success of Zionism; I do not have hundreds of thousands of Arabs among my constituents." [11] In fact, there were approximately a half-million Americans of Arab descent at the time. They would wait three years for their first official meeting with a U.S. president. In 1951—after the Federation of Syrian-Lebanese Clubs finally achieved national unity (it was short-lived)—a visibly uncomfortable Truman met with a federation delegation. [12]

Immigrants from a Lost Palestine

Many Palestinian Americans who survived the 1948 full-scale war that created Israel speak of it with bitterness, incredulity, sorrow. But none I met had lived through quite so much as Naim Halabi, 83 when I interviewed him in northern California, and none managed to match, in spite of such dislocations, his magnetic serenity. With a head of hair white as a swan's wing and white moustache to match, the handsome Halabi, though a latecomer to these shores, declared the U.S. Constitution to be "a second Bible." A brother of his named Abraham was nicknamed "Abraham Lincoln" when young. Halabi visited America briefly in 1937, after the break-up of the nonviolent general strike in Palestine, in which he had played a part. He lived through the evacuation of his native Jaffa by the Turks in World War I (French warships were shelling the coast), though he said, "One noble thing about it—not a single house was looted or touched [by the Turks]." Halabi, who was an English teacher, tennis coach, and importer of India tires from Scotland in prewar Palestine, was critical of British double-dealings and Arab lack of cooperation with the British mandate commissions: "This was one of the stumbling blocks. Until now we say no, no, no. We are not taking things positively, you see, and so we make mistakes. It's a weakness on the part of the Arabs." Halabi, who counsels Zionists "to look far to the distant future, not only the present, and see they are living in an ocean of Arabs and they have to befriend

them, not subdue or degrade them," also would say to Yasser Arafat: "Yasser, don't stick to arms and ammunitions. You have tried it and you have failed." This Halabi, who was raising the five children of his sister in 1948 after their father died (they all came to America), who was asked by Sabra (native-born) Jews to hide them should the war turn against them, who saw parts of bodies fly by after an Arab coffeehouse was blown up across from his building on Ben Yehuda Street, whose building itself was exploded, spoke with a fixation of homes stripped in Jerusalem by the insurgents:

> For centuries we have cultivated the land, we built homes. Jerusalem, Ramallah, Beit Jala, Jaffa—all built of solid stones, not bricks or cement. . . . I went on Thursday morning on the fifteenth of May downtown to the garage. I took the rotor arm from our car and put it in my pocket. . . . On Monday morning I saw our car on the main street [looted], people looting other houses. I put sand sacks on the windows of our home. The Jews of Jerusalem had gotten short of food. So they went after food when the war broke out. They took all the food from the [Arab] houses [in Jerusalem]. Then they took mattresses and covers. Rugs, every home had several rugs. They exchanged them with America to get ammunition. They started to loot everything—pianos, furniture, everything, everything! On Saturday when they left their synagogues they used to come in scores to the houses, break in and take things. After a few days they put us in a [military] zone. Architects would take what we use and their doctors what they use from clinics. Even they took the wire, cable from the roads. They took shutters, window shutters, because they are wooden. They used to come up to basins which are fixed into the walls, or washtubs, or water heaters, see. Once I stood in front of a [Israeli] tractor and said, "I can't move from here until you go. This is part of the house. It's not movable." It was difficult to oppose them, and in the end, they took everything.[13]

Under the new Israeli rule, Halabi suddenly could not find work. He was refused an import license. A fellow Mason would not let him sell gasoline because he was an Arab. After scratching a living with a small clothing shop, he went with his family to Jordanian-occupied East Jerusalem in 1956. In 1958, he left for Lebanon. In 1977, after living through the worst years of the civil war in Beirut, he finally emigrated to the United States, and San Francisco. His favorite home after losing so many homes? "Where there is peace."

I sought out a number of Second Wave Palestinian immigrants in the United States who had long since taken citizenship and rooted, however precariously, in American society after their abrupt exile from an ancient, heretofore holy, land. Many had tales of woe concerning al-Nakbah (or "The Catastrophe," as the Palestinian Arabs call Israel's war of independence). Among the most interesting of these were Aziz Shihab of Dallas, Texas; Dr. Edward Said of New York City; Dr. Hisham Sharabi of Washington, D.C.; and Nabila Cronfel of Houston, Texas.

It is not often that one is introduced to someone via a poem. But a young poet from San Antonio, Texas, captures her father in love with figs, "ripe tokens / . . . of a world that was always his own."

Over the years I have come to know Naomi Shihab Nye and could not resist scouting out the exact declination and shade afforded by her father's fig tree. The tree is in the middle of Dallas, a city not known for anything as viable as figs but rather typified by freeways and long, dry expanses filled by shopping centers on the ground and Texas storms in the sky. It is a particularly tall tree, as if given freer rein than most figs are given. There is, as well, another one in the front yard. But this one in the backyard was Aziz Shihab's pride, and he filed through the branches of fig as if going through the years of his life.

Shihab is a native of Sinjil (West Bank), a Muslim whose father had had four wives. He had spent the dark days of the 1948 conflict working as a newspaper-man only to discover in the disengagement agreements between Israel and Jordan that the Jordanian chief negotiator cared more about spit-shined shoes than the details of the treaty he was to sign. He would become one of the only Americans of Arab background—and certainly the only Palestinian—to be an editor on a major U.S. daily newspaper.

Shihab took me for a midnight stroll of two miles in a lawn-green, quiet night, lifting his walking stick on each stride and placing it ahead of himself in military style. This was a man who craved ritual, not for official sake, but for the sake of personal meaning. A short man, but with strong legs, his taciturn demeanor flew into a squawking laugh if the right chord was hit. He pointed out who lived where on the block, and it struck me that few people who live in large cities would bother to identify their neighbors. Aziz also lifted the cane to demonstrate dis-tances, to refer to where one building once was and is no longer in the incessant building passion of Dallas. Perhaps, too, he was doing something he would do if in Jerusalem, which he has revisited on occasion to see his mother, who still lives in Sinjil, twenty-five miles to the northeast of the sacred city. The home once inhabited in Jerusalem is now being occupied by an Israeli school for rabbis.

Shihab's work with the city desk of the *Dallas Morning News* was shifted in 1983 to special sections. It was easier, less strenuous work, welcome since his heart attack in 1978. If there were political motivations, Aziz did not know about them.

Born in 1927, Aziz Shihab spent much of his youth in Jerusalem away from Sinjil and in a boarding school because of his father's wives. "Whenever I came home it was a good deal of tension between wives," he said.[14] They all lived in the same compound with a courtyard; Aziz' mother was the first wife and she is the only survivor of them.

Aziz' father worked for the British when they held the Palestine Mandate, with the Department of Roads, smoothing potholes and putting in directional signs. Aziz himself would bicycle and walk these roads, such as the one from Jerusalem to Ramallah, during the general strike of 1936 in which Palestinians protested British occupation and Zionist immigration.

But he was young at that time. By 1948, however, he was 21 and teaching in a school in Jerusalem. Like many Palestinians in America, he could recall little emnity between Arabs and Jews in Palestine on a person-to-person level: "In fact, a lot of our neighbors were Jews and I never felt any tension. I personally did not realize this was a Jew or this an Arab. In fact, I remember my father going to the Jewish doctors when he had eye trouble and I did not distinguish between Arabs and Jews."

He witnessed many battles of the 1948 war, including the collapse of the old Jewish part of Jerusalem. His view of the Arab forces was dim: "The Jews were very organized and knew exactly what they were doing and the Arab army came in—they didn't really know what they were there for. It was very obvious. They were not organized; their leadership was pretty strange, pretty poor. When you have five Israelis who were organized with a goal against even one hundred Arabs who didn't really know what they were there for—that's why the big defeat."

As for the British, "I remember specifically one incident walking in Jerusalem with a fez on, kind of bourgeois and I was pretty happy," he said. "I was cool, putting it on the corner of my head. A soldier came and kicked it off my head and said, 'You are nothing but an Arab.' We didn't have a great deal of luck."

After the smoke cleared in 1948, West Jerusalem was captured by the forces of the Haganah and the Irgun, and Aziz' family gave up their house and moved to Sinjil, on the road to Nablus. Aziz commuted to East Jerusalem to work at a radio station as a broadcaster and then assumed duties as, of all things, the censorship director for the press office of the Jordanian army. He became close to the Jordanian governor of Jerusalem, with whom he worked until leaving the area for the United States. What he witnessed, however, during the disengagement talks was less than edifying and remained riveted in his memory forty years later halfway around the world—in particular, a phone call from Moshe Dayan.

The commanding officer of Jordan's army was away from his desk one day when the phone rang. Aziz picked it up and discovered Moshe Dayan on the line, a leader of the Jewish victors with whom, certainly, no one on the Jordan side was supposed to be talking. When Aziz' boss found out, "he was very upset [and] wanted me to never mention it again to anyone, and that shook me up. Because I thought Moshe Dayan was a great enemy and the war was going on and people were killed. What's he talking to Moshe Dayan for? I didn't know what was going on."

When there was a cease-fire, and the sides had agreed through intermediaries to hold a disengagement meeting and sign a truce agreement, Moshe Dayan represented the Israeli side in Jerusalem, and Aziz' boss represented the Arab side. "He was so concerned that his shoes were shined and suit was pressed," Aziz recalled with bile in his voice. "I couldn't believe it. And I mentioned, you know, that's not important. We are going to decide the fate of so many people. His concern was for the cane that he carried, that the brass was shined, his shoes shined, his pants were perfectly ironed. And when we got there Moshe Dayan looked like

a bum." There was also some difficulty over reading maps: "It was puzzling to me that the Jordanian officers really didn't even know how to read a map. They didn't know the difference . . . this is why, I think, once the truce was signed, villages were divided right down the middle. They didn't know the difference. Israel was playing games with them. So they were good people, but not battle-type people. They didn't know much about Palestine and I don't think they cared much for Palestinians."

Being a second-class citizen under Jordanians made him itch to leave: "I wanted to get out of there and the best way to get out was to go to school." At first he made arrangements for the Jordanian government to pay for university education for him in the States, but "they never pursued it; they never paid anything." He was accepted by Washington University in St. Louis and was soon on "an old beat-up-looking ship" sailing through the Mediterranean from Beirut to Marseilles to Ellis Island, then in its last years of operation. "I was glad to get out, with the intention of staying out as long as the situation [in Palestine] was what it was," he declared.

He debarked in New York in 1950 from a Greek ship, after having thrown all his shoes overboard except the ones he was wearing. He vowed to buy all new shoes in America. Aziz described his arrival, which just happened to coincide with the mayhem of a Columbus Day parade:

> I had the phone number of somebody who was a Palestinian to call and he wanted me to come to his home. "If you come here don't talk, don't mention the Jews because I have Jews who are guests in my home." So I never did go. I stayed in a hotel and the very next morning there was the Columbus Day parade. I couldn't believe the number of people, all the strange silliness in the streets of New York. It was just overwhelming. The parade went right in front of the hotel and it was just far too many people. I can't remember the name of the hotel; there were Arabs, and I started talking to them. A lot of them were Palestinian merchants who came here to get rich. And I did not know if they were living in the hotel or just congregating in it. But they knew I had just came from [Palestine] and they were asking how the situation was. I told them a few things about it. But they really seemed interested mostly in a story than anything else. You know you take a Jew in this country—even now if he has never been there he talks about Israel like his home. Even those people [Palestinian Arabs] who came from there—there was nothing special.

Aziz married Miriam Allwardt of St. Louis and finished college at Washington University. By 1956 and the Suez crisis he had taken American citizenship. His experience as a journalist in Jerusalem and his fluency in English landed him work in the fifties with the *St. Louis Globe Democrat*. He was enthusiastic in those years for the Arab cause and gave liberally of his time to lecture clubs and organizations about the Palestinians. And it hurt him:

I was speaking a lot and I spoke to a group in St. Louis where there was a man named Morton May, who was president of May Company department stores and obviously a Zionist. From what I understood later, he made a call to the newspaper. They came and told me, "You can't do that." I said, "Why can't I do that in my own town?" "Well," they said, "you can't go around attacking the Jews." I said I wasn't attacking the Jews, I was attacking the Zionists and Israel. "Well," they said, "Morton May is one of our biggest advertisers." He owned Famous Stores in St. Louis. [And he had told them], "You tell him he just can't do that." Later they fired me, I think because of that.

The newspaper guild, however, stood by Shihab; he was an active member, a shop steward. Their pressure kept him on the paper for a while, but he was demoted from the editorial department to circulation, which he knew nothing about. "They were trying to force me to quit, which I finally did, and they paid me severance pay," he said. In his judgment, the May fiasco was the cause. There was no bitterness in Aziz Shihab's voice, but a sternness, a recounting of facts however unpleasant by a seasoned journalist, though in this case the injustice had been done to him as an American by an American.

At this point Aziz and Miriam packed up their belongings and two children, Naomi and Adlai (named after the two-time losing Democratic presidential candidate Adlai Stevenson), and went to Kansas City, where he and his wife had first met. They stayed some peaceful years there until something got under Aziz' skin—he was offered a chance to edit a newspaper in Jerusalem in 1966 and he took it. The Shihab family left, however, on the eve of the June War of 1967 in which Israel captured the West Bank and, with it, Shihab's village of Sinjil. They had been tipped off by an American friend at the United Nations five days before the lightning-quick war commenced.

For seven years, Aziz worked for the San Antonio, Texas, daily. In 1975 he moved to Dallas to assume a job on the city desk of the *Dallas Morning News*. I wondered if after the 1967 invasion he felt as compelled to speak before American groups as he had after 1948:

When I came back I did the same thing but not to the same extent. I spoke again and became known through the newspaper. I was president of a [newly formed] American Arab Club in San Antonio and we would meet at the university there and invite speakers. But I realized two things. One, the American audiences really didn't care for the hard facts. After your speech you are leaving [and] somebody would ask you the most strange questions. "Oh, you came from Jerusalem, so you are a Jew." After you spend an hour speaking to them! So you know they are not listening. The second thing was the Arab members of the club—50–60 altogether—were just another Arab world, so divided, fighting each other.

Aziz leaned forward at this juncture and spread his hands at the base of his Jerusalem nontapered leisure shirt. "All these years in this country, after what I know—maybe I just got comfortable in my life, I don't know—but I decided that all this business of Arab information offices, letters to the editor, speeches to clubs, is an exercise in futility," he said with some vehemence. "It doesn't really mean a damn thing. If they are going to solve the problem they are going to have to do two things: one, solve it themselves and, two, solve it on the ground where it is, not in America."

The editor rubbed his furrowed forehead. His disillusionment was real. He had the smell of defeat about him, but also of seering, unmitigated realism. He was not against giving "the facts" to those who "honestly and sincerely want to know" about what happened to the Palestinians from 1948 on, but it was clear where his chief complaint lay. "I am more disappointed in the Arab world and the Arabs than I am disappointed in the United States"—he said it cold.

Battles—not with the Zionists—but with the Arab community in Dallas helped sour Shihab, no doubt. Because of his unusual position as an editor of a major daily, and because the community often felt it was alone and unheard, Shihab was particularly deluged everytime Israel bombed South Lebanon or started a new settlement on the West Bank.

Even at the celebration for the groundbreaking of a mosque in Dallas, a fight broke out, Aziz said, and the police were called: "It's pathetic." For him the fact of internecine Arab strife had taken on the size of myth, of quandary in his mind, something mysterious that—if answered—would unlock so much in Aziz' world: "I hope that someday I will know the answer to why the Arabs cannot unite and like each other. When I see an Arab I don't care whether I have never met him; I have a strong feeling for him. But you listen to them for ten minutes and you don't want to see them again. I don't know what it is. I don't know if it's our history of being occupied by other people that divided us. I don't know if it's our mentality, because we certainly have a lot of love. But why we don't direct the love to each other I don't know."

About the Israeli invasion of Lebanon in 1982—one that galvanized the community more than any other event since 1948—did it stir the toughened sensibilities of Shihab? He said, matter-of-factly, "I am not surprised at anything the Israelis do. I am not surprised that they want to expand and kick out all the Arabs from there. That's been their policy since they were created. So when the Arabs come and scream . . . so what? What's new about it?" But as an American, had his cynicism taken over completely? Was there nothing as a private citizen he felt compelled to do to help the fate of those he left behind?

"I am a fatalist," was the slow return. "I believe the pendulum turns. How it's going to happen, I don't know. It is not going to happen because Israel is going to say we are going to stop expanding. It's not going to happen because America is going to stop supporting Israel. Because every ruling administration depends

upon the support of the Jews. If the Arabs united that would be fine, but whether they would be able to kick Israel out or not, I don't know. So I have no solution. Just wait and see."

At this point we went into the kitchen and Miriam Shihab sat down with us. She was dressed in a kind of folk dress whose ethnic origin could not be determined—some fanciful breed of angel, no doubt. It looked to be a self-made dress and she is a self-made person. She smiled and said that her daughter is more devoted to the "Arab cause" now than her husband.[15] I couldn't resist asking her if there were adjustments marrying a Muslim Arab, and a Palestinian for that matter, after growing up Protestant in St. Louis.

"Of course, you know there would be," her blue-gray eyes flashed. "After we had two children one of their teachers came to our house and said, 'Oh we just think you made the most wonderful adjustment.' I said, 'What's that? What are you talking about? What's so special? You know, we just got along because we are happy to get along. He's different; I'm different—okay. No big deal. You don't think of it as adjusting—you just do it!' "

But after the coffee was poured, Miriam Shihab let her hair down and recalled some humorous contrasts about this new man from the Levant: "He was old country first. Don't wear sleeveless dresses, don't wear shorts, don't speak to another man on the street even if you work with him or know him very well! Return a wedding present from a boyfriend with a note—'We don't want your wedding present'—and things like that were a little hard to do!" She looked over at Aziz, who sat motionless, brows perennially pursed, but with the habit of giving his wife her say. "Now he has adjusted and he wears shorts and I can *almost* dress as I please. I can speak to *almost* anybody, not quite! You know, he gets mad—but I do what I please more or less. Perhaps as we get older I notice the differences more—maybe the first blush of infatuation goes away and you think, 'What am I doing?' If your children are gone and then there's only two of you, you think, why do I have to take this all my life. I want my freedom!" She said the last with mock excitement that almost pulled her over a synthesized inner brink.

"We are lucky," Miriam concluded, recovering from her doubt. "A lot of people don't make it to thirty-two years of marriage." As for mixed marriages between an American and foreign-born spouse of a different culture, "I don't advise it for anybody. I always tell people don't do it unless you find you can't function or get along without each other."

They took me to an Arab market in Dallas filled with sacks of thyme, cardamom, sweet basil, and other herbs and spices that always thrust me back onto a porch in my past. We stopped at a very small new café run by Lebanese expatriates come more recently, since the civil war. Aziz wanted to patronize them and help them get started and wasn't much interested in their politics—though a cross tattoo burned into the owner's skin showed him to be a Christian. Finally, we returned to their modest home with the immodest fig trees. A ladder stood inside the one out back, though it was a month to go before August would fatten the

sweet, pliant fruit. I imagined Aziz standing on that ladder at night, testing the softness of the figs far from Jerusalem.

If there is any final peace to be made between the Palestinians and Israelis, and if the U.S. government is ever to talk to the PLO, one American may carry more of the burden than anyone else. He is not the U.S. president. He is a professor of comparative literature at Columbia University, a Palestinian American born in Jerusalem, and one of two American members of the Palestine National Council.

Edward Said's life embodies enough contradictions that it is a wonder his soul hasn't split right down the center. In a country where English professors are largely conservative in both habit and politics—given more to tweeds than flak jackets—Said, as an author, television commentator, and sought-after speaker, has represented Palestinians and the PLO. He comes from a blue-stripe, preppie, Princeton educational background (add a Ph.D. from Harvard) and yet is close to Yasser Arafat. He lives in New York City, the cradle of American Zionism, and yet is an outspoken Palestinian critic of Zionism. Famous as a Middle East thinker, he is professionally known as one of the foremost literary critics of our time whose initial academic work dealt with Joseph Conrad. His life is fundamentally given to seeking justice for Palestinian Arabs, yet he counts few Arabs as his closest friends. His father was an American GI in World War I; he is a major critic of U.S. military policy.

Yet Said's worlds—literary and political—have always been interlinked. Increasingly, the foundation of his literary criticism *assumes* a political and moral commitment. After his first writings on Conrad and a book exploring how and why novelists "begin" their stories, Said wrote a quartet of books concerning the Middle East (*Orientalism, The Question of Palestine, Covering Islam,* and *After the Last Sky*). Said has hatched a new trend in modern literary criticism, one that is engaging, committed, politically sophisticated, and skeptical. He espouses "secular criticism" and aims a broadside volley at the New Critics of the fifties who have dominated American approaches to literature for three decades:

> But it is no accident that the emergence of so narrowly defined a philosophy of pure textuality and critical noninterference has coincided with the ascendancy of Reaganism, or for that matter with a new cold war, increased militarism and defense spending, and a massive turn to the right on matters touching the economy, social services, and organized labor. . . . A precious jargon has grown up, and its formidable complexities obscure social realities that, strange though it may seem, encourage a scholarship of "modes of excellence" very far removed from daily life in an age of declining American power. Criticism can no longer cooperate in or pretend to ignore this enterprise.[16]

Ivory tower, this philosophy of criticism is not. Said does sit in a brick tower, however. It is located on the second floor of Columbia's administration building, just above the university's president.

It was a cold October day when I got off the bus at the 116th Street entrance to Columbia University and walked across the green of the venerable school on the upper West Side. In many ways, the setting fits Said—the walls of ivy and peace on the outskirts of destitute Harlem.

Said's shirt was a mauve grid—the effect was proper but somewhat contrary, even melancholic. He appeared ten years younger than his age, except for strands of gray in the coal-black hair along his ears. His eyes shine like coal; he has a puckish, dimpled smile and a boyish but resonant voice. For one of such pronounced, even famous, controversial opinions, I found him at times self-deprecating and impatient with renown. In his Byzantine sentences, he was above all kind and even whimsical in his recollections of early days in Palestine, where he was born in 1935.

Conrad seemed a good boat in which to launch. I wondered if he noticed something of *The Heart of Darkness* in Beirut today. "No, no," he reached for the professorial pipe and wandered around the desk looking for tobacco. "I mean, my interest in Conrad is really because it strikes me that he wrote from a point of view that resembles my own experiences. He was born in one society and wrote in another and wrote about a third one. The dislocation and peculiar angle of vision, and then the difficulty of sort of getting it right in a language that was always trying to write about a reality slipping away, is what struck me." [17]

Said was aware of a dislocation in his life "at the very beginning." He was an Arab going to an English school, a Christian in a Muslim society. Even his Episcopal faith put him outside the larger Christian minorities. "Let's say I was never completely at one with the culture or society of which I was a part," he said. "There was always a part of me that wasn't there."

Said's father ran the family business in Jerusalem—the Palestine Educational Foundation—and it was the largest vendor of books and magazines in Palestine at the time. After founding it at the turn of the century, Wadie Said later branched out to publishing and to marketing office machinery and Arabic typewriters. In Cairo, part of the family business thrived even more than in Jerusalem. But in 1911, Wadie left Palestine because the Ottoman Turks were about to draft him into the army to fight in Bulgaria. He was one of the few First Wave Palestinians to join their Syrian brothers in coming to America.

The son's eyes sparkled when recalling that his father had enlisted in the U.S. Army in World War I, like others, ready to fight for democracy but not for autocracy with the Turks. Edward recalled with some mirth Wadie's trip across the ocean to the United States. It had been a story told often in Said households in Jerusalem, Cairo, and Lebanon:

He went from Palestine to Port Said and Alexandria, was stuck there a while, then spent some time in Southampton, England. He worked his way across the ocean as a waiter. He was very seasick. He used to wait on tables and then go and throw up in the galley. And the story he liked to tell a lot was that a purser

asked, "Have you ever been on ship before?" And he said, "Yes." And the purser said, "All right, the first thing I want you to do is clean the portholes." My father didn't have any idea what the portholes were, so he cleaned everything *but* the portholes!

Wadie jumped ship in New York City—getting on a streetcar with a friend and not coming back. "He qualified for illegal entry," Said recalled, bemused.

The "typical self-made man who credited America with a lot of his business know-how," Said's father ran a successful paint company in Cleveland for a number of years and studied at night at Case Western Reserve to become a lawyer. But the pressure on him to take care of his family back in Jerusalem was too great. He returned in 1920, married a woman who was half-Lebanese in Nazareth in 1932, and, though he kept his citizenship papers, only returned to the United States briefly in 1951 to escort Edward to school.

Edward Said remembered the partitioning of Jerusalem into zones; when he was a schoolboy at St. George's High School, "you couldn't cross from one zone to another without a pass to go to school. There was a lot of worry about going to the wrong kind of theater—a Jewish one, or an Arab one." The reason was simple: movie theaters were blown up. As for classmates who were on the other side, Said recalled a Jewish boy named David Ezra: "One felt some kind of tension. I liked him. We were friendly."

Before the end, Said had many wonderful times in Palestine, which he recounted to me. His "fondest memory," however, was not an event but a condition, being "always surrounded by a large number of family members, cousins, aunts, uncles, and so forth. And not only in Jerusalem, because my mother's family lived in Ramallah and Jaffa and Haifa." Nowadays, that closeness, he admitted, was lost: "What really happened after was a tremendous dispersal."

He especially liked day trips to Safed as a boy, and going up to Tiberias along the Sea of Galilee to swim and have a picnic. One of the Galilean villages he recalled was Tubrah, where you could buy roasted corn-on-the-cob from carriage vendors, black ears of fresh corn: "That's a very important early memory that I have," he said wistfully, looking over his shoulder out the window that showed the cold university green. "The last time I was at that shore was almost forty years ago."

What brought the scholar, finally, to America was a very unscholarly activity—he was kicked out of a prep school in Cairo for bad behavior. The boy had gone to Cairo with his family after the 1948 war. Said explained his fall from academic grace at Victoria College Prep:

> The atmosphere at school—all the students were essentially Arab and all the teachers English—was charged. I thought the British—though of generally high caliber—were essentially hostile, for reasons that had to do with British imperialism. There's a certain kind of condescension. The relationship between teachers and students was adversarial. So I was kind of a ringleader . . . And we would

insult them openly, in Arabic, which they didn't understand. I feel that it was sort of a good thing that I left in that way rather than doing what a lot of my class-mates did, which was finish the school. I didn't get a school certificate. A lot of my clever classmates went to Oxford and Cambridge, but I came to the United States.

Another run-in with the British, one that, according to Said, "seems to have made the most impression on me when I was a kid in Cairo," resulted in his being ejected by the secretary of the posh al-Jazīrah Country Club. Said's family, being upper class, were allowable members, but when Edward strolled across one of the club's greens at dusk one day, a Mr. Pilly stopped him and told him to get out. "You're an Arab and we don't allow Arabs here," the secretary said. "This was one of the first indications in my life of the importance of race over class," he reflected, one cinder of anger remaining in his voice.

Said was allowed back in Victoria Prep on probation, but he left anyway. And through a friend of his father who was at the American University of Cairo, he was accepted at a prep school in Connecticut. In 1951, together with parents, Said voyaged across the seas. They went back, leaving him alone in America, as his father had been forty years before.

Said credited his early years in the United States for creating his Palestinian consciousness, "because from the moment I arrived, really, until now, one is al-ways aware of the tremendous interest in Israel which bears on you as a Palestin-ian and as an Arab." Like many Arab American youth, he was called camel trader, rug dealer, and the like and was "singled out for especially unfair treat-ment in various ways" but nothing as severe as a beating. "No, I was always too big and strong," he laughed. "No, I never had that experience in my life."

He was a humanities major at Princeton, finishing in three years of indepen-dent study. He did not study with Philip Hitti there or delve academically into Middle Eastern affairs at all. In fact, Said knew little about Arabic poetry; edu-cated at British schools, he was more versed in European literature and had to study his Arabic at home with tutors. Living in Cairo had sparked an interest in opera and theater. He remembered seeing Gilbert playing Hamlet in Cairo in 1944.

During the Suez War of 1956, which took place during his last year in college, Said began to test an appetite for the Middle East fray, publishing an article in the *Princeton Tiger* about the war. It was mixed with a few tentative speeches on campus and elsewhere. He did have friends who were becoming politically active back in the Middle East, people he visited on summer vacations, particularly in Lebanon, where his father had moved after the nationalization of various indus-tries in Egypt by Gamal Abdul Nasser. Said's father believed that his American citizenship wouldn't help him anymore in Egypt. Ironically, Abdul Nasser es-poused political policies that Said agreed with. More ironic and sad, although Wadie Said loved Lebanon and especially the mountain town of Dhour el Schweir where the family would summer, when he died a threat forced the family out of

the place. Said recalled, "Almost his dying breath [in 1971] was 'Bury me in Dhour el Schweir.' But we were unable to buy the lot because we were considered outsiders. My mother wanted to build a little memorial, just a slab with a small park around it. A quiet place. I was on sabbatical in Lebanon in 1972–73 and I went up to negotiate. You had to buy a graveyard plot—we finally settled on a Catholic graveyard. And then we got threatening phone calls: 'If you build anything here, we'll blow it up.' So that was the first indication, already in early 1973, of bad feelings between the various communities. Perhaps it was that my father's Palestinian. I don't know." [18]

By the time he received his doctorate from Harvard in the early sixties, Edward Said knew he was staying in the United States. The June War of 1967 was an important date in his evolving self-consciousness as a Palestinian. "I felt a complete collapse of expectation," he exclaimed, tapping the pipe on an ashtray. "I mean, one thought that there would at least be a fight."

He called a leave year at the University of Illinois in 1967 "the worst year of my life." Three things combined in this period of "tremendous upheaval" in his personal life: "The shock at the actual quick results of the war, the hostility and tremendous pressure I felt from the surroundings, and my own trauma, which was independent of that."

Shortly thereafter what became the germ of the classic *Orientalism* was solicited by an old friend, Dr. Ibrahim Abu-Lughod. The two scholars had been students together at Princeton (Abu-Lughod was a graduate student) and Ibrahim asked Edward for an article for an anthology he was editing on the Arab-Israeli crisis. Said wrote "The Arab Portrayed," his inaugural effort in how the West perceived the East.

The phone rang. It was a friend from Yale University discussing a speech Said had just given, which had stirred up a furor among some anti-Palestinian students. The friend read him an article written for the Yale student newspaper by Jonathan Kessler, a staff member of the American Israel Public Affairs Committee (AIPAC). Said's eyebrows hiked upward and he smiled puckishly. "Read this," Said thrust the article over his desk to me.

I read out loud, "Said is a master propagandist. He takes in much of his audience because much of his propaganda doesn't come across as propaganda." "He says that what I say is 'accurate but not true.'" Said grinned. We both agreed that was an interesting concept. I asked him if he'd ever been physically assaulted during his numerous talks around the country.

"I've been threatened a lot," he began to reload his pipe. "But that [Yale] audience wasn't hostile. The speech was given in a chapel; it was jam-packed, hundreds of people, and I got a standing ovation. Generally speaking, I think, with one exception that I can remember in ten years, when there was a lot of screaming and shouting and interrupting at the University of Miami, most of what I've done has been reasonably well received."

One professor at Wake Forest University whom I had talked with told me that

when Edward Said was there for a talk he was tersely introduced by the English Department chairman, who then left the room, giving the impression that establishment departments aren't that crazy about him and his controversial opinions.

I don't think that's entirely accurate [he insisted]. There are two aspects to my work that are difficult for some people. One is that my literary work, strictly speaking, is what I have called "oppositional." It goes against some of the currents in the academic study of literature. But it's still considered too establishment in the sense that I teach at a big university, tend to be characterized, foolishly, as a kind of academic "star" of some sort. You know, I've done the Gauss Lectures at Princeton—all that kind of stuff. There's that side to it. Within the establishment I'm considered a kind of sport.

But then unlike anyone roughly in my comparable position, I have this other political side that is difficult for a lot of people to deal with. Now I don't blame them. I mean, I find it difficult myself. Only rarely do I feel that I'm paying a price for my political views, however. It's not something that I am forced to confront every day, mainly because what I teach really has very little to do with my active political involvement. And I make a point—rightly or wrongly—never to teach anything to do with the Middle East although I've had opportunities to do that.

His latest work, since *Orientalism,* has "more and more converged on political issues in the study of culture." Currently he is examining literary paradigms to show "there's always been a political undercurrent within literature in this country; first, there was the battle against Stalinism and then there was McCarthyism, then Vietnam."
Many forget that Walt Whitman ministered to soldiers in Washington, D.C., I noted. "No, no, absolutely," Said exclaimed.

But there's a deliberate, very powerful current trying to extricate literature, culture generally, from the overtly political. I think it's a misreading. I mean that in itself is a political gesture and more and more people are aware of that. It had to do with the way certain writers are studied. In my field for example—modern literature—the tremendous emphasis upon people like Wordsworth and Keats in the Romantic period to the exclusion of Shelley is a part of this attempt to deal with people who are not only nonpolitical, but antipolitical. Wordsworth and Coleridge, in particular, turned their backs on the French Revolution, became more conservative, and so on. The ethos of romantic scholarship has a lot to do with that. A lot of my work in modern literature has to do with reestablishing those connections which have been suppressed.

We came back to a suppression more immediate and violent: namely, that of Palestinian nationalism represented by Israel's invasion of Beirut and expulsion of the PLO from Beirut in 1982. What was Said's reaction? "Helplessness, outrage," he said quickly in a voice sharpened to precision point. "My entire family

was there for that. And my wife's family was there, too. It's a sense of outrage and anger and a very powerful sense of injustice and isolation. You know, a lot of people support the Palestinians, but the fact is in the Arab world what's happened is the continuing isolation of the Palestinian movement."

The eloquent man began to unravel:

You know, there are certain things that defy understanding. One of them is how can you drive a people off its land and say that it didn't happen, or in some way justify it, or in some way pretend that it's their fault for having been there in the first place. All that sort of argument. Another is how you explain the continued victimization of those people after you've done that—killing them, calling them terrorists, colonizing what's left of them, subjugating them, oppressing them in the worst possible way. How do you account for the fact that, even as this is taking place, the people who are doing it get credit for being democratic, lovable people?

Said felt "denial formation" was the most accurate psychoanalytic description of how the Arabs looked at Palestinians now: "You say, 'This isn't happening, or in some way it's good for them or it's good for us.' All the attempt to deny that these quite acute sufferings are in fact taking place. That's the only way I can explain it."

For Said the real solution remains "a Palestinian state, I think, in some measure federated with Jordan"—somewhat akin to the Reagan plan. "I think that would make a great deal of sense," Said continued.

Even at this point, after the assassinations of PLO moderates like Issam Sartawi, Fahd Kawasmeh, and Said Hammami, Said still could say, "I do believe in reconciliation. I do think it's possible. I shudder to think of a state of conflict that is going to endure, because it seems to me that the stakes rise, positions harden, and the outcome is likely to be even more violent than anything we've seen."

Turning to Arab American culture, I wondered if Edward Said felt an Arab American *Exodus* or *Fiddler on the Roof* was in the making. "I don't know," he pondered carefully. "I'm not sure that in this culture you can have one frankly." He continued:

Sociologically there aren't enough—or there isn't a tradition yet of Arab Americans who write, who are involved in the arts. Second, it's not perceived as particularly important. You know, maybe there are other issues that are more important, like surviving, maintaining your identity, and so on. And don't forget the problem with language. For most of us, language is not something that's easily taken over. It requires an almost sublime act of arrogance to say that I'm going to do something of this sort. But the question is, can you make an impression in the face of the dominant culture? I think the dominant culture in terms of the imagination is largely Jewish. You know, there's a lot of very important work in its own terms. Not only in its own terms, but in absolute terms, very good cultural

discourse in essays or fiction and so on. And in that, the Arab American simply plays a very tiny, marginal, unimportant role.

As for shortcomings in the Arab American community at large and a prognosis for the future, Said felt two fundamentally opposed currents—nostalgia among recent arrivals from the Middle East and assimilation urges—still skewered the community:

> The main problem is the inability of the Arab American to make the two stay together in order to create a mode which is Arab American, which isn't laughable and bumbling and halfhearted. You know, Danny Thomas is an example of that, a kind of folkloric, ethnic, self-neutralizing kind of thing. The prognosis can't be worse than that; it has to be better. What forms it will take is hard to tell. I think there is now developing a mode which is Arab American which has its own idioms with some logic. It's not very strong; it doesn't make much of an impression on the American scene, culturally, politically, economically. It's very much in a gestating stage.

I could not resist the final question to which everything, ultimately, must move in his mind as a Palestinian exile and an American. If there were a West Bank Palestinian state, would he return there?

"I'm fully of two minds," he said earnestly. "In other words, on the one hand I would say yes, I would like to do that. But I'm also committed by force of habit, to a sense of exile and rootlessness. New York, I think, enhances that."

Within minutes I was crossing the cold lawn of Columbia to the New York subway, that chilly tunnel filled with gibberish writing and furtive glances and the crashing sound of the train that told me Edward Said had probably had his decision made for him long ago.

He is a short man, utterly serious, on whose taciturn face a smile seems never to have passed. His wit comes in a syringe-full of acid and he had been known to make mincemeat of formidable thinkers with his cutting analyses. You don't expect Hisham Sharabi to tell you he had a maid in his aristocratic family home in Jaffa, a German Jewish woman whom he loved, who adjusted his starched white shirt on his graduation from grammar school with a fond exhortation, "Der blousa must be this way." You laugh. And Sharabi barely lets one corner of his stony mouth crinkle.

Hisham Sharabi is an institution. Author of numerous books on the Arab world, many used as text books, co-founder of Georgetown's unique Contemporary Arab Studies Program and the Arab American Cultural Foundation, Sharabi is probably the reigning dean of committed Palestinian intellectuals in this country. Like Edward Said, however, his academic training was not in Middle East studies or Arabic but, in his case, philosophy.

With a calm born of absolute skepticism, Sharabi folded his hands and told

me he was quite ready to leave the United States at any time up until the mid-seventies: "I was, psychologically speaking, always ready and packed to go back. I never really unpacked until December 1975 when the war in Lebanon made it clear to me that I can't go back home. Even to Lebanon." [19]

Sharabi called Lebanon "a second home" because his mother's family came from Tripoli, and the Jaffa brood would often summer in Aley in the Lebanese mountains. Too, Sharabi went to high school in Beirut and then attended the American University of Beirut. Thus, the expulsion of the PLO and Palestinians in general from Lebanon after Israel's invasion made Sharabi admit, "I've lost two homelands, so to speak."

Like so many Palestinian intellectuals in the United States, Sharabi—considered a moderate who has spoken in forums with Israelis—believed that the Arabs had hurt themselves: "Lebanon itself has broken down as a society and as a state. As for the Arab world, we have missed the bus in the sense that the historic opportunity of an economic, social, political breakthrough based on the power that the Arabs have almost by divine intervention come to possess—this opportunity has been lost over the last seven, eight years."

Similar to Edward Said's, Sharabi's mother still lives in Beirut, and he has brothers and sisters in Syria, Jordan, and Saudi Arabia. But Jaffa was the origin point, famous for its oranges, which he noted "are still called Jaffa oranges in London and Germany and France where they are being exported by Israel. These orchards, which have surrounded the town, were for generations Arab owned, run by Arabs. Now they are owned and run by Jews, but they've been paying Arab workers."

It seems that Sharabi's sternness may have resulted from his growing up fast. He was sent away to boarding school early in life at the age of seven, to the Quaker school in Ramallah. His memories of Jaffa, therefore, are not voluminous; the section of town he was born in, Mashia, is now totally razed to the ground. When he would come home from school he loved to take in a film at the Alhambra cinema in Jaffa, which is still standing. And summer vacations were a dream of blue sea at his grandfather's place in Acre in the northern tip of Palestine. There he would swim and fish with his cousins. In fact, at his office at Georgetown University there are only three photos on the walls—of Acre, "because they bring me back to my boyhood."

Unlike Edward Said—part of whose home city of Jerusalem might be given to a West Bank state—for Hisham Sharabi, Jaffa and Acre are lost forever. He could visit Israel with his American passport, but declines. "Who wants to see it in its present form?" he asked sharply.

One of Sharabi's favorite activities as a boy—bizarre enough—was visiting cemeteries: "We used to love cemeteries, for some reason. Because in Acre on the Feast Days people would go out and visit their dead and take food just to make a picnic out of it, slipping around the graves. My family never did it because I don't think we had so many dead there."

As Sharabi ticked off the key dates of the conflict from the Balfour Declaration (1917) to the 1982 war in Lebanon, he said, "The Palestinian struggle against Jewish colonization of Palestine is one of the most determined and certainly the longest in history of any colonial situation. Three generations have been living this nightmare."

For Sharabi, one of the dominant impressions of his early years was a train robbery, not by western outlaws, but of the Palestine Railroad by Irgun terrorists. He was 8 years old:

> It must have been '37, or '36. The train goes out from Jaffa, from the center of town, through Tel Aviv to Lydda. And then from there to Haifa. When we got to Tel Aviv we were ambushed and they tried to kill the driver of the first engine to derail the whole train. But apparently they didn't succeed in doing that. They kept shooting at the passenger cars and I remember my mother covering me with her body on the floor. Everybody yelling and shouting. That is probably my only memory of being in a state of danger, directly exposed to Jewish terrorist attack.

When the Haganah and Irgun irregulars attacked Jaffa, Sharabi's mother was at his grandfather's home in Acre. His brother and father fled Jaffa to Nablus, where his father's family came from, thence to Amman, Jordan. His mother and her family ended up in Beirut. In essence, the Israeli war of independence split the Sharabi family in two.

The bewildered, pained graduate student Sharabi faced the strange city of Chicago during the dispossession. He was 21 and, like Edward Said, he was invited to speak on Palestine to various student clubs. The first talk was packed with interested students. He was surprised to find that everyone was Jewish, including two fellow residents of his international house: "They were not hostile to me. But [other] Americans were not interested in the problem. They were Jewish and their concerns were totally different from the ordinary American. Nothing in my environment moved at all on this issue except American Jews and, of course, the American press. I used to buy the *New York Times* every day at 11 A.M. when it arrived by plane. I sat and read the unfolding of the catastrophe. It was very hard, I must admit. Very hard and alone."

Yes, he said, with a slight smirk, when he was a little boy he was watched over by a German Jewish nanny who told him to button "der blousa." Sharabi also studied the violin in Jaffa with a Jewish violinist, German or Hungarian. And his very first nurse was named Rachel. These figures were like strange sylphs, guardian angels who came, helped, and disappeared from the young Sharabi's life. Other than them, he indicated, "We didn't see the Jews of Palestine. You'd be surprised at how little contact there was."

In 1979, defying hardliners, Sharabi was the only well-known Palestinian American who spoke at the *New Outlook* Conference in Washington, D.C., arranged by a humanist, dovish Israeli journal. Still, he told me that Israel's current path was a "defiance of everything that makes up history." He went on:

This colonization is unique in many respects. In the first place, it occurs at a time when the entire region has been decolonized. It's a movement in reverse. It comes at a time when the colonial world has collapsed everywhere in the world. They simply have come too late to that part of the world. Within two decades [Israel] it will be over 50 percent Palestinian Arab. And then surrounding Palestine is another two million Palestinians. There are four million Palestinians today. No, I don't think Israel has a future as a colonial society. The Jews have a future, but not as colonists, not as a racist, superior, dominating power. This is a phase that will pass. Israel is vulnerable to sophisticated war more than the Arabs. Destroying certain basic industries would paralyze the whole state.

As for the Arabs, "the infrastructure of a modern society is already being formed. And when that society is completed it will be like Hong Kong or Taiwan confronting China."

The jubilant reaction of most Americans at large to Israel's lightning-fast victory in the 1967 June War shook Sharabi: "It was a traumatic experience. It had a radicalizing effect on me. But I belong to the older generation and to become radicalized at forty is literally a very responsible experience," he admitted. "It's no longer rhetoric. So suddenly Marx and the whole Marxist tradition opened up. Now there was a constant re-thinking of inherited values. I don't mean only of my country but those inherited from my Western education. So I gazed in self-criticism, not only as an Arab, but as a Muslim and also as [one] belonging in a very intrinsic way to a Western tradition that sets up individual freedom in the very heart of a meaningful life."

Although he was raised a Sunni Muslim, in his teens the religion fell away from his life: "My grandmother was very devout. I would hear the Koran constantly, I'd see everybody praying five times a day. They tried to send me to get religious instruction as a little boy, during the summer, in the neighboring mosque. But somehow it didn't catch."

"What today would you bow your head to?" I asked Sharabi. "What system, or collection of absolutes?"

"None whatsoever," came the reply. "I have become through the years more and more relativistic. My approach is certainly very tolerant, but on the whole, skeptical of absolutes. Truth, with a capital T, good with a capital G."

Sharabi's assessment of the lobby he helped to form in 1972 was mixed: "We had high hopes for NAAA [National Association of Arab Americans]. But NAAA is not the national organization we had conceived a national organization to be. Its membership is still very limited. It's going to take much longer than I thought." Sharabi felt that for successful Arab Americans, "those who make it, one of the first reactions is to get out of it, to disassociate themselves—they want nothing to do with the community. It's like the opposite of the Jews. When the Jew becomes wealthy and socially prominent, he becomes correspondingly responsible for the community."

There is a silence that surrounds Hisham Sharabi, repelling some, attracting others. My strongest memory of him is his chairing a meeting of West Bank notables from all factions, whom he had gathered in Washington, D.C., in an emergency conference in November of 1982, just after Sabra and Shatila. Sharabi hoped to gather a broad-based delegation to speak with Secretary of State George Shultz and convince the United States that the West Bank supports the PLO, and can make peace with Israel. But the meeting was predictably raucous, and a PLO representative in the room apparently exercised a veto on the large delegation. Sharabi—after hours of argument—finally rose, drew all eyes, gave a speech filled with subtle rebuke that, once again, the Palestinians were missing the boat due to technicalities and fear. He then left the room.

But, obviously, Jaffa and its sea and Acre and its wall and all the pall of the Palestinian diaspora had not left him.

The Second Wave Palestinian sorrows tend to be elegies over a lost world. They may be indignant as with Said, even foreboding as Sharabi's, but underneath most testimony is a thick layer of skepticism and disillusionment, such as mirrored by Aziz Shihab.

Some Second Wave Palestinians emigrated later than 1948 after fleeing to neighboring Arab countries. They often are very successful and tempered by unsavory, or disappointing, experiences in the Arab host countries, which—except for Jordan—did not grant Palestinians citizenship and kept them at a political arm's length and in pariahdom. One such Second Waver is Nabila Cronfel, a beauteous, lithe director of a fashionable high-rise apartment condominium in Houston, who came to the United States from Damascus in 1960.

It took twenty-five years in America for Nabila's father to try the impossible: a Disneyland-like replication of the Cronfel home in Jerusalem, but in Laredo, Texas. In 1975 (the year before he died), Elias Cronfel purchased the biggest house in Laredo, a historic landmark in town, as a birthday present for his wife, Aimee. The structure was in a shambles, a real fixer-upper, and, as it turned out, no Cronfel ever lived there. In 1983, a private school leased it. But Elias had been attracted to it because it was made of limestone—a traditional building block of Palestinian houses—and he told his wife, "I want to return you to Jerusalem!" Nabila lifted the lids of her olive green eyes and smiled, "It was totally impractical, the big old Salinas House. But he did it."[20]

In Jerusalem before 1948, Elias Cronfel was a prosperous importer of English linens and men's clothes. He owned the city's Spinney Building and did a lot of business with the British. His respected opinion was sought after by one of the many international committees that toured Palestine. As for the 1947 partition of Palestine into two states—not accepted by most Arabs—Elias Cronfel thought it was all right.

But squads of the Irgun and the Stern Gang were shooting up the Arab sectors of Jerusalem from armored cars. Nabila said, "The terrorists came driving down

our peaceful residential street shooting and the maid fell on two children, my brothers." The violence of 1947 was to her mother "the last straw," and by 1948, as full-scale war broke out, the Cronfels left Jerusalem for Syria. They left all their possessions—Bohemian crystal, silver from China, Bombay beveled glass, rare mahogany pieces, clothes, photos of relatives. They also abandoned some of the choicest property in Jerusalem near the King David Hotel, which today houses Israeli government buildings. The only member of the family to return was Nabila's sister—in 1967. "She was cursed by Israeli residents," Nabila said ruefully.

Damascus was not much more hospitable in those early, trying, chaotic years of putting things together after the tragedy than it is today to Palestinians, official jargon to the contrary. Nabila was born there in 1954, but by 1960, Elias had decided to take the whole family to the United States. As with the First Wave immigrants, they took a boat and got seasick.

They arrived in New York City, but quickly made their way southwest to the border town of Laredo where two Cronfel brothers had gone in the 1930s, coming up at that time from Honduras. "If I put myself in my parents' position, it is hardship," Nabila said in her scratchy voice, a definite contrast to the gentle beauty of her face. "My mother knew no English or Spanish. My father was in his fifties and to start all over is not easy with four kids. He took nothing for granted, coming out of the hardships in the Middle East war. And mother was an independent woman."

There was a small community of Arabs at the time in Laredo. Elias slowly expanded from a dry goods store selling women's lingerie to an electronics shop. Soon he was trading with Mexico over the border and his company registered at one time one of the highest volumes of U.S.-Mexican trade on record. But as the peso was devalued and the recessions of the late seventies hit, the Cronfel family business was also hit. In 1983, unemployment in Laredo was a whopping 27 percent. One by one the Cronfels followed Nabila to Houston where there is a sizable and prominent community of about fifteen thousand Arab Americans. It is growing with Third Wave immigrants, quite a few from Lebanon, and wealthy Syrians who are "not too happy with what's going on" in the Assad regime. The Saudis who come often to Houston do not stay. "They like it too much back there!" Nabila confirmed.

Nabila Cronfel's office in the Warwick Hotel is floored with plush carpet, and one wall is all glass. But there seems nothing fragile about Nabila, who possesses a sternness that purses her eyebrows and a voice almost raw by nature. She has been back to Syria and Lebanon four times, but has never seen her family homeland in Jerusalem. And yet she admitted, "I feel more Palestinian. Even my mother—who was born in Syria—felt more so, too." Nabila, at 29, was one of the leaders of the community, a self-proclaimed "political and social person" who has been the community chapter chair of the NAAA and ADC.

"Why am I so involved?" she asked rhetorically. "It goes beyond your con-

scious memory. The conversations of my mother over card games with my aunts covering Jerusalem make a knife go right through me. I was hurt. A woman from Bethlehem was here for open heart surgery and Mother reminisced with her. And it hurt me again. My family was not militant. There was a loving feeling for the culture, and we were required to speak Arabic in the home growing up."

By 1983, although she said about the political situation abroad that "there's always hope," she had to admit, "I really don't see the path now. It's stifling. No door. No exit. Constant harassment and torture stories are very depressing, and little of it reaches the press. You meet a lot of Palestinians in the Gulf and they take nothing for granted—they've lost everything. So they plan. I'll say one thing—here in the United States Palestinians aren't afraid to admit they are Palestinian. The Syrians and the Lebanese? Not so much!"

Other Second Wave Immigrants from Arab Regimes

The Second Wave of Palestinians, Egyptians, Iraqis, Syrians, Lebanese, Yemenis, and others was a small one, about eighty thousand immigrants in nineteen years. Aside from Palestinians, the rest constituted new immigrants from countries just emerging into independence and going through growing pains that included revolution, purges, redistribution of wealth, corruption, and megalomania. The largest portion of these immigrants were Egyptian (about 20,000).

Sophia Loren–like Shahdan El Shazly, a successful investment advisor in San Francisco, did not come to the United States for political reasons. In fact, at the time of her immigration—1960—her father was one of President Nasser's confidants. El Shazly came out of a very positive, youthful love of freedom and a not negligible factor: she fell in love with a Chinese American from Chinatown, San Francisco.

The boil of cultures from the Middle East, the Far East, and the Far West of the California coast cooled into an earthy mix in El Shazly, born in Cairo in 1944 into a military family. Her father would go on to become the general who would lead Egypt's forces to the turning-point crossing of the Suez Canal in 1973. Saad El Shazly would become an Egyptian hero, and the credible military showing against the heretofore invincible Israelis paved the way for the Sinai disengagement and the Camp David Accords.

But the general believed that Anwar Sadat, president of Egypt, had botched directives to the general staff during the war, compromising field positions that could have ensured, if not victory, better cards at the bargaining table. His *The Crossing of the Suez* was banned in Egypt and caused El Shazly to be deported. While ambassador to Portugal, El Shazly was exiled because of his criticism of the Camp David agreement. Today he resides in Algiers. His daughter had come to an Arab American convention in Washington, D.C., with a petition to Hosni Mubarak on behalf of her father. Shahdan was suave, svelte, with hair in a mod-

est Afro and glistening dark eyes and wide smile that spoke of someone who by her own admission "has never had an identity crisis." [21]

She was Egypt's first woman paratrooper; years later she was one of the first women in San Francisco to make a mark in the investment business. And though meeting Frank Chinn in London when she was 17 was a turning point in her life and propelled her to America and San Francisco's Chinese community, she admitted that the idea of equality of sexes in America had appealed to her before that: "I think I thought about it [leaving Egypt] long before that. I think I was fascinated mostly with the freedom that I thought then women had." But she continued, taking a drag from her cigarette, "Of course at the time I was very young—freedom to me was chewing gum and smoking and wearing pants!"

Freedom was barely what she got in her whirlwind romance and marriage. An international businessman, Chinn took Shahdan to California, then Hawaii and Southeast Asia. By the time she was 21, she had two children. But perhaps, as she feels today, she was spared psychological burdens: "I often thought about getting married young and what that means. I think it's not all bad as so many people say because the twenties are a very turbulent time and when you've married, they're not, because you are too busy—shopping, cooking, taking care of the kids—to worry about your identity."

Even in the leading liberal city in the United States, there were indications that she had not landed in complete feminist utopia. One day she and another woman investor found themselves at a meeting at the all-male University Club, where they were told they couldn't take the regular elevator because "sometimes there are men with no clothes." They ended up riding the service elevator to the meeting. But she wasn't resentful: "I was happy to be one of only two women in the group."

"And then you ask me what is feminine identity?" she smiled. "I don't know. There's something you feel inside of yourself, I think." "You have it," I ventured. Dressed in a jump suit with a scarf tucked at the neck she was: herself. "I think so; yes, I have it," she laughed. "I think it probably has to do with the long culture of female identity [in Egypt], which I don't think this culture has. I don't think you have to ape the corporate identity of the man. It's not necessary."

Lack of identity crisis, she confirmed, came from having "a strong family and an extended family." The many-layered Egyptian past contributed to a sense of belonging, of a wisdom chain, whereas "America really has no history." She said with disdain, "You take a kid here and the furthest he will remember is maybe his grandfather." For her, five thousand years of culture comes bursting into the consciousness of the Egyptian through proverbs, things not told in school, but *known* through family and tale. One of her favorite proverbs is, "A child in a mother's eye is a gazelle."

El Shazly's own children, born American, have given her cause to reflect on Egyptian and American approaches to modern troubles. One boy at 15 had difficulty with his mother's divorce. He had been to private school in England and

starred for its soccer team. Coming back to San Francisco he had to enroll in a public school where gang wars prevailed. He refused. It caused a family ruckus. Her ex-husband recommended that the boy go to jail as a wayward child. Her current husband recommended a psychiatrist. But for Shahdan, there was a warmer way, and she pinpointed it in an Arab proverb, "Take the child as big as his brains." The English of it would be, "Take him at his own level." "It's very American to go to a psychiatrist because if you're not achieving there's something wrong with you," she said. She rode the waves of her son's agonies and doubts and he turned out fine.

Ultimately, though she is happy in America, she misses "a sense of permanence which I have never felt in this country." In Egypt there is timelessness: "People don't move; people don't change jobs; people don't change addresses. I mean I go back to Egypt and it's the same. Twenty years later, for example, I find that the man at the club who is the porter is the same man. I find the same waiters there. I go to my old school and all the teachers that were there when I was a child are still there. At the Ministry of Information where I worked one summer in high school I go back now and the elevator man is the same, the department is the same."

Now twenty-five years an American and middle-aged, El Shazly thinks of growing old in the United States and it distresses her. She told me she "would probably like to grow old in Egypt and not here." I asked her why. She said: "For the elderly, it's a terrible society, I think. Old people here—there's no respect for old people. There's natural respect that we have for our elders in the Arab world; it doesn't exist here. I am constantly amazed and appalled at the people that put their parents away in these institutions. I can't imagine an Arab woman alive and well putting her mother away, or an Arab man for that matter." I informed her that indeed the first Arab American rest home had been opened in 1983 in Brooklyn, the community's oldest colony. It was not being patronized hugely, but a few elders were being admitted. "That's the Americanization, isn't it?" she exclaimed.

Political changes in government since 1960 may have boxed her out. She was persona non grata along with her father under Sadat because she kept promoting his book in the United States; it might be difficult for her under Mubarak as well. Her sisters remain in Cairo but are not politically involved. The irony is that America allowed her the political freedom she wasn't missing when she came, but would come to need.

Father had a big influence on her. Because her parents had no boys—three girls—her father tended to see them in roles that men would adopt, and he raised some Egyptian eyebrows along the way: "At age 16 I joined the paratroopers and I was the first woman paratrooper in Egypt. I was in a German Catholic school and my father went to speak to the Mother Superior and get permission that I be out of school for three weeks. She said, 'What happened to Muslim women?' My father, of course a revolutionary, says, 'These are the women of the future. There

is no difference between men and women; for the country to advance we have to have both sexes involved.' As my mother would say, 'An education is a weapon.'"

At this point, El Shazly's second husband strolled into the hotel room. Tall and blond, when asked what it was like being married to an Egyptian American, he said, "The worst thing is, we go to a basketball game and she says, 'Anybody scored a touchdown?'" He grinned, blue eyes snapping. He resembled a retired linebacker. He got more serious, sitting down:

> I grew up in a middle-class family where I was taught rules. You abide by these
> rules and you'll succeed. [Shahdan] has an orientation that's much broader, much
> more worldly and isn't driven to success. She understands life; it's not just her as
> an individual. All Egyptians I've met through her have a broader and deeper
> understanding of life. They discuss life all the time, and philosophy and history
> and politics. They're discussing life and we're discussing the mechanics of living.
> How do you work, how is your job, how do you commute, what your kids are
> doing. Tax shelters. But these people are in the life of living, instead of the life
> of working. They've been in touch with a few millenniums, and Americans just
> can't even come close to that. I can't.

San Francisco with its Golden Gate and agate blue bays and ever-reeling wind did not give her the same feeling as Cairo: "I've lived in San Francisco for so long now, you know, and I never had the feeling when I go home, to Egypt. I walk out of the airplane and I smell the country. You know? It just gives me a feeling of, I don't know . . . security. Call it whatever you will. I don't have that feeling in San Francisco. I've seen San Francisco change so much in the last ten years—constantly everything is changing. New building, new laws."

Her arrival in America was another twist on the familiar theme of bewilderment, wonder, loneliness. At just the time of her trip the recent union of Egypt and Syria had split up and left her with no passport, momentarily countryless. The Chinns left their trunk on the dock in New York harbor and sought out a hotel in the city. But passportless and without bags, she and her new husband were taken for one-night standers: "I looked too young checking into a hotel with no bags. We went to two, three hotels. Finally we went to a flea-trap, this terrible place. It was very cold and awful. I said to myself, I wonder about America."

Her first husband's family was fourth-generation Chinese American, and though very Westernized, "his thinking process was Eastern. A fatalistic attitude." They had a "terrible personality conflict," she said. It appears the Middle Eastern part of Shahdan gave in more to the West than did the Chinese part of her husband, though he had been in the country longer.

So humiliating was the Egyptian defeat to Israel in 1967—it was the third one—so little recourse did there seem to gaining any advantage on the field of battle, Egyptian young men would do anything to escape the draft. Many came to the United States for that reason, just as Canada was a haven for Vietnam era

resisters and evaders. But Shahdan said that newspaper ads recently run in Egypt were announcing a new policy to persuade emigrants who left because of the war to come back to Egypt. For two thousand pounds the Mubarak government would forgive draft evaders; they would not be prosecuted or forced to serve in the military. It was a shrewd way to raise money to bolster the sagging Egyptian economy. Make pounds, not war! One of her two San Franciscan Egyptian friends—a doctor—was considering paying the amnesty fee.

Shahdan remembered the 1948 war; only a child, she hid with her grandmother in Cairo in bomb shelters during the Israeli raids. Her father was a general who fought in the 1948 war, as he had against Rommel in World War II, during which, after getting orders to withdraw, he had gotten a reputation of intrepidness and fortitude by staying behind and destroying all the Egyptian matériel before Rommel could seize it.

During the 1956 Suez War in which the British, French, and Israeli forces colluded to attack Egypt, Shahdan El Shazly again endured the bombing and the tracers "that looked like lanterns in the sky, slow flares like with a parachute" to illuminate the blacked-out city for bombs: "We had a neighbor and she would come downstairs because that's safer. She was upstairs. And she would get to laughing because she's so scared she would just crack up. The more the bombs we hear them, the more she would laugh. Yes! And she would say, 'Oh don't be afraid. Don't be afraid. You should have been here during Hitler's time' . . . We found a big piece of shrapnel. Anti-aircraft guns—you heard them—they were pretty close. We went to my father's village in the Nile delta where they farm cotton. We were there for several months."

In 1967, General El Shazly was the only Egyptian general to actually get inside Israel, Shahdan said. "He was also the only Egyptian general who came back with his troops and his equipment intact," she continued. A Douglas MacArthur–type figure, her father kept running into the politicians head-on. When he retreated with his troops in the 1967 debacle, he did not get into a Jeep or convoy; he walked through the desert with his troops all the way to Cairo. His men respected him immensely.

Inevitably, the conversation turned toward Anwar Sadat and her father's falling out with him after Camp David. What did Shahdan feel, as an American, about Sadat's bold move to Jerusalem in 1977?

> I truly believed when Sadat first started that he was going to drag everybody to the brink and then change his mind and prove to the world that, you see, it is the Israelis [who are the problem], not the Egyptians. I never believed he would sign [a treaty]. And when he went to Jerusalem I said, "Son of a bitch, he's going to get the Nobel Peace Prize." But I never really thought he would sign. After he signed and things continued [to get worse] I thought he was duped. Now I'm beginning to believe that he really knew what he was doing; he didn't care. He

wanted to do something in his lifetime and let somebody else worry about implications, you know.

Camp David, to her, was responsible for the conflagration in Lebanon today because it took Egypt out of the equation. But I wanted to know what use had it been for Egypt to fight four wars to no avail. The military struggles seemed pointless.

"Quite the opposite," she countered. "Because the 1973 war made it imperative for the Israelis and the Americans to stop this because the 1973 war was too close for comfort. No longer can they [the Israelis] be considered invincible and no longer can they say a war would not work. If it wasn't for Sadat, the 1973 war would have worked. This has been validated by a lot of people in Egypt, the high command, Mohammed Heikal. Nobody said Sadat was right and El Shazly was wrong."

If Shahdan El Shazly came to the United States as almost a child bride in 1960, as a grown-up she was staying, though, she said, "in human relations I think America is really lacking." But for her son—the one who went through his puberty troubles—Egypt's pulls had suddenly struck. After spending several summers there, he found himself attached to the intricate network of family. Shahdan shook her head in wonder, "I am amazed that all of a sudden he wants to become Egyptian in his heart." In 1983 he was in college playing soccer for the UNLV team, but he didn't like it and returned to San Francisco.

As for the beautiful city by the bay, Shahdan, the apostle of freedom, had worried words. "Now we're afraid of AIDS. We don't go to restaurants anymore where we used to."

AIDS won't make her leave. But her son . . .?

Although by far the biggest surge of Lebanese coming to America was the First Wave at the turn of the century, some Lebanese began to leave in the 1950s and 1960s, even though life there was relatively peaceful. The Third Wave immigrants would swell with the outbreak of full-scale civil war in 1975. But I did visit with some of the eight thousand nomadic Lebanese of the Second Wave, who left the country even in its peak years.

Dr. Aida McKellar is a psychiatrist at the huge Texas Medical Center in Houston. A short-haired blonde with blue eyes whose charm is not concealed by a face lined and pocked, Aida is one of those fair-skinned Lebanese with a hint of Crusader in their eyes. She admitted to me when I visited her in her office at the Veterans Administration Medical Center, where she treats U.S. veterans with psychological problems, "I don't really like to call myself an Arab. Because it's so terrible in this country—an Arab is dirt." [22]

Born in Beirut, Aida came to the United States in 1956 after marrying Arch McKellar, an American businessman. She had already graduated from the Ameri-

can University of Beirut as only the thirteenth woman doctor. The Arab world needed general practitioners badly. She and her husband took work in Saudi Arabia in the 1950s; she smiled at the memory, "I delivered babies all over the place. The royal family used to take me by private plane two times a week. They said, 'No slacks.' But I had to drive to many remote places. I said, 'No slacks, no drive.' I was the first woman to drive a car in Saudi Arabia!"

She remembered Beirut of the forties as a place safe at night for bicycles, and romantics. Even in the 1950s, it was "poor, but nice." But by the late 1960s and 1970s, already "it had become unsafe, with a dirty, nouveau riche atmosphere." Aida attributed much of the problem to the influx of Palestinian refugees—"the street men and farmers"—to Lebanon, which spawned the biggest base of the PLO.

"Imagine," she said, lifting her finger, "Rhode Island invaded by two million Vietnamese."

But Dr. McKellar is too shrewd to place all of Lebanon's current turmoil solely on Palestinian shoulders. "I don't think the destruction of the PLO will help," she sifted the effect of the Israeli invasion of 1982.

"By starting trouble these refugees have revived a lot of feudal warfare, all the buried animosities between Druze and Christians, for example. It would be like a refugee people coming to the Deep South and reviving the black versus white conflict. Any nation that is formed by many nationalities united under one flag can be disturbed by an invasion from the outside by very antisocial elements. It could happen in any society."

She had known Pierre Gemayel, the patriarch of the Phalangist party in Lebanon, but she said, "He was always a fanatic person." To Aida, the elder Gemayel was a stronger personality than either of his two sons, Bashir or Amin. The latter, now president of Lebanon, "is too young, and inexperienced." In sum, she declared, "I am very pessimistic about Lebanon—those with any know-how have left."

They had been leaving for a long time. Today there are more Lebanese outside the country than inside. South America has in itself 3 million Lebanese immigrants and their descendants; the United States at least 1.5 million. For Aida McKellar, who still has family in Beirut, "the Lebanese have no common denominator unfortunately, right now, and that is why they have been conquered so often." As for the Israelis, "their big mistake was coming into Lebanon as a conqueror rather than with the attitude of 'Let's live together.'"

The softness of the Mediterranean scenery, a nostalgia of sunshine and flies buzzing around, the proximity to so many things in the tiny country where "everyone knew everybody else" nevertheless made Aida sad in recall. "The Lebanese villages were cosmopolitan, like French village life," she tapped her desk at Houston's medical complex. "Here in the United States, if you are in a small town it's dead and boring."

Aida McKellar has lived the quintessential life of the Lebanese émigré—a

nomadic one filled with challenges. She has been anything but parsimonious with her medical skills. In 1961, she worked with the World Health Organization in the Belgian Congo. She traveled the Middle East with her husband, who chose Houston over New York or Los Angeles because of its Middle East access for international business. "My husband and I loved to travel and work in so many places that when we woke up it was too late to have children," her voice trailed off, but she recovered quickly when I asked how she got into psychiatry. It was during their life in California in 1963. She had to admit that Lebanon—mad as it was—was not a place to start a psychiatric practice.

"Psychiatry is practiced in countries where they realize there is more to life than the physical, when you have good sewers, and water, and you find the quality of life is up, not only the quantity," she said. "Eat, sleep, and reproduce is the way of the Third World." Obviously, this was not going to be an apologetic headshrinker. And Lebanon was not unscathed mentally: "They have some psychological problems in the Old Country, but they're just not aware of it." Aida believed that psychiatry has taken the place of the priest, old friend, and older member of a family. She vehemently denied that intelligence helped ward off illness: "You can have a very high IQ and not have emotional growth and maturity. Emotions have to grow, too."

"Emigrant children are always a foot taller and more capable individuals," she affirmed. "It comes from good nutrition, freedom, stimulations."

For this wandering Lebanese American, America could not have remained static on her rest stops. Aida, who once saw Americans as "very clean-cut and naïve, a prototype of cleanliness and honesty," believes they are now "much less naïve." She called the trends of recent years "the Europeanization of America— look at the consumption of wine today! And the cheeses! There used to be only Velveeta."

Dr. McKellar—articulate, charming, intelligent—seemed to take to the chance to speak about her life and Lebanon with a professional commitment and inclusiveness. We spoke for the better part of an afternoon in humid Houston, with mentally disabled veterans coming and going. She looked up at me from making notes at one point and said, "It is like a soul that had been crushed—Lebanon."

Casualties in her own family exist. One old aunt in Beirut died during the Israeli invasion—"She literally died of terror." She herself was on her way to Beirut from Paris when the invasion started and blocked her return visit. Her sister worked with the Lebanese Red Cross during the 1982 war. "They tried to squeeze blood out of turnips," Aida related her sister's harrowing experience during the siege by Israel. Aida was shocked by much, not the least that the Israelis stole the Butrus' grape presses in the Biqaᶜ, which made the best wine in Lebanon. In October of 1982, her sister came to Houston very depressed, on the brink of a nervous breakdown. "She has more roots than I do," said Aida McKellar, the traveler, the healthy one, the survivor-American who came before the explosion.

A Syrian Second Waver who landed in Rhode Island in 1952 lives among factory workers, old textile weavers, and dyers. For Father Abdulahad Doumato, a priest in the Jacobite rite of the Eastern Orthodoxy—an obscure sect that has about fifteen thousand adherents in the United States—ministry is his life. He has seen holy oil emerge miraculously from the cement altar of the Jacobite, or Syrian Orthodox, churches along the border of Syria and Turkey.

Holed up in a small, board-framed house in Central Falls, Rhode Island, Father Doumato has been repeatedly victimized by crime. Thieves recently stole the chalice off the altar of St. Ephraim's, the church of which he is the pastor; thieves also pilfered some gold pens he had on his desk at home. Crime has made quite a different America for this kind, warm, but sad priest than the one that greeted him in the early fifties. He believes in holy olive oil miracles; he cannot believe the rise in crime.

When asked if he would have come to the United States knowing what he knows now, the priest—a U.S. citizen for almost thirty years—said, "No. I thought America was the best country," Father Doumato told me on the dreary first day of March 1983 in the living room of his home, with his old, blind father rocking nearby and a younger, bearded priest from a neighborhood parish thriving past St. Ephraim's. "I mean, how can you find freedom outside America? That's what I used to think, and I came and I saw it that way and was never sorry. I was happy with my neighbors, with my fellow man, my parishioners. I never had any hardship—never. I was well respected. But things happen that I don't like. I still believe in the American way, the Americans as Christian people. But there are newcomers and involvement here and there. If they want the country to go bigger and larger and more active, they are supposed to police it better. They don't put the effort." [23]

There are fifteen Jacobite Syrian Orthodox churches in the United States. The main distinguishing factor between them and the mainstream Antiochian Orthodox is that for their mass the Syrian Orthodox use Syriac, which is similar to Aramaic, Christ's tongue. In fact, Father Doumato translated the Lord's Prayer into Aramaic, still spoken in only three villages in the world, in Syria. The translated Lord's Prayer flows in a script less curved and scimitarlike than Arabic; Aramaic seems to be a cross between Arabic and Hebrew. It bends to the left in straight, diagonal tails, as if in an unvarying wind.

During the troubled years leading to the war at the turn of the century, Syrian Orthodox moved down from Turkey into Syria proper and Lebanon, most to the section of Jazira in Syria, where 100,000 are said to live. After the Second World War more moved to Lebanon, which today has about two thousand Jacobite families. But since the Lebanon civil war, the Jacobites have been on the move again, this time to the New World. People like Father Doumato had made the beachhead in America. For years St. Ephraim's had only forty families; since the civil war, it has one hundred families.

The Syrian Orthodox—united with neither Rome nor Byzantium—came to America, according to Doumato, because of "persecution and hardship." Like all minorities, the more minority you become the more isolated and suspect you are.

"Among the three or four million Syriani in Turkey today, they never identify themselves as Turks," he said. "They never accept it, even on paper." He noted that once when he was a citizen of Turkey they labeled him as Syrian Orthodox. In Syria, they accept it more; in Lebanon they accept it probably because many Lebanese are Christian. He told with enthusiasm about a meeting of the Jacobite Orthodox patriarch in Jezira with the top Muslim imam of the area: The imam said, "*Sayadna,* your eminence, we are welcoming you warmly because we are of the same blood. We lived for generations as Christians; that's what our fore-fathers told us. But they were cowards; they accepted [to be] Muslim. You are stronger; you stay with your faith."

Father Doumato said that the Christians there call the Muslim Arabs *tayo,* a Syriac word that emphasizes their Christian roots. He spread his hands and told with animation stories of Syrian Orthodox finding fellows of their small sect as far out in the desert as Palmyra. "On paper, they say they are Syrian Arabs, but deep down they say, 'We are Syriani.' They keep the faith and religion first."

I mentioned Sidnaya, the miracle site out in the Syrian desert, which we had visited in 1972, and Father Doumato nodded knowingly, though Sidnaya was Rūm (Antiochian Orthodox) and there were miraculous sites particular to the Jacobite in Kamisne, near Turkey. His eyes widened: "Back there it's a different life. Here they believe by material things and the dollar. There they believe by faith. In our churches, near the border of Turkey, in Kamisne, still until today every once in a while oil comes from either the altar or the wall or part of the church. So many people—Christian and non-Christian—and the government, went and examined these places. There is nothing wrong with it. Just miracle. *Zayt,* olive oil. Some from icons, some from the ground, some from the wall, mostly around the altar area. It's amazing."

Father Doumato was convinced that back in time I was Syrian Orthodox be-cause of my last name. He told me a story about Orfa, or Urfa, which is in Turk-ish Armenia. He said the king there (Apgar) wrote the only extant letter to Christ, asking him to visit his city to cure him of some skin disease. A native saint, Ephraim, born in Sabeen in the Syrian district, because of persecution moved to Urfa, where he taught and became a famous preacher. He died in Urfa, which is still largely Armenian Catholic and Syrian Orthodox Christian.

Father Doumato brought his four children and wife to the United States in 1952 to be a pastor to the Central Falls church, built in the 1920s. He was chosen and he chose to come. He was glad because the education in America, he felt, would be better for his children. But he misses the tightly knit family he left in Syria:

See, the whole world's changed today; we used to keep the family together. I was just telling some people, you go to Damascus or Aleppo or Homs on this narrow road; you see those Orfali families! Five, six, ten houses. Not anymore, not like before. Not like that here. They live two-, three-story houses, each one different, but they don't talk to each other. They don't know each other. Back there it's more closer life. I'm sorry to say one thing about America. When stranger used to pass by, they'd all look at me, you know. But now, they all are stranger. Now I feel I'm in a different country. You know, the way they talk different languages, and cheap, not like it's real American life.

Father Doumato lived for years in America before his church and home were broken into in 1983. The drunken vandals even started a fire in the sacristy after taking the chalice and smashing the organ. What really burns inside him is the lackadaisical police. He saw a hit-and-run accident in front of the church one day; the driver was drunk. The police came and Father Doumato shouted to them to pursue him. The police didn't give chase, just wrote up a report. Doumato wondered whose car it was. They shrugged their shoulders—stolen by some Italian from Providence. "They don't care," Doumato sighed. "If they rob you, or they kill you here, they come, just take note."

It was a common phenomenon—an original immigrant who probably had little English badgered later on by more recent immigrants who don't know any English. But Father Doumato did not have the leavening ingredient of the First Wave immigrants who had to live with terrible prejudice because of their foreignness. He arrived in America at the peak of its prosperity and stature in the world, the 1950s. He was educated, too, and knew some English. The descent into crime of the modern American megalopolis was more precipitous an adjustment, perhaps, for him than for older folk who had done the hard-knock factory work or peddling when Syrians were considered Chinese.

But they were dying out. And Father Doumato was very much in the middle age, with miles to go before he slept. And the new immigrant speaking Spanish, lighting his cigarette on the corner in loneliness or anger, spoke eloquently of a tougher reality than the Syrian Orthodox could comprehend. Perhaps he and the Puerto Ricans shared more than he thought: despair.

5 The Third Wave: West Bank Captured, Lebanon Torn Asunder, the Iran-Iraq War, 1967–1985

Why would the period from 1967 to the present be considered a distinct Third Wave of Arab immigration to the United States? It is true that the 250,000 Arab immigrants from 1967 to 1985 shared much with those who came from 1948 to 1966. The largest segment of Third Wavers were probably Palestinian though they may have come to the United States through Jordan, Syria, Lebanon, and Persian Gulf countries. The 52,132 listed under "Jordan" alone are mostly Palestinian. Many Third Wavers were professionals like the Second Wavers; if anything, the trend was intensifying. Naff documents that, between 1965 and 1976, 15 percent of Arab immigrants to the United States were professional and technical workers, once again mostly Palestinian. On September 16, 1983, *Middle East International* reported that half of all Arab science and engineering Ph.D.s had left the Arab world.

But the question remains: what differentiates Third Wavers from Second Wavers? First, and most obvious, the Third Wave is three times larger than the Second, due to a great extent to the loosening of U.S. immigration restrictions in 1965. Second, the Third Wave was fleeing not only intensified Israeli aggression but also intra-Arab warfare on a scale not seen since the mid-nineteenth century. Those Iraqis, Lebanese, and Syrians, for instance, were not just leaving situations that had been shaken by change of rule, or new economic structures, as in Nasser's Egypt. They were leaving societies wracked by abysmal violence.

After the Palestinians—whose absence was beginning to make certain West Bank towns, such as Ramallah, resemble homes for the aged just like those left by famine-stricken Lebanese during World War One—the contemporary Lebanese constituted the second-largest group of Arab immigrants from the Third Wave. The intolerable barbarism of the civil war—and Israel's 1982 invasion—brought 43,141 new Lebanese immigrants to America since its inception in 1975. Iraqis began for the first time to come to the United States in sizable numbers (40,289 since 1967); some of this influx was due to professionals who did not want to throw their lives away fighting a meaningless war of attrition with Khomeini's Iran, a war that by its sixth year had caused over a million casualties. Syria, whose prospering economy was beginning to plunge by the mid-eighties, did contribute sizable numbers to the Third Wave immigrants (25,936 since 1967), some disillusioned by corruption or the occasional brutality of the Assad

regime, whose crushing of Islamic fundamentalist rebels at Hama in 1982 caused the death of 20,000 civilians.

Third, one cannot discount the rise of Islamic fundamentalism throughout the Middle East—aided no doubt by the continuing unanswered occupations by Israel but also by a public disenchantment with secularism in general—which has fueled the Third Wave immigration by Christian Arabs, though at least 60 percent of Third Wavers are Muslim. Certain Christian sects, such as the Iraqi Chaldeans and Egyptian Copts, felt increasingly isolated in their societies, and with beachheads already established by a handful of earlier immigrants to America, they began coming in larger numbers. The Chaldean community in Detroit, for instance, grew 600 percent from 3,000 in 1960 to 20,000 by 1980. Egyptians immigrating from 1967 to 1985 number 51,980, many of them Copts.

In sum, the Third Wave Arab immigrants carried a greater burden of internecine conflict than did previous waves, and hence they would tend to be less likely than previous groups to consider going home. At the same time, because so many of the Third Wave were Palestinians—highly educated—they felt a greater drive to participate in the new Arab American political groups that grew in the wake of the 1967 June War. Third Wave Palestinians, with the homeland still fresh in their minds, were ready to be foot soldiers in the tedious, frustrating task of lobbying U.S. policymakers, unlike First or Second Wavers who could either be cynical or despairing and in any event tended to be isolated chiefs. More angry with America, the Third Wave paradoxically made more enthusiastic Americans. With a kind of crude symmetry, the number of Palestinians coming to America increased as the number of American-financed Israeli settlements increased on the West Bank and in Gaza, occupied since the 1967 June War. It was as if America were paying these immigrants to relocate away from Israel, giving Israel a free hand with expropriated land.

Iraqis, Yemenis, and Egyptian Copts

Aside from the Palestinians and Lebanese, wracked, it seemed, by unending wars, burgeoning communities of Iraqi Chaldeans in Detroit, Egyptian Copts in places like Jersey City, New Jersey, and Yemenis in Detroit factories and on California farms represented unique immigrant experiences in America, with wide swings of the pendulum between the urge to stay in the United States and the desire to return to impoverished or chaotic origins.

Chances are that the bagged lunch purchased on a noon break in Detroit is today wrapped by a Chaldean immigrant from Telkaif, located in northern Iraq just outside the ancient ruins of Nineveh. Those fast from turmoil (and the expropriation of private property) who now own over four hundred grocery stores in Detroit are Chaldean Catholics. The Chaldeans—sometimes called Assyrians— are a fiercely proud people who trace their Christianity back to St. Paul's missionary journey to what was then Assyria and Babylon. There are fifty thousand

Chaldeans in the United States, most in Detroit, with smaller groups in Chicago and in San Diego and Turlock, California.

In 1889, probably seeking the Trade Exhibition, the first Chaldean arrived in the United States and settled in Philadelphia, through he later went back to Telkaif. Chaldeans began to gather in groups in Detroit around 1910, taking up work peddling and in the new car factories. Their motives were primarily economic. The Second Wave Chaldean immigrants in the wake of World War II were largely part of the brain drain and came from major Iraqi cities like Baghdad. But after 1965, the loosening of immigration restrictions by the United States, and the ascension in 1968 of the socialist Baᶜath Party in Iraq, Chaldeans began coming directly from Telkaif in greater numbers.

Like the Jacobites, the Chaldeans use Syriac, an Aramaic language sometimes called Assyrian, in their liturgy. A few members of the Chaldean faith prefer an age-old allegiance to an early church heretic, Nestorius, who differed from Rome on several doctrinal issues. These Nestorian Chaldeans in the United States live mostly in Chicago.

As with other Third Wavers, the Chaldeans had overtly political reasons for leaving the Arab world. In their case, the strife between the Iraqi government and the ethnic Kurds in northern Iraq spilled over into Telkaif. The Detroit Chaldean community's swift growth proved once again that one nation's war is another nation's cheap sandwich. It has been speculated that should the Chaldean grocery store owners—which some estimate to be as high as one thousand instead of four hundred—ever band together they would wield considerable political weight in Detroit and even rival the Safeways and A&Ps. But, according to Mary Sengstock, this has not come to pass for old reasons: ". . . all tend to be operated independently, and there is little cooperation between owners." [1]

More important, again in Sengstock's analysis, the Chaldeans have always felt at arm's length from the prevailing Arab culture into which they were born. Besides the language preference of "Assyrian" over Arabic, many Chaldeans testify that they were subject to discrimination by Muslim Arabs of Iraq. Moreover, Telkaif was considered a backwater village scorned by most Iraqis: "In fact, the term 'Telkefee' was used in Baghdad as a term of derision, applied to anyone from the Mosul region, and indicated an ignorant, small town hick, a term somewhat akin to the American term, 'hillbilly.' " [2]

Even more recent Iraqi immigrants than the Chaldeans are Muslims fleeing the constant carnage of the Iran-Iraq War. Few families have not been hit by at least one casualty in the seemingly endless war of attrition that started, ostensibly, over who would control—in an era of the sky—an anciently contested waterway. Clearly it is now a test of wills between two absolute rulers—Iran's Ayatollah Khomeini and Iraq's Saddam Hussein. Since the war's start, at least 150,000 Iraqis have died. Many Iraqis have left their land and have found shelter in the United States. One of these is a university professor of pharmacology in Houston who otherwise describes himself as a "sedentary" man.

Karim Alkadhi, born in Iraq in 1938, feels strongly that life in Iraq, even to-day, is more lucrative, serves as a better medium in which to raise children than the drug-riddled United States, and is generally not as lonely as America. Yet in 1980 he brought his young family—wife and two children—to Houston, where he teaches at the University of Houston. "To be very frank," he told me, "there were some things done in preparation for the war we didn't like. All the foreign wives, for instance, should apply for Iraqi citizenship, said the government. I asked why." He never got a satisfactory answer. "I served five years in Iraq . . . it was time to move on."[3]

Alkadhi described his attachment to Iraq, nevertheless, still as "very strong." His son, Isam, and daughter, Rheim [or "desert gazelle"], both know Arabic—though it was learned on the road in Libya. "In terms of money, we were doing better in Iraq," he admitted. "I didn't come to the United States for dollars that grew on trees." But it is in discussing politics and the question of freedom of expression that Alkadhi revealed the subliminal stimulus for emigration: "The leaders in the Middle East—they are hell. You can say as much as you like here. I think that's good. What counts is that I can criticize anyone without endangering my life or my freedom. If you don't criticize the government in Iraq, you're all right."

In many other ways the Alkadhis were "very happy in Baghdad," where, Al-kadhi said, "we had the best of both worlds"—Western lifestyle and goods and Middle Eastern closeness and family orientation. "Baghdad was booming," he said. "Money was flowing out the ears from agriculture and oil revenues. Thousands of Iraqis were taking vacations in Europe—even small shopkeepers were splurging." Before the war, the government was liberal in allowing hard currency out of the country—up to $3,300 per person. When the war began in 1980, this was greatly reduced.

At first, Alkadhi thought the war was launched out of "personal animosity," but as it dragged on he came to the realization that "it was going to be a war whether Iraq had attacked or not." Khomeini's agents had exploded a number of Iraqi installations over the border in the months before the war. "If Iran wanted to make peace it would have sued for peace," Alkahdi said. "Khomeini obviously wants to take Iraq, or put in his own lackeys."

"It would probably be better for my kids to grow up in Iraq," he felt. "There you don't have to worry about peer pressure and drugs. There are plenty of cousins there to play with. Individualism here and its attending psychic disorders you don't find there. Schools conform to procedure—the school is boss there. There is no conflict, for instance, about prayer in the classroom. If you are non-Muslim, you just leave the class at prayer time."

A secularist, Alkadhi does not think fundamentalism would take hold in Iraq: "On the whole, Iraqis are not very religious, really. There are three or four breweries in Iraq for beer and that's not enough to fill demand. They import it." And the disunity of his homeland didn't help. "I felt the Arab world becoming so tat-

tered," he sighed. "Syria and Libya supported Khomeini, and even some Palestinians. It was disgusting! The whole idea of Arab nationalism is falling apart."

I had to laugh when he said he found Houston similar to Baghdad: "The boom, the Mercedeses, the rubbish is more like home than Connecticut [where his family lived awhile]." It did not come as a surprise when Alkadhi said he would probably take U.S. citizenship himself, though he had once let his green card lapse in student days. Among other things, his son was becoming old enough to be drafted into the army confronting Khomeini and his hara-kiri foot soldiers.

Hugging the Detroit River—and the Chrysler and Ford motor factories—a fair distance from the suburban Iraqi Chaldeans and Alkadhi's Houston is an entirely different group of recent Arab immigrants to the United States, the Yemenis. Yemen occupies the mountainous southern and southwest corners of the Arabian peninsula, actually two Yemens: one to the north and capitalist (Yemen Arab Republic), one to the south and communist (People's Democratic Republic of Yemen). A sprinkling of seafaring Yemenis came to the United States after the opening of the Suez Canal in 1869. Of the 11,633 Yemenis listed as immigrants since 1948, most journeyed to the United States after the 1968 civil war that created the two Yemens. Some Yemeni immigrants to the United States actually came through Vietnam, where they worked as watchmen in warehouses, in shops, and on the docks. Though there it was easier to get a visa without being literate, they left Vietnam during the war against the French.[4] They followed various pathways to jobs—over 500,000 to Saudi Arabia and three Gulf states in the oil boom. In the United States they found work in car factories in Detroit, on farms in California's San Joaquin Valley, as well as in foundries in Buffalo, New York, and Canton, Ohio.

There really is no Arab immigrant group comparable to the Yemenis, 90 percent of whom are unaccompanied young males, semi-literate or illiterate, with little knowledge of English. Uniquely, most Yemenis, even fifteen years after their migration commenced, have not taken root here. Most shuttle back and forth on jumbo planes to Yemen, buying homes back there with earned money. In short, the Yemenis—with some exceptions—constitute the most definitely "Arab" of any migrating group from the Arab world over this century, and may be considered—as a group—more temporary workers than immigrants. Their presence in the Detroit area, especially in the Southend of Dearborn, is the most concentrated of any Arab population in the United States. Only Atlantic Avenue in Brooklyn rivals the bazaar that sports myriad Arab signs and shops down Dearborn's Dix Avenue.

The Yemenis of Detroit have been closely studied by sociologists and anthropologists, most notably Nabeel Abraham of Henry Ford Community College. In 1983, Abraham found that one thousand to five thousand Yemeni workers constituted up to 15 percent of Chrysler's Hamtramck plant (known as "Dodge Main"). Scrambling for work when the car factories closed, many Yemenis could be

found busing tables, washing dishes, and even manning cargo ships. One estimate found fully 20 percent of seafarers on the Great Lakes to be the dark-skinned, lithe, Arabic-speaking Yemenis.[5]

Though as late as 1959 most of the Muslim-dominated Southend of Dearborn was Lebanese, the steady influx of Yemenis assured that community of dominance there, where by the late 1970s two thousand to three thousand Yemenis were living and working. Dix Avenue is peopled with Yemenis hanging out at myriad coffeehouses, playing cards, gossiping, preparing to go to work. Over half the stores in the Southend are now owned by Yemenis, a telling pattern of the belated pull of American soil. So heavy was the Yemeni influence becoming in the Southend that the old Lebanese mosque built in the 1930s on Dix Avenue had its control wrested by a fervent Yemeni religious sheikh in 1976.[6]

It may be a bit of a surprise to discover that the large majority (70 to 80 percent) of Yemenis coming to America emigrate from capitalist Yemen and not the communist regime of southern Yemen. Interestingly, however, the few hundred from southern Yemen are far more educated and urbane than their northern counterparts. Many emigrants come from a hot spot along the two Yemens' border. It would be as if residents of the border between Confederate Virginia and Union Maryland—let's say Harper's Ferry—grew tired of conflict and decided to take off to parts unknown. In Yemen's case, the Harper's Ferry was a city called Ash-Shaar, just over the border in northern Yemen, that contributed more to Yemeni emigration than any other town.

In return for a little "coffee money" (*qahwah*), native Yemeni lenders (*wakīl al-mughtaribīn*) will finance everything from the rural immigrant's plane tickets to subsequent construction of the addition of a bedroom to his Yemeni home. This "coffee money" is a service that takes the place of interest, forbidden in Islam. So important is the *wakīl,* a latter-day "sharper," in this migration pattern that it is to him the laborer's paycheck money is sent before it is distributed to the immigrant's family in Yemen.

The key indicator of Yemeni loyalty to Yemen is the amount of money sent back home. It appears that Yemeni salaries in Detroit range from around $10,000 to $15,000, and that it is not uncommon to find auto workers remitting two-thirds of these amounts to family back home. The extent of the Yemenis' patriotism in the midst of the hustle of modern America—their own hustle included—was seen when the president of Dodge Main UAW Local 3 tried to coax the Yemenis to settle their families in Detroit. He offered six-month leaves (two months higher than the norm) to any Yemeni who would go back to Yemen and retrieve his family for relocation in Detroit. Even seven years later, no one had taken Joe Davis up on his offer!

The clash of cultures elicits some interesting social phenomena amongst the Yemenis. Involvement with drugs, alcohol, women, and gambling among Yemeni youths caused some to be dubbed *taʾishīn* (or "the frivolous ones"), whose rough equivalent in English would be "hippies." Vagrants and those stricken with alco-

holism who walk Dix Avenue and do not work are called *bumīn* (bums). These are all ostracized by the immigrant community, unless they meet their share of home remittances through work. Work forgives a litany of vices to the Yemenis as, indeed, it does with most Americans.

Except for the stray youth seen taking his blonde girlfriend to the movies, interaction between Yemenis and the host society is probably the most restricted of any Arab immigrant group. In the 1976 Detroit municipal elections, for instance, though several Arab American candidates sought Yemeni citizen support, those few who had the vote didn't use it. Though Yemenis belong to the labor unions, they look dimly on strikes and refuse to participate. (In the California farmlands, few Yemenis joined the Chavez union.) Indeed, in the early seventies, the city of Detroit's plan to raze much of the Southend of Dearborn where so many Yemenis live met with little resistance. For the most part, the Yemenis are content to replicate their village structures in their coffeehouses (villagers tend to stick to patronizing the coffeehouses of other co-villagers in Yemen, not co-neighborhood dwellers in the United States).[7]

As for the Egyptian Copts, whose Christianity dates back to St. Mark the Evangelist's trip to Alexandria in A.D. 62, they began arriving in the United States in significant numbers in the mid-1960s. The first two Coptic churches were established in New Jersey and California. There are now nine Coptic churches in America, and about fifty thousand Copts. The largest community is nestled in Jersey City, New Jersey, where Copts own grocery stores and work in factories.[8]

Third Wave Palestinians and Lebanese

When I was growing up in Los Angeles, the only newspaper that serviced the Arab American community there was the *Star News* edited by Henry Awad. After it went under in the early sixties, Palestinian Joseph Haiek, now living in Glendale, started the *News Circle,* which gradually worked its way to normal column justification, grammar, and spelling. Today it is a readable, interesting monthly magazine with full-color covers, the only independent one of its kind in the United States.

A short, genial man with a grin that offsets his balding pate, Joe Haiek welcomed me in the midst of a translation job the office was doing for some company. The *News Circle* survives by using family employees—the time-honored way for the small immigrant businessman. Translation for companies and a new publication dealing with auctions help him pay his bills—barely. Getting people to pay for the magazine is a perennial problem (Haiek offers wealthy Arab Americans the front cover photograph and lead story for $2,000, a kind of vanity press feature to pay for the bulk of the issue).

At the outbreak of the 1948 war, Haiek was at the Salesian Catholic High School in Jerusalem: "We saw some fighting around the school, and the occupation, but we were not harmed."[9] Being in Jerusalem he also heard about the massacre at Deir Yassin nearby, but his family did not flee, except to cross the city to the Jordanian-administered East Side.

I asked Joe if his own personal advancement continued after Israel was established. Sitting in front of an open window through which the rush of freeway cars could be heard, he shook his head: "No. When you are under occupation, you will be a robot. Try to go up in other circles and you can't, because why would they let an Arab occupy that place when an Israeli can? It's impossible. So you have to be on your own or you have to submit to whatever is there." We discussed the case of Fouzi al-Asmar in Ramle, whom Joe knew from boyhood days. Al-Asmar couldn't get schooling in his chosen field, electrical engineering: "It became apparent to me that not only newspaper advertisements, but also most other things in this country, apart from laws and taxes, were not for Arabs."[10] After serving some time in prison for activism, al-Asmar came to America in the early 1970s.

Joe Haiek got along for awhile in just about the only field Arabs could eke out a minor living—services. In his case, he bought and sold tractors, American made, that Israeli farmers weren't using. He'd recycle used ones to Arab farmers who still had a shred of land left in Israel (most was expropriated) or were tenant farmers. He also did unsalaried work helping to manage a plot of land for the Latin patriarch near Jerusalem, which supported vineyards and hay. He was also involved wih the Terra Sancta Club, an organization of Christian lay people in Jerusalem, and cut his journalistic teeth putting out its newsletter.

I wondered what it would be like to grow up as a Christian playing in the very paths Christ walked. "This question—I call it 'the American question,'" he pursed his eyebrows, "because they feel it so important where Christ went. We are walking all our lives the way Christ went, day in, day out, including His cross on our back. The life of the Palestinian people is a continuous crucifixion!" He brightened, relishing the phrase, "Crucifixion, not only from the Israelis, but also from world politics and our Arab brothers. They all can arrange to cut the Palestinians out of their system."

Haiek first got his notion to leave the land of his birth during the 1956 Suez War when Egypt was vanquished: "*Khalaṣ*, I thought, it is finished." It took him "ten minutes" to make up his mind to leave what he felt was a losing cause for his people, and eleven years to finally go. He arrived in Los Angeles with his family in 1967 just after the June War. "We had to go through the hardship of changing language, being new here, can't find jobs," he related. Though there were a few family members here already, he believed that "family is not enough because there is a social life around you."

Why Los Angeles? For him, "L.A. had the same weather as Palestine. When we came in September the smog was at its peak, but we didn't feel it. We went

through that." Before long he was working at Northrop—a maker, ironically enough, of jet fighters that the United States sends to Israel. He found himself in an assembly line. Language was a steady block on the job, then and now. "I am with you here fifteen years and with broken English, a heavy accent!" he said, chagrined. He told a story about being laid off and not being trusted because of his English: "There was a lady who was polite to my face but would tell my supervisor, 'Don't send Joe to bring blueprints, I can hardly understand him!' She was very pretty. Many around her just wanted to sleep with her. Once when she was alone I told her a joke. She started laughing. And I said, 'This is what really amazes me. How come you understand my jokes, but you can't understand the number of the blueprint and you tell your surpervisor you can't understand?'"

Though the ADC and NAAA try to fill a political vacuum, politics is not enough for Haiek: "The Third Wave of which I am a part want to show the Arab world that politically they are wrong. But there is a missing link—to show our own here an identity within the ethnic group." He was excited about my wanderings to collect material on the community: "If nobody write about them, it means they are nothing. How can you fulfill the needs of the community when they are nothing? What puts them up? Not their Cadillacs, not their $6,000 ring, not their perfumes or a limousine."

The wonderful frustration of Haiek turns to a kind of melancholy in a younger Palestinian immigrant to the United States. One would think that Bassam Idais would be fiery in his anger. But he, too, had been through his own baptism of loss and now appears to be in the United States—and San Antonio, Texas— to stay, in spite of being knifed while working at a family icehouse one dreary, hot night.

Having been born into a slice of the Holy Land already under foreign occupation in 1954—Sinjil on the West Bank—Idais had not been scarred by the jolt of 1948. He remembered occasional radio broadcasts from Egypt and Jordan during those early years with exhortations to throw the Israelis into the sea and wild claims of impending victory, but he didn't see any real violence until the 1967 June War:

I was in school at the time. Officials began running and saying, "Close the school! Get out!" We left the school and my family saw the jet fighters all over there and we slept in shelters. "Don't sleep in the house or try to go outside in the field or under a tree—stay inside." We kept listening to the radio and from the way they were talking the Arabs were victorious. "We knocked down twenty, fifty planes!" Within twelve hours a few guys came from a town close to Ramallah and said the Israeli soldiers are already inside Jerusalem and had taken over the whole of it and were driving toward Ramallah . . . The Israelis were getting closer and closer to Sinjil and we just raised those white flags. There was no defense at all.[11]

At first there were no arrests by the occupying army. But after two weeks the Israelis began calling on young people to see if they had any connection with the PLO or were hiding weapons. Bassam's father was jailed twice because he was accused of having guns. "My dad never carried a gun," Idais said, looking around the green backyard of his cousin in America. "He was a policeman during the Jordanian rule, but he never had a gun." The pressure, he assured me, never let up until his own departure six years later.

On a recent trip back to Sinjil, Bassam was, typically, detained for six hours enduring a strip search and stiff interrogation. "They even offered me a job one time, saying 'What do you do in the United States? How much do you make? We are willing to pay you more. If you make a thousand dollars, we'll pay you two thousand,'" Bassam related about the Israeli agents. "You want me to work against my people?" he shot back. Clearly, they wanted him as a spy and grilled him for information about the PLO.

And so, faced with a situation he had come to find "intolerable," Bassam Idais, who hadn't enough money "to go to a café and drink a Coke," decided to leave in 1973. The only available jobs under the Israelis were waiting tables in restaurants or manual labor in construction. He had tried to work for the Israeli government for one week, planting trees on Temple Mount in Jerusalem for two dollars a day. "There was no future," he said glumly. "They treated you like slaves."

Sinjil was a town of about four thousand people in 1967. Today, according to Idais, most of its young people have left, leaving two thousand aging residents. All twenty-seven of his high school classmates are now in the United States. His aging father, however, went back to live in Sinjil.

Wasn't there a real irony in migrating to the very land that funds the country that is expropriating the Palestinian West Bank day by day? Don't the immigrants think about this? "They think about it," Idais admitted. "But they have no choice. Where can they go? We're hoping that one of these days there'll be peace and a Palestinian state. We're not so happy here. I mean, I would rather live in my country. I don't care how good life is here or the schooling or the job."

Bassam has known loss in war. During the 1967 conflict, a close friend's father was killed on the border of Lebanon. The friend joined the PLO. "A lot of people joined the PLO right away during that war," he stated. "Sons and brothers of the dead joined the PLO immediately."

A stabbing at work—inflicted by a crazed Vietnam vet who thought Bassam was Vietnamese—will sober a man. It certainly brought home to him the feeling that "you're not safe in America. Since then I just hate to walk into a convenience store," he admitted. "I hate to see somebody carrying knives. It just scares me. You know, in Sinjil there is war all the time, but people are friendly. A lot of people leave their houses unlocked, even now. They can go anywhere. They don't have any bother that somebody will rob them or hold them up or rape them. You never heard of such a word as 'rape' before, back home. They have a manner, a

pride, morals—all kinds of good things—even if they're poor they're happy with what they have." It was a dramatic irony, and one I would hear from a number of Palestinian immigrants to America—the peace of the United States contained threats that the war of the Middle East didn't.

Prejudice came up. An accounting major, Bassam had applied in several market chains, such as Seven Eleven and HEB markets to be an auditor or accountant. He believed he was rejected, even though he had more schooling than one person hired (who had only a high school diploma), because of his accent. More specifically, he has encountered the inevitable discomfort some Jewish Americans have in facing a recent Palestinian immigrant:

> One time a man at Foley's at Northstar Mall where we were shopping noticed me speaking to a friend in Arabic and he asked, "Are you from Israel?" I said, "I'm from Palestine." He looked at me and said, "There's no Palestine. It's Israel now." I said, "No. It's still Palestine." He didn't like that. He said, "Why don't you say Israel?" "It's not Israel," I responded. "It was the West Bank of the Jordan under the Jordanian government!" He was angry, looking around; I think he was scared, too. Everytime we see him, he'd go to the other way. But we're not criminals here.

For Diana Sahwani, life in Israel as an Arab was "a suffocation; it's a kind of death." [12] Living there for her was like living "in a big prison." Though about 15 percent of Israel is Arab (about 650,000 of 4 million), these people can form no independent political parties, they go to segregated schools, and some live in the worst slums in the state. On the list of Israeli municipal improvement priorities, the Arab neighborhoods are at the bottom. The once-proud Arab sector of Haifa is now reduced to shanties and dirty streets. Ancient buildings in Israeli sectors are preserved; in Wadi Nisnas of Haifa, they are let go to seed. Tax money paid by locals goes elsewhere.

As she talked, Diana would barely move a muscle in her near perfect, ivory face. She admitted she had had any spontaneity drained out of her by the time she was a teenager. "Growing up in Israel is so frustrating," she said, touching a hand to her swept-back black hair. "There was no falling in love—feelings did not exist in an extremely conservative Arab subculture. Emotions were like a disease. If you don't have any you're much better off, because this way you keep your family name unblemished."

I asked Diana to explain. Slowly she opened up to me about the mutual isolation of Jews and Arabs in Israel, and the identity crisis of the Israeli Arabs who stayed behind, thinking they would hold stubbornly to what was theirs, only to be engulfed by the expanding tentacles of the Jewish state that instead of embracing them isolated them. It was a kind of apartheid, and emotional protest was fruitless at best and dangerous at worst. "I wanted to be a writer," she lit her cigarette. "But it is too emotional. Not being able to be indifferent I would get too

involved; thus it would hurt me to write. I picked something strong, where no emotions were involved—engineering." She worked for an aircraft company on a missile program in Wichita, Kansas.

She thought about participating in the Israeli Communist Party (Rakah)—the only one that was sympathetic to the grievances of Israel's Arabs—but didn't because her father forbid it. She endured, as all Israeli Arabs, having to show her ID card at agencies, on streetcorners, to policemen who stopped her for traffic tickets, to cash checks. But unlike our SSI or driver's license numbers, the fact of being an Israeli Arab is coded into the ID number. First, under "Nationality" on the ID card is stated either Arab or Jew, not Israeli. ("Jew" is listed only if the holder's mother is Jewish, which has led to an identity crisis in Israel over just what constitutes a Jew). Second, the Arabs of the state all have ID numbers that start with 53 or 2, and the number is recorded on your passport. It sickens Diana to think about the last time race was identified by number.

Intermarriage is not as uncommon as it used to be between Israeli Jews and Arabs, particularly when an Arab man marries a Jewish woman. In that case, the children are identified as Jews; unlike Arabs, they are drafted into the army (unless the mother converts to the religion of the father). Diana told me about an Arab man, a next door neighbor to the Sahwanis in Haifa, who had married a Jew and whose children did not speak Arabic, but rather Hebrew, and completely identified with the symbols of the Jewish state. Nevertheless, they had left Israel before the age of 18 to avoid fighting in battles against neighboring Arab countries.

Much rarer is for a Jewish man to marry an Israeli Arab woman, largely because it is not accepted in either society. To Orthodox Israeli Jews, lineage is passed through the mother and therefore such children would be outcasts. Likewise, for the Arabs there is great reluctance to see their daughters marry Israeli Jews. It is simply not accepted, she said. An Arab mother cannot convert to Judaism because, according to Diana, in Israel Judaism had become not only a religion but also a race.

For Diana, a highly attractive woman with a desire to achieve in the professions, outmarriage was practically impossible, and marriage within her own society would have kept her in hovels and political subjugation. She had to leave. She was "suffocated." She crushed her cigarette. When she got her green card in the United States in 1980, she was asked her nationality. "I refused to put 'Israeli' because Israel doesn't call Arabs Israelis, but Arabs," she explained. "The immigration officer said, 'Arab is not a nation, and Palestine does not exist—we can't put either down.' He was right, of course. So I suggested 'stateless.' It was accepted and that was recorded under my 'Nationality.'"

The Lebanese of the Third Wave are coming to America for drastically different reasons than did those who braved the first steamship trails to Ellis Island. Their country has been torn asunder, from without and from within. With close

to 2 million Arab Americans of Lebanese background, 56,233 have come here since 1967, 43,141 of them since the civil war commenced in 1975. Each violent spasm in a country where central government's role in public life is practically nonexistent causes new immigrants. According to Dr. Tony Khater—who came to the United States in 1972—if not for the rich, the poor, and the stubborn, over 75 percent of Lebanon would have left the country by now.

Self-described as "hyper," my friend Tony has a difficult time sitting still. Typically, he would visit my apartment for a coffee (coffee, in Tony's parlance, is a solid—you "take a coffee" and thereby have life in all its grounds). First, he would pour himself a glass of water from the tap, then have the coffee, chatter about the latest flare-up in Lebanon (his parents still live in Beirut), and then abruptly stand up and say it was time to leave.

Just after he took work at ADC, Tony received word from Beirut that his older sister, Samia, had died of a rare blood disease. He flew home in the war-weary atmosphere to mourn for her with his parents. Another sister, Ehsan, froze in the middle of the streets one day during the civil war, caught by gunfire, and suffered shellshock for a year afterward. His father, a retired soldier in the Lebanese army, had been hit in the streets by a stray bullet. Typically, after months of huddling in Tony's Washington apartment, Ehsan ventured out to the new world to get work at Blackie's House of Beef as a hatcheck girl. His brother, Bassam, labored in an optometrist's shop. But for Tony, the Lebanese way of going into business was not to be—he worked in the Arab American groups, especially adept at community organizing and linkage with other ethnic and special interest groups. He had friends in every community—black, Hispanic, feminist.

On many occasions, however, Tony bemoaned that he was making a living off the suffering of his country and longed to leave the political groups. After securing his green card he left ADC and NAAA and entered law school at Georgetown University. His father admonished over a crackling long-distance phone call from Beirut to his 32-year-old son, "Tony, do me a favor—try and enroll for once in the marriage school!"

I asked him why he had come to the United States in 1972. After making a list in his inimitable way, he said that the main reason was "economic suffocation." Though he had been accepted by the American University of Beirut and St. Joseph University in Lebanon, his parents could not afford it. He had had a friend in Buffalo who told him about a foreign student tuition waiver program. At SUNY Buffalo, he worked his way to a Ph.D. in political science.

"Immigration has always been a sort of safety valve for Lebanon," Tony explained. "Lebanon is one of the most densely populated countries in the world. University graduates were on the increase there in the late 1960s and early 1970s, and they had no job prospects. Hence they turned to the United States, to Latin America, Africa, and Australia." [13]

In spite of his denial of political content, he did admit being disturbed when, at

the time he was working for the Lebanese Ministry of Defense's topographical unit mapping the country in the mountains around Bsharri, he discovered Lebanese army officers training agents with the Phalange:

> The army felt that there was no way to curb guerrilla activities through Lebanon without kind of throwing the country apart, so the only option available to them was to arm the Phalange to balance the presence of the guerrillas.
>
> But I guess I don't go back because I never was crazy about Lebanon. I mean—this is hard to say and I may regret it—but I think for class reasons I feel that way. Lebanon, to me, was always a very class-conscious country, a society with too many pretenses. Lots of Lebanese know what I am talking about. For example, I had to pay to go to the beach. Now if my father were an officer in the army, his children would be able to go for free to a very nice, clean, well-taken-care-of beach.

Tony estimated that most Maronite youth fought for the Phalange during the civil war in Lebanon, and if they didn't their sympathy was still deep. He chose not to fight—as a Maronite. But here he suffered:

> I mean, your country is your point of reference and when it is being displaced, phased off the map, you feel it. It was like hearing the news that a mother or father was dying of cancer and you are unable to go back. We lost touch with my parents for a few months in 1976. Then I heard they needed money. I tried to get them some—all I had, two hundred dollars—but the bank told me it would have to send the money to Damascus where they would have to pick it up. It was ridiculous. They wouldn't have done it. I later heard that my father was prepared with lots of food stored up. A bomb hit the apartment where we lived. My mother told me all the canned food spilled on the floor, sardines, tuna, you name it. She was happy it did not hit the other side of the kitchen where the new refrigerator was!
>
> Water—it was hard to get. In wintertime, they collected water on the roof of the building. Bassam would put a hose on the roof down the balcony to them into a bucket. Then they would go to Baabda—which had a polluted spring—and carried off water in their cars. It was really a hard time. They were always baking bread, in the mountains. These times were just awful. Walking over to their shelter was in itself a danger. My father got shot in his side by Palestinians at Tal Zaatar. It was a tough time sleeping.

"And yet you didn't want to fight?" I persisted.

"On whose side to fight?" his voice cracked, and his forehead furrowed. "There's where it was a bit weird. If I knew whose side I wanted to fight on, I would have had less of a problem."

"It wasn't so easy for you to be pro-Phalange?"

"No," he was definite. "The Phalange were suicidal. They were exploding the whole country just to kill an ant."

But what about the tremendous corruption in Lebanese politics that showed the state to be decayed from within, aside from the Palestinian element. "Corruption everyone took for granted," Tony said nonchalantly. "In the elections of 1970 I was paid fifty Lebanese pounds to take my parents to their hometown of Saghbine to vote for a certain list. My first bribe! I liked it."

Tony actually grew up in Marjayoun, south of Saghbine on the Lebanon-Israel border. He warmed to this topic. Marjayoun, he said, was a scenic, gorgeous village with many homes of red brick. There were a number of wealthy people who kept the town up. Dr. Michael DeBakey—the famous heart surgeon—had parents who came from Marjayoun, as do U.S. Representative Nick Joe Rahall (D-W.Va.) and James Abourezk.

Tony's grandfather was typical of Marjayoun—a jeweler who went bankrupt and owned part of a store he tended to when he wasn't drinking ʿaraq or coffee at a local café. Tony's uncle was a cobbler and sold cartridges for hunting. His grandfather also repaired hunters' guns and resisted all attempts by relatives to convince him to move to Beirut where he could be a jeweler again. He loved to drink ʿaraq and eat pomegranates and huṣrum, a kind of sour grape. He also had "Communist tendencies" and kept his store full of books and magazines extolling the achievements of the Bolshevik Revolution. Often he would take walks with a friend, Rames, to a plot of land he had on the Palestine border, from which you could see Metulla, now in northern Israel.

"They were really absolutely lazy!" Tony laughed. "If I didn't find my grandfather at his store I knew he was having ʿaraq and laḥm mashwī (grilled meat) at the local restaurant. They never worked over there." It was a lost world. There were two doctors—one who dressed elegantly and one who dressed shoddily—who drank with his grandfather. The latter he would visit in his apple orchard. There was Jirdan, the grocer, who "was always shouting and screaming at people." To the left of the store was the restaurant and then the square with its taxi stand.

But now Marjayoun—according to Tony's mother—has gone downhill. "The streets are lousy—you can't even drive on them. Bombs have made craters all over the place, and the water and sewage systems are running loose all over the place. There are huge foxholes and bomb craters. There's not one single Muslim left in Marjayoun."

Tony fondly recalled youthful days walking with his grandfather about fifteen minutes from the store to a Shiʿite village nearby, Dibin. They had lunch there often and had to cross cemeteries to get there. "There was a jāmiʿ [mosque] there and they started chanting Allāh akbar [God is great]," he recalled with a distant gaze. "It was so pleasant. Until I was 17 I didn't have any sense of Muslim-Christian conflict in Lebanon. Our school, though mostly Christian, had about one-fourth Muslims, usually rich ones. The two groups fraternized a lot."

Did he feel bitter about Israel having occupied southern Lebanon for three years, and Marjayoun still? "It doesn't make me feel more sad than I would feel

for Lebanon in general," he said. "I mean, I am attached to Marjayoun, but the whole country is in sad shape. I hear now in the town they build new houses with bomb shelters. I think they must have gotten them from the Israelis."

Tony's adjustment to Washington, D.C., and the United States in general has been difficult, as for most new immigrants. The concept of "privacy" and time alone was new to him. "It's a bit too much here," he thought. "But I still would rather have it than have less privacy in Lebanon. You have no privacy whatsoever."

Tired of "making money off the suffering of Lebanon," he left the Arab American organizations. But he also could not take the hypocrisy that would not address certain Arab states' violations of human rights along with Israel's. "Either you keep silent, or you train your sights on all of them," he said.

But while Tony Khater was to take the pledge of allegiance in 1987, Dr. ʿAlāʾ Drooby—a Lebanese immigrant from Beirut in 1978—will not. A man of few words, a not uncommon minority strain in the Arab character, Drooby sat in his office at the Houston Medical Center, a few strands of hair combed like a median strip over his head. His expression was intense, concentrated, quiet, his demeanor that of a mongoose, one who has had plenty of run-ins with cobras.

I was told by leaders of the Houston community that Dr. Drooby was a "must" interview, and not just because he headed the sizable Houston contingent of the Arab American Medical Association. Drooby tells it like it is—stripped.

I left Lebanon on account of three kinds of pollution that I had found there [he stated in rat-a-tat-tat style]. I had said to myself, either love it or leave it. So I left. The three kinds of pollution are social, aesthetic, and acoustic. People were too noisy, radios blaring, car hoots. The lack of respect for the beauty of Lebanon—which, of couse, nobody puts merit in, but there is no merit in disfiguring it. They would cut trees and build ugly buildings. Now let's move to the serious part, namely, the various corruptions that everyone knew about and seemed to expect to come to an end through some sort of magic. Of course, I don't believe in magic, so I thought that, since we were living in a country that was above all committed to Western ideas, I should raise my family in a Western country. Australia was a good mixture of English and American cultures and habits.[14]

Drooby did not stay in Australia because his American-born daughter had graduated from university and wanted to settle in the land of her birth. She also left Lebanon after an eight-month stint doing social work in 1977 when she realized the hatred "was an irreversible course." His two sons—a physician and a realtor—also came from abroad to the United States the year the whole family decided to transplant to America for good. They followed the route of the daughter, who had tried the hardest to mend Lebanon; America waited at the end of the failed experiment. Now Drooby teaches at Baylor College of Medicine and

works at the Texas Medical Center, as does Aida McKellar, with Vietnam veterans who are emotionally disturbed.

Tony Khater had mentioned vote-rigging as a kind of corruption in Lebanon. What had repelled Drooby?

> Instead of paying taxes like you do here for services you expect to be provided to the citizens, people are really at the mercy of the whims and contributions of citizens directly to these civil servants. You wouldn't have services—water, telephone, electricity, repairs—unless you gave money and favors to some people in the government.
>
> I thought that I would represent Lebanon much better in a place where I could talk about the country—the people and the contributions of the Middle East and Lebanese culture—rather than stay there and develop ulcers and hypertension because of the extreme corruption.

I caught something here, the tendency of the Lebanese—and this could apply to Palestinians as well—of preferring a homeland or of becoming more comfortable with a homeland "of the mind." This attitude is made blatant in Gibran's poem *Your Lebanon Is Not My Lebanon,* in which he opposed a land of violence and greed to one of verdancy and beauty, the latter clearly mental. Something similar occurs in the poetry of Palestinian American Fawaz Turki, for whom the return from diaspora takes on transcendental dimensions.

Though Drooby was lucky enough to take "the good part of Lebanese life" before he got out, the suffering of those he left behind haunts him: "There is no way to quantify the misery of people who have lost their children, their parents, who have been killed for no worthy cause—bystanders. People who were standing in their homes who just got killed. Or people who were standing in front of bakeries who were machine-gunned. And other people preventing the fire department from coming to offer help to burning homes . . ." His voice trailed off. He was revolted by the massacres at Sabra and Shatila, but even more so that the Lebanese inquest took a year to convene and in the end indicted no one: "Now this is a continuation of what has driven me out. There was no guts to state things black and white. Open television; open radio. Listen, and you will find nothing but wordy statements. Not worthy—*wordy*—like good old Shakespeare said, nothing but words."

Typically for émigré Lebanese, Drooby spoke as an internationalist: "I have found that human beings behave exactly the same way wherever you are, even if you are in Alaska or Siberia." Iconoclast to the end, Drooby even thought the traditional hospitality of the Lebanese was "a put on." "This cult of 'I can knock at your door and have coffee' is not true," he emphasized. "Coffee was always offered to people who didn't need it. But if someone came and needed less than coffee, he wasn't given coffee or sugar or anything."

I didn't think Drooby was leaning toward accepting American citizenship with

these comments and I was right. "You don't know me, but I've always said nationalism is the first poison," he put his hand firmly on his desk. "I don't mind becoming a Tierra del Fuegan. I don't care. I would pay my dues. I would limit myself to moral ethics like I've always done. It doesn't matter two hoots what passport I am."

Arab Americans, to Drooby, did not show signs of being able to organize effectively as a political entity: "I think it takes some training. It begins with very rudimentary things, like not being particularly upset at stopping at red lights in the middle of the night. Then there is the constant fear that this political organization might alienate them from their present country or environment." He did not, however, ever experience prejudice, though he has been politically active. On the contrary, he believed that some professional colleagues who had experienced prejudice were to blame themselves: "I think it's exclusively their doing."

Then there's no need for an American-Arab Anti-Discrimination Committee?

"No," he said bluntly. "ADC will not be able to change the behavior of its members, nor the members their own behavior. This is something you cannot get from meetings or reading pamphlets."

"So you are saying discrimination or ill will is caused by the victim, the insecure one who needs an adversary?"

"Yeah. I would like to add to this that, of course, as in clapping, one hand will not do it. There will be certain attitudes waiting to be confirmed in the recipients. In other words, if I go into an environment that is anti-Arab and I confirm their opinion, it will be anti-Arab. But if I *disconfirm* it, if I know *how* to disconfirm it, then it will be different. That is a difficult job. It is very unsettling to the people whose attitudes you have disconfirmed. But we will always have prejudice in human nature."

Would Arab culture and mores be something he would want to instill in his children and grandchildren? "No," he said. "I do not need to instill it. It will be witnessed. With my death, it will disappear, because these are modeling things. It's not by precept; it's by example. But even in the Middle East, it's adulterated. There's no such thing as a pure culture; it's all bastardized."

He felt no conflict between being a Muslim and practicing psychiatry; he was, predictably, against all fundamentalism, Christian or Muslim. "From discussing God's fish to discussing God's politics, or His love—it's the same, all of it. You'll find that in African tribes, in Australian aborigines." He had been on a *hajj*, a pilgrimage, to Mecca in 1971, and he said with typical bluntness that it was "just a version of a meditative exercise," and that he had gone out of curiosity. "I don't think that God is better in one geographical spot," he said. He did not think that revolutionary Islam—such as Khomeini's brutal version—was valid: "This is no Islam at all."

Drooby called God "the First Principle," and I wondered how he reached Him through prayer. He explained, "Anything that goes through the mind must be

wrong. Any explanation that is a noetic one must be wrong, very reductionist. The First Principle is not capable of being described, or visualized, or conceptualized. No."

At this moment we were interrupted by a knock on the door. It was a tall, dark man looking disoriented, wearing army fatigues. Dr. Drooby excused himself, saying he had to get him his medicine.

6 Before the Flames

For many Americans today, the question of land is a moot one—land is unaffordable unless it is inherited. But we are here in southern Lebanon because of the issue of "land"—who took whose. The land is the Holy Land, not any ordinary land, and this is not an ordinary meal.

In an Orange Grove at Tyre

In an orange grove that in two months will be razed, Colonel Azmi of the Palestine Liberation Organization is administering communion. It is April 1982 in southern Lebanon. Under the tight mesh of orange trees while his soldiers look on and smoke, Colonel Azmi, the commander of the Tyre pocket, tears morsels from a lamb shank. *Agnus dei, qui tollis peccata mundi* . . . [Lamb of God, who taketh away the sins of the world . . .]. His men, in fatigues that blend with the waxy leaves above, have brought two large tin platters of rice, pine nuts, and lamb. We—two from America, three from Italy, one from Jamaica—are motioned to the table, a wooden table that recalls childhood picnics in orange groves in California. This table is not redwood, however, and there are no sprinklers spraying delight. Aging may be said to be a process in which sprinklers disappear.

Stopping in front of each guest, Colonel Azmi pulls mutton off the bone, and each opens his mouth. The lamb is placed on the tongue and is chewed with a strange, stunned smile. The handsome colonel, whose russet-colored hair is cut neatly, does not break into a smile but his amber eyes shine. For a minute he is Puck, as well as priest and guerrilla leader. As he stands in front of me I notice the deep scar on his forehead. They say he received it in battle with King Hussein's marauding troops in Jordan, 1970. Then—Black September. Now—Orange April, with the heat coming.

"More! More!" the colonel urges us, sitting down, pulling at his bone with his teeth. It is the best rice and lamb I have ever had. The pine nuts, or *sunūbar,* are plentiful, not like the very few placed in the center of a *kibbah* [meatball]. As children in America, we would eat each *sunūbar* slowly, the way you would eat the three-colored candy corn, slowly, taking each color—yellow, orange, and white—one at a time, until the sweetness is gone.

Here in the orange grove of the revolution along the ancient city of Tyre, pine nuts in rice are plentiful, the air is suffused with orange blossoms, and the branches are so tightly interwoven we cannot see the sky.

A soldier brings a glass jug of water to the colonel, who lifts it over his face and catches the thin cascade with his tongue, guiding it down his throat. See? We nod. Around the table goes the *ibrīq*. In Lebanon, it holds water, not wine as the earthen *porrones* do in Spain. In two months, the *ibrīq* of Lebanon will be filled with the blood of Adonis.

Earlier in the day we drove on a bridge over the Litani River, in which Palestinian and Lebanese peasant women were washing their clothes and filling their jugs. The Litani empties into the Mediterranean at Tyre, taking one clear blue vein to its god. Most everyone in Lebanon believes the Israelis want the Litani. The Israelis have bullets and jets, but not much water. The Lebanese have water and a beautiful snowy mountain, but no jets. The Palestinians have no jets or water and only slivers of land sucked away from them daily in the West Bank and Gaza. But here in Lebanon, at least for now, they still have a kind of priesthood of injustice, a few orange groves in which to hide, and wait.

The colonel has said, "No questions until we eat." And so back in his tent after the meal, near a lamp that glows even in daytime because the grove is dark, the questions start. "Against the sea? It is we who are being driven into the sea . . . tell your Congress . . . tell your president . . . the bias in the media . . ." It goes on and on, but the lamb is on my mind, given by three fingers the way an Orthodox priest blesses himself. I can hear the Kalashnikovs of the guerrillas knock against the trays and glass jug in removing them. Above all of us the Israeli jets look for a hole in the orange trees. They don't need a hole. They can make a hole.

So this is the communion of those whose cause to live is older than I and from whose land my family came nearly one hundred years ago to America. This is the communion for those who loved America so much that ideals burst like roses and browned. This is the communion against the F-15 and the Rockeye cluster bomb. This is also the communion of those who may have wandered too far to find their heritage. The heritage is oranges and war. One seemed to mean the other.

As the Plane Lowers over Cyprus

At Orly Airport in 1972 three generations of Americans from the Levant were smiling. And why not? Damascene and Beruiti relatives were waiting to celebrate with the Awads and Orfaleas. 1972 was a "peak" year for Lebanon: tourism was at its highest, commerce and banking were flourishing. The world-famous jazz festival in the Temple of Jupiter at Baalbek was sporting Ella Fitzgerald.

It is 1982; there is no family with me, and no smile on my face or on the faces of passengers who line up for the Beirut connection of Air France, now from Charles de Gaulle Airport in Paris. The Lebanese, though, seem more sober than somber. Some women wear designer jeans and coats with fur collars; some men

have Homburg hats and attaché cases of leather. Thick eye shadow on the lovely Lebanese women hides the shadow of war. Here are émigrés coming back to Beirut to see family briefly and then leave. Here are Beirut businessmen who have taken a Parisian breather. One dark-haired woman wears a blue T-shirt with an arrow pointing downward to "Baby." I am with no family, but another writer, Grace Halsell. My mission: what happened in ten years to Beirut, to friends, to family, to the political causes we began to champion.

As the plane lowers over Cyprus, the orchid on each empty seat in first class begins to move, and the empty hangers in the first class closet jostle softly. The Mediterranean glitters like a silver ladder whose rungs melt across the water east of Cyprus. Rather than chance the international airport in West Beirut, the Phalangists take hydrofoils from Cyprus to Jounieh Bay above East Beirut, except for "big shots" like their leader, Bashir Gemayal, who has a helicopter waiting at the airport to lift him from West Beirut to the right-wing Maronite Catholic stronghold in the East.

Most everyone on my flight has worn earphones, as has the gentleman sitting next to me. Little by little, he reveals himself, in a torrent of philosophy that mirrors two Phoenician precursors of the Lebanese: Zeno the Stoic and Epicurus. I am later told that people can be very talkative on the Paris-Beirut flight because once on the ground they have to take care what they say and to whom.

Samir, a Lebanese architect born in Senegal, educated in France, now working in Beirut, responds to my compliment that he resembles a U.S. congressman, Nick Joe Rahall (D-W. Va.), whose family is from Marjayoun, southern Lebanon. After sharing a Davidoff (Russian) thin cigar, he gestures with manicured hands and eyes of unending blackness:

> Listen to me. I make myself whomever people would like me to be. If a Muslim talks to me I answer back in a Muslim accent; if a Christian, in Christian accent—and you learn to know both. If a stranger speaks French, then French; if English, then English. What are nations? What do they matter? Survival is the key. For that, I am nobody, nothing, and yet everybody.
>
> Look, the Lebanese are optimists. If I shed tears tonight over one who is killed, tomorrow I'm up selling my fruit on Hamra Street because life goes on. How do you say? *Esperance.* Hope. That's a big word with Lebanese. We have had seven years of violence and I'm still alive. So—why not seven more? [At this he lights another thin cigar.]
>
> Business and money. Very important here. Business to take our minds off the death, and money to buy security. We make lots of money because there are no taxes, no assessments, no government! *Anarchisme, oui?* Believe me, don't skimp on money while you're here. Take a taxi—a yellow one—from your hotel anywhere. It will cost more—$20 from the airport to Hamra for instance—but you have to spend money for security. That's a very important word here—security.

This fixation with security and the chameleon internationalism is peculiarly Lebanese. Samir compares the Middle East conflict to both theater (America is the producer, Israel the director) and a meal of lamb and salad (Israel, the lamb, eats the salad made of the Arabs, and the United States eats them both).

"Haddad, Gemayel, Arafat are all playing bit parts and they don't know it," he scowls. "You have to be a diplomat here. The other day my sister who is very beautiful was harassed by some goons with guns. I made jokes with them, though in reality I wanted to shoot them. They let her go, laughing. But I had no gun and they had three. I had to make a joke and bear this humiliation. Everyone in Lebanon is a diplomat."

As we cross over the silvery water of an afternoon, Beirut harbor grows into the window pane, then the green hills, the limestone houses, and the abrupt mountain covered with an April snow. *Lubnān.* Ancient semitic root-word meaning "white," white as the treasured snowy mountain (*laban,* yogurt in Arabic) where hermits and anchorites and clans of all sorts escaped the plunderers. And developed their own paranoias . . .

Samir insists I take the remaining Davidoff cigars. "I would like to have you to my house, but if you should get blown up by a car bomb, I would never forgive myself," he says.

As we descend from the plane, at the base of the stairs are two Lebanese army soldiers—tall, cheeks sharp and reddened—pointing with M-16 submachine guns to where our feet should walk between them.

Soldiers Get Younger

I have forgotten how young soldiers are. These two look like they just finished playing soccer. Behind them a sea of porters surges forward amidst a swell of men in different battle fatigues. My architect friend, Samir, waves good-bye and is carried away in the sea.

We arrived in a dawn ten years ago. Now it is afternoon. Jaddu had to pay off a few Lebanese custom officials back in 1972 because we had extra boxes of clothing for our poor relatives in Damascus. Now—astonishingly—when the risk of smuggled weapons or drugs is so much higher—our bags are hardly touched. A customs man asks what we're carrying. "Personal belongings," is the answer. He doesn't even lift his head before waving us on. Most wars would make customs agonizing: in Lebanon, customs is superfluous. Anarchy has made the term "corruption" quaint.

A timid-looking, navy blue–shirted man in his thirties comes up to us and mentions softly that he is our guide, Mohammed. He has an immediately reassuring voice, a chipmunklike moustache, and friendly eyes. Later in the week, after a late dinner at the hotel in which he will have castigated a Finnish photographer for being touchy about Arab men and tried to convert an Indonesian stew-

ardess into being a revolutionary, he will pull a revolver from the back of his belt and say, "I am reassuring because of this."

Mohammed helps us with our baggage into a beat-up Mercedes and sheepishly turns his hands upward when the porter stands glaring for a tip. Mohammed does not have any Lebanese pounds, and neither do we, having just arrived. The porter with a three-day growth of beard fumes and does not blink his blue eyes before walking away, pushing his cart abruptly. Is he Lebanese? Our guide is Palestinian. I do not think Mohammed intentionally slighted the man, who is scraping for a living like everyone else in Lebanon (except for the builders and the gunrunners, who make fortunes off destruction). There seems no overt snubbing on our guide's part. And yet . . .

It takes me back a decade to the lunch thrown for us in Zahle in the mountains by the aunt who set a bountiful table for Jaddu and his group: *mazzah, kibbah, tabbūlah, ḥummuṣ, baba ghannūj,* all the sainted foods. My aunt took our appetites away when she ordered her young Palestinian maid to sleep on the stone floor.

In between these two perhaps unconscious snubs—one of a Lebanese to a Palestinian, the other the reverse—60,000 died in a vicious civil war (or 2 percent of the population), one-fifth of the Lebanese (600,000) emigrated to other lands, forty different armed militias sprang up, and hundreds of thousands of Lebanese and Palestinian civilians were made homeless by the Israeli invasion of 1978 alone.[1] Both Palestinians and their Lebanese hosts jockeyed for a foothold in what seemed to be building up to the "Little Bighorn" for the former, perennial refugees since the establishment of Israel in 1948.

We drive up from the airport through three checkpoints—one Lebanese army, two Syrian—before getting to Palestinian security just south of Beirut's center. One Syrian soldier asks if we have "magazines." "That's a new one," Mohammed smirks. "He wants heroin, money, or guns and says—'Magazines?' "

Traffic thickens as the airport road moves near three large Palestinian refugee camps—Sabra, Shatila, and Bourj al-Barajneh. It is 2:30 P.M., and already rush hour in Beirut. Most government and professional offices close at 2:00 P.M. in West Beirut for security reasons. Still, vendors have a go of it until nightfall, taking their chances. The contrast of poverty and wealth so pervasive in Beirut ten years ago is still here. In front of Sabra runs a wall—not of sandbags—but of designer shoes from Paris and Rome, the vendor sitting on a wooden chair.

We pass open-air shops of chickens and parakeets and shrieking parrots. Stalls of furniture and small appliances. Alongside a stall of plucked chickens hanging from hooks are tricycles hanging from hooks. I think, there will be children who will pass them these next few months, want one, be denied, and will not live to ask for a tricycle again.

"You trust me?" Mohammed pulls a Marlboro pack from his shirt pocket. "That's pretty good for a terrorist!" He offers us cigarettes and I will refuse six times such an offer the first day. In the Middle East, cigarettes are tantamount to

oxygen. One offers cigarettes the same way you would roll down the window of a car to give a passenger "fresh air" or offer a thirsty traveler water.

Finally we pull up at the Hotel Beau Rivage two blocks from the Ramlat al-Baydah ("White Sands") beach—a key target, we are told later, for an Israeli sea assault. It's a fine place, with a small circular drive underneath shade palms flicking in the breeze, a doorman, a huge dark-gray lobby where the television is the center of attention, and a dining room with windows fronting all sides. There's an excellent view of the Mediterranean. And also a Syrian tank seen just as one dips down his fork for a lemon-soaked cod. A boy in uniform is washing the tank with bucket and soap the way one would wash a car.

The Beach of Cans and Bottles

In 1976, U.S. Ambassador Francis Meloy was shot and killed within view of the Beau Rivage on the beach road. A few blocks south, in the Jnah section of Beirut, the Iraqi Embassy was blown sky high in December 1981. The building was supposed to be "bomb proof" and its leveling was more than the usual embarrassment to the neutered Lebanese government. Some say the explosion—which killed sixty, including the Iraqi ambassador—was an "inside job" by Iraqi dissidents, as the dynamite was planted deep underneath the structure of the building. The Iraqis were so incensed they moved their headquarters to East Beirut in Hazmieh near the presidential estate of Baabda—one of the only areas of Beirut patrolled by Lebanon's own army.

A great story of survival is told about the exploded Iraqi Embassy. A man survived in the rubble (though pinned) for two weeks on some chocolate in a smashed pantry and a trickle of water from a pipe ripped open by the blast. The story emboldens itself on my brain over the next few weeks as quintessentially Lebanese in its absurd, almost heroic determinism. One man survived on chocolate; sixty others perished writing memos or swabbing floors.

I walk along the shore one of the first nights, past kids playing soccer in front of the Syrian tank, past a Palestinian guard near an anti-aircraft gun housed in the bed of a truck.

It was dawn when we arrived ten years ago. We were family linked like a chromosonal chain expanded to life-size. We had come to link with the other helix of life that was ours, that had stayed in the ancient land where Christ had brought wine from water, Mohammed had ascended into the sky, and Moses had drawn open the Red Sea. My mother—a serene dark-haired beauty with wide smile, teeth almost bluish white, and eyes luminous as onyx—walked with me from our beach hotel in Beirut toward the sunrise seizing the mist. We walked in silence that did not make us fear. (Silence in Beirut now is one of the most oppressive things I have ever heard. One is always listening to silence during the night, waiting for it to crack.)

The sand of a sundown in Beirut sweeps down from the bunkers along the sea. Seven years of war had made Beirut's beach a minefield of trash. Along the seawall runs a strip ten yards across and two feet deep of rusted cans, glass bottles, and empty plastic containers of Sanīn and Sohat springwater. Beyond, the old Mediterranean uncoils. It is not inviting. It is as if the sea is a cobra raising its head, hissing: *Stay out.*

The soldiers guarding against an Israeli attack tonight are not Lebanese, but Palestinian and Syrian. And the sun grows like a tumor in the sky over everyone—uniformed or not. A burning lethal pinkness that makes everyone civilian. It is Saturday night. Drivers of souped-up cars are gunning their engines along the beach road, spinning out in a frenzy as if this were some final Grand Prix. The "drag strip" down by Summerland south of the city on the way to Damour (curious—there's a "Summerland" just south of Santa Barbara, too) has been shut down to these anxious cruisers and so they have taken to racing closer to the city. The drivers are not just teenagers, either. It is as if all the tension of Beirut has gathered here, engines roaring. When they die down, the gunshots begin.

Enough. I have seen the cans and bottles and disposable diapers of the West pile up at the doorstep of the Orient. I must get back to the Beau Rivage. The Syrian soldier squints when I call hello to him, "*Marḥaban,*" the way you announce yourself in a dark forest if you hear rustling in the underbrush.

Mahmoud Labadi Turns the Car Ignition

. . . and in the backseat of a yellow Toyota I instinctively turn my head. In the first three months of 1982 at least 126 people were killed in Beirut by the explosion of cars. The car bombs are a new twist in the string of anarchy and brutality in this city of vicious contrasts. It is one thing to worry about carbon monoxide pollution from the Great American Freedom Machine. It is another to walk the Beiruti streets wondering: Is this the one that destroys me? The one whose fender fills with an image when I squeeze by, touching it?

But Labadi's engine grinds to a normal start and he backs out of a parking space right on the curb, alongside a car lot with hundreds of cars. No parking lot attendant is to be found. This amazes us the whole trip: the minimal security surrounding key PLO offices. We are not searched once in three weeks. The author I travel with states that in Israel "even my lipstick was searched!"

Labadi drives on the left side of the road, on its shoulder, in order to make a turn as they do in Greece, and for a second the world is topsy-turvy again. We pass by Raousche on the northwest edge of the city where assorted shops came after the civil war leveled the downtown *suqs*. Beirut is a phoenix, a city ceaselessly rising from its own ashes. And the poor shopkeepers who fled the horrid no-man's-land (the Green Line, which ends in the *zaytūnah* section near the seashore) have placed their corrugated tin hovels at the very end of the land at Raousche, overlooking a sheer cliff and Pigeon Rocks offshore. Some have fallen off.

To survive one catastrophe in Beirut is child's play. One must learn to rise up and rise up repeatedly. Labadi points to a section of the Raousche market exploded by two car bombs on February 23. Thirty of the ramshackle shops were destroyed as well as sixty parked cars. Unable to depend on the government, or the leftist Lebanese National Movement, or Palestinian groups in the area, the shopkeepers quickly banded together in a committee and in one month's time rebuilt the torn blocks of the market. The Lebanese are like the Palestinians: slapped down here, they appear there. They are like mercury. Or protoplasm.

Finally, we arrive at a coastal restaurant called the Sultan Ibrahim, which serves a four-inch-long fish of the same name, a delicacy throughout the eastern Mediterranean. Labadi scoops up the silvery fish in large hands (muscular, of medium height, he resembles a defensive back) and throws them into a basin the waiter holds. "Grilled!" he orders calmly and by the time we take our seats everyone in the restaurant is buzzing.

Labadi tells us that lunch with visitors is his only vacation. He works from dawn to way past dusk. What of PLO Chairman Yasser Arafat? "He is a prisoner," he says. "The people at the head of a revolution are the least free." Labadi is sparing when talking about himself. Near forty, he joined the PLO in 1965 while a university student in Bonn, Germany, a city he "really loved." He has been in the resistance for seventeen years and has seen some friends give into despair or disillusionment. "We are a free organization," he says, with head bowed. "People can come and go freely." His voice lowers when speaking of his predecessor as PLO spokesman, Kamal Nasser, under whom he had worked. "He was shot in the mouth." Labadi puts a flange of bread into a *ḥummuṣ* bowl and chews slowly.

Nasser was a much-revered poet of the Palestinians. He was sitting at his desk at home April 10, 1973, when a commando unit of Israelis burst into the room, killing him and two others. One Israeli shot him in the mouth because he was a poet: a legend among Palestinians here and abroad. Another story surrounding Nasser's grisly death is that as a Christian Arab he was shot in the palms, the feet, and the side of his chest.

Labadi steers conversation to the Western media, which he feels has been more sensitive to the Palestinian question the past year or two. He has a copy of ABC's "Under the Israeli Thumb" on Betamax, and calls *Washington Post* correspondent Ed Cody "a personal friend who has the courage to write what he sees." (Later, Cody will tell me at the Commodore Hotel bar that he is able to report objectively because "I don't care for either side.")

Arts and sports could further world reception of Palestinian rights, thinks Labadi. "We need a Palestinian *Exodus*, yes," he nods, referring to the novel by Leon Uris that sold over twenty million copies by 1967 alone. "But Palestinian directors are not so good as the Egyptians." There is a Palestinian soccer team with a coach named Zhivago, but "it is terrible: they even lost to Yemen. My God, if they lost to Yemen, what would they do in London?"

After barking impatiently at the Lebanese waiter for water, Labadi sidesteps questions about his wife: she is American and she is seriously ill. We cannot know that in a year he will turn against Arafat, joining the rebels of Abu Musa in Damascus.

Yasser Arafatu!

March 30. Squashed into an auditorium in the UNESCO complex facing the painted poster INTERNATIONAL DAY IN SOLIDARITY WITH THE POPULAR UPRISING IN OCCUPIED PALESTINE AND THE GOLAN HEIGHTS. The stage seems set for a school play. *Julius Caesar? Hamlet?* Yasser Arafat as the Dane.

Curious to note that the Lebanese and Palestinian flags draped over long card tables share the same colors—red, green, and white—except one. For the Palestinians, black is added. A well-ordered Palestinian military band wearing purple berets and gold braid on their shoulders plays bagpipes—an inheritance, no doubt, from the British who had the Palestine Mandate from 1918 to 1948. What a contrast—this proper military band with security guards in T-shirts and jeans running back and forth, their pistols sagging from their belts.

We are addressed by a woman lawyer from France, Frances Weyl, who is kissed on the forehead by Arafat as if she were a nun. She is followed by an Algerian representative, who gets the best cheer of all. Then come a Greek, an Egyptian (mild applause), a Czech, and a young Japanese man who salutes "Yasser Arafatu!"

A funny thing happens with the representative from Cuba. His Arab translator—prematurely gray, skinny as a rail, wearing thick glasses and thick moustache—is the most dramatic translator I have ever seen. His voice is shrill and weepy at the same time. The Cuban looks like he has lost his place in his speech. The translator flies way past the time mark, past the page. He may not even know Spanish. The Cuban may never come to Beirut again. He seems already looking for a boat to Havana. The translator-turned-demagogue. The Cuban resumes speaking Spanish. He has to play catch up. Who is translating whom at this point? He springs his finger high until his face turns red. He spits. He grips his paper hard. Fidel! Bay of Pigs! Freedom! Then comes back the translator in Arabic. The crowd likes the heavy part, which the translator surely is making heavier. Back and forth, back and forth. But the Cuban will not be upstaged. He swings his fist, his cowlick quivers, his chin vibrates with anger. The crowd is going wild. The Cuban wins!

By this time—three hours of speeches—even the master of ceremonies is tired. He sits cross-legged on the floor in front of the podium, smoking. At just this moment Arafat rises to speak. The audience comes alive. Huge applause and loud chanting. Arafat—who comes across in English interviews as very mild, soft—has a rousing masculine voice in Arabic. It takes on many timbres: it is powerful, angry, but also gentle, prankish, warm. He dips his head low and

smiles, raising his eyebrows, slowly lifting his right hand, then forcefully bringing it down.

"Why . . . why do we only share bad times with the Lebanese?" he asks the audience as if sitting in the living room with cousins, forehead furrowing, voice imploring. "Why never the good? We want only a path in Lebanon, not a home. I appreciate the Lebanese people very much because they are suffering very much for the Palestinians. And still they support us."

At critical junctures in Arafat's speech, a spindly, tan youth who had called out "All the fronts!" leaps up again and hurls two lines of spontaneous poetry at Arafat. It underscores the folk love that Palestinians have for Arafat. But it also seems to be a kind of unconscious warning to the leader not to detach himself too much from his people.

When he is done, the crowd applauds and then files out in a manner that is surprisingly civil. With all the guns, pistols, passions and rhetoric—no one is hurt.

Weeds Grow from Sandbags on Rue UNESCO

The streets of West Beirut are quiet. It is Sunday, and, contrary to the journalistic shorthand, West Beirut is not all Muslim but contains at least 70,000 Christians. Some are going to the Sts. Peter and Paul Orthodox Church, others to the Church of the Capuchins, the French-language Catholic church—both in the Hamra district in the center of West Beirut. The sun is hot but there is a cold wind flapping at a dusty palm or two and swaying the fallen telephone wires on Rue UNESCO, moving on the concrete like tentacles of a beached squid.

Drained, troubled by the Palestinian Land Day speeches I heard the day before, I take a walk alone from Ramlat al-Baydah along the Corniche Mazraa up to the heart of West Beirut in Hamra. Though it would seem no one would want to advertise political fealty in the hornet's nest of militias and gangs here, posters—political and cinematic—are plastered everywhere. In the poster race, Hafez al-Assad, president of Syria, has the lead, with Kamal Jumblatt, patron saint of Lebanese leftists, a distant second. Jumblatt, well loved by the Lebanese, was assassinated by the Syrians in 1977. Being dead and a mystic, Jumblatt is relatively safe to advertise. A very tall poster of him from head to toe hovers like an angel above a Shell gas pump where Rue UNESCO goes into Rue Verdun. A few Assad-Qaddafi posters exist, a yoking of separate portraits of the two—about as natural as the alliance of Syria and Libya. Here and there a shot of the disappeared Imam Musa Sadr, the "absent" leader of the Lebanese Shiʿites. Surprisingly few posters of Arafat line the limestone and yellow stucco walls, and hardly any of the president of Lebanon himself, Elias Sarkis.

As for movies, it's just like home: sex and violence. *Montenegro* (or "Pigs and Pearls") sports a woman's legs wrapped around a man as he carries her; *Suzanne* ("The most erotic film of the Eighties") shows a man on top of a woman, both

naked; *The Magnificent Daredevil* with hot rods and guns. Another film poster has a boy giving a flower to a nude blonde with big thighs. The posters are splayed in multiple copies along a wall as if they were celluloid frames. Was it really irony or prophecy that when the first Syrian tank arrived in Beirut in 1976 to police the cease-fire it turned off its engine in front of the Rivoli Theater marquee in the Place des Canons (Place des Martyrs) that advertised *Les Divorcées*? For eighteen months of bloodshed in the civil war, "The Divorced Women" had been playing to no one.[2] People in Beirut, I am told, do venture out occasionally for a quick movie, but most don't dare the streets and stay home with Betamax— home movie cassettes is a booming business. One poster of an actress, or *artiste*, has mud or excrement smeared on her eyes and mouth.

As I walk, people beep their horns—not untypical of a Mediterranean city. But it can either be an invitation to a cheap taxi ride or a warning to jump back into the maze of parked cars that line Beirut streets. Then comes the fear as adrenaline shoves up the sides of the temples. I squeeze through two fenders: is this the one with a bomb? When open space finally does come it is a vast relief. So the pedestrian in Beirut has a choice—dodge the beeping cars out in the street or feel the constriction of maneuvering among the diabolic parked cars.

As the days mount (days do not progress in Beirut, they *mount*), even the presence of car bombs fades in the brain. T. S. Eliot once said human beings can take only so much reality, an appropriate notion for Beirut. The mind flips and transposes an oppressive reality in order simply to get by: *This is not Beirut, it is L.A., and all these cars are parked in Disneyland . . .*

On Rue UNESCO three images rivet me. The first is a small wooden chair sitting in the middle of the road, two stones atop cinder block on its seat and a green plant growing out of the chair's back. Have artifacts become the only soil of Lebanon? Have chairs become road dividers?

Moving on, I come across a young boy sitting in a burlap bag begging in the gutter. Cars miss him by inches. Ten years ago there were beggars in Beirut. And there were the lame. I remember a man with no legs propped on a median strip begging with a hat to both incoming and outgoing traffic. Ingenious! This boy, though, is not ingenious but deeply pathetic. He appears as so much flotsam in a gutter of dust. Legless, he seems the cipher of a whole world. The passengers don't even reach him.

Finally, at a Syrian checkpoint, there is a kind of mute Lebanese protest. In a pile of sandbags, weeds are growing. For a moment, the sun plants a mark on my forehead. The war had gone on this long. There was the tragedy of Beirut and Lebanon, but there was also its secret answer. Weeds would grow from sand, from the very armrests of guns. Pray the weeds would win.

Return to the Salaam House

In Beirut, perhaps more than in any place in the world, "destruction" and "construction" co-exist and imply each other. Holes of red earth are everywhere ("Hamra" in central West Beirut means "red") and the single most pervasive item besides guns is cinder block. But today is Sunday and the cinder block is mute as so many squared bones, and the Caterpillars snore.

Rue UNESCO runs into Rue Verdun, then Rue Dunant and Rue du Rome until finally I am in the heart of Hamra—its shops, vendors, and small hotels—piles of its red soil everywhere. City of open wounds. City of lipstick and bomb craters. An obsolete map pulls me as if by a withered hand. There it is. Two blocks off Rue Hamra.

Ten years ago the Salaam House slid like a warm membrane around the intestines that threatens now to tear or, worse, be chilled. The hotel's beige stucco is filthy; its turquoise shutters, dirty as well. Cardboard boxes, bottles, plastic containers of Sohat water are strewn on its front porch, the porch on which the old Iraqi diplomat used to take his tea and recite poetry to us from the Abbasid caliphate of the tenth century. The pension is boarded up, a sphinx with plywood on its windows. The afternoon breeze disturbs the corrugated boxes on the porch.

I ask a boy selling fruit and cigarettes in the street if he has heard of the owners, where they are, if they are alive. He goes across the street and questions a neighbor. They converse in an Arabic too fast for a pilgrim whose hair is whitening at the root. Finally, we mount the stairs of the hotel from a side entrance. He rings a bell. Ten years fall on the floor like earth. There is a face in the open door, a dark face with no makeup, hair tucked in a bun, a face above a black dress as if she knew I was coming and wanted to show that the lover of Lebanon was in mourning. "You've come."

Two young boys cling to her brown calves. "Please come in." The crow's-feet pull from her eyes as she kisses me on both cheeks, though the rest of her face is brown and smooth. Before I can exclaim what is almost a question—*Hind, you are still alive*—she sits me near a five-foot-long puzzle on a coffee table. "It's a scene of some woods, the kind we used to go to in Lebanon with no fear," she says, looking directly at me. "But I wish there were some running water in this scene!"

Hind asks if I like Turkish coffee *hilwah* (sweet), *wasaṭ* (medium), or *murrah* (bitter). I pick *wasaṭ*; she picks *murrah*. Within minutes I am to realize Hind's courage and bitterness in a city of murderous solitudes. She married the very son of the old Iraqi diplomat who sat on the veranda, a Muslim in fact (she is Maronite Catholic). "Be sure I did it before the war [in 1975], for after, to marry an Iraqi here would be impossible," she relates, holding onto her screeching younger son.

Her husband is gone for months at a time; he works in the Gulf as do many Lebanese men, leaving a covey of tough and strained wives living in the war zone. She works as a schoolteacher but stays inside most afternoons and evenings. With the puzzle . . .

"Since there has been such a 'brain drain' from Lebanon, what is left here is the get-rich-quick people, the nouveau riche," Hind says, pouring the thick coffee from a brass pot. When I ask if they make it off drugs, she flicks her hand upward as if shooing flies: "Drugs? Drugs are too cheap here to make much money. They're making money from building and guns, my dear. As well as protection money. Everyone in West Beirut pays protection money to a different gang. In East Beirut they pay their tax—it's protection money of course—to the Kata'ib."

"Believe me," she says with a huskiness, "my husband would work in Beirut for half the money he gets now if there were jobs. But there are no jobs here, unless it's building or blowing up buildings."

She turns to the past and smiles: "Ah, such times we had!" And yes, she had a "thing" for my kid uncle, whose newly planted hair, alas, she recalls with a laugh: "They are grown in."

"They are."

"Your uncle is the only one of us to conquer time."

"Not true."

"Hmm?"

"He robbed from the rich to give to the poor."

"Eh . . . ?"

"He stole hair from the back of his head for the front, and now he's got a bald spot in back!"

Hind laughs so hard the boys ignite, and the little one with an astigmatism runs into her treasured puzzle, destroying half her forest. She barks—not a shout, but a clear verbal lash of a mother trying to keep order in a family surrounded by chaos.

"What am I to do," she sips her coffee. "But you—what has happened to you? You have hardly changed."

"I am a good faker."

"You escaped marriage."

"Or the other way around." A fiancée took up with a yogurt salesman. "A great insult to the Arab pride," I drop. "I shall never eat a spoonful of *laban* again with pure pleasure."

"But this is the sugar-yogurt you speak of, I am sure. The candy-yogurt. You are not speaking of the real, *sour* yogurt, that is our life?" Hind shows her white teeth.

"For that I will take you to Zahle!"

"Zahle, the beautiful mountain city along the Bardūnī River. Wasn't your grandmother from there?"

"Yes."

"It's a good thing you didn't see the street fighting in 1975 and '76 in West Beirut," she lowers her coffee, eyes following her rampaging sons. "And one thing which kills us—every day, two parties *from this side* fight each other. There were at least one hundred parties. Do you think that they are satisfied to shoot

each other? *Lā*. People sitting at home, or in their beds or writing." She juts her forehead toward my pen.

Innocent people killed, not the armed people. And if an armed person gets killed, they throw bombs in the emergency room. They try to kill doctors. I was there once with my son. He was burned on his hand. The doctor told me, thank God, to meet him on the third floor. They came in the lobby of the hospital and started shooting. All for one bloody Palestinian who's hurt. This is why even the Muslims are scared. How do you want the Lebanese to accept this? Our problem is the Muslims have been scared up to this point; they are not as courageous as the Christians. But now each Muslim is against what is happening. But they don't dare say it aloud.

Hind escaped to Baghdad with her husband for four years after the brunt of the war, but didn't like it. "It is the same with the Lebanese everywhere—they go to Australia, to Argentina, or Paris, or the United States, but they cannot forget Beirut. I missed it here. So I returned. They will, too. But be sure, we are not in control now," she sets her eyes on her visitor. "It is not our country." Long pause. "Is your uncle still pro-Palestinian?" When I respond yes, she waves us both off as deluded fools. "Didn't I tell you then? You didn't listen? Now look what they have done to Lebanon."

After a short while, she holds herself back; she seals up the lava. But there are great tensions, contradictions in her anger. She praises East Beirut where the Phalangists run a tight shop—clean streets, civil order—but she will not live there, because, echoing Palestinians on the West Bank: "This is where I grew up, here, in West Beirut. It is my home—I prefer it!" The Salaam House itself was hit by Phalangist shells, but she says flatly it was return fire against Syrian and Palestinian shelling. She loathes the trouble the homeless Palestinians brought to Lebanon, but she is proud the Lebanese gave them the most sustained and free haven in the Arab world. She thinks the PLO should be disarmed, but she reserves strong admiration for those guerrillas who "really fight and not talk."

Just before the civil war started the hotel was closed, for financial reasons. Otherwise it would have been completely lost to refugees. As it is, the Salaam House's first two floors are inhabited by refugees from Baalbek.

"But Israel has not struck Baalbek, has it?"

"They are squatters. Poor people who took advantage of all the refugees from Israel's bombing of the south and came to Beirut. Now they demand a price to leave which we cannot pay. So they stay. What can we do? They are here. They are all over Beirut."

At just this moment her eldest boy speeds over, steals my pen, yipping and laughing as I try to wrangle it out of his hand. He bites my hand. Hind raises her hand and the two boys fly from the room, laughing, but with fear in their eyes, too.

"Boys will be boys."

"Boys will *not* be boys. What can I do? Do you think I am going to take them

for a day in the park with all these guns? They stay inside. They get frustrated. With my husband here, we sometimes go out on Hamra for an hour or two. But that is it. Do you know, this very room was your room—yours and Gary's—the one we are squeezed in now? And what do you see now, outside your hotel shower window?"

An apartment crammed with refugees. Clothes strung like patches of an un-coalesced flag on balconies. Garbage. A Syrian tank. And at night, a small fire near which a Palestinian guerrilla keeps watch and rubs his hands.

"Are you blind? Can't you see Mt. Sanīn?"

I shake my head. "You are right. I can see Mt. Sanīn. And it is still snow capped."

"Come back in a week for dinner. I will have some friends over." She smiles, "I remember the marshmallows we cooked till they were black on the beach by the Casino. Oh, those were the best days!"

And what happened to Cynthia, the blonde friend of hers? "She married an Egyptian. They moved to Hawaii where he teaches. She went the furthest of anyone."

"Like the best days."

"Come back."

The Israelis Break the Sound Barrier

The nights begin to mount like the days. Nights I lay sleepless but exhausted on my hotel bed staring at a ceiling with cracks. I keep the glass door open to the balcony for a night breeze. By 7:00 P.M. the sound of cars fades from the road. By 9:00 P.M. shots ring out, some distant like termites in the foundation of earth, some close like fireworks. Who is fighting whom is anybody's guess.

But during the day the bustle of the city desperately rebuilding itself domi-nates. Except for one sound. *Turn your cheek, God.* Two slaps. *Bum. Bum.* Sabri Jiryis clutches the jiggling tea cups and looks out the window. Shrieks in the street. Rattle of groundfire. As if in control of Time itself, the Israeli Air Force breaks the sound barrier. F-15s strike noon; Israel is Beirut's clock tower.

"But they are not quite precise now," says Jiryis, the first scholar to examine the problem of Israeli Arabs—being one himself from Galilee—and now direc-tor of the PLO Research Center in Beirut. "They do their reconnaissance every day in the past. Now you don't know when or if it's going to be an attack."

The day after visiting the broken-down Salaam House and its embattled Leba-nese housewife, I visit three intellectuals—two Palestinian, one Syrian. Jiryis is the author of a book that revealed half a million Arabs living inside Israel as a second-class minority with roughly the status of blacks in the pre–civil rights American South.[3] After arrests and harassments by the Israelis he left his home-town with two suitcases of clothes and a bag of books.

"Actually, the PLO asked me in their Hebrew broadcast to leave Israel and run

their Hebrew broadcast from Cairo," he relates. "But the moment I went there, Black September happened [the decimation of PLO forces in Jordan]. So the radio station was shut down and I came to Beirut."

Jiryis is a quiet man whose office is meticulously neat. He seems to hunch over himself, his face pitted and filled with dark birthmarks. His skin has the color of day-old coffee, his suit is immaculate and brown. The spotless office is almost clinical, as if a doctor of medicine were here in a ward filled with antitoxin.

Jiryis calls his secretary on the intercom and gently asks if the firing we heard was anti-aircraft. He smiles wanly. It is a common joke in Beirut that the rat-a-tat-tat after the big *bum bum* is so slow to come and so inadequate that by the time you hear it, "they're back in Tel Aviv."

"Well, some of our people will be happy now to try this new four-barrelled anti-aircraft gun, a Russian one used in the October War," he says. It's called a Stalin Organ.

Jiryis is asked if the Palestinian state is closer or farther away than ten years ago. "I don't look at it that way," he speaks slowly, carefully. "It's dialectical. But more and more an impression that is almost controlling me is that a Palestinian state won't be made peacefully. I can't believe the Israelis will accept it unless you force it on them."

What can the United States do about the problem? Jiryis sighs. It seems this wolverine has been out all night and found little to eat or comfort. "The United States has to deal seriously with the Palestine question," he taps his tea cup in measured beats as if saying a mantra known to be ineffective. What if the United States invited Arafat to Washington? Jiryis lifts the dark circles around his eyes. "That's too good to be true."

From Jiryis' stainless office I go to the founder of the Institute for Palestine Studies (IPS), a pro-Palestinian think tank. There Constantine Zurayk, 80, clasps the large, swollen pink fingers of the aged and delivers what could be his last lecture. (Intellectuals in Beirut are always on the verge of their last lecture.)

> It is unfortunate, but the United States has brought the Soviets into the Middle East [he says]. And one of the ways you have done this is with the allegation of terrorism. Now, either the United States is naïve or deliberately hostile. Suppose the Afghan people blow up bridges, kill Soviets in their offices—all forces of terrorism. Will the United States be against that? I think not. This harping on the question of terrorism is befuddling the whole issue. If the PLO resort to violence it is because they have no other way to attract public opinion. Unless the United States gets out from under the Zionist influence and recognizes the Palestine problem for what it really is—I see no solution, rather deterioration. The United States is not at present ready for a correct view of the situation and a sound solution. So I am rather pessimistic.

How would the United States be ready for the "sound solution"? Zurayk lifts the fingers from their clasp so that they all point like exclamation marks: "Only

internal pressure in the United States itself will change U.S. official opinion. America should really make its claim true that it is a democracy and dedicated to defend the rights of man. Who else is going to defend these rights? Really—the conflict here is not a conflict of Zionists and Arabs. It is between a certain attitude—an old one—and a new one."

Dr. Zurayk picks up his cane, breathes heavily, shows me pictures from World War I peace conferences on the Middle East. I am led to the next office; it is on fire.

I first met Dr. Elias Shoufani eleven years ago when, as a senior at Georgetown University, I had written an article for the student newspaper on the roots of Palestinian nationalism and violence. Shoufani does not remember me. He is perturbed that I am late. He calls me "Mister."

According to Shoufani, U.S. support for Israel is not done for altruism, but is purely and simply to secure a forward base for its power interests in the Middle East. "Mister, the only way the United States can secure the continuing plundering of our natural resources is using the Israeli machine to subjugate Arab national movements," he states. "If the strategic cooperation agreement with Israel is canceled, how come the Negev airstrip is still being built by you for Israel and how come [Jeane] Kirkpatrick is not voting to stop the West Bank crackdown? Israel supports the Americans one hundred times. Israel for the United States is a complete net profit!"

A smirk. Shoufani is square headed, with gray flecks in his thick, widow's-peaked hair. A good-looking tough who knows it. No longer a professor of Arabic. On the Revolutionary Committee of Al-Fatah. He lights his pipe and stokes it continuously for a plume of smoke to the ceiling.

"But like all capitalists you want your cake and eat it too. You want Arab oil and trade with friendly Arab countries as well. But believe me, if there weren't oil—no one would give a damn about Arabs or Jews. Israel is definitely not a state for the Jews—less than 20 percent of the world's Jews live there, and now more Jews leave Israel each year than come to stay. The Israel lobby did not devise the Carter Doctrine. It is in U.S. interests to support Israel for one reason. Oil."

The Arab oil embargo, he scoffs, was orchestrated inside the U.S. State Department in concert with companies to raise the price of oil, nothing more. "No, the lousy Arab regimes were not and are not doing us any favors," he says. "I had to re-educate myself when I came back here from the United States," he says with that glimmering smile. "And I am not angry at the United States. It is a struggle to put things straight."

Leaving, my hand touches the door. The varnish is melting.

The Wind at Nabatiyeh

The old Palestine Railroad is periodically swallowed by sand south of Beirut. This pride of the Palestinians under the British Mandate that once ran from El

Arish through Gaza, Jaffa, Acre, all the way up the coast to Beirut in the twenties and thirties is now a mirage of iron ties, now rising, now sinking into the sand along the shore. The battle zone in Lebanon is in the south. And the ties of the old Palestine Railroad follow you like the broken promises of the past and the promise of oblivion in the future.

After driving south past grapevines lacing barbed wire, anti-aircraft guns on bluffs, "blue sleeves" protecting Lebanese bananas from insect marks, past more strewn telephone lines, broken water mains in the streets of Sidon, past dredges mining beach sand for cement for cinder block that will erode from salt that is in this sand because the Lebanese can't get to their main river—the Litani—to mine saltless sand, past the TAP-line oil conduit from Iraq that is sabotaged by everyone from Syria to Israel, past the carcass of a decapitated cow—I come to stand in the wind at Nabatiyeh.

Nabatiyeh is the southernmost market town in Lebanon, 20 km from the Israeli border, probably the most shelled noncoastal town in Lebanon. Here for centuries in the mostly agricultural south of Lebanon, farmers brought sheaves of tobacco, boxes of oranges and lemons, vats of olives stewing in brine to a central market. Now Nabatiyeh seems to receive more howitzer shells than food; the town contains a major PLO garrison.

I am on a high ridge overlooking the infamous "Gap," a two-mile-wide spot on the Lebanese-Israeli border not patrolled by any of the six thousand UNIFIL (United Nations Interim Force in Lebanon) troops placed here after the 1978 Israeli invasion of southern Lebanon. The "Gap" was to be filled by one thousand new UNIFIL troops approved by the U.N., but Israel forestalled their entry. The impending Israel invasion is expected by most to come through the "Gap."

The only thing standing between Nabatiyeh and the forty thousand Israeli troops massing on the border is a thousand-year-old Crusader castle—Beaufort—manned by a few hundred PLO guerrillas. The Israelis failed to take the castle in 1978. But now they have twice the ground force and an even more lethal air force, and a different president in the White House.

I can see that Beaufort Castle sits atop a stark rise below, and below all of us is a vast, quiet green that does not indicate where Lebanon ends and Israel begins. It is sunny, the calm almost frightfully serene. Mustard shines and bends in the breeze; chlorophyll moves in the grass and alfalfa and an abundant fern called *nastar*. How can a war happen here? How can steel break this process of oxygen releasing into a blue sky for the lungs of the aged, of children? I breathe low, as if to let the green conquer.

On a high ridge, an orphanage of fortified concrete was hit as if by a karate chop on top, collapsing the third floor, forcing walls to fly out. The wind blows through the concrete, scouring the iron rods. Orphans orphaned by the orphans: that is the horror of the Middle East.

Craters—footprints of a modern Goliath—approach the orphanage. I step inside one and pull out a rock sheared in half by a bomb. *Tell me, stratas of time,*

where these children will go. The only wall left on Nabatiyeh ridge is a stand of pine; one almost hears sap moving through the life-wall, except for the wind.

On April Fool's Day at the Modca Café

. . . a loud crash is heard and cups clatter, coffee spills, and faces turn. Car bomb? Stalin Organ? Israeli *bum bum*? Rolled foreheads and tense eyes focus on a boy who has knocked over three white café chairs. He picks himself up, sheepishly grinning at the terrified café dwellers, whose foreheads just begin to uncoil as he runs off down Rue Hamra.

At the Lebanese tourist office across from the leading newspaper, *An-Nahar,* I place a call to Damascus. Two women with blank faces operate the phones in an office with nothing on its walls, not even a picture of fabled Lebanon. The call takes forty-five minutes to get through and when it does a snowstorm of static comes with it. It is said the line from Beirut is clearer to the United States than to Damascus, only sixty miles away. My cousin Suad begins to cry when she knows it is my voice. How am I? How is the family in California? Who has died? Why am I here? When I mention the war threat in Beirut she steers the conversation to something else, such as my getting sick on a Hindu apricot in Damascus ten years before. Her children are all grown; her son, Nino, is out of college and wants to study surgery in the United States, but it is so hard to get a visa if you are a Syrian.

Can I help? What am I doing here? *Snowstorm.* Where is my wife? *Static.* Before snow completely consumes the Beirut-Damascus line we make a date. I will come to see them in one week, via taxi, over the Lebanese mountains.

The Man Who Makes the False Legs

A crucial question concerning the future of the Palestinian national movement might be: how long can the man who makes the artificial limbs hold out? In Beirut a sizable network of a Palestinian government-in-exile was built over the years, including factories, unions, service organizations, medical corps. The many economic and political departments of the PLO bore striking resemblance to the Jewish Agency functions of the twenties and thirties that culminated in the Israeli state.[4]

At the Ramle Physiotherapy and Rehabilitation Center in Beirut, the most modern equipment is utilized: hydrotherapy baths, ultrasonic therapy, crutches, splints, braces, corsets. And in a basement that doubles as a bomb shelter, a man with false legs is in charge of making artificial limbs. Underneath a yellow light, feet of wood line a long shelf like shoes, waiting to walk. The foreman knocks an artificial limb with a small hammer. The sound is absorbed in the thick walls. This is an important man. The foot and leg maker at the Ramle Center may be the

one person assured of continual employment in Beirut. He is absorbed and barely acknowledges we are there. He believes he is making the limbs of a nation.

A brochure of the Ramle Center notes in a clash of pride and suffering: "More and more injured call on the Center to benefit from its services." As if enforcing a new reality, the brochure coins a new word: "injuree." There is status in being an injured Palestinian, and martyrdom assures one a framed photograph in the corridors of the Palestine Welfare Society, run by the wife of the military commander of the PLO, Um Jihad. The Israeli government may not quite understand the implications of conceding nothing in the face of this sensibility.

In back of Nuwad Iskanderan's Samed (Palestine Martyrs Work Society) workshop is a sight that fills the heart with awe and dread: young men are cutting raw pine wood (it has been layered like sandstone) to make miniature maps of Palestine. The rough borders are lathed, filed, sanded by hand until they are exact. They are the borders of the original British-mandated Palestine: the West Bank, Gaza, and all of what is known as Israel.

We leave the filings of the borders of Palestine to surface in a very odd weather outdoors—murky, cloudy, as if an electric storm is approaching. Everything— the refugee hovels, the omnipresent clothes lines, the pots and trucks and cinder block—seems to be caught up in a slow-motion sandstorm.

Hugging a sandstone wall are three large howitzers, and nearby a troop of Ashbāl (tiger cubs) train and bark out the response for revolution, *Thawrah!* When we pass them they break up their drills and ask us for photos. The photo I wanted—but couldn't take because they were drilling at the time—was of three slightly older boys, 15 maybe, perched on a mutilated wall above a bombed-out window watching the little ones drill with live guns, watching pensively as if troubled that guerrilla life was not all it was cut out to be, and Palestine no closer.

The Banyan Tree at AUB

The undamaged parts of Beirut have shrunk down to one spot—the American University of Beirut. Calm—unearthly calm—is felt the minute one ducks into one of many portals in the long orange limestone wall on Rue Bliss.

Still, two banyan trees realize their peril and are doing what should be unnatural—spilling roots from branches in addition to the trunk, which can no longer be trusted any more than Arab nationalism. Like an armless man who learns to write with his feet, the banyan tree at AUB is dropping ropes from its arms to hold onto the poor earth, like the Lebanese. Like the Palestinians.

Dining with the Revolution

Two days later I visit the family of Kahlil al-Wazir, also known as Abu Jihad, the head of the PLO's military forces and a close aide to Arafat. His younger brother,

Zuhair, is president of the General Union of Palestinian Students (GUPS), which oversees the education of four thousand Palestinians worldwide in some thirty-seven branches. Their favorite lands to study in are the United States (25 branches of GUPS), the Soviet Union, and Romania. Zuhair, who studied in Romania, has a medical degree himself and is proud of historical Arab contributions to medicine. He says medicine and engineering are the most popular fields for Palestinian students abroad and that they are second only to the United States in the degree of education, by ratio to population, in the world.

I lunch at the al-Wazir family home in Beirut, a walk-up apartment in a guarded building to which I am taken in a guarded car. There I am introduced to an old couple in traditional Palestinian dress, the parents of Khalil and Zuhair, whose robes and headdresses form a sharp contrast to the Western-style dress of their children. They appear to have stepped out of the past or to have been preserved that way. The mother, large and squat like Zuhair, begins to narrate the flight from Ramle in 1948 as if she had been thinking about it forever: "I carried Zuhair and Abu Jihad and one more child for three days from Ramle. We went to Qabab, a wheat village. We were afraid to sleep. We were completely surrounded by Zionists. My girl was so thirsty she almost broke down. Then we reached Salbīt, which had a well, and drank and washed our faces. At midnight mortars were thrown around us, but we slept anyway because we thought—if we're going to die, we'll die. The Zionists came and shouted, 'Yella! Go to Abdullah! [king of Jordan].'" [5]

Suddenly Abu Jihad bursts into the room in military fatigues. He is a well-built, slender man of medium height. His movements are determined; he greets my author friend and me and announces even as he is picking up a piece of Arabic bread, "We have confirmed that the Israeli forces are moving into 'the Gap' and will invade in 24 to 48 hours. But we are ready for them and will hurt them. As Abu Ammar [Arafat] has said—if they come, they are welcome." Far from being nervous, he seems almost relieved, as if the tension of an impending attack has finally burst. It stuns me, how easily he hoists his daughter Hannan on his knee and greets his family, ready to eat with strangers. Wonder at such collection clashes with fear.

Before leaving I regard the al-Wazir memorabilia on a table: two brass roosters, a ceramic rabbit, and a tray from Niagara Falls.

Pigeon Rocks

Pigeon Rocks—offshore from the northwest corniche of Beirut jutting into the Mediterranean like the toe of a languid female—are as gorgeous as ever. Lined by aeons of the old sea's crashing ardor, rilled like an old man's face that has seen it all, Pigeon Rocks are Berytus, Phoenicia, in modern Lebanon. Could these striated limbs of stone in water be targets for bombs, too?

There may be dangerous pigeons out there. It is known that pigeons—plotters

of the worst kind who crap all over sidewalks in Tel Aviv—fly north and rest here. If they are not here this glistening morning, they should be. They will arrive soon, these malevolent pigeons, with their oily necks and nervous ticks. Bought—that's what they are! Terrorist pigeons bought by oil money! They've got nerve to take refuge on a rock.

Beirut is a love story of constant betrayal. The sea is a man, the corniche the ankle of a languid woman who is tipping her last glass of Ricard, whose high heel is hanging by a single leather strap off her instep. We cannot have this. We will strike soon. We will demolish Pigeon Rocks into a million pebbles.

I am at the Casino Nasr café on the corniche overlooking the Beirut bay. The café is virtually empty—more waiters than tourists. Who wants to see a war but journalists? And journalists tend to stay near the Commodore Hotel downtown and miss Pigeon Rocks (and the crushed corrugated shacks off the cliff at Raousche). Journalists like explosions; they don't much go for the refuse.

A tremendous sadness fills me in this perch. I am an American waiting in Beirut for the clock to stop. Waiting for the bombs of my taxes to greet me. I think perhaps I am crazy to be here, or to pay such taxes. Or both. Down the misty coast, blood is running in the gums and fear is boiling in the brain.

The taxi driver, Zuhair, who takes me back to the hotel has a lot to say about Lebanon. We find ourselves following a donkey cart hauling kerosene. He explains:

The poor people can't afford electricity or propane stoves so they use kerosene. They even heat the water to wash their clothes with kerosene. What is America saying about us? I say the Palestinians are wrong and the Lebanese are wrong and I am wrong—you have to say this. If you want to die here you can do it easily— just blame one side or the other for the trouble. I want to stay alive so I blame no one. Look at the Cola Bridge. It is ten years being built and it is still not finished. Why? Graft—feather-bedding you say—contractors estimate more than it should cost, as well as the war.

When someone is injured by a bomb, I don't run to accuse who did it. No. Just help the wounded. That is all you can do. That is all you should do.

Dust envelopes the taxi, as does the coming night. Passing the last of the Raousche tin shops of the poor, we head into the unreal sight of a huge multi-colored Ferris wheel, twirling neon. I listen for screams of joy. There are none. But like Lebanon, the wheel is turning in a hostile night and its color is a kind of defiance.

Alone at the Syrian Border

For days I try to find a way to get into Syria to meet my cousins from Arbeen for the first time in a decade. Unlike ten years before, when visas were routinely

given at the border, the war has made transfer into Syria more difficult. And I do not have a visa.

I begin counting Syrian checkpoints out of Beirut, over the mountains, through the Biqaᶜ. There are ten. The taxi trip seems endless, and endlessly tense. The only rest stop is at Shatturah, where we eat some of the famed sweets. I buy some wine and delights for my relatives, who are finally to meet me at the border just in case there is a mix-up over a visa. I am sure Adeeb Awad Hanna, my dear leprechaun lawyer cousin, will settle everything.

When the driver lets me off at the border customs check, I give him a phone number to call my relative Suad, Jaddu's niece, to inform her that I am at the border.

The Syrian soldier inside shakes his head. Sorry. An American? He gives me a desultory look as if to say, big deal. We don't give visas here anymore. Another soldier outside says he can't do anything. No one allows me to call Damascus. I wait for three hours. By 3:00 P.M., the winds of the foothills at the border send a chill through the bones. People are coming and going since this is Easter weekend. Two huge busloads with Saudi flags pass by. Mecca is a long way off.

The taxi driver has disappeared. None of my relatives come. Hungry and cold, I finally flag a cabbie with some room to return to Beirut. Only months later will I discover that the first driver did not call my relatives. And that they had prepared a meal for me that went very cold.

A woman in the back seat with two children is a Palestinian returning to the Sabra refugee camp. The driver inexplicably stops in Aley in the mountains and leaves us sitting for an hour and a half in the damp weather. It is night when we return, the woman is let out in the darkened dust at the camp. On an impulse, I decide to get off on the coast road and walk back to the hotel, each passing truck from the south roaring by with guerrillas, or frenzied merchants, honking at me. I have never felt more alone.

Good Friday and Fakhani

"Just like an American, trying to force or charm your way into Syria," Abu Ahmad, the PLO representative to North Korea, lambasts me the next morning. "Why didn't you wait for your visa?" How do you tell someone who has been waiting all his life that you are too afraid to wait?

The deadline has arrived for Abu Jihad's prediction of an invasion. It is Good Friday, April 9. Abu Ahmad possesses gallows humor; he tells some Christian ministers, "You will go to the south today and see the spring flowers and the shells singing. What was that nursery rhyme? 'Twinkle, twinkle, little star, how I wonder what you are?' Now it will be 'Twinkle, twinkle, little shell, I know what you are!' Don't worry. You will see the fire all around, the anti-aircraft and the rockets—very beautiful. Only one thing is special this time—the Israelis have

new bombs with copper casings. Great! We will use the copper to hold food and make glasses and plates from it."

I make a date to meet George Azar, an Arab American photographer from Berkeley, downtown where he will take me to Fakhani, the densely populated sector where the Israelis dropped their bombs on July 17, 1981.

In the afternoon, I stand up for the Fourteen Stations of the Cross at the Capuchin church in Hamra. But it was in Fakhani that I saw the Cross. The Cross was in the form of iron reinforcings in concrete upended and bent like the limbs and antennae of dead insects. On this day of the Lord's highest sorrow, I picked a child's shoe out of the rubble made by the bomb. The foot was in heaven. For the first time since childhood, I bow to the prayers before each Station, of Veronica wiping the face of Jesus, of the women of Jerusalem being told not to weep for the Christ but for themselves and their children.

The Israelis flew low to bomb Fakhani. They missed Labadi and Arafat's office by 500 meters, but they hit hundreds of civilians in one half hour of strafing and bombing. Six floors of a building were excised and collapsed. What would happen if the World Trade Center were hit this way in New York, or the *Daily Planet* building in Los Angeles? What would the world say? What would it do?

My eyes blur in the incense and I recall the remnants of clothes wedded to the rumble in Fakhani, heaps of trash, tires. A man holding a baby girl says he saw it all. What was he doing when the planes struck? "What does it matter?" he clicks his tongue. "*Maᶜalish.*" I pocket the child's shoe to take home.

Now the dirge resounds at the Capuchin church, the incense swirls, paraffin thickens the air. We have reached Calvary; Christ is being nailed to the Cross. Just as the choir intones in French, "Prie pitié, de nous Seigneur"—Take pity on us, Lord—the whole church vibrates. A jet from the south is flying over Beirut again. Reconnaissance. This time. And what will this God do that we pray to? The same God prayed to by the Phalange is invoked from the minaret at noon, called to by the bearded ones in Jerusalem at the Wailing Wall, all wanting protection, some asking for vengeance. I think of Kierkegaard, who saw that there was no reason for faith in the face of a God who could demand a son to be killed for Him. He stayed Abraham's dagger over Isaac at the last moment. But who is to stay the hand of Menachem Begin now, who quotes Lamentations and Joshua? Who will stay the hand of the Phalangist who pastes decals of Mary on his tank? Who will stay the hand of the Palestinian who hijacks planes or throws rocks? Now Arafat holds to the cease-fire; is God staying the hand of the ones most sinned against? Are the Palestinians reenacting Golgotha? Is the Roman soldier the United States, dipping a sponge in gall for the hanged man? Is the throng for Barabbas—or Saad Haddad? And Bethlehem—the *real* Bethlehem of today—people are not only slouching there, they also are being forced to lie in the mud. The rough beast is coming in on Arava tanks and U.S. howitzers. This is not a slouch. The only slouch is away from Bethlehem—the innocents are slouching away and coming to the United States.

Betamax in Ashrafiyeh

Ten years ago, I easily walked to East Beirut and Ashrafiyeh to visit Cynthia's mother. We stopped for coffee where the Green Line now exists, then a bustling business world of merchants. We took our time, and loved. Now there is no Cynthia, no merchants, and emptiness that one must plot to cross.

I call ahead to my old journalist friend Joseph, who lives in Ashrafiyeh. He is very surprised that I am here, but he cannot meet me in West Beirut. He says I can go over the Green Line by the Museum Crossing at the National Museum and the Hippodrome—but will have to deal with the Syrians—or through the Port Crossing, the empty sector, and deal with the PLO and then the Phalange. The latter route is faster, but riskier. He recommends neither, but will meet me.

I take a taxi from Hamra downtown near the An-Nahar building for $25 to go the one mile through the Port Crossing. The driver says nothing as we pass slowly by an upended barge in the harbor, a series of rusting boats listing in the oily, refuse-strewn water. Suddenly, there is no one but us. And streets of empty buildings with windows blown out, rats knocking over a can. It is like traversing Hades. Hell must be this quiet and this empty. This is the catecombs, above earth. This is where civilization is going if we do not change—the Green Line of Beirut.

Joseph has traded in his job as a news reporter and commentator for running a video store in Ashrafiyeh. But it is evident that more than job has changed in his life. Once sympathetic to the Palestinians and, as a Maronite, one who tried scrupulously to remain in the center, he has been carried by events to siding with the forces of the Christian right. Trilingual, stacking his video cassettes—business is booming since no one goes out—he is more upset and exasperated than two years back when he visited my Washington office with his picture book documenting all sides of the carnage in the Lebanese civil war.

"Is shelling Ashrafiyeh yesterday contributing to liberating Palestine?" he asks as he works in front of me. "For years I have tried to stay apart, an observer. Now I am engaged." He points out that the shelling of Zahle by the Syrians in the spring of 1981 and of Beirut made him reconsider his neutrality. "Forty-five people killed all around us," he strains his voice. "Why? I changed my mind when I saw children hurt. All our beliefs were shaken. The Syrians never did this to the Israelis. They annex the Golan Heights and we get it?" He dismisses the Phalangist attempt to secure a foothold in Zahle as a trifle.

Joseph has moved six times in four years because of Palestinian and Syrian shelling of East Beirut. "My 11-year-old is under stress," he pleads. " 'J'ai peur,' she says. My 10-year-old boy asks me, 'Why are the Muslims doing this?' I try to explain it is not the Muslims."

I tell him I am trying to get all sides of the story. Knowing that I have been talking to the PLO leaders, he seems to try to use me as a conduit. "Even Bashir [Gemayel] cannot criticize the minimum Palestinian claims," he says. "I am not fanatically against them, or for the Phalange. But we are losing energy; they [the

PLO] are losing potential allies. We are in the same area. We are facing the same expansive Israeli nation. America is losing everybody. They have no plan; they are losing Lebanon, without gaining a thing. The Israelis have only one ally—themselves. I do not trust the Israeli government one bit. The Israelis hope they will use the Christian card until all Christians are expelled from Arab countries, to get Christians to let the Arabs down. But we belong to the Arab family. We like the Palestinian cause."

All of this is said in a frenzy; then he quotes Gemayel: "A man who is drowning grabs even a snake." He does expect that the Phalange will link up with the Israelis south at Damour for the much-discussed "pinch" of Beirut "in one week."

Joseph has no more expectancy of help from the United States than do PLO leaders: "How long will America cut off aid to Israel? Two weeks? America is giving us to the Soviets."

He introjects in a black mood, "They used to say we were the most vicious people in a most sacred land, and I thought that racist, but now I say it's true." He believes that because of the bad actions of the PLO, swaggering in the Shiʿite south for instance, "the Palestinians in the West Bank are more serious." He thinks the West Bankers will become "the new leaders."

A gentleman in a blue velvet coat enters to take a seat, jutting his chin up like some arrogant Kirk Douglas as he talks. He has just been to West Beirut conducting business with some Libyan colleagues. He scoffs at the idea that the Israelis want Lebanon's Litani River—"If they wanted it they would have taken it twenty-five years ago. They have the Jordan River now. No. Their purpose is to get the Palestinians out of Lebanon."

When it is revealed that Libya has supplied arms to the Phalange, I balk. "Nothing should surprise you if you want to work in this country," Joseph shakes his head. But he isn't as sure as his friend of the worth of an invasion. "It is worth it to fight for Lebanon as a whole; it's not worth it to die for a Christian Lebanon. People of good faith have no religion." Then, in an almost desperate plea, he tells me as I leave, "Go tell the Palestinians—we are not going to abandon the ship. We are not their enemies. We have the same aim—to be independent."

As I leave the Video Un of the ex-journalist, I spy 88888 blinking on a digital clock, a kind of black infinity.

The Shiʿite Women of Raousche

"We seek something more important than love—we have to live." Thus speaks a tall, big-boned Lebanese Shiʿite woman just back from teaching English in Saudi Arabia. Suhayla and her equally attractive, tall but more demure sister, Fatima—also a schoolteacher—offer me and a Lebanese friend fruit in their Raousche apartment. They confirm that eligible as they might be in their early twenties for marriage, love relationships are far from their mind.

I ask them about the more conservative Lebanese Sunni Muslims and their

attitudes toward the chaotic situation. Fatima perks up, "Rich Muslims are like rich Christians!" Suhayla confirms that the Sunnis are fed up with the chaos and car bombs and getting tired of the PLO dominance in West Beirut. As for the Shiʿites, their impatience with the PLO has become more and more glaring. "Three years ago we were in complete solidarity with the Palestinians," Suhayla mentions. "It was more clear then." Now the Shiʿite militia, Amal, is clashing with the PLO. Now the Syrians, who ogle women at checkpoints, grate on them as much as on their Christian sisters. And the Syrians are identified, of course, with the Palestinians.

Even my Lebanese friend Suhail Yaccoub, a personal friend of Arafat, admits that the PLO have "made many mistakes" in Lebanon recently in controlling areas in which Lebanese of all stripes live.

Suhayla disapproves of the American faculty at Ras Tanura, Saudi Arabia, which she found racist, and isn't too enthusiastic about the Saudis in general. She wants to go to the United States to study politics. Suhail Yaccoub makes coy remarks to Fatima, carrying on a charade of wooing her. As we leave I venture that he should marry her.

"I can't," he says like someone who wishes he could feel more. "She's too tall." Suhail is short. He is also divorced from an American wife. He returned to Lebanon to teach at the Lebanese Arab University and to care for aging parents. Marriage—for all Lebanon's former romance—is not what the country is about today. Sex and drink, on the other hand, are plentiful.

Drunk at the Salaam House, and a Farewell

Alone, I seek out Youmna, a secretary at AUB finishing her master's degree on the Syrians in Lebanon, who is engaged to an American managing garbage collection in Saudi Arabia. And so I am to accompany a woman betrothed to another to a farewell dinner at the Salaam House. Typical of Beirut—no one is with who they should be with, politically or otherwise.

Squeezed into the top floor of the Salaam House, greeting us and laughing, are Hind herself, her sister and accompanying fiancé, as well as the foreign-desk editor of *L'Orient le Jour* and his wife. Immediately the three Lebanese languages fly out in unpredictable fashion—"*J'aime beaucoup le kibbah lākinnī ufaḍḍilu al-tabbūlah,* you know?"—and I am certain that Lebanon's Achilles heel is xenophilia, not xenophobia. Scotch flows, as well as ʿaraq and a 1963 wine from Shatturah. Hind serves an Iraqi *kibbah* with a hot sauce, the best I have ever had.

"What is your heaven on earth?" I ask each.

For the fiancé, with his bushy moustache, it is a car rally from Damascus to Beirut. For the editor and his wife, a trip to the Greek isle of Mykonos. For both Hind's sister and Youmna—Paris is heaven. For me, Pau, France, where I once lived and worked as a gardener and wrote a bad novel. Hind grows silent amid the laughter. "Lebanon," she murmurs. "Only Lebanon."

Both Youmna and the editor prefer Bashir Gemayel to his older, less brash brother, Amin, whom they call the "diplomat" and "a smooth talker." Bashir, they say, is a "straight talker" and will admit when he is wrong. The editor opens, "It is incredible how such a naïve politician could have grown so quickly adept, facile, and intelligent in politics." Thoughts are reserved about how adept and facile he became in the intra-Arab butchery.

"How was your trip through the Port Crossing?" Youmna asks.

"Instant antiquity."

Hind steers the conversation away from the war to fruit. She places a bowl of oranges, apples, strawberries, dried figs, and almonds before us. I mention my favorite image of Lebanon—the vendor of green-velveted almonds on Hamra fashioning them into exact pyramids topped with a sprig of rhododendron. Order amid all the choas. Hind salutes. And all chime into a litany of fruit as if there is nothing else on earth to bother the mind. In April we have strawberries, *lūz* (almonds), and fig de Barbary. In November, there is *kākī* (Japanese persimmon), a sweet tomato, and the expensive *qishṭah,* the prickly custard apple that looks like a mountain with many little peaks. Record! There are apples December through March, and oranges all year round. Don't forget the *clementines,* or tangerines, without seeds yet. The almond you can eat whole throughout spring, but then in summer the husk dries and you must smash it. The plum (*khūkh*) is green in spring and eaten with salt. We love the sour. In summer it is sweet, but that is only normal. Apricots in May. Peaches in July. Figs in Août (August). Watermelon, *battīkh,* in summer, as are pears. *Write it!* Pomegranates (*rummān*), grapes, pistachio (*fustuq halabī*) with red shells in summer that come from Syria and Turkey. Bananas the year round. The black cherry. And your name. Are you forgetting that your name derives from the word for "cinnamon"? *Qirfah.* We define ourselves by this fruit and its seasons, not this war. Write it! And don't forget![6]

7 A Celebration of Community

My search for the meaning of my heritage could not, in the final analysis, remain true if it ended in bitterness. The community's spirit, after all, was not solely framed by its encountering the problems of the Middle East. I decided to end my quest with a last swing through the communities. This trip became a kind of farewell, not just to the community but also to my father even though it commenced in my mother's Brooklyn.

Dance over the Death Home (Brooklyn)

My mother was raised above a mortuary in Bay Ridge, Brooklyn. For many years the memory of it was painful to her, but, once in the sheet of sunlight that is California, she recalled the darkness, the funeral home lit by a flickering lamp, and the poverty in which her mother would rock a cradle with one foot and press the wrought iron pedal of a sewing machine with the other.

How did she spend Brooklyn teenage years in World War II? "We danced the Lindy over the dead," Mother's smile lit her white teeth, and she went for another cup of coffee for the ghost who is always coming to the home of an Arab for hospitality. That ghost may sit in the flesh of a neighbor, a Japanese gardener, even a housekeeper from El Salvador. For a day I was the ghost, a son taking the apricot jam and the muddy coffee, the Syrian bread and the yogurt. When I grew up in Los Angeles, you never put fruit in yogurt; you ate it sour as it was meant to be eaten.

Mother's actual birthplace on Henry Street is near Atlantic Avenue, the road in downtown Brooklyn from where so many of the original Arab Americans coursed in a widespread delta. A short walk from the two blocks of old Arab markets, restaurants, and record stores shows a most breathtaking vista of Manhattan from Brooklyn Heights. Antonios Bishallany, the first Lebanese immigrant, was buried in 1856 in Brooklyn's Greenwood Cemetery.

More than 125 years later, the original Brooklyn Arab American community is dying. It is being replaced by a large influx of Greek immigrants, recent refugees from the escalating Palestinian-Israeli wars, and escapees from such impoverished Arab homelands as Yemen, which are not booming with oil riches. The old Brooklynite Lebanese and Syrians are pulling up their pomegranate-colored Ori-

ental rugs and moving to Englewood, New Jersey, the new seat of North America's Antiochian Orthodox bishop. As if reading the ill wind of change, the old Brooklynites established the first Arab American home for the aged in America in 1982.

Something is being lost. My mother's life-out-of-death dance when she rattled the floor boards over the funeral home with her Lindy has always seemed typical of the Arab American spirit to me. I sought out her Brooklyn before it, too, flickered like the gas lamp near her home above the Home, and died.

My first stop was Atlantic Avenue, the Baghdad of the East River, where frankincense and myrrh, olives, cheese, *tahīnah* (sesame seed oil), *halāwah* (a sweet made of crushed sesame), bulgur wheat, and Arabic bread round and flat as a beret sustain a cultural tie to Arab American households across the country. An Orthodox priest once told me, "When I was growing up in Canton, Ohio, one of the Malko Brothers would arrive from Atlantic Avenue in Brooklyn peddling *hummuṣ*, olives, *baqlāwah*. That's a pretty long milk run!" [1] Out in California I grew up on Sahadi desserts, condiments, Arab *mazzah,* especially *halāwah* (pronounced *ha-ley-wee* in Lebanese dialect), which has the texture of dried peanut butter. I used to think of it as a sweet chunk of the desert.

A. Sahadi & Co. sits opposite Malko Imports, both under tenements colored royal blue and purple. To walk into Sahadi's is to assault the nose with everything from pickled turnips to Izmir figs to olives soaked in brine. On a Saturday the place is tightly packed with customers of every race tasting twelve different kinds of olives. Charles Sahadi, whose great-uncle, Abraham, founded the company back in the 1890s, manned the old cash register that still rings a bell with a sale. The young bearded Sahadi, resembling a Vietnam veteran in his combat green fatigue shirt, pointed his finger. "Two pounds pistachio," he sang. "Two pounds it is. Who's next?"

He gave me a free piece of myrrh—which resembles hardened sludge—nothing like what you would expect the Wise Men to give the Christ child. "The Wise Men came all the way to Sahadi's to get this for Bethlehem?" "Wise guy, huh?" he snickered, and told me to go see Rashid at the record store down the block.

Kitty-corner from the bombed-out Tripoli Restaurant is Rashid Sales Company, vendor and nationwide distributor of Arabic records, books, and films since 1934. Albert Rashid sat at his small, wooden desk piled with papers in the back of the store and peered over thick-lensed glasses. Yes, I can sit down on that black stool. Lots of reporters coming around since the Tripoli was fire-bombed. No, he doesn't know who did it (police suspected the Jewish Defense League). A black Muslim arrived, tingling a brass bell hanging from the top of the front door.

Rashid wasted no time in telling me the war in Lebanon last summer was bad for business. "The people who come here were humiliated," he said. "They couldn't believe the Arab countries did nothing to help the Palestinians and Lebanese." [2]

A man with Einstein-like white hair flying up from the sides of his head,

Rashid looked down through the hard water of his lenses and quietly recited a tale of disappointment. "In addition to our mainstay business in books and records, and our nonprofit radio program, I also sell key chains and T-shirts with the national emblems of Iraq, Syria, Morocco, Algeria, Saudi Arabia, and all. These are things few people want at the moment."[3]

Rashid kept an eye out for the purple-robed Muslim who was thumbing through records by Abdul Halim Hafez, Fayrūz, and Umm Kulthūm, an Egyptian singer who drew more Egyptians to her funeral—three million—than did Sadat or Nasser.

Born in the southern Lebanon town of Marjayoun in 1908, Rashid—like many Arab immigrants at the time—came to America in 1920 on the heels of a brother who was fleeing conscription in the Turkish army. More than sixty years later, Rashid still had sharp memories of Ellis Island. One was the strange music that was piped through the speakers—opera—quite different from anything played with an ʿud or a ṭablah (a tubular drum). Also, he fondly remembered a pitiful teenage Arab girl immigrant who panicked because she could not write in Arabic or English. Rashid taught her the first two lines of the Lord's Prayer as they waited for their medical exam. "She crossed herself and started reciting, 'Our Father, Who art in heaven . . .' and the immigration official was touched and let her go without lifting a pencil!" he laughed softly.

From Ellis Island Rashid took a slow train to La Fayette, Illinois, where his brother was the only Arab in town. The small stream of dark-skinned Lebanese that got off the train in the Midwest that 1920s day caused a stir among the townspeople, who gawked out their windows. He later took a college degree, worked in the war industrial plants in Chicago, and finally came back to port-of-entry and Brooklyn. For years, his store on Atlantic Avenue was the sole filter of Arab voices, which can hold a note in the air for minutes like a luminous eel. Umm Kulthūm's first and last stand in America.

The man with baggy gray suit pants, the limp gray tie, and white hair flying in clouds off his head jumped from his desk to help a customer. He showed the poster that illustrates, in microscopic print, the entire Koran illuminated in gold. The wars have come and gone and will come again back home, but here, surrounded by Oriental clocks, brass urns, tapestries, books, and records, the old immigrant seemed quite at home squinting at the black Muslim, who was peddling beads.

"Plenty of quality work went into them," said the peddler in the ʿabā robe with a thin wire ring in his nose.

"I'm not worried about the work," Rashid mumbled, turning the plastic, colored beads in his hand. "It's the material I'm worried about." And the ageless peddler cycle began anew. This time the Arab looked American, and the black looked Arab.

In the 1920s, one block from Sahadi's was a grocery store owned by Alex Habib. His young son, Philip, helped stock the shelves with canned goods, marking the prices with a black crayon. Philip would later sweat in a sheet metal factory in Brooklyn making metal boxes. He would also be the chief negotiator for the president of the United States in Vietnam, the Philippines, Nicaragua, and war-torn Beirut, shuttling inside the scream of Israeli howitzers, dive bombers, PLO Katyshas (Soviet mortars), and the agony of the half-million trapped Beirutis.

One searches for boyhood preparations for such a pressure-cooker role. Habib actually grew up in the Jewish section of Brooklyn—Bensonhurst—and belonged to a street club called the Lone Eagles.

At the end of an arduous day in early March of 1983, after meeting with Israeli Foreign Minister Yithzak Shamir (it was said that Shamir had come to leapfrog an adamant Habib), the special ambassador welcomed me into his office. One is accustomed to finding Persian rugs, brassware, calligraphies, and the like in offices of State Department Arabists. Here—in the office of a "real" Arab—the cupboard was bare. Nothing on the white walls, and not much else on the floor. Neither a subtle nor showy office. The office of a man who likes to get to the point. Nothing to distract a visitor in search of soaking up a few precious minutes—maybe hours—with the details of an Andalusian print and the vicissitudes of a Koranic inscription. Look, the bare walls seemed to say, you are talking to a man who has seen the walls go white with heart attacks, and the destruction of the capital of his father's land of birth. We're here to end a war. Now let's get to it.

Before I finished blurting out that my mother lived in Brooklyn above a funeral parlor, Habib grabbed the phone and called his sister in Brooklyn: "Yeah, Violet. What are you tired of? What are you sick of? You're sick and tired? Accidents happen, Violet. What can you do? How the hell do I know from one month to the other! I've been away for six weeks." Habib's hands flailed the air; his wolverine-like head dipped down and up, restless, twanging the words with Brooklynese ("month" becomes "monss"). Listen, do you know a Rose Awad back in the old days?" he asked. "She lived above Cronin and Sons, I think. No? What's that? Violet, you are a political innocent. The ALL is the Kata'ib. You just live your good, happy life. Okay. Eat! Eat! You're my Jewish mother—eat the *kibbah,* the *mughlīyah* [powdered rice with spices]."[4]

It seemed that Habib's sister was attending—unsuspectingly—a meeting of an American Lebanese League (ALL), which is closely allied with the Lebanese right-wing Phalange. Habib hung up, saying that his sister's life back home and his were worlds apart and had been since he left Brooklyn at 17 for school in Idaho. He seemed a man caught in a whirlwind, who, for a second, was given a chance to step outside it. Typically, the step was taken toward family, the mainstay of the wandering, venturesome life of the Arab American. His sister, he said, speaks fluent Arabic: simple Arabic he still understands and speaks.

Habib believed that "it took a long time for the Lebanese to come up the ladder

of success in America. We lived in ghettos, were very clannish, and used to think of ourselves as second-class citizens. We're not." It took thirty-five years in the foreign service for an American of Arab background to be given a post in the Middle East. "In the old days of the foreign service they wouldn't send Greeks to Greece, and all," he said. Habib himself served in Africa, as special negotiator at the Paris peace talks concerning Vietnam, and from 1976 to 1978 as under secretary of state for political affairs. It was then that he was rocked by a series of heart attacks and resigned the post to recuperate at his home in San Francisco. But one year later, in 1979, he finally broke the "ethnic area barrier" as a presidential troubleshooter, trying to stave off an all-out war in Lebanon. On July 24, 1981, Habib negotiated a cease-fire that held for nine months. He also "got" the cease-fire (as he put it) in August 1982, after the Israeli invasion. When asked why the latter took 2-1/2 months to "get," Habib went silent, the forehead furrowed, the raconteur-uncle gesticulations halted.

"In this business, you don't try and look back on what you could have done," he mumbled. "That can kill you." Would Israel ever withdraw from Lebanon? "Yes," was his quick answer. Political questions were curtailed. "I never discuss politics," he said, in a rasp.

When we both stood, the sundown in the American capital stole into the bare office of a man whose father was born in Sidon, a city of chalk-white walls, before the flames that his son would drive through in a protected black car.

Bob Thabit, legal counsel for the United Nations Mission of the PLO, Libya, and other Arab countries, traveled a very different road than Philip Habib, though they were both born in Brooklyn of Lebanese parents and in mid-life found themselves scrambling to help save the tortured country of their ancestors. While Habib was shuttling for the American president amid mortar fire, Thabit was testifying to Congress as president of the NAAA. Unlike Habib, except for a brief stay in Beirut in the fifties, Thabit never left Brooklyn.

The smell of za ʿtar (thyme) filled the air the spring morning Thabit opened the door to the family home in Bay Ridge. He and his wife, Vivian, welcomed me immediately to the kitchen and bid me sit, take a round loaf of the bitter bread with za ʿtar seeds soaking in hot oil. That is a taste of the earth itself, hard to compare to anything in another cuisine. It speaks of our heritage—grainy, bitter, earthen, warm. Za ʿtar lines the walls of the mouth and the tongue with unspeakable loves and tragedies. When you are a child, you hate it. Nothing American, such as pizza, popcorn, Coke, cotton candy, can match it. You may never know you're an adult until you discover you like za ʿtar.

"It was by and large a blissful community growing up amongst the Syrians in Brooklyn," said Thabit, a mild man in his fifties, with thinning gray hair and goatee belied by a boyish smile and shining eyes. "There wasn't much prejudice—I didn't notice any. As Arabs we were very well integrated into the society." [5]

New York has never been known to be a politically active seat for Arab Ameri-

cans. Detroit, yes; Los Angeles, somewhat. But the boroughs of New York—
never. The mere mention of organizing the Arab American community politi-
cally brings frustration into Thabit's voice: "But frustation goes with the turf.
Our people are unfortunately not doing enough . . . I would think that the fact
that New York City is the bastion of Zionism would compel . . . look, there were
250,000 people in the streets in Israel protesting the war in Lebanon and Dr.
Mehdi [New York activist for the Arab cause] gets what? Fifty? I think it's an
insult."

Now Thabit took me through the kitchen, through his study with wall photos
of a desert sheikh, of himself shaking hands with President Ford. From the Sev-
enties block, in the cold spring air at his door that stiffened the threads of his
Persian rugs, he pointed to the Eighties up the street. "Go see your Uncle Eddie,"
Thabit gestured. "He never got involved in politics—smart man! A sweet guy,
your uncle." He closed the door on the za‛tar.

For most of his life, Eddie Baloutine never got involved with moving, either.
He lived in the same house in Bay Ridge in which his father—a Palestinian from
Haifa—raised the family. It may have been one of the oldest homes in America
continually inhabited by Palestinians.

A steady stream of people entered this old brownstone—the brick is purplish-
red—from the backyard, where the breakfast table had Eddie spreading a news-
paper. He retired after thirty years in the baby wear business; his partner was a
Syrian Jew who is paralyzed in a wheelchair. Eddie visits him frequently. "We
use to speak together in Arabic," he said to me after the coffee was poured.
"Now I just wait for him to nod yes or no. We had a good business relationship
and were friendly. We had him and his wife over a couple of times for dinner, but
it was hard. They wanted strictly kosher meals. Don't get me on California, will
you? I got beautiful pear trees out back. What do I need oranges for? What in
hell are you writing about the Arabs for? It's all the same story here—they were
good citizens, they prospered in business, and they didn't help each other."

"What was that?"

"Well, they're an independent people, what can I tell you." [6]

Eddie's father came to the United States at the turn of the century, another case
of escaping Turkish conscription. He took a trip to Japan and soon was a middle-
man in the silk trade from Japan to the United States.

"What does Baloutine mean?"

"You mean 'Ballantine'?" he laughed. "That's what they always called me.
Somebody from the bilād told me it comes from balāṭ ṭin (concrete and mud), or
the guy who wets the cement. A cement wetter. That's what we were."

A jokester in the community, Eddie will pillory California at the first chance.
He had it in for all the Brooklynites (my mother's family being one branch) who
escaped Brooklyn for California. He thinks Californians have their heads dried
out by the sun, that they are forever tottering on extinction by earthquake, tidal

wave, or free sex. His only story about the Arab-Israeli crisis hitting home to him in New York City concerned one Israeli fund-raising dinner to which he was invited, no one apparently aware of his origin. "One man would stand up and say, 'Mr. Chairman, last year I pledged $1,000 to Israel and this year I pledge $5,000!' and everyone would cheer," he told in animated voice. "The next guy was called *Mr. Goldstein.* 'Mr. Chairman,' he said, 'last year I gave $10,000 to Israel and this year I give the same amount!' Then they said, *Eddie Baloutine.* 'Mr. Chairman,' I said, 'I pledge to you this year exactly what I gave Israel last year.' Everybody cheered. They thought I'd donated a million!"

But this retired manufacturer of baby's clothes, who wouldn't call himself Arab or Palestinian ("Syrian is what they called us"), who labeled the Arab Americans as selfish, runs off twice a week to help a crippled girl on his block take whirlpool therapy. He also took me to St. Nicholas Home, the first Arab American home for the aged in the United States. Eddie is one of the directors, as is Bob Thabit.

The old men were huddled in the cold along a stucco walk breathing vapor in cones outside St. Nicholas Home on Ovington Avenue, formerly the Bay Ridge Hospital. In 1978 the Arab community purchased the decrepit building and land for $2 million. It now houses seventy-five residents, many of whom are Arab in origin. Its success has been surprising, for the Syrian and Lebanese families cling to their elderly. The irony is that for many original immigrants, like Sadie Stonbely, St. Nicholas Home is a new sociological phenomenon—a place where the culture is completely integrated. There are Irish Catholics, Poles, Germans, and others.

Mrs. Stonbely, 85, born in Aleppo, Syria, became the first resident of the Brooklyn home. Sharp of mind, and clear of eye, she recalled her brother escaping a riot in which a man's head was decapitated in Tripoli, Lebanon. Shortly thereafter, Sadie and her family came to Ellis Island, where her eye was damaged for life from the poke of the trachoma examiner.[7]

The smell of age, a kind of powdered skin, clings to the home's faint, mint-colored walls. Handrails run everywhere. The chef, Raja Ramadan, saluted from the kitchen where he was fixing grape leaves, *ṣafīḥah* and *kibbah.* Most American residents acquire a taste for Arabic food, and many non-Arabs have been known to smuggle extra bird's nest (*kunāfah*) desserts to their rooms. Chef Ramadan loves the elderly; he left a job as head chef with the Biltmore Hotel in Manhattan, taking a salary cut.

Besides the distinction of being the only one of its kind in the United States, St. Nicholas has another claim to uniqueness. "Here we have the very antithesis of the Middle East situation where they have been fighting for generations," explained Joe Atallah, the executive director of the home.[8] The Board of Directors contains Arab Americans from every Arab religious sect and is led by Richard Zarick. He sees the home as a community center eventually, with everything from a library to Arabic classes offered to help revive the dying Arab culture in

Brooklyn. In a bad economy, too, the home has been an employment clearing house, even an apartment referral service.

"Let your light so shine," said Zarick, "that it will brighten the path for others." When asked about the apparent political torpidity of Brooklyn Arab Americans, Zarick drummed his fingers. "I believe you shine your light without killing your battery." [9]

Driving along the shore, Eddie Baloutine reminisced: "We used to use pearl buttons for bait to fish off Brooklyn pier." And then he sped up to get home in time to give therapy. He did not say the word "give."

Boxing had been a favorite sport of Eddie Baloutine in his youth; he had been in a few amateur fights himself. "You've got to go see Mustapha Hamsho," he urged. Hamsho, the number-one contender for professional boxing's middle-weight crown in 1983, lives in Brooklyn and hails from Syria. His relatives live next door to Eddie Baloutine, and my Christian uncle joked that he'd given the aggressive Muslim fighter a few tips.

Hamsho had been a ship painter from his native Latakia, Syria, when in 1974 he jumped ship in Providence, Rhode Island, to further a boxing career hampered in Syria where there is no professional boxing. He explained, "I've been to other countries before. But America, to me, was the best place to live. It's where all people can live together—blacks, whites, Jews, and Arabs. There's no repression here. I like that."

Hamsho worked for awhile for his cousin Sammy Moustapha as a dishwasher in a Middle Eastern restaurant in Brooklyn. Sammy, a fight enthusiast, intro-duced him to the legendary promoter Paddy Flood. Soon the relentless left-handed puncher was in the ring, though he first fought under the pseudonym Mike "Rocky" Estafire to avoid immigration authorities, who would deport him as an illegal alien. Flood, who came up with the new name for Hamsho, said he "had a lot of fire in his workouts and resembled Sylvester Stallone." His corner-man of forty years' experience, Al Braverman, compared Hamsho to one of the greatest middleweights of all time, Harry Greb. "He's a real tough sonofabitch; a real take-'em-apart guy." [10]

Hamsho lost his first professional fight in 1976, against Pat Cuillo, who was twenty-five pounds heavier. But it was his only loss for seven years until a title bout with Marvelous Marvin Hagler in 1981, when the champion stopped the "slugging Syrian" on a TKO in twelve rounds of a bloody fight that left Hamsho's face raw; he took fifty stitches.

One writer compared Hamsho's unlikely title match with Hagler—whom many believe is the greatest middleweight of all time—to "a hockey player from Mex-ico skating in a Stanley Cup series or a thoroughbred arriving from Tibet to run in the Kentucky Derby." [11] Though little news of world boxing filtered into Syria, Hamsho knew of Muhammed Ali and from an early age dreamed of being like him. At age 15, he fought an older man who was supposed to be Syria's best

amateur boxer and beat him: "My father never knew anything about the sport, but he cried when they announced my name as the winner and people cheered."

The first Hagler fight earned him respect in boxing circles for his relentlessness. The "half-Syrian, half-American, but all-heart challenger from Bayonne" earned a purse of $200,000 "and a red badge of courage by battling until his cornerman, Al Braverman, and Paddy Flood could not bear to look any longer at the face which had been sliced into a sanguinary mask." Hagler complimented the Syrian: "Hamsho wanted it and I wanted it. He gave it his all. He did. He even had his mother there." [12]

In 1983, Hamsho opened a restaurant in Brooklyn's Atlantic Avenue Syrian colony, Hamsho's House. We met there, the fighter accompanied by a number of Syrian relatives and his personal advisor and confidant, Irish cop Jimmy Dennedy. Arabic food and coffee were served. Hamsho, a handsome, broad-faced man of 157 pounds, trim and solid, said he wanted to give a fresh quality in food to people, like in Syria: "We don't have any alcohol in Latakia, all Muslim, you know. Life is really clear, everything fresh, we don't have a freezer. The fruit you eat there is of course different than here because everything there is natural. You don't put chemical stuff on food." [13]

His father drove a seven-horse cart like a taxi in Latakia. Myths about America were whispered to him early on—not gold in streets, but money thrown like rain: "One friend had come to the United States as a fighter and he said people were throwing money at him in the ring, almost a thousand dollars, like it was raining money! He told me in America if you want to work, to be somebody, you can be. Anything you want." When he arrived he found it lonely but a strange comfort that all immigrants were alike: "Everybody's a stranger here. Nobody's a real American."

In the 1967 war, Hamsho was 14, and he remembered being sent by his father up to the mountains to hide from air raids. Though patriotic, Hamsho was critical of the regime, "Assad is against his own people, you know. He is there by force, not by choice." He was revolted by the massacre by the government of its citizenry in Hama while quashing fundamentalist rebels. Hamsho himself is an Alawite Mulsim, as is Assad. He felt sorrow over the destruction in Lebanon.

Hamsho thought a strict upbringing in which he could be beaten if he did something wrong was good discipline, and he did not approve of the lax mores in America, fearing for his young daughter with exposure to drugs and free sex. "I don't want her to grow up and one day she comes home with a boyfriend and I shoot them both!" he laughed. In Syria, one goes quickly to prison for drug possession, yet Hamsho thought, "We have more freedom there than here. I'm not against America at all," he said. "I am more against Russia than America."

Still, he detailed incidents in which he has come against what he feels is discrimination here, especially with professional boxing's system of ratings. He recalled the boxing promoter Bob Arum stalling on setting up the championship fight with Hagler. "He says to my manager, 'You think that I'm going to help

your fighter? He's an Arab. I'm a Jew. You think I'm going to let him do any-thing?' " Eddie Baloutine had told me he's seen a Hamsho fight where the an-nouncer referred to Hamsho as "that bad Arab." His friend Jimmy Dennedy con-firmed that Hamsho had a difficult time moving up in the ratings, even after winning big fights and with an impeccable record. Only after the Hagler fight was his ability undeniable to the rating makers.

"I'm proud to be a Syrian," Hamsho said, glad that his fights were written up and viewed back in Syria. Though Hamsho is scrupulous about not talking reli-gion or politics, Jimmy said, "They downplay him every chance they get. It's a stereotype right off the bat. It's not usually a direct ethnic slur, like that 'dopey Arab.' But if the opponent scores they say, 'Oh look at that, that was great.' If Mustapha scores they say, 'He's just a mauler.' "

"I want to win the championship," Hamsho said. "I want to prove that an Arab or Syrian can do like any other American, because sometimes they look at me like I have long ears or am like an animal."

I thought the close rapport between Dennedy and Hamsho, the Irishman and the Syrian, was uncanny, when one remembers the fights between the two commu-nities at the turn of the century on Washington Street. They met when Dennedy was on patrol and gave Hamsho a ticket for illegal parking. He let him go, and later met him through an Irish boxer.

Hamsho prays five times a day at the New York mosque on Fifth Street, a de-vout Muslim. He does not find boxing to be a violent sport as many have said, and he thinks that most of the criticism comes from nonboxers. Though he was mourning a boxing friend who had died the week before from a fight, he asserted that, if you keep in shape, you "will never get angry, or hurt."

We drove in his big, old Cadillac to a friend's house to watch a Hagler fight. Hamsho was riveted in front of the television, silently taking in all the moves he must parry. He did not know that in 1984 he would lose a rematch to Marvelous Marvin Hagler by a knockout in the third round, and that by the end of 1985 his boxing record would be 39-3-2, dropping his ranking to twelfth. But he continues to pray.

When a fellow Brooklynite of Hamsho's was baptised, the priest poured water over his head and pronounced his name, "Farid Mir͑ī Ibrahim." Over the years, the Farid would turn to Fred, the Mir͑ī to Murray, and the Ibrahim to Abraham. And F. Murray Abraham—often taken for Jewish—would move from his native Pittsburgh, work at the Farah slacks plant in El Paso, Texas, and become a citizen of Brooklyn. He would also become the first Arab American to win an Academy Award, as best actor for his role as Antonio Salieri, the composer jealous of Mozart, in *Amadeus.*

F. Murray Abraham is an Italian Arab American? It was a question on thou-sands of lips in the weeks after that night in 1985 when he held the Oscar high. Perhaps the Salieri role was fated. "Salieri's great compassion is what kills him,"

Abraham told me the night I met him in Baltimore. Anyone who has been on the outside—and what Semite hasn't?—can understand this.

I took a Syrian cousin of mine to a Baltimore Mozart concert, where Abraham gave dramatic readings. Dr. Nabeel al-Annouf had come from Damascus for advanced studies in surgery and pathology at Baltimore's Union Memorial Hospital, one of only a handful of Syrian students accepted in the United States that year. Nabeel, or Nino as we called him, had been a young boy when we visited Damascus in 1972; his father had been the one to spirit my own father on the midnight ride to find us in Lebanon. Nino himself was filled with curiosity and pride for Murray Abraham's feat; it was also his first classical symphony ever, one he had looked forward to all his life, having listened to many classical music tapes. After the stirring performance,[14] Abraham was mobbed by autograph seekers, whom he handled with care and even brio.

Alone with him in a black limousine going to a reception, I was very nervous. He was exhausted and said absently, "They don't know how much it takes out of you." I wondered if he was referring to the autograph hounds or the show. "It's all the show," he said. I tried to make small talk to break the silence, but he stopped me. "Please. Give me some time to rest."[15] And he leaned back, stretched out his legs, and closed his eyes. In a while his eyes fluttered open and he asked me to explain the purpose of my book. As the black car cruised through Baltimore, we began to exchange stories of our family life. He had had two brothers die as a result of military service, one in the U.S. Army, the other a Marine in Vietnam. Suddenly, I found myself telling him about my sister's decade-long struggle with psychological problems. He had this quality—to make even a stranger open, trusting. His voice softened, "I'm sorry. It affects you, doesn't it?" All I said was, "My parents," and he intuitively understood.

The reception was a happy affair—Baltimoreans are more relaxed, ebullient than the sometimes proper and sardonic Washingtonians. (Baltimore was appropriate: blacks there in pony carts selling hard crabs used to be called "Ay-rabs.") When it came time to leave, Abraham did something touching that went awry. He tried to give the infant boy of our hosts his powder blue tie, one given him by Diana, Princess of Wales. The boy would not take it and turned away. Abraham stood there, chagrined, "It matches your suit. It matches your giggle!" But try as he might, the boy wouldn't take it. He stood there tie in hand, curiously like Salieri, his generosity turning sour.

Murray Abraham was born into the Syrian colony in Pittsburgh in 1940, his father from a village three days by oxcart from Damascus. He grew up to stories of his grandfather, who had recorded a record with his lilting voice at the turn of the century, a remarkable feat for the time. "His voice would carry literally for miles and people would come when they heard him sing and sit in huge circles." As for the famine that rocked Syria and Lebanon during the First World War, Abraham said his own father, Farid, had been the only male child to survive it and "the terrible attacks of the locusts." When growing up, he had heard stories

of cannibalism from the dreaded time and his grandmother was so shaken by the experience of starvation she "simply wouldn't talk about it."

"My aunts spoke of the day-long search for grass and weeds to make soup," he recounted. "All of my uncles died during the famine. I wonder why the word 'holocaust' has come to mean something so specifically Jewish when in reality it is a horror that so many people have experienced: Armenians, Russians, Chinese, Japanese, Gypsies, American Indians. It is all a holocaust. And the lesson to be learned is that it must never again happen to anyone."

He and his wife had given his children Arab names, Jamili and Farid, who is nicknamed Mick. His reasons? "It was time. I think these things take care of themselves."

His mother is Italian, and growing up in Pittsburgh the co-mingling of Syrian and Italian halves of his family "seemed very natural to me." He was emphatic about what was most precious in life to him: "The family is the most important element in our society. There's no doubt in my mind about it. I believe in the extended family, too. I don't believe in the so-called atomic family." He and his Irish-American wife had been married twenty-three years.

Would he have fought as his brother had in Vietnam? "Good question," he pondered. "I was a flower child, a product of the 1960s. I wouldn't have fought. But the men and women who did fight should get all the financial and medical and moral support we can give them. The same thing happened to those guys who were sent to Lebanon. What did Reagan prove?"

I wondered why he chose acting when the Syrian community pushed so many into business. "What you're talking about isn't strictly Syrians, Italians, or Lebanese. It's an old American thing—making a better life, money in the bank, something solid. But the fact is nothing is solid, especially in the current economy. Given the shaky nature of acting, I am more prepared than the average worker for this shaky economy."

He spoke enthusiastically of his recent testimony at a Senate subcommittee on behalf of the National Endowment for the Arts: "The hostage crisis was fermenting at the time and all I did was talk about the value of art in terms of international communications. Art can communicate when nothing else will."

Was he ever denied roles because of being of Syrian descent? "I'll never know. But at least 60 percent of the people for whom I've worked were Jews. And I intend to continue doing it. A lot of roles I've played have been Jewish, such as Teibele, the Jewish scholar, in *Teibele and Her Demon,* a great role. I also played the Rabbi of Prague in *The Golem.* I'm half Syrian, half Italian—of course I empathize with any Mediterranean people, especially Semites."

Media coverage of the Lebanon war bothered him: "When Arabs are killed, they're suddenly 'a bunch of Arabs.' They have no name, no history. Why? Is it possible editors don't know that Arabs are human beings?" He called the siege of Beirut in 1982 "a pogrom against Arabs."

He continued: "My struggle has always been an individual one. I've never

aligned myself with any group. I am primarily a man, a family man, an artist, and an American. And I have this heritage that goes back across the ocean. The more I know about myself through my heritage, I think, the more free that instinct will be."

Had a man who—in spite of excellent theater credits—been somewhat anonymous heretofore in his film career been spoiled by sudden fame? Hardly. There was "a very rare atmosphere" at the Academy Awards party. He saw "the elite," saying to himself, watching the crowd, "C'mon, you're no star. Jimmy Stewart's a star. Cary Grant, Kirk Douglas, Burt Lancaster, Laurence Olivier. You win an Oscar, and it's wonderful. But there's a world of work to do." [16] The roles he would choose from now on? "The best. That's all. Mostly I'd like my work to make a difference in the world."

It was now close to three in the morning; we were both exhausted. It had been a moving and very special encounter. Murray Abraham watched me out the door of his room, shaking his head, laughing softly when I told him I was going to drive fifty miles back to Washington, D.C., to get up for work at 7:00 A.M. I heard his words echo on the drive back on the empty freeway: "Salieri is obsessed with flying, but he is earthbound."

The Green behind the Steel (Pittsburgh)

A few miles outside Pittsburgh, in the small, leafy town of Bridgeville where the early Syrians first set up their dry goods stores after peddling, I met probably the oldest Arab American—Murray Toney, at the time 104 years old.

Toney came out of a back room a breezy May morning in 1983 in white shirt and trousers, fending off help from his daughter, Arlene Deep, and his rosy-cheeked wife, Naseema, a young 68. He was not thin or fat, but solid; his head was square, skin pale enough as not to appear Syrian. But the truly aged have no ethnic origin; they appear to all be one, drained of their color, having entered at some indistinct point the realm of the timeless. Work is decades gone; friends and relatives one's own age are gone. If anything, Murray Toney's squinting eyes and bunched facial features made him appear an ancient Chinaman.

Before I could get a question out, Murray Toney launched in falsetto voice into a millenarian ecstasy: "Whole world! This is Jesus, Messiah, water going all over the place! Rising up, all the trees come up, fish, junk—everything! Ocean. Allah! The ground come up. Some people eat, some no eat. God made everything from dirt!" [17]

Throughout our conversation—a melange of English and Arabic that his daughter and wife tried desperately to sort out for me—Murray Toney would interject apochryphal feelings about a great flood—the creation of the world, or its end. Perhaps this was not so unusual, however, for one who had never watched television, who had never read English, and whose only Arabic reading was the

Bible. He was in the realm of the timeless in Bridgeville. "Everything! Jesus! Air! No eat—it's too bad."

I noticed a tattoo on his arm. "From ink. It's broke." As for many First Wave immigrants, a doctor in the old country had left his tattoo mark after setting Toney's broken arm three-quarters of a century ago before.

Murray Toney arrived in Buenos Aires in 1908, and in 1910 he brought his mother, his sister, and her husband with him to the United States. For three years, he pack-peddled in Carnegie, Pennsylvania, selling shirts and yard goods before he set up a one-room dry goods store in Bridgeville and grubstaked other peddlers.

What had he done in Bṣawmaʾah, the town of his birth some miles outside Homs, Syria? He had farmed in corn and wheat. "If you had a cow, you had everything!" he shrieked. His motive for coming to the New World was like that of so many, money. "Oh, yeah, everybody coming from Syria to working much money!" he said.

Like many early peddlers, with little grasp of English, Murray Toney got lost in America. Once, after turning $25 of goods to $50 return on the road, he tried to get a train ticket back to Carnegie, but didn't get off until Woodville. The conductor gave him trouble; the police came. And a confused Toney spent the night in jail until a cousin bailed him out: "He told me, mistake. I'm mad. I want to go back to my country! Mistake!"

In his Bridgeville dry goods store, he sold everything from bread to shoes and socks. He remembered that at the time bread was 2-1/2 cents. But for twelve years it was a lonely life—he had left a wife and children in Syria; when his wife died there in 1929, he want back to Bṣawmaʾah. But Toney, whom his daughter called "a tough hombre" in his day, did not wait long to get going again. He married Naseema, who was all of 14 years old at the time, and brought her back to America, where they had three children. The stockmarket crash greeted them. Naseema said with a wry smile, "He always say I brought the weight of Depression to this country!"

As high pitched as it was, his voice was still strong, and it became even stronger—almost indignant—when he mentioned he was the last of a generation in Pittsburgh and in Bṣawmaʾah.

Toney was one of the fifteen founders of the Orthodox Church and its cemetery in Bridgeville. "All my friends that I loan money to—New Castle, Kensington, whole Tristate area—all have passed on!" he said in Arabic. But he was glad that at least with the cemetery "I do something good."

I asked him his opinions on the Arab-Israeli crisis; he didn't know anything about it. How could he, not having read a paper or watched television in his life. When Israel was created in 1948, Murray Toney was over 60.

He pulled out four large holy cards from his Bible and gazed fondly on one of the Ascension of Christ into heaven. "Everybody fight!" he suddenly said. "Nobody knows who win. God, that's all. Fight, fight, fight—for nothing! No war," he bellowed from one hundred years. "No *ḥarb!*"

What advice would he give young people on how to live a good life? "Nobody can tell anything to young people but God!" he said in Arabic.

The opposite of many immigrants, when Naseema Nassif came with her older husband to the United States in 1929, the houses she saw from the train in Pennsylvania appeared "too little." She said, "In Syria, big one. All high. Where I live we have big building, all stone." I got the feeling that she measured the American wood homes not so much by the height, but their frailty. They were not stone, therefore they were small.

Murray in his reverie recalled another man whose debt he forgave, and surprised me by using an American idiom, "He kicked the bucket!"

"Is your wife a good cook?" I asked.

"Oh, best!"

"That's the first time I ever heard that from him!" Naseema marveled. "After fifty-four years."

Murray Toney was blessed with freedom from illness in his life, "Except one time he had a backache," according to Naseema. He also broke his shoulder. That was it.

I thought I'd chance running a few famous contemporary names by him to see what response he'd give. When I hit John F. Kennedy, Murray said, "Nice man, nice man United States. And somebody always can shoot you. It's not right. Wrong, Wrong. Even if you're the best man in the United States, that give no right to kill someone!" Ronald Reagan? Murray didn't like him, thought everyone was out of work because of him. But he did point proudly to a card the president had sent him, "Congratulations on your 102nd birthday." Archbishop Anthony Bashir? "Oh, big shot!" Murray bellowed.

Inevitably, one wants to know the secret of being able to live over a hundred years. Murray Toney said, "Ask God. Try and do good for people, that's all. I help the church. I help poor. That's all."

But the very last thing he said, with a note of real sorrow, was "I wish God take me with my friends. God forget me. He lost my number!"

In the old days in Bridgeville, Murray Toney once cut his finger and the doctor thought it would have to be amputated. In desperation he went to the mother of Ethel Antion, who was known to possess secret knowledge of the curative methods of the old country. Ethel's mother, who came to the United States in 1901 as one of the earliest settlers in Carnegie, took a button leaf, like clover (*khubbayzah* in Arabic), boiled it, dipped a cloth in it, and wrapped it around Murray's finger. Though there were red streaks up his arms from infection, the potion worked. His finger was cured.

"My mother believed you could only kill infection with infection sometimes," Ethel told me. She would use matches to burn off warts, but also would break a pimple caused by acne, take the yellow substance and put it on the wart, which

invariably cured it. "She would say to watch the first wart you get—the 'Mother' wart she called it," Ethel related with a chortle.[18]

Retired from years at Bell Telephone Company and a divorcée, Ethel had many folktales she had learned from her father, who had immigrated at the turn of the century from Ain al-Ajuz (or "The Old Lady's Well"), a village at the base of Bṣawmaʾah, near Homs. And true to the reputation of Homs people as being slightly cuckoo, she had some tall tales to tell. One was about mules and hyenas: "In Syria, they packed everything on mules, but when they started making music they had smelled hyenas. In the middle of their song a man was once eaten by hyenas. My great-grandfather was once followed by hyenas and the mules knew it because they came in front and behind him to protect him. They knew there was danger! They say mules are dumb, a jackass. That's not true!"

She also recalled an aunt who was bitten by a snake on the toe. She was taken to Homs: "They made a swing for her and twirled her around and gave her yogurt, until she puked the poison up; it was green. The peeps [chickens] were picking at what she was puking and they were dying from what she puked. They had to lock the peeps up in the coop. When the puke wasn't green, the poison was gone and she was cured. Then a chicken flew from the coop onto my aunt's toe and knocked it off. When she came here to the United States she really had no big toe! In the old country they took us to show where she sat when she was bit!"

Amazon trader. Bicycle repairman. Owner of a department store in Carmichaels, Pennsylvania. No one I met fit the bill of the "self-made" businessman as well as Jean Abinader, Sr., born in 1910, whose jury-rigged bicycle-built-for-two allows only him to steer.

Jean Abinader, Sr., immigrated to the United States in 1938 at the age of 28, but he had spent years before that running a trader boat up and down the Amazon in Brazil with his father, Rashid. Jean related about his father, "One time the Turks asked him to pay twenty gold pieces to the Sultan of Turkey, and my father said, "I'm the sultan!" and took the Turkish flag, tore it, and stepped on it."[19] Someone apparently did a good talking job to keep him from hanging, explaining to the governor that the Lebanese didn't really know what the Turkish flag looked like. Rashid went to South America in 1923 to develop a trader business he had started there in 1906. Jean soon followed.

On the Amazon, working out of what is today's Brasília, the Abinaders sold guns, clothes, Brazil nuts in winter, rubber in summer. In the Brazilian revolution of 1930, they lost two canoes to rebels who needed transport. During the Depression, prices on the Amazon plummeted.

Jean remembered getting very ill at this time from food poisoning and measles. There was a flood:

The water came face down and make too much sand bank. One piece would be thirty feet of water, another piece two feet of water. And we work very hard all

day until nine o'clock at night—wet. At night we was hungry, we didn't cook. We make eggs and sardines with our clothes wet and we ate. I had black skin. I started swollen. I almost died. Food poisoning.

Another time we stopped at Paracón at big boss with rubber man. He owe us money there, to collect rubber from him coming down. I stayed in the bedroom. Afterwhile, they call me. The young daughter of the boss there; she was back from college and she say, come back; she want to talk to me. She have her eyes on me. I didn't have eyes on nobody. I was thinking about living, nothing. She was beautiful young lady. We talk in Portuguese. She took apple from her parasol. "I'm keeping this for two weeks for you," she say. I took the apple, tell her goodbye. But she had the measles. [Soon, so did he.]

Back from the Amazon, Abinader married his first cousin Elizabeth, in Abdelli. Eschewing work in the tobacco fields and vineyards and in love with long walks and bicycling, he thought for awhile of opening a bicycle shop. He was looked upon in the village, as was his father, as a counselor, "because I never took sides," and won the respect of the people for fighting against the French mandate power in the thirties. But finally he gave in to his mother-in-law's wish that the couple go seek their fortune in the United States.

What most characterized the Lebanese? "They're resilient people," he said thoughtfully. "Lebanese no go down, you see. Lebanese could be going out peddling. He don't feel like he's a lower man. He feel like he do you a favor!" He believed that the Arab peddlers showed Americans how to "take the company's control from their necks," especially the working-class immigrants of other nationalities, by the example of self-employed peddling. "They liberate these people!" he pronounced.

Jean himself peddled "floor coverings" from an old car and he'd see other Syrian peddlers out on the road carrying their packs. Apparently, peddling hung on in rural areas long after its peak in 1910. "It used to hurt to see women doing this job, sometimes even pregnant women. It was hard job but very honest." Later, he ran a general store in McClelland and was drafted into the army during World War II, but he ended up working stateside for the war effort at a lathe in Newcastle.

In the early fifties, he settled in Carmichaels, then a coal mining town that slowly lost population as the mines deteriorated. He bought ninety-six gallons of paint and refurbished a general store. But early on he had trouble with the locals over his dark skin and heavy accent. A sympathetic realtor advised him over a cup of coffee one day, "You are a Catholic and you are a foreigner and here they don't like to sell to foreigners or Catholics." A dentist confronted him, "We don't allow niggers in our town." Abinader had a quick comeback: "This now is my town. If you don't like it, you may leave."

But he hung on and fought for his rights and won the respect of the townspeople. Now he sticks up for the town as if it were Abdelli. If people ask him, what does Carmichaels have now that coal is gone, he retorts, "Carmichaels is

beautiful, best place to live. Other places have chemical waste, hurricane, floods. I think we are in the bestness of the country. Nobody kill nobody, no crooks. If you don't like town, leave it."

Reflecting on the early days, though, when he was subject to prejudice, he advised, "In anything people find weakness they take advantage. If you want to be respected by friends, you should be strong all the time. You have to compete, you have to fight." It sounded quintessentially Lebanese to me.

Abinader lost no words in hailing America: "The American spirit is the richest spirit in the whole world. They have the charity. They answer to appeals. They feel with other people. They fight, they kill, they make wars, but when over, they are ready to help and pick the other fellow up. Americans have good spirit, like me!"

A man who loves Arab food and dancing and has the energy of three men, Abinader had a curiously contemplative favorite pastime in the old country. "I was like water," he smiled. "When is raining and storming, I used to put raincoat on and go to the forest. I used to like to work in tempests, even. Most of the time, climb in a tree, sit in a tree. I used to go when the kids play, making noise. I like to go sit by myself and watch sceneries. I used to study the cloud in the sky, the formation. At night, I never played card, I used to get so quiet, so many little animals appear and start walking around and running, you never see them before. I watch how the stars move." Love of nature and of the sea and its sweeping marvel of cloud water: these he had kept in his blood from his native Lebanon.

This red-white-and-blue American confessed, "I miss the old country. I'm forty-five years here but my mind always there. I said I not going to do like somebody else—let my roots come down in the ground I can't go back." Jean was disturbed by the influx of "strangers" and refugees in Beirut. In Abdelli, once filled with livestock and farms with chickens and barnyard animals, he saw only one cow, no goats, barely a handful of chickens. The beautiful vineyards were overgrown with bushes. And he summed it up, "In place of the jackass, they have the car. Five hundred yards they don't want to walk." People walk more in Carmichaels than they do in Lebanon, he thought.

Taking up half the road with his side-by-side bicycles linked, he turned left around a corner. Instinctively, I tried to turn my handlebars, but couldn't. "You can't have two steering at the same time," he winked, and we rode on into the green Pennsylvania sundown, one of us at least *very* secure!

At the University of Pittsburgh Library there is a Lebanon Room among the various rooms decorated in ethnic traditions. Helped to Pittsburgh by Robert Bitar, an immigrant doctor from Bazbina, the room is lined with hard eighteenth-century cushions, good for a bad back that took respite there for an afternoon. But the windowless, ornate room began to make me cry out for air. The marble benches appear to have grown red-and-white striped satin, the walls and ceilings gesso painting. A mosque lamp from Cairo hangs from the ceiling and must have

been fashioned by someone with a breast fixation. Nine green see-through cups of light form the lamp, each with a large nipple.

I met poet Samuel Hazo, who teaches at Pittsburgh's Duquesne University, for a late lunch and told him about oldsters I had interviewed in Bridgeville, Carmichaels, and Greentree. "They are so definite!" he marveled. "They're here to stay." Hazo, the Arab American community's most accomplished poet with 14 collections to his name, as well as two novels and works of criticism, spoke about the aunt who raised him, Katherine Abdou. Only 6 years old when his mother died, Hazo was guarded to manhood by Aunt Katherine, an inspiration and toughie. "She'd have a rosary in one hand and a deck of cards in another," he laughed. The day she died she was sitting in a chair, calmly put a hand on her breast and said, "Sam, I have a pain in my ticker. Please call a doctor."

Later I crossed over the many bridges of Pittsburgh, a city at the nub of three aortas of sludge—the rivers Ohio, Allegheny, and Monongahela—and regarded its dark buildings, which are not skyscrapers. There is a feeling of earthiness, even humility to Pittsburgh and always, past the old factories and vacated buildings and the tall magenta I-beam structure of U.S. Steel (or USX), there is green at the end of every road and tunnel. Nature buttresses, or recollects, industrial Pittsburgh's origins as the first outpost in the West during America's colonial days.

In black pullover and black trousers, appearing like a sleuth, Hazo greeted me at his house and, after chatting with a visiting neighbor, he escorted me to his basement study for a tête-à-tête before dinner. Lined on three walls with books, it also contained a bench with weights and a four-foot-high curved Irish harp that Hazo had rescued from the trash heap. Music is close to him; his mother would sing at *ṣahrahs,* parties, and his father had the first record collection in Pittsburgh of oudist Abdul Wahab. All during our interview, Sam Hazo, Jr.'s, rock band practiced in the garage.

Hazo's poems are impassioned contemplations, brooding on war, the nature of America, its dizzying commands to progress at all costs, as well as the solace and demands of family. Although Hazo himself is quite physical—he once coached high school basketball, baseball, and football and was in excellent shape at 55— his poems are mental meanderings of a troubled, serious thinker. It did not surprise me that he named Shakespeare, Keats, Wilfred Owen, and Hart Crane as chief influences. Crane—whose dense wordplay is found in Hazo himself—was the subject of his critical work *Smithereened Apart.*

The Middle East was very much on Hazo's mind, though few of his poems deal with it. He was at work on a new novel, *When Free Men Shall Stand,* based on the life of Hisham Sharabi. "It's about an American reporter and an intellectual with no country, who says to his friend, 'What if you can't pick your cause? What if you and your cause are one and the same, and you don't have the luxury of choice?'" Hazo said, "Like America itself, the reporter doesn't become truly American until he has the courage of the lost cause."

He was pessimistic about the fate of the Palestinians: "They're going to exist

the way they have existed in the past thirty years. That is, creating their nationality wherever they are."[20] He saw them as internationalists by virtue of their homelessness.

His novel *The Very Fall of the Sun* is a kind of Socratic dialogue between a guerrilla whose nationality is kept purposely vague and an American professor he kidnaps. I wondered why Hazo did not specify geography or background. He lit a cigar. "Violence has never been part and parcel of any one people and the question of fighting something within the limits of the law and finding out you can't is a universal struggle," he said. "But the central question of my book is— and it is a Camusvian question—when do you take resistance to the point of blood? When do you throw the bomb over the wall and you don't know who is on the other side of the wall. And you justify it the way Begin justifies everything he did by saying he did it for the Jewish people."

An ex-Marine, Hazo is haunted by war. In one poem, he refers to listing battleships in a lagoon as "toys." He has wrestled with the issue of whether or not man is basically predatory: "I don't believe that now because I think that even the most predatory of men, if you expose them to love or to the finer things of life, music, even good food, or the domestic influence of a good woman who loves them, they will find the life of the trenches repugnant."

I wondered if he shied away from subjects that were directly Arab in his own work.

"Sure," he said.

"Why?"

"Because you can write out of ethnic or national feeling and mistake it for inspiration. It has the same intensity. Some other people may be able to do it well. I can't. I find once I get into that, I am at the level of skirmish."

I thought this was unfortunate, seeing as how he was the senior Arab American poet, and mentioned the strong sense of ethnicity in some of the finest Jewish authors, such as Saul Bellow, Bernard Malamud, Isaac Bashevis Singer.

"Let me say one thing about that," he ventured. "Being a Jew eventually brings a writer back to himself, because Judaism is all wrapped up in the Jews. So this is a box without an opening. You can do it like Roth, satirically; like Bellow, somewhat seriously; or Sholom Aleichem, ethnically. You can do it like Begin, ideologically. They're right back on home turf; they can't escape themselves."

Had Hazo ever felt that his career suffered because he was of Arab background? He was forthright:

Well, the answer is yes, I have. It's nothing I can put my finger on. I have never won an award or grant in my life. Never been cited. Never been published in *Poetry.* I did a review of John Hollander's book; I did not like it and said so. The next year the *Hudson Review,* which published the review, did not receive $5,000 from the Ingram Merrill Foundation because Hollander was a friend of Henry Ford, a new board member of that foundation. I could tell you stories. At the

1973 National Book Awards meeting I was a nominee. Helen Vendler and Harold Bloom announced they were going to vote for Archie [A.R.] Ammons before the meeting started! To answer your question, I don't know. Part of it may be envy over the International Party Forum [which Hazo runs] or they think I've got it made. In a way I'm kind of glad because I'm beholden to nobody.

He had been a lifelong Pittsburgher, yet the city did not play a strong role in his writing, as had, say, Detroit in the poetry of Lawrence Joseph. Hazo lit the fire in his eyes. "To be perfectly blunt about it, the thing you look for in poetry or fiction is man in action. Your purpose is not to be the litmus paper of the particular real estate where you find yourself. 'The Luck of the Roaring Camp' is a good story; the characters make it, not because it is about a camp."

And music—always music with Sam Hazo—grounded his life and work and those he had most loved. His mother, though a nurse, played the ʿud with his grandfather in their village of Atanit, near Sidon, Lebanon. His grandfather would play "at the Orthodox Church at 9:00 A.M. and then go the Maronite Church and play and sing the liturgy there," he marveled. "Ecumenical!"

His father, whose Assyrian blood traces back to Iraq, "memorized the whole eastern seaboard" while peddling rugs and linens; some of his customers were among the elite, such as Laurance Rockefeller and George Eastman of the Kodak Company. "We used to kid him that he never saw snow," Hazo recalled. "He would go to Florida for the winter and Lake Placid for the summer."

In an age of the computer, with people so impatient they rarely read newspapers much less books, relying on TV news, what could the purpose of a poet be? Hazo thought carefully:

You get recognition with pictures, not understanding. The language we are talking about, the language of vision, there is no substitute for that. You can listen to a news broadcaster and he will give you news in the order of decreasing calamity. After two or three pieces he will stop and say, "More after this." And there will be a pause for a commercial and then he will come on with some more catastrophes. Poetry doesn't say that. Poetry says "Less after this" or "Nothing after this." After this, you wonder. You don't wait for more grist for your mill. You just want to say, hey, wait a minute. This particular thing changed me."

I noticed that in a brief interview with his wife, Mary Anne, she hardly talked about herself but rather her parents and Sam. Prodded, she typified herself as having "an Italian stomach, a Greek soul, and a Lebanese heart." When we pulled Sam Junior from his rock guitar, I asked if she'd like him to marry an Arab American girl. "It would please me tremendously," she said quietly. "But I would never tell him that." [21]

Mary Anne Hazo had mentioned almost going to Lebanon during the 1982 war with Bill Monsour. Many had told me, "You have to go see the Monsour broth-

ers. They are a riot." In 1983, the Monsour brothers were Robert (67), Roy (66), Howard (61), and Bill (55). They are all medical doctors and have their own hospital, the Monsour Medical Center in Jeannette, southeast of Pittsburgh. I met them all at the home of their mother, Nafeeli Hanna Zakhour Monsour, 88, who appeared to be spicy enough to have another child at any moment. On hearing of my arrival, Bill, Roy, and Howard beelined it to their mother's home; the place was filled with banter and laughs. Bill's fourth wife, Maureen, was there, too— the head nurse at their clinic—with infant daughter Sophie.

Controversy surrounds the Monsours: they have been involved with lawsuits with Blue Cross, led the effort to bring maimed children from the Lebanon war to America, bought a newspaper to fight back against another one whose publisher abused them, and linked with Ralph Nader to fight pollution in drinking water. They are also legendary for their generosity and compassion, and each brother has a different style: Robert is the patriarch; Roy, the tender, warm one; Howard, frank, insistent; and Bill, the passionate rebel. All of them have made a name for themselves bucking the tide of the general conservatism of the Arab American community and, in fact, led a new strain of social activists in the professional class. I found them all extraordinarily open, frank, protecting nothing. Self-assured to the last toe.

It started, of course, with Nafeeli, born in 1896 in the Syrian town of El Ayoun El Wadi ("Spring of the Valley") and immigrated to America in 1912. She sat for me in her warm, elegant living room, large boned, stately, abundant gray hair coifed, and a sly smile on her face when she needed it. She spoke in a cackle. Bill mentioned that when she was recently in the hospital Nafeeli dreamed she saw somebody in a white cloak at her bedside and asked, "Who are you?" The ghost said, "Jesus Christ." There was no laughter on this; this was serious. But laughter and mayhem followed, interspersed with the serious throughout the afternoon.

Nafeeli was that bulldozer kind of mother who took an active role in spurring her sons into medicine. Robert had been first in his class; but Bill, the youngest, had had some trouble and her personal lobbying with the dean had helped break the logjam on his admission. She didn't seem like the kind of person to sit back and wait for opportunity.

"Don't sit down!" she cried. "Walk and push, *habībī* [my love]!" [22] Nafeeli was quick to put her trust in God, however. "She doesn't walk without crossing herself," Bill noted. But it was obvious she wasn't going to wait for God, either!

The Monsour hospital was started in 1952 with 6 beds, by 1963 there were 97 beds, and in 1971 they expanded by building a big round tower. Today they have 233 beds and are affiliated with the Penn State School of Medicine.

Bill Monsour has his mother's feisty spirit, but not her serenity. He is a restless soul and attributes a lot of this to the fateful move his family made from a largely Italian neighborhood when he was a kid to an Anglo-Saxon one. "For three solid years I had the highest score on the final examination," he recalled. "And each

time that they would tally up the scores, they would tally them in favor of the Anglo-Saxon kids. I had to take my score up and have it retallied three or four times. The preferential treatment for those kids was there right from the first grade." [23]

This rankled him through high school. It made him stick up for Italian football players who were forced out of the academic program in their senior year to take a manual training program, just because they were from "the other side of the tracks." He got the principal to reverse his decision. But Bill was still called nicknames like camel jockey, desert rider, and one I hadn't heard before, "Habla Habla," which mimicked Arabic speech.

"What they [his brothers] don't understand is that I had a miserable childhood," Bill stressed. "I was ganged every day by the Anglo-Saxon boys because I was the only dark-complexioned kid in the neighborhood. They didn't even know what a Syrian was; they called me a 'dirty Dago' and ganged me."

"Yeah, Bill fought everybody in the neighborhood," Roy dropped.

"I don't like the Anglo-Saxons," Bill shot back. "I hate to generalize but I don't. I've had very bad experiences with all of them. I can embrace a Jew anytime before I can an Anglo-Saxon."

Roy spoke like an older brother on the verge of a reprimand. "He was pretty rough, you know. He wasn't calm, cool, and collected at all. He never was as long as I have known him." Roy thought being the "baby" of the family might have made Bill "a little spoiled." What amazed me throughout this exchange was that though tempers came close to flaring, the brothers rounded conversation out, taking off the rough edges, and no one bolted the room. They were together in disagreement as well as agreement, a quality one would like to have seen more of in Arab American politics.

Community life with the Syrians was convivial, so much so that growing up "like brothers and sisters together, there was no pressure to marry each other because it wasn't romantic," Bill said. Of the fifteen Syrian families of Jeannette, they could only point to one Syrian girl who married another Syrian. The Monsour brothers had all married non-Syrian women. As for finding someone like his mother, Bill said, "You don't find her qualities in anybody, Arab American or not. They are just rare."

Oddly, the nearby Greensburg Country Club welcomed Syrians from the beginning, though they had shut out Italians until only a decade ago. "It is an amazing thing, but I think it is more difficult for this country to accept second- or third-generation Arabs than it was for the first generation [born on American soil]. It was a melting pot then; everyone was an immigrant. But the whole process of denigrating the Arabs because of Israeli propaganda made it more difficult for your generation than it did for ours."

Bill Monsour is known as the leading Arab American activist in Pittsburgh. But in college the Mideast crisis didn't mean much to him, though he noticed

Jewish students passing out leaflets, and a debate between Ben-Gurion and Quentin Roosevelt at Pitt. Bill and other Syrian boys on the Pitt football team, like Bill Abraham and Sam Haddad, had to keep order while the debate went on. This was 1948, during the partition of Palestine.

But he did little about the Mideast until 1967, the year the ears of many Arab Americans began to perk up. "It was a total disgrace when comedians were on TV and you were the butt of every joke," he said. "It was the first galvanization process—shame. Everybody started hiding behind the Lebanese name. Syrians became Lebanese, as did Palestinians. There was a resurgence of pride in 1973 and we strutted like turkeys a little bit, but still there wasn't a thing that we could do."

Bill Monsour thought the swing of Senate-candidate Abourezk through Pittsburgh in 1974 changed things. He, Sam Hazo, and Eddie Ayoub, then economic advisor to the United Steelworkers Union, put on a fund raiser. A heated argument ensued between Bill and Richard Shadyac at Ayoub's house; Shadyac defended King Hussein's ouster of the Palestinians in 1970 and Monsour was ready to "take the shirt off my back." Abourezk broke it up; Monsour thought he "didn't know a goddam thing about the Middle East" and if anything was pro-Zionist at the time.

Monsour pegged Abourezk's first trip to Lebanon in 1974—he had been persuaded to go there by the Lebanese ambassador to the Soviet Union whom he met in Moscow—as having changed his career. Abourezk phoned Monsour from Lebanon, crying on the telephone, "You've got to come to Lebanon now and see this refugee camp. You can't believe it. You've got to come in the midst of the squalor and see what's happening."

It was the start of a long involvement for both Abourezk and Monsour. Bill was the ex-senator's best man at his second marriage in 1983. "No one could have galvanized us as much as Abourezk except the carnage we saw in Lebanon in 1982," Mounsour thought. "And that was a pretty goddamned expensive price to pay."

Howard, commanding the floor with a strong voice, after listening to Bill and Roy, related an unusual story in which he had personally lobbied for $10 million in Congress to send a hospital ship to aid the wounded at Tal Zaatar during the Lebanese civil war in 1976. He had little success reaching Phil Habib, but met with Gen. Brent Scowcroft, head of the National Security Council under President Ford. Helen Thomas of UPI had set up the meeting. Howard had letters from all the major bishops of the various Eastern churches supporting the hospital ship and both Scowcroft and his aide, Robert Oakley (later head of the counterterrorism unit under Reagan), were impressed. "If you folks were this united there are many in high places for the Arabs who would come out of the woodwork," Oakley told him.

The mercy ship was torpedoed into extinction before it could get out of port by Henry Kissinger, who thought, said Howard, "it would cause World War III."

Abourezk had sent a Jewish aide to the meeting to represent Arab Americans on the final decision. Howard, livid when it was scotched, called the aide: "What the hell are you afraid of a mercy ship for?"

Bill took over again, "I think there has to be hope. I think the Arab Americans have to work swiftly. I just am mostly disappointed with the recent turn of events. And although many people consider the Palestinian issue a moot one, I never did and never will."

The Monsour hospital has been involved in many leading efforts in medical research, including being chosen by the National Institutes for Health as one of twenty U.S. hospitals to conduct research into heart disease. But it was with a Pittsburgh publisher of a local county newspaper, Richard Mellon Scafe, that the Monsours ran up against prejudice that brought their hospital intense public scrutiny. The Middle East and medicine combined in a threatening way.

Scafe told his editor of the *Tribune Review* to halt publicity on the clinic's recent accolades and publish nothing on the Monsours again. Bill told the weird story: "His problem was that other WASP people in the medical community who were jealous didn't want to see the Arab cockroaches arrive at any fulfillment. And as a result, without ever seeing his face, this man began to attack this institution vehemently from 1973 on. This man instituted an FBI investigation against this institution. It started by his alleging to the U.S. attorney [who became governor of Pennslyvania] that two Monsour brothers—myself and Doctor Howard—had given the PLO a half a million dollars."

Monsour decided to fight fire with fire. He bought an ailing local weekly newspaper, turned it into a daily, and routinely attacked every position of Scafe's that was anti–blue collar, antiunion, and anticonsumer. One of the biggest issues was drinking water after a Monsour group affiliated with Ralph Nader discovered that the chlorinated purification system added fifty-two carcinogens to tap water. His newspaper printed a cartoon of Richard Mellon Scafe, whose head was in the body of a snake and whose body was slithering through water called Rolling Rock, a spring on Scafe's estate in Ligonier that was pure because it was filtered through charcoal. The caption read: "Would he drink chlorinated water?" Scafe's position "backfired on him," Monsour said.

Scafe's persecution of the Monsours exemplified Bill's claim that he had had more trouble with WASPs than Jews; what drove Scafe was "personal hatred toward me and all Arabs." Monsour published Ralph Nader as a columnist and wrote editorials criticizing Israeli policies. Soon Jewish merchants were not advertising. The paper died in 1980 after five years of operations, a loss of $2 million. Thus passed the first and only English daily newspaper ever owned by an Arab American.

Pittsburgh, Bill thought, produced a different type of Arab American than many of the more conservative, less unionized cities, such as Los Angeles and New York. Arab American immigrants and their children grew up "in the streets"

and developed more of a social conscience. The pride he takes in his heritage is deep: "I feel a kinship with Arabs anywhere in the world." He remembered when his brother Roy would arrive in some town on tour with the army and the first thing he would do is go through a telephone book looking for Arabic names for camaraderie.

Bill and Roy took me on a tour of the Monsour Medical Center. It was a robust, kinetic place, much like the brothers Monsour, the staff friendly and conversant, committed. I found the hallways a little cluttered, some of the department signs off-kilter, and the walls needing a paint job. Unvarnished as the Monsours themselves, their hospital—one of a dying breed of those privately owned in the country—exemplified the best of Arab American qualities—initiative and heart.

Pittsburgh's Arab American community is—if sometimes embattled—an accomplished, entrenched one whose members do not often leave it for other cities. At a recent reunion of natives of nearby Clairton, folks swapped stories while playing poker, dancing, eating *kibbah*. Father Samuel David, pastor of St. George's Orthodox Church in Pittsburgh, had a funny tale to tell about trying to "get pregnant":

> I had been married for four years and we didn't have children. Now in Lebanese circles if a couple doesn't have kids within a year, people start talking. Some of the local Lebanese counseled me to take my wife to a special beach and a miracle would happen. Go to that beach and pray, they said. I believe them. My wife didn't but we went anyway, and we prayed. That same night our beach prayer session was the talk of Lebanon. A village elder soon came to see me. He said, "I am sorry. You took your wife to the wrong beach. If you really want a baby, you must go north 10 kilometers. You'll find the right beach there." This time my wife refused to budge. We went back to the United States. Nine months later, wrong beach or right beach, we were blessed with a baby boy.[24]

And it would have to have been the solid but sweet-as-maple community of Pittsburgh that welcomed the first shortstop of Arab American heritage to professional baseball. Sam Khalifa was "the only player in baseball who has ever fielded a grounder in Tripoli, Libya."[25] The Pittsburgh Pirates infielder is an Egyptian American. His hitting needs work, his glove is divine, and on the base paths he could become a terror.

The Slave of Balfour House (Vicksburg)

It was Christmas Eve 1862. A ball saluting the Confederate Army stationed at Vicksburg was in full swing at the home of Dr. William T. Balfour. Known as the "Gibraltar of the Confederacy," Vicksburg's battlements were thought impreg-

nable and its port on the lower Mississippi River the navel of an umbilical cord that tied the Confederacy together. If Richmond was the South's brains and Charleston its heart, Vicksburg was its solar plexus.

The Balfour House, designed in 1835 by a slave, shook—not from the whistle of parrot shells, but from the plucked strings of violin and cello and the dancers' booted feet. No one knew that a shadow-figure of the anonymous slave-architect burned into an interior plank of an upstairs fireplace was kicking up its heels. Only a century later would the burnt silhouette be exposed when the Balfour House was restored by Dr. Phillip Weinberger in 1982. Likewise, no one heard the first gunboats of Gen. William Tecumseh Sherman rounding Milliken's Bend ten miles north of Vicksburg in preparation for the bloodiest siege of the War between the States.

During the forty-seven-day siege in the spring when the city's population would come close to starving, they would take to living in caves. I journeyed to Vicksburg to explore the legacy of another people who came to Vicksburg to escape starvation and who were also familiar with caves. They were the Lebanese; they were said to own Vicksburg.

The Syro-Lebanese began to emigrate to Vicksburg as early as the 1880s, making it one of their earliest settlements in the country outside New York and Boston. The Lebanese on the high bluffs here apparently did better with the kudzu vines than their relatives did with each other in Lebanon. Their influence in both business and regional politics is disproportionate to their numbers; they are the largest ethnic community (600 of ca. 25,000) other than blacks in the city, followed by the Italians. Storefront names tell the story: Monsour, Abraham, Jabour, Nasif, Nassour, Baladi.

Why Vicksburg? Father Nicholas Saikley, pastor of the one Eastern church in town, explained, "They came in from the Port of New Orleans as well as Ellis Island. They sailed up river 175 miles and saw the town as a promontory. It appeared to be set just like El Munsif and Jbeil [Byblos], which overlook the Mediterranean 20 miles north of Beirut. They said, 'Hey, we're home!'"

According to Father Saikley, who became my guardian angel for the week, 50 percent of the major businesses in Warren County, in which Vicksburg is located, are owned by Lebanese. Father Saikley had these facts out before he had sat down in the Old Southern Tea Room. He was quickly finagling with musician friends of mine to form a Vicksburg symphony orchestra. He owned an old black padre hat, called the ladies "Darlin'" and the men "Sweetheart." His movements were assured, nervously so, and he said he couldn't sleep at night and so arose before dawn. He called me "sleepy" because I was ten minutes late for breakfast one morning.

"My father was a wetback from Ain Shaara, Syria, who came into the United States through Brownsville, Texas, using the backstroke,"[26] Father related. "I

myself have a different form of backstroke." He scratched my neck and asked, "What can I do for you?"

"I want to know why the Syrians here are so prominent. I've seen prosperous everywhere from Los Angeles to Boston. But prominent—not much. They tend to be successful at business and blending."

"Well, I tell you, it may have to do with the fact that the early shopkeepers worked so damn hard. John Nosser's 86 years old and he's still putting in eight hours a day at his general store on Main Street. That's a slowdown for him. For years it was 5:00 A.M. to 11:00 P.M."

"What about their attitudes toward the Middle East crisis?" I asked. "I should think the Lebanese could carry some weight here in that direction."

Father Nick laughed and rolled up his carpeted forehead.

Our people here are too laid back on that one. In the 1967 war, I was able to collect all of $25 for the refugees. Our brethren on the other side of the Jordan and Mississippi rivers collected $100,000 in Vicksburg alone. I had my people at the Orthodox church saying, "Oh, the poor Jews!"

Many were agonized, many were silent, some confused. I tell you this—and don't mention her name—but one of my parishioners got a phone call after our Marines were killed in Beirut. The caller said, "From now on, for every American boy that's killed in Lebanon, a Lebanese home is going to burn in Vicksburg."

The man who set the Mississippi state senate's record for longevity of service—thirty-six years—visited me at my hotel that afternoon. Over the phone to Washington, D.C., his voice had been a halting, collected one, cordial and honest. But there was a kind of groping in it. I found out why. Ellis Bodron is blind.

Accompanied by his wife, a striking blonde with shining blue eyes, Bodron in dark glasses and silver hair appeared a character right out of Faulkner, or Carson McCullers. The Old Southern Tea Room was abustle. Senator Bodron is known throughout the state, as much a fixture as John Stennis, or Strom Thurmond in South Carolina. For twenty years chairman of the state's Finance Committee, Bodron held the second-most powerful position in Mississippi besides the governorship. Much of what he did and didn't do came down on him in 1982 when he lost his first election since 1947. As he said, "It's axiomatic that the people you annoy or offend remember you a hell of a lot longer than the people that you favor or please."

His own manner is matter-of-fact and unflinching. When I asked why he got into politics—few Lebanese Americans do—he downplayed it: "The answer's going to disappoint you. I graduated from law school and I figured that'd be a good way to advertise that I was back in Vicksburg to practice law. There were four other lawyers running, too."[27]

A conservative Democrat, Bodron held the purse strings tightly in a state that never had enough money for services that other states took for granted. He felt, however, that his crowning achievement was the Education Reform Act of 1982, which established a statewide compulsory kindergarten and a reading aide program—a small revolution for a state whose education quality has been one of the lowest in America.

Country club politics came up. Bodron acknowledged that the Lebanese of Vicksburg were not always accepted and were in fact—unlike in Pittsburgh—shut out of the country club until the late 1950s. The critical point was a complaint by a grocer, Pete Nosser, to the legislator.

> Pete said, "You know I don't care about belonging to any clubs but I've got daughters and primarily my sons-in-laws . . ." All of his sons-in-law were non-Arab but were excluded from clubs because of their marriage to his daughters. Now Pete Nosser had four large supermarkets and was very successful. I said to him, "You buy a lot of things from a lot of different people—you're putting money in banks and you buy insurance. So don't [do it]. Determine who you buy from—a lot of them are influential at this club. You're in a position to correct the situation if you're not happy about it.
>
> The situation began to change very shortly after that [Bodron grinned]. You know, history hasn't changed a whole lot. There ain't nothing more important than economics.

The country club's president is Shouphie Habeeb, owner of the First Federal Savings and Loan; he is the first president since 1966 to bring the club into the black.

We discussed the turbulent times of school desegregation and racial confrontation in the South during the sixties. Though a strong supporter of civil rights, Bodron believed that the growing number of black voters may have questioned his fiscal conservatism and hesitance to finance social programs other than his pet project of education.

"Intellectual integrity" was the key to sound politics, Bodron felt. Robert Taft, Winston Churchill, Barry Goldwater were examples of politicians he admired for putting honesty before everything and not bending to special interest pressure. In any case, Bodron was less than enthusiastic about the U.S. Congress for which he had run once; his friends there convince him "they don't really do a whole hell of a lot."

Middle Eastern politics never came up on the floor of the Mississippi legislature in all his thirty-six years, Bodron said, though in states like New York, California, and Florida the issue often arises in assemblies. (The Santa Monica City Council, for instance, endorsed Israel's invasion of Lebanon on the urging of candidate Tom Hayden.) Bodron's views on the current debacle showed insight and knowledge: he felt "either the granting by Israel or the compelling of Israel to grant some territory which the Palestinians can call theirs . . . is an absolutely indispensable element to any permanent solution."

About the siege of Beirut, he stirred, "Well, hell, I had all the resentment of it that anybody could have. I understood the claims of self-defense and territorial protection were preposterous. And I communicated that to some of my friends in Congress."

During our discussion, the legislator emeritus wiped his eyes and snapped his wristwatch band. Two fingers were wrapped in gauze and a rubber splint. "He accidentally got his hand stuck in a car door this week," Mrs. Bodron shook her head. One of their two sons had been in a near-fatal car crash recently. It had been a difficult two years for the Bodrons. Yet you wouldn't know it by the man's generous allotment of time, his repeated calls to my hotel room to see how my work was going, and an offer to tour the State Capitol at Jackson.

When the couple left the Old Southern Tea Room, a marvelous thing happened. Jane Bodron took her husband's hands and looped them underneath her arms from behind. Bodron followed her as if they were doing a dance called the Locomotion out the room, his wife's blue eyes brimming with light.

It reminded me of an old Arab exclamation of love: *Ya ʿuyūnī,* which means "My eyes."

Parrot shells and grapeshot bullets are still lodged in some walls of the eight antebellum homes restored in Vicksburg, scars of the siege. With nature victorious in forsythia and new leaves, I awoke early the next morning and ambled up Crawford Street. There I was drawn into the Roman-columned entry of the Balfour House, the most recent restoration (1982).

The wife of Dr. William T. Balfour, who had bought the house in 1850, was one of the few downtown residents who stayed home during the entire forty-seven-day siege by the Union. She couldn't stand the mosquitoes in the caves where many townspeople hid. Emma Balfour kept one of the few extant diaries of the siege by a civilian. As I read it, while ascending the elegant winding staircase, I could not help but think of Beirut or, for that matter, Anne Frank.

In the massive master bedroom on the third floor lived in today by the Dr. Philip Weinberger family, Emma Balfour tried to sleep but couldn't with the shatter of shells falling "like hail." There she sewed, wrote, prepared bandages, and filled cartridges with powder. By the time of the surrender, ten thousand Confederate soldiers were too ill and ill-fed to lift a rifle. Supplies were completely exhausted. Nevertheless, Emma kept her humor: "I have quite a collection of shells which have fallen around us and if this goes on much longer I can build a pyramid." [28]

On the bed was a photo of a silhouette that riveted me. It was the burned image of the slave who designed the Balfour House, found inside the brickwork of the bedroom fireplace during restoration. There, kicking up his heels, was the anonymous signature of not just a house, but a whole people, a whole cause. It was like the First Hurrah of the oppressed, a watermark, a tattoo of a claimant to the new throne of freedom thirty years before it was proclaimed the cause by Abraham

Lincoln, 100 years before the Voting Rights Act, and 125 years before daylight struck the shadow-man's dance in modern Vicksburg.

One Balfour stood proudly against the Union; another—Lord David Balfour in 1917—stood proudly for homeless Jews and pompously against the rooted inhabitants of the land.[29] But the Balfour I was growing to love was Emma, who spoke to me, as we descended her staircase, of the tragedy of war and the absurdity of brother fighting brother: "(May 30, 1863) Conversations occur nightly between friends on the opposite sides. Two Missourian brothers held a conversation very friendly—one sent the other coffee and whiskey. Then they parted with an oath and an exclamation from one that he would 'blow the other's head off tomorrow.' How unnatural all this is."

After the light evaporated at the Balfour House, I took to the Old Southern Tea Room to meet an Arab judge. Justice John Ellis stood up, all six feet six inches of him, and said, "I knew you were a brother." Born in 1939, Ellis has done it all or had a crack at it all. As a senior at Ole Miss he was treasurer of the state's Young Democrats and handled John F. Kennedy's 1960 campaign here.

He was also elected commander of the University Grays, a fraternity established in 1861 during the Civil War. At 28, he was elected district attorney of Warren County, taking over from a man who had served thirty-three years; Ellis won 70 percent of the vote. Today he is one of the youngest senior circuit court judges in the country and one of the few judges of Arab background in the United States, responsible for four counties, three which abut the Mississippi River.

Ellis ("Elia" in Arabic) has presided over thousands of civil cases, lawsuits ranging from $10,000 to many millions, and criminal cases up to capital murder when a man was sentenced to the gas chamber. He attributes his career to two influences—John F. Kennedy and the blacks of Vicksburg. "I wanted to be a banker," Ellis recalled in a slow, calm southern drawl. "But Kennedy showed me politics is a matter of working with people and their problems and not being selfish in the way you do it. I liked that." [30]

He hinted at an early bond between the Lebanese and blacks:

The blacks taught me something years ago. Their ancestors had come over from Africa before we Lebanese came in the 1880s. We had set up shops on the main streets of town, however, and they told me, "Look, we helped your people get started because your people treated us fair." They were still recalling from the old days of slavery and plantations.

I've consistently won reelection by wide margins, so if there were prejudice against me you don't feel it. The blacks have felt closer to me from a political standpoint. They say, "Well, look, you can understand us more when you administer justice because you've heard some racial comments against your people."

John Ellis is like the hero of the folk song about Big John—he is a Big, Big Man. Not portly, his limbs are meaty and his head large with dark hair coming

down to a widow's peak on the brown forehead. The smile makes him Smokey the Bear, with a gavel. Ducking under some scaffolding of workmen outside the courthouse, he stopped briefly to greet the men. They stayed their acetylene torches and raised their visors a second. He is well liked and, maybe, well feared.

One of many fond Ellis stories came out just before entering the new building as he looked over his shoulder at the Old Courthouse across the street; it is now a museum. "I used to play on the lawn of that place there, ballgames. And I would hear some hammering going on, some yelling inside the building. I thought it was a torture chamber! But of course it was the judge's gavel. Little did I know that one of the voices was the man I would defeat for D.A. when I grew up."

Judge Ellis is rooted, a tall cypress in the bogland. He loves the Mississippi basin and warmed to my thought that the townspeople of Vicksburg seemed to be the most natural on my trail southward. "As you get closer to the Mississippi River," he smiled, "you see the water changes people."

Raised Roman Catholic by the Brothers of the Sacred Heart, Ellis himself was not spared by prejudice. "A lot of black-headed fellows were at our school," he said, including black Irish and Italians. "But I didn't know there was any difference between Ay-rabs, Lebanese, and Eye-talians. I knew we ate *kibbah* on Sunday. But my size—I'm probably larger than most Lebanese—no one was going to say anything to offend me. I was the one to protect them from the wolves." When he said "Ay-rab" he wasn't joking; that is the southern pronunciation.

"Dago" spread over both Lebanese and Italians in the early days. Ellis took pleasure in unwinding a yarn about a black man with political power in one of his districts whose nickname was "Dago." Before he was born, his mother bought such sundry items as thread, needles, and linens from a peddler she referred to as "the Dago man." This peddler had excellent prices and did not avoid the black neighborhoods. When she was pregnant with Ellis' friend, however, she couldn't catch up to the Dago man. One of her neighbors joked, "Don't worry, honey. You got the Dago man inside you!" Thus her son was nicknamed, "Dago." Possibly the peddler was not Italian, but Lebanese. Thus an Arab became an Italian who became a black!

Family records at the courthouse are combed by locals seeking heritage a century or so back. But Judge Ellis had traced his own family back to the fourth century A.D. Originally the Jurige family south of Damascus, they fled to El Munsif in Lebanon due to religious intolerance. They were Orthodox Christians. Only recently had the family sold its last tract of land in El Munsif. The Ellis lineage traced itself right up to the Old Courthouse of Vicksburg—Ellis' father was born three blocks from it, Ellis two blocks away. It was almost as if law in America drew the Ellis clan close even as Lebanon moved further into lawlessness.

If the government is going to work to preserve civilization it has to have the loyalty of its subjects [he said, knocking his pipe on an ashtray like a gavel]. Otherwise you've got nothing but warlords, the rule of force. Every time there's a

bullet fired, a person killed, it persists for generations. There are old scores to be settled. Italy had that problem—they called it the Mafia. I don't like to see the countryside of Lebanon blown apart. But here we have been in the United States for over a century. We have been distanced some.

We have a similar problem here in the South. The whites cannot hold the blacks down economically, politically. If they do, they have a war. In this country we learned a lot since the civil rights days of the sixties. We need the blacks and the blacks need us. We have to get along with each other and learn how to cooperate.

Over in Lebanon, they're gonna have to have a Civil Rights Act! [he crinkled his brow].

[The Judge cleared his throat, and refilled his pipe slowly.]

When you get down to it, these politicians are here today, gone tomorrow. But Israel, Palestine, and Lebanon will still be there making history one hundred years from now. People have got to take a bigger view. I imagine if this government wanted to put the muzzle on Israel it could have. Whoever controls the purse strings is the one who should be able to dictate policy. We ought to be able to call the shots in Israel, without any ifs, ands, buts, or doubts about it. The president should be prepared to take any backlash.

As long as the Jews or Christians are holding down the Muslims, you've got a brewing powder keg.

We took a break and Judge Ellis brewed not a powder keg but a pot of coffee. He took the cup and went to the great bay window of his large, mahogany-walled office, viewing the Old Courthouse through a grove of cypress and oak. He remembered the day World War II ended and wash tubs were beaten in the parade down Washington Street for General Eisenhower. He recalled his pride in the medal-laden figure of GI Johnny Haddad, the community's hero (pronounced "Hay-dad" there), as well as the newly elected Lebanese legislator Ellis Bodron in the car with Ike. Bodron's disability swelled him all the more.

What cases, I wondered, were his most difficult and serious? One was a kind of *Body Heat*–type plan of a Lebanese man and his lover to murder her husband. (It had failed; the man only got four years because the husband didn't care!) He was the only Lebanese indicted and tried in his sixteen years of service. Did the man's background influence him? "No," Judge Ellis said flatly. "If he violated the law he violated the law."

Ellis had seen a jury turn a guilty man loose, once for something as flimsy as a typographical error on a confession. People turn up in the soda shop or barber shop years later and remind him of a jury on which they served. "But one thing is certain—everybody from the shoeshine boy to the doctor is a sentencing expert," he laughed. "I've never hit it right—either the sentence is too high or too low."

Would Judge Ellis' Lebanese background inhibit a successful run for national

office in Congress? "On the contrary, it would help. As I said, the blacks are the key. And they like us here."

Peter Nosser's original introduction to the dream of America came in the form of a gift of chewing gum. The man who broke the race barrier at Vicksburg's country club told me of receiving a package of Wrigley's from the hand of a missionary-doctor in his village of El Munsif before World War I. It was different, sweeter. The ʿilkī (or chewing gum) the children were used to combined būkhūr (incense) with beeswax They chewed a holy substance. But they were enamored with the sweet unholy.

"When I was that age I thought all of America was like that fellow who examined me on his lap and gave me that gum," Pete said, adjusting his thick-lensed glasses. "But here I was disappointed—a lot of people were not as kind as that man." [31] Searching for sweetness would be a theme in Pete's life. Docked at Le Havre for the final leg of his emigration in 1920, he went to a store. "I wanted to buy something sweet, having been used to figs and ḥalāwah in Lebanon," he said. "I picked out a tin with a label which seemed to be figs. I found out rather quickly that it was English peas. From then on I read the tin labels real well."

Pete Nosser was one of the three octagenarian original Lebanese immigrants, all storekeepers, whom I met in steady succession. He recalled, as did his cousin, Johnny Nosser, witnessing an earthquake the day of the Armistice in 1918. Added to the horror was a plague of locusts, which Pete remembered: "All of a sudden it was like clouds settling on the ground. They were eight times as big as a grasshopper. As big as a finger. Anything green they ate. We would beat on a tin can to scare them—it was the only remedy." This coincided with my own grandmother's habit in California of hanging tin can lids by string in her fig trees to ward off marauding blue jays.

Born in 1902, Pete Nosser lives alone since his wife passed away decades ago. In spite of cataract surgery, his mind's eye was sharp. The fateful trip across the oceans in 1920, with twenty or thirty of his clan, came back to him. Packed in sailor's "cuts" on the ship from Beirut, they stopped and bought dates in Algiers, where they had no fear of thieves because "we had nothing to steal. Poverty made us leave. My father said there was nothing to do there [in El Munsif]." Lost in Vicksburg, he was directed to his family by a black man.

"'What are you?' he asked me," recounted Pete. "I said, 'Syrian.' He said, 'I know a Syrian family.' And he led me to the woman who breast fed me in El Munsif! I ended up marrying her daughter," he smiled.

As with so many of the original Lebanese immigrants, religion filled Pete Nosser's fibers. Raising his silver-haired crown, he told of an interchange between Archbishop Anthony Bashir, who founded the parish in Vicksburg in 1906, and a skeptic, who once asked him, "Where is God?" According to Pete, the archbishop responded, "Some will ask questions to understand, others to irri-

tate. I cannot show you the Good Lord. If you keep the commandments, you go to heaven. If there's no God, what have you lost?"

"Uncle Johnny" Nosser, at 86, was the reigning patriarch of the community in 1984 and much celebrated by the town. He had been written up a couple of times by the Vicksburg paper, "been put to sleep seventeen times—the Lord is good," caught bream at the corner of First and Washington streets during the 1927 flood, and worked like a dog eighteen hours a day at his sixty-year-old store.

"They used to farm and I supplied horse collars, cow bells, harnesses for mules," Johnny announced, eyes a kilowatt of light. "Everything you need, I had. They couldn't find tire patches; I had 'em. 'Here ya go.' Nails of any description! Bolts, guns, chairs, iron pots for fried fish!"[32] He could have gone on forever and I would not have found out anything about him but what was in his store—an inventory that sounded like Walt Whitman's "Song of Myself."

Johnny Nosser was dressed impeccably when we met at the Orthodox church: chocolate sports coat, yellow cotton shirt, dark brown tie. There is no word for the veins on his long, spotted hands. They are runoff from the Mississippi and, maybe, the Dog River in Lebanon.

I asked him to name the best qualities of the Lebanese people. "That's easy," he said crisply, snapping a digit to the sky. "Number one, they pay for what they get. Number two, they care about their name if they was to be broke. Number three, they're religious. Number four, they love one another, they love everybody. And they pay their debts." But Lebanon was hardly peace loving.

"In the world—we need a lot of teaching!" he called out. Then his voice settled, became humble. "I love to have peace in Lebanon. I'd love to have the government get together and be 50/50. I don't want our boys getting killed in Beirut. The Lebanese unfortunately couldn't help—their sons are getting killed, too, each day on the streets."

Johnny was only too happy in 1920 to arrive in America and forget the horrors he lived through in the Great War. First he tried working in a car factory in Cleveland making batteries. But the battery acid ruined his lungs. He took to a candy factory. Finally Vicksburg beckoned through some relatives.

He is an unabashed believer in miracles, having risen off the operating table so many times. Pittsburgh radio took his story and put it on the air. He has the form letter to prove it. But Johnny is nothing like a form letter. He knows the Palestinian case "is hard to sell."

"This case could be tried in High Court right now," he thought out loud. "If I was on the Grand Jury, I think the Palestinians ought to have a country to live in. Where I don't know. I don't think these people should be mistreated like this— running them all over the world."

He fairly jumped from his seat as if hit by an electric current: "You'll never see yesterday! Twenty years from today is closer than yesterday." And then the smile, as if he had just dripped the eight ball in the side pocket, a turn of the head, a pull

of purplish cheek upward from the mouth, and the twinkling eye.

As for Haseeb Abraham, 82, who bought out the site where the first Coca Cola was bottled in America to expand his store, by 1917 in Bishmizeen, "everything was played out—six days would pass when we had nothing to eat at all." [33] The Turks forbid anyone to travel from the northern mountains to Tripoli to buy wheat. "Mother got us bran," said Haseeb, a short, armadillolike man with a face of pinched magenta. "This was the chaff of the wheat. We had to take it with water—it wouldn't go down. We ate grass. Sixty-five percent of our village starved to death. We ate anything—dewberry, *khirsānah* [wild grass], a plant that looks like garlic [*tūm*] to live off it."

The key relationship between blacks and Lebanese storeowners was explained further by Haseeb's daughter, Frances Abraham Thomas: "We worked with the black sharecroppers. They'd have a $100 mistake on their paychecks and we felt bad for them. We'd fix their errors and those of their employers so they wouldn't get taken again. When my mother passed away in 1983 I never saw blacks mourning the passing of a white like her."

For Mayme Farris, however, the view from the bridge on race and Lebanon is more complex—or perhaps less so. Mayme had the first formal marriage in St. George Orthodox Church in 1922. Her views are made all the more difficult by the strain it is for her to ease down her staircase, having broken her hip months before and rarely coming downstairs. Her view is this: the blacks were treated worse by the Union soldiers and carpetbaggers than by any men in Confederate gray; Michael Jackson ain't no good for blacks, making them avaricious and uppity; and Lebanon would do better if there were more Jews there.

Mayme Farris, one of the first girls born to the Vicksburg émigré colony, in 1902, is an old southern country gentlewoman—short, buxom, the beauty still present in her slender ankles. She is wise, sharp witted, imbued with history, a bit prejudiced and very sympathetic. But she is *all* Lebanese, even if every phrase comes out with a southern accent.

Of the people I met in Vicksburg she was the most strongly anti-Muslim and pro-Christian Lebanese, even to the point of asking, incredulously, "You call the Druze Lebanese? I don't!" Father Saikley argued with her to no avail. "They're not Lebanese like I am." [34] You'd think she had been born in El Munsif!

Proud to nurture a family of writers, Mayme has a daughter teaching English in college and a grandson who published a short story in the *New Yorker* at the age of 20, a remarkable feat. As for her own writing, done for the Vicksburg Historical Society and the early Syrian Progressive Aid Society, she said, "I couldn't work out, honey. I had to work at the kinsfolk."

Mayme Farris on the Lebanese achievement in Vicksburg: "Sometimes the governor would get up and brag about the Lebanese. They don't need that. The blacks and Jews—they need it. But the Lebanese lived it [prejudice] down by

natural force: they were self-sustaining. I also found them clannish."

Mayme on love: "What they call love nowadays should be scratched out with a black marker."

Mayme on conforming: "I feel sorry for people that can't conform. Because I can. Not that I sanction what I am conforming to. But because I know who's talking to me is a human being and has his rights in the world."

Mayme on the lack of nationwide Lebanese political power: "You know as well as I that if you have a nice car and a nice home and you're going to give a little wine and dine you can get anybody. ANYBODY. That is the easiest thing in the world to do, a little wine and dine. But our people could not entertain; they entertained one another."

Mayme on intermarriage: "When our children intermarry [the spouses] become Lebanese pretty quick. Our heritage is so strong that our boys need not worry. [The spouses] are gonna come over."

Mayme on Muslims: "Why are the Muslims taking over our country? But they're more loyal to their faith than we are. In Beirut there's a mosque every other block, and they chant from the minaret, *Al-ṣalāh afḍal min al-nawm*, 'Prayer is better than sleep.'"

Mayme on the solution to Lebanon's problems: "I hate for any Lebanese to hear me but if the Jews just had this country [Lebanon]. I wish they could let some Jews in there! We had it here, honey—Jews and Arabs—competition. Why, that's the salt of the earth!"

Mayme on the reason for America's generosity to Israel: "How many of Sudi [Saudi] Arabia you have come to America and help make America what it is? Do you realize 75 percent of your wealth and success in this country are Yahudes? If they don't want to head it up, they put Mr. Baptist, or Mr. Abeed."

Mayme on the number of Arab Americans: "Two million? No! No! You're counting the nonbelievers."

In her grandson James Hughes' short story, a character, Fig, tells his brother: "People don't lose their lust for life. Anybody who says they've lost it never had it in the first place. I know dozens of people not even out of high school who spend all their time feeling sorry for themselves. They think they know what grief is all about, but all they're really into is self-pity. Why can't they get their grieving done and then get the hell on with business?" [35]

The lust for life was in Mayme Farris' determined descent of her staircase, dressed up as if for the king. It was in the embroidered pillow of Byblos exhibited prominently on her fireplace mantel, as if the waters of that ancient seaport would boil. Hughes had written an epitaph for the whole Lebanese diaspora— "Get their grieving done and then get the hell on with business."

The last night of my visit to the city of crape myrtle, forsythia, and bluffs I looked out from Fort Hill which, 120 years earlier, had anchored the Confederate left flank against the worst siege of an American city in the country's history.

The Lebanese had made a mark for themselves here, many years from one war and many miles from another. Their home country, however, was center stage in world affairs for the last quarter of the twentieth century, torn by a vicious civil war in which many thought the final battle of nations was being brewed. They had left at the onset and in the wake of the first Great War of this century, opened shops in Vicksburg, been peacemakers between the defeated Johnny Reb and the blacks. Having starved, they sold food.

How much more horrid was the Lebanon civil war than our own? Eighty thousand Lebanese and Palestinians had died since 1975; but more Americans had been killed in a shorter time between 1860 and 1865 in an era of rifles and no repeating weapons other than a few Gatling guns—600,000. (The mortality rate of America's Civil War was 3 percent of the population; in the Lebanese civil war about 2 percent.) We have become conditioned in America to think that wars in other lands were somehow more bestial, that their place in the endless, bloody struggle for human dignity would suck us down.

In Vicksburg the Arabs had achieved unity where they hadn't in Lebanon. They had found peace after they had had none. It was not so unusual that the Lebanese built one of their most prominent roosts in America in the seat of the new country's worst civil war siege. They were planting mint in ashes—an old habit. Their success in Vicksburg was measured by how much good they could do for the downtrodden—a lesson not yet carried over in Lebanon itself.

Twenty years after the Union boys watched in unusual silence as Gen. John C. Pemberton surrendered to a grizzled U. S. Grant, the Lebanese began to come, were taken for Italians, opened stores for clothing and food, and wove the holes in the bills of the freed blacks; and the slave of the Balfour House slowly emerged from hiding. In the emergent spring, I thought of the words of Emma Balfour, in another spring when blossoms were threatened by shot, and how her humanity seemed larger in its respect for all creation than that of her illustrious namesake in Britain.

It was now dark. The moon rose like a silver button on a midnight breechcoat behind a obelisk of the Union Navy Memorial in honor of the sailors who braved the Confederate batteries. The wind drew its breath in and pulled the grass around to yearn. Now the waters below were silvery, the night air suffuse with flower and the graves sleeping. No, the river below Fort Hill was not strictly the Mississippi but the Yazoo River Diversion Canal. The Great River had grown tired of it all and, in a storm, moved.

Perhaps the Litani River or the Nahr El Kelb or the Jordan itself would have the same good taste. And let people live, come out from under the brick not as shadows but as free men speaking Arabic, or Hebrew, or joy.

The Sunni Who Sells Insurance (Cedar Rapids)

Stand on the red Cedar River in eastern Iowa and inhale. You will smell oats, for this is the home of the Quaker Oats Company. Also, there is blood from the stockyards, the moaty smell of the river itself, and the odor of corn. Cedar Rapids has been dubbed "The City of Seven Smells."

If you are an American Muslim, chances are you will sooner or later pass through Cedar Rapids in the heartland of the country. Among mosques in the United States, the one here is home to a growing and surprisingly serene Muslim community. A renowned American scholar—a convert to Islam—left a prestigious slot at an Eastern university in order to practice his faith in a thriving atmosphere. His choice was Cedar Rapids.

There are about two thousand Arab Americans in Cedar Rapids, two hundred of whom are Muslim. Each year the mosque, built originally in 1934, puts on a joint dinner with the St. George Orthodox Church. The first families from Arab lands in Cedar Rapids came to Iowa in the 1880s, the Boucharas and the Kseeras. They were peddlers. The first Muslims in the state, the Habhabs, arrived at about the same time in Fort Dodge, 170 miles northwest of Cedar Rapids. Three Muslim families nurtured the mosque at its inception—the Aosseys, the Sheronicks, and the Igrams.

Ahmed Sheronick, a Lebanese Sunni Muslim from the Biqaᶜ Valley where eight remaining American hostages might be held captive, is not a hijacker, kidnapper, renegade, or rogue. Ahmed Sheronick is the top salesman of the Prudential Life Insurance Company in Cedar Rapids, Iowa. He has worked for the company for twenty-five years and has been an American citizen for the same stretch of time. In Lebanon, he was a dirt farmer looking for a better life. In the United States, he sells insurance to those who work America's richest soil. Ahmed was outraged by the hijacking of American civilians in 1985 and his reaction to sectarian solidarity is, "Baloney."

Americans prone to seek scapegoats for economic problems, crime, lost prestige, and international vulnerability may be in need of a closer look at the world of a Lebanese Muslim, especially if that world is here.

Sheronick, tall and lean in short-sleeved white shirt and tie, gave the homily at the annual end of Ramadan feast day in July called ᶜId al-Fitr. He was pinch-hitting for a Yugoslavian imam who had left the country over some romantic involvement. Sheronick's wife and children were among those who rested on their tucked legs in the simple circular room under the dome. Ahmed did not wear a turban; his voice did not wail. Instead of speaking from on top of the pulpit in the Cedar Rapids mosque, he addressed the faithful from the staircase, leaning informally on the steps. In a quiet voice he urged the efficacy of learning "the hunger of the truly hungry" symbolized by the month-long fasting of Ramadan.

The ᶜId is like Easter in its sunniness. All were dressed well; many women were unveiled. Later, over the raucous ᶜId feast in the mosque hall, Sheronick

said he has found the same message of ennobled suffering in the letters of St. Paul and in the Book of Job. "To be a good Muslim is to be a good Christian," he felt. "In fact, to be a good anything!" [36] He laughed like someone who had put bitterness in the shed and chosen to spend his life out harvesting.

In Lebanon, "Jibjibnine was a small town then," he said. "Fridays—our Sabbath—I'd spend my time evenly between three groups, Eastern Orthodox, Catholic, and Muslim. There were no feelings of hatred or discord between Muslims and Christians. We visited the other churches as often as we visited our own mosque because every time there was an occasion—a wedding, Christmas, or something—well, we said, this belongs to us! It was just marvelous; it added variety."

This melding of different faiths—incredible as it sounds today with Lebanon's ongoing chaos—was typified by Ahmed's father, Hussein. When there weren't Christian priests available for a wedding, he would officiate. Hussein had blazed the trail to Cedar Rapids years before Ahmed was born; he was financed in his trip by a Christian family. "No notes, no assurance, no interest charged, nothing except his word that he will return the money," Ahmed recalled. When the elder Sheronick arrived in Cedar Rapids, some earlier Christian Lebanese immigrants helped get him started as a peddler.

It wasn't long before Hussein—marveling at the long fields of wheat, corn, and barley—decided to move up the scale from hawker of wares on the street. He became a grubstaker for other peddlers, and it is said that the Muslim community of Cedar Rapids originated in Hussein Sheronick's general store, which set up emigrant Lebanese Shiʿite and Sunni peddlers with suitcases full of dry goods and later, if they succeeded, with a horse and wagon.

Ahmed himself never felt prejudice in the United States. His father, however, had some run-ins with people who were terrified of Muslims: "They had heard about the Turks from the missionaries and how they drink blood and eat babies, you know," Ahmed said, smiling. His father often told a favorite story about meeting farmers who would give him a barn to sleep in but "unfailingly were amazed to find he was a Muslim and would ask, 'Are you going to eat us? Gonna eat our kids?'" It was hard for Hussein because he didn't know much English. He let them lead him to their churches to show, "Here's a Muslim—he's got ears and a nose and eyes just like us, you know!"

One night, crossing an old wooden bridge in subzero weather in the middle of winter, Hussein's horse and wagon fell off the bridge, through the ice, and into the freezing water. Somehow he made it to a nearby farmhouse "on the brink of death" from exposure, and the farmers, in Ahmed's words, "saved his life." It was an American favor the elder never forgot, nor did the son hearing the story in Jibjibnine.

It wasn't fighting the French, exactly, that stirred the young Ahmed to leave Lebanon, though he "did hear cannons blowing." Communications about the Druze-led revolt were poor; there were only two radios in the whole town, one in

a car, and Ahmed said, "We were more interested in hearing the instrument than in what people were saying." Though the villagers felt "strong displeasure" over harsh French tactics, they were powerless and cut off, complacent. They watched as the French rewarded the Maronite Catholic towns with "a few extra roads, a few extra schools, a few extra jobs."

Ahmed did about everything he could with his land. "I worked myself from a very humble start where I was sowing my ground under the rain, in every possible, miserable way. No protection, you know, fighting all the way against the elements." Though he now sells insurance, he said with pride, "I consider myself an authority on anything that has to do with the land." In 1950, the furthest horizon in Jibjibnine was the mayorship of the village. He wasn't satisfied. He saw his friends become more successful through schooling and leave the village. And he took the bait of the "new."

"Organization." That's what Ahmed Sheronick was most impressed by on touchdown at Idlewild Airport in New York City. "It was a striking, striking difference that frightened me," he admitted. But this was immediately assuaged by the "care and interest in the way people handled" him on his arrival, "where probably back home nobody would give me the time of day" in such a predicament. He was moved by the industriousness he saw all around him, especially in the dead of winter. "There was snow and these workers were working on the railroad tracks, and I thought this was fantastic," Ahmed marveled. "In Jibjibnine people hibernated most of the winter and didn't work."

Soon he was taken by the trend toward innovation in America, and was sold on the primacy of logic. In Lebanon, rural life and its customs were ageless and there had been little encouragement to improve. Ahmed remembered trying a new commercial fertilizer once in the soil to shake the torpor of custom, but it didn't move his fellows. In the United States there was a reason behind everything," he saw. "If it makes sense, you do it. Americans think they are abused and that their laws are bad and the government is bad. But this really, to me, is a most wonderful system. You would go before a judge and you're just as much an equal as anybody else. I was so in love with this country you just couldn't believe it." He confessed for the first time that in those early years in America without permanent resident papers he would wake in the middle of the night broken out in a cold sweat, murmuring, "What if they don't let me stay in this country?"

If there were any reinforcement to stay needed, a trip back to Lebanon in 1960 served. He saw "chaos and hate and disorder. No respect for the law. I predicted in 1960 what would happen because the whole thing was just hanging on a thin thread about to break. I didn't appreciate the morals and even the language." For the first time, too, Sheronick saw "Muslim trying to take advantage of Christian, Christian trying to take advantage of Muslim." He tried to warn both sides in the village but found both blind, arguing with him "like I was the enemy." When the

country blew-up in full-scale civil war in 1975 that has not stopped, Sheronick was not surprised.

Now far from the conflagration, Ahmed Sheronick reads the Bible as much as the beloved Koran. "I feel we all have the same religion," he said. "The same God, the same principles for heaven's sake." The ideal communion of the sects in his childhood had dissolved in bitter warfare. He felt more than ever that "man should not live for his religion. Religion should live for him. If religion doesn't uplift you, then it's not much of a religion. The Muslim, for instance is supposed to pray five times a day. Should you go pray fifty times a day, or day and night if life is good? How about a hundred? That's ridiculous. That's in the realm of fanaticism. You could say all Muslims are my brothers and non-Muslims are not. Baloney! All men are brothers. How do you think I'm making a living? How many Muslims come into my insurance business? About one hundredth of one percent."

There have been sticky times when Sheronick, who doesn't eat pork, had to stare at bacon in the kitchen of American Christian friends. But now it is cause for humor, Ahmed often ribbing his prospective host with, "Now what are you going to feed me?" At banquets if ham is served, he laughed, "I always get a more deluxe meal than the rest!"

As do most in his community, he shuns Arab American political groups because "I'm not a slanted person. I despise anybody who takes me out in the road and just tries to tell me how wrong the other side is and how right this side is because I know full well that both are wrong and anybody that approaches me that way is insulting my intelligence."

Sheronick reflected on the contemporary scene in Lebanon: "I do not say the Muslims are angels; I do not say Christians are angels. I daresay both are crazy."

Most repugnant to Sheronick are the armed Lebanese factions and pecuniary rewards for violence: "If you carry a gun and work for somebody you don't need to go and work in the fields. That's all. You are somebody's man, and they pay you handsomely to be a gunman. And I must say you could be a gunman for two different groups. That's the kind of nation that is in danger."

In the meantime, the Iowa wheat extends to infinity for this Muslim Lebanese who hijacked only himself when he went away for something called freedom and a guarantee of diversity. He holds these things hostage in the privacy of his heart and will not let them be traded for myopia, sectarianism, or some ancient desire for revenge.

The Mosque and the Prairie (Ross, North Dakota)

The largest grain elevator between Minot and Williston is in Ross, a town of fewer than one hundred people in the northwest corner of North Dakota. In Ross, people love rain. You do not speak against the rain. Common expressions are "S'pose so," "Well, forevermore!," and "It'll have to do." To leave farming and

work for anyone else is to "work out." The milk cows are patient. Saskatchewan is north about thirty miles, Montana mountains due west over the horizon. Teddy Roosevelt once shot bison south of here near Medora. Otherwise, the wind is the only constant. There is nothing much historical. Almost.

On a still summer day in 1978, with not a touch of tornado or cloud in the sky, Omar Hamdan bulldozed the first Muslim mosque built in North America. It was in Ross. On Memorial Day 1983, Omar Hamdan poisoned gophers in the cemetery of his ancestors. It did not seem to follow from the act of someone who singlehandedly destroyed the first American Islamic house of worship. Omar is torn, like the rocky northern terrain he farms—"With used equipment," he says. "I never buy new." It is June. He has just turned the stubble—fallow farmed. He is also confused by more than a vanishing Syrian past. The U.S. government announced in March 1983 that it will pay North Dakota farmers *not* to farm, in bushels of wheat.

"Now that would be just like when Chrysler went down," Omar looks at his Indian-red hand. "Just like paying Chrysler in automobiles. Wouldn't have made any sense, would it? It don't for us either. We don't need more wheat—we need markets." [37] Unsellable wheat choking the elevators, too much snow and no apricots, government money going for missiles instead of bellies, decades of women in short-shorts on Main Street of Stanley instead of veils—was this it? Maybe it was his wife, whose heritage is "everything . . . she doesn't know what all is in there," maybe the icy slough beyond the Muslim cemetery, but Omar leveled the *jāmiᶜ* on a hot summer day where the land is infinite as the sky. The twenty Syrians left in Ross and Stanley called it a desecration. One old woman named Nazira stood on the stoop of her trailer, took off her glasses, rubbed her blue eyes, and said, "It was like the death of my child."

Omar claimed ignorance when told of the historicity of the Ross mosque, dedicated in 1930 at the height of the Great Depression to bolster the colony of Syrians. Others might have known we were worth something here—in the large concentrations of the 200,000 Arab American Muslims, such as Detroit; Michigan City, Indiana; and Cedar Rapids, Iowa. We didn't, says Omar. The North Dakota Syrians hadn't held a service at the mosque for ten years. Most of the area's Muslims had turned Lutheran because of time and dwindling numbers. For a long while they had gathered themselves and their language like a cairn separated from the stony soil to the side of the wheat. But now intermarriage and migration to Canada had broken down the identity of the group of eastern Mediterraneans in a blond sea.

Against the farmer's bitter purge stood the last fluent speaker of Arabic in the area, Shahati "Charlie" Juma, a huge-fisted, raisin-skinned man with a tenacious shock of salt-and-pepper hair cut high above the ears as if in defiance. Charlie Juma shakes the hand of every living thing in Stanley, population 1,800. His hand is a warm clamp; he won't let go until he's read your fortune, raised you on

your toes for a laugh, or told you off. Knocking a Norseman's beer belly—a man who towers above him—Charlie quips. "Hey Pete. You got two in there?"

Charlie was the first child born to the Ross Syrians, in 1903, on the Juma homestead. In 1899, his father, Hassan, gawked out the window of the Great Northern train, liked what he saw in Dakota, got out at Ross, walked down the railroad ties, and threw a painted stone to mark where he'd take his free 160 acres, thank you. Today Amtrak's Empire Builder line goes right through the original Juma homestead. There were few people in Ross back then. The Juma family grew with the town; Charlie's memory is the memory of Ross, the Norwegians, Syrians, Bohemians, the duck ponds, rattlers, and tornadoes.

A member of every civic board in Montrail County, from the Board of Education to the Grain Elevator Stockholders Association, farmer Charlie is loved by the people of the area. He walks down Main Street of Stanley like an old squat bear, holding people up with his paw and quip. Charlie is a North Dakota Sancho Panza. But when it comes to his heritage, he is an olive tree thrashing in a field of flax. Lines on the bridge of his nose betray pain at the passing of an entire way of life. Ramadan in the fields. *Ṣalli* (pray) with a rug in the wheat.

One senses a showdown between Charlie Juma and Omar Hamdan. It will match a short, burly octagenarian with meaty hands ("I got 'em digging manure") and a wiry, handsome, brooding farmer who wears a cap with a hunter lifting a shotgun over the heads of two English setters.

Sally's Café is Charlie Juma's stage. It sports some of the holy icons of America's breadbasket on its walls. There are cheap copper paintings on black satin of the gods: three different John Waynes, Elvis Presley with the fat chin, various American Indians with their heads bowed on palominos, and way back in the café's rear, a plug-in painting of Christ in the Garden of Gethsemane, electric copper stars twinkling above His head. Charlie is joined under a bust of Wayne by a cousin, Laila Omar, and her husband, Clem. Laila works at the bank. Though wearing a common pullover and jeans, with her short black hair and bottomless brown eyes she is an exotic addition to Sally's.

The subject of prejudice comes up—Laila confirms that in the old days they were called Black Syrians, and there were fist fights. Everal McKinnon, a field worker for the Historical Data Project in Bismark who interviewed the Syrians in Ross, wrote in his report on 1939: "Their homes, barns and other farm buildings are, in most cases, just shacks and look very much neglected. In most cases the barns look much better than the houses. They have exceptionally nice looking horses but only one out of ten of the men are able to drive and handle horses well, although they all have them."

Charlie, who was one of the few Syrians to speak to McKinnon in detail, is insulted by that section of his report. He won't raise his voice, but his anger forty years later is evident in a quick jab of words. McKinnon was wrong: our way with

horses was just fine and our houses no different from anyone else's. And Charlie's nephew, Marshall Juma, was in 1983 the Midwest's number-one bareback bronco rider on the professional rodeo circuit.

"I think the Scandinavians have less prejudice than the Germans or Bohemians," Clem drawls. "My folks didn't impose prejudice on me—we're Swede. It's what you're taught at home in the final result."

Charlie butts in: "And you know, back in the old days there were no partialities between Christian and Muslim Syrians in Ross and Stanley. We had a few Christians. No partialities like they had down there in Williston." [38] Williston—about fifty miles west of Ross—has a thriving Arab American population now of over one hundred. They own real estate—the Habhabs, Josephs, Seebs. Another smaller community of Arab Americans is in nearby Bone Trail.

Strangely, none of the Muslims in the area has any idea what sect of Islam their ancestors were. Until the recent headlines of Sunni-Shiᶜa struggles in Iraq and Iran and Lebanon, as well as the Arab-Israeli wars, Charlie admits he didn't even know there was a difference. There was unity in the small community, and then the religion vanished. It never developed enough animosities and jealousies to bifurcate.

Coffee is poured by a girl with flaxen hair, meadow-blue eyes, and a sweat moustache. She rushes to cover all the outstretched cups of the farmers. The heat from grill and the bright street collide. Everyone sweats.

And the ruined mosque. "It's a ḥarām [forbidden], a shame they tore it down," Laila's eyes flare. "I don't want to talk about it." She crushes her cigarette and looks knowingly at her husband. "Charlie and I weren't invited to the meeting." The way she says this, it is obvious there was no meeting.

Charlie is really mixing at the annual Grain Elevator Association meeting. He zigs like a bumblebee toward three ladies whose white hair has an aura of honey. "Gals," he proclaims, "I'm a Finlander." They laugh and hold tight to their plates of potatoes and gravy.

Charlie and visitor stand in line to get some food. Ahead is a glum lady with baggy arms. "There's a gal who's 75. She used to sit in front of me at grade school. She says I used to dip her pigtails in the inkwell!" Later, Charlie will point out that the Ross schoolhouse had become yet another grain elevator. At the table the very picture of Lutheran suspicion and forebearance bursts like a dandelion in a fast breeze when Charlie asks about her children. Her name is Mrs. Shroteek. Before leaving she bends over to shake the newcomer's hand and underlines, "We love Syrians. They work hard. I'm a Norwegian, you know. We're all together now and that's good."

Towheaded kids are getting antsy. More coffee. Seconds. Thirds. Charlie wants to leave before the speeches start—he's heard them all before anyway, and it's getting dimmer out. People wave good-bye as he passes. A giant farmer who

traces his family back to Prague lets out a hoot when he sees Charlie and goes into a spiel about the price of wheat.

He stabs Charlie with a finger in the chest as they shake hands. "You know, Charlie, I wonder what ever happened to that musique you all had? 'Member? Darndist tale I ever heard, a musique in North Dakota. What ever happened to that musique?"

There's no more music at the mew-zeek. Only the wind.

Under the arc of a crescent moon and star—welded in steel tubing—Charlie struggles with the gate to the Muslim cemetery in Ross. The wind is blowing, the tall grass waving like the hair of a beautiful cousin who went away. Charlie clanks open the lock to the gate and silently moves on a field of poorly tended graves. Beyond, the cold slough ripples.

"That's where the *jāmiᶜ* was," he points to a large, dark patch of bending grass. A mermaid sank here, Charlie, the wind is saying. She had long green hair and came up from the Barada River that runs through Damascus. She followed up the Missouri River and sank. Her hair is not lime green like the rest. Dark green.

The Syrians still pay a man fifty dollars a year to mow the turf of the cemetery. He must be on strike.

The 1939 Historical Data Project account of the mosque went as follows: "This basement church is 18 × 30 feet in size and rises four feet off the ground. The walls are built of cement and rock and the roof is temporary. It has four windows on each side and two on each end. The cash cost of the church was $400, and members did considerable work themselves. It was dedicated on Oct. 31, 1930. Furnishings of the church consist of chairs, benches, a large rug, a coal heater and range. Members bring their own rugs for use in worshipping." It never occurred to the writer to use any other word than "church" to describe the mosque.

The oldest grave in the little cemetery is marked by a white-painted cinder block, nothing more. Someone crudely scrawled in a two-foot strip of cement, SOLOMON HODGE, D. 1940. Hodge was the first Syrian peddler in the area and the only one to keep it up as a profession—a cheery man whose wife and kids in Syria were cut off from him all his life. Hodge's name may have been a twisting of "Hajj," indicating a family whose ancestors had made the *hajj* to Mecca.

Many of the graves have a crude hump of concrete on them, like a stifling coverlet, but no marker. He points one out—it is his father in an unmarked grave. No, the custom is not Islamic. Charlie doesn't know why it was done this way. Only two headstones in the cemetery have the star-cresent motif etched into them. On some graves the earth is buckled as if the dead was restless. Grass overgrows most, gopher holes abound, and no grave has fresh flowers.

Charlie calls off the names as he walks: Osman, Omar. Juma, Hassan. Alex Asmel, D. 1941. A private in the 158th Infantry, 40th Division, a Muslim Arab

American killed in World War II fighting for the United States. Belinda Osman Hudson: "She remarried a goddam drunk."

"Here's little Alex Hassan," Charlie nods over a small stone the size of a common brick. "He died at the age of 1. An infant. Richard Hassan was his father, but he died. He has relatives living in Detroit [the largest colony of Arab Americans at 200,000]. But his older brothers there don't even know about him. I called them up and told them they had had a baby brother."

"Goddamit!" Charlie shouts, flinging a bear claw at the ground. "I'm the one that does all the dirty work! I make the calls. I get people together for the ʿId. When I die, who is going to remember Alex?"

The gate shuts. The rain-filled clouds move in a steel stencil of an Islamic moon. On the way back to Stanley, Charlie stops in the well-kept Lutheran cemetery where the graves all have headstones, are equally spaced, where the grass is watered and cut, and flowers, fake or not, are present. He points out his wife, Mary's, grave and his own place beside her, waiting. But why is his own family's selected spot here and not out in Ross at the Muslim grounds? Without a hitch he replies, "It's more livable."

The sun is setting on the old Juma homestead. Nine quarters in size (a quarter equals 160 acres) of barley, durum wheat, flax, and oats, as well as cattle, Charlie gave it all to his son, Charles Junior, who built a new house a mile up the road. The old Juma farmhouse is boarded up. For Charlie and many old farmers the days of the combine are over; the days of combining are not. They move, like refugees from solitude, into town.

A proud stillness holds the Juma spread. A forties Ford truck, purple as a hard-shelled beetle, leans into a broken fence. A barn sags down the middle as if it had been straddled too long by a heavy rider. It was brought in two huge pieces, Charlie explains, fingering his ear, in 1939 from twenty-five miles away. There was no timber long enough to move it in one section. It sags from the weight of many snows and its own fault line. Old hay inside is spotted with oil along the floor from dead tools.

What does it take for an American farmer to "make it?" Charlie's father started with one quarter in 1900 and that sufficed. Today two quarters, or 320 acres, are not enough to float a farmer. With good moisture, at least five quarters are needed to make farming a viable business and, Charlie estimates, $100,000 up front for suitable equipment.

In North Dakota the life of a farm is often told in tornadoes. Those that hit, when they did, what they took with them. Farmers tell of tornadoes like you would mark the scars on the body to show where you have lived the most. Tornadoes according to Charlie: "It forms the cloud in the sky and comes down. It's a dark black cloud. And when it hits it's just like a snake, dips down and goes up, turning and jumping."

In 1950, there was a bad tornado in Ross. In 1962, Charlie and his wife were

visiting a daughter in Texas. In the middle of the night the wife woke up in bed and said, "Something's happened to our farm. There's water, raining." The dream was prophetic—a twister had touched down on the Juma barn and pulled the top off like the cap from a bald man. The walls collapsed. Charlie described it: "Rose [daughter] was there doing the milk cows while we were away. She had just got up to the house with milk when the tornado come and took the barn and the lean on the east side. Neighbors to the east, Alan Kincannon, had a couple of milk cows and she was supposed to go over there and milk Kincannon's cows. But she didn't go. Later two boys in a tractor out on the road got killed from a car accident with the tornado dipping and jumping."

The most recent tornado in the area was in 1979—right on the Fourth of July. The twister took the air-conditioner off the roof of Rosie's trailer house and twirled the kids, who were sleeping in a tent. "It scared the devil out of them," Charlie recounts. "Then it crossed the crick to the northwest of us and took two, three trailers down."

But the worst tornado of the century in the Dakotas struck twenty miles south of Ross at the Missouri River. It is a legend, dated 1935.

> It struck across the river at Charleston I guess. They found a pair of pants that had a flat iron in the pocket and the pants was hanging on the fence. It took buildings all the way across the river. Just sucked the water out of the river so they could see the bare ground. Then it took a schoolhouse on the north side, went up, oh, several miles and struck the damn farm buildings on this particular farm. They hid or run away, I can't remember what. Then it went a little ways further and the kids was in the pasture bringing in some milk cows. The father went after them with a pickup. But that didn't help. It took him and the two kids.
>
> Then it took mail from Ernest Myers' farm clear up into Canada, about a hundred miles. They mailed the letter back to us from Canada.

Did the Syrians—who surely would never have seen anything like them—react in any special way to tornadoes? "They would say—a gift of God, you know," Charlie mused. "It's the doings of God. It shows what power God has. Not Christ, not Jesus, not Mohammed, nobody but the good Lord. He dips down and He does what He wants."

Near the Juma farmhouse two rusted children's swings dangle from their chains as if pulled by the tall green grass. Each hangs from a single chain, vertically. The tornado of time has been through here.

The real loss for Charlie—beyond ancestral ways—is that of his first-born son, Hassan, who died at 39 in 1970. A wallet photo shows Hassan, winsome, fairer skinned than the father, a Tyrone Power face. He will say it many times in many places over a few days, but the most expression he will allow himself is: "Hassan's death was a letdown."

Up at the new spread, Charles Junior is washing off some garden tools in front of his house. He's a burly, friendly fellow who once was knifed in a bar by a guy

who teased him by swiping his cap. Charles Junior pursued, took the cap back. The fellow swung. Charles wrestled him with a bear hug and then felt a cold draft in his stomach. "He thought it was a bottle opener," Charlie recounts. But it was a knife. And guess who watched the entire battle, blood and all? Omar Hamdan, downing a tall one at the bar.

The next morning is Sunday—visiting time. Charlie's driving. A Jeep speeds by. "That fella is going like a house afire."

First there's Mrs. Andreeson on Main Street who tells Charlie she met him many years ago. "You're a hundred years old?" he holds her hand and blinks the eye. She laughs.

A group of three women in their sixties is up ahead. Charlie used to give them rides to school in his horse-drawn sledge over the snow. Now they're in white shorts and thongs. "By God, girls, when are you gonna put your clothes on?" For a moment cackles turn to giggles and they go into Sally's Café with blushing wrinkles.

"Now I couldn't do that in Minot or Washington, D.C., could I?" Charlie pronounces. "There's an advantage to being in a small town. You know just how to talk to everybody. You know what they like and what they dislike." Ah, the Levantine diplomat! The walking bridge! The impresario of human relations who leaves his homeland in smoking ruins.

When asked how a Muslim puts up with women wearing such scant clothes in America, Charlie scoffs, "Bikinis in public, eh? But it's a free country. Who's gonna stop you if you show the *ṭiz?*" And what about his running a bar in Ross, as a Muslim? "I admit it. I broke the rules."

His daughter, Rosie, wants us for dinner and Nazira—the oldest Arab woman in town—for supper. So at noon it's off to Rosie's. Aromas of *kūsah* (zucchini), *kibbah,* and *waraq ʿinab* (grape leaves) rise in a little kitchen surrounded by farms. Rosie is a widow; her only child, Will, wears a John Deere tractor hat. Like the rest of Charlie's children, she married a non-Arab. In fact, no surviving first- or second-generation Syrian in the two small towns is married to a Syrian.

Snow is caught in her black hair. Rosie lifts the plates of steaming food with strong arms and a gentle voice. "I find *samīd* [farina or semolina] at our store for *kibbah,*" she says. As for olives, the Greek owner of a market outside Stanley gets them every other month. Arabic bread? In North Dakota it is called "Syrian flatbread," a takeoff of Norwegian flatbread. Rosie tells a story of a Norwegian couple who tried to make flatbread Syrian-style (more body, butter, and a higher rise). "They were stretching and pulling at that dough from both sides like it was a bedspread! Impossible! Finally, my Mother arrived and the Norwegian lady threw the dough down in a huff and said, 'Okay. You finish it.'"

Red *zūm,* a juice, is poured over *kūsah;* steam jumps like a genie around the table. *"Zūm, zūm, zūm!"* Arab kids sing at table and it means, "More juice of the zucchini!" The grape leaves roll off onto the plate like green cigars.

Dawn is here. She lives with her Grandad Charlie until her family's move to Nebraska is complete. With fair skin, brown eyes and hair, she talks with pleasure of participating each year in the local Norsehoostafest, the Norwegian festival. She is in her second year at Minot State. She laughs in telling of a fellow "half-breed" who asserts she's "half Syrian, half crazy!"

Talk goes around the table like a bottomless dish. The only restaurant in the area that serves Arab food is in Williston. It is called the Viking! Oh, the weddings, says Charlie, were great for dancing the *dabkah*. Omar Hamdan's father was especially good at dancing with a handkerchief wrapped in his palm. "He was light on his feet after he got drunk," Charlie drops.

Screwing up her forehead and staring off out the window, Dawn comes to the conclusion that she has never seen an Arab dance, and she notes, in all seriousness, "except, you know, *Fiddler on the Roof.*" Astonishingly, no one corrects her. No one seems to know that the famous play she refers to is about persecuted Jews in Russia.

Thank you to Rosie when all leave—she returns with the Nordic long *O*'s in her slow cadenced speech, "Yoor very welcoom." It's "nooz" for "news" and "aboot" for "about." Out front, what is this rusted old tub in the midst of Rosie's marigolds? It was used to scald pigs, she says. After that, the old Syrian farmers would clean out the bristle and dregs of pig and use the tub to soak *samīd* for *kibbah*. It may have been the only lamb around with an aftertaste of pork!

At Nazira Kurdi Omar's trailer the *kibbah* is plain and the Syrian bread flaky and too thin, like the Norwegian, without substance. But she spouts flocks of language, birds with damaged wings, in broken Syrian and English and you have to love her. Born in Birey, Syria, in 1908 or 1912, she can't remember which, Nazira is delighted to have company since her seven children are all gone, one as far away as Anchorage, Alaska. She wears thick glasses, her face rubbery with deep rills.

Charlie respects Nazira and lets her talk in the hopes her Arabic will spear some of the emotion flying out so fast. We have been warned by Dawn that few people can understand Nazira, who never studied English or Arabic and simply raised seven kids in a strange country. Her husband, *Allāh yarhamu,* died young, a sickly man. Her birdlike voice is not loud, and many times she ends a thought with an "I don't know anyway."

An innocent at 71 or 75, Nazira is the only remaining member of the Syrian community to refuse, on principle, to attend the Lutheran church. There is no more mosque, she rubs the welling of water from her eyes. "So I will go nowhere else."

After many rounds of food that seems drained of spice and piquancy by the long winters and her loneliness, Nazira pronounces with untypical clarity, "I want to be myself, not anybody else." [39]

Anyway.

Omar knocks at Charlie's door, darkening the screen. The showdown at last. Omar's eyes are red and he does not take off his hunter's cap, but tips it. Charlie smiles, does not shake his hand, rather feints a blow to Omar's belly. It is play with tension behind it.

Perhaps Omar has been drinking, but it is also possible that the capillaries of his eyes are swollen from pollen or dust from fallow farming. Maybe he has not slept since he heard there was someone in town concerned about the history of the Syrians in Ross. Charlie's eyes, however, are as clear as crystal, the whites white as ivory. Omar is going to plug Charlie or Charlie is going to strangle Omar. This is it—the O.K. Corral. The prize will not be a woman but the key to the corral of memory.

Small talk. The men test each other. Omar, born in 1929, is the son of Abdul Karim Hamdan from Rafid, Syria, a town a few miles from Birey, from where most of the Syrians in the area originate. Omar is a Rafidi. A man already apart. Life in Rafid, as in Birey, was poor. "My father told me if a boy got a toy pistol over there it was as good as a Cadillac here," Omar murmurs.

Omar mentions the bind he's in with the government's payoff system of wheat for laying off work: "We give enough in taxes don't we? The government has to use all these taxes somehow, so they'll examine the sex life of flies in Argentina if they have to." He's got it in for Argentina, which has been stealing a lot of North Dakota's international grain markets. He speaks without moving his long, brown hand, palm down, from the table. A derringer there?

Charlie puts on coffee to break the silence after Omar has spoken of the sex life of flies. He makes a couple of calls to others and tells them Omar's here; no one else comes. It seems to be their first meeting in a long while. The coffee boils over. Charlie's left eye is clear, but twitching a mile a minute. Omar's is red, looking downward. The coffee is poured. "Yeah, seem to recall a lawnmower catching fire the last service out at the old mosque," he puts forward in his low, dark voice. "Poured too much gas. Burned the thing to a crisp."

When was this? "1969, wasn't it, Charlie? The year before Hassan died, right?" Charlie says something unintelligible.

The visitor would like him to explain why he destroyed the mosque. ". . . our information here is so slack that everybody around the world knows it was the first and we don't," he says, midstream in a thought. "So we put it underneath."

"Put it underneath, under the table," Charlie drones, caught by Omar's "we."

"Yeah, just sorta covered it up. It was kind of an eyesore for many years and of course there wasn't enough in the congregation to . . . you know, keep it up. So it looked kinda bad. Deteriorating. And the windows were boarded up. And the cellar was a sump hole."

Silence. Charlie's arms folded.

"I found out I was the most unpopular one of the whole works, see, after this came up. Now my uncle told me that his daughter had already read in one of the

books that that was a historic church and he tried to tell me and I wouldn't listen. Now, I don't remember him trying to tell me that."

More silence. Like that which called you to prayer. There was no muezzin in the minaret then. There were so very few who could lead a service at all. Only the Dakota wind called to prayer on Friday.

It's an awful strict religion [Omar continues]. That's why it's tough for kids to follow in a country where there is freedom. There's no way I'm going to send my kids to the religion I was brought up on. Heck, I'm not . . . in fact, if I was to say I was religious, it would be a disgrace to my religion, really.

That's what kinda discouraged us a little bit . . . the fact that the religion was so strict and yet nobody really followed it. It's like the Christians—go to church and get their sins forgiven and then start off Monday morning again. Give them hell, you see.

Omar breaks a sly smile, then goes back to his studied expressionlessness.

Is this where Charlie throws his haymaker right? No. Because Omar begins reciting the Koran. Yes, he remembers a passage, a favorite: "Great God, the Savior of the World, Most Gracious and Most Merciful Master on the Day of Judgment. Thee We Do Worship and Thine Aid We Seek. Show Us the Straight Way . . ." As Omar recites, Charlie's eye stops twitching. He is stunned.

"I didn't know about it being the first mosque in America," Omar admits, with the first hint of remorse. "If I did maybe I wouldn't have done it."

"He dozed it," Charlie speaks quietly.

"If they're talkin' about building a new one, okay. That's fine, or maybe a historical plaque or something. But the way it was, with rats and gophers . . ."

"Omar," Charlie stands. "Who's gonna do this when I'm gone?" On the table before him are piles of old photos of the Syrians in the Dakotas, articles for the North Dakota Historical Society, plaques and presentations in Arabic. But he is facing a loner. He is pleading with him with emotions cooled by eighty years in the northern zone. There is no flailing of the hands. Only the eye twitching again. It is strange. In a pang of sympathy, Charlie reaches out to the prodigal son.

A quiet settles on the Juma house, bought by a retired farmer whose father came from Syria in 1899 and bowed his head to the east calling *Allāh akbar* in the wheat. It may be that Omar remembers that call, packed deeper inside him than anyone. Contrary to the obvious, Omar bulldozed the mosque not to slap Allah in the face but to hurt the community into realizing what its lassitude had done to its customs. Omar shocked the Muslims of Ross and Stanley. He was punishing them, and therefore himself, for not praying five times a day and not keeping the faith, and not inculcating enough steel resolve to resist the tide of Norsehoostafests and the ever-loving English. He was punishing himself for wanting the blue-eyed girl in the bathing suit of the movies and billboards that never stops coming at you in America. Omar, in his heretic way, suffered from a

hunger for meaning and righteousness. His violent act reducing the *jāmiᶜ* to dust may have been his most ardent act of faith since childhood. God, you deserve better, he seemed to be saying over the roar of his machine. Better than us. Better than this. Better than me.

As for Charlie, a more devout and temperate man whose father founded the mosque, he will be put to rest in the Lutheran cemetery because it's more livable. He has fought the good fight, but because fate is against the Syrians in Ross, and the Lutheran church is here to stay and its grass is well trimmed, he sides with the inevitable. Why, after all, had he left his father's grave unmarked all these years? Was this devotion to the Muslim ways? He will complain about gophers digging holes in the Muslim graves, but Omar—the recondite—will be the one to poison them.

Just who felt the passing of an era more, who was the assimilationist and who the keeper of the flame, is not so easy to tell. What is not difficult to surmise, however, is that by the year 2000 there will be only one Syrian farmer left in Stanley-Ross. His children may read about mosques in books, but that is all. His name will be Charles Juma, Jr. He will drive a Winnebago. And know no Arabic.

The Storm of a Belly Dancer (Texas)

Tanya Zwan has been belly dancing since she was four. It is the summer of 1983, and the college student from Tyler, Texas, is in San Antonio to shake her nutmeg body for the huge crowd of ten-gallon hats and spurred cowboy boots at the city's annual Texas Folklife Festival. It has just been announced that, of thirty-four ethnic groups, the Lebanese booths and exhibits have been given first prize, followed by the Germans, British, and Greeks. The small of Tanya's brown back is sweating as she pulls some cowboys up on stage to mimic the throw of her hips. She laughs, tossing her veil in the wind like a see-through eel. Behind the outdoor stage and the delighted throng and the tall Tower of the Americas spindle, black clouds are gathered. Tanya doesn't mind; her dance says—Let the storm come. For once, the Arabs have won!

It is my last day of ten days spent in the Texas Triangle communities of San Antonio, Dallas, and Houston. The land of Jim Bowie and Sam Houston has been especially good to the community and some of the most prominent Arab Americans in the country—the Haggars, DeBakeys, and Jamails—call Texas their home. Perhaps in no other area in the country—with the exception of Vicksburg and Detroit—are they as free to be themselves publicly, achieving stature in business, medicine, law, and politics. Levantine individualism and warmth found a simpatico spur in Texas brashness; their native humility took on a cock-of-the-roost confidence here and their love of open, dry, hot spaces bloomed on the Texan range like desert flowers. More than once I have been greeted, *Slim*

Alickum, the Texas version of *al-Salamu ʿalykum,* or Peace be with you. The Slim Pickens way of being an Arab.

Perhaps the entwining of Mexican culture with Texas made the Arabs less strange here; most of them originate from First Wave immigrants who came up through Mexico as peddlers who serviced the booming oil fields after the Spindletop gusher of 1906. Some of them—like Bobby Manziel, George Kadane, and Mike Halbouty—uncorked a few gushers themselves. Others stuck to olive oil.

Naomi Shihab Nye, whose San Antonio home was my chief outpost in the Triangle, is flying through the ethnic booths in her sarape. Ever gay, hair in pigtails like a young girl, in her thirties Naomi has already become one of the most promising young poets in America.

Today she captured my heart when, as a farewell, I awoke to find a miniature circus spread out on the dining room table at her Main Street house. It was for my thirty-fourth birthday—August 9—she said; cardboard cutouts of a grandstand with spectators, acrobats, jugglers, and bareback riders circled a birthday cake and two votive candles—an appropriate mixture of the Wild West and the Arab East. For Naomi, evidently, this is one of her "Different Ways to Pray" (the title of her first book). It is also her standard fare for a birthday—a makeshift circus on a table!

The storm is getting closer at HemisFair Plaza, moving in its clouds like the swirl of Tanya Zwan's veils. Naomi proposes that we dance to the tunes of a nearby fiddler and we do. The crowd in abubble, the belly dancer's beads of sweat coagulating like morning dew. The fiddler zings his strings; the hips pop at the *darabukkah* and the spurs. And I feel the Texas journey come back to greet the storm.

Dallas was not stormy but flung flat under a cloudless sky. It was the hottest day of the summer, and the sun grilled gold leaf that covers two tall buildings downtown, edifices of a modern Golden Calf.

The man who started the largest men's slack manufacturing company in America—now with $56 million in annual sales—walked out to greet me by means of his "third foot"—a teakwood, mother-of-pearl-inlaid walking stick, a gift from a Philippine friend. He was half an hour early for our appointment. J. M. Haggar (he traded in the Maroun for Jim years back) was 91—his hair white, face pink, and eyes a milky blue. But he still was forceful enough not to allow anyone else to drive his Cadillac and spry enough to stop a pretty blonde worker at the plant and say, "You look skinny in those britches!" One of seven thousand Haggar employees rolled her eyes; it was communicated quickly that this nonagenarian is still one for the ladies.

Hunched over, the small man led the way for a quick tour of the main plant, one of fifteen Haggar plants in Oklahoma and Texas. He took me proudly through a spotless white room filled with $30 million worth of computers, in which the

company made a pioneering investment twenty years ago. The computers' whirr was not as noisy as the storm of sewing machines.

As if to stave off worry about his driving capabilities, he pointed out two small signs on his dashboard: Honor God, and Live Life One Day at a Time.

Like so many of the First Wavers, Haggar had lost a parent, his father, when he was age 2. Very little is said about his early life in Lebanon—which he left at age 13—in his biography, *That Haggar Man,* and nothing at all about his opinions on the Middle East. So I determined to probe there some.

His father had been a tanner in the mountain town of Jazzine but the lack of "something to do" brought him and his mother to America in 1906. His memories are dim from Lebanon—no recollection of Muslim-Christian strife at all but of a clear stream in the village, huge watermelons, and playing games with sticks. No, not much to do. Go, peddler, fatherless, to America.

The boat trip to Veracruz took forty days and made him swear he would never take a boat trip again. On arrival, "I kissed the ground where I was standing, like the Pope did. I was glad to get off the ocean. I was scared to death." [40] The new immigrant did everything from wash windows and dishes to peddling linens. He never thought he'd be pulling up on a hot-as-hell day in a blue Cadillac to the swank, elegant Melrose Hotel in Dallas, nor that having once broken his back to pick cotton, he would become legendary in the garment industry for being able to pick quality piece goods cotton for his clothes by "feel." Nor that he would give over $200 million to charities. "Easy come, easy go," he shrugged opening a tall menu. "That easy come is hard work."

He happened to know the Maloufs of Hollywood, California, an old Lebanese family that founded Mode O'Day Corporation, a chain of seven hundred women's dress shops, some of which my father had opened as Mode O'Day's northwest regional manager in the 1940s. Other than his wife's family, the Wasaffs, and Eblan Malouf, a local merchant with whom he shoots quail and plays backgammon (fiercely, gives no quarter), Haggar admitted not knowing too many Lebanese in Texas, though he called Danny Thomas a friend. He figured he had given close to $400,000 to St. Jude's Hospital over the years.

The biggest change in American society he had seen in his eighty years here? "It is not as good today as it was then," he said. "We have the dollar principle instead of the moral principle." The soaring national deficit troubled the millionaire who made his money from the street up and paid all his debts long ago. The other problem he sees is the unions: "The unions and the politicians ruined America." Haggar Company is not unionized: "We spend $300,000 a year to keep them out!" As for his chief competitor—Farah Slacks of El Paso (another Lebanese-owned outfit), which is unionized—Haggar had short words, "He sleeps with them. I don't."

But Haggar was quick to demonstrate that he had a better alternative to unions: his company was one of the first to institute profit sharing. As well as receiving

better pay and working conditions than other garment workers, plus the four-day work week, Haggar employees share in company profits. He claimed that seamstresses walked away after twenty years with the firm with an extra $40,000 in their pockets. "Our profit sharing is good, better than General Motors or Ford," he said. "We take care of our people." It was an approach I saw many Arab American manufacturers use—a family approach—and I had to admit that in many cases it appeared to work.

The gap between rich and poor worried the millionaire: "You got a lot of Mexicans, blacks, that never had anything. Now they want the same thing you have and I have. And I don't blame them for one thing. That's where the problem is." At the same time doling money out on welfare was not his way; he believed in rewarding merit: "I don't know you can close the gap you are always going to have between smart people and dumb people."

His opinions on the Middle East were surprisingly knowledgeable and sharp for an older man unconnected to any political group: "The Arabs can't do anything because Israel is strong with its army and equipment. Hell, they are really making it miserable for the Palestinians. Whether they are Jews, Moslems, whatever, they are human beings. And they are taking their land and forcing them out. They forced them out of their homes and they went into Lebanon. The Lebanese wanted to get them out; they couldn't because they have to have a place to sleep. What caused the whole thing was wrong."

Had J. M. Haggar—a man with a lot of clout—met with his Texan senators, Bentsen and Tower? "They can't do a damn thing," he dropped sourly. "Nobody has any influence on Israel in this country. They can do anything they want because they are the people running this country. Let's not kid ourselves. They may be quiet about it, but they are. Money does a lot of things and they got the votes." He liked the Jewish people, however, and said, "They aren't bad, but the only trouble is when they get into power, they get to be awful hard to handle."

These statements might be understandable from a working-class Palestinian, but not from a Maronite millionaire. I couldn't resist asking why he and others like him hadn't given some of their money to fund the Arab American lobby. "Peanuts," he said dryly. "We got peanuts compared to what the Jews got. I have one Jewish friend who when he died gave everything he had—$100 million—to Israel. I can't do that. Plus they've got all the stuff tax free." When I mentioned that Dwight Eisenhower had been the last president to talk straight to the Israelis, threatening to cut off aid over the invasion of Suez, he said, "He should have." Was there a Haggar solution for Middle East peace? "It's got to be a peaceful solution or it will be the end of the world," he said, brows knitted.

Back at the Haggar plant, the patriarch showed me his office, with a bronze bust by Stephen Paderewski of the boss. I complimented it; Haggar dismissed me, "It's lousy."

He had visited Lebanon a number of times since immigrating, the last in 1970,

and sang in Arabic, "There are no better men in the world than those in Zahle!" The founder of the Haggar dynasty is the last member of his family to know Arabic.

They say the first word uttered on the moon was "Houston." NASA, the guider of Apollo and other space shots, is based in Houston. In addition, a moonlike landscape of spectacular glass buildings is evidence that Houston was in 1983 America's fastest-growing city (the nation's fourth largest behind New York, Los Angeles, and Chicago).

To add to the moonscape, a jet traveler is treated to a frightening sight as the plane taxis at Houston's Hobby Airport: white smoke pours from the plane's ceiling. No, this is not a massive dose of pretakeoff oxygen, nor is it Star Wars with spurs and lariat. This is condensation caused by Houston's extreme humidity, weather a lot like that of the Arabian Gulf where gas and petroleum burn-off jets are never far from sight.

Maybe this is why in 1983 Houston opened the largest Islamic art exhibition in America's history. Queen Noor of Jordan (whose father, Najeeb Halaby, hails from nearby Dallas) delivered the speech dedicating "The Heritage of Islam," which toured six U.S. cities to acclaim. There is a sizable Houston Arab American community (12,000), no doubt abetted by decades of U.S.-Saudi oil expertise exchange.

To the practiced eye, the imprint of the Arab world can be found all over Houston. If one is searching for truffles, caviar, fine wine, or the oldest cheese in town the place to go is Jamail's, Houston's gourmet supermarket. However, due to a split in the old Lebanese American family, there are now two Jamail's: Jim Jamail and Sons, and Jamail Brothers. Sound like a good ole Middle Eastern rift? In 1985, another Joe Jamail—the attorney—was to win the first round of the biggest oil lawsuit by defeating Pennzoil.[41] And the name? Yes, the Jamails are part of the House of Gemayel. When Lebanon's president, Amin Gemayel, came to the United States in the summer of 1983, he made the last of two stops in Houston, just to see family. Two thousand Texans showed up.

Here is perhaps the only surgeon on daily world call. Dr. Michael DeBakey, the pioneer of open heart surgery, of Lebanese origin, requires reservations months in advance for the service of his miraculous hands. At 75, DeBakey was still doing an average of a dozen operations a day. The eminent doctor is science advisor to President Reagan's Committee for the Reconstruction of Lebanon.

Here, too, is a successful Arab American businessman I shall call "Sam." Watching the gathering clouds in San Antonio fly the belly dancer's veils out from her waist and fling a cowboy hat or two into the wind, I recalled the day Sam strode into his offices like a Panhandle tornado.

I won't mention much about Sam, since after reviewing his quoted material from our interview, he demanded I take his name out of the book. This reversal—

unique among all those I interviewed—was all the more disconcerting since Sam had told me that he loved Lebanon with a passion and even boasted that he was the very person to try and do something for Lebanon even in his college years. I was prepared for bravado, not unusual for a Texan; but I was not prepared for his withering.

The tragedy of the Middle East certainly hit him deeply. He bowed his head, thankful his parents had not survived to witness the destruction of the 1982 invasion of Lebanon. But when I asked if he thought an arms halt to Israel over the invasion was justified, he became upset. The Jewish lobby was too strong, he said, with eyes widening. He thought that lobby could do anything from a media standpoint. At times when he had spoken out in criticism of a policy, he had had a Jewish friend call him up and tell him he'd gone too far. He expressed a similar checkmate three years later, and I gave him the anonymity he desired.

It was hard to tell what was legitimate worry and what was paranoia in Sam's demeanor. He was obviously of two minds—one wanting to speak out (our interview in 1983 had lasted 1-1/2 hours), and one afraid of exposure.

He mentioned at the time of our talk that he had said publicly in 1948 that Great Britain and the United States were making a great mistake; about the resultant Palestinian refugees, he had admonished that close to a million people couldn't be dispossessed with no place waiting for them. Though he expressed admiration for the cohesiveness and generosity of the Jewish people, he thought they had been remiss in not taking care of those they had disinherited. He linked Arabs and Jews in a noncompliment: Semitic peoples don't forget or forgive.

The massacres at Sabra and Shatila camps by what Sam called Haddad Christians made him vehemently question if peace were possible at all. Though he seemed to have glossed over the role of the Phalangist Christians in that atrocity, I didn't blink. As long as people protected their fiefdoms by wanton killings, he felt, the situation was medieval, and peace impossible.

As for Arab Americans helping, he zeroed in with a high-noon staredown, snapping that Lebanese in the United States didn't give a bleep, which rang ironic three years later.

However passionately delivered, on the whole Sam's observations were perceptive. He had personally counseled Lebanese leaders to "integrate" the country, deconfessionalize completely, or risk partition. His opinions about Palestinian disenfranchisement and Lebanese factionalism were not dissimilar from those of former presidents Nixon, Ford, and Carter, numerous experts of various ethnic stripes, and some of none. Many of my informants were as direct in their exercise of the right of free speech as Sam, and even more so.

And yet it was his second mind, no doubt, which opined that someone might place a bomb in his building over some of his statements. And it was that second mind, the one dominated not by pride, candor, or perceptiveness but by fear, that won out.

In retrospect, one sees the plummeting situation in the Middle East since

1983, as well as the plummeting image of the Arab in this country, as reinforcing Sam's brick-in-the-wall-of-silence disposition. The death by pipe bomb of ADC activist Alex Odeh in Los Angeles in 1985 surely did not help reinforce Sam's Texas outspokenness. Nevertheless, for a figure certainly not one to shrink from the halls of political or commercial power to declare such self-impotence, even— in spite of all his embattled pride—to delete himself from the history, was not salubrious for Arab American efforts to contribute to the shaping of American Middle East foreign policy and, worse, was not efficacious concerning the exercise of free speech by such an ethnic group as a whole.

Ralph Nader had eluded me in Washington.[42] And Dr. Michael DeBakey did so in Houston. I wrote, I called, I pleaded with his sister, Dr. Lois DeBakey, who works as a specialist in scientific communication and illiteracy near her brother at Baylor College of Medicine. No luck. I might have had the chance if I had needed a heart bypass and had lifted the sheet while under anesthesia to ask groggily, "Dr. DeBakey, do you have a free minute?" I have no doubt his answer would have been, "No. Your heart is more important that I am. Close your eyes."

Piecing together a portrait of the founder of modern open heart surgery was not easy. DeBakey was born a Virgo (September 7, 1908)—and thus a perfectionist—in Lake Charles, Louisiana, the son of Shaker Morris and Raheeja DeBakey, Lebanese immigrants who had established a chain of drugstores. The father was vigorous at 80, and there is every indication that his surgeon son—who has been called the most famous doctor in the world—continues that tradition.

His own list of achievements is staggering. While still a medical student in the 1930s, he invented a synthetic heart-lung pump, which led to the first open heart surgery in 1953. He developed the Dacron artificial arteries used in coronary bypasses; in 1953 he performed the first successful carotid endarterectomy, thereby establishing the field of surgery for strokes; in 1964 he performed the first coronary bypass operation with vein grafts; in 1968 he led a team of surgeons in performing a historical multiple transplantation, in which the heart, kidneys, and one lung of a donor were transplanted into four different people.

DeBakey has performed some sixty thousand operations in his life—about five hundred coronary bypasses a year—averaging twelve operations a day. In 1981, U.S. News and World Report named DeBakey as one of the five most influential Americans in the health field. He has won the Medal of Freedom, the highest honor a citizen can receive from the president of the United States; the USSR Academy of Sciences 50th Anniversary Jubilee Award; the Prix International Dag Hammarskjöld; the Eleanor Roosevelt Humanitarian Award—the list is endless.

Described as a "trim, tallish man who wears operating room garments with the easy comfort of a second skin," someone "lean with words as he is in appear-

ance," DeBakey has a terse answer for any thoughts of retirement: "Man was meant to work hard." [43] Perhaps he is humbled by the example of that pumping organ he has held so preciously, so often, in his hands.

There are no records of how many patients DeBakey has lost. Death in the face of the best that medical science can offer humbles and aggrieves him: "There is always a feeling of tremendous loss when one of my patients dies. Not only that, but you also sometimes feel helpless about it, because of our limited knowledge in what we can do. Remember the book, *The Agony and the Ecstasy?* We [surgeons] experience that every day. The ecstasy of getting a patient through, saving his life and restoring him or her to normalcy. Or the agony of losing him or her. You never get over that. Never. With children, the agony is more. It touches the very heart." [44]

I had some of my own family to sign off with in Houston. One was Uncle Joe Hamrah, actually my father's first cousin, one of ten children of the zany Hamrah clan whose relatives I had found running a juice bar and carpenter shop in Lebanon a decade before. Uncle Joe, one of the great "cards" I have ever known, was now in retirement after running four women's retail shops in Houston and, before that, a lingerie firm in New York. He had also been quite a skirt chaser, by his own admission, before settling down to marry. With cigar, brush moustache, and pink face, Joe found humor in everything, including falling in a fountain in Zahle when he was a boy: "My father walked in and saw me struggling in the water and picked me up, saying to my grandmother, 'Can't you see the boy almost drowned?' in Arabic. She said, "I thought it was a girl!" " [45]

Joe's father came to the United States in the earliest wave of immigration from Lebanon—1890—peddling out from Washington Street in New York, finally setting up an importing business with linens and laces. He returned to Lebanon in 1912, married, and had five of the children there, Joe that year. He would have stayed, preferring it to America, but for Joe's mother—my grandmother Nazera's sister—who was, in his inimitable words, "bugs on education."

Itinerant Druze would pitch their tents in the summertime in Zahle, Joe remembered; Christians shopped in the Jewish quarter of town and went to a Muslim neighbor's funeral. He never witnessed internecine fighting, though he did remember the murder of a woman whose husband threw her down a well and was "paraded [as a criminal] all over town." The chief suffering he lived through as a child in World War I was the famine in the Lebanon mountains: "My brother Freddie kept the family alive. He wheeled and dealt with the Germans, the English, and the French. He used to come in with blankets. He'd come in with food from their army, canned goods. Things were tough. They were cutting camels, I remember, and boiling them. Cutting pieces and making a little stew out of camel meat."

He fondly recollected village life, sitting eating watermelons in their court-

yard, and a favorite pastime of his: digging in ruins of old civilizations: "I used to dig up a little bit. I never got a city, though!"

Was there any difference between the Hamrah children born in Zahle and those born in America? "We're all high strung," Joe barked. "We all gotta be chiefs." He told a story of a Lebanese doctor friend who, when in school in Lebanon, listened to the teacher ask the class for a volunteer representative. "And they all stood up!" Joe laughed. "They're all pretty distinct." He remembered my grandmother Nazera as of that type, "She was like a buzz saw. I can never get over her sitting there without glasses, and she's eighty-something, reading the paper. She was right on top of everything. She can talk to you about politics, medicine, anything."

Coming to the United States in 1924, the Hamrah family settled in New Haven, Connecticut, where the father set up a linen and lace store catering to wealthy New England families. Joe recalled the joy the children had in "stealing toilet paper and hiding it all over our body because we never had paper, we never saw paper like that." But the landing at Ellis Island had been wondrous: "We landed at night. All the lights and everything—I was dazzled!"

Joe's mother peddled with my grandmother, slept in garages and haylofts. His father once had gotten shot while peddling. Like so many immigrant children, Joe was picked on as being strange and, when he fought back, "became a kind of monster to these kids." He laughed, remembering that on St. Valentine's Day. "I used to get a card from every kid. They were all afraid not to give me one. Like I was in the Mafia!"

How had the Hamrahs come to Texas? Strangely, Joe attributed the move to nylon.

> I guess it had something to do with that. I was in manufacturing in New York, doing lingerie. I went broke in 1948. I was dealing in crepe slips and gowns. And then this miracle fabric—nylon—came in. It was all controlled by the army. Then in 1948—I'll never forget it, in November, just before my Christmas deliveries—Truman lifted restrictions on nylon for consumption by the public. So it was $1.35 a yard for crepe and the stuff overnight went down to 35 cents a yard. I couldn't sell it. Everybody wanted nylon!
>
> I lost money with every dozen I sold. I used to sell to Foley's here in Houston. So I figured I'd come down and dump the stuff at Foley's because I figured nylon in the South would be crazy because it used to stick to you. Well, the southerners were told not to buy crepe because they want to be up-to-date with what the people want.

Now, of course, many consumers like natural fibers and shun synthetics, but then Joe was forced to seek another path. He bought a retail dress store and ended up starting three more, the Town Shops.

At 42, Joe married his wife, June, a stunning, gracious southern blonde. As

were many, he had been pressured to marry an Arab girl, but wilted: "When it came to Lebanese girls, I was tongue-tied. I think I had so much respect for them that I didn't know how to go about talking to them. I love my heritage. In fact, this is my problem. I admire them so much, I respect them so much, that I don't know how to handle myself!" Even today, June is more conversant with his Lebanese family and friends than he is: "I feel awkward."

He did recall the Palestine conflict and the establishment of Israel in 1948, which occurred at about the time his lingerie business went under. He was incredulous then and still is: "All my comprehension under the sun, I just couldn't understand until today, and it'll be until tomorrow and forever, how you can come in and take people's home that was left to them through generations in their family. I just can't comprehend it. We're not ants. We're human beings. The Palestinians—I have no great love for them. I don't know them from Adam. But they're just people. If they had done it to the Chinese, I'd feel the same way."

He gave an analogy. When he and his brother Salim revisited Zahle after many years, some of his relations were worried they would buy up their old house and resettle everyone in it. "How can I come in there, no matter what story they tell me, and uproot somebody? Tell them they can't live in there. The same thing Israel was involved in."

He remembered being surprised to find, coming South, that in some ways blacks were more integral to the society than in the North. He found few restaurants in the North employing black waiters, though it was common in the South. But the South had its prejudices, of course. When he opened his Town Shop in Houston, the former owner "didn't allow colored people to carry lingerie in there to try on brassieres. When a colored girl came in and wanted to buy a brassiere, I said 'Sure, go into the dressing room and try it on.' But the salesgirls wanted to leave. They didn't want to work for me anymore. I was from New York. I was a no-good so-and-so, letting colored people come. But today everybody is looking for their business."

He renounced what in Arabic is called *harkashah,* putting needles into things, stirring things up. He longed for the Arab Americans to "get our act together, no matter what the act is, let's be together, let's have a country." As for seemingly hopeless Lebanon, he said, "We're searching to get something to hold onto. When you're searching, you're grabbing at straws." He had been to the Amin Gemayel shindig in Houston and quipped, "He's got ugly eyes. I made a building like him!"

I ended up the Houston swing staying overnight with my cousin Jeff Baloutine, whose father, Eddie, had taken me around the old Brooklyn community. Jeff took me on a tour of the mansions of the palatial River Oaks section, which abuts the poorest section of Houston, the Fourth Ward. A thousand of Houston's poor live in squalid, two-story housing, 60 percent of whom are Vietnamese, the rest mostly black. Jeff himself was in charge of the project that would recommend to

either renovate or destroy the Fourth Ward. Picture that! A Palestinian American holding the fate of Vietnamese boat people in his hands. Only in America.

Lightning bolts hurl down from the black clouds at the festival, not unlike those that lit the sky above the dedication of St. George's Maronite Church in 1976, preface to what became known as "the miracle of San Antonio." Maronite Catholics stood, stunned, as the heavy rain parted to leave a dry space over the ceremony. Ralph Karam, named the El Rey Feo, or "King of the Forgotten," for the city's Folklife Festival,[46] and also the chief fund raiser for the new church, sat in his Mexican restaurant one day to tell me about the miracles that have enchanted the community here.

"Slim Alickum," Karam greeted me in twangy Arabic. A tall, rough-hewn man with a winning smile and a face not unlike that of the actor Robert Ryan, Karam immediately ordered margaritas for all. The restaurant, in hot red-and-yellow decor, resembles an expanded chili pepper and is considered to have the best Mexican food in San Antonio; the menu brags of "Lo especial de la Casa— the original Karam's margarita—copied all over the U.S. with no success!"

He hadn't really felt like he was a Maronite until he was 44, but now, "when I go to Mass with the Maronite rite, I feel like I am really communicating with God. Simple as that. I go to the Roman Church I don't have the same feeling." He wasn't big on the changes in that church since Vatican II: "I'm a little old-fashioned. I go to church to pray and I don't want to hear guitars, bands, nothing. These things turn me off. Of course, I've got to be broadminded. The church is trying to bring all the youth back. So I can neither condone nor condemn."[47]

St. George's is still the only Maronite church in Texas. The old church had to be moved in the late 1940s because of a proposed expressway and was severely damaged in the process. It also found itself condemned by an urban renewal project in 1968. Karam came up with an idea of an annual fund raising *ḥaflah,* "Magic Is the Night," that eventually brought in enough funds to build a modern, beautiful Mediterranean-style church that is the new St. George's twelve miles outside town on a pastoral lot. Belly dancing helped build God's temple, but also the arm-twisting finagling of Ralph Karam.

He took on the outraged parishioners, and a new priest from Lebanon, Father Wlademer Wakeekee, whom he quickly dubbed "the banty rooster" for his small size and combativeness. He described his sales pitch to the skeptical: "I never told them what to do. I always talked in innuendos. Basically, people are selfish and they always wonder 'What's in it for me?' I told them, nothing. If you want to let go of a few extra prayers for me, okay, but there's nothing you got that I want." He began to disarm them, "Niceness is good to a certain point. But as trustee I didn't like this cut-and-dried stuff. I create—I don't fight—I like a stormy atmosphere because you get more to the gut things that have to be done."

He approached an old friend, a fallen-away Catholic, with whom he'd play

golf, who was talking about dying, and challenged him bluntly, "You're getting old, you're going to die, and you're going to hell." The man gave him a $10,000 check. "You can't buy God for $10,000!" Karam crowed. The man added another $10,000 but that didn't satisfy Karam; then came a check for $40,000. Karam squawked, "You son-of-a-bitch. What'd you do with the other $10,000?" The man finally brought his donation to $50,000, adding $10,000 borrowed from his wife. "I'm a doubting Thomas when it comes to miracles," Karam said, gulping his margarita. "I don't pray that much because there's many ways to pray. I do it by doing things. But this fund raising became like a miracle."

But Karam estimated that he raised a million dollars all told, visiting over twenty thousand people, many outside the Maronite community, including a Jewish friend, who donated $200,000. "I got the knack of making people sentimental and crying," Karam winked.

But the miracle of San Antonio that people talk about to this day occurred over the church of St. George. When the priest went to bless the ground, "a meteor burst overhead. In fact, we found some of the little round pieces of iron." When the church was finally being dedicated in 1976, it had been raining heavily all morning and Ralph Karam turned to his friend and said, "Take my word for it, it ain't going to rain." When they got to the church grounds, it was raining three inches an hour, but "there was not one inch of water dropped on the ground. I was standing next to two reporters and they reported it. People had come from all over the state of Texas for this. A little hole opened up in the clouds and the sun shone through that hole, and on that fifteen-acre plot, no rain fell. Ten minutes after we left the grounds, it started pouring cats and dogs. That is the truth."

Karam had no patience with those who tried to squeeze money for political causes in Lebanon and brought factionalism to Maronites. To him, "the Maronite rite does not belong just to the Lebanese, it belongs to all people. I'm not Lebanese. I am an American Maronite and that comes first. Period. If the Lebanese people ever learned how to forgive and stop losing their temper, they would be the greatest race on earth. You can't take their natural-born intelligence away from them. We recognize the fact that Lebanon is in trouble. We're going to bat for them. But as Americans. Clothing and thousands of dollars on its way. But if these old-timers are going to bring those political problems here, they're in the wrong ball game."

Texas sure had its Arab mark, a brisk one at that. As for my San Antonio hostess, Naomi Shihab Nye, she had stuck with me all the way. Though the daughter of a Muslim Palestinian and raised a Unitarian, she accompanied me to mass at St. George's Maronite Church and loved the Aramaic, the exquisite silences at the consecration of the Host in a deep whisper by Father James Khoury. She told Ralph Karam, "You are the man!" and he had heard of her poetry. She even coaxed me, after the circus birthday party, to go out back and rescue her

dead chicken, probably bitten by a snake. Ants swarmed all over it, and Naomi's sadness was covered by her mirth at the incongruity of a dead chicken after birthday cake.

The fiddler had stopped. But the belly dancer was still whirling, her head proud and moving like a peacock's, everything still but her vibrating hips and belly, whipped by the storm, to which they in love and in delight were a kind of answer.

A Porch in Pasadena (California)

"We're gettin' old, honey." So Matile Malouf Awad said on a sunny spring day as she hoisted herself up the steps, grasping the wrought-iron handrails just installed by my cousin Dennis. And for the first time I realize that Thatee (grandmother) is in the neighborhood of 75, though she still walks swiftly each morning with her silky terrier, Mickey.

Thatee goes in the front door, which opens onto her dining room. And I turn left to enter the large L-shaped porch, a breezy alcove of legends where relatives and friends gathered in the years of my childhood, speaking of famine from the old land, dresses in the new, picking apricots that grew over the banisters. No screened-in porch, this blessed zone. This sweeping view on the corner of Bresee and Asbury streets sold the house to Jaddu Kamel Awad before he even walked into it. Was he to blame that the place only had two bedrooms for his four children and wife? A wide look at the world with the wind was more important.

And the odor on the porch today? Heaven. An aroma of the afterlife. The sun is clear and bright. All the world is a page of illuminated manuscript. I have finally come home in my long journey to the point I began—Los Angeles— which was the final point of the Arab community's own *hijrah* in America, as it was for so many others. The old community sank its firmest roots here in Pasadena under shade of pepper and eucalyptus trees, under the crest of the San Gabriel mountains, always hugging close to a mountain as if they were hunting out in their final moves not only the sun but also Mount Lebanon.

Here the world is good at core, the robins and jays and owls that feed here pay no heed to our wars or those of the Middle East. The spiked head of the bird-of-paradise gawks over the walkway; the first blossoms of apricot, resurrected from last night's rain—white with drops of magenta at the center—are praising the sun. The wind plays with the new leaves. Light cargoes of purple nature have touched deliberately on the new leaves and in the center of blossoms. It is as if nature herself demands a nip of wine in the veins of each reborn leaf.

Here Thatee has planted a sumptuous garden of shrubs and flowers she doesn't tear at as she did half a century ago when there was no food in Lebanon. But this garden is a total contrast to the one of the old German lady next door. There is a plot of rectangles and squares; a perimeter of pansies surrounds that front yard like the chalk marks on a football field. This is order! Flowers, attention! Even

her porch is hung with pots and in geometrical succession as if the plants had to be in step with the air, musical notes ascending a musical sheet, bar and cleft. Beethoven would not have liked this pretty, delineated place. Beethoven would have defected over the chain link fence to Lebanon.

Here in the Lebanon of Thatee's mind in Pasadena, the mountains rise behind us in the mist. Here the ferns, onions, daffodils, hydrangeas, and lilacs loll over their stucco borders and swallow the flagstone walkway to the water spigot. Once arranged in an undulating pattern to hug the house, now all is tender chaos. The apricot trees will soon be filled with pale orange clusters thrust easily over the porch's banister. Beauty cared for enough to be allowed direction of its own. Inhale, traveler for roots. "The scent of your garments is like the scent of Lebanon . . ." For this is a garden built of hunger and hunger is not a mental thing.

If Haifa's hills recall San Francisco, if Beirut's steep mountain rise from the sea bears resemblance to Santa Barbara, the Middle East itself, as a beaten path of cultures in flux and conquest, could be compared to another desert that "bloomed" with cloverleaf freeways, palms, and ivy—Los Angeles, Town of the Lost Angels.

This is a city whose very soul is in motion: a looping, intersecting, elongated concrete monument to the American Bedouin. Those with sun in the blood— take Jews and Arabs—found plenty of beauty in the quaint county that was Los Angeles, which nearly doubled its population in the fifteen years after World War II. Since then both communities have burgeoned along with the city until today there are 550,000 Jewish and 100,000 Arab Americans in Los Angeles, often living as neighbors. Many, such as the fathers Blumberg and Orfalea, who lived facing each other in the San Fernando Valley, commuted twenty-five miles downtown to slave in the garment industry. The "rag," or *shmate,* business, in Los Angeles has been a prototype of Arab-Jewish cooperation and competition, with the sons of Sem partners in making everything from lingerie to evening gowns.

Settling patterns are not easy to label in Los Angeles, which has the largest geographic area of any city in the country (464 square miles for the city proper, 4,083 square miles for Los Angeles County). Early Syrians picked Pasadena with its pepper and carob trees and huge porches. Recent Palestinian immigrants seem to favor Orange County, the most conservative county in the state. One family has established a "little Ramallah" in Fountain Valley with three hundred members; they all live on a cul-de-sac and work in one family business, typically enough, a large clothing store. Many Arab American garment manufacturers, lawyers, bankers, realtors, and construction firm owners live in the San Fernando and San Gabriel valleys. Out toward Riverside there is the Druze orange grower Amil Shab.

The Los Angeles Arab American community may well be the wealthiest, per capita, in America. From only a few hundred people in the early 1920s, the community swelled from the East Coast migration after the Second World War to be the largest Arab American population outside Detroit. It would produce excellence in fields as diverse as furniture making (Sam Maloof)[48] and agriculture

(Robert Andrews).[49] Of course the community's share of television and movie stars are here, many living in Beverly Hills, such as Danny Thomas, Jamie Farr, Vic Tayback.

One noteworthy Beverly Hills mansion houses the voice that has been called the "most familiar, listened to" in the world. Those vocal chords belong to an American Druze named Kamal Amin Kasem, otherwise known to millions of fans across the nation as disc jockey Casey Kasem. He is a small man, 5'6" in stature, but there the smallness ends. Casey Kasem has been reaching higher than his grasp for years, and what is most amazing is that he often grasps what had seemed long out of reach. He often has converted liability to achievement. His dream as a teenager was to be a baseball player; but when he ended up striking out like Casey at the Bat, he settled for a catchy nickname. Unable to break into the kind of acting roles he had wanted from early days studying with the likes of George C. Scott in Detroit, he reached further than most actors get—with his voice. That voice is heard on over 1,000 radio stations around the world with the progam *America's Top 40*, several thousand radio and television commercial spots for 175 different companies, over 2,000 individual cartoon episodes and, recently, in the flesh on 150 television stations with his new show, *America's Top 10*. He even reached high in his choice for a mate—second wife Jean Kasem is a striking, statuesque blonde actress.

But Kasem's largest reach to date would have to be presidential politics. Kasem was so taken with Jesse Jackson's presentation in 1979 at Sammy Davis, Jr.'s, home, that he contributed a hefty sum to the minister's Operation PUSH. In 1980, he asked the Reverend Jackson to officiate at his wedding to Jean, which Jackson graciously agreed to. On June 3, 1984, at his mansion, Mille Fleurs, Kasem raised $60,000 for Jesse Jackson's landmark presidential campaign—the first ever of a black American. The crowd was filled with Hollywood celebrities and was as multiethnic as America itself, including many Arab and Jewish Americans. One elated Jewish doctor, Jack Kent, said of the "Evening under the Stars": "Jesse understands what it means to put your life on the line. Today the world is different. Last night, the earth's axis changed somewhat. What a thrill— history in the making!"

Kasem was no stranger to politics before his Jackson leap. A registered Republican, he had contributed $70,000 to his friend Mike Curb's successful campaign for California lieutenant-governor, and also hosted a fund raiser for Reagan and Bush in 1980. But something had changed in four years, "I don't think this is the time to go with a political party. It's the time to go with someone who says what I want to hear. Because I think we're just on the brink of Armageddon." [50] What he wanted to hear was something new about the Middle East, where the town of Armageddon (Megiddo, Israel) is located. He especially wanted to hear it after his ancestral Druze homeland in Lebanon was shelled by the U.S.S. *New Jersey* in 1983.

I met Casey Kasem after he had emceed an evening under a tent near the Capitol for the National Association of Arab Americans, hosting film actors Michael Ansara (*Broken Arrow*) and Vic Tayback (*Alice*). His wife, wearing a backless dress, had caught a cold on the chilly night, and Casey seemed on the verge of one. But he sat for three hours with me, gracious, thoughtful, soft spoken, with that famous voice measuring its opinion in a tone that seemed lined with fur to take off the edges. One critic said of this million-dollar treble of Kasem's: "Slightly breathless, ever so polished, anxious to please. A salesman's voice. Most importantly, it is without regional accent, thereby coming to you from everywhere and nowhere at once. Call it Americaspeak." [51]

Kasem was born in Detroit in 1932, the son of a Druze immigrant grocer from al-Moukhtara, Lebanon, whose family name was actually Konsow. Amin Kasem's wedding to an American Druze girl from Carbondale, Pennsylvania, in his home village caused a controversy as the first "modern" wedding among the Druze in the mountains in 1929. Though Amin was illiterate himself, his wedding host wrote a monograph about the unusual event, transcribing some of Amin's own thoughts. Proud of his Druze identity (which, as a schismatic sect of Islam, believes in transmigration of souls, among other things), Amin Kasem had also been to America:

> My dear brethren, you know very well that the demands of time, place, and interests do not allow a person in my situation to marry but an educated, unveiled, and sociable lady to accompany me to this modern society—a lady who does not need a veil to endow her with virtue because virtue comes from within her. God guided me to Helen Safa. She has no need for a veil. She is modern and I am modern; she is unveiled and I believe in unveiling . . . You don't have to give me a reply for I am departing to the country of freedom where such an ado about nothing is never heard. [52]

His father's principled stance in marrying his mother affected Casey Kasem: "If I ever through my genes inherited anything from him I think it was sort of an innate sense of honesty and integrity that he must have inherited from somebody." [53]

In Detroit's large Arab community Kasem stuck to his own Druze group of about one hundred people. Fondly, he remembered the men separating from the women sipping coffee and carrying on verbal one-upsmanship: "The blacks call it 'the Dozens.' In other words, if you've got a question, I've got a dozen answers. Well, the Arabs had that going for them with poetry."

As a student at Wayne State University, Kasem acted his way through voice on radio shows of the *Lone Ranger* and *Sergeant Preston of the Yukon*. He announced for WJLB, the foreign-language and black music station where Danny Thomas had met his singer-wife, Rosie. In San Francisco, he chanced upon a copy of *Who's Who in Pop Music, 1962* that someone had thrown in a trash can; Kasem pulled it out, and in a sense pulled out his ticket to fame. He traveled to Los Angeles to take a job with KRLA radio, where he began his patented format

of "tease and bio" introducing rock selections. He also happened into a teenage Mike Curb, who launched him as a commercial voice-over. In 1970, Kasem and a friend, Don Bustany, started the *American Top 40* show, which lost money in its first three years but eventually made Kasem the Dick Clark of his generation. He also went on to be the Voice of NBC.

Kasem has acknowledged that the "familiarity" of his voice gives him, in a sense, great power: "Words are like weapons bouncing around in the brain of a vulnerable listener. I could be lethal if I weren't responsible." [54] Kasem surprised me by saying that when he started out he didn't particularly like any variety of music and didn't appreciate rock and roll until he learned to dance to it in 1958. He had never formed his own personal "Top Ten" but said that one tune he is sentimentally attached to is "With You I'm Born Again," by Bill Preston, played at his wedding to Jean.

Dark-skinned, Kasem said he "always felt that I was different" growing up, but that "I was never led to feel anything but pride for my heritage and religion." He grew up in a neighborhood with Jews, and in the army a black man called him a Jew: "I didn't argue with him. I let him think that I was Jewish because I already had a feeling for the sensitivities of a minority group. I never did sit comfortably with ethnic jokes."

Admitting once that all the singers and broadcasters want to be actors, "where the image is 40 times bigger than you are," [55] he told me, "every actor thinks that he would make a great trial lawyer or statesman. I got involved in politics today because if you have a friend who is drunk you don't put him in a car and send him home. I liken that to perhaps my friends who are Jewish, who because of the emotional feelings from the Holocaust will never be able to really grasp the situation as it now stands in the Middle East, when they should be the first to understand the plight of the Palestinians." For him, the effort is no less than trying to stave off a "third world war."

> I don't think there's a man or woman anywhere in the history of my career in broadcasting who would ever be able to say that they have ever heard me say anything negative about Jews. But they have heard me say that our foreign policy with regards to the Middle East is imbalanced, always has been, and that the rest of the world doesn't think like the United States does. So I think that's one of the reasons that I was able—perhaps like nobody in show business before—to back a man like Jesse Jackson in a community where there's half a million Jews. I think I got one nasty letter.

Kasem's left leg bounced as nervously as a drummer's while he probed his feelings about the Middle East. He plowed forward: "There is no time left. If people don't get involved, then we may all be incinerated. And the key to solving the nuclear problem is to eliminate the fuse where it is the shortest—the Middle East."

His solution was simple; he said: "Let the Israelis speak with the PLO who

represent the Palestinian people and a solution will come very quickly. The Israelis must realize they have to go back to the 1967 boundaries. Once the United States realizes that we're heading for a nuclear catastrophe if we don't solve the problems in the Middle East, I think they will have to force the Israelis, economically, to see in terms of justice." Kasem began, finally, to tire, but was certain that in time the Middle East equation would change: "A hundred years from today the Jews and the Arabs will be like the Germans, Japanese, and Americans today."

Many Los Angelenos, like Kasem, tend to be more politically involved in the Middle East problems than are their New York City counterparts. Some, such as the Mickools of Chatsworth, reached out in adopting a Lebanese orphan.[56] Tragically, Los Angeles contributed a "martyr" of sorts to the community nationwide when poet and teacher Alex Odeh was fatally pipebombed in 1985 after expressing rather moderate views on television.[57]

I was on Thatee's porch another day—but a rainy one—when she came and urged me to come inside, that I would catch cold. When I pleaded with her that I was used to a misty cold after years in the East, she relented and brought me a blanket, with a bowl of *kibbah maʾa kishk* (meatball with bulgur and sour milk).

A call came from an aunt: I should really see Joe Jacobs since I was in Pasadena. The owner of the $300 million Jacobs Engineering Group, Inc., an émigré from the Brooklyn community in California like my mother's family, instantly agreed. I was lucky to catch him in the state, much less the country.

Dr. Joseph Jacobs, a Maronite born in Brooklyn in 1919, was just putting the finishing touches on what the World Bank has described as the finest manufacturing endeavor of its kind in the Middle East—the Arab Potash plant in Jordan. The old Palestine Potash company, built in 1928, had been destroyed during the 1948 war. Thirty-five years later, the son of a Lebanese immigrant peddler was helping to restore what, in a sense, had been wrecked by forces America had sided with. It was a project, he admitted, in which he had a deep emotional investment.

Dr. Jacobs is a marvelous combination of the straight-talking Brooklynite and the carefully wrought product of academia. He also had a knack for sales and management—his company is two thousand employees strong, with seven branch offices in the United States, Puerto Rico, and Ireland. Judging from the animated way he described his father's experience in America, dating back to arrival at Ellis Island in 1886, there is no doubt he feels gratitude for the perseverance of his forebear. His acceptance speech of an award from the respected engineering Newcomen Society both begins and ends with praise to his father.[58]

His father, Yusef Ibn Yaʿqub, fled Beirut and "the oppression of the Ottoman Turks" after he strangled a Turkish officer in a fit of temper. Jacobs pointed to two traits his father imbued in him that he traced back to the Phoenicians—a knack for trading and standing by one's word. Yaʿqub was changed to Jacobs at Ellis Island, and the immigrant soon traded his notions case for his own shop.

For a period during World War I, any American male who got up in the morning and stared at his unshaven mug in the mirror owed his deliverance to Yusef Ibn Ya⁣ᶜqub Jacobs, who had a virtual monopoly on the manufacture of straight razors when those imported from Germany were cut off by war.

What was ease for the consumer after the war—the invention of the safety razor—broke Yusef Jacobs; other attempts at business left him a casualty of the Depression, the son's voice choking at the memory. Yet Jacobs converted his father's fall and efforts to stand up—as did many firstborn Americans at the time—into a lesson. On his desk is a sign, "Babe Ruth Struck Out 1,330 Times." He also attributed something of his father's daring to cross the seas to his own restless compulsion to leave for California: "I guess sort of imprinted on my mind was that with a little courage, and a little guts, one can find new worlds to conquer and I guess it was a subtle psychological way of emulating my father." [59]

Jacobs married Violet Jabara, a relative of the famed ace pilot Jimmy Jabara, and for awhile worked for Merck & Company, involved in the development of new processes for making Vitamins B and C, as well as penicillin and DDT. A chance offer to work for a firm in California had him traveling to San Francisco in 1944. It fit his own restlessness: "Otherwise I would have done what 95 percent of my close friends in those days did, that is, stay in the Lebanese American community of Brooklyn."

Jacobs finally went out on his own, setting up Jacobs Engineering Company in Pasadena, and soon he was building plants for Southwest Potash (now AMAX) and Kaiser Aluminum. In 1974, the company was merged with the Pace Companies of Houston to form Jacobs Engineering Group, Inc., which today grosses $300 million a year and nets $5 million. He first put a feeler out for the potash plant in Jordan in 1961 (it was not signed into contract until 1979). He was impressed with the numbers of highly educated Palestinians in high places in Jordan even then and got into a debate with a court judge in Amman at the Hotel Philadelphia, the judge venting steam about the Israelis. Jacobs thought recognition of Israel was a better strategy. The judge didn't buy it then, but Jacobs noted that most Arab states had come around to be willing to offer that recognition.

On another trip he was impressed when a Palestinian who had been a school superintendent and later owned and ran a cigarette business in Jordan explained how the Palestinians had progressed so well in Jordan and elsewhere in their exile: "Very simple," the man told him. "We were trained by the British and we competed with the Jews. There is no better training in the world."

Jacobs identified a sociocultural reason for the lack of progress in the Middle East peace: "The Jews have never been victors. They have always been oppressed, so they didn't know how to handle victory. Very few countries have learned how to handle power; the Israelis haven't. And they threw away an opportunity in 1967. They could have secured a just and lasting peace, if they had reached down their hand and lifted up the Arabs and brushed them off." Instead, he said, the Israelis were trying to make the Arabs "negotiate from their knees"

and showed no sensitivity to restoring some dignity to their defeat.

By the same token, he felt that Arab righteousness was leading nowhere:

> There is an Arab trait that says, look, if I can have an argument with you and I can convince you logically that I am right, therefore I am right. And the whole world will recognize it. And we all have this tendency to say, "Can't anyone see how we have been unjustly treated, driven out of our homes?" It's almost the same thing that happened to the Jews in Germany. Why doesn't the world have sympathy for us? And the fact of the matter is, it couldn't care less. How the hell are we going to compete with the Jews who have done it for two thousand years? The Jewish lobby is absolutely aces at playing at those guilt feelings.

Jacobs has friends in high places in Sen. Robert Dole and Attorney General Edwin Meese. When I talked with him in 1983, he had not yet had a chance to weigh in with Republicans on the invasion of Lebanon. However, he would have told Reagan: "You owe it to the Jewish people and Israel to stop these two mad-men, Begin and Sharon. You have the right as the sponsor of Israel because you want Israel to exist to just put the screws on Sharon and Begin and tell them if you don't get out of Lebanon I will invoke the Arms Export Control Act and cut off all aid. The use of preemptive strike as a weapon of foreign policy is anath-ema to Americans. When the Germans did it in the Ruhr, we didn't like it. When the Japanese did it to us at Pearl Harbor, we resented it. And we are not going to support you with arms for what we consider to be an immoral act."

The high-level gathering of Jewish and Arab American businessmen that Na-jeeb Halaby had told me about, which included Occidental Petroleum's president at that time, Robert Abboud, had recently been hosted privately by Jacobs at his home for a weekend. "I'm the perennial optimist," he said. "I keep hoping. People can't live with a garrison mentality forever, building up hatred on both sides."

Pink-faced, blond hair whitened, with blue eyes, Jacobs nodded bemusement that he was often taken for a Jew, especially with his last name. When asked if his Arab background had helped him in business, he retorted, "Surprisingly, in my dealings with the Arab world, it has hindered me more than helped." He referred to the endless waiting game that Gulf states would play with him—"a way of sort of getting back at Americans"—and he didn't deal with Saudi Arabia for that reason. At his project in Jordan, even, there were practices, like petty bribery at lower levels, that bothered him: "We won't tolerate it. It's hard being an American of Arab background to know that those things don't have to be that way and having to put up with that garbage." He also looked critically on the tendency of some Arabs not to successfully delegate authority, or to "talk a problem to death," lacking decisiveness. "We want to get on with it and get it done as Americans," he said.

Los Angeles potato king Amean Haddad agreed with Jacobs about Lebanese thriving more after they'd taken to the road away from their drum-tight commu-

nities, though Haddad was speaking of Lebanon rather than Brooklyn: "Why they can't get along with their own in their own country, where they were born, has been a mystery. Because it shouldn't be—the first love is in the town in which you are born; therefore, it should accumulate love and interest and friendship. They cannot get rich in their own hometown, but they go to any country and they make success." [60] Haddad rubbed his bronzed forehead, leathered by decades out in the sun of the San Joaquin Valley where his workers dug up potatoes that supplied Safeway stores with half their stock. "That teaches me one thing, that they have it in them, but they are either afraid to hurt someone [of their own] in getting successful . . . I don't know what it is. I cannot give you the answer."

Haddad's Encino office is as spare as any I have seen, akin in its blankness to that of Philip Habib's at the State Department. There is no Oriental filling of empty space here. Except for a 1965 photo of his packing shed in Bakersfield and his 120 workers and a desk picture of Mr. and Mrs. Reagan thanking him for his GOP contributions, the cupboard is as bare as Haddad's life has been full.

From the age of 3 till manhood, he was left parentless—his folks went to America, leaving him to be raised by a grandfather in Kabb Elias, the village of Vance Bourjaily's ancestors. Haddad spoke with the matter-of-factness of something ingrained about picking up dozens of bodies to be hauled in trucks or thrown in mass graves, and of the locust plague that stripped the trees naked of fruit and bark in 1916. "Anyone with a mind wants to go forward—a lesson was taught—because there was hunger, there was abuse, and I think this was the best school in the world for me," Haddad said carefully.

Born in 1902, Amean Haddad is one of the pillars of the Los Angeles community, one of its oldest, most successful members, and one of the earliest to have come to California, in 1920. On arrival he worked as a butcher in Los Angeles, the same trade that allowed him to save enough money to come to America. Tired out, one ate a lot to sustain energy, and it was at a restaurant with his kid brother who wanted nothing but potatoes that Haddad realized everybody else was eating potatoes, too. "I want to be in a business everybody needs," he concluded, and soon he became a potato farmer, with fields in four western states, though today he has consolidated his farms to Oregon and Bakersfield. Haddad called his workers "quality people" and, like Haggar, preferred a family approach to the unions: "I'm a great believer in one thing. I like it to be open. And I'm a great believer in freedom. You can choose your friends and your business relations, but you can't choose your relatives."

Vital and active as any octogenarian could be, Haddad attributed this to his heritage and, of course, to potatoes. He then handed me his business card, which is a folded photo of a russet potato, a strain he helped develop. Inside the fold was a list of nutrients. A most unusual card—but perhaps not so much for one who had almost starved to death. I suddenly had a craving for french fries, but Amean Haddad reminded me that he does not sell to McDonald's and produces a potato only for boiling and baking.

Haddad told me a story close to his heart, an experience when at age 9 he was taking water at a well with his grandfather in the desert between the Lebanon mountains and Syria. Because he had "a clean set of brains," the event "stuck in my mind."

> We saw dust from far away. Out of the dust came horseback riders. The leader was a man in middle age and the rest younger men, maybe forty or fifty of them, to take on water. My grandfather became inquisitive. "Who may you be?" he asked. The man said he was Mohammed Assam, and the other riders were his sons. He was a Matawilah [Lebanese Shiʿite Muslim]. My grandfather asked, "Do you love one more than the others?" The man replied, "Yes and no. I love the one more who is far away from us until he comes back, and I love the sick one more until he gets well."

When he arrived in America, literally on a cattle boat, in 1920, he finally met his parents, but felt like they were strangers to him. Before butchering, he actually took work in a factory making wash tubs, a sweaty, dirty job that had him dipping the metal tubs into liquid solder at 500 degrees. His mother insulted him, viewing his clothes soiled from the factory work, saying he was "raised like an animal in the Old Country," and he would "always work for wages because you have no education." This rebuke hit Haddad where he lived; he immediately quit and went to work for a Greek butcher at 50th and Western, developing his skills to "cut the meat like paper, no holes." Soon he opened up his own butcher shop and, like so many other Arab immigrants, began a life as a self-employed man. Typically, the mother approved and he later became a favored son.

He remembered the days when Los Angeles had no freeways and the trolley from downtown to Venice took fifty minutes, though today it can be driven in fifteen minutes (if there's no traffic). His protestations that he never had time to become close to the community because of building a business are not exactly true; Haddad has been generous, particularly to St. Nicholas Orthodox Church.

The old-young potato king called his wife, Wydea, affectionately addressing her as "Sugar" and "Baby," a little of Hollywood having rubbed off on him. His secretary, an old but plucky woman, ushered me out with grace. "Make sure you see Uncle Mike!" Haddad called as I left. "He knows what we went through!"

The circle was closing. I sat on the porch again, shaded from the strong sunlight, gazing out at Thatee's thick grass, how it dips in one place. It was there that Uncle Gary, when barely old enough to talk, felt the earth withdraw below him and found himself clinging to a precipice. The earth had fallen twenty feet into a cesspool and left little Gary crying out. How he had the gumption to hold onto the thick grass hovering at the top above a stinking black shaft is a mystery, as mysterious as why the Lebanese prosper only far away from home, as Amean Haddad had said. Gary has always held on; the community, too, has always held on, propelled by some gaping, stinking hole of the past. Gary's sensible crying

finally roused Thatee, who rescued him, as she had rescued so many, instinctively. Did she see in a blurring second her younger brothers crying out before they expired from hunger? She fairly leapt from the porch. It was all written up in the *Pasadena Star News*. They filled the cesspool with boulders, but a slight dip remained, which I used to walk on as a child, testing it.

Testing . . . I lay back on the cool, faded pillows of the porch's couch and closed my eyes. What was it that joined the disparate lives of the three men I had just interviewed? It wasn't religion—Casey Kasem was a Druze; Joe Jacobs, a Maronite; Amean Haddad, an Orthodox. They were of different generations, Kasem and Jacobs first-born Americans, Haddad a First Wave immigrant. Their chosen fields couldn't have been more different—radio broadcasting, chemical engineering, potato farming. They began their lives in America in three different cities: Detroit, Brooklyn, Los Angeles. Though Kasem and Jacobs were clearly haunted by the conflict in the Middle East, Haddad was not; he was the stoic. Perhaps he spoke for many of the First Wave when he related stories of a living hell that made the Arab-Israeli conflict pale. He had suffered everything a man can suffer and still survive in this world before there was ever a Palestine issue. About the only surface thing they shared was success, and an ancestral past traced to Lebanon.

Still, there were peddlers in all their backgrounds, though Kasem's father eventually set up a grocery, and Jacobs' a razor blade manufacturing plant, and Haddad himself a butcher shop and later potato farms. And they themselves in their various ways set out in early days to try to grasp what appeared beyond their grasp, to confront the unknown, Kasem bringing his voice to millions out of the milieu of a grocery store; Jacobs to pull away from the Depression and his dying father, to probe the atoms of chemicals; Haddad to flee starvation only to dig relentlessly for potatoes that would feed America. Kasem and Jacobs were still not satisfied; now they reached back to the fire of the Middle East as if to an original scar, to try to heal it. Testiness, perhaps, they shared.

One could cite their obvious love of family and pride in heritage, too, except these accepted virtues of the Arab Americans were revealed on close inspection to be fraught with ambivalence. It was not Haddad's closeness to his parents that spurred him forward, but his absence from them. He had also drawn the line in dealing in business with his fellow Arabs, as if the well of feeling between them would drown them. Jacobs had admitted—as did many firstborn Americans—of being embarrassed by his family's "difference," trying everything himself to be American pure and simple, except in later years it was not so simple, when he found himself restoring a factory destroyed in the first Arab-Israeli war. The need to help was urgent; but the imprint of American pragmatism distanced him even now from certain things in Arab culture that he could not accept or understand. However courageous, Kasem's backing of Jesse Jackson and public criticism of U.S. Mideast policy were, he admitted himself, recent phenomena.

Yet they spoke to me as if speaking for the first time about things that had lain

heavily on their hearts for years, as if, in the context of a book with others of the community that spanned the country, they could participate in a kind of national voice. Though all prominent, it was as if each had a cache of secret sorrows held too long, too tightly, fighting off what for years had seemed a natural reticence to discuss controversy or adversity, that nefarious fear of ʿayb (shame) that Naff identified as part of the traditional Arab psyche. I could not honor myself that my project brought something out in them that wasn't ready to come out. It had always been there, waiting, shared perhaps among friends and associates, but hesitant, perhaps, that there was no public forum that would or even should care.

Things blurred in my mind, as a rush of the immigrants and their children I had met and talked with sped across it. What could be boiled down as the quintessential Arab American spirit? What could be culled as the nugget that would sidestep stereotype when in fact the community was as diverse as the human spirit itself?

In their candor, in their courage, these people who farmed in North Dakota or labored in Detroit's auto factories, voted in the Halls of Congress or stitched together dresses, had shown that ultimately their relation to their heritage was one of ambivalence, of strong love, but of almost as strong puzzlement and even disdain. It seemed to me now—though my mind was barely clearing in the wind on Thatee's porch—that their virtues implied their faults, that each was the flip side of the other and had both lifted them up and held them back in America.

Cached in their ancient pride was a deference that had helped them assimilate so successfully in American society they were rarely identifiable by ancestry (Italian? Spanish? Greek? Jewish?). Odd as it seems to assert today, they had become the "new man" the American republic promised immigrants better than many ethnic peoples; at the same time, this "quick melt" had kept them politically distant from one another and the seats of power. They were not often complainers or critics even if their complaints or criticisms were legitimate. Their industriousness was born of want, or even, as the recent Palestinian and Lebanese immigrants showed—of futility. Their verve for life was the other side of temper, their gregariousness the other side of an acute sense of solitude brought on by—who knows?—millenniums of life eked out in empty spaces, forbidding mountains, the clutch of empire, or now in a wary America they had long held dear. They cherished relatedness as one clings to green shoots in a desert. But their extraordinary love and nurturing of family had in some ways kept them isolated and resistant to change and the adjustments that love teaches. (Given the community's deep religious roots, some undoubtedly would say there are adjustments—to drugs, to free sex—love would do better not to teach.) In fact, America had magnified their individuality and their love of family—two at times opposing forces—with the result that both were reaching a critical mass in the community, mirroring a similar volatility in the society at large.

Though they were, as Mayme Farris had put it, "clannish," and never learned to "wine and dine" the powerful, they had a native internationalism that often

countered American provincialism. It was, after all, the stifling provincialism of those mountain Lebanese villages or West Bank towns under military occupation—that made so many of them immigrate in the first place.

After all my travels the central paradox of the Arab Americans still stood: they could be so exceptionally individual and yet so collectively anonymous. However fecund they found American values of self-reliance, with notable exceptions— Nader, Bill Monsour, Sammie Abbott,[61] for example—they often stopped short of dissent. They took to Thoreau's pond; they did not take to his jail.

No doubt, as I mentioned at the outset of the book, the heritage of the beknighted stranger, the protected one, that Abraham Rihbany had noted early in the century in Lebanon, had something to do with it. One was better off remaining a bit "strange," unidentifiable, elusive, for to be labeled in the feudalistic Middle East of the nineteenth century was to become part of a sect and inherit all its enemies. Better the "no partialities," as Charlie Juma had found in Ross, North Dakota, or Mama Ayesha of Washington, D.C.'s exclamation, "Everybody in America is my child!"

There were, to be sure, political reasons for their cloistering of culture, for their preference of the sideless stranger. Both in the Old Country, and in the new land where as the century waned their names, or accents, or opinions, or memories could immediately link them to a world marked Terrorist. It was one thing to be considered strange, a stranger; but it was quite another to be considered the embodiment of evil. Better to be a stranger, to stand back, to stand away.

Yet undeniably—Taxi Joe with his Rhode Island jay bird laugh, Aziz Shihab with his midnight walk through Dallas, Bill Ezzy sewing up his tent holes in Alaska—they stood out. The barriers through which venerable journalist Helen Thomas rather naturally broke serve as prominent examples of something revealed to me time and again. They liked obstacles. And when you overcome obstacles, whether you like it or not you are going to stand out. They did not indulge in self-analysis, the way Freud would define it. Yet they were curious, even driven, to speculate about the world outside. Self-knowledge often came to them through macrocosm, not infinitesimal self-scrutiny, but through the plentitude of experience. Their eyes were on the tapestry's whole, not the corner where the deer is bleeding to death. It made for survival, not art, at least as art had come to be known in America: a magnification of self to the point of burning.

But something inside them did burn, else why would so many have spoken to me with little reserve? Perhaps the time had come. The self—after a hundred years in America—was ready to assert its presence as a self, and as something more: part of an aggregate life. It did not surprise me at times that this brought exhaustion, even pain. The old fears of backlash, of losing Jewish customers or backing, of hatred, of judgment, of misjudgment were there. But what surprised me was that this assertion came with such gusts of freedom, or relief. The time had come for speaking as an American to Americans about what it was like to be in this remarkable, sad, hopeful, strange, disturbing land as part of a community

with ancestral veins that could trace to the cradle of civilization. They would risk not being strangers. Out of, what? Pride, self-assuredness, accomplishment, a sense of emergency, defeat, mortality, the pure passage of time.

"Hurry, *ya ʿaynī*. We have to go see Auntie Hisson before Uncle Mike and Uncle Assad come!" It was Thatee's lilting voice breaking through my thoughts. The circle was closing. I got up to go down the street with her.

Hisson (Helen) Arbeely Dalool is probably the closest surviving relative of the original Arab immigrant family to America. Her mother, Mary Arbeely, was a cousin of the Joseph Arbeely family who came to the United States from Arbeen, Syria, in 1878. Auntie Hisson, however, thinks it is possible that the wife of Joseph's son Ibrahim may still be living somewhere in Glendora, California, though I could not find her in the telephone book. Dr. Ibrahim Arbeely's wife had been at Auntie Hisson's son's wedding some years back, but they'd lost touch.

Seeing Auntie Hisson as she labored making Arabic bread was a throwback to my childhood. She is a study in incongruity: she still dresses like an Arab village woman in the old country, with billowing dress, large apron, and a white kerchief tied around her head. But the incongruity is that her English is completely un-accented. This is because she came to America at a very early age, in 1907. She is not sure of her age, but thinks she was born around 1900, making her 83 when I interviewed her.

Her memories of Syria are dim. She dates her birth by a story told by her mother. Her parents met in a crowd viewing the German king's visit to Damascus. They married shortly thereafter, and Hisson was born a year after that. Her father was Khalil Bedaweeya, a name with a Bedouin ring to it, who worked in a quarry. He rejected going to America, but his wife went instead: "She wanted adventure."

Hisson came over on the boat to America with an aunt and uncle and settled on the legendary Washington Street near the wharf across from Ellis Island. Ibrahim Arbeely, who lived then in Washington, D.C., was a frequent guest at her home. Arbeely even took little Hisson and other cousins to an orphanage in New York to sing for the children.

It seems that Hisson's visit to America was spurred by her husband-to-be's pro-posal to make her his bride; he sent the tickets for her trip, having only to wait for her to grow up! The aunt she came over with was detained in Marseilles with trachoma, and then was sent back to Syria. After a seasick journey when they put her in the captain's room, Hisson landed at Pawtucket, Rhode Island, on Christmas Day and was escorted to New York by her husband-to-be. "He used to take me shopping!" Hisson reminisced. "When I used to go with him, they would say, my father!"[62] Hisson's marriage to Khalil Dalool brought nine children into the world, seven still surviving when we talked.

Hisson and her husband ran the Courtland Hotel on Washington Street, and she worked cleaning out the rooms, changing the beds, the linens, for new immi-

grants and others. Later, they had another hotel on Midland Beach in Staten Island. She was, in fact, married at the Courtland Hotel by Father Nicholas Kherbawi, the legendary Orthodox priest of the Washington Street community.

In a romantic way, Hisson played a part in my grandmother Matile's young marriage to Kamel Awad, and she related a story I had heard many times growing up. Kamel actually lived with the Dalools in Brooklyn, and he petitioned Hisson for help when he fell in love with a beautiful 15-year-old who was the sister of his employer, Mike Malouf. Hisson hired the taxi that skirted Thatee away from the Maloufs to a train to Plainfield, New Jersey, to Mike's great anger. Hisson's brother-in-law Nageeb Dalool was the young couple's best man.

Thatee grew animated at this and spoke: "I was crying on the train, 'When I go back home?' Hisson told me, 'Nobody's gonna hit you, honey.' 'Twelve o'clock is gonna come and I'm not home to eat my lunch [from school]. My mother gonna hit me!' Hisson said, 'Nobody is going to hit you. This is your husband.' And I never forgot that."

"That's been a real good marriage," Hisson smiled, though Grandfather had been dead for ten years. She remembered him visiting her in Pasadena, though he suffered from emphysema: "He used to be very sick and coming up you could see him shaking. 'Kamel, why did you have to come? Why don't you take care of yourself?' 'I have to see you,' he says. 'You're all alone. You have nobody to take care of you.'" Hisson sighed and her eyes watered, "Oh, oh, I tell you, I never forgot him, never, never, never!"

I piped up, recalling our trip to Arbeen in 1972, "Well, if it wasn't for Jaddu, I probably wouldn't even be writing this book."

"He got your momma!" Thatee sang from her tears.

Hisson thought Kamel Awad was "closer relations" to the original Arbeely family than her mother. She referred to them as "Arbini" and said they called themselves Arbeely but many called them "Arbini."

Hisson visited California in 1946, disenchanted with the neighborhood where she kept furnished rooms on State Street in Brooklyn—it was getting run down and she had trouble collecting rent from the Puerto Ricans. By 1950, she had settled in Pasadena: "It's a cleaner life here. But people are distant; they are not as close as they are in New York. There we were like one happy family. In the summertime, sitting on the stoops."

Religion, as with many oldsters, was sunk in her bones as was the secret to longevity: "It's no secret, dear. It's all in the hands of the Lord. Every word in my mouth is nothing but the Lord."

Up the steps of Thatee's porch chugged Great Uncle Mike Malouf and his brother-in-law Assad Roum, the last remaining patriarchs of our family, two pillars of the Los Angeles community, their faith in America as constant as Mike's unswerving allegiance to Buicks. He had stayed with Buick for decades, the three holes on the car's side growing narrower each year.

Mike Malouf, 80, ex-boxer, race car driver, auto repairman, and realtor, is built solid, with a neck so thick it strains his collar. His handshake has scared away many a young man and some older ones; even as we met he pulled me to the ground with his clasp, laughing silently as is his fashion. Uncle Mike has the unnerving habit of grabbing you by the neck in what appears to be an affectionate hold, only to pinch you like a vise. Even my father could be made to yelp.

Uncle Assad Roum is a smaller man, with thick glasses and an endearing smile that causes his whole face to turn upward and his eyes to sparkle. His voice is not as strong as Mike's, but is tender. He greets me with one of a thousand terms of Arab endearment, one special to him, however: "*Kīfak baᶜdī* [How are you, part of me]?" We all moved into the dining room to feast under Thatee's large chandelier. And to talk.

Assad was orphaned before he was 10 years old. His mother had contracted typhus in Arbeen, but she died in a freak accident when, bending dizzy over a well to take water with her medicine, she fell into it. She was dead when they pulled her out. "She musta died before she fell," Assad thought. As for his father, the end was no less apocalyptic. After his wife died, he had a nightmare where he, too, was approaching water, from a bridge, and lost his shoe in the stream. Later, during the fruit picking season, he went to harvest apricots, olives, almonds, and walnuts at a big farm outside Arbeen. Assad watched his father being taunted by some workers as he knocked the almonds free with a long pole. But he lost his balance and fell and hit his head on the ground. "He gets down there, he talks nonsense,"[63] Assad ruminated. His father soon after died in 1914.

With the onset of World War I, Assad endured much hardship. His uncle was shot trying to desert from the Turkish army. His brother Mike had left for America, riding a train to Damascus and Beirut like a hobo just before the war started, and tried to get word to Assad to follow. Mike Roum had begun working with Hisson Dalool in the Courtland Hotel. Meanwhile, Assad had taken a room with Kamel Awad in Damascus, where my grandfather had gone to seek his fortune in the jewelry shops of the Street of Gold. He worked with his cousins Habib and Yusuf Arbeely.

After the war, Assad had a ticket to go to America and asked Kamel if he'd like to come. "No," Grandfather said. But Assad, his cousin, convinced him to try his luck. If they had made it six miles from Arbeen to Damascus, why not go six thousand to New York? Their tickets cost two gold pounds each—about $15—to go from Damascus to New York and they boarded a steamship in Beirut. Along with them was an orphan girl, Mary Mazawi, raised by Muslims. Avoiding steerage, hoisting blankets, they slept on the poop deck. Assad described deadpan the Spanish- or Italian-speaking examining officer at Ellis Island: "Kamel Awad. Bono. Mary Mazawi. Bono. Assad Roum. No bono!" Assad had to stay at Ellis Island until the eye inflammation he had from a cold subsided. He was comforted, however, by Dr. Salim Barbari, who had replaced the deceased Dr. Nageeb Arbeely as chief Arabic-speaking inspector at the island. When they

arrived in New York, they met their distinguished ancestor, Dr. Ibrahim Arbeely at the Courtland Hotel; he was to die within months.

Assad remembered a huge, muscular Russian at a steam factory in which they worked, who used to taunt my grandfather to tears, pushing a huge wheel onto Jaddu's shoulders: "He wants to show them nobody can do this job but himself." The Russian dropped Jaddu to the floor, pushing him. After six months of punching their time cards at 6:30 A.M., the Roum brothers and Kamel were worn out and left the job. For awhile, Assad worked at a Greek import-export grocer on Washington Street. He often got lost in the crowded streets, not knowing any English to ask directions, seeing the American crowd "all looking alike." Once, on a delivery, lost on 42nd Street, he literally followed his nose to a restaurant customer: "I find it from smelling the *ahwi* [coffee]."

Assad and Kamel moved across the Brooklyn Bridge to live with Auntie Hisson on 25th Street downtown and commuted to Bonnaz Embroidery on Harrison Street, run by Joseph Azar, doing pleating and stitching. Soon they saved enough money to buy five embroidery machines from a Syrian making kimonos and founded their first business in America, Pyramid Embroidery. Assad remembered with delight carrying his embroideries on the subway to deliver them. Slowly, by reading the newspaper, English seeped into the tongues. They made a card for their new business, located on 177 Court Street in Brooklyn. It was 1926.

But it was in that sweatshop hunched over embroidery machines that Jaddu's asthma worsened. He even took a trip back to Syria in the twenties to consult with doctors there. They urged him to return for good, that the dry, hot clime would help his breathing. He was in Damascus when my mother, Rose, was born on Henry Street above a candy store (later she would grow up above the funeral parlor). But Kamel was troubled by the turmoil in the country over the uprising against the French at the time and, missing his family and the life in America, came back, facing his asthma. Assad watched Kamel labor on the embroidery machine. "He used to get lotta attack. He's fainting on the machine, *ya ḥarām*. Breathing harder!" The memory made Assad's eyes moist.

His deteriorating lungs and the Depression, devastating effects on their business, made Kamel begin thinking of going to California. Meanwhile, Assad and his three single brothers were beginning to hunger for the settled life. They had been cared for in America by their sister, Wardi (who later married Uncle Mike Malouf). In 1937, Assad went back to Syria after seventeen years in America, on an invitation from an uncle who wanted to match him up with his cousin Nora, who had been all of 6 years old when Assad had originally left Damascus. His relatives met him in Beirut, and he proudly showed them the cabins of the ship and let them be awed by something they had never seen. He was also welcomed by Ibrahim Arbeely's sister, who was teaching at AUB; she greeted him, "*Wayn al-ᶜarūs* [Where's the bride]?" Finally, the caravan of taxis left for Damascus.

Uncle Assad took out his handkerchief in describing his wife-to-be: "I love her

very much on first sight. I first think I like her too because she was my first cousin. And other thing, she a beautiful lady, a wonderful girl. I got a life of my life! Forty-six years!" Sadly, Assad had recently become a widower.

By 1938, Assad had become the first Syrian in New York to start Corday handbag manufacturing, something Kamel also took up. After the war, Assad's brothers Mike and Charlie made first feelers out to the West Coast, where so many Americans returning from battle wanted to go. The attraction of hot, dry weather was also important for Kamel and his asthma. Finally they decided to leave: "Before our children got married we figured, let's get to California." On May 22, 1948, the Maloufs, Roums, and Awads packed into cars to head west. "We always say we wish we had come straight here to Los Angeles instead of New York," Assad raised his hands, elated.

"It used to be a most beautiful country," Assad reminisced about his life in America. "No fear, you safe. You used to leave, go on vacation, no problem. Today you can't trust yourself to walk on the streets at night. Even day time! That's the difference. You can't trust anybody today. There was a lady neighbor of mine who found a sick man in the car. It turned out to be a woman!"

Regarding the current chaos in the Middle East and the Arab-Israeli war, Assad Roum could only contrast the enmity with the warm relations between Arab and Jew in the Syria of his youth: "We have Jews in Damascus; my brother Nick, he was mixing too much [Honorifically "a lot"]. We invited about twenty Jewish girls from Damascus to Arbeen. They even ate Arab foods with us, not kosher. Musa Zaga, the Jewish shoemaker, helped put this party together. We never think there was any division."

Mike Malouf wanted to know where I stayed in Brooklyn to do my interviews. Eddie Baloutine's house, but once at the Hotel Gregory, a real dive. Everybody laughed, but Mike said it was once the best hotel in Brooklyn. As a realtor who had thoroughly worked the district between Vermont and Western in Los Angeles, he knew something about the deterioration: "I started real estate work in the 1950s here near the Ambassador Hotel. All I used to smell is perfume, and I says, 'Gee, there are nice people living over there. We've got to buy this building. We go in there, check the building—oh, used to be glorious, beautiful! Everybody gets beautiful linens, maid service, everything. Today, you walk over there, you get a doghouse." [64]

Deterioration wasn't the word for the Lebanon mountains closed tight by the blockade of Beirut harbor by the Allies during World War I. Uncle Mike lost three brothers to the war, two from starvation. He has often told me a story about how he hauled a chandelier they had bought from a monastery for two gold pounds up over the mountains for food, a story I once turned into fiction. [65] But his memories about this tragic time seemed bottomless. This day he told me a number of incidents I had never heard before. He mentioned the devastation wrought in Lebanon by a six-foot-deep trench dug by the Turks from Beirut

twenty-five miles to the Lebanon mountains: "If your house is in the way, down it goes. Don't mean nothing. You can't say nothing. If the trenches go that way, down it goes."

Mike got a job during the war with a Turkish captain, who asked him to take care of donkeys. The captain, a tall, imposing man, was wining and dining two young women in Beirut and gave Mike one gold pound to buy a bag of oats to feed the donkeys. "I saw one gold pound and I went crazy," he laughed. "I'm going to feed the *ḥimār* oats? So I started getting some grass for him. And I kept the money and start going enjoying myself with the gold pound. Bought bananas, bought food. I wanna eat, not the *ḥimār!* So on the way back the Turkish officer asked, 'Did you feed them good?' 'Sure,' I said. 'He ate very, very good.' On the way up the mountain, instead of him riding the *ḥimār,* he had to push him to go up!"

Shortly after his brush with postwar "justice" (he was arrested for accidentally knifing a man with a tobacco shearing blade), Mike and his family arranged papers to come to America. "When I get on that ship, I look back at Beirut from the deck and I said, 'I never want to see this country again! The people, the country, and everything that's in it!'" he bellowed, as if reliving the humiliation and anger and sorrow. Thatee, of course, came with him.

I began to total up the reasons for my four grandparents coming to America: Matile Malouf came from starvation and war; Kamel Awad, from poverty; Aref Orfalea, from Homs, Syria, I had heard, for sheer opportunity; Nazera Jabaly, from Zahle, Lebanon, because her mother had abandoned the family. Starvation, poverty, opportunity, abandonment—these were the seeds that bloomed into the pungent flowers of my family in America, and I think the reasons are representative of many immigrants.

Mike Malouf's affinities to large blades carried over to America, where his first job as a machinist had him sitting down on a stubborn long power saw, breaking the blade. No doubt he was getting back at all blades by this time!

With an effortless, sweet, low tenor voice, Mike would sing to the Syrian immigrants in Brooklyn on their stoops, and play the violin, while setting up a car repair shop near the courthouse, vulcanizing tires, and the like. Soon he was hooked up to the Goodyear Tire and Rubber Company and even made his own racing car, which he drove competitively. "There was a big ad in the paper one time saying Mike Malouf was like Lindbergh, builds his own cars!" he smiled. He would break up fights between the Irish, Italians, and Syrians, many street bums that hung out near his garage. "Everything I have is because of my labor," he hit the table with his palm, rattling the chandelier above.

After helping to bail Assad Roum out from the Depression (and marrying Assad's sister, Wardi), Mike was subpoened to go to California because a car stolen from his garage was picked up by police in Los Angeles. Thus in 1931 he got his first glimpse of the palm-laden, dusty town on the Pacific. He got a letter of intro-

duction from the U.S. marshal in New York, due to prodding from a friend, George Dagher, who was a leader of the New York Republicans at the time.

"You could have bought downtown Los Angeles for a dime then," Mike crooned. "It was dirt cheap then. There wasn't many people there." But the war experience in Lebanon during the famine and the locust plague skewer his memory, keep him from ever laughing out loud, cut his sentences off short, hold his celebration of life at bay. They had called the First World War "the war to end all wars." Mike Malouf scoffed at that: "There's no such thing. As long as there's two people in the world, there'll be wars. Remember that. I want what you have, you want what I have. Remember that."

I remember someone who used to jump in between two warring people a lot coming to pick me up at the porch. It was a day of full spring; the sun could not have been higher, water lapped anymore fervently by the roots. My father, out of work for five years following the demise of his million dollar garment manufacturing business in the late 1970s, wanted to come with me that day to visit the Yemeni farmworkers in Delano. He volunteered to drive. I got off the porch, kissed Thatee goodbye, and entered his Mercury. It was the first trip we would take alone together since I was a boy commuting with him on summer days to the dress factory in downtown Los Angeles. It had been twenty years since we shared a front seat on a highway, and he would put on the news, turn it off, smoke, tell me about yardage, turnbacks, larcenous salesmen, and his brilliant new "line." Only now do I realize that in those summers I was my father's sounding board for such ideas as the granny dress.

Those hot days the freeway was always rush hour; we developed a bond in that sluggish traffic. Now, we were headed north on Route 5 in late morning, and the road was clear, the windows open. Dad as eager as I to meet the Yemenis. We could have driven to heaven!

The Yemenis laboring in the California farmlands are the most recent Arab immigrants to America. Working from dawn to dusk (and often afterward, under a spotlight) harvesting the early asparagus, row crops, stone fruits, and grapes, they are in some ways the most unusual arrivals, as well.[66] Unique in that they are the only numbers of people from the Arabian Peninsula to settle in the United States, the Yemenis came for a reason that Saudi Arabians, for instance, would never have: poverty. The Yemens are among the poorest countries in the world, separated from the oil kingdoms by a sharp mountain range and empty desert. In 1985, industry accounted for less than 4 percent of jobs in northern Yemen and 28 percent in southern Yemen, and the annual per capita income in both Yemens was $350. Most work is subsistence farming for cotton and coffee. Average life expectancy for the Yemens was forty-six years, and the literacy rate only 10 percent in northern Yemen and 32 percent in southern Yemen.

Yemenis, astride the historic sealanes between the Mediterranean Sea and the

Indian Ocean, have a tradition of wandering far from home, not unlike the Lebanese. It has been estimated that one million, or two-thirds of Yemeni males, live outside Yemen. Unlike the Lebanese, however, the Yemenis tend to stay in transit—although a TWA representative in Los Angeles listed 100,000 airlifted from Yemen to California in the period 1965–1975, by 1983, Ahmed Shaibi, a Yemeni labor leader, estimated about 6,000 currently working in the San Joaquin Valley. Passage back and forth to Yemen is frequent, often occurring yearly after the harvests. Only a few have taken U.S. citizenship.

My father and I pulled into Delano, a small farming town about 125 miles north of Los Angeles in the heart of the San Joaquin Valley. We were greeted at the spare office on the dusty main street of Delano by Ahmed Shaibi, a former grape picker, unionizer with Cesar Chavez, and then ADC representative for the Yemenis in the valley. Shaibi, a stout, friendly man in his thirties, introduced us to two other Yemeni workers, one disabled, Mike Shaw (once Mohammed E. Shaibi), and one out of work, Kassem Shaibi. Shaw wore the Arab ḥaṭṭah under his cap to shade his neck from the sun.

Ahmed came to the United States through New York eleven years before. He had been the unusual migrant who had been to college (in Southern Yemen), but he also sought economic opportunity and adventure. The very first day in California he was picking grapes at the Zaninovich farm: "It was very, very hard for me. I said if I stay in Yemen, was better." [67] When he saw the squalid conditions in the twelve Yemeni camps, Shaibi decided to join Chavez to help Yemenis. But in 1982, he left the UFW, disillusioned. "They are not pushing for the Yemenis as much," Ahmed said. "They are pushing for the Mexicans. I call that discrimination, and I talk to them about that and they blame it on the Yemeni workers. They said they didn't stand up for the union. I know they did when the union was very strong. But now they are scared from the UFW; they are scared from the growers." We toured the Yemeni camp in the fields, discovering blackened toilets, deckings of rotted wood in the showers, mold lining the dirty latrines and sleeping quarters.

One morning hauling heavy crates of steel needles to tie up grape vines, Mike Shaw's back went out. His life for the next two years became a frustrating cycle of being denied workman's compensation and unemployment insurance. And Shaw himself was now persona non grata: "If you're injured more than one month, you're out," he said. [68]

Kassem Shaibi had gotten his seaman's papers in 1967 and worked over a decade as a stevedore out of Yemen. Recently, though, he had stayed in Yemen for some months without working the seas, and when he returned he found that he had lost his seniority: though he was a Seaman's A, jobs were going to B's and C's before him. He sought out the farms of Delano, but so far was having a rough time —his association with ADC's Ahmed Shaibi not helping him, Ahmed thought.

Ahmed translated Kassem's Arabic: "Thirteen years ago with the Vietnam war he was sleeping in his motel room, not even looking for a job. The union went

into his bedroom and woke him up [to work in the shipyards] because most of the young boys, they run away because they don't want to get to Vietnam. Right now he lost ninety days and he have a reason." [69] Father said, "They wanted him then, when they needed him. They won't accept him now." Ahmed and Kassem nodded their heads in agreement. Father took a drag off his cigarette. Mike Shaw adjusted his *ḥaṭṭah*.

Ahmed himself said he would probably be treated "very nicely" back home and could have had a cushy job in the Southern Yemen government by now. But he explained, "I already come to this country and I'm involved with the Yemeni workers and I enjoy it. I love to help my people." Ahmed wanted to bring his wife and child over. He was honest enough to admit freedom in America had bitten him: "If I don't get involved in politics with the government, I don't think anybody is going to tell me, 'Why you go drink beer?' or 'Why you go to that place and dance with that woman?' But in Yemen, the law is very strict. I respect my country but that's some of the reasons why we leave."

We toured one of the Yemeni camps with Ahmed with his two unemployed friends. For a second I felt a flashback of having done this when viewing the Palestinian refugee camps a decade before with Dad; but these people had come by choice, and this squalor was in California.

Saying goodbye, my father thought it was "very important" that the Yemenis meet with the growers, too, to defuse the situtation of resentment, to table all matters. Ahmed Shaibi said that was a good idea. And they saluted us and waved, Mike Shaw's *ḥaṭṭah* rising in the dust our tires kicked up. I think they liked the fact that we were there, father and son, and interested in them. Yet our worlds seemed so far apart.

Were they? Driving down Main Street of Delano, I noticed Dad was slowing progress, as if he didn't want to leave. "Look at that!" he pointed, cutting an astonished grin. It was a Mode O'Day store, one he himself had opened up for the Malouf family chain when he worked for them in the late forties and early fifties. The product of one young man's initiative thirty years before might today be selling dresses to a Yemeni for his Mexican girlfriend, or wife at home. He had planted a little seed before anyone in Delano even knew what a Yemeni was or he had thought of himself as "Arab American."

The incongruity of it all made him laugh softly to himself as we pulled onto the main highway, traveling south in a dusky light. He had gone on in 1952 to start his own dress manufacturing firm and, in the space of twenty-five years in that industry, reach its pinnacle, being named vice-president of the prestigious California Fashion Creators.

But he closed Mr. Aref of California in 1978 for a host of reasons—financial losses, attrition from bad salesmen, the recession, the inability to relocate his plant in cheaper overseas places like Hong Kong, not to mention his own nagging exhaustion with the grueling pace of a dress manufacturer who must restyle a product line five times a year.

I say he had been unemployed for five years, but this is not quite true. Father tried everything to seek a new path: starting a new company to computerize piece goods inventories, working for other manufacturers. Perhaps what was hardest to tolerate was suddenly not being one's own boss, and knowing that at age 60 with no college education—though with a wealth of management experience—his options were limited and closing by the day. He sent out hundreds of résumés, telling me he had never used a résumé in his life. When I ghostwrote one for him, he acquiesced silently.

I watched him sell his cars, his Harley Davidson motorcycle, trying to lose himself fixing things around the house. Mother for the first time in her life took work outside, at a men's wear plant, at the University of Judaism. It was very painful to watch this vital man who was wounded fighting in the Second World War as a paratrooper, who had traveled the length of America establishing sales offices at merchandise marts, reduced to wandering, muttering incoherently to himself, in the front yard.

Perhaps he understood the Yemeni workers. I marveled later going over the interviews how he asked just the right questions with sincere interest and respect for them, a secret sharer of my project, steering me toward economy and perceptions I would have missed. I recalled as we drove in silence with the sun just touching the crag of the Sierras how generous he had been with his own workers; it always seemed he hired the kind of people who would have trouble finding work elsewhere: a black shipper with a cleft palate; two apprentice Mexican cutters who barely spoke English; a French designer with a hunchback; an Eastern European Jewish bookkeeper who was 70 and supporting his invalid brother; a Chinese picker.

And though he was demanding and had a temper, he treated them all with respect; many stayed on to the bitter end, not wanting to leave him. He was not physically debilitated like Mike Shaw. But he was out of work, too, and he was beginning to know what it meant to touch bottom with one's enthusiasm and ability unused, discarded. He was on disability—the disability of a capitalist economy increasingly indifferent to the small businessman, to the needs of the aging, fixed on academic "credentials," the card of a man rather than his vital essence.

My father, more than anyone else in my family, also had felt the injustice of America's Middle East policy for years; his empathy was never more evident than when, after visiting the Palestinian refugee camp in Damascus, his stomach began to bleed. In 1973, he had helped take out a full-page ad in the *Los Angeles Times,* whose bold headline read, "Wake Up, Americans!" I had watched with admiration and bitterness his unanswered attempt to offer his formidable powers of salesmanship to the NAAA after his business went under.

I had often asked him whether he thought his outspokenness had harmed his dress business. I can't remember a categorical answer, though my mother ventured it may have. He had been partners with two Jewish Americans, both of whom became fast family friends and one of whom still celebrates Christmas

with us each year and is considered very much a part of our family. I do know that one cousin who owned another dress firm and was more circumspect in his criticism of U.S. Mideast policy had often chided Father for his direct, open opinions in "mixed" (i.e., Arab and Jewish) gatherings.

As we drove, I regarded the fine lines of Dad's face, the high forehead, the long but not hooked nose, the carefully trimmed moustache, the handsome receding hairline. He wore a white pullover sweater. And I thought him in that second as ever-young, with not a hint of antipathy for a living thing in his soul.

When I ran out of money on my Arab American odyssey, Dad was first to send me a check, though he had to take out a new mortgage on his house to do it. He felt that what I was doing was important, to give some voice to what had too long been voiceless, to help eradicate the distortions, the stereotypes that make it easy to hate. He told me that what I was doing was something he had wanted to do himself since he was a young man but had been prevented from doing with the onrush of family, business, the myriad responsibilities that pull one from the direct involvement in social injustices. He had looked forward to the book more, even, than to his own waning hope for success.

He would not live to read it. He did, however, humble himself to open a store of a photocopying chain and take it in two years into the black, designing it with the style of an artist. "I should have been an architect!" he once looked wistfully out a window. As his own father—the Syrian from Homs—had gone from being a Cleveland millionaire to operating a lathe after the Depression, he had fallen from designing dresses that were his and his alone, to photocopying. He did photocopy early parts of my manuscript. Is it my imagination alone that sees him there, feeding the paper, printing by accident the shadow of his hand on my work?

We swerved off the road to have dinner and after the delicious, jovial meal over which we shared our hopes and dejections, I remember him pulling alongside a college girl in Ventura to ask directions, talking with her animatedly, and I had to laugh to myself. It was something I would have done! He raised his eyebrows driving away, shaking his head, ever the lover of beauty.

My father was an original. But he would have been the first to say: so is every human being, Arab and Arab American included. We entered the night road home, together, filled with the wind and the coming stars, all of a piece in a lost spring.

Appendixes

APPENDIX 1

Number of Arrivals in the United States from Turkey in Asia, by Sex, 1869–1898

Year	Males	Females	Total
1869	2	0	0
1870	0	0	0
1871	2	2	4
1872	0	0	0
1873	3	0	3
1874	2	4	6
1875	1	0	1
1876	5	3	8
1877	3	0	3
1878	—	—	—
1879	19	12	31
1880	1	3	4
1881	5	0	5
1882	0	0	0
1883	0	0	0
1884	0	0	0
1885	0	0	0
1886	14	1	15
1887	184	24	208
1888	230	43	273
1889	499	94	593
1890	841	285	1,126
1891	1,774	714	2,488
1892	—	—	—
1893	—	—	—
1894	—	—	—
1895	—	—	2,767
1896	2,915	1,224	4,139
1897	3,203	1,529	4,732
1898	2,651	1,624	4,275
Total	12,356	5,565	20,690

SOURCE: *International Migration Statistics,* Vol. 1, National Bureau of Economic Research, Inc., 1925, Table II-a "Distribution of Immigrant Aliens by Sex and Country of Origin," 1869–1898, pp. 418–431.
— Data not available.

APPENDIX 2

Number of Arrivals from Syria in the United States by Sex, 1899–1924

Year	Males	Females	Total
1899	2,446	1,262	3,708
1900	1,813	1,107	2,920
1901	2,729	1,335	4,034
1902	3,337	1,645	4,932
1903	3,749	1,802	5,551
1904	2,480	1,173	3,653
1905	3,248	1,574	4,822
1906	4,100	1,724	5,824
1907	4,276	1,604	5,880
1908	3,926	1,594	5,520
1909	2,383	1,285	3,668
1910	4,148	2,169	6,317
1911	3,609	1,835	5,444
1912	3,646	1,879	5,525
1913	6,177	3,033	9,210
1914	6,391	2,632	9,023
1915	1,174	593	1,767
1916	474	202	676
1917	690	286	976
1918	143	67	210
1919	157	74	231
1920	1,915	1,132	3,047
1921	2,783	2,322	5,105
1922	685	649	1,334
1923	605	601	1,207
1924	801	794	1,595
1925	205	245	450
1926	184	304	488
1927	302	382	684
1928	226	387	613
1929	245	387	632
1930	249	388	637
1931	103	241	344
1932	114	170	284
Total	69,514	36,877	106,391

SOURCE: *International Migration Statistics*, Table X, pp. 432–443, for data to 1925. Data from 1925 on are found in *Annual Reports of Commissioner General of Immigration*, 1926 to 1933, Table(s) VIII, "Immigrant Aliens Admitted Fiscal Year Ending June 30 by Race or People, Sex and Age."

APPENDIX 3

Arab Immigration to the United States, 1948–1985

Year	Leb	Syr	Egy	Pal[a]	Jor[b]	Iraq	Alg	SA	Ku
1948	—	345	184	376	—	107	—	1	—
1949	19	331	165	234	4	100	—	2	—
1950	204	130	165	212	14	116	—	4	—
1951	220	131	169	210	74	109	—	2	—
1952	175	107	156	156	132	102	—	1	13
1953	261	124	168	118	186	125	36	—	—
1954	324	180	264	165	181	162	117	3	0
1955	276	155	214	140	271	159	112	5	3
1956	390	185	272	384	430	163	109	3	2
1957	411	198	332	475	519	180	166	7	2
1958	366	209	498	151	377	215	167	2	2
1959	438	234	1,177	247	360	238	122	9	1
1960	511	207	854	205	371	304	111	3	0
1961	498	191	452	173	485	256	112	11	0
1962	406	245	384	256	515	314	139	3	0
1963	448	226	760	196	556	426	233	11	0
1964	410	244	828	197	529	381	189	13	9
1965	430	255	1,429	170	532	279	206	6	1
1966	535	333	1,181	320	1,005	657	151	10	2
1967	752	555	1,703	421	1,183	1,071	105	14	14
1968	892	644	2,124	—	2,010	540	138	21	15
1969	1,313	904	3,411	—	2,617	1,208	79	25	30
1970	1,903	1,026	4,937	—	2,842	1,202	115	33	24
1971	1,867	951	3,643	—	2,588	1,231	102	48	35
1972	1,984	1,012	2,512	—	2,756	1,491	102	55	46
1973	1,977	1,128	2,274	—	2,450	1,039	96	50	61
1974	2,400	1,082	1,831	—	2,838	2,281	92	48	96
1975	2,075	1,222	1,707	—	2,578	2,796	72	51	142
1976	4,532	1,666	2,290	—	3,328	4,038	110	58	133
1977	5,685	1,676	2,328	—	2,875	2,811	89	55	160
1978	4,556	1,416	2,836	—	3,483	2,188	145	109	168
1979	4,634	1,528	3,241	—	3,360	2,871	140	93	303
1980	4,136	1,658	2,833	—	3,322	2,658	175	133	257
1981	3,955	2,127	3,366	—	2,825	2,535	184	159	317
1982	3,529	2,354	2,800	—	2,923	3,105	190	134	286
1983	2,941	1,683	2,600	—	2,718	2,343	201	170	344
1984	3,213	1,723	2,642	—	2,438	2,930	197	208	437
1985	3,385	1,518	2,802	—	2,998	1,951	202	228	503
Total	62,051	29,972	61,530	4,806	58,633	52,260	4,402	1,764	3,087

SOURCE: U.S. Immigration and Naturalization Service.
Note: Total Arab immigration to the United States, 1948–1985: 331,958. Data are based on country of birth of immigrant.
— Data not available.
[a]Beginning FY 1968, data for Palestine are included in Jordan.

Bah[c]	A.Pen[d]	UAE	Lib	Mor	Sud	Tun	SYem	NYem	Oman	Dji	Qat
—	—	—	—	103	—	—	—	—	—	—	—
—	—	—	—	118	—	—	—	—	—	—	—
—	—	—	—	95	—	—	—	10	—	—	—
—	—	—	—	111	—	—	—	20	—	—	—
13	—	—	—	77	—	—	—	62	—	—	—
4	—	—	11	132	2	41	—	132	—	—	—
0	—	0	43	186	13	118	20	87	0	6	0
2	—	0	83	215	14	123	19	59	1	0	1
5	—	0	150	259	20	131	25	64	1	1	1
8	—	0	132	280	40	149	40	52	0	1	1
3	—	0	101	295	44	144	36	58	0	4	0
2	—	0	122	344	30	154	20	69	1	0	1
—	11	—	82	355	68	152	17	87	2	1	—
—	11	—	118	276	43	129	15	102	0	3	—
—	13	—	85	274	27	144	11	106	0	0	—
—	6	—	97	282	30	97	10	106	1	0	—
—	13	—	79	303	57	151	29	103	1	2	—
—	23	—	11	280	47	93	55	89	0	0	—
—	21	—	4	298	68	116	79	130	0	1	—
—	7	—	4	457	57	78	32	127	1	0	—
—	19	—	10	442	56	142	20	138	1	0	—
—	17	—	8	589	47	112	20	361	0	1	—
—	12	—	15	475	64	107	48	515	9	1	—
—	19	—	11	391	51	80	38	564	2	0	—
—	27	—	10	421	41	112	94	920	5	3	—
—	29	—	5	445	65	84	139	121	2	1	—
9	—	3	14	455	43	67	113	561	7	1	11
21	—	3	10	390	38	93	97	227	0	1	8
13	—	7	76	516	60	82	60	682	8	3	23
8	—	13	65	401	48	78	48	376	9	3	13
14	—	11	86	461	71	86	126	258	15	5	11
22	—	30	111	486	77	90	174	203	24	2	5
39	—	32	163	465	83	92	261	160	20	2	16
28	—	24	165	512	65	98	347	230	18	8	22
22	—	40	196	445	78	99	179	305	13	7	13
25	—	31	221	479	128	91	239	268	15	6	19
29	—	76	206	506	199	97	7	324	7	2	17
43	—	92	242	570	271	92	3	432	7	8	28
								11,633[e]			
302	232	361	2,736	12,344	198	3,423	2,427	8,982	170	76	191

[b] Ibid.
[c] For FY 1960–1973 Bahrein, Qatar, and United Arab Emirates are consolidated under Arabian Peninsula.
[d] Ibid.
[e] Total is for both Yemens, 1948–1985; for 1948–1953, figures are for Yemen before the division.

APPENDIX 4

Arab Eastern Rite Christian, Muslim, and Druze Population in the U.S.

Eastern Rite Christian*	Members	Parishes	Priests
1. Antiochian Orthodox	100,000	130	200[a]
2. Maronite Catholic	50,893	52	58[b]
3. Melkite Catholic	24,218	37	36[c]
4. Chaldean Catholic	50,000	9	13[d]
5. Syrian (Jacobite) Orthodox	15,000	8	15[e]
6. Coptic	50,000	9	[f]
	Members	Mosques	Imams
Muslim	200,000	200	[g]
Druze	22,500		[h]

*Figures reflect members listed on parish rolls and active priests. There has been, obviously, a great deal of attrition from Eastern rite sects to Roman Catholicism and Protestantism, as well as non-aligned secular humanism.

[a] According to Father Anthony Gabriel, author of a history-in-progress, "Antiochian Orthodoxy: Yesterday and Today." Other estimates range from 250,000 to 500,000 members.

[b] Figures listed in the 1986 Catholic Directory. (There are 72 Maronite priests in total.) According to Monsignors Hector Doueihi and Seely Beggiani of the Maronite Catholic Seminary in Washington, D.C., in 1961 Maronite leaders totaled 200,000 American Maronites, based on immigrant parentage (at that rate, probably 300,000 today). But that sum includes a large portion of Maronites who practice in the Roman Catholic Church, or Protestant churches, as well as those who practice no religion. On the other hand, the Catholic Directory figure is probably somewhat low, as pastors tend to estimate their parishioner count at low rates.

[c] Figures listed in the 1986 Catholic Directory. (There are 63 Melkite priests in total.) A good source on Melkite figures is Father Nicholas Samra, American Melkite historian and pastor of St. Ann's, West Paterson, New Jersey.

[d] According to Mary Sengstock, author of *The Chaldeans in America* (1982). The Chaldean community in Turlock, California, is not from an Arab country, but rather Iran.

[e] According to the Reverend Abdulahad Doumato, pastor of St. Ephraim's Church, Central Falls, Rhode Island. There are estimates of 20,000 U.S. Jacobite Orthodox *in toto*.

[f] Estimate based on the sizable number (over 50,000) of Egyptian immigrants to the United States since 1967.

[g] There are between 1.5 million (figure given to Yvonne Haddad, American Muslim scholar, by a leader of an umbrella Muslim group) and 3 million (consensus figure of Muslim leaders in 1979) American Muslims, the vast majority of which are Black Muslims. Estimates of Arab American Muslims can be notoriously inaccurate and overblown (one imam thought there were 1.5 million). Haddad estimates 400 mosques and Islamic associations in the United States, which could include group meetings in homes, schools, and so on. There is virtually no way to estimate the number of Muslim imams, or spiritual leaders, as there is—similar to some Baptist churches—no credentialing process for clerics. In 1966, Elkholy estimated the number of American Arab Muslims at 78,000. My estimate is based on calculating that at least half of all Arab immigrants since 1967 to the U.S. are Muslim.

[h] According to the American Druze Society. There are no Druze mosques or imams, so to speak.

Notes

1. Generations Reunite in Arbeen, Syria

1. According to Sami's brother, Adeeb, under the Ottoman Turks, members of *bayt* Awad (or the Awad family) were told to identify themselves as "Hanna" because they were Christians. Awad could be either Muslim or Christian, Hanna only Christian (Hanna is "John" in Arabic). Apparently, the last name of Hanna persisted for the younger Awads of Arbeen.

2. Philip K. Hitti, *Capital Cities of Islam*, pp. 61–84.

3. *The Orthodox Patriarcal Convent of Our Lady of Saydanaya*.

4. Fawaz Turki, "Beirut," in his *Tel Zaatar Was the Hill of Thyme*, p. 19.

2. Seeds to the Wind

1. Charles Michael Boland, *They All Discovered America*. One enthusiast near Mechanicsburg is Joseph Ayoob, who authored "Were the Phoenicians the First to Discover America?," *Compiler* (Aliquippa, Pa.), 1950.

2. Barry Fell, *Saga America*, pp. 236–306.

3. Beverlee Turner Mehdi, *The Arabs in America, 1492–1977*, p. 1.

4. Ibid., p. 60.

5. Nadim Makdisi, "Arab Adventurers in the New World," *Yearbook 1965–66*. See also testimony of Larry Williams of Okracoke Island, North Carolina, in Gregory Orfalea and Libby Jackowski, "The Arab Americans," *Aramco World Magazine* 37, no. 5 (September–October 1986): 23.

6. Herman Eilts, "Ahmad Bin Naaman's Mission to the United States in 1840," *Essex Institute Quarterly,* October 1962.

7. Eric Hooglund, ed., *Taking Root,* vol. II "Introduction," p. ii.

8. *First Immigrant*, p. 23.

9. Ibid., p. 30.

10. Ibid., p. 31.

11. Lewis Burt Lesley, ed., *Uncle Sam's Camels*, p. 159.

12. Jay J. Wagoner, *Early Arizona's Pre-History to the Civil War*, p. 342 (cited in Issa Peters, "The Arabic-Speaking Community in Central Arizona before 1940," paper delivered at the Philip K. Hitti Symposium, University of Minnesota, June 4, 1983).

13. John Considine, "Jeff Davis' Camels in Arizona," *Sunset,* May 1923, p. 31.

14. Edward Peplow, Jr., *The History of Arizona*, p. 34. Cited in Peters, "The Arabic-Speaking Community in Central Arizona."

15. Charles Issawi, ed., *The Economic History of the Middle East, 1800–1914*, p. 269; Philip M. Kayal and Joseph M. Kayal, *The Syrian-Lebanese in America*, p. 61.

16. Salom Rizk, *Syrian Yankee*. p. 38.

17. Issawi, *The Economic History*, p. 269.

18. Adele Younis, "The Coming of the Arabic-Speaking People to the United States," Ph.D. dissertation, p. 2.

19. "The Maronite patriarch pronounced anathema on the missionaries and their converts. Maronites were 'not to visit or employ them or do them a favor, but let them be avoided as a putrid member and a hellish dragon.' Native Christians who turned Protestant were persecuted. Their shops were boycotted, native teachers and ministers banished, men and women stoned in the streets, hung up by their thumbs, spat upon and struck in the face, tortured with bastinado and imprisoned without charge or trial" (Robert L. David, "American Influence in the Near East before 1861," *American Quarterly* 16, no. 1 [Spring 1964]: 70).

20. Pliny Fisk, "The Holy Land an Interesting Field of Missionary Enterprise," in *Sermons of Rev. Messrs. Fisk & Parsons Just before Their Departure on the Palestine Mission*, pp. 30, 33–34.

21. Ibid., pp. 46, 49.

22. Edward Said, *Orientalism*, p. 69.

23. Levi Parsons, *Memoir of Levi Parsons, Late Missionary to Palestine*, ed. Rev. Daniel O. Marton, p. 218; journals of Parsons and Fisk, Houghton Library, Harvard University (cited in Adele Younis, "Salem and the Early Syrian Venture," *Essex Historical Collection*, October 1966, p. 304).

24. Younis, "The Coming of the Arabic-Speaking People," pp. 15–16.

25. Henry Jessup, *Fifty-three Years in Syria*, p. 170.

26. Letter in H. C. Hayden, ed., *American Heroes in Mission Fields*, p. 23.

27. Jessup, *Fifty-three Years in Syria*, p. 201.

28. I. M. Smilianskaya, "The Disintegration of Feudal Relations in Syria and Lebanon in the Middle of the Nineteenth Century," in Issawi, ed., *The Economic History*, p. 233.

29. *The Evangelist*, December 19, 1895 (cited in Younis, "The Coming of the Arabic-Speaking People," p. 90).

30. Daniel Bliss, *Reminiscenses of Daniel Bliss*, p. 212.

31. Michael Shadid, *A Doctor for the People*, p. 25.

32. Younis, "The Coming of the Arabic-Speaking People," p. 120.

33. Interview with Hisson Arbeely Dalool, Pasadena, California, March 22, 1983.

34. A French family-planning organization set figures in 1977 confirming that today's Lebanon has a 60 percent majority of Muslims. The breakdown of sects is 28 percent Shiᶜite Muslims; 25 percent Maronite Catholics; 24 percent Sunni Muslims; 8 percent Druze; 15 percent other (mostly Eastern Orthodox and Melkite Catholics). If anything—with continuing Christian emigration—the Muslim majority is larger today.

35. Druze also live in the Hauran area in southern Syria, in Israel, and in the Israeli-occupied Golan Heights. There is a sprinkling of Palestinian Maronites.

36. Jonathan Randal, *Going All the Way*, p. 38.

37. Ibid., p. 42.

38. Jessup, *Fifty-three Years in Syria*, p. 156.

39. Kayal and Kayal, *The Syrian-Lebanese*, p. 62.

40. Said Joseph Sakir, *The Original Eulogy of the Deceased Arbeely Family*, pp. 1–17.

41. Quoted in Morris Zelditch, "The Syrians in Pittsburgh," M.A. thesis, p. 10.

42. George Hamid, *Circus*, pp. 16–17.

43. Rizk, *Syrian Yankee*, p. 17.

44. Interview with Assad Roum, Pasadena, California, March 23, 1983.

45. Abraham Mitry Rihbany, *A Far Journey*, pp. 74–75. There is an Arab proverb that expresses the opposite sentiment: "My brother and I against my cousin; my cousin and I against the stranger," which has been cited often to "explain" the incredible brutality of the Lebanese civil war. But I think it is not as convincing an explanation on close inspection as it seems (as with our own Civil War, brothers have found themselves on different sides of a battle) and certainly is not as operable in explaining the psychology of Arab immigrants as is Rihbany's thankful, "protected" strangers. In any case, another Arab proverb tends to support Rihbany: "Your friend who is near and not the brother who is far."

46. Issawi, *The Economic History*, p. 207.

47. Ibid., pp. 207–208.

48. Interview with Abdeen Jabara, Detroit, Michigan, May 20, 1983.

49. Najib Saliba, "Emigration from Syria," in *Arabs in the New World*, ed. Nabeel Abraham and Sameer Y. Abraham, p. 32.

50. Joy Spiegel, *That Haggar Man*, p. 171.

51. Interview with Vance Bourjaily, Iowa City, Iowa, July 9, 1983.

52. Interview with Albert Rashid, Brooklyn, New York, February 2, 1983.

53. Dr. Kenneth J. Perkins, "Three Middle Eastern States Helped America Celebrate Its Centennial in Philadelphia," *Aramco World Magazine* 26, no. 6 (November–December 1976): 8.

54. Sir John Glubb, *A Short History of the Arab Peoples*, p. 246.

55. Interview with Michael Malouf, Pasadena, California, March 22, 1983.

56. Interview with Simon Rihbany, West Roxbury, Massachusetts, February 26, 1983.

57. E. J. Dillon, "Turkey's Plight," *Contemporary Review*, July 1913, pp. 123, 128 (cited in Kayal and Kayal, *The Syrian-Lebanese*, p. 65).

58. Interview with Dr. Joseph Jacobs, Pasadena, California, April 4, 1983.

59. Saliba, "Emigration from Syria," p. 37.

60. Rizk, *Syrian Yankee*, p. 37.

61. Interview with Matile Awad, Pasadena, California, January 1983. Seventy years later, an Orthodox priest visited Shreen and was shocked to find its church gutted and its homes destroyed by the civil war (see "A Song of Hope" by Father Basil Essey in *The Word* 31, no. 5 [May 1987]: 9–11).

62. Philip K. Hitti, *A Short History of Lebanon*, pp. 216–217.

63. Philip K. Hitti, *Syria: A Short History*, p. 239.

64. Interview with Amean Haddad, Encino, California, March 24, 1983.

65. Interview with Michael Malouf.

66. Interview with Peter Nosser, Vicksburg, Mississippi, March 15, 1984.

67. Saliba, "Emigration from Syria," p. 39.

68. Interview with Assad Roum.

69. Francis Brown and Joseph Roucik, eds., *One America*, p. 286.

70. Rihbany, *A Far Journey*, p. 172.

71. Interview with Joseph Hamrah, Houston, Texas, August 8, 1983.

72. Ameen Rihani, *The Book of Khalid*, p. 28.

73. Rizk, *Syrian Yankee*, p. 118.

74. Interview with Andrew Ghareeb, Bethesda, Maryland, March 25, 1985.

75. Interview by Gary Awad with Said Hanna, Pasadena, California, 1978.

76. "Five Recruited for Turkey—Story of the Arabs Now at Castle Gardens," *New York Daily Tribune*, May 24, 1877.

77. Interview with Sadie Stonbely, Brooklyn, New York, February 18, 1983.

78. Interview with Elias Joseph, Woonsocket, Rhode Island, March 1, 1983.

79. Philip K. Hitti, *The Syrians in America*, p. 66. It is part of my mother's family folklore that Theodore Roosevelt—through Dr. Ibrahim Arbeely—interceded for the release of my great-grandfather from a Turkish prison (see Gregory Orfalea, "Deeb Awad," *Greenfield Review* 8, nos. 3–4 [Fall 1980]: 187–190).

80. Interview with Sadie Stonbely.

81. Salloum Mokarzel, "History of the Syrians in New York," *Syrian World* 2, no. 5 (November 1927): 3–13.

82. Interview with Matile Awad.

83. Interview with Sadie Stonbely.

84. Interview with Vance Bourjaily.

85. Edward Corsi, *The Shadow of Liberty*, pp. 261–266.

86. Mokarzel, "History of the Syrians in New York."

87. Lucius Hopkins Miller, *Our Syrian Population*, p. 51.

88. See Gregory Orfalea, "There's a Wire Brush at My Bones," in *Crossing the Waters*, ed. Eric Hooglund.

89. Interview with Hisson Arbeely Dalool.

90. Interview with Mrs. George Fauty, Brooklyn, New York, February 16, 1983.

91. Henry Chapman Ford, "Why I Wrote a Syrian Play," *Syrian World* 2, no. 1 (July 1927).

92. Henry Chapman Ford, "Anna Ascends," *Syrian World* 2, no. 1 (July 1927): 35.

93. Sam Hamod, *Dying with the Wrong Name*, p. 19.

94. Interview with Mayor George Latimer, St. Paul, Minnesota, June 5, 1983.

95. Interview with Casey Kasem, Washington, D.C., April 4, 1985.

96. Philip Forzley, ed., "Autobiography of Bishara Khalil Forzley," memoir, August 2, 1953, Immigration History and Research Center, University of Minnesota, p. 8.

97. Interview with Aliya Hassan, Dearborn, Michigan, May 19, 1983.

98. Interview with Ellis Bodron, Vicksburg, Mississippi, March 14, 1984.

99. Interview with Joseph Hamrah.

100. Alixa Naff, *Becoming American*, p. 183.

101. Ibid., p. 184.

102. Ibid., p. 164.

103. Interview with Thomas Nassif, Washington, D.C., February 23, 1983.

104. An important debunking of the thesis that a majority of early Syrians peddled was presented by Dr. Eric Hooglund in his introduction to the 1985 volume *Taking Root*. Dr. Hooglund and the ADC Research Institute tapped recently unsealed records of the U.S. Census Bureau to discover that in ten communities in five states in 1900 and 1910 a majority of Syrian workers were listed as factory laborers. Though using those communities (most of which were northeastern) as a barometer to disprove the peddler theory is not entirely foolproof (one should note that peddlers by nature of their work were on the road and perhaps not as easily polled by Census officials), Hooglund's conclusion is compelling: "It

is reasonable to say, however, that the 'Syrian peddler' idea is a stereotype . . . the experience of the early Arabs in America was as diverse as that of other ethnic groups who came in the great immigration wave during the generation leading up to World War I."

105. Interview with Elias Joseph.

106. Katrina Thomas, "Festival in Fall River," *Aramco World Magazine* 27, no. 6 (November–December 1976): 6.

107. Dr. Eric Hooglund, "From Down East to Near East: Ethnic Arabs in Waterville, Maine," in *Crossing the Waters.*

108. Sameer Y. Abraham, "Detroits Arab-American Community: A Survey of Diversity and Commonality," in *Arabs in the New World,* ed. Abraham and Abraham, p. 90.

109. Hays Gorey, *Nader and the Power of Everyman,* pp. 166–167.

110. Michael Kinsley, "St. Ralph," *Washington Post,* November 21, 1985.

111. Interview with William Ezzy, Alameda, California, March 3, 1983.

112. Orfalea and Jackowski, "The Arab Americans."

113. Interview with George Fauty, Brooklyn, New York, February 16, 1983.

114. Lucille Baldwin Van Slyke, "The Peddler," *American Magazine* 74 (August 1912): 411; Alice E. Christgau, *The Laugh Peddler* (quoted in Naff, *Becoming American,* pp. 180–181).

115. Orfalea, "There's a Wire Brush."

116. See Reverend Basil Kherbawi, *History of the United States and the History of the Syrian Immigration.*

117. Father Nicholas Samra, "Rugby Update," *Sophia* 13, no. 6 (November–December 1983): 2. See also his "Early Beginnings of the Melkite Church in the U.S.," *Sophia* 13, no. 2 (March–April 1983): 3.

118. Kayal and Kayal, *The Syrian-Lebanese,* p. 122.

119. Interview with Father James Khoury, San Antonio, Texas, August 4, 1983.

120. Mary Haddad Macron, *Arab-Americans and Their Communities of Cleveland.*

121. Salloum Mokarzel, "Christian-Moslem Marriages," *Syrian World* 2 (April 1928): 14.

122. Naff, *Becoming American,* p. 120.

123. Interview with Mrs. Nelly Bitar, Greentree, Pennsylvania, May 12, 1983.

124. Toby Smith, "Arrows from Strong Bows," *New Mexico Magazine,* February 1982, p. 25.

125. Hitti, *The Syrians in America,* p. 103.

126. Michael W. Suleiman, "Early Arab-Americans: The Search for Identity," in *Crossing the Waters,* ed. Hooglund.

127. Interview with Elias Joseph.

128. Ashad G. Hawie, *The Rainbow Ends,* pp. 85–104.

129. Sami Bache, "A Trip to the Interior of the Middle East," in *Greetings from Home.*

130. Mikhail Naimy, "My Brother," in *Grape Leaves,* ed. Gregory Orfalea and Sharif Elmusa.

131. In *History of Greene County* (cited in Nadim Makdisi, "The Moslems of America," *Christian Century* 76 [August 26, 1959]: 969–971).

132. Interview with Abdeen Jabara.

133. Abdo A. Elkholy, *The Arab Muslims in the United States,* p. 17.

134. Interview with Abe Ayad, San Francisco, California, December 14, 1983.

135. Hamod, "Lines to My Father," in *Dying with the Wrong Name,* p. 7.

136. Interview with H. S. Hamod, Washington, D.C., February 25, 1986.

137. Kathy Jaber Stevenson, "Modern Day Forty-Niners: The Druze of Southern California," *Our World* 1, no. 2 (Winter 1985): 36–38.

138. Smith, "Arrows from Strong Bows," p. 23.

139. Interview with Charles Juma, Sr., Stanley, North Dakota, June 11, 1983.

140. Interview with Omar Hamdan, Stanley, North Dakota, June 11, 1983.

3. Transplanting the Fig Tree

1. Interview with Sam Kanaan, West Roxbury, Massachusetts, March 2, 1983.

2. Interview with Shukri Khouri, Chevy Chase, Maryland, September 12, 1983.

3. Peters, "The Arabic-Speaking Community in Central Arizona before 1940."

4. Interview with George Fauty.

5. Interview with Michael Malouf.

6. Interview with Assad Roum.

7. Interview with Elias Joseph.

8. Spiegel, *That Haggar Man,* p. 30.

9. Interview with John Nosser, Vicksburg, Mississippi, March 15, 1984.

10. Faith Latimer, "Cultural Autobiography," paper, University of Minnesota, May 13, 1982.

11. "Relief Movements among U.S. Syrians," *Syrian World* 6, no. 2 (October 1931): 54–55.

12. Marlene Khoury Smith, "The Arabic-Speaking Communities in Rhode Island," in *Hidden Minorities,* ed. Joan H. Rollins, p. 156.

13. Mikhail Naimy, "Hunger" (March 14, 1928), "A Solemn Vow" (April 1, 1928), "The Endless Race," (August 30, 1928), *New York Times.*

14. "Hard Times," *Syrian World* 6, no. 6 (February 1932): 44–45.

15. Khoury Smith, "The Arabic-Speaking Communities in Rhode Island," p. 169.

16. "First American Jet Ace Dies as Car Overturns in Florida," *New York Times,* November 18, 1966.

17. Najeeb Halaby, *Crosswinds,* pp. 30–33.

18. "Flies 30 Missions, None of Crew Hurt," *Minneapolis Daily Times,* July 1, 1944, p. 6.

19. Louis LaHood, *Wings in the Hands of the Lord,* pp. 32, 42, 46.

20. Vance Bourjaily, *The End of My Life,* p. 183.

21. Ibid., pp. 28–29.

22. Interview with Danny Thomas, Beverly Hills, California, March 23, 1983.

23. Danny Thomas, "The Vow I Almost Forgot," *Guideposts* 36, no. 3 (May 1981): 4.

24. Deborah Papier, "Helen Thomas on the White House Beat," *Washington Times,* December 5, 1984.

25. Interview with Helen Thomas, Washington, D.C., 1983.

26. Helen Thomas, *Dateline: Washington,* p. xi.

27. Papier, "Helen Thomas," p. 20.

28. Thomas, *Dateline,* p. 37.

29. Ibid., p. 87.

30. Interview with Ayesha Howar, Washington, D.C., July 6–7, 1985.

31. Philip Harsham, "One Arab's America," *Aramco World Magazine* 26, no. 2 (March–April 1975): 14–15.

32. Halaby, *Crosswinds,* p. 4.

33. Ibid., p. 5.

34. Interview with Najeeb Halaby, Washington, D.C., March 25, 1983.

35. Halaby, *Crosswinds,* p. 124.

36. Ibid., p. 317.

37. Vance Bourjaily, "My Father's Life," *Esquire,* March 1984.

38. Interview with Vance Bourjaily.

39. Bourjaily, "My Father's Life."

40. Vance Bourjaily, autobiographical entry, *Contemporary Authors Autobiography Series,* 1:63–79.

41. Ibid.

42. Vance Bourjaily, *Confessions of a Spent Youth,* pp. 239, 15, 273.

43. Evelyn Shakir, "Pretending to Be an Arab: Role-Playing in Vance Bourjaily's 'The Fractional Man,'" *MELUS* 9, no. 1 (Spring 1982): 7–21.

4. The Palestine Debacle

1. Interview with Alfred Farradj, San Francisco, California, March 10, 1983.

2. See Elias H. Tuma, "The Palestinians in America," *The Link* 14, no. 3 (July–August 1981): 1–14. Tuma cites estimates of the Palestine Institute of Statistics and *al-Fajr,* the West Bank daily newspaper, that the 1981 Palestinian American population was 110,200. I have added 10,000 based on U.S. immigration statistics in the subsequent four years. Such statistics are based on country of birth not departure, but since immigration figures from the "Palestine" column abruptly (and bizarrely) disappear after 1967 [see Appendix 3], it is difficult to tell from U.S. immigration figures just who is Palestinian. It seems safe to assume, at the very least, that half the Arab immigrants from Lebanon, Syria, Iraq, and the Gulf states since 1967 were Palestinian, and that two-thirds of the Jordanian immigrants since 1967 were also Palestinian. This will more than account for the estimate of 120,000 current Palestinian Americans.

3. Interviews with Dr. Hisham Sharabi, Washington, D.C., February 2, March 10, September 1, 1983.

4. "Will the Palestinians Tolerate Such?." *Al-Bayan,* November 16, 1927; translated in *Syrian World* 2, no. 6 (December 1927).

5. Interview with Alfred Farradj.

6. Interview with Naim Halabi, Foster City, California, April 18, 1983.

7. Interview with Shukri Khouri.

8. Interview with [name withheld], Kensington, Maryland, September 18, 1983.

9. See "Interview with Jonathan Kuttub," *Arab-American Affairs* 16 (Spring 1986): 120–127. Kuttub, with Mubarak Awad, is the recent founder of the East Jerusalem–based Palestinian Center for Non-Violence. See also Mubarak Awad, "Nonviolent Resistance: A Strategy for the Occupied Territories, *Journal of Palestine Studies* 13, no. 4 (Summer 1984): 22–36.

10. Seth Tillman, *The United States and the Middle East,* p. 14.

11. Alfred Lilienthal, *The Zionist Connection,* p. 93.

12. Documents at the Truman Library in Independence, Missouri, reveal that Truman agreed to the meeting only after he was assured by acting Secretary of State James Webb that it would last only ten minutes. The Webb memo, signed by the president, leaves no doubt that the meeting was arranged solely for public relations purposes: "In view of the precarious state of our relations with the Arab countries, it would be advantageous if you could find time to receive the committee of the Federation. It would be a simple courtesy call; publicity of the event by overseas news, radio and information agencies would have a favorable impact on the Arab world." An eleven-person delegation of Arab Americans met with Truman on the White House lawn October 3 and presented him with a seven-point program for peace in the Middle East. Summarizing it, Faris Malouf noted the desire that U.S. foreign policy not "be influenced and affected by domestic considerations" and that a "generous and final" solution to the Arab refugee problem not "stretch over a period of years." The eleven in attendance were Malouf, Monsour Zanaty (National Federations president), Frank Maria, James Batal, George Barakat, Ellis Abide, Anthony Abraham, Mrs. Louis Nassif, Simon Rihbany, Rogers Bite, and Joseph Sado. A photograph that the *Federation Herald* ran of the event in its October 1951 issue is revealing. All but white-haired Simon Rihbany face a portly Faris Malouf, who, reading the document, faces not the president but Frank Maria. A brooding Truman stands back from the podium with the presidential seal, hands clasped, looking groundward.

13. Interview with Naim Halabi.

14. Interview with Aziz Shihab, Dallas, Texas, August 6, 1983.

15. See Naomi Shihab Nye, "One Village," *Journal of Palestine Studies* 13, no. 2 (January 1984): 31–47.

16. Edward Said, *The World, the Text, the Critic*, p. 4.

17. Interview with Edward Said, New York, New York, October 7, 1983.

18. See Edward Said, *After the Last Sky*, p. 172.

19. Interview with Hisham Sharabi.

20. Interview with Nabila Cronfel, Houston, Texas, August 3, 1983.

21. Interview with Shahdan El Shazly, Washington, D.C., November 11, 1983.

22. Interview with Dr. Aida McKellar, Houston, Texas, August 3, 1983.

23. Interview with Father Abdulahad Doumato, Central Falls, Rhode Island, March 1, 1983.

5. The Third Wave

1. Mary Sengstock, "Detroit's Iraqi Chaldeans," in *Arabs in the New World*, ed. Abraham and Abraham, p. 139.

2. Ibid., p. 141.

3. Interview with Dr. Karim Alkadhi, Houston, Texas, August 10, 1983.

4. Dr. Jon Swanson, "Sojourners and Settlers in Yemen and America," ms., 1985, p. 13.

5. Susan Morse, "Dearborn Seamen Awarded $750,000 for Ship Accident," *Detroit Free Press*, January 16, 1977.

6. Nabeel Abraham, "The Yemeni Immigrant Community of Detroit Background, Emigration, and Community Life," in *Arabs in the New World*, ed. Abraham and Abraham, p. 114.

7. Ibid., pp. 120–121, 126–128.

8. See Joseph R. Haiek, ed., *Arab American Almanac*, pp. 107–108.

9. Interview with Joseph Haiek, Glendale, California, March 22, 1983.

10. Fouzi al-Asmar, *To Be an Arab in Israel*, p. 57.

11. Interview with Bassam Idais, San Antonio, Texas, August 7, 1983.

12. Interview with Diana Sahwani, Washington, D.C., March 1983.

13. Interview with Dr. Tony Khater, Washington, D.C., July 25, 1983.

14. Interview with Dr. ʿAlāʾ Drooby, Houston, Texas, August 2, 1983.

6. Before the Flames

1. See Walid Khalidi, *Conflict and Violence in Lebanon;* also Randal, *Going All the Way.*

2. Joseph Chami, *Days of Tragedy*, pp. 288–289.

3. See Sabri Jiryis, *The Arabs in Israel.*

4. See Helena Cobban, *The Palestine Liberation Organization.*

5. See Jonathan Dimbleby, *The Palestinians*, pp. 85–94.

6. Within two months of my return to Washington, D.C., from Beirut, the Israel invasion commenced. Col. Azmi Saghiyeh committed a spectacular suicide when, holed up in Sidon with Israelis he had taken prisoner, he was surrounded by Israeli forces, who refused to allow him passage to Beirut. He exploded a grenade, killing himself and the prisoners. Mahmoud Labadi, as mentioned, deserted Arafat a year later and joined the forces of the Abu Musa faction, which, with Syrian troops, laid siege to Arafat in Tripoli. Sabri Jiryis' wife was killed during the bombardment of Beirut, and many of his priceless historical records were taken by Israeli troops. George Azar returned to the States looking for negatives of photographs he had taken of the war for *Newsweek;* the magazine refused to release them to him. Suhayla, the Shiʿite woman, watched the seige of Beirut on television in Saudi Arabia and saw a relative of Suhail Yaccoub arrested by Israeli troops during the broadcast. Youmna managed to escape to Cyprus, where she married her American beau among Greek ruins in the middle of the war, later emigrating with him to Washington, D.C. Jack Dagilitis, a longtime American resident of Beirut who hosted me during my visit, suddenly appeared in my office that summer. He recounted that Americans were included among those who were drinking their own urine at the height of the seige, which had cut off water supply. He had been elected by an ex-patriate group to journey to Washington, D.C., to plead with U.S. officials to do something. May Sayegh, head of a Palestinian women's union, who cooked a supper for me in Beirut, called late that terrible summer to say she had evacuated with the PLO. She was in Washington, D.C., anonymously, to visit two children schooling in America. She could not meet me but wanted to hear my voice. "We are dispersed to the ends of the earth," she sobbed.

The 1982 invasion of Lebanon spurred an unprecedented Arab American political activism, which itself declined precipitously after the shocking massacre of Palestinians at Sabra and Shatila by right-wing Lebanese Christians, the confusing turning on Arafat by the Syrians at Tripoli, which seemed to mimic Israel's own seige of Beirut, and the extraordinary terrorism that erupted from many, often faceless quarters. For a number of reasons, lobbying efforts of Arab Americans during this tragic time—heartfelt but for the most part fruitless—are not recounted in this book. My own tracing of Arab American

politics and the rise and fall of various groups from the early part of this century through and beyond the 1982 invasion of Lebanon is part of a forthcoming book.

7. A Celebration of Community

1. Interview with Father George Rados, Washington, D.C., February 22, 1983.

2. Interview with Albert Rashid.

3. On Brooklyn, see also "Beirut Was Such a Marvelous City," *Village Voice*, February 28, 1984, pp. 11–12, 3d; for a lively description of a large family reunion, see Carla Hall, "The Rashids: It's All Relatives," *Washington Post*, July 8, 1985, C1–C4.

4. Interview with Philip Habib, Washington, D.C., March 15, 1983.

5. Interview with Robert Thabit, Brooklyn, New York, February 20, 1983.

6. Interview with Edward Baloutine, Brooklyn, New York, February 16, 1983. In late 1985, Edward Baloutine followed the Bay Ridge colony's exodus to New Jersey, settling in Washington Township.

7. Interview with Sadie Stonbely.

8. Interview with Joseph Atallah, Brooklyn, New York, February 18, 1983.

9. Interview with Richard Zarick, Brooklyn, New York, February 18, 1983.

10. Joe Tintle, "Mustapha Hamsho: Syrian-Bred, American-Based," *Ring Magazine*, December 1980, p. 35.

11. Mike Marley, "Hagler Lives Up to Tradition of Middleweight Champions," *New York Post*, October 3, 1981.

12. Joe Chessari, "Hagler Not Surprised at Hamsho's Win, Welcomes Rematch," *Dispatch* (Hudson/Bergen County, N.J.), July 27, 1983.

13. Interview with Mustapha Hamsho, Brooklyn, New York, October 8, 1983.

14. Alfred Hayes, "Abraham Perfect in BSO Narration," *Baltimore Sun*, July 11, 1985.

15. Interview with F. Murray Abraham, Baltimore, Maryland, July 10, 1985.

16. See "F. Murray Abraham's Class Act," *International Herald Tribune*, October 4–5, 1986, p. 20.

17. Interview with Murray Toney, Bridgeville, Pennsylvania, May 13, 1983.

18. Interview with Ethel Antion, Bridgeville, Pennsylvania, May 16, 1983.

19. Interview with Jean Abinader, Carmichaels, Pennsylvania, May 11, 1983.

20. Interview with Samuel Hazo, Pittsburgh, Pennsylvania, May 15, 1983.

21. Interview with Mary Anne Hazo, Pittsburgh, Pennsylvania, May 15, 1983.

22. Interview with Nafeeli Monsour, Jeannette, Pennsylvania, May 16, 1983.

23. Interview with Drs. William, Roy, and Howard Monsour, Jeannette, Pennsylvania, May 16, 1983.

24. Jack Shaheen, "A Gathering of 4 Generations," *Pittsburgh Post Gazette*, August 22, 1983.

25. David Elfin, "Khalifa: Potential Pirate from the Shore of Tripoli," *Washington Post*, July 10, 1983; see also Brian Clark, "Khalifa at the Bat," *Aramco World Magazine* 37, no. 3 (May–June 1986): 6–13.

26. Interview with Father Nicolas Saikley, Vicksburg, Mississippi, March 14, 1984.

27. Interview with Ellis Bodron.

28. Emma Balfour, *Vicksburg, a City under Siege*, excerpts of a 1893 diary.

29. In 1917, Lord David Balfour, the prime minister of Great Britain, wrote Lord

Lionel Rothschild underscoring Britain's commitment to build a national home for the Jewish people, "it being clearly understood that nothing shall be done which may prejudice the civil and religious rights of the existing non-Jewish population." Later, Balfour dismissed his own guarantee to the 93 percent Arab population of Palestine.

30. Interview with Judge John Ellis, Vicksburg, Mississippi, March 15, 1984. Another judge of Lebanese background is Sen. George Mitchell of Maine, who distinguished himself in 1987 as a member of the U.S. Senate investigatory committee on the Iran-Contra arms affair.

31. Interview with Peter Nosser.

32. Interview with John Nosser.

33. Interview with Haseeb Abraham, Vicksburg, Mississippi, March 15, 1984.

34. Interview with Mayme Farris, Vicksburg, Mississippi, March 16, 1984.

35. James Hughes, "An Open House," *New Yorker,* October 1980.

36. Interview with Ahmed Sheronick, Cedar Rapids, Iowa, July 11, 1983.

37. Interview with Omar Hamdan.

38. Interview with Charles Juma, Sr.

39. Interview with Nazira Kurdi Omar, Stanley, North Dakota, June 12, 1983.

40. Interview with J. M. Haggar, Sr., Dallas, Texas, August 5, 1983.

41. Steven Coll, "Down Home with the $10 Billion Barrister: Joe Jamail, a Law unto Himself," *Washington Post,* July 31, 1986.

42. Though I did not possess the wire cutters strong enough to cut through the fence around the chief American protector of the consuming citizen, I did discover along the way some possible reasons why he would not grant an audience. In 1978, after years of being hounded by Ralph Nader, Paul Rand Dixon, who headed the Federal Trade Commission, lashed out in a hearing, calling Nader "a dirty Arab." In one of four biographies of Nader that range from penetrating to vituperous—all written by former associates—David Sanford (*Me and Ralph*) revealed that one of the chief things keeping Ralph Nader from being president was "the Arab-Israeli thing" and the fact that Nader is of Arab (Lebanese) descent. Joseph Page, a colleague of Nader who drafted the final report that became OSHA (Occupational and Safety Hazard Act), confessed that, when they were law students at Harvard, Nader had sympathy for Palestinians. In short, the man who fears no giant corporation (he brought General Motors to its knees), no president, and certainly no woman with a spartan lifestyle that has foreclosed marriage, apparently fears letting his guard down on a foreign policy issue that has toppled presidents and kept war boiling for four decades in the Middle East. Nader's accomplishments, of course, stand, making him, according to Walter Mondale, "a man without parallel in American history." In 1971, a Gallup poll rated him the sixth most popular man *in the world;* the next year he declined two invitations to be vice-presidential running mate to both George McGovern and Edmund Muskie. Since publishing *Unsafe at any Speed* in 1965, which exposed flaws in the design of Chevrolet's Corvair, Nader has authored or co-authored over thirty-five books that have blown the whistle on everything from Dupont Chemical to the U.S. Congress. With $250,000 yearly earnings today from lecturing, Nader has spun off a plethora of activist watchdog groups, particularly the thirty Public Research Interest Groups (PIRGs). To me, his legendary spartan monkishness coupled with an intense concern for community is no contradiction. The Lebanese anchorite dances with the crowd as long as he is assured of his cave.

43. Mary Jane Scriber, "DeBakey Keeps Ambitious Pace as He Nears 75," *Houston Post*, September 4, 1983.

44. Stan Reddy, "DeBakey," *Houston Chronicle* (*Texas Magazine*), October 12, 1980.

45. Interview with Joseph Hamrah.

46. Blair Corning, "Meet San Antonio's King of the Forgotten," *San Antonio Expresss-News*, November 28, 1982.

47. Interview with Ralph Karam, San Antonio, Texas, August 8, 1983.

48. See Bevis Hillier, "California Craftsmen," *Los Angeles Times Home Magazine*, November 25, 1984, pp. 12–14.

49. See Mary Tahan, "Bob Andrews Heads Lettuce Kingdom While Scoring High in Community Services," *News Circle*, 9, no. 103 (January 1981): 23–29.

50. Merrill Shindler, "Jean and Casey Kasem Raise Pot of Gold for the Rainbow Coalition," *News Circle* 12, no. 144 (June 1984): 32.

51. Nathan Pop, "Casey Kasem," *Boston Globe*, March 30, 1985.

52. Milhem Safa, ed., "A Farewell Speech to My Brethren, the Druze," ms., Qara Qool al Druze, Lebanon, January 22, 1931.

53. Interview with Casey Kasem.

54. Richard J. Piestschmann, "Casey's Quandary," *Los Angeles Magazine*, April 1, 1983, p. 132.

55. Ibid.

56. Nicole Yorkin, "KNBC Newsman Helps Bring Couple Orphan Boy to L.A.," *Los Angeles Herald-Examiner*, December 1, 1983.

57. See "Alex Odeh: First Victim of Terrorism against Arab-Americans in the United States," *News Circle* 14, no. 160 (October 1985).

58. Joseph J. Jacobs, *Jacobs Engineering Group, Inc.: A Story of Pride, Reputation, and Integrity.*

59. Interview with Dr. Joseph Jacobs.

60. Interview with Amean Haddad.

61. Sammie Abbott, the popular Marxist former mayor of Takoma Park, Maryland, helped prepare America's Abraham Lincoln Brigade that fought against fascists during the Spanish Civil War. See Henry Allen, "What Makes Sammie Abbott So Angry?," *Washington Post*, September 22, 1985.

62. Interview with Hisson Dalool.

63. Interview with Assad Roum.

64. Interview with Michael Malouf.

65. Gregory Orfalea, "The Chandelier," *Triquarterly* 61 (Fall 1984): 27–36.

66. See Mary Bisharat, "Yemeni Migrant Workers," in *Arabs in America*, ed. Baha Abu-Laban and Faith T. Zeadey.

67. Interview with Ahmed Shaibi, Delano, California, April 5, 1983.

68. Interview with Mike Shaw, Delano, California, April 5, 1983.

69. Interview with Kassem Shaibi, Delano, California, April 5, 1983.

Glossary

The Arabic words are given according to the Library of Congress transliteration system. That system uses literary, or classical, Arabic as a standard, which is the Arabic used in writing. Spoken Arabic has many dialects. Syro-Lebanese immigrants and their descendants rarely pronounce, for instance, an initial "q," or qaf, and tend to turn many "ah" endings into "ee." To give only one example: a Syrian or Lebanese would never ask for coffee by asking for qahwah, *the classical written form, which is also what an Egyptian would say; he would ask for* ahwee, *or* ahwi.

ʿabā: cloak, robe

ʿa bilādna: to our country, or village

ʿadas: lentils

Adhrāʾ: Blessed Mother, Virgin

Ahlan wa sahlan, ya akhi: Welcome, my brother.

ahwi. *See* qahwah

Akbar minnak, walad: I'm older than you, kid.

ʿAla mahlak!: Take it easy!

Allāh akbar: God is great.

Allāh yarhamu: God rest his soul.

Allāh yarhamu, dashshiruh: God rest his soul, let him be.

Allāh yikhalliki: May God preserve you [fem.].

ʿammu: uncle

ʿaraq: licorice-flavored clear liquor; water turns it white

arjīlah: hubble-bubble, water pipe

Ashbāl: "Tiger Cubs," military unit of youngsters

ʿayb: shame

ʿayshah: life (li-ʿayshah: to life)

aywah: yes

baba ghannūj: eggplant dip

bab: gate

balāṭ ṭin: concrete and mud

baqlāwah: diamond-shaped sweet

basrah: card game

battīkh: watermelon

bayt: house or home

bayt al-hurrīyah: the house of freedom

bilād: home country

bilād kufr: land of unbelief

braak. *See* ibrīq

būkhūr: incense

bumīn: bums

burnus: cloak with hood

dabkah: a circle dance

darabukkah: bongo drum

dibs kharrūb: bucket of carob syrup

fūl: fava beans

fustuq halabī: pistaschio

ḥabībī: my love

ḥaflah: party

hajj: pilgrimage

ḥalāwah: a sweet made of crushed sesame

ḥarām: forbidden; pitiful

ḥarām, al-humār: the poor ass

ḥarb: war

ḥarkashah: one who stirs things up

ḥaṭṭah: the cloth worn underneath the Arab headpiece fastener (*ʿiqāl*)

al-hawa al-asfar: yellow fever

hijrah: flight to escape danger

ḥimār: donkey

ḥummuṣ: a spread/dip made from chick-
peas

huṣrum: a kind of sour grape

ibrīq: glass water jug

ᶜilkī: chewing gum

ᶜiqāl: ropelike fastener for a *kūfīyah*

jaddu: grandfather

jāmiᶜ: mosque

jarād: locust

kākī: Japanese persimmon

kashishi. *See* qashshah

Khalāṣ: It is finished.

khirsānah: wild grass

khubbayzah: clover

khubz: bread

khūkh: plum

khūrī: Orthodox priest

kibbah: meatball

kibbah maᵓa kishk: meatball with bulgur
and sour milk

kibbah nayah: raw lamb

Kīfak baᶜdī?: How are you, part of me?

kūfīyah: headdress

kuftah: meatball with bulgur

kull shayᵓ: everything

kunāfah: bird's nest (a sweet)

kūsah: zucchini

lā: no

laban: yogurt

labanī: yogurt spread

laḥm mashwī: grilled meat

lākin: but

lākinnī: but I

lawajh Allāh: for the face of God

layl: night

lubnān: white

lūz: almonds

Maᶜalish?: What does it matter?

madjidy: Turkish dollar

Maktūb: It is written.

Marḥaban: Hello.

māᵓzahr: orange water

mazzah: hors d'oeuvre

mishmish Hindī: loquat

Mnerfaᶜ al-mawta min al-qabr: We can
raise the dead from the tomb; we can do
anything.

muezzin: Muslim chanter who calls out
the times for prayers

mughlīyah: powdered rice with spices,
sugar, and nuts; made in celebration of
newborns

murrah: bitter

mutaṣarrif: ruler, governor; protectorate

al-Nakbah: "The Catastrophe," Israel's
war of independence

naᶜnāᶜ: mint

nashkur Allāh: thanks to God.

nastar: a fern

nilᶜab waraq: play cards

qahwah: coffee

qamar al-dīn: pressed apricot (literally,
moon of the religion)

qamḥ: wheat kernels, sweetened barley

qashshah: peddler's bag

qirfah: cinnamon

qishṭah: prickly custard apple

Qult, "Mat": I said, "He died."

qūnah: icon

rummān: pomegranates

ṣafīḥah: meat pies
ṣahrah: party
Al-ṣalāh afḍal min al-nawm: Prayer is
 better than sleep.
Salamtik: Your [fem.] health
al-Salāmu ʿalykum ("Slim Al-
 ickum"): Peace be with you,
 Greetings.
ṣalli: pray [imperative]
samīd: farina or semolina; a ring-shaped
 biscuit sprinkled with sesame seed
Sarit tibki, ḥarām: She started to cry, sad
 to say.
sayadna: your eminence
shū ismūh: what's his name
sunūbar: pine nuts
sūq: marketplace

tabbūlah: parsley and bulgur salad
ṭablah: tubular drum
taḥīnah: sesame seed oil
taʾishīn: frivolous ones
ṭarbūsh: fez
tāwilah: backgammon
tayo: Syriac for early Christians
taytah: grandmother
tadhkarah: passport
thatee. See taytah
thawrah: revolution
ṭiz: buttocks
tūm: garlic

tunbur: wagon

ʿud: musical instrument similar to a man-
 dolin; oudist, one who plays an ʿud
ufaḍḍilu: I prefer

wakīl al-mughtaribīn: native Yemeni
 lenders
Wallah: by God
waraq ʿinab: grape leaves
wasaṭ: medium
Wayn al-ʿarūs?: Where's the bride?
Wayn fataḥ?: Where are you opening?
Wiynu akhūkī?: Where's your [fem.]
 brother?

ya Allah: my God
Ya ʿayni! Ya akhī: My eye! My brother!
ya ʿuyūnī: my eyes
ya dīnī: my religion
Ya ḥarām: What a shame.
Yallah!: Let's go!
Ya tiqburnī: Bury me.

zaghrūt: a woman's trilling cry of joy
zajal: folk poetry
zaʿtar: thyme
zayt: oil
zaytūnah: an olive
zibib: raisins
zidra: stone bowl
zūm: juice

Bibliography

Abraham, Nabeel, and Sameer Y. Abraham. *Arabs in the New World: Studies on Arab American Communities*. Detroit: Wayne State University Center for Urban Ethnic Studies, 1983.

Abu-Laban, Baha, and Faith T. Zeadey, eds. *Arabs in America: Myths and Realities*. Wilmette, Ill.: Medina University Press International, 1975.

"Alex Odeh: First Victim of Terrorism against Arab-Americans in the United States." *News Circle* 14, no. 160 (October 1985).

Allen, Henry. "What Makes Sammie Abbott So Angry?," *Washington Post*, September 22, 1985.

Anderson, Jack, and Dale Van Atta. "Israelis Harass Arab-American." *Washington Post*, November 5, 1986.

Apone, Carl. "Variety's Dapper Diplomat" [Joe Ferris]. *Pittsburgh Press*, April 29, 1962.

"Arab: An Inside Look at a Community under Siege." *Michigan Magazine of the Detroit News*, April 6, 1986.

The Arab-American Community: A Demographic Profile. New York: American-Arab Association for Commerce and Industry, 1980.

al-Asmar, Fouzi. *To Be an Arab in Israel*. Beirut: Institute of Palestine Studies, 1978.

Assali, Nicholas. *A Doctor's Life*. New York: Doubleday, 1979.

Aswad, Barbara. *Arabic-Speaking Communities in American Cities*. New York: Center for Migration Studies and the Association of Arab-American University Graduates, 1974.

Atiyeh, George, ed. *Arab and American Cultures*. Washington, D.C.: American Enterprise Institute for Public Policy Research, 1977.

Awad, Joseph. *The Neon Distances*. Francestown, N.H.: Golden Quill Press, 1980.

Awad, Mubarak. "Nonviolent Resistance: A Strategy for the Occupied Territories." *Journal of Palestine Studies* 13, no. 4 (Summer 1984): 22–36.

Ayoob, Joseph. "Were the Phoenicians the First to Discover America?." *Compiler* (Aliquippa, Pa.), 1950.

Bache, Sami. "A Trip to the Interior of the Middle East." In *Greetings from Home*. Brooklyn, Privately published, July 4, 1944.

Balfour, Emma. *Vicksburg, a City under Siege*. Vicksburg: Philip C. Weinberger [privately printed], 1983.

"Beirut Was Such a Marvelous City." *Village Voice*, February 28, 1984.

Benet, Lorenzo. "A Community Coming of Age: Arab-Americans in L.A." *Daily News*, May 12, 1986.

Bengough, W. "The Syrian Colony." *Harper's Weekly*, August 3, 1895, p. 746.

Benyon, E. D. "The Near East in Flint, Michigan: Assyrians and Druses and Their Ante-
cedents." *Geographical Review* 24 (January 1944): 272–273.

Berger, Morroe. "America's Syrian Community." *Commentary* 25, no. 4 (April 1958):
314–323.

Bishara, K. A. "The Contribution of the Syrian Immigrant to America." *Syrian World* 1,
no. 7 (January 1927): 16–18.

Blair, Clay. *Ridgeway's Paratroopers*. New York: Dial Press, 1985.

Blatty, William Peter. *I'll Tell Them I Remember You*. New York: W. W. Norton & Co.,
1973.

———. *Which Way to Mecca, Jack?*. New York: B. Geis, 1960.

Bliss, Daniel. *Reminiscenses of Daniel Bliss*. New York: Fleming H. Revell Co., 1920.

Boland, Charles Michael. *They All Discovered America*. New York: Doubleday, 1961.

Bourjaily, Vance. *Confessions of a Spent Youth*. New York: Arbor House, 1986 (reissue).

———. *The End of My Life*. New York: Arbor House, 1984 (reissue).

———. "My Father's Life." *Esquire,* March 1984.

Brown, Francis, and Joseph Roucik, eds. *One America*. New York: Prentice-Hall, 1945.

Brown, Warren. "Detroit: Arabs' Mecca in the Midwest." *Washington Post,* October 30,
1978.

Chami, Joseph. *Days of Tragedy*. Beirut: Shousan, 1978.

Chessari, Joe. "Hagler Not Surprised at Hamsho's Win, Welcomes Rematch." *Dispatch*
(Hudson/Bergen County, N.J.), July 27, 1983.

Clark, Brian. "Khalifa at the Bat." *Aramco World Magazine* 37, no. 3 (May–June 1986):
6–13.

Cobban, Helena. *The Palestine Liberation Organization*. New York: Cambridge Univer-
sity Press, 1984.

Coll, Steven. "Down Home with the $10 Billion Barrister: Joe Jamail, a Law unto Him-
self." *Washington Post,* July 31, 1986.

Considine, John. "Jeff Davis' Camels in Arizona." *Sunset,* May, 1923.

Contemporary Authors Autobiography Series. Detroit: Gale Research Co., 1984.

Corning, Blair. "Meet San Antonio's King of the Forgotten." *San Antonio Express-News,*
November 28, 1982.

Corsi, Edward. *The Shadow of Liberty*. New York: Macmillan, 1935.

Courtemanche, Dolores. "Worcester's Lebanese-Syrian Community: An Ethnic Success
Story." *Sunday Telegram,* September 14, 1980.

David, Robert L. "American Influence in the Near East before 1861." *American Quar-
terly* 16, no. 1 (Spring 1964) 70.

DeBakey, Michael E., and Lois DeBakey. "Relighting the Lamp of Excellence." *Forum
on Medicine* 2, no. 8 (August 1979): 523–528.

Demaret, Kent. "Heart Surgeon Michael DeBakey's Sisters Teach Doctors How to Cut Out
That Confusing Jargon." *People Weekly* 17, no. 4 (February 1, 1982): 89–90.

Dimbleby, Jonathan. *The Palestinians*. New York: Quartet Books, 1980.

Doche, Vivian. *Cedars by the Mississippi: The Lebanese-Americans in the Twin Cities*.
San Francisco: R & E Research Associates, 1978.

Donahue, Jack. *Wildcatter: The Story of Michel T. Halbouty*. New York: McGraw-Hill,
1979.

Eilts, Herman. "Ahmad Bin Naaman's Mission to the United States in 1840." *Essex Insti-
tute Quarterly,* October 1962.

Eisenstein, Paul. "Detroit's Lebanese Achieve Harmony Homeland Lacks." *USA Today,* July 22, 1983.

Elfin, David. "Khalifa: Potential Pirate from the Shore of Tripoli." *Washington Post,* July 10, 1983.

Elkholy, Abdo A. *The Arab Muslims in the United States: Religion and Assimilation.* New Haven, Conn.: College and University Press, 1966.

Essey, Father Basil. "A Song of Hope." *The Word* 31, no. 5 (May 1987): 9–11.

"F. Murray Abraham's Class Act." *International Herald Tribune,* October 4–5, 1986, p. 20.

"Factional War Is Waged between Syrians in New York City." *New York Herald,* October 29, 1905.

Fell, Barry. *Saga America.* New York: Times Books, 1980.

Ferris, George A. "Syrians' Future in America." *Syrian World* 3, no. 11 (May 1929): 3–8.

Ferris, Joseph W. "Syrian Naturalization Questions in the United States: Certain Legal Aspects of Our Naturalization Laws." *Syrian World* 2, no. 8 (February 1928): 3–11; no. 9 (March 1928): 18–24.

"First American Jet Ace Dies as Car Overturns in Florida." *New York Times,* November 18, 1966.

First Immigrant. Beirut: World Lebanese Cultural Union, 1972.

Fisk, Pliny. "The Holy Land an Interesting Field of Missionary Enterprise." In *Sermons of Rev. Messrs. Fisk & Parsons Just before Their Departure on the Palestine Mission.* Boston: Samuel T. Armstrong, 1819.

"Five Recruited for Turkey—Story of the Arabs Now at Castle Gardens." *New York Daily Tribune,* May 24, 1877.

"Flies 30 Missions, None of Crew Hurt." *Minneapolis Daily Times,* July 1, 1944.

Ford, Henry Chapman. "Anna Ascends." *Syrian World* 2, no. 1 (July 1927).

———. "Why I Wrote a Syrian Play." *Syrian World* 2, no. 1 (July 1927).

Franklin, Stephen. "Arab-Americans Organize for a Role in U.S. Politics." *Philadelphia Inquirer,* April 8, 1984.

Geerhold, William. "The Mosque on Massachusetts Avenue." *Aramco World Magazine* 16 (May–June 1965): 20–21.

"Ghetto Sights." *Cedar Rapids Evening Gazette,* November 9, 1897.

Gibran, Jean, and Kahlil Gibran. *Kahlil Gibran: His Life and World.* New York: Avenel Books, 1981.

Gibran, Kahlil. "To Young Americans of Syrian Origin." *Syrian World* 1, no. 1 (July 1926): 4–5.

Glubb, Sir John. *A Short History of the Arab Peoples.* New York: Stein and Day, 1969.

Goldberg, Merle. "Casbah in Brooklyn." *New York Magazine,* July 14, 1969, pp. 62–65.

Gorey, Hays. *Nader and the Power of Everyman.* New York: Grosset and Dunlap, 1975.

Graff, Gary. "Oakland County's Arabs: Traditional, American." *Detroit Free Press,* February 17, 1983.

Haddad, Ameen. "The Return Home." *Federation Herald,* January 1953.

Hagopian, Elaine C., and Ann Paden, eds. *The Arab Americans: Studies in Assimilation.* Wilmette, Ill.: Medina University Press International, 1969.

Haiek, Joseph R., ed. *Arab American Almanac.* 3d ed. Glendale, Calif.: News Circle Publishing Co., 1984.

Hakim, A. "Conflicting Standards in the Syrian Home in America." *Syrian World* 6, no. 3 (November 1931): 38–40.

Halaby, Najeeb. *Crosswinds.* New York: Doubleday, 1978.

Hall, Carla. "The Rashids: All Relatives." *Washington Post,* July 8, 1985.

Halsell, Grace. "Will the Arab Lobby Please Stand Up?." *Middle East,* no. 98 (December 1982).

Hamid, George. *Circus.* New York: Sterling Publishing Co., 1953.

Hamod, Sam. *Dying with the Wrong Name.* New York: Anthe Publications, 1980.

"Hard Times." *Syrian World* 6, no. 6 (February 1932): 44–45.

Harsham, Philip. "Arabs in America." *Aramco World Magazine* 26, no. 2 (March–April 1975).

———. "Islam in Iowa." *Aramco World Magazine* 27 (November–December 1976): 30–36.

———. "One Arab's America." *Aramco World Magazine* 26, no. 2 (March–April 1975): 14–15.

Hawie, Ashad G. *The Rainbow Ends.* New York: T. Gaus' Sons, 1942.

Hayden, H. C., ed. *American Heroes in Mission Fields.* New York: American Tract Society, 1890.

Hayes, Alfred. "Abraham Perfect in BSO Narration." *Baltimore Sun,* July 11, 1985.

Hazo, Samuel. "A Poet's Journey: An American in the Land of His Ancestors." *Jubilee,* December 1965, pp. 44–49.

———. *Thank a Bored Angel: Selected Poems.* New York: New Directions, 1983.

———. *The Very Fall of the Sun.* New York: Pocket Books, 1979.

Hillier, Bevis. "California Craftsmen." *Los Angeles Times Home Magazine,* November 25, 1984, pp. 12–14.

Hitti, Philip K. *Capital Cities of Islam.* Minneapolis: University of Minnesota Press, 1973.

———. *A Short History of Lebanon.* New York: St. Martin's Press, 1965.

———. *Syria: A Short History.* London: Macmillan, 1959.

———. *The Syrians in America.* New York: George Doran, 1924.

Al Hoda. *The Story of Lebanon and Its Emigrants.* New York: Al Hoda Press, 1968.

Hooglund, Eric, ed. *Crossing the Waters: Arabic-Speaking Immigrants to the United States before 1940.* Washington, D.C.: Smithsonian Institution Press, 1987.

———, ed. *Taking Root.* Washington, D.C.: American-Arab Anti-Discrimination Committee, 1985.

Houghton, Louise Seymour. "The Syrians in the United States." *Survey* 26, nos. 1–4 (1911): 480–495, 647–665, 786–802, 957–968.

Howe, Russell Warren. "Arab-Americans Seen as Pro-Reagan." *Washington Times,* August 31, 1984.

Hughes, James. "An Open House." *New Yorker,* October 1980.

"The Hyaks and the Alkeks, among the Pioneer Grocerymen of Victoria." In *The Victoria Sesquicentennial Scrapbook, 1824–1974.* Victoria, Tex.: Advocate Printing, 1974.

"Interview with Jonathan Kuttub." *Arab-American Affairs* 16 (Spring 1986): 120–127.

Issawi, Charles, ed. *The Economic History of the Middle East, 1800–1914.* Chicago: University of Chicago Press/Midway Reprint, 1975.

Jaafari, Lafi Ibrahim. "The Brain Drain to the United States: The Migration of Jordanian

and Palestinian Professionals and Students." *Journal of Palestine Studies* 3, no. 1 (1971): 119–131.

Jacobs, Joseph J. *Jacobs Engineering Group, Inc.: A Story of Pride, Reputation, and Integrity.* Princeton, N.J.: Newcomen Society, 1980.

———. "Lebanon Reconstruction: Fantasy Amid Chaos." Paper delivered to a seminar at the Center for International Development, University of Maryland, July 23, 1985.

Jessup, Henry. *Fifty-three Years in Syria.* New York: Fleming H. Revell Co., 1910.

Jiryis, Sabri. *The Arabs in Israel.* New York: Monthly Review Press, 1976.

Joseph, Lawrence. *Shouting at No One.* Pittsburgh: University of Pittsburgh Press, 1983.

Jubran, Zakia Makla. "The Makla Family History." ms., Brooklyn, 1981.

Karkabi, Barbara, and Rebecca Trounson. "Houston's Arab-Americas: Trying to Pull Together." *Houston Chronicle,* January 18, 19, 20, 1986.

Katibah, Habib Ibrahim. "Syrian Americans," in *One America,* ed. Francis J. Brown and Joseph S. Roucek, pp. 291–297. New York: Prentice-Hall, 1945.

———, and Farhat Ziadeh. *Arabic-Speaking Americans.* New York: Institute of Arab American Affairs, 1941.

Kayal, Philip M. *An Arab-American Bibliographic Guide.* Belmont, Mass.: Association of Arab-American University Graduates, 1985.

———, and Joseph M. Kayal. *The Syrian-Lebanese in America: A Study in Religion and Assimilation.* Boston: Twayne, 1975.

Khalidi, Walid. *Conflict and Violence in Lebanon.* Cambridge, Mass.: Harvard University Press, 1979.

Kherbawi, Reverend Basil. *History of the United States and the History of the Syrian Immigration* (in Arabic). New York: Al-Dalil Press, 1913.

El-Khourie, H. A. "In Defense of the Semitic and the Syrian Especially." *Birmingham Ledger,* September 20, 1907.

Kinsley, Michael. "St. Ralph." *Washington Post,* November 21, 1985.

LaHood, Louis. *Wings in the Hands of the Lord: A World War II Journal.* Peoria, Ill.: Privately published, 1977.

Lamb, David. "U.S. Arabs Close Ranks over Bias." *Los Angeles Times,* March 13, 1987, pp. 1, 26, 27.

Latham, Scott. "No Slack Season for Haggar Chief." *Dallas Times-Herald,* November 18, 1976.

Lesley, Lewis Burt, ed. *Uncle Sam's Camels.* Cambridge, Mass.: Harvard University Press, 1929.

Lilienthal, Alfred. *The Zionist Connection II: What Price Peace?.* Seal Beach, Calif.: Concord Books, 1983.

"The Lutemaker of Brooklyn" [Ernest Maliha]. *Aramco World Magazine* 9 (November 1958): 3–5.

McGarry, Charles. *Citizen Nader.* New York: Saturday Review Press, 1972.

Macron, Mary Haddad. *Arab-Americans and Their Communities of Cleveland.* Cleveland: Cleveland State University Ethnic Heritage Studies, 1979.

Madison, Christopher. "Arab-American Lobby Fights Rearguard Battle to Influence U.S. Mideast Policy." *National Journal,* August 31, 1985, pp. 1934–1939.

Makdisi, Nadim. "Arab Adventurers in the New World." *Yearbook 1965–66.* New York: Action Committee on Arab American Relations, 1966.

————. "The Maronite in the Americas and in Atlanta." In *Golden Jubilee Book*. Atlanta: Atlanta Maronite Community, 1962.

————. "The Moslems of America." *Christian Century* 76 (August 26, 1959): 969–971.

Maloof, Sam. *Woodworker*. Tokyo: Kodoshan, 1984.

Mansur, W. A. "Problems of Syrian Youth in America." *Syrian World* 2, no. 6 (December 1927): 8–12; no. 7 (January 1928): 9–14.

Marley, Mike. "Hagler Lives Up to Tradition of Middleweight Champions." *New York Post,* October 3, 1981.

May, Clifford. "Lebanese in Africa: Tale of Success (and Anxiety)." *New York Times,* July 9, 1984.

Mehdi, Beverlee Turner. *The Arabs in America, 1492–1977: A Chronology and Fact Book*. Dobbs Ferry, N.Y.: Oceana Publications, 1978.

Melhem, D. H. *Rest in Love*. New York: Dovetail Press, 1975.

Melkites in America: A Dictionary and Informative Handbook. West Newton, Mass.: Melkite Exarchate, 1971.

Milbert, Neil. "Syrian Challenger Has Exotic Fight Credentials, Too." *Chicago Tribune,* September 29, 1981.

Miller, Lucius Hopkins. *Our Syrian Population: A Study of the Syrian Communities of Greater New York*. San Francisco: R. D. Reed, 1969 (reprint of the 1904 edition).

Moehinger, J. R. "Said's Style Is Convincing, Charisma Seen as Dangerous." *Yale Daily News,* October 4, 1983.

Mokarzel, Salloum. "Christian-Moslem Marriages." *Syrian World* 2 (April 1928): 14.

————. *The History of the Syrian American Immigrants in America, 1920–1921* (in Arabic). New York: Syrian American Press, n.d.

————. "History of the Syrians in New York." *Syrian World* 2, no. 5 (November 1927): 3–13.

————. "A Picturesque Colony." *New York Tribune,* October 2, 1892, p. 21.

Morse, Susan. "Dearborn Seamen Awarded $750,000 for Ship Accident." *Detroit Free Press,* January 16, 1977.

Moses, John G. *From Mt. Lebanon to the Mohawk Valley: The Story of Syro-Lebanese Americans of the Utica Area*. Utica, N.Y.: Published by the author, 1981.

Murphy, Caryle. "Some Libyans Fear Qaddafi's Reach." *Washington Post,* July 24, 1985.

————. "Tending Middle East Wounds, 12 Young Arabs Brought to U.S. for Treatment." *Washington Post,* March 5, 1983.

Naff, Alixa. "Arabs." In *Harvard Encyclopedia of American Ethnic Groups,* ed. Stephen Thernstrom et al., pp. 128–136. Cambridge, Mass.: Belknap Press of Harvard University Press, 1980.

————. *Becoming American: The Early Arab Immigrant Experience*. Carbondale, Ill.: Southern Illinois University Press, 1985.

Nasser, Eugene Paul. *Wind of the Land*. Detroit: Association of Arab-American University Graduates, 1979.

Neima, Dr. Theodore G. "An Epic Tale That Came Out of the Valley of Lebanon, a Biography of the Haddad Brothers." *News Circle* 10, no. 117 (March 1982): 36–39.

Noble, Alice. "Men's Clothing Store Only Sells American-Made Merchandise." *Chicago Tribune,* March 22, 1981.

Nye, Naomi Shihab. *Different Ways to Pray*. Portland, Ore.: Breitenbush Publications, 1980.

————. *Hugging the Jukebox*. New York: E. P. Dutton, 1982.

————. "One Village." *Journal of Palestine Studies* 13, no. 2 (January 1984): 31–47.

————. *Yellow Glove*. Portland, Ore.: Breitenbush Publications, 1986.

"Once Numerous Moslem Community Now Reduced to Half Dozen." *Minot* [N.D.] *Daily News*, December 7, 1968.

Orfalea, Gregory. "An A-rab in America." *Middle East International*, December 21, 1981, pp. 8–9.

————. "The Awakening of the Arab Americans." *Middle East International*, January 15, 1982, pp. 11–13.

————. *The Capital of Solitude*. Greenfield Center, N.Y.: Ithaca House, 1988.

————. "The Chandelier." *Triquarterly* 61 (Fall 1984): 27–36.

————. "Deeb Awad." *Greenfield Review* 8, nos. 3–4 (Fall 1980): 187–190.

————, ed. "Nazera: The Last Words." Selection of the journals of Nazera Jabaly Orfalea. 1982.

————. "To Hope." *Jewish Currents*, May 1982, pp. 17–19, 35.

————. *U.S.-Arab Relations: The Literary Dimension*. Washington, D.C.: National Council on U.S.-Arab Relations, 1984.

————, and Sharif Elmusa, eds. *Grape Leaves*. Salt Lake City: University of Utah Press, 1988.

————, and Libby Jackowski. "The Arab Americans." *Aramco World Magazine* 37, no. 5 (September–October 1986): 16–32.

The Orthodox Patriarchal Convent of Our Lady of Saydanaya. Jerusalem: Commercial Press, 1954.

Othman, Ibrahim. *Arabs in the United States: A Study of an Arab American Community*. Amman, Jordan: Shashan and the University of Jordan, 1974.

Papier, Deborah. "Helen Thomas on the White House Beat." *Washington Times*, December 5, 1984.

Parsons, Levi. *Memoir of Levi Parsons, Late Missionary to Palestine*. Edited by Rev. Daniel O. Marton. Poultney, Vt.: 1924.

Perkins, Dr. Kenneth J. "Three Middle Eastern States Helped America Celebrate Its Centennial in Philadelphia." *Aramco World Magazine* 26, no. 6 (November–December 1976).

Peters, Issa. "The Arabic-Speaking Community in Central Arizona before 1940." Paper delivered at the Philip K. Hitti Symposium, Immigration History and Research Center, University of Minnesota, June 4, 1983.

Phelon, Craig. "Her Life Is a Festival All Year Long: A Day in the Life of Jo Ann Andera." *San Antonio Express News Sunday Magazine*, July 31, 1983.

Piestschmann, Richard J. "Casey's Quandary." *Los Angeles Magazine*. April 1, 1983, p. 132.

Pop, Nathan. "Casey Kasem." *Boston Globe*, March 30, 1985.

Al-Qazzaz, Ayad. *Transnational Links between Arab Community in the United States and the Arab World*. Sacramento: Cal Central Press, 1979.

Randal, Jonathan. *Going All the Way: Christian Warlords, Israeli Adventurers, and the War in Lebanon*. New York: Viking, 1983.

"The Rashids: It's All Relatives." *Washington Post*, July 8, 1985.

Reddy, Stan. "DeBakey." *Houston Chronicle* (*Texas Magazine*), October 12, 1980.

"Relief Movements among U.S. Syrians." *Syrian World* 6, no. 2 (October 1931): 54–55.

Rihani, Ameen. *The Book of Khalid*. New York: Dodd, Mead, 1911.

Rihbany, Abraham Mitry. *A Far Journey*. Boston: Houghton Mifflin, 1914.

Rizk, Salom. *Syrian Yankee*. Garden City, N.Y.: Doubleday, 1943.

Rowe, Jonathan. "Nader Reconsidered." *Washington Monthly*, March 1985, pp. 12–21.

Sadd, Gladys Shibley. "First Generation Americans: A Stroll Down Memory Lane." *New Lebanese American Journal* 9, no. 34 (December 6, 1982): 8, 10.

Safa, Milhem, ed. "A Farewell Speech to My Brethren, the Druze." MS., Qara Qool al Druze, Lebanon, January 22, 1931.

Said, Edward. *After the Last Sky*. New York: Pantheon, 1986.

———. *Orientalism*. New York: Vintage Books, 1978.

———. *The World, the Text, the Critic*. Cambridge, Mass.: Harvard University Press, 1983.

Sakir, Said Joseph. *The Original Eulogy of the Deceased Arbeely Family*. New York: Kowkab America, 1904. [Arabic]

Salamey, Margaret K. *Grandmother Told Me*. Utica, N.Y.: Published by the author, 1982.

Samore, Lee T. "A Sociologistic Survey of the Lebanese Orthodox-Christian Community in Sioux City, Iowa." Paper delivered at the Philip K. Hitti Symposium, Immigration History and Research Center, University of Minnesota, June 4, 1983.

Samra, Father Nicholas. "Early Beginnings of the Melkite Church in the U.S." *Sophia* 13, no. 2 (March–April 1983): 3.

———. "Rugby Update." *Sophia* 13, no. 6 (November–December 1983): 2.

Schmidt, Dana Adams. "Arab-Americans Gearing for Los Angeles Olympics." *Middle East Times*, July 7–14, 1984.

Scriber, Mary Jane. "DeBakey Keeps Ambitious Pace as He Nears 75." *Houston Post*, September 4, 1983.

Selim, George Dimitri. *The Arabs in the United States: A Selected List of References*. Washington, D.C.: Library of Congress, 1983.

Sengstock, Mary C. *Chaldean Americans: Changing Conceptions of Ethnic Identity*. Staten Island, N.Y.: Center for Migration Studies, 1982.

Shadid, Michael. *A Doctor for the People: The Autobiography of the Founder of America's First Cooperative Hospital*. New York: Vanguard Press, 1939.

Shaheen, Jack. "A Gathering of 4 Generations." *Pittsburgh Post Gazette*, August 22, 1983.

Shakir, Evelyn. "Pretending to Be an Arab: Role-Playing in Vance Bourjaily's 'The Fractional Man,'" *MELOS* 9, no. 1 (Spring 1982): 7–21.

———. "Starting Anew: Arab-American Poetry." *Ethnic Forum* 7, no. 1 (1983): 9–13.

Shatara, F. I. "Health Problems of the Syrians in the United States." *Syrian World* 1, no. 3 (September 1926): 8–10.

Shihab, Aziz. *Sirhan*. San Antonio: Naylor Co., 1969.

Shindler, Merrill. "Jean and Casey Kasem Raise Pot of Gold for the Rainbow Coalition." *News Circle* 12, no. 144 (June 1984): 32.

Smith, Marlene Khoury. "The Arabic-Speaking Communities in Rhode Island." In *Hidden Minorities: The Persistence of Ethnicity in American Life*, ed. Joan H. Rollins. Washington, D.C.: University Press of America, 1981.

Smith, Toby. "Arrows from Strong Bows." *New Mexico Magazine*, February 1982, p. 25.

Spiegel, Joy. *That Haggar Man: A Biographical Portrait*. New York: Random House, 1978.

Stern, Zelda. *Ethnic New York*. New York: St. Martin's Press, 1980.

Stevenson, Kathy Jaber. "Modern Day Forty-Niners: The Druze of Southern California." *Our World* 1, no. 2 (Winter 1985): 36–38.

Sullivan, Michael B. "Damascus in Brooklyn." *Aramco World Magazine* 17 (May–June 1961): 28–33.

Swanson, Dr. Jon. "Sojourners and Settlers in Yemen and America." *Ms.*, 1985.

The Syrian and Lebanese Texans. San Antonio: Institute of Texan Cultures, 1974.

"Syrians of Boston Present Symbolic Painting." *Syrian World* 6, no. 8 (May 1932): 51.

Tahan, Mary. "Bob Andrews Heads Lettuce Kingdom While Scoring High in Community Services." *News Circle* 9, no. 103 (January 1981): 23–29.

―――. "A Grateful Salute to the Haddads: Amean, Holline, Wydea, and Nazera." *News Circle* 10, no. 117 (March 1982): 34–35.

Tanber, George Joseph. "John's World: The Story of John Abood." *Toledo (Blade) Magazine,* January 18–24, 1987, pp. 6–12.

Tannous, Afif. "Acculturation of an Arab-Syrian Community in the Deep South." *American Sociological Review* 8 (June 1943): 264–271.

Thomas, Danny. "The Vow I Almost Forgot." *Guideposts* 36, no. 3 (May 1981): 4.

Thomas, Helen. *Dateline: Washington*. New York: Macmillan, 1975.

Thomas, Katrina. "Festival in Fall River." *Aramco World Magazine* 27, no. 6 (November–December 1976): 2–7.

Tillman, Seth. *The United States and the Middle East*. Bloomington: Indiana University Press, 1982.

Tintle, Joe. "Mustapha Hamsho: Syrian-Bred, American-Based." *Ring Magazine,* December 1980, p. 35.

Tuma, Elias H. "The Palestinians in America." *The Link* 14, no. 3 (July–August 1981): 1–14.

Turki, Fawaz. *Tel Zaatar Was the Hill of Thyme*. Washington, D.C.: Palestine Review Press, 1978.

Van Slyke, Lucille Baldwin. "The Peddler." *American Magazine* 74 (August 1912): 411.

Viorst, Milton. "Building an Arab-American Lobby." *Washington Post Magazine,* September 14, 1980.

Wasfi, Atif A. *An Islamic-Lebanese Community in the U.S.A.: A Study in Cultural Anthropology*. Beirut: Beirut Arab University, 1971.

Wilbon, Michael. "Seikaly Is a Man of the World, a Babe on the Basketball Court." *Washington Post,* February 22, 1987.

"Will the Palestinians Tolerate Such?." *Al-Bayan,* November 16, 1927. Translated in *Syrian World* 2, no. 6 (December 1927).

Yorkin, Nicole. "KNBC Newsman Helps Bring Couple Orphan Boy to L.A." *Los Angeles Herald-Examiner,* December 1, 1983.

Younis, Adele. "The Arabs Who Followed Columbus." *Arab World* (New York) 12 (March 1966): 13–14; (August 1966): 14–15.

―――. "The Coming of the Arabic-Speaking People to the United States." Doctoral thesis, Boston University, 1961.

―――. "Salem and the Early Syrian Venture." *Essex Historical Collection,* October 1966, p. 304.

Zelditch, Morris. "The Syrians in Pittsburgh." M.A. thesis, University of Pennsylvania, 1936.

Index